ÉDOUARD VUILLARD

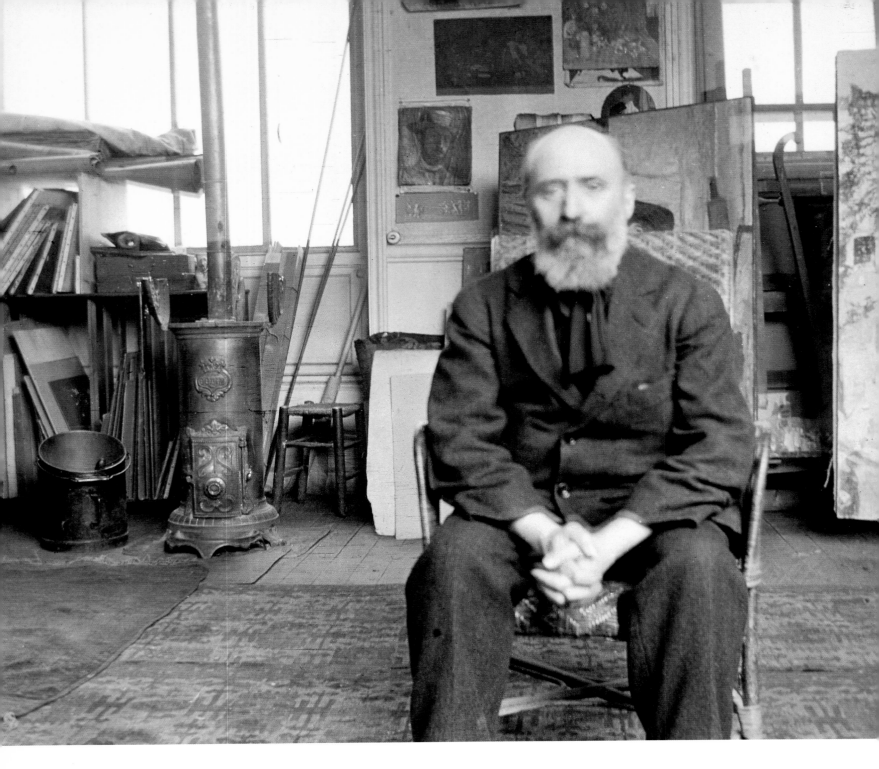

National Gallery of Art, Washington
*19 January — 20 April 2003*

———

The Montreal Museum of Fine Arts
*15 May — 24 August 2003*

———

Galeries nationales du Grand Palais, Paris
*23 September 2003 — 4 January 2004*

———

Royal Academy of Arts, London
*31 January — 18 April 2004*

ÉDOUARD VUILLARD

Copublished by

The Montreal Museum
of Fine Arts

National Gallery
of Art, Washington

in association with

Yale University Press
New Haven and London

Guy Cogeval

with

Kimberly Jones
Laurence des Cars
MaryAnne Stevens

contributions by

Dario Gamboni
Elizabeth Easton
Mathias Chivot

THE EXHIBITION IN WASHINGTON AND
PARIS IS MADE POSSIBLE BY
GENEROUS SUPPORT FROM AIRBUS

The exhibition has been organized
by the National Gallery of Art,
Washington, the Montreal Museum
of Fine Arts (Jean-Noël Desmarais
Pavilion), the Réunion des musées
nationaux / Musée d'Orsay, Paris, and
the Royal Academy of Arts, London.

The exhibition is supported by an
indemnity from the Federal Council
on the Arts and the Humanities,
Washington, D.C.

The Montreal Museum of Fine Arts
international exhibition program
receives assistance from Canadian
Heritage through the Canada Trav-
elling Exhibitions Indemnification
Program and financial support from
the Exhibition Fund of the Montreal
Museum of Fine Arts Foundation
and the Paul G. Desmarais Fund.

The Royal Academy of Arts is
grateful to Her Majesty's Govern-
ment for agreeing to indemnify
this exhibition under the National
Heritage Act 1980, and Resource,
The Council for Museums, Archives
and Libraries, for its help in arrang-
ing the indemnity.

The hardcover edition is published
by The Montreal Museum of Fine
Arts and the National Gallery of
Art, Washington, in association with
Yale University Press, New Haven
and London.

**Curators of the Exhibition**

Guy Cogeval, general curator;
Kimberly Jones, Laurence des Cars,
and MaryAnne Stevens

Edited and translated by the
Publishing Department of The
Montreal Museum of Fine Arts

Francine Lavoie, *Head of Publishing*
Judith Terry, *Editor*
assisted by Douglas Campbell,
Donald Pistolesi
Jill Corner, *Translator*
assisted by Marcia Couëlle,
Donald McGrath

Produced by the Publishing Office,
National Gallery of Art, Washington

Judy Metro, *Editor in Chief*
Karen Sagstetter, *Project Manager*

Designed by Margaret Bauer

The quote by Vuillard on the back
cover comes from his *Journal* 1.2, 68
(January 1894).

**Library of Congress
Cataloguing-in-Publication Data**

Cogeval, Guy.
Édouard Vuillard / Guy Cogeval
with Kimberly Jones…[et al.]

    p.   cm.

National Gallery of Art, Washington,
19 January–20 April 2003, The
Montreal Museum of Fine Arts,
15 May–24 August 2003, Galeries
nationales du Grand Palais, Paris,
23 September 2003–4 January 2004,
Royal Academy of Arts, London,
31 January–18 April 2004.

ISBN 0-89468-297-0
(pbk.: alk. paper, USA)

ISBN 0-300-09737-9
(hardcover, USA )

Includes bibliographical references
and index.

1. Vuillard, Édouard, 1868–1940—
Exhibitions. I. Vuillard, Édouard,
1868–1940. II. National Gallery
of Art (U.S.) III. Title.

N6853.V85 A4 2003
759.4 — dc21       2002151120

**National Library of Canada
Bibliothèque nationale du Québec**

ISBN 2-89192-260-3
(softcover, Canada )

ISBN 2-89192-261-1
(hardcover, Canada )

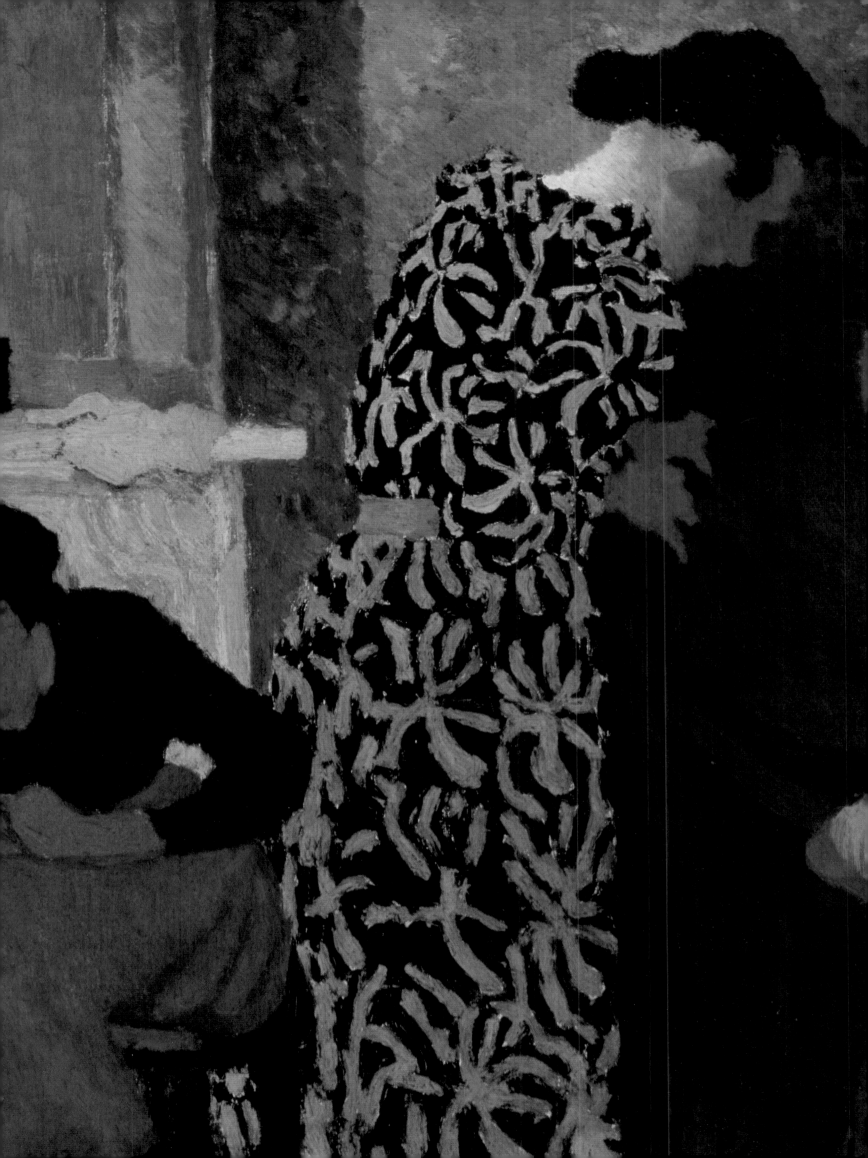

# CONTENTS

Directors' Foreword · viii

Acknowledgments · xii

Note to the Reader · xvii

Lenders to the Exhibition · xviii

INTRODUCTION · 1

CATALOGUE · 51

ESSAYS · 405

Chronology · 473

Exhibitions and Sources Cited · 483

Index · 491

Index of Works by Vuillard
Illustrated in the Catalogue · 497

Credits · 501

INTRODUCTION

1 · Backward Glances
   *Guy Cogeval*

CATALOGUE

51 · Permanent Transgression
   Nos. 1–34

91 · Vuillard Onstage
   Nos. 35–75

129 · Behind Closed Doors
   Nos. 76–102

163 · The Decorative Impulse
   Nos. 103–142

205 · The Turning Point
   Nos. 143–165

239 · Vuillard and His Photographs
   Nos. 166–253

283 · The Triumph of Light
   Nos. 254–276

323 · Tradition, Genre, Modernity
   Nos. 277–296

355 · "I Don't Paint Portraits"
   Nos. 297–334

ESSAYS

405 · Vuillard and Ambiguity
   *Dario Gamboni*

423 · The Intentional Snapshot
   *Elizabeth Easton*

439 · Vuillard and the "Villégiature"
   *Kimberly Jones*

459 · Vuillard between Two Centuries
   *Laurence des Cars*

The first retrospective devoted to the art of Édouard Vuillard was held in 1938, just two years prior to the painter's death. Comprising more than three hundred works, the exhibition was a critical success that firmly established Vuillard's status as one of the great modern masters of his generation. Now, sixty-five years later, the National Gallery of Art, Washington, the Montreal Museum of Fine Arts, the Réunion des musées nationaux / Musée d'Orsay, Paris, and the Royal Academy of Arts, London, take great pleasure in presenting *Édouard Vuillard*, the most comprehensive exhibition ever devoted to this important artist.

The organization of an exhibition on a single artist is generally a long and exacting task—this one perhaps more than most, for the goal was to take stock of years of research on an artist who is relatively well-known but not always adequately understood. Our aim was to build up a rather more accurate and balanced picture of Édouard Vuillard's personality as a creative artist, and also as a human being, with all his contradictions and passions. From this research there emerged the figure of a leading protagonist of Post-Impressionism, a contemporary of Gauguin and Seurat who nevertheless painted two-thirds of his oeuvre during the twentieth century. He was, therefore, also a contemporary of Matisse, Picasso, Cubism, and the "Recall to Order" of the post-First World War period, an artist who succeeded in finding his place alongside these towering geniuses and powerful movements. Historically, there has been a tendency to consider Vuillard a shy, monkish figure, turned in on himself, and unworldly. Many writers have been willing to concede that he excelled in certain fields: the intimism of his *petit-bourgeois* scenes, and the great decorative panels where he could display his outstanding technical virtuosity; others have even gone so far as to admire his late portraits. Our research revealed a colourful character, discreetly authoritative, sometimes quick-tempered, decisive, passionate, a man able to impose his views on those around him, and above all an artist who transformed the unimportant happenings of everyday life into the very stuff of his painting. Indeed, a number of his hermetic interiors tell stories of events in his life, real dramas that affected him, while many of his large decorative panels contain

specific allusions to his entourage, the people he loved, to an extent that no one guessed until now. Over a span of fifty years Vuillard created a body of work that raises the question of his place within the modern tradition.

This body of work has rarely been considered in its entirety. Vuillard's oeuvre is astounding not only in its size, but in its range and diversity. He explored a remarkable variety of media—easel paintings, large-scale decorations for both private and public spaces, drawings, prints, photographs, stage sets, theatre programs and decorative arts—and delighted in the challenge presented by unconventional formats such as folding screens and difficult materials such as *peinture à la colle* or distemper. This variety is similarly reflected in the subjects treated by the artist. In addition to his justly renowned domestic interiors, Vuillard also painted portraits, still lifes, landscapes and genre scenes. No subject was too humble or too refined to escape the artist's keen eye.

This exhibition and the accompanying catalogue, the product of very close and intense collaboration among our four institutions over several years, coincide with the publication of the long anticipated catalogue raisonné authored by Guy Cogeval and published by the Wildenstein Institute. The curatorial team has had unprecedented access to unpublished documents, photographs, and other archival material, as well as to research from the catalogue raisonné itself, which have been invaluable to this project.

Fundamental to the success of any exhibition is the expertise of its curators. Guy Cogeval, as general curator of the exhibition, is extremely grateful to his collaborator Mathias Chivot from the Vuillard catalogue raisonné, as well as to his fellow curators Kimberly Jones of the National Gallery of Art, Laurence des Cars of the Musée d'Orsay, and MaryAnne Stevens of the Royal Academy of Arts. Their knowledge and dedication have been greatly appreciated.

Such an ambitious endeavour would not have been possible without the support of numerous private collectors, museum directors, and curators across Europe and North and South America. We were overwhelmed by the enthusiasm with which our requests were met and the generosity with which they were honoured. It is rare to see so many

owners part so willingly with their greatest masterpieces so that others might enjoy the delights of such a gathering. On behalf of the fortunate visitors to the exhibition, we express our thanks.

The exhibition is generously supported in Washington and Paris by Airbus. The National Gallery is extremely pleased to welcome Airbus back for its third sponsorship. Airbus' continuing contributions to the National Gallery's exhibition programs are greatly appreciated. It is our pleasure to recognize the Federal Council on the Arts and the Humanities for granting U.S. Government Indemnity, without which such an ambitious project would not have been possible.

The Montreal Museum of Fine Arts wishes to thank Quebec's Ministère de la Culture et des Communications for its ongoing support, as well as *La Presse*, *The Gazette*, Société Radio Canada and 105.7 RYTHME FM, its media partners. The Museum's international exhibition program receives assistance from Canadian Heritage through the Canada Travelling Exhibitions Indemnification Program and financial support from the Exhibition Fund of the Montreal Museum of Fine Arts Foundation and the Paul G. Desmarais Fund.

The Royal Academy of Arts is grateful to Her Majesty's Government for agreeing to indemnify this exhibition and Resource, The Council for Museums, Archives and Libraries, for its help in arranging the indemnity.

It is the organizers' intention that the exhibition and its catalogue serve to make the work of this important artist better known to and appreciated by our audiences in North America and Europe.

**Earl A. Powell III**  *Director, National Gallery of Art*
**Guy Cogeval**  *Director, The Montreal Museum of Fine Arts*
**Francine Mariani-Ducray**  *Director, Musées de France*
**Serge Lemoine**  *Director, Musée d'Orsay*
**Phillip King**  CBE, *President, Royal Academy of Arts*

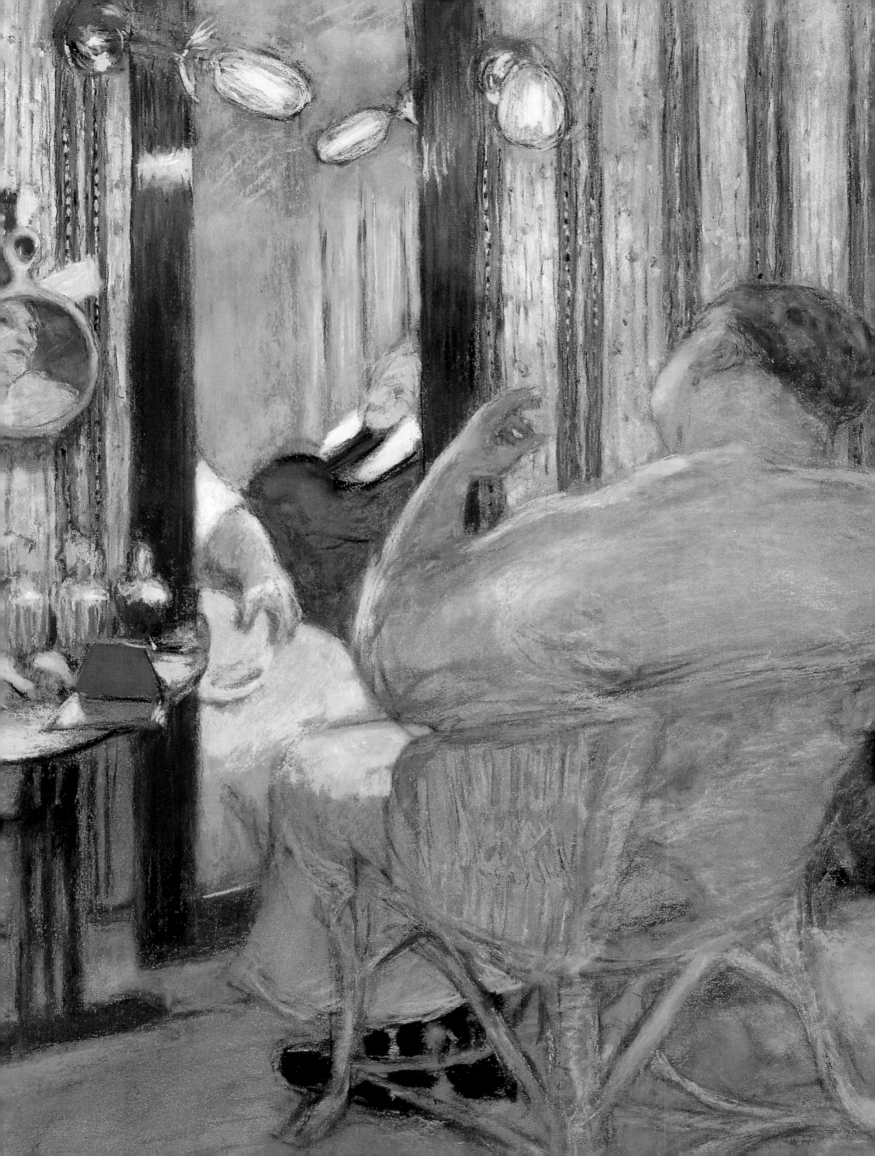

## ACKNOWLEDGMENTS

We are extremely grateful to the many people who have contributed to this catalogue and exhibition over a period of many years. The outcome of the *Édouard Vuillard* exhibition has been closely linked to the creation of the catalogue raisonné, *Vuillard: Critical Catalogue of Paintings and Pastels*. This compendious work, under preparation since the end of the Second World War, is scheduled for publication in 2003. The writing of the catalogue raisonné was entrusted to Guy Cogeval by the Salomon family and the Institut Wildenstein in the summer of 1996, and the research and the extended entries of the catalogue raisonné were made available to the curatorial team before publication. The volume contains almost two thousand pages, and bringing it to completion for publication has therefore been a lengthy task. The destinies of the exhibition and of the catalogue raisonné were intertwined, and the Salomon family made the documentation available on the condition that both projects were undertaken simultaneously so as to complement one another.

Guy Cogeval—personally and on behalf of us all—would like to express his warmest gratitude first to Antoine and Colette Salomon, Édouard Vuillard's heirs, who for many years have been passionately concerned that this work should culminate in wider recognition of the great Édouard. The complete access to the archival holdings they so kindly granted Guy Cogeval, and the absolute freedom he was given to make use of them, were remarkable. He wishes to thank Antoine Salomon for trusting him from the start, and especially Colette Salomon, who for six years gave him access to her apartment, in which a sitting room had been transformed into a real Vuillard library. The archives contain letters and postcards received by the artist, a number of letters from his family and friends, bought back by Antoine Salomon over the course of the last fifty years, the technical entries for each work, a complete collection of photographs, and some six to seven thousand preparatory drawings. All this information enabled the general curator to establish dates for paintings hitherto only approximately dated.

Guy Cogeval would like to express heartfelt gratitude to Daniel Wildenstein, who sadly passed away before he could witness the completion of the research he initiated. Thanks go also to his sons, Guy and Alec, together with the staff of the

Wildenstein Institute who worked tirelessly to publish the catalogue raisonné: Joseph Baillio, Ay-Whang Hsia, Marie-Christine Maufus and Elisabeth Raffy.

Like the catalogue raisonné, the exhibition has undergone a long genesis. It was first planned as a joint venture between the National Gallery and the Musée d'Orsay, later joined by colleagues at the Montreal Museum of Fine Arts and the Royal Academy. For their support and encouragement, we are grateful to Earl A. Powell III, director, National Gallery of Art; Francine Mariani-Ducray, director, Musées de France; Philippe Durey, director, École du Louvre, and former chief administrator, Réunion des musées nationaux; Serge Lemoine, director, Musée d'Orsay; Henri Loyrette, president-director, Musée du Louvre, and former director, Musée d'Orsay; and Norman Rosenthal, exhibitions secretary, Royal Academy of Arts.

Many warm thanks go to contributing authors Elizabeth Easton, curator, European Painting and Sculpture, Brooklyn Museum of Art; Dario Gamboni, Institute of Art History, Amsterdam; and Mathias Chivot, the researcher who assisted Guy Cogeval for six years, and worked unflaggingly studying documents in the libraries of Paris and collating the texts.

Our gratitude, too, to the many people who offered valuable information and advice: Anisabelle Bérès, Claire Denis, the late Anne Gruson, Sylvie Legrand, Jean-Michel Nectoux, and Lionel Pissarro. Among the people who graciously assisted in various capacities are Jean-Claude Bellier, Galerie Bellier, Paris; Luc Bellier, Galerie Bellier, Paris; Stéphane Cosman Connery, Sotheby's; David J. Nash, Lucy Dew, Mitchell, Inness & Nash, New York; Christopher Eykyn, Christie's New York; John Golding; Mr. and Mrs. Spencer Hays; Sabine Helms; Waring Hopkins, Galerie Hopkins-Custot, Paris; Samuel, Paul, and Ellen Josefowitz; Christian Neffe, Neffe-Degandt Gallery, London; Henry Neville, Mallet & Son, London; Mrs. Sam Pease; Mark Peploe; Joachim Pissarro; Rodolphe Rapetti; Robert Rosenblum; Monty M. Simmonds; Sir Anthony Tennant; Diane Upright, New York; Nicholas Watkins; Wolfgang Werner; and Nancy Whyte, Nancy Whyte Fine Arts.

For contributions and assistance in scholarly and curatorial matters, we are grateful to Gloria Groom, David and Mary Winton Green Curator, Department of European Painting, Art Institute of Chicago; Faye Wrubel, paintings conservator, Art Institute of Chicago; Sylvain Bellenger, curator of paintings, Cleveland Museum of Art; Ursula Perruchi and Villa Flora, Winterthur Museum; and Marina Ducrey, author of the Vallotton catalogue raisonné. We offer sincerest thanks to all those colleagues and friends whose collaboration helped make this catalogue a real tool for research: Véronique Berecz, Claire Bergeaud, Brigitte Bitker-Ranson, Emmanuel Bréon, André Cariou, Annie Champié, Isabelle Collet, Monsieur Convert, Frédéric Dassas, Marie Davaine, Elisabeth de Farcy, Laure de Margerie, Louise Eliasof, Catherine Feildel, Odile Fraigneau, Claire Frèches, Georges Fréchet, Isabelle Lesmane de Chermont, Jeremy Lewison (Tate), Vicente Madrigal, Janie Munro (Fitzwilliam Museum, Cambridge), Dominique Païni, Christian Paty, Jean-Pierre Pélissier, Anne Pingeot, Marie-Hélène Poix, Katia Poletti, Chris Riopelle (National Gallery, London), Antoinette Romain, Anne Roquebert, Marie-Anne Sarda, William Kelly Simpson, Madame Usumo, and Alix Walsh.

At the Montreal Museum of Fine Arts, we would like to thank Nathalie Bondil, chief curator; Paul Lavallée, director of administration; and Danielle Champagne, director of communications. In the Curatorial Division, gratitude is extended to Pascal Normandin, Monique Dénommée and Sylvie Ouellet; Danièle Archambault, head, Archives; Rodrigue Bédard, head, Conservation; Joanne Déry, head, Library; Francine Lavoie, head, Publishing; Hélène Nadeau, head, Education and Public Programs; Paul Tellier, head, Technical Services; and their teams. In the Administrative Division, we thank Gaétan Bouchard, head, Computer Services; Christine Hamel, manager, Museum Boutique and Bookstore; Francis Mailloux, head, Purchasing and Auxiliary Services; Claude Paradis, head, Security, Information Desk and Ticket Counter; Guy Parent, head, Financial Control and Accounting; and their teams. In the Communications Division, we are grateful to Katia Raveneau as well as Serge Bergeron, head, Editorial Services and Graphic Design; Wanda Palma, head, Public Relations; Michelle Prévost, head, Development and Membership; and their teams.

At the National Gallery of Art, we wish to thank Philip Conisbee, senior curator of European paintings; Michelle Bird, staff assistant; and Ana Maria Zavala, former staff assistant, Department of French Paintings; D. Dodge Thompson, chief of exhibitions; Ann Bigley Robertson, exhibition officer; and Jennifer Overton, Suzanne Sarraf, Tamara L. Wilson, Wendy Battaglino, Elizabeth Middelkoop, and David Allen, Department of Exhibitions, for their care in administrative matters; Susan Arensberg, head, Department of Exhibition Programs; Carroll Moore, film and video producer; Lynn Matheny, assistant curator; and interns Alison Unruh and Debbie DeWitt; Mark Leithauser, chief of design, Department of Design and Installation; Judy Metro, editor in chief; Karen Sagstetter, project manager; Chris Vogel, production manager; Margaret Bauer, designer; Ira Bartfield and Sara Sanders-Buell, Publishing Office; Sally Freitag, chief registrar; Michelle Fondas, registrar of exhibitions; Ann Hoenigswald, conservator; Mervin Richard, deputy chief of conservation and head of department; Hugh Phibbs, coordinator of matting-framing services; Isabelle Raval, assistant general counsel; Christine Myers, chief corporate relations officer and Susan McCullough, sponsorship manager, Office of Corporate Relations; Andrew Robison, Andrew W. Mellon Senior Curator of Prints and Drawings; and Sarah Greenough, curator, Department of Photographs.

At the Musée d'Orsay we wish to acknowledge Anne Distel, senior curator; Sylvie Patin, Caroline Mathieu, and Chantal Georgel, chief curators; Marie-Pierre Salé, curator; Catherine Derosier-Pouchous, former head of audiovisual productions; Patrice Schmidt and the photographic studio; Manou Dufour and the Régie des œuvres. At the Réunion des musées nationaux, we thank Sophie Aurand, chief administrator; Bruno Girveau, project assistant to the chief administrator; Bénédicte Boissonnas, head of exhibitions; and Juliette Armand, administrative assistant; Hélène Flon, exhibition officer; Jean Naudin, head of exhibitions registration; and Marion Tenbusch, registrar; Béatrice Foulon, head of publishing, and Marie-Dominique de Teneuille; Sybille Heftler, patronage; Alain Madeleine-Perdrillat, head of communications; Gilles Romillat and Cécile Vignot.

At the Galeries nationales du Grand Palais, we thank David Guillet, administrator, and Martine Guichard, public relations. At the Centre de recherche et de restauration des musées de France, we thank Nathalie Volle, head; Jacqueline Bret, and Odile Cortet. Our warm thanks to Hubert Le Gall, exhibition designer in Montreal and Paris.

At the Royal Academy of Arts, we wish to thank Norman Rosenthal, exhibitions secretary; David Breuer, chief executive, Royal Academy Enterprises; Emeline Max, Susan Thompson, and Annie Starkey, exhibitions organizers; Miranda Bennion and Roberta Stansfield, photographic coordinators; Hilary Taylor, curatorial assistant; Sue Graves, assistant to MaryAnne Stevens; and Anne Winton, assistant to Norman Rosenthal.

Without the dedication of these many experts, the exhibition and its catalogue could not have become a reality.

**Guy Cogeval** *The Montreal Museum of Fine Arts*
**Kimberly Jones** *National Gallery of Art, Washington*
**Laurence des Cars** *Musée d'Orsay, Paris*
**MaryAnne Stevens** *Royal Academy of Arts, London*

The majority of the works presented in the exhibition are being shown in all four venues—Washington, Montreal, Paris and London—but for reasons of conservation and availability, some have a more limited circulation. However, the catalogue entries that follow reflect the exhibition in its entirety.

The technical information included in the catalogue entries has been largely drawn from the new catalogue raisonné of Vuillard's work (Guy Cogeval and Antoine Salomon, *Vuillard: Critical Catalogue of Paintings and Pastels* [Paris: Wildenstein / Milan: Skira, 2003]). Each painting is accompanied by a Cogeval-Salomon number (abbreviated to c-s in the captions, notes and texts) that links it to the corresponding entry in the catalogue raisonné. All entries include a full provenance and a select exhibition history and bibliography. Priority has been given to exhibitions held during the artist's lifetime and to major exhibitions held after his death; the bibliography sections are limited to the sources most relevant to the work under discussion. Readers are referred to the catalogue raisonné for complete exhibition and bibliographical information. The texts of the entries, while making extensive use of the latest Vuillard research, published for the first time by Guy Cogeval in the catalogue raisonné, constitute original contributions by the various authors.

Titles for all works included in the exhibition are given in both English and the original French. All dimensions are given in centimetres.

## The Journal

One of the most invaluable resources for the study of Vuillard is the artist's journal (cited throughout the present volume as *Journal*). The more than fifty extant volumes, housed in the Institut de France, Paris, span Vuillard's entire career, from 1888 until his death in 1940. The volumes at the Institut are classified as follows:

Volume I (ms. 5396): part 1, 1890 (actually 1888-1890); part 2, 1890—1905

Volume II (ms. 5397): 1907—1916, 9 *carnets*

Volume III (ms. 5398): 1916—1922, 11 *carnets*

Volume IV (ms. 5399): 1929—1940, 13 *carnets*

In addition to the date of the entry, all journal references include three components: volume number, *carnet* number, and folio number (recto or verso). The exception to this are the entries from volume I, part 2, which in addition to folio pages also include a number of loose sheets of paper inserted randomly into the notebook. These are referred to by sheet number.

Unfortunately, of Vuillard's journal containing daily entries, only those notebooks dating from 1907 until his death have come down to us. The entire decade between 1896 and 1906 thus remains largely unaccounted for. There are, however, two chronologies written by the artist, summarizing important events in his life, that help fill this gap. The first of these, probably written in 1905, appears in *Journal*, 1.2, fol. 77v—78. The second, dating from November 11—12, 1908, appears in *Journal*, II.2, fol. 12.

The translations of the journal entries provided in this volume adhere rigorously to the texts as they appear in the original. In order to avoid imposing a meaning on Vuillard's words that was not intended, there has been no attempt to correct either the grammar or the unpunctuated style of his writing.

## Author Abbreviations

The catalogue entries have been written by the following authors:

Guy Cogeval: GC
Laurence des Cars: LC
Kimberly Jones: KJ
MaryAnne Stevens: MAS

## LENDERS TO THE EXHIBITION

Mrs. Margaret Altman

Art Gallery of Ontario, Toronto

The Art Institute of Chicago

Barber Institute of Fine Arts, Birmingham

Mr. Albert Bauer

Collection of Hans-Peter Bauer

Anne Searle Bent

Bibliothèque d'art et d'archéologie, Fondation Jacques Doucet, Paris

Carnegie Museum of Art, Pittsburgh

The Cleveland Museum of Art

Sir Sean and Lady Connery

Mr. Alan G. Fenton

Flint Institute of Arts

Foundation E. G. Bührle Collection, Zurich

Fred Jones, Jr. Museum of Art, The University of Oklahoma

Tom James Company/ Oxxford Clothes

Private Collection Courtesy Kunsthandel Sabine Helms, Munich

Hirshhorn Museum and Sculpture Garden, Smithsonian Institution, Washington

M. Waring Hopkins

Indianapolis Museum of Art

Josefowitz Collection

Kunsthaus Zürich

Los Angeles County Museum of Art

Mr. Vicente Madrigal

Collection Françoise Marquet, Paris

Collection of Mr. and Mrs. Paul Mellon, Upperville, Virginia

Memorial Art Gallery of the University of Rochester

The Memphis Brooks Museum of Art, Memphis

The Metropolitan Museum of Art, New York

The Montreal Museum of Fine Arts

Musée d'Art Moderne de la Ville de Paris

Musée d'Histoire Contemporaine, Paris

Musée d'Orsay, Paris

Musée du Louvre, département des arts graphiques, Paris

Musée de l'Annonciade, Saint-Tropez

Musée des Beaux-Arts, Dijon

Musée des Beaux-Arts, Jules Chéret, Nice

Musée du Petit Palais, Paris

Musées de la Cour d'Or, Metz

Musées Royaux des Beaux-Arts de Belgique, Brussels

Museu de Arte de São Paulo Assis Chateaubriand

The Museum of Fine Arts, Houston

The Museum of Modern Art, New York

The National Gallery, London

National Gallery of Art, Washington

Neffe-Degandt Gallery

Philadelphia Museum of Art

The Phillips Collection, Washington

Sally Engelhard Pingree

Private Collections*

Private Collection Courtesy Galerie Bernheim-Jeune, Paris

Private Collection Courtesy Galerie Hopkins-Custot

Private Collection Courtesy Galerie Bellier

Private Collection Courtesy Mitchell Innes & Nash

Private Collection Courtesy Nancy Whyte Fine Arts, Inc.

The Saint Louis Art Museum

Scottish National Gallery of Modern Art, Edinburgh

Collection William Kelly Simpson, New York

Smith College Museum of Art, Northampton

Mrs. Beverly Sommer

Tate Gallery, London

Triton Foundation

Virginia Museum of Fine Arts, Richmond

Walker Art Gallery, Liverpool

Kunsthandel Wolfgang Werner Bremen/Berlin

Collection of Malcolm H. Wiener

Dian and Andrea Woodner, New York

Yale University Art Gallery, New Haven

*Our thanks to all lenders who wish to remain anonymous

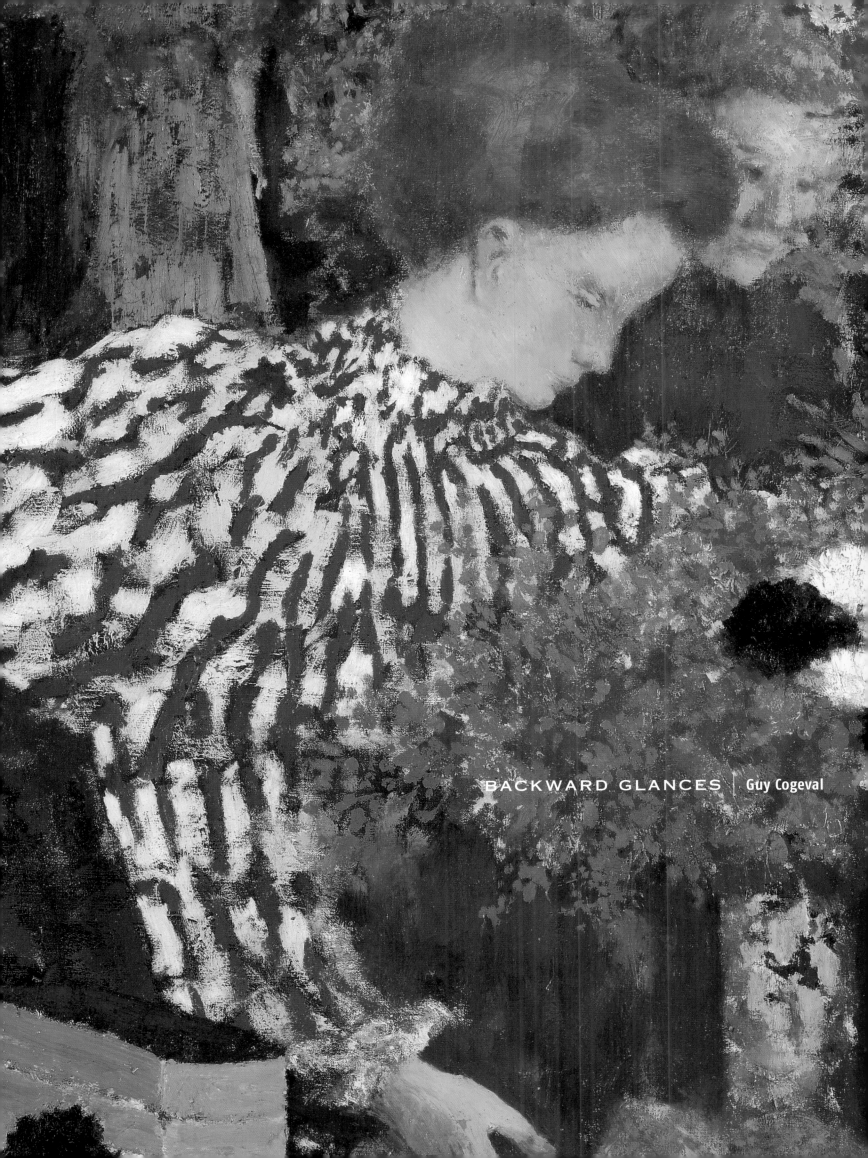

BACKWARD GLANCES | Guy Cogeval

*Oh soul,*
*be changed into little*
*water drops*
*And fall in the ocean,*
*ne'er be found*[1]
· Christopher Marlowe ·

THE MORNING OF December 17, 1928, began inauspiciously: Édouard Vuillard had just left his home on Place Vintimille, where his mother, who had recently fallen ill, was in the grip of a "new general malaise."[2] Worried, he had given her all the phone numbers and addresses where he could be reached during the day. His main obligation that day was to continue his endless reworking of the portrait of the Countess de Polignac (cat. 320), started a month earlier. The countess had sent her driver to take him to Neuilly-sur-Seine. He did not work long: "begin sitting construction bed figure, telephone calling me back home; leave immediately, anguish, delay, confusion find Mama in her armchair."[3] Back at his apartment he witnessed his parent's final struggle, and the words in his journal mirror the convulsive progress of the signs of death, which left him quite helpless: "Ever more painful moments wait in agony for Parvu[4] 'it's too much; it hurts too much, it's in my back.' telephone Parvu again. Parvu comes around two o'clock; soaked under her towel. let me lose consciousness, moans; Parvu tries two injections camphorated oil, no change; decides on injection of pantopon, long wait while Marie fetches the pantopon; drowsiness at last calms her; sit beside her hold her hand under the sheet; squeeze it from time to time; feel the pulse beating, then lose it, same state remainder of the day; cold sweats, wipe her forehead; eau de cologne; handkerchief on her head; asks me to put some scent on my beard; my good little mother; says I'm not good I'm not wicked; convulsion, responds less and less to kisses; afraid to move."[5] Madame Vuillard dies in great pain, passing gradually away in her son's arms…"she's very bad; she's going to die; her back turned; I see her glassy gaze fixed sightlessly on the ceiling, the mouth twisted to one side; hand clenched once more over her stomach; end; I hold her head still, my fingers near her eyes which I gently close after Parvu has raised a lid. Acceptance. Brief sobs from Marie."[6] Vuillard had never written like this before. The loss of his mother ushered in the final period of the painter's life: his old age and his own journey toward death. He would henceforth feel lonely, abandoned, and éver more dependent on the friendship of the Hessels, who invited him to the Château des Clayes almost every day. He had managed to stay with his mother throughout his life, from one apartment to the next, in a relationship of filial love but also of friendly understanding that aroused the admiration of those close to him.[7] It was in a sense an adult relationship. Madame Vuillard was the antithesis of the insufferable, abusive mother. After she really began to decline, between 1926 and 1928, he made no more paintings of her, but continued to capture her likeness in photographs that are among the most disconcerting he ever produced. Several (cats. 251–252) show Madame Vuillard—by this time little more than skin and bone—at her toilette, when she had lost not only her hair but also all sense of pride in front of the camera. Yet she still found the strength to smile. Another particularly beautiful photograph (fig. 1) shows her looking out at Place Vintimille from the balcony of their new apartment at number 6; she could be Bertold Brecht's "Unseemly Old Lady," for she is dressed in unaccustomedly elegant outdoor clothes (fig. 2), as if reminding us that she once made dresses on Rue Saint-Honoré. In 1938, one of Vuillard's best and most faithful friends, the author Pierre Veber, wrote an unforgettable description of "Madame mère":

He was the third child of an admirable mother, who made her living from a women's clothing business operating out of a dark mezzanine on Rue du Marché-Saint-Honoré. We went there often to see our friend, and we felt for Madame Vuillard an almost filial affection. She was a figure of extraordinary purity and nobility. Her tenderness toward our friend was marvellous. She believed in his mission and devoted herself to it with exemplary confidence and self-denial. It is because of her that Édouard Vuillard became the perfect artist that he is, and also the man whose loyal intelligence and open, frank nature won our friendship. It was from her that this powerful artist inherited the extraordinary modesty he invariably displayed, even in the face of unhoped-for success.[8]

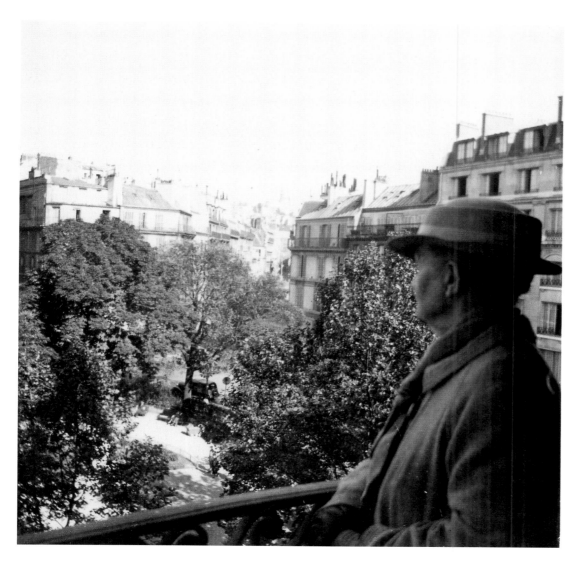

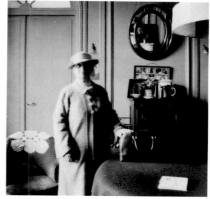

1

Photograph by Vuillard of Madame Vuillard, Place Vintimille, c. 1927–1928, private collection.

2

Photograph by Vuillard of Madame Vuillard dressed to go out, c. 1927–1928, private collection.

Madame Vuillard had indeed served as the protective goddess of the household, the guardian angel of her gifted son; from the beginning she encouraged his enthusiasm for art, no matter what the cost, and despite the fact that he had shown an early interest in following a military career, like his elder brother Alexander. Intelligent and unfailingly good-natured, she willingly posed for her son's pictorial experiments, enveloping him in an atmosphere of understanding rare in *petit-bourgeois* French families of the time: if he arrived home in the middle of the evening with a group of friends, she would don her apron and set about making them a potluck supper—Madame Vuillard's boiled beef was famous. Later, when her son took to photography, it was to her

that he entrusted the task of keeping track of when the negatives submerged in soup bowls of developing fluid were due to be turned. She would listen with tender admiration as he told his enthralled family about his plans for the sets he would make for Aurélien Lugné-Poe's theatre company. Jacques Salomon shares a memory dating from around 1920, when the two of them were waiting for Madame Vuillard at the Vaucresson station: "Just as the train was drawing into the station, he said to me with a touching look on his face, 'My mother is my muse!'"[9]

Vuillard's clock stopped in December 1928, for all one's memories come flooding back when one's mother dies. In passing away, she left Vuillard alone with himself, and the last eleven years of his life were to be a time of introspection and of reconsideration of all that had gone before. He was an artist who discarded nothing, kept every possible paper; if certain documents are missing, this is no doubt due to the haste with which he left his home during the collapse of France in June 1940. Vuillard had a constant need to take stock of his own life in order to know where his art stood, and to situate himself in relation to the evolving ideas of his time. But with a critical eye. And in a surprising way it was Madame Vuillard, perhaps more than Misia or Lucy Hessel, who was his guiding star. Vuillard was always making references to the past. In a passage of his *Journal* written on his fortieth birthday (November 11, 1908) he compiled a series of "autobiographical notes" going back to his adolescence, proof that he still remembered vividly events that had marked him in his youth.[10] At the time of this retrospective quest, a rather clumsy version of the *Rückblicke* written by Kandinsky some years later (1913),[11] his mother played the part of a time-defying idol. Now she was nothing but a fading image, destined to join the cache of archival material the artist had collected to recapture and comprehend his own truth—along with letters from Misia, souvenirs of country holidays, wedding announcements, train timetables, letters from patrons. As Gaston Bachelard reminds us: "To *love* an image is always to *illustrate* a love; to love an image is to find, without knowing it, a new metaphor for an old love. To love the *infinite* universe is to give a material meaning, an objective meaning, to the *infinity* of the love for a mother."[12] Now he could no longer confirm the past from day to day with her, when they came together each evening for dinner. Never again would they relive their combined memories together. The death of his mother was not only a turning point in his life, it was paradoxically an *Urszene*, a primal or "primitive" scene that had a lasting impact on the artist and triggered his retrospective search for the fragments of memory within his grasp. The last part of his life was to be a subtle process of critical recollection, a past-oriented operation that reorganized in his mind the evidence of the past. Perhaps we can help put some of the pieces together…

**The Solitary Stroller** | LIKE MOST ARTISTS BORN in the provinces, Vuillard was a confirmed lover of Paris. He came from the Jura, and all his life he retained, as Romain Coolus noted, the psychological traits characteristic of the people of the region: "The men of this region are not voluble, not sensitive to eloquence; they do not live in the public square, and do not take the same noisy delight in arena sports or politics as southern populations…nor do they have that deep-seated melancholy, that vague haze of

sadness that clouds the Breton soul…As far removed from the petulant optimism of the former as from the resigned pessimism of the latter, they are simply disposed by heredity to consider life seriously, with thoughtful gravity, to weigh their judgements for some while before expressing them, and to improvise nothing in either their deeds or their works."[13] All Vuillard's contemporaries and his first major biographers (Jacques Salomon, Claude Roger-Marx) stressed his reserved manner and his propriety. It is true, however, that these men came to know him in his later years; those who shared his youth conjure, by contrast, a Vuillard with a childlike soul, capable of great bursts of laughter, of scratching his nose "from the base to the tip,"[14] of interrupting a conversation in a furious rage—in short, nothing like the white-bearded *Pater Seraphicus* he became at the end of his life. With the aid of a state scholarship—his father, a semi-retired military man, died in 1884—Vuillard entered the Lycée Condorcet, one of the most celebrated schools in Paris, which was to have a definitive impact on his future. A non-boarding establishment, the Lycée owed its reputation as one of the best academic institutions in France to the astonishing open-mindedness of its teaching and its liberal approach to discipline. Its professors were famous: Mallarmé and Bergson both taught there for a time. A number of the great figures of Vuillard's generation, intellectuals and artists, were educated at the Lycée and were among those who were "taking over" the galleries, concert halls, magazines and government departments of Paris during the 1890s.[15] The generation of 1890 could even be compared to that of 1830, the Romantics of the Jeunes-France movement. At Condorcet, Vuillard encountered fellow students who would always remain his friends: among the very first were the architect Frédéric Henry and the musician Pierre Hermant; most importantly, in the 1882–1883 school year, while in the third class, he met Kerr-Xavier Roussel, who was to become his best and lifelong friend. From the start they must have discussed Puvis de Chavannes and Mallarmé. In these intermediate classes Vuillard was considered a "very gentle and attentive child" whose abilities were "paralyzed by shyness."[16] Roussel, on the other hand, was already a brilliant, self-confident dandy whose teachers considered him "something of a dilettante, inconsistent and irregular."[17] He seemed immensely cultivated. Vuillard met Pierre Veber in the "Rhetoric" class (1884–1885), and it was during this year that his results improved and his teachers finally judged him an excellent student.

At the time, he was still hesitating between several careers, but his drawings—still part of his studio archives—were accumulating. As was natural, he was thoroughly steeped from the start in the teachings of the academic artists who ruled the roost at the École des Beaux-Arts and the Académie Julian. His earliest drawings, made when he was between fifteen and seventeen, illustrate traditional, hackneyed subjects such as *The Temptation of Saint Anthony* (fig. 3), *The Abduction of Persephone* and *Zenobia Found on the Banks of the Araxes*, subjects suitable for the Prix de Rome. Although rather awkward, sketchy attempts, they already demonstrate a sure sense of caricature and narrative, together with the subtle humour that would remain characteristic of him all his life. After failing the entrance exam three times, he finally became a student at the École des Beaux-Arts on July 21, 1887.

3
Édouard Vuillard, *The Temptation of Saint Anthony*, 1884, pen, brush and ink over graphite on paper, private collection.

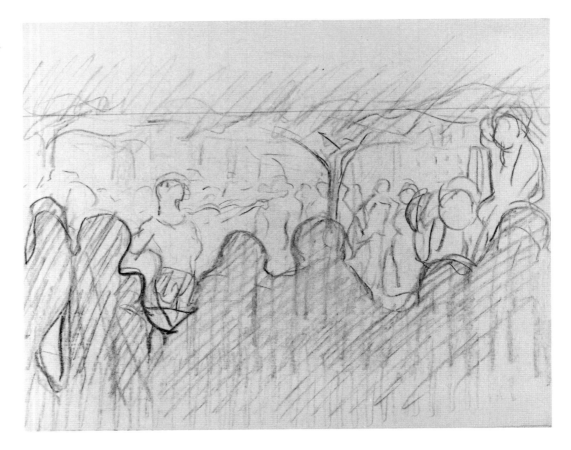

4

Édouard Vuillard, *A Street Strongman*,
c. 1890, charcoal on paper, private
collection.

The thing to retain from this period is that Vuillard was a reserved artist, a
younger double of the "solitary Puvis" celebrated by Mallarmé around this time. He
had two marked inclinations. One was a greater predilection than most of his fellow stu-
dents for the Old Masters at the Louvre. The other was a love of strolling in the parks
and streets (fig. 4). These passions are documented from late 1888, when he began keep-
ing a journal, where in quick sketches and telegraphic phrases he reveals his delight in
observant wanderings and great paintings. Respect for the Old Masters was not general
among the students in studios, where the idea of *imitating nature* was *the* inflexible norm.
Most aspiring artists preferred to rely on the tested "tricks" of Bouguereau, Cormon
and Gérôme, believing them to be followers of the great tradition, when in fact they
were merely painfully bad imitations. With the Beaux-Arts daubers slavishly copying
the "virtuosities" of Meisonnier and Fernand Cormon, it is not hard to imagine Vuil-
lard's horror at the remarkable ignorance of his fellow students on Quai Malaquais.

His journal is different from those of other painters, and the pages from late
1888 to 1889 remain the choicest elements in all the wealth of information about himself
that Vuillard left to posterity. The diary was begun in November 1888 and abandoned
as the Germans were advancing toward Paris in June 1940. The fact that much of it is
missing hampers research on the painter, and for one of the most fruitful periods in his
creative development—that of the Vaquez decoration: it seems probable that the note-
books from 1895 to 1907 were spirited away during the confused peregrinations to which
the whole diary was subjected after the artist's death. It went from hand to hand, from
Juliette Weil to the Hessels by way of Alfred Daber, among others. Jacques Salomon
accuses Jos Hessel of having read "selected" passages aloud to strangers[18] before every-

thing could be rightfully restored to Vuillard's family. In 1941, Kerr and Marie Roussel decided to deposit the *Journal* at the Institut de France, where the artist was a member from 1938 to 1940. It is highly likely that someone—perhaps Jos Hessel, perhaps (though less probably) the Roussels—injudiciously removed or "mislaid" certain notebooks during the various shifts of 1940–1941,[19] notebooks that covered the very period when Vuillard's friendship with Lucy Hessel was deepening and they were on the point of becoming lovers.

Be that as it may. In 1888–1889 Vuillard began his endless work on memory, cursorily jotting down[20] isolated phrases and rapid sketches of paintings in the Louvre by artists as varied as Perugino, Ingres, Rembrandt, Holbein, Ter Borch and Poussin. His almost daily wanderings through the great museum's galleries would become a life-long habit. For many years he lived close by. Between 1885 and 1887 he lived with his family at 6, rue du Marché-Saint-Honoré, near the church of Saint-Roch. In 1891 he moved back to the neighbourhood of Saint-Honoré, where he stayed until 1897. During these years Vuillard would regularly saunter along the banks of the Seine, cross the Tuileries, attend anatomy classes at the École de Médecine and observe the riverside activity from one or other of the bridges. His discovery of new realities, the broadening of his wide culture, his ever-alert intellectual curiosity—all were bound up with his growing love of *strolling* through the city. It even affected the composition of his journal, whose automatic writing conveys how a sound, a reflection on the surface of the Seine (see cat. 5), the gleam of the setting sun, and a host of other auditory and visual stimuli collided and combined in his mind (figs. 5–6). Thanks to these notebooks we know about his encounters, his acquaintanceships, the surprises that enlivened his walks. We learn

5
—
A page from Vuillard's journal
(I.1, fol. 10r; November 21, 1888).

6
—
A page from Vuillard's journal
(I.1, fol. 23r, December 5, 1888).

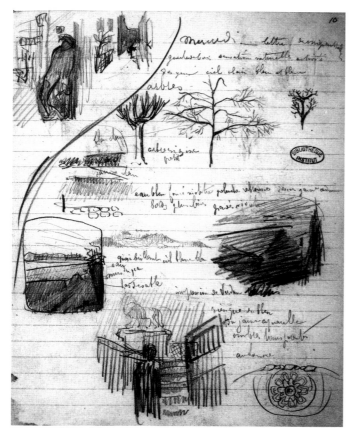

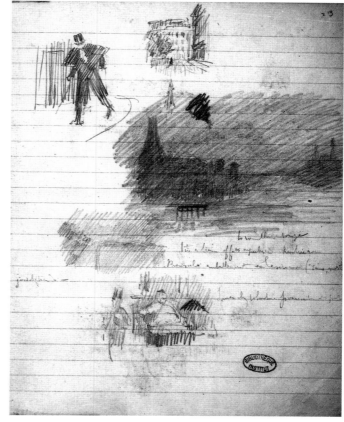

what stage he had reached in the execution of some of his paintings. Clearly, like that of all great artists, Vuillard's writing reveals but also conceals the self, and a thorough knowledge of his paintings is required to gain a full sense of the hopes and torments that haunted him.

Some pages of this long confession seem almost like a Surrealist *cadavre exquis*. Others are stamped with a delicate humour, a permanent hallmark of his personality. On one page he brings together in the same space a milliner's shop, his sister and Grandmother Michaud at home, a carriage in front of a porch and a sketch of Ghirlandaio's *Portrait of an Old Man with a Young Boy*.[21] The journal also provides some wonderful glimpses of the Eiffel Tower under construction, as it gradually rose up beside the old Palais du Trocadéro. Paris was in a state of high excitement at the time because of the imminence of the Universal Exposition of 1889—hence the dockworkers on the banks of the Seine laboriously pushing barrows of sand and gravel. Finally, the journal from these very early years is remarkable for the small windows that open inside the text, revealing tenebrist experiments on such subjects as the corner of a park, with the street-lamps casting a strange light over people and monuments. Even more interesting, there begin to appear in this first notebook dark, hermetic interiors penetrated by a single light source, obviously inspired by Dutch painting. These experiments with the effects of light undoubtedly played a role in his penchant for unusual lighting in the theatre sets he would later design.

His continual walks through Paris, his almost metronomically obsessive observation of the slightest detail that "shimmered" in his mind, opened up many perspectives. In 1888, it would have been very difficult to foresee that Vuillard would become a Nabi and would invent a bold, synthetist style with violent colours and a radically provocative sense of framing. He was still a reserved and sceptical youth (fig. 7), and his still lifes recall (for the moment) Chardin's iridescent delicacy. Vuillard's truly precocious brilliance can be seen in his self-portraits (1887–1889; fig. 8). *Self-portrait with Bamboo Mirror* (c. 1890, United States, priv. coll., c-s 1.100) captures his reflection in a mirror, eyes closed, in the pose of a Renaissance artist self-portrayed as a "dreaming genius." In 1889, still intent on exploring the world within a mirror, he painted his own portrait with his friend Waroquy (cat. 1) "in grandmama's room."[22] Here he reveals his narcissistic fear of death and castration, conjured by the appearance in the image of a double, the *Doppelgänger* dear to Otto Rank[23]—a subject to which Freud often referred, obsessed as he was by "the connections which the 'double' has with reflections in mirrors, with shadows, with guardian spirits, with the belief in the soul and with the fear of death... For the 'double' was originally an insurance against the destruction of the ego..."[24]

Thus, even before being converted by the Nabis, Vuillard was capable of producing intellectual, complex and surprising work, stamped with his own unusual personality. It is generally agreed that he "joined" the Nabi group in 1889. In his "autobiographical notes" he repeats "1890 Sérusier year" and "acquaintance with Sérusier."[25] This does not necessarily mean that he had only just met Sérusier—possibly, rather, that he had become acquainted with Serusier's passionately held theories, so attractive to the younger generation of the time. It is also worth remembering that he had likely known

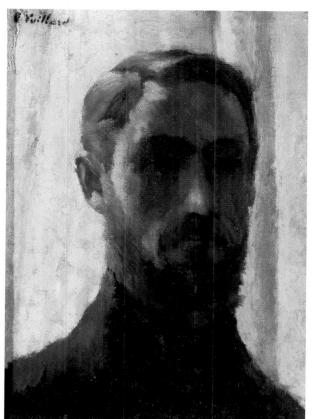

Maurice Denis for some time, since the latter became a student at the Lycée Condorcet in 1885. But Vuillard was at first thoroughly disconcerted by Denis's painting.[26] He himself was still concerned with precise detail and with exploring a psychological approach. His art carefully avoided strictly codified theories. And when he joined the avant-garde group in 1889, it was no doubt mainly because of the intellectual rigour displayed by these young men, who could endlessly discuss Swedenborg and Wagner, Schuré and Mallarmé, Puvis and Gauguin. Vuillard was entering a circle whose every member, like him, placed cerebral construction above the pleasure of painting.

The Nabis also helped Vuillard to exorcize one of his great fears, that of being found inadequate, which was based on his dislike of his own appearance (something that goes a long way to explaining the numerous self-portraits). Like many young people, he did not like himself as he was; we sense that he felt ill-at-ease; he considered himself too short; he was beginning to lose his hair; and his physical complexes were aggravated by his financial embarrassments. And yet he was surrounded by sympathetic, boisterous friends who were both handsome and wealthy: Henri Colmet d'Âage, Julien Magnin and, above all, Kerr-Xavier Roussel, then extrovert and attractive, who exerted an absolute fascination over the painter. Vuillard's path as an artist had of necessity to include a victory over himself.

**A Subtle Symbolist** | VUILLARD MUST UNDOUBTEDLY have felt some reservations about the Rosicrucian, decadent and rapturous excesses of his friends Sérusier and Ranson, both so steeped in the language of esotericism. Nevertheless, his acceptance into the Nabi fraternity had brought him two obvious advantages: first, the courage to paint

7
Pierre Bonnard, *Vuillard's Profile*, c. 1891, private collection.

8
Édouard Vuillard, *Self-Portrait against the Light*, c. 1888, oil on canvas, private collection, C-S I.82.

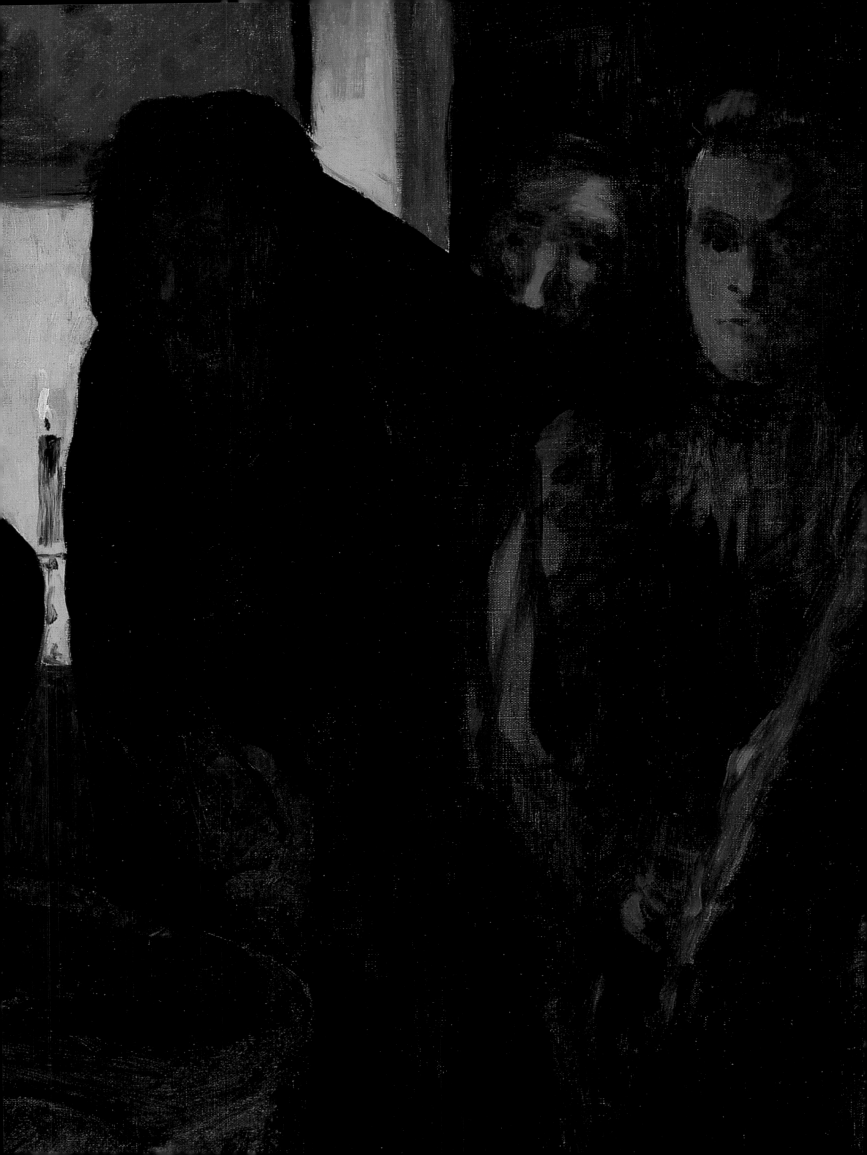

in a free manner in terms of chromatic combinations, with outlined areas of flat colour and daring framings. In this respect the summer of 1890, when Paul Ranson lent him his studio on Boulevard du Montparnasse, was a crucial period. With *Christ and the Buddha* and *Nabi Landscape* as examples, Vuillard could venture some experimental paintings of his own, such as the *Octagonal Self-portrait* (cat. 6) and *The Dressmakers* (cat. 12). The other benefit of his time as a Nabi was that his friends compelled him to become a little less solitary, to come out of his shell. Much later on Maurice Denis recalled: "We met periodically around the humble table of a bistro near the studio, in a squalid little mezza-nine that Ranson's imagination turned into an Arabian Nights palace when he talked about us and our feasts, for the sole purpose of mystifying the bourgeoisie. Our discus-sions were passionate. Each man had to bring an 'icon,' a sketch whose composition had to be as unordinary as possible."[27] Seeing Sérusier, Denis, Ibels, Ranson and Bonnard several times a week helped Vuillard to analyze his own aims, to measure his goals against his comrades' most inventive ideas. In short, he was living in a kind of commu-nity, which was excellent for such a naturally solitary person. The new notion of *collec-tive creation* was to be a characteristic of twentieth-century art movements, from the Ballets Russes to the Surrealists, the Bauhaus to the Bloomsbury Group. The image of the artist as an isolated creator was becoming less convincing, with the exception of unsociable characters like Cézanne, for example, who was never able to be part of a group. The century of artists' communities was on the horizon, and in a way the Nabis could be said to have inaugurated this new artistic *modus operandi*.

9
Édouard Vuillard, *Dinnertime* (detail)
c. 1889, oil on canvas, New York,
The Museum of Modern Art, Gift of
Mr. and Mrs. Sam Salz and an anony-
mous donor, 1961, C-S IV.2 (cat. 2).

In 1890 the idealist and symbolist generation was convinced that art must become more subtle: the goal was not to *show* things as they are, but to allow the real meaning, hidden behind appearances, to *show through*. A number of Vuillard's early works are clearly on the fringe of Symbolism. One such is *Dinnertime* (cat. 2 and fig. 9), a cruel and darkly Gothic melodrama, in which he settles old scores with his family. The portrait of Grandmother Michaud in front of the window (cat. 3) can, in its feeling for the richness of materials, also be compared favourably with certain contemporary canvases by the Belgian artists Khnopff, Van de Velde and Mellery. And no one at the time—not even Seurat and the Neo-Impressionists—went as far as Vuillard did in the unreadable painting *The Stevedores* (cat. 5): from the most commonplace of subjects he makes an almost abstract composition, far ahead of its time, in which reality splinters into flakes of colour.

But it was primarily in the field of theatre that Vuillard flirted with Symbolism. His variations on *Pierrot* from 1890 (cats. 50–53) are still stamped with an elegant style borrowed from the gallantry of the eighteenth century. The experiments he embarked upon as soon as he joined forces with Paul Fort's Théâtre d'Art were very different. In the theatre Vuillard learned to work quickly, to take firm decisions and to come to terms with the taste of public and critics alike. Once again Maurice Denis has left a vivid pic-ture of the collective endeavour involved in the staging. "Sérusier seized on the opportu-nity with Lugné and the Théâtre d'Art to satisfy an adolescent passion for stage direc-tion. Interminable discussions around café tables: wonderful plans for revolutionizing the theatre; sackcloth drop scenes painted on the floor; the delight of inexpensively improvised

performances; unexpected happenings at dress rehearsals; and the amusing surprise of the reaction of a public who were submissive, scandalized, never indifferent."[28] It was possibly from Sérusier that Vuillard took his fondness for stage sets that depended on a hieratic distancing of gesture and the isolation of the characters behind a gauze veil, a technique Sérusier had used for Pierre Quillard's *La Fille aux mains coupées* in March 1891. The fashion was for slow movements, monotonous delivery, symbolic characters and gauze screens that separated the actors from the narrator, who stood, motionless and detached, at the edge of the stage; also popular were repeated decorative motifs, of medieval inspiration, against a gold background.

As far as sophisticated audiences were concerned, Vuillard's "official" launch into stage design came with Maeterlinck's *L'Intruse* in May 1891 (see cat. 57); the performance was a benefit show for Verlaine and Gauguin, with the entire Symbolist generation packing the auditorium. The production's predominantly sombre tones, the gradual bringing up of the lights, the inexorable terror that gripped both actors and audience, revealed Vuillard's—and Lugné's—penchant for the dark, contemporary allusive style reminiscent of Edgar Allan Poe, based not on the iconography of chivalry or religion but, on the contrary, on the immemorial terrors assailing modern society, so admirably expressed by Maurice Maeterlinck.[29] Vuillard might have echoed Victor Hugo's famous remark: "There's nothing more interesting than a wall behind which something is happening."[30] We know that Lugné-Poe, "the sleepwalking clergyman,"[31] demanded a bizarre kind of diction of his actors; Robichez describes the "slow-paced chant that makes use of no professional tricks: no planned pause that, by an abrupt silence, arouses curiosity or gives the impression that the actor is searching for the lines he is about to utter; none of the haste that propels a story on, skims over some of it and gallops head-long with it up to the very last word. Everything is even and unified...A linear recitation in which each word is presented in its nakedness without the actor imbuing it with any sort of intention or effect."[32] Vuillard, then, felt an affinity with this abstruse, intellectual and distanced kind of drama. His triumph on the boards blossomed during the glorious years of 1893 and 1894, when he painted the sets for several Ibsen plays, including *Rosmersholm* and *The Master Builder*, as well as Henri de Régnier's *La Gardienne* and Maurice Beaubourg's *La Vie muette* (cats. 66, 72, 74–75). He was already deeply affected by Maeterlinck's overwhelming sense of *fate*. In fact, around this time Vuillard sought to transpose this same "work of destiny" into his painting. He sympathized equally with Maeterlinck's "delocalized" characters, living in castles and gloomy forests, and with the tense situations presented by the Norwegian playwright, in which tragedy is sealed by hereditary fate. The most important thing to remember about the whole of his theatrical experience is that *he transposed the principles of his stage sets into his own painting*: sloping planes, transparent screens across the proscenium arch, an obsession with suffocating atmospheres infected by fear, where lamps take forever to go out. His protagonists, whether seamstresses, apprentices, clients or members of his family, give bodily substance to Ibsen's creations: Nora, Hedda Gabler, Mrs. Alving (fig. 10). They are a "precipitate" of immaterial theatrical form. The Nabi painter's ordinary little women, hesitating in a doorway, standing timidly on tiptoe, accepting reprimands without complaint, are like their everyday counterparts. Between 1892 and 1894, he concentrated on a limited

number of familiar situations, and the gestures he gives his characters seem almost to belong to a *repertoire*. His world progresses by marking time, just as Maeterlinck's heroes stammer or wall themselves up in the enforced silence of their stupor. In the preface to his *Théâtre*, the Belgian playwright had justified "those astonished repetitions that give the characters the appearance of slightly deaf sleepwalkers, continually torn awake from a painful dream."[33]

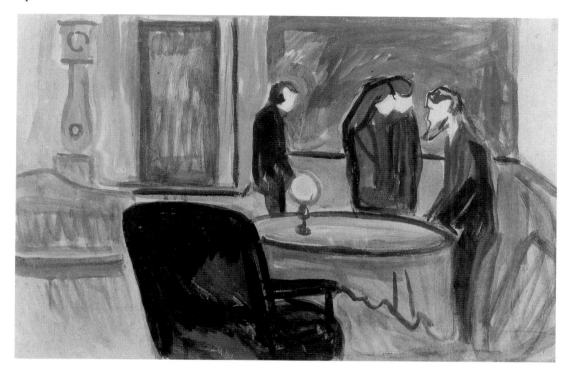

10

Edvard Munch, *Sketch for Ibsen's "Ghosts": Oswald, Mrs. Alving, Pastor Manders and Carpenter Engstrand*, 1906, Munch Museet, Oslo, © Munch Museum / Munch-Ellingsen Group / ARS (New York) 2002.

Vuillard thus played an important role in the forging of a new theatrical space, which got under way in Europe around 1890. It might even be said that he was its figurehead. In 1895, when *The Master Builder* was revived in London by Alfred Sutro, a stagehand who had installed Vuillard's sets the wrong way round defended his mistake: for him it worked just as well either way.[34] This amusing anecdote suggests that Vuillard was unwittingly anticipating Kandinsky's famous amazement at not recognizing, in his own studio, one of his own paintings that was leaning sideways against the wall.[35] With Vuillard we are truly entering the twentieth century. Some of his compositions revel in their own indecipherability and can almost be read in any direction. The theatre had also enabled him to thoroughly master the technique of *peinture à la colle*, or distemper. His friends admired the virtuosity with which, armed with a broom dipped in paint, he would spread across the floor colours that initially looked dull but, as they dried, were transformed into fictional décors that were both glowing and subtle. Distemper became his signature medium, especially after 1905–1910. He acknowledged this particular debt to Lugné-Poe in a handwritten note: "It is not for me to speak of what the theatre owes him, but I can say that I owe him a very special debt of gratitude. He gave me the opportunity, while I was helping in a small way with the improvised fabrication of sets for his earliest shows, to discover a method of painting with distemper, which was to prove extremely valuable to me in my own work."[36] In fact, Vuillard was the only really professional scenographer among the Nabis. His style was well suited to the demanding repertoire of Ibsen; as Lugné-Poe later wrote: "*Rosmersholm* was a triumph, thanks in large

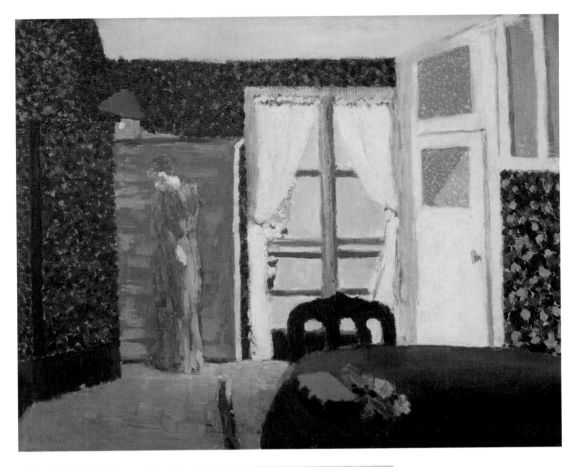

11
Édouard Vuillard, *The Window*,
1894, oil on board mounted on
cradled panel, The Museum of Modern
Art, New York, The William S. Paley
Collection, C–S IV.155.

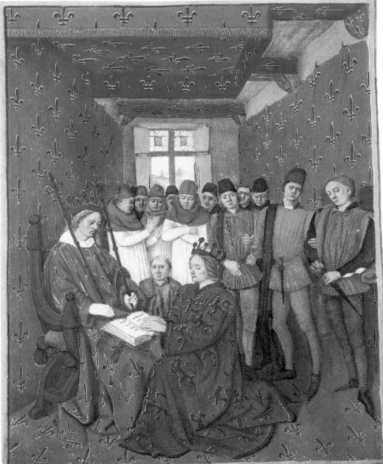

12
Anonymous, *Edward of England
Pays Homage to Philippe Le Bel for
Aquitaine*, The Great Chronicles of
France, c. 1460, parchment, Biblio-
thèque Nationale, Paris.

14

part to the contributions of Édouard Vuillard and Hermann Bang. Vuillard was marvellous with his economical inventiveness and his flair for creating stage sets and atmosphere. The décor for the second act added distinction and intimacy to our acting. For the first time, Ibsen was being *authentically performed* in Paris."[37] Vuillard's experiments in the theatre, as he adapted them to his painting, were not only important—they were crucial.

To this experience must be added his love of Japanese art, which he probably first discovered at the major exhibition of Japanese prints held at the École des Beaux-Arts in 1890. But in my view an even stronger influence on his oeuvre was his passion for medieval art. He sometimes actually went to the Bibliothèque Nationale to pore over illuminated manuscripts. This almost scholarly approach was something quite new, if we exclude the troubadour period when Ingres, Isabey and Baron Taylor were doing much the same thing. Maurice Denis must certainly have encouraged him in this quest for the primitive: for the "Nabi of the Beautiful Icons," the "naive" art of the late Middle Ages, along with that of Botticelli and Giotto, was the high point in the history of art.

What characterized Vuillard's abstruse symbolism during those years? It was a rarefied art of interiors, where the figures appear constrained by their clothes and the decoration seems to abandon the walls and float alongside the subjects. A screen of short, separate brushstrokes evens out the surface, reduces the sense of depth and distorts relationships of scale. The bedrooms full of seamstresses, the barred kitchen windows, the restricted views onto apartment building courtyards—all these elements help create an impervious, closed world that, with its wildly exaggerated perspectives, is sometimes powerfully reminiscent of medieval illuminations. Such is the case with *Mother and Sister of the Artist* (cat. 85) and *The Window* (fig. 11), whose perspective, accurately identified as "Expressionist," can nevertheless be found in many mid-fifteenth-century Books of Hours (fig. 12). Vuillard spent a long time perfecting this original pictorial "theatricality." And in so doing he was obliged to make patience and reflection integral parts of his creative process.

**The Manipulator** | THE FEMININE ENVIRONMENT in which he lived, like the adoring family circle that protected him, provided Vuillard with a solid base in the general flux of signs. Far from yielding to the "sound, realistic good sense" that too many critics attribute to him, he clearly ranked spatial perception *after* the allusive and perverse re-invention of reality, in which his subtle approach to chromatic relationships is darkened by the weight of a theatrical *fatum*. Vuillard's interiors may be intimate (it has been said often), but they are first and foremost disturbing, artificial, stamped with strangeness —the *Unheimlich* that so preoccupied Freud. They are still broadly speaking Symbolist, but anchored in modernity, a displaced, unreal modernity. In the workshop of the Théâtre de l'Oeuvre, "open to every draught,"[38] Vuillard diluted his colours with the glue medium on large sheets of paper, sometimes on canvas when he could afford it. Back at home he became an authoritarian and unquestioned stage director, as inspired as Lugné-Poe, imposing on his family his dramatic view of life.

A number of paintings from 1892–1893 show his mother and sister in the apartment at 346, rue Saint-Honoré. The "gentle" Vuillard, who liked nothing better

than to work behind closed doors, invented for them a range of theatrical situations and gestures: engaged in silent confrontation by lamplight, their bodies contorted like Utamaro courtesans, they manifest a violent hostility that we are certain did not reflect their everyday domestic reality. At most, perhaps, Marie's prolonged spinsterhood may occasionally have irritated her mother—in the late nineteenth century, to be still unmarried at the age of thirty was unusual—but nothing in their relationship seems to have justified his creation of Expressionist scenes where the mother exerts an almost sado-masochistic power over her daughter. For her part poor Marie, with her unhealthy pallor and timid, infrequent gestures, appears to bend under the weight of her unhappy fate and almost disappears into the undulations of the décor. It really seems as if Vuillard was imposing the muffled atmosphere, the confined fatality of the world of Maeterlinck, Beaubourg and Ibsen on his own family; and this bespeaks the extraordinary influence literature and the art of theatre had over him, uncommon among the artists of the day. Furthermore, the plays presented by Paul Fort and Lugné enabled Vuillard to push reality beyond his limited, modest, socially restrictive world to the glamour of theatrical production—oppressive, no doubt, but likely to be admired and understood by the coterie of *La Revue blanche*. Each small painting he executed during this period, usually in oils on small pieces of board, is an excerpt from *one and the same play*, in which Madame Vuillard argues with her daughter, trembles with rage and demands explanations (cat. 77). Yet the family papers from the 1890s give every indication that the situation was unclouded, peaceful—in a word, normal. Evidently too ordinary and down-to-earth, in fact, for our dissatisfied "Henrik Vuillard."

In *Mother and Daughter against a Red Background* (cat. 27) and *Mother and Sister of the Artist* (cat. 85), artfully fomented storms seem ready to erupt at any moment. The artist injects poison into evenings behind closed doors, corrupts the peace of family gatherings and condemns his figures to perpetual confinement within the pictorial frame. It is a drama of murmuring and stifled whispers; the characters seem almost to have been placed on a microscope slide and scrutinized in close-up. Vuillard was fond of transposing Maeterlinck's displaced pantomimes onto his family, assigning the parts of characters who brush against each other without speaking and unwittingly carry the burden of their own destiny. He shared a penchant for *pupazzi* with Maeterlinck and Edward Gordon Craig,[39] and his familiarity with puppet theatre (see "Vuillard Onstage," in the present volume) doubtless reinforced his conception of the human being as activated by invisible wires, cunningly pulled by incomprehensible forces. The conclusion is inevitably reached, then, that Vuillard *manipulated* his household in order to transform small family dramas into subjects for his painting. Furthermore, this taste for manipulation, though he kept it discreet, would remain part of his personality for the rest of his life. The gentle Monsieur Vuillard had become a self-confident adult, someone who knew how to get what he wanted from those around him.

His life underwent many more "dramatic" vicissitudes than has usually been thought. And—even more surprising—these ups and downs had a direct and enriching influence on his art. Many of his paintings, hitherto taken for imaginary, "abstract" scenes, tell stories, with a narrative that links them to each other in time. Study of the letters in the Salomon Archives has enabled me to reconstruct isolated episodes in which

Kerr-Xavier Roussel played the main part. Attractive and compulsive, Kerr was known for his imprudent womanizing. One such affair was to provide Vuillard with the opportunity to reverse the balance of power in their close friendship: in 1892 it was the shy Vuillard who for once took the initiative. It seems that early in the year Roussel had been seeing a great deal of a girl called "Caro," who had fallen in love with him; the affair had gone quite far, since she had actually moved some furniture into Roussel's small apartment. However, like all Don Juans, he soon tired of her or, worse, made her pregnant and was at a loss as to how to deal with such a blunder. In any case, there was no question of marrying her. As always happened in bourgeois circles of the period, family and friends formed a united front against her: it was she they judged to have been guilty of imprudence. In order to extricate Kerr, Vuillard arranged a trip to Belgium and Holland to escape the recriminations of the poor girl, who was going around knocking at the doors of Vuillard's friends and family. Other less dramatic solutions might have been considered, but Vuillard was immovable. He was even prepared to give up his commission for Madame Desmarais's screen (1892–1893, priv. coll., c-s v.32-1 to 5) and pass it on to Bonnard—proof of how important his friendship with Kerr-Xavier Roussel was to him. Kerr and Vuillard therefore fled to the Low Countries, where they discovered the Van Eycks, the Van der Weydens and the work of Petrus Christus in the museums of Bruges and Brussels, and the Rembrandts in Amsterdam, while the unfortunate Caro complained to one and all. Madame Vuillard wrote to her temporarily exiled son: "It is vital that you stay away, C[aro], the lady is at it again here. She's going to people's houses, and she might do something crazy if she managed to find out where you are."[40] This escapade strengthened the bond between the two artists, and also gave Vuillard the opportunity to conceive of an antidote to his best friend's dissolute life: the quite mad and extremely selfish notion of thrusting Roussel into the arms of his sister, Marie.

Marie was seven years older than the handsome, dashing Roussel. She was overcome with love and mortification in his presence, no doubt believing herself physically unattractive and embarrassed by her supposed lack of wit. Madame Vuillard intervened, so ill-suited did the two seem, but her son was adamant. His brother Alexandre sent him an intelligent letter in which he emphasized the differences separating the engaged couple: "I saw a major problem in the age difference and the financial position."[41] In vain. The marriage would take place.

Paintings of the family, therefore, would inevitably follow in 1893. Vuillard won on two counts: Roussel would really become his brother-in-law, and in addition he could recast family events in a stylized, universally comprehensible form. *The Suitor* (cat. 89 and fig. 13) is the first of his paintings relating to Kerr and Marie's marriage. The fiancé is seen coming in through a door covered with wallpaper, ready to pay court to the young woman in the stiff, comical pose of a puppet. Vuillard was probably inspired here by a then-famous show that was attracting all of Paris society to the Musée Grévin: the optical pantomimes projected by the praxinoscope, a forerunner of the Lumière brothers' cinematograph invented by Émile Reynaud in 1892–1893. One of these perforated strips, on which each image was painted by hand so that it could be projected onto a screen, is entitled *Autour d'une cabine*. It shows Harlequin paying court to Columbine while the duped Pierrot has gone for a walk (fig. 14). Harlequin's gesture, as he

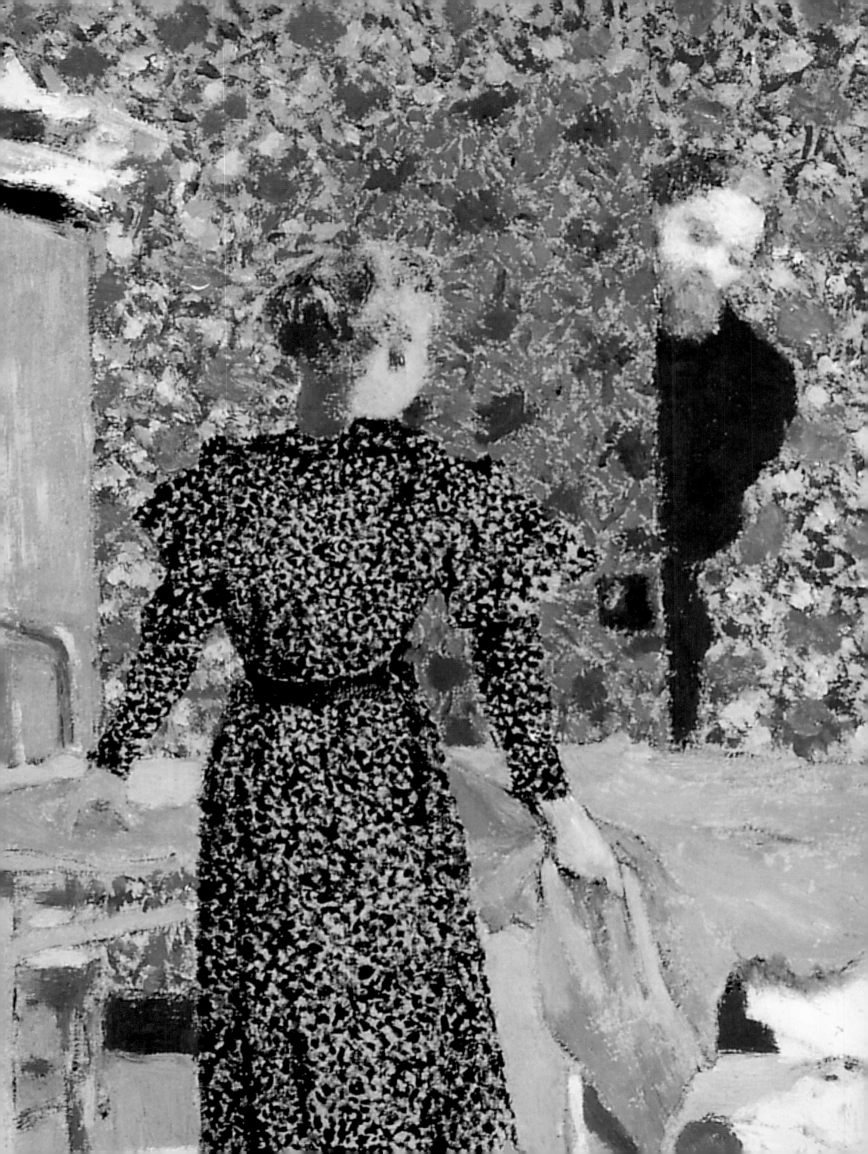

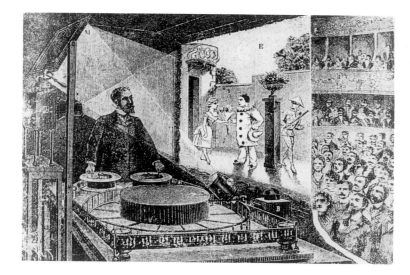 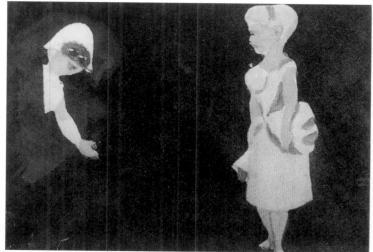

leans through the slit in the black curtain toward the bewildered Columbine (fig. 15), is the same as that of Kerr in the painting. It should be recalled that Vuillard was a devotee of the Chinese shadow theatre shows presented at the Chat Noir and the Divan Japonais, and that he often made use of the stiff, mechanical poses of people transformed into automatons.[42] *Interior with Red Bed*, also known as *The Bridal Chamber* (cat. 90), which is linked to *The Suitor*—a fact only recently established (see cat. 91)—shows Marie looking toward the viewer, apparently radiantly happy; she is preparing the newlyweds' bedroom, one of the rooms in the Vuillards' apartment, soon to become cramped as it accommodates the young couple. Thereafter, still part of this "nuptial suite in several movements," Madame Vuillard can be seen in *The Chat* (cat. 92) issuing her final words of advice on the wedding day. Vuillard's efforts as a matchmaker had proved a great success. The discovery of certain turbulent events in Vuillard's life has enabled us to pinpoint much more precisely the true iconographic significance of some of his paintings, but without really compromising their abstract power, the hermetic quality of their formal structure or, indeed, the charm of their complex interweavings. Not only did Vuillard register everything he saw with dogged precision—*he even provoked what he was going to paint*, an approach rare in the history of painting.

The little family on Rue Saint-Honoré soon had to put up with Roussel's depressions and frequent outbursts of rage, as well as quarrels between the newlyweds. Misfortune befell the young couple in December 1894, shortly after Vuillard had finished *The Public Gardens* for Alexandre Natanson: Marie, after weeks of illness, gave birth to a stillborn child. This was a cruel blow to Vuillard. In 1895 the situation deteriorated. Kerr disappeared from the family home on a number of occasions, having fallen in love—at first discreetly and then quite openly—with France Ranson's sister, the beautiful Germaine Rousseau, whose mane of red hair was the Nabi coterie's secret passion. Shocking as it was, the scandal was completely hushed up. After this, there appeared in Vuillard's painting—constituting one of its great moments—those tense dinner scenes where no one ventures to speak and Roussel retreats into impenetrable silence (cat. 96 and fig. 16). The artist had no scruples about depicting the forlorn Marie staring out of a window at the courtyard or busying herself with embroidery to take her mind off her distress (cat. 97). In my view *Woman in Blue* (cat. 95) can be seen as the caricatural

13

Édouard Vuillard, *Interior with Worktable*, also known as *The Suitor* (detail), 1893, oil on board, Northampton, Mass., Smith College Museum of Art, purchased with the Drayton Hillyer Fund, C-S IV.132 (cat. 89).

14

Illustration by Louis Poyet of *Émile Reynaud and His Théâtre Optique*, 1892, taken from vol. 1 of *Musée du cinéma Henri Langlois*, Huguette Marquand Ferreux (ed.), Paris, Maeght, 1991.

15

Anonymous, *Poor Pierrot*, hand-painted still from one of Émile Reynaud's *pantomimes lumineuses*, 1892, taken from vol. 1 of *Musée du cinéma Henri Langlois*, Huguette Marquand Ferreux (ed.), Paris, Maeght, 1991.

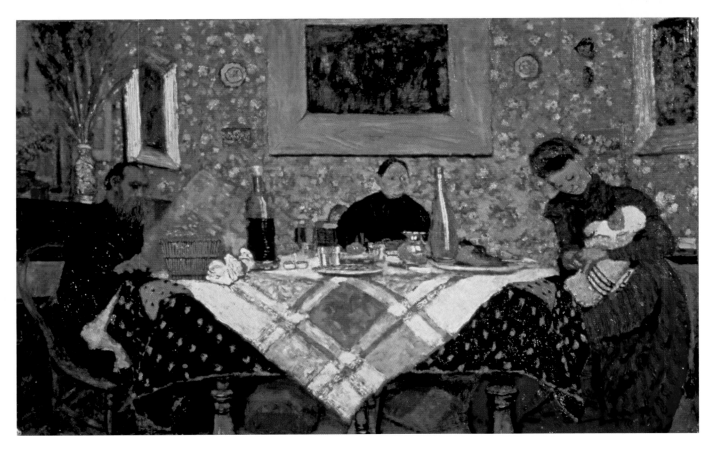

portrayal of a scene in which four women are talking about the Kerr-Germaine "affair"
in the Ransons' drawing room; France, convulsed with fury, lets fly at her sister. Most
importantly, though, the iconographic significance of *Large Interior with Six Figures*
(cat. 143 and fig. 17), about which everyone has remained mute for years, is clearly
related to a family discussion at the Ranson home, during which Madame Vuillard and
Paul Ranson firmly told Germaine Rousseau and Kerr-Xavier Roussel that they had to
separate. On the basis of the evidence provided in a painting by Vallotton, *Woman
in a Purple Dress by Lamplight* (see cat. 143, fig. 1), in which *Large Interior* can be seen
hanging on a wall,[43] we have formed the hypothesis that Vuillard, in an early version of
this brilliant painting—which he must have started just after the scene took place, in late
1895—painted his brother-in-law at the rear of the room, with his back turned to the
quarrel like an actor playing a scene from Ibsen. Later, the artist must have erased Kerr-
Xavier and replaced him with Ida Rousseau, the mother of France and Germaine, who
can be seen at the door, doubtless in order to attenuate the excessive emotional content
of the canvas and make it suitable for exhibition at the Galerie Vollard in 1897 (all the
Nabis being well aware of the affair and able to identify the protagonists). All this dem-
onstrates the extent to which Vuillard would allow nothing to stand in his way once he
had found a subject he felt would be strong and convincing. There was in his attitude an
element of quite remarkable thoughtlessness.

In the end, Madame Vuillard and her son managed to patch things up, and
1896 dawned happily for the Roussels. Unfortunately, fate took a hand again, and the
baby boy born to Marie in August of that year, "Petit-Jean," died only a couple of months
later, while Vuillard was on holiday at Valvins. Two shattering paintings came of this
event: in *Married Life* (1896, priv. coll, C-S IV.217), Kerr and Marie, their grief still raw,

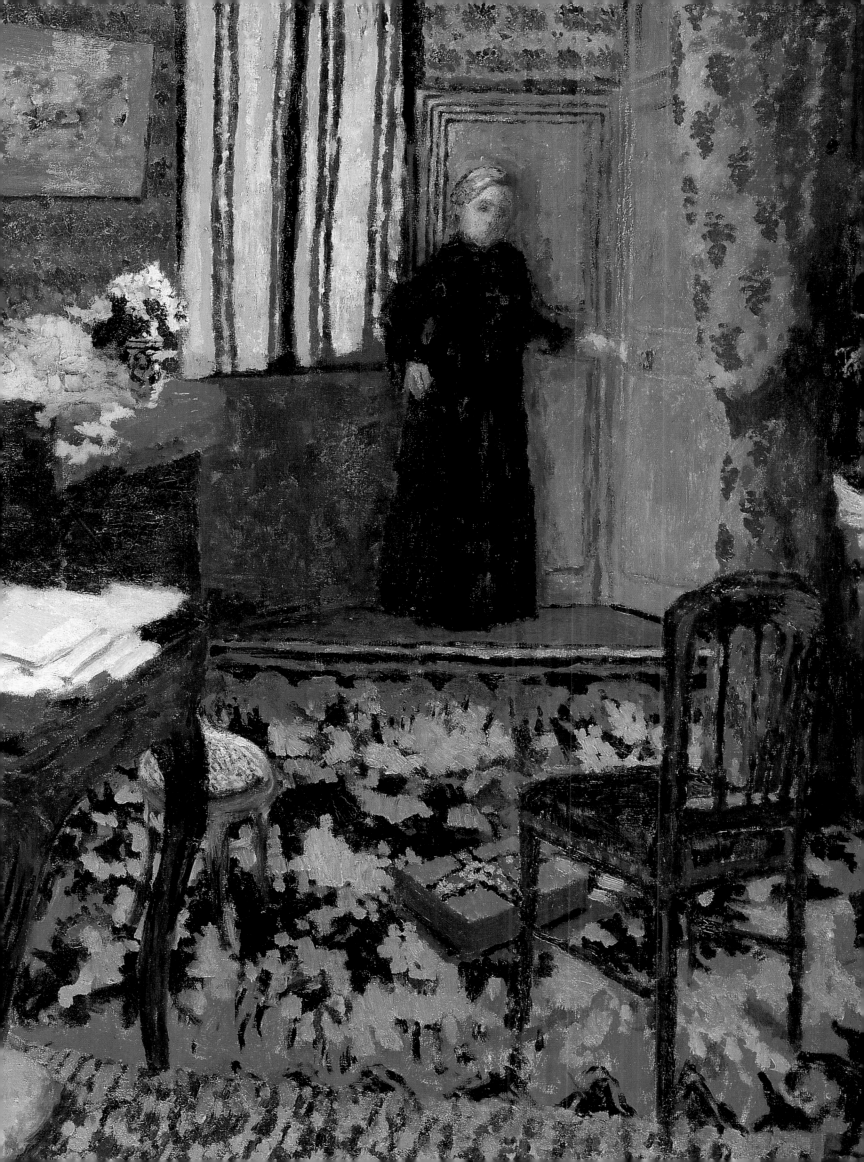

stare mutely into space beside a now superfluous child's highchair, while *Interior, Mystery* (cat. 144) shows the corner of an apartment in a funereal light. The leaden atmosphere with which the artist chose to imbue these glimpses of private moments, the sense that the scene is frozen in an instant of intensity, are strongly reminiscent of Ibsen's tense dramas, where the determinism of heredity also plays a crushing role. Later, after the birth of little Annette in 1898 had brought the Roussels some happiness, Vuillard could not resist adding a sombre note in some brilliant canvases. In *Family Lunch* (fig. 16), an indifferent Kerr reads the newspaper while Marie, huddled in on herself, holds the baby in her arms; seated between the couple, Madame Vuillard glances uneasily at this silent tête-à-tête.

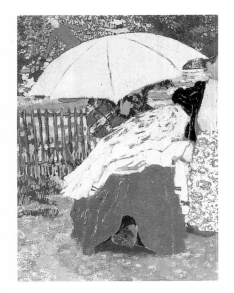

Vuillard seems to have been profoundly touched by the subject of infant death, rather in the manner of Gustav Mahler, who composed his *Kindertotenlieder* two years before the death of his first daughter. A cycle like *The Public Gardens* (cats. 111–118, 123 –124) is certainly impressive in its decorative virtuosity, the artist's way of composing and juxtaposing colours and his brilliant evocation of a series of interlinked "slices of happiness"; but it is hard not to see these nine panels taken together as a pantheistic cycle in which human beings are regenerated in nature and children are reborn under the benign foliage of great parks. Looking at the central part, we see three seated women: the one on the left, her face hidden by a sunshade, holds an infant wrapped in a white gauze veiling that suggests a shroud or winding-sheet (fig. 18).[44] The work was painted in September, when it was raining constantly in Paris,[45] so it seems unlikely that Vuillard was portraying a very hot day, which might have explained the veiling. He may, like many Symbolist artists—Munch, Vrubel and Klimt come to mind—have been subject to premonitions, in this case of Marie's sorrow. It is not hard to find elements in the nine panels that support this sad and sombre interpretation, the most pervasive of which is the Maeterlinckian sense of doom that pervades these spacious late-summer afternoons bathed in an eclipse-like light. The sunshade nearly in the centre of the panel (and of the cycle) that conceals the mother's face represents the shadow of death. This brings Vuillard oddly close to certain compositions by Edvard Munch, in particular his *Inheritance* (fig. 19), in which—and the similarity is troubling—a mother weeps over the dead body of her child reverted to the embryonic state and dead from syphilis. Behind the railings in Vuillard's painting strange beings appear—children dressed up as rabbits, a puppet giving a sermon—life in its most bizarre forms triumphs in spite of misfortune. All these elements support a new interpretation of *The Public Gardens* and demolish the politely realist view of the cycle.

**Sensuality** | AMONG THE COMMENTARIES ON Vuillard's life, allusions to his sensuality are not uncommon. One would have to be blind not to sense immediately a kind of sensuality in the women who move strangely among the flowers of the *Natanson Panels* (cats. 126–129) or in the predilection for muted tones evident in the *Île-de-France* landscapes (see cat. 142). More perceptive, perhaps, than Claude Roger-Marx or Jacques Salomon, the loyal Thadée Natanson stressed this aspect of Vuillard's art: "Félix Vallotton, also a very sensual being beneath his impassive exterior, almost pathologically sensual, considered Vuillard to be the painter who, after Ingres of course, afforded him the greatest pleasure. He, just like the decorator Alexandre Benois, would readily have

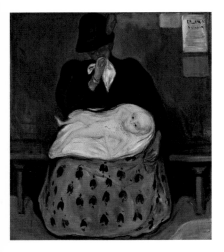

18

Édouard Vuillard, *The Public Gardens: The Conversation* (detail), 1894, reworked in 1936, distemper on canvas, Paris, Musée d'Orsay, C-S V.39-4 (cat. 114).

19

Edvard Munch, *Inheritance*, 1897– 1899, Oslo, Munch Museum, © Munch Museum / Munch-Ellingsen Group / ARS (New York) 2002.

22

called his intense liking for Vuillard's paintings a vice. He marvelled at the discoveries his sensuality was capable of making and admitted he could not understand the spell by which he succeeded in expressing them."[46]

Vuillard's delight in pleasurable sensations—generally discreet, in keeping with his reserved character—is already subtly present in his Nabi works of 1890–1892. But it is clearly in the great decorative works of the 1894–1900 period that this trait, closely allied to his tender-heartedness, is most abundantly apparent. This may seem at first paradoxical, since we know of few romantic attachments before the late 1890s. His excessive shyness, combined with the complexes about his physical appearance he bore like a cross, had left him something of an innocent in this respect. In his diary for 1894, he speaks explicitly about his physiognomy: "Seeing my face in the looking glass, my beard golden in the light, the skin, the dull eyes, the pupil with its square highlight, the slightly greasy forehead, the thin, uneven hair, unhealthy, a silver grey colour, the shaggy eyebrows that shade the eyes. The easygoing, attentive look."[47] The passage does not really reveal a man at peace with himself. Surrounded by extrovert charmers (Sérusier, Magnin, Colmet, Roussel), the shy artist was at a loss in the company of a woman he did not know. While he was working on *The Public Gardens* in the summer of 1894, he wrote: "I went down to the square. The same woman as yesterday came and sat on my bench…rather disturbed."[48] And yet, as he wrote in his "autobiographical notes," 1894 was a year marked by "love affairs,"[49] and this is confirmed by his journal entries for the period. "On leaving the Louvre, confided my love for the first time to Bonnard. sad."[50] We do not know the nature of this "confidence." For Vuillard, as for many young men living in the city at the time, the options were somewhat limited: one either courted a young woman of one's own milieu with a view to marriage, or else one pursued the rather more accessible and amusing girls to be found in the *café-concerts* and brothels. It is possible that his fondness for the great parks of Paris was at least partly rooted in a timid quest for amorous encounters: in the daytime the city gardens were full of young nannies, some of whom were no doubt forthcoming.

All the affection of his youth seems, then, to have been focused on the three women who ran his household. And they, for their part, admired and doted on him. He often depicted the women who figure in his paintings as very tightly corseted, but he also had a genius for capturing their poses, giving a marvellous tilt to their hips, representing their bodies on the deliberately flat surface of the painting in contrapposto perspectives reduced to a single convulsive arabesque. He was more familiar than most with this *mundus muliebris*, forever associated in his mind with the fabrics, silks, chintzes and wallpapers that (since Grandmother Michaud, his Uncle Saurel and his mother all worked with textiles) had always surrounded him. The women in the workshop, as well as his own family, created a flexible yet reassuring setting that helped to train his artist's eye and to shape his somewhat covert sensuality. Some of his early works demonstrate a surprising sexual aggressiveness; two such are *The Flirt* (cat. 18) and *The Pursued Woman* (c. 1891, loc. unkn., c-s II.122), in which the "weaker sex" is threatened by the aggression of men transformed into hunters—and likely into rapists, as in the strange *Bois de Boulogne* (fig. 20 and fig. 5 in "Vuillard and Ambiguity," in the present volume), where in the corner of the wood, a man in a top hat lies in wait as a woman with a parasol approaches. The Desmarais panels

20

Édouard Vuillard, *Sketch for "The Bois de Boulogne,"* c. 1890, Conté crayon, private collection.

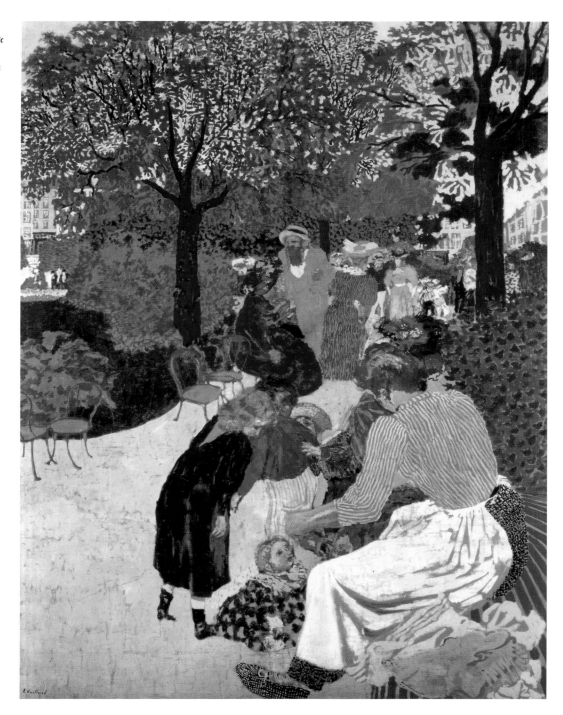

24

(cats. 103–108), on the other hand, reflect an obvious change in attitude: in the two *Dressmaking Studios*, marvellously elegant women, sheathed in silks with hypnotic patterns, move to the rhythm of a strange, slow waltz; their contortions and swaying hips are signs of what might almost be called a diffuse eroticism. From this point on, Vuillard really began to create a world of the feminine, which permitted the ascendancy of a flowing sensuality that grew stronger day after day. Women had filled his imagination since childhood; now they became the fulcrum of the disruption of reality he sought.

Eighteen ninety-four was certainly a crucial year for Vuillard. While exploring the subject for *The Public Gardens*, he painted the extraordinary *Square de la Trinité* (fig. 21), which he had initially intended as the central panel of the triptych now at the Musée d'Orsay. Here the organization of space is radically different from anything he had done so far, even though the texture, as André Chastel rightly noted, seems "as tight-woven

as a tapestry."[51] But what strikes one at first glance is the way the light infuses the composition, uniting both foliage and figures in a single homogenous symphony: "All this is composed within the rich and graceful curve of an *arabesque*, finely sustained and very legible, which loops and turns in a spiral, like the musical motif in the Debussy pieces that have precisely that title."[52] The arabesque was to become the signature of a subtle eroticism that was moving steadily closer to the cerebral eroticism of Mallarmé ("the considerable bush"). Vuillard's language of voluptuousness reaches a high point in the great decorative works, where the human figure is woven into the background and long undulating lines help achieve the closure of the composition. Looking at a painting like *Square de la Trinité* we feel a hedonistic pleasure, and at the same time we realize that Vuillard's art—and this was henceforth to be one of its dominant characteristics— plays on exciting the nerves and exacerbating the senses, rather like the music of Ernest Chausson and César Franck.

The most important milestone in Vuillard's "conquest of the sensual" was his first meeting with Misia and his gradual taming at the hands of this highly gifted young Polish woman, whom Thadée Natanson had married in April 1893, when she was only sixteen (fig. 22). It seems obvious today that Vuillard fell madly in love with her— either immediately, or slowly but surely, as the predictable result of daily contact. Not only was the painter of *The Public Gardens* one of the key figures at *La Revue blanche*, whose offices he visited often, sometimes weekly; he also helped Misia finish decorating her apartment[53] and accompanied her to exhibitions. In 1896, the three of them began taking holidays together, and their intimacy must certainly have intensified between 1897 and 1899, after the Natansons rented the estate of Les Relais at Villeneuve-sur-Yonne in Burgundy and Vuillard explored the surrounding countryside with Misia (fig. 23). These years—definitive ones for him, that unleashed a kind of "revolution"[54] in his mind— inspired him to paint some of his most accomplished works, like the two Schopfer panels, *Woman Reading on a Bench* and *Woman Seated in an Armchair* (1898, priv. coll., C-S VI.99-1 and C-S VI.99-2), the Stéphane Natanson screen (cat. 141) and the rather rough, austere *Promenade in the Vineyard* (cat. 151). It is doubtful whether the relationship between Misia

22
Misia Natanson, photographed around 1895, private collection.

23
Photograph by Alfred Natanson of Thadée and Misia Natanson at Villeneuve, c. 1899, Annette Vaillant Archives.

and Vuillard was consummated before 1900, although the one with Romain Coolus, another bachelor with whom she dallied, almost certainly was. Vuillard's painting, even when his muse was not part of the picture, was conditioned during this period by the imprint in space of her passing. The very beautiful *Cipa Listening to Misia* (1897–1898, Kunsthalle Karlsruhe, c-s vi.38) is a tribute to the remarkable musicianship of Thadée's wife, who had been a favourite pupil of Gabriel Fauré. The way the objects, the bodies of the protagonists, the background décor and the distances blend into a harmonious unity shows that Vuillard, sensually awakened by Misia, was striving during these years to unite music and painting—one of the dreams of the French Symbolists. Artistically, he was at the height of his powers. An exactly contemporary print by Vallotton (*The Symphony*, fig. 24) shows Misia in the same drawing room, playing the piano before an enthralled audience,

among whom we recognize the pianist Alfred Cortot (with monocle and moustache) and, dominating the group, Vuillard, his eyes closed as if in prayer while he listens to the music. The extremely intimate *Nape of Misia's Neck* (cat. 149) is one of the most beautiful love songs Vuillard ever created for the musician enchantress. The way her hair hides her face, the wonderful curve of her neck and, above all, the glorious summer sunshine rendered tactile are clear indications that Vuillard had moved into another era.

Misia, a brilliant intellectual, could be insufferable and capricious. Her about-faces were legendary. In her memoirs, written late in life, she blithely casts herself in the sympathetic role, but a quite accurate picture of the situations and protagonists of the period emerges from between the lines. In a famous passage, she recounts what may be considered Vuillard's "declaration" to her during a stroll on the banks of the Yonne

(see cat. 149). She also includes a wonderful undated letter sent her by the painter around the same time: "I have always been shy in your presence, but the security, the assurance of a perfect understanding relieved me of all embarrassment; nothing was lost by this understanding being a wordless one. Now that we have been so long without seeing each other I have sometimes anxiously wondered if it is still as perfect as it once was. Your post-card arrived in answer to my question. And no, I found nothing ridiculous in your thought; I saw it simply as a token of your affection."[55] And a while later: "...you met half-way a desire that flashed across my mind yesterday and that I was afraid of not having *time* to mention to you. So there is something better than wireless communication. The best thing was that you were there! It seems to me I am happy now, thanks to you. I am calm..."[56] This game of cat and mouse went on for a long time. Cosseted by Thadée, who admired her unconditionally, she loved to make conquests; such was the case with Vallotton, Toulouse-Lautrec, Bonnard, and indeed most of the men she invited for country holidays. But if Vuillard began to give free rein to his sensuality, abandoning himself to what Chastel aptly called a "libertinism of sensation,"[57] it was due to Misia, to her presence in his world and to the obsessions that her voice, her scent and her movements awakened in him. With *Interior, The Salon with Three Lamps* (cat. 156) and the first Schopfer panels (c-s VI.99-1 and 99-2) Vuillard confidently demonstrates that he has reached the height of his powers. At this period he was making Misia a part of all his large decorative panels, even though those who had commissioned them were less than delighted about it. Thadée's wife was to be seen everywhere, the perfect embodiment of the potential "conspiracy" between painting and music that was the artist's ardent goal. His "interminable" gaze, which melded bodies, faces, inanimate objects, flowers, draperies and light into a single speckled surface, had been developed and supported by his contact with Misia, whose presence in the interiors he shared represented for the painter a daily miracle. It was she, ultimately, who enabled him to move on to an "adult sensuality."

Any discussion of Vuillard's decorative work must take account of this sensual imperative. It triumphs in two of the greatest masterpieces of his career: the five 1895 panels known as *The Album* (cats. 126–129) and the Vaquez panels, painted the following year (cats. 137–140). Here he achieves the ultimate in cerebral art, handling like a sorcerer a language of the senses that integrates objects and flesh so they are visually indistinguishable. In the panels of *The Album* there is no "near" or "far," and almost no "up" or "down." The relationships of scale and perspective he imposes on us are those of intoxication, opium dreams and orgasm combined. Looking at them, we find ourselves floating in an indeterminate space, the verisimilitude of which springs from the kind of *Klangfarbenmelodie*[58] dear to the Viennese school. A Wagnerian might say that these panels by Vuillard are *durchkomponiert*, meaning that their logic derives from the progressive exposing of their structure. The curved line alone locates the beings in space, and the women seem to emerge from some primordial sea, whose endless tides are mirrored in the curls and scrolls of the fabrics. Probably inspired by the style of Odilon Redon's series of lithographs *Origins*, a copy of which Vuillard had bought in about 1893, *The Album* introduced this poetry of transitional states, where water mingles with

hair and the female body is the protagonist of primeval creation. In going so far, Vuillard came close to shocking his admirers. Claude Roger-Marx exclaimed: "It is impossible to discover to what family belong the bouquets—half hortensias, half chrysanthemums—that spangle the spaces with whites and greens and contrast with the flowers on the wallpaper, turning the persons into something like ghosts…The spell resides in these vaguely sketched gestures, embryonic states of mind and the correspondences invented between objects, faces and environment."[59]

The magnificent Schopfer panels show obvious signs of a shift toward new concerns: the texture is less dense, but paradoxically it conveys even better the impression of a woven image; in a less Expressionist style, *Woman Seated in an Armchair* (fig. 25)

and *Woman Reading on a Bench* reveal the pleasure of the aristocratic *dolce far niente* and constitute the crucible of a perfect communion between man and nature. The vague sense of melancholy emanating from these grey harmonies, like the changeless cadences of a calm sky, belongs to that voluptuous (and late Symbolist) penchant for *perpetuum mobile* and sensual torpor that links the symphonic music of Claude Debussy and the art of Édouard Vuillard.

The year 1900 was a clear turning point. After that date, the artist began to move in a new circle of friends, although still maintaining several old friendships (Thadée, Romain Coolus and Tristan Bernard). It was around this time that he became the lover of Lucy Hessel,[60] and a holiday at the Vallottons' in La Naz, Switzerland, likely provided the opportunity. From then on, although he remained in touch with Misia,[61] Lucy, with the indifferent acquiescence of her husband Jos (more concerned with selling the artist's paintings than with his wife's behaviour),

25

Édouard Vuillard, *Woman Seated in an Armchair*, 1898, distemper on canvas, private collection, C-S VI.99-2.

became the new muse in Vuillard's life—although it might be more accurate to say that the painter appeared to be the buxom Madame Hessel's *cicisbeo*.[62] She was more reliable than Misia and remained steadfastly devoted to him until 1940, even when he pursued other women—something that happened frequently after 1900. The arrival of Lucy in Vuillard's life heralded a new period of creativity, rather as happened with Pablo Picasso's work, in which the succession of women in his life is perceptible: Olga, Marie-Thérèse, Françoise, Jacqueline. Vuillard's version was evidently cosier and more bourgeois. Lucy went to art galleries with him, talked about museum collections, affectionately

26

Photograph by Vuillard of Lucy Hessel
and Marcelle Aron on the beach
at Vasouy, *The Two Sunshades*, 1902,
private collection.

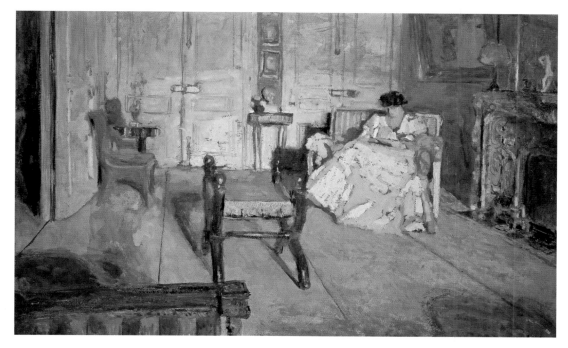

27

Édouard Vuillard, *The White Salon*,
1904, oil on board, Paris, private
collection, C-S VII.332.

scolded him for always wearing such shabby clothes and accompanied him to the opera,
concerts and the "cinematograph." Violent tiffs, generally in front of witnesses, added to
the couple's notoriety.[63] And most importantly, from 1901 to 1914 she took him with her
on holiday to Normandy: every year, with clockwork regularity, Vuillard left Paris for
the months of July, August and September (fig. 26). It was in large country houses, filled
with impossible furniture and visited by many friends, that his painting evolved toward
a sort of late Impressionism: views of beaches and the neighbouring woods, lazy after-
noons—*felix otium*—and meals that went on forever. These paintings are less complex,
less abstruse, more open to sunlight and tawny colours (fig. 27). In "chamber music"
mode, Lucy's somewhat matronly sensuality permeates everything, lingers in the endless
seaside panoramas; henceforth, Vuillard would turn more and more frequently from oil
to distemper, of which he was the supreme exponent.

He no longer needed to prove to himself that he was a great painter. He did what he liked, depicted *whoever* he liked in his works; the decorative panel *The Alley* (1907, Paris, Musée d'Orsay, c-s VIII.226-1), executed in 1907 for Prince Bibesco, is the largest portrait of Lucy he ever painted, even though the prince was no great admirer of Madame Hessel. The prevailing mood from this point on was a creative indolence that produced masterpieces comparable to the successes of his youth: in the *Five Panel Screen for Miss Marguerite Chapin* (cat. 271), the triumph of springtime is apparent in the luxuriant vegetation of Place Vintimille, as profuse as a tropical jungle and scarcely contained by the garden railings. This folding panorama is animated by Vuillard's consuming passion for the lovely Marguerite Chapin—it was not reciprocated—whom he celebrated as an icon of beauty in *The Library* (fig. 28): she appears silhouetted against the light from the hearth, a modern Venus who all by herself is sufficient justification for this brilliant collage of an antique marble sculpture,[64] a tapestry inspired by Titian and small columns and cabochons from the Italian Renaissance, the whole rendered in a rough, fabric-like pictorial surface.

Vuillard had lost his complex about his appearance, since he now had no difficulty (to say the least) in attracting women who appealed to him. The models came and went in the studio he had been obliged to rent on Boulevard Malesherbes so as not to shock his mother in their apartment on Rue Truffaut and, later, Rue de la Tour. During the First World War this habit became compulsive, since Paris was inhabited mainly by women, the young men having all been sent to the front. It was around this time that he met a young aspiring actress of radiant beauty who may well have been the love of his life: Lucie Belin. No one seems to have been aware of the intensity of their romantic but stormy relationship. With her, Vuillard felt young again; and unlike Misia and Lucy, she was to have no influence on his painting beyond the portraits he made of her, the most celebrated of which is *Lucie Belin Smiling* (cat. 307). But she was the subject of his loveliest photographic portraits (fig. 29). He had never depicted anyone close to him as he did Lucie Belin. Whether picturing her in her little Bohemian bed-sitting room or posed in his studio on Boulevard Malesherbes, he used the camera to express his love. And he was loved in return. Lucie Belin had completely lost her heart to the aging artist, who, it seems, adored being caught up in this youthful infatuation. Calling herself "Lucie Ralph" (her "stage" name), she reveals in her letters an all-consuming passion: "darling friend, I am very unhappy not to have seen you. I beg of you, could you at three o'clock Boulevard Malesherbes? I shall be there if only for a moment, be there too, darling. I send you a thousand tender kisses but spending today without seeing you would be horribly painful for me. If you cannot come will you telephone your concierge so she can tell me whether I should wait—please do come if you possibly can. All my love. Lucie."[65] And in another scribbled message: "…I want so much to kiss you too, to cuddle up in your arms, to sleep right up against you…"[66] We knew that Vuillard was hardly a hermit, but this effusiveness is nonetheless surprising. He kept in touch with Lucie after the war, and tried in vain to find her an opening in the theatre, approaching directors and actors among his friends (Bathy, Darzens, Géraldy, Suzanne Després); when she fell ill in the late 1920s, he discreetly arranged to have a small pension paid to

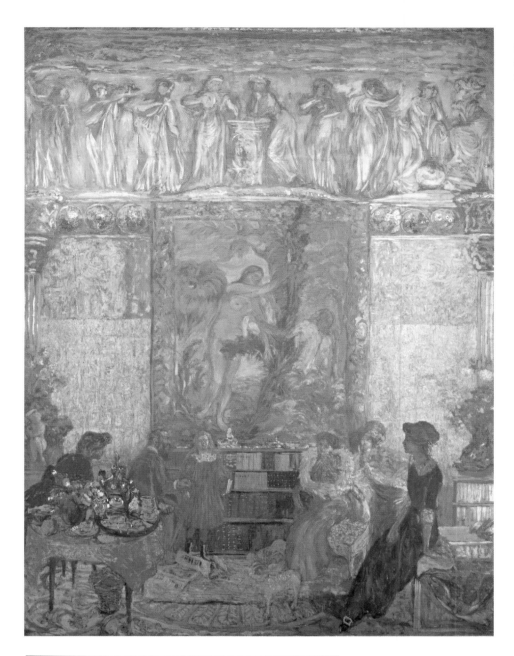

Édouard Vuillard, *The Library*,
1910–1911, distemper on canvas, Paris,
Musée d'Orsay, C-S IX.164.

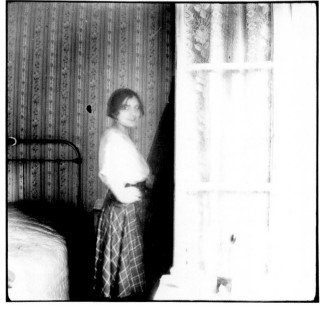

29

Photograph by Vuillard of Lucy Belin
in her room, Rue D'Alboni, c. 1915–1916,
private collection.

her until her death.[67] After this affair, the artist made further conquests, goading Lucy Hessel to fury; her letters of the 1920s are peppered with bitter reproaches. The greatest threat to Lucy was undoubtedly Juliette Weil. In 1922 Vuillard made a portrait of her with her children (cat. 316), and we can imagine that he took his time with the painting — rather like Penelope at her loom — in order to pursue his seduction of her. But this liaison was even more bourgeois and stifling than his relationship with Lucy, and there seems to be no trace whatever of Juliette in Vuillard's work. By the time the First World War was over he was into middle age and his sensual gaze, while not extinguished, was now turned toward landscapes, fragments of garden he would paint at the Château des Clayes, and small interiors. His main concern from 1918 to 1940 was the completion of several large commissioned decorations that were linked to the more "political" aspect of his life.

**Politics . . . Irony . . . Wisdom?** | ÉDOUARD VUILLARD'S LIFE and career coincided almost exactly with the longest regime France has ever known: the Third Republic (1875 –1940). Although he was born in 1868, under the Second Empire, the path of his life was linked closely to that of the republican regime he had not chosen but certainly cherished. His family had received support from the state, for his father, wounded in combat in Senegal, had been given a "reserved occupation" as a tax inspector in Cuiseaux (Saône-et-Loire). As a soldier's daughter, Vuillard's sister was allowed a place as a boarder at the Légion d'honneur school, while his brother Alexandre, six years his senior, was a student at the Polytechnique. For some time Vuillard considered attending the Saint-Cyr academy with a view to embarking on a military career, like his elder brother. The Republic began under the most precarious circumstances: the Wallon amendment introduced the word "republic" on the sly in January 1875, and this clandestine measure was accepted by the then monarchist Chamber by a margin of only one vote. There could hardly have been a more shaky beginning, and no one would have bet a franc on the survival of a regime introduced by such underhand means. Certainly, the Republic kept France isolated for many years from the rest of Europe, at the time a patchwork of constitutional monarchies, but it was difficult for a young Frenchman to judge the matter. Was Paris not still the capital of the world, the place where developments in avant-garde art reached an unparalleled intensity? France would soon, in fact, behave like the other major powers — England, Germany, Russia — and build a real colonial empire to ensure her prosperity. Before the First World War it was undoubtedly one of the richest countries in the world, with gold reserves equivalent to half the world's total, and capable, moreover, of mounting the Paris Universal Expositions (1878, 1889, 1900), world fairs of staggering pomp and luxury that were completely open to the latest technology and scientific discoveries of the day. During the years between 1889 and 1898, glorious ones for Vuillard's oeuvre, the country was led by a conservative government, that of the "opportunist republicans" (fig. 30). The presidents of the Republic were Sadi Carnot, Jean Casimir-Périer and Félix Faure. After 1898, the scandal of the Dreyfus affair brought to power a left-wing majority (Waldeck-Rousseau), which would institute radical reforms of political and social institutions particularly affecting the relationship

32

between the Catholic Church and the State. During the Nabi years, Vuillard, like all his Parisian artist friends, delighted in making fun of the bourgeois and jeering at policemen (see *The Demonstration*, cat. 11); he also shared with them a violent loathing for the politicians then in power and for the military. At a time when protectionist laws (Méline) isolated France from the rest of the globe, and when the Panama scandal (which broke in November 1892) was tarnishing the whole republican system, Vuillard followed the events perturbing this dismal era with the greatest interest. Some of his oil sketches poke gentle fun at the bourgeoisie, but it would be pointless to expect from a man who avoided contributing to the satirical journal *L'Assiette au beurre* the social indictments of artists like Steinlen and Hermann-Paul. Nevertheless, around 1893–1894, Vuillard, along with his friends Roussel and Vallotton, did have a brief flirtation with the anarchists: in 1894 he followed closely the case of the Thirty, in which his friend from *La Revue blanche*, Félix Fénéon, was seriously implicated, suspected of having himself made the bomb that exploded at the Restaurant Foyot in April 1894. It was all in the spirit of the times: it is not uncommon for intellectuals to find themselves opposed to the government in power. Some ten years later, during the "leftist" republic of Émile Combes, many of them drifted toward the right. Vuillard painted a picture that was an allusion to politics— *The Electoral Meeting* (1893, priv. coll., c-s v.36)[68]—and a Théâtre de l'Oeuvre production of Gerhardt Hauptmann's play *Âmes solitaires*, with sets by Vuillard, was interrupted for a time by the then prefect of police, Louis Lépine, the real "bogeyman" of the Republic. While "there were more and more arrests and foreign libertarians were being extradited," Lugné-Poe wrote later, "for the first time in my life I had to wangle permission at the offices of the Prefecture to perform at least the dress rehearsal, and Lépine…had never been interested in art or literature. The opening in Paris was a flop, but very eventful in Brussels, where we played the next day. Yet there was nothing very revolutionary in this fine play by Gerhardt Hauptmann…"[69] Vuillard did not attempt in his lithographs anything like Vallotton's comically appalling assessments of Parisian bourgeois society of the time: the Swiss artist's woodcuts present a sly and salutary vision of perverse schoolboys, deceitful women, middle-class fat cats interested only in money, and especially policemen wielding their truncheons. But Vuillard's political position was not so far removed from that of his Nabi comrade. It should not be forgotten that Vuillard was a friend of the unpredictable Alfred Jarry, who obstinately propagated the "Ubu spirit" (fig. 31) in the pages of *La Revue blanche*; the painter entirely shared the sentiments expressed in the writer's hilarious *Chanson du Décervelage*—set to music by Claude Terrasse—in which the bourgeois are threatened with dreadful brutality: "Watch the landlord tremble! Watch their brains explode!" But Vuillard would never be a militant.

During the Dreyfus affair he quickly found himself in the camp of those who defended the unjustly exiled captain, and he disapproved of the anti-Semitic attacks to which his closest friends, the Natansons, and half the contributors of *La Revue blanche* were subjected at the time. The periodical in a way signed its own death warrant in order to achieve victory in the review of the Dreyfus case. It won in the end, but at the cost of its own existence. At one point there was a split in the Nabi group, with Sérusier and Denis taking a clearly anti-Dreyfus position—as did Edgar Degas and Forain—while

30

Anonymous, *1792–1892, Fêtes du centenaire de la République française*, poster, colour lithograph, printed by E. Pichot, 1892 (Paris, Bibliothèque Nationale), taken from Maurice Agulhon's book *La République, de Jules Ferry à François Mitterand, 1880 à nos jours*, Paris, Hachette, 1990.

31

Alfred Jarry, *Design for the Program of the Inaugural Production of "Ubu-Roi,"* 1896, taken from the *Encyclopédie du Théâtre contemporain*, vol. 1, 1850–1914, Paris, Les Publications de France, 1957.

Bonnard, Vuillard and Ibels were on the opposite side (although, in Vuillard's case, without a great deal of fuss) (fig. 32). In his diary of March 1899 Maurice Denis, who was gradually moving closer to the Action Française, comments on the exhibition then showing at the Galerie Durand-Ruel, *Les Symbolistes et les Néo-impressionnistes*, in which his own canvases hung side by side with those of the other Nabis: "Vuillard, Bonnard,

UN DINER EN FAMILLE

— Surtout ! ne parlons pas de l'affaire Dreyfus !

... Ils en ont parlé...

Vallotton group: 1. small paintings; 2. dark; 3. from life...; 7. complicated medium— Semitic taste...Sérusier, me, Ranson group: 1. large paintings; 2. painted with pure, more or less dark colours; 3. symbolic...; 7. very simple unified medium—Latin taste..."[70] Classical clarity was timeless for Maurice Denis, "Latin," as opposed to the hazards of an obscure, "Semitic" language; the notions of "Latin taste" and "Semitic taste," here introduced, would be recklessly reused by certain critics during the 1920s and 1930s (Camille Mauclair and Walde-mar George to the fore) with even more sickening overtones. The lives of people like Thadée Natanson, Léon Blum, Tristan Bernard, Lucien Muhlfeld and the com-poser Paul Dukas give us a glimpse of an era when leading Jewish families respected their rites but had no qualms about send-ing their children to Catholic schools. Theirs was not a strongly asserted Judaism, although the "Affair" led many of them to ponder deeply on just how solid their integration into French society actually was: the aspirations of Zionism are largely

rooted in these events. Tristan Bernard was in the habit of declaring: "Not only am I a Jew, but my financial position permits me not to be an Israelite!" And Natanson, like the people around him, was very patriotic; everyone hoped some day to witness France's revenge against the Prussians, although without ever using the same sabre-rattling language as those two ridiculous clowns of nationalism, Rochefort and Deroulède. Throughout his life Vuillard maintained a brotherly affection for Thadée, his two brothers Alexandre and Alfred and their families, and for Coolus—and indeed for more recently acquired friends, notably the Hessels. During the 1930s, when his circle of intimates included other new faces—Prosper-Émile Weil and his wife, the art dealer Alfred Daber, Georges Wildenstein, Sam Salz—and the Hessels affectionately "confined" him in the Château des Clayes, the artist's journal shows him to be increasingly worried about the rise of anti-Semitism, especially after Léon Blum was manhandled and seriously

injured in the street by hoodlums from the Action Française.[71] Some months later, he again noted "the anti-Semitism against Léon."[72] To Vuillard's mind, the Republic had survived many vicissitudes and would always manage to extricate itself from the worst difficulties: had it not been the principal architect of the victory of 1918? Speaking of Rembrandt's *The Carpenter's Family*, Vuillard noted humorously: "He too only painted Jews!"[73] Some weeks before his death, when his state of health was already giving cause for concern, the Jewish art dealer Alfred Daber went to find a Catholic priest so that Vuillard could make his peace with God. But in vain: the artist refused. And it was the faithful Hessels who, in the confusion of the German invasion, when many of the artist's friends had vanished into the woodwork, were there to close the old painter's eyes when he died on June 21, 1940, at La Baule.

Vuillard was, then, a "child" of the Third Republic, like so many in France outside of a few confirmed monarchists. In 1912, the government (Raymond Poincaré was currently prime minister) named him to the Legion of Honour, along with Roussel and Bonnard. They unanimously refused the award, and the press made much of the gesture. In *Gil Blas* on October 25, 1912, an article clamoured, "The medals were scorned," while in *Le Temps* the following day we read, "Three artists refuse the red ribbon." Vuillard agreed to explain his position in an interview, published in the same article of *Le Temps*:

I am much angered by the fuss over our decision. My friends and I had no intention at any time of making any sort of demonstration. Although we are close friends, none of us knew that the government was thinking of offering the red ribbon to any of us. Our refusal was in no way a concerted action. But spontaneously, each of us declined the very flattering offer made to us, by which we felt honoured and moved. I consider for my part that artists should keep their distance from official life. I have always believed in the positive effect of these honours, which celebrate without distinction a diversity of merits and a range of talents. I believe that we have to make choices, and I do not care about approval. I go on with my work according to my conscience, endeavouring to express what I feel and what I love, and I have no other goal.[74]

Just as in his youth he had not thought it worthwhile applying for the Prix de Rome, so Vuillard, always discreet and reserved, would refuse all honours for many years. Not until the end of his life did he accept them, probably in memory of his dead mother. Prior to 1929, when the government acquired the central triptych of *The Public Gardens* at the Alexandre Natanson sale, the museums of France possessed no other major works by him. Vuillard's friend Alfred Sutro, the theatre producer, dwelt at length in his memoirs *Celebrities and Simple Souls* (1933) on the disinterested uprightness of his old comrade:

Vuillard comes nearer than any man I have known to the old Italian painters one reads of in Vasari; his devotion to his art is intense, and there is a curious simplicity and whole-heartedness about this devotion, a complete giving-up of self, a passionate love of the work for the sake of the work. I have told how he painted the scene for Lugné's play; Vuillard was always ready to help, in any good cause...He is famous to-day, and his pictures fetch very high prices; he has remained as he was, the painter who sits quietly in his studio and goes on painting, indifferent to fame, distinction, honours, never sending his work to exhibitions, never trying to push himself, get himself talked about.[75]

But this did not prevent Vuillard from feeling proud to be appreciated by a small coterie of intellectuals (Arsène Alexandre, André Gide, Octave Maus, Charles Morice, Walter Sickert) and proprietors of fashionable Paris art galleries (the Bernheim brothers). The fact is that he had, *in petto*, the highest opinion of his own creative and inventive capabilities.

During the First World War, which like most Europeans he had failed to see coming, Vuillard stood firm with a Republic under threat from the German Empire. It was the "Sacred Union." References to news from the front, his evident anxiety when France seemed to be losing ground to the enemy forces—such concerns found their way, exceptionally, into his diary. Kerr-Xavier Roussel, for his part, was completely distraught about the butchery that became inevitable once the soldiers were in the trenches; he fell into a serious depression and was obliged to go to Switzerland, for treatment at Dr. Widmer's renowned clinic. On February 24, 1915, Roussel took his wife Marie and daughter Annette with him to Valmont, and Vuillard made use of his political contacts to obtain for them a safe-conduct, almost impossible to procure in time of war. The other major reason for Kerr's semi-exile was his rowdy pacifism and the proto-communism

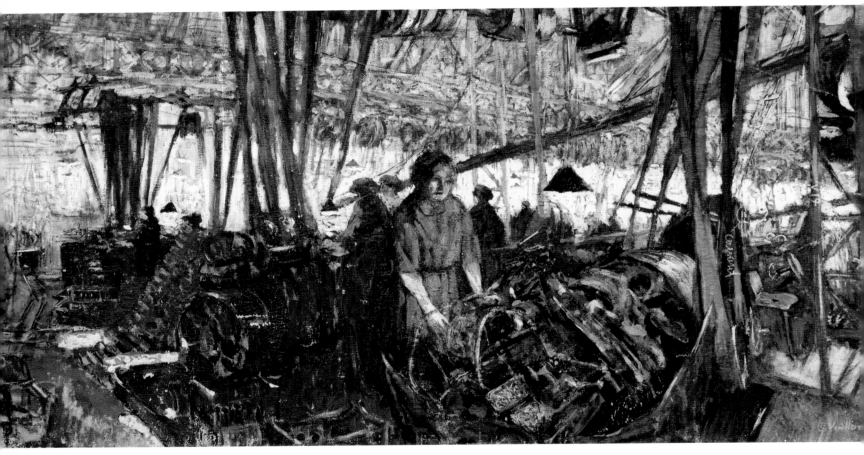

that made him suspect in wartime; Vuillard undoubtedly advised him to go abroad and lie low. On occasion Édouard would lose his temper over his brother-in-law's defeatism: "Arrival of Kerr while I am dressing. Question of his journey to Rome. Admit to him my exasperation: he has done little about his future."[76] During the war Vuillard was careful to avoid nationalist grandiloquence in his paintings: in *Interrogation of the Prisoner* (cat. 282), he shows sympathy for the poor German, pathetic in his grey coat, being

34
Photographs by Vuillard of a war factory at Oullins, 1917, private collection.

interrogated by French soldiers. *The Chapel at the Château de Versailles* (cat. 283) is a tribute to France, in great danger in June 1917, as her Russian allies were collapsing in the east; but it is also a tribute to the classical tradition, to the ideal union of music, sculpture and architecture. The masterpieces of this period are the two panels—*War Factory (Daytime)* and *War Factory (Evening)* (C-S X.32-1 and 2; fig. 33)—commissioned by Lazare Lévy, the chairman of Éclairage Électrique: the painter, thrilled by the deafening racket of the machines making munitions for the front, produced a stark modern vision that is also dreamlike and magical. The photographs he brought back from the factory at Oullins can well be compared to Rodchenko's "Constructivist" snapshots (fig. 34). November 11, 1918, which brought the signing of the armistice and France's victory at the head of the Allied armies, was one of the happiest dates of the artist's life, especially as it coincided exactly with his fiftieth birthday.

After 1920 Vuillard was considered one of Europe's greatest living portraitists. He had become friends with certain leading civil servants and politicians of the Third Republic. They included Philippe Berthelot, the indispensable secretary-general of the Quai d'Orsay; Albert Sarrault, who must have held the portfolio for every ministry in the Republic; Louis Loucheur, the Minister of Labour known for the law that bears his name, which authorized advance funding from the government for building societies and the department for low-income housing (thus enabling countless French citizens of modest means to become homeowners); and Paul Ramadier, who would be one of the few parliamentarians to oppose the delegation of full powers to Marshal Pétain in 1940. Vuillard petitioned Albert Sarrault, through the good offices of the banker Jean Laroche, in order to obtain the Legion of Honour for his brother Alexandre in 1923.[77] He also made portraits of a number of industrialists (*Lucien Rosengart*, cat. 321; *Charles Malégarie*, C-S XII.144), all of them notable personalities linked in one way or another to the world of boulevard theatre, the arts and easy money.

Vuillard's political opinions are hard to summarize. For some of those who knew him, he remained a man of the extreme left, even close to being a communist.[78] Marie-Blanche de Polignac offers a slightly different view. After having commissioned the artist to do a portrait of her mother, Jeanne Lanvin (cat. 326), she visited his apartment:

"One day she [Jeanne Lanvin] took me to Place Vintimille, to the small apartment where he lived with his elderly mother. A very modest apartment, almost that of a workman. But since every window reminded you of a painting by him, it became the most luxurious of palaces." One wonders, in passing, whether Marie-Blanche de Polignac had seen many workmen's flats if she thought a home on Place Vintimille unworthy of a bourgeois. She goes on: "It was around this time that Blum came to power. Vuillard was excited. As a socialist and a friend of Léon Blum during the *Revue blanche* days, he was jubilant and anticipating better times. I—who instinctively loathed that period of raised fists and was tired of hearing 'All is very well Madame the Marchioness' sung every time I got into a car in front of a workman—was won over by Vuillard...But he was less enthusiastic about the Front Populaire."[79] Indeed, Vuillard's diary shows him to be rather moderate in his views and unhappy about the Stalinist excesses of his brother-in-law and his nephew Jacques; more significantly, he watched with real horror the growing dangers in the period prior to the second war. References to current events dominate the last six years of the journal: he notes the suicide, on November 18, 1936, of Roger Salengro, the Front Populaire's minister of the interior (who had been attacked by the far-right press), he mentions the abdication of Edward VIII of England on December 10 of the same year, and during a dinner at the Hessels, when the author of *The Counterfeiters* had just bravely published *Retour de l'URSS*, unleashing the fury of the French Communist Party, he admits—despite Roussel's protestations—"great interest Gide return from Russia" (December 18, 1936).[80]

Far from feeling that the last twenty years of his life constituted a slow decline compared to those that had gone before, Vuillard entered a period in which, full of wisdom, he fused into a unified vision his careful observation of the social behaviour of the upper classes he associated with (fig. 35), his interest in things political, and a biting, supercilious irony. The *Portrait of Philippe Berthelot* (fig. 36), which depicts the subject in his office at the Ministry of Foreign Affairs, exemplifies the attitude of attenuated sympathy that Vuillard strove to convey in most of the so-called "late" portraits. He made a large number of sketches and pastels in preparation for this complex image, capturing the reflection of a clock or an inkwell, and spending a lot of time on the hands. He presents the senior civil servant as someone he genuinely likes—intelligent, cultivated, a tireless worker (and a night owl like himself). But if we look longer at the portrait, we have the growing impression that the man we have before us is a devious police commissioner from a Céline novel, who might say to a suspect: "My friend, you aren't making my job any easier. Again, if you'd be kind enough to confess—I have all the time in the world!" The subject of the *Portrait of André Bénac* (1935–1936, Zurich, Fondation Rau, C-S XII.127), another mainstay of socialist policies in the Third Republic—known as "the workers' friend"—aroused Vuillard's sympathy. Bénac was a good age by this time, and one guesses that

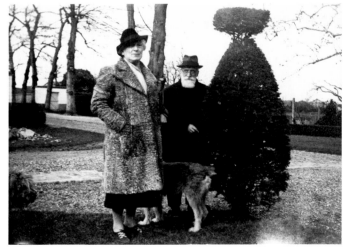

35
Anonymous photograph of Vuillard and Lucy Hessel at the Château des Clayes, c. 1935, private collection.

38

Édouard Vuillard, *Portrait of Philippe Berthelot*, 1928, distemper on canvas, private collection, C–S XI.269.

despite his sly gaze he must have dozed off during the sittings and snored portentously. What interests us in this "fake daub" is the objects on the table: they have been rendered, in distemper, with a perceptive skill that leaves us aghast. If we examine the surface from close to, the reflection in the spectacles on the table, the magnifying glass and the flask seem like nothing more than a kind of coloured mud. But if we step back a few paces, all these items take on an obvious density and volume. And as Claude Roger-Marx has noted, the winter landscape framed by the window, with its leafless trees, is like a painting within a painting. Vuillard, an incomparable psychologist, always focused first on the most peripheral elements in his sitters' surroundings. He made inanimate objects the

main protagonists in the composition: a filing cabinet, an inkstand, pieces of fabric spilling out of a drawer, perilous stacks of files. Thereafter, he tackled the face, which is not always the most successful part of the painting (*The Black Cups*, fig. 39; *Jeanne Lanvin*). He often said: "You start a portrait without knowing the sitter. When you've finished, you know the sitter, but the portrait is no longer a likeness."[81]

Around 1910, Vuillard began adapting the techniques of distemper and pastel (highlighted with charcoal and gouache) to portraiture, undertaking many virtuoso experiments. The colours of *Sacha Guitry in His Dressing Room* (cat. 302), for example, have an unusually glowing power. The focal point of this large pastel is clearly the reflection of the actor's face in the small round mirror hanging on the wall. This subtle detail was undoubtedly borrowed from one of the "Tapestries of the Apocalypse" (which he knew well from having gone so often to admire them in the museum at Angers)—*The Great Harlot* (1373–1380) by Nicolas Bataille, in which the heroine's face is reflected in a small oval mirror, a sign of her duplicity. We know that Vuillard had loved the great tradition of French tapestry since his youth. It is fascinating how in the last years of his life he was able to combine, with extraordinary finesse, the most unexpected and disparate influences.

The portrait may also have served him as an exorcism of death. There had been no plan to paint four portraits of his old Nabi friends, *The Anabaptists* (cats. 291–292). He had simply begun in the normal way on a portrait of Maillol. Since Maillol's studio in Marly was close to Kerr-Xavier Roussel's at L'Étang, he very soon, in 1923, added sketches for a portrait of Roussel. Vallotton's death, which occurred in 1925, shocked him deeply. It was then that he decided to paint the other survivors from the Nabi years, whose influence on him had endured from his youth. He therefore decided to add a portrait of Bonnard in his studio and one of Maurice Denis in the chapel of Rouen. But even with his closest friends, he could not prevent himself from enlivening the compositions with darkly ironic touches that were in each case extremely psychologically acute. Roussel (see cats. 291–292, fig. 1), for instance, is shown in his studio as a sad Faust, surrounded by the paintings on which he incessantly works. The stormy, leaden sky seen through the large window seems like a metaphor for the artist's depressive nature, which Vuillard could not help revealing.

What he most enjoyed was painting the portraits of people at the height of their profession, hard at work. One of his most astonishing creations is certainly *The Surgeons* (cat. 306 and fig. 37)—actually anything but a portrait—which shows his friend Dr. Antonin Gosset performing an operation. It was in this kind of painting that Vuillard truly showed himself to be a "painter of modern life," attentive to the tiniest detail and to the "scientific" accuracy of gestures, but in a way that never compromises the unreal violence of the whole. Another example is the portrait of *Henry and Marcel Kapferer* (cat. 305), which shows the two bachelor brothers, businessmen and art lovers, in their home, awaiting the latest stock market figures; the focal point of the composition is the two-colour telephone cord that twists wildly, in what seems like an effort to upstage the two brothers. In these and other works Vuillard recorded specimens of *social types* that are immediately recognizable: the banker-collector (*Jean Laroche, David David-Weil*), the industrialist (*Rosengart, Malégarie*), the actor (*Lucien Guitry*), the actress (*Yvonne Printemps, Simone Berriau*), the dress designer (*Lanvin*), the aristocratic artist (*Polignac*) and the government minister (*Loucheur*).

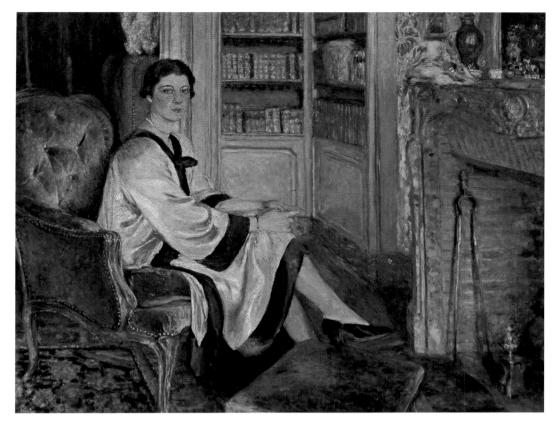

38
*Jacqueline Baudoin*, 1925–1927,
oil on canvas, Algiers, Musée des
beaux-arts, C-S XI.246.

Some women impressed him with their beauty. There is no irony underlying the magnificent "neoclassical" portrait of *Jacqueline Baudouin* (fig. 38), wife of a celebrated auctioneer of the time; unusually for Vuillard, the pictorial surface is smooth, almost Ingres-like. He seems also to have been quite stunned by what he called the "difficult Spanish type"[82] of beauty he saw in Lilita Abreu, the ravishing Cuban wife of Albert Henraux, one of the key administrators of the Beaux-Arts (*Madame Albert Henraux*, 1935, C-S XII.126). His late portraits demonstrate the three constants of his declining years: his enthusiasm for spotting the flaws in contemporary society, an irony that was sometimes quite destructive, and a certain wisdom—the fruit of advancing age. At certain periods, his daily agenda was like a small directory of society's élite. He rarely asked wealthy members of the bourgeoisie to pose in his studio, but worked on their portraits in their homes all over Paris: his daily routine suggests the vigorous health of a much younger man. On the back of an undated wedding announcement (that of Jean Laroche and Fridette Fatton), he made a note of his appointments for one particular day, including the telephone numbers: "from 11 o'clock to quarter to 1 at Madame de Polignac's, Wagram 93.11 / from 1 to half past 2 at Madame Lanvin's, 16 rue Barbet-de-Jouy, Ségur 00.97 / from half past 2 to 4 at Madame Gaston Lévy's, 33 avenue Hoche, Élysée 27.21."[83] So he never spent longer than two hours with his sitters, feverishly sketching a few details that preoccupied him into a notebook so as to move ahead with the composition. On several pieces of paper lying about in his studio, the artist had copied out Valéry's words: "There is no detail in the execution."[84] Some portraits, like that of Jeanne Lanvin, were painted very quickly. Others, by contrast, seem to have been almost impossible to complete and dragged on for years. Such was the case with the portrait of Misia, *The Black Cups* (fig. 39), which he started in 1925 and reworked until

1935–1937. He had her pose in the Chinese drawing room in her apartment at 19, rue Barbet-de-Jouy, with her niece Mimi, who was shortly to be married. Vuillard was especially dissatisfied with this painting: "Painting Misia awful; decide to blur the cold tones with liquid transparent tones, beginnings of a slightly less unsatisfactory effect."[85] In my view this canvas, which shows his old friend as a bloated bourgeoise caught up in a sadomasochistic relationship with her niece (which was actually the case), is one of the most ferocious examples of Vuillard settling accounts with his past. The sphinx who had tormented the shy, lovesick painter in his youth now sits enthroned in a flashy drawing room, a self-satisfied, puffy-looking old trout, holding her horrid little dog in her arms.

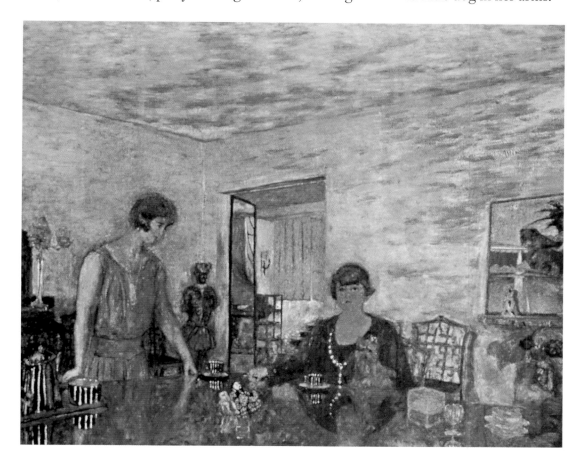

39

Édouard Vuillard, *The Black Cups*, 1925, reworked in 1934–1937, distemper on canvas, London, Christian Neffe – Neffe-Degandt Fine Art, C–S XI.224.

Thus, after 1925, Vuillard began painting some of the most perverse "anti-portraits" of his career. He would certainly have subscribed to the saying that sums up comedy: *castigat ridendo mores*.[86] He knew that the society by which he profited and on which he depended would soon disappear. The important thing for him was the great tradition of French painting that had started with Le Sueur, La Hyre and Poussin and was ending with Bonnard, one or two others, and himself. He accepted his election to the Institut—many considered this decision to be a betrayal of his most deeply-held principles—because the Académie was a place where the wealthy bourgeois, the critics, the newly rich art dealers, the arrogant bankers and the upmarket tarts among whom he moved were unable to get at him. And the last period of his career was like a fifteen-year target practice. Vuillard could not have known, while painting one of his best-known portraits of contemporary industrialists, *Lucien Rosengart* (cat. 321), that the automobile magnate (who was also a skilled entrepreneur and the inventor of the "Rosalie," the

popular people's car)—would find the painting too expensive. The artist saw this as a crime of pure *lèse-majesté:* deeply humiliated, he refused to negotiate.[87] Nevertheless, even before this unhappy outcome, the artist had given hints in his painting of his low opinion of the industrialist: under artificial lighting the latter gives us a cold and haughty look; through the closed curtains can be seen a sliver of blue sky. Another incredible character assassination is the portrait of *Countess Anna de Noailles* (cat. 322). Vuillard spares no detail of the ravaged face of this aristocratic drug addict, although he enjoyed her uncontrollable eccentricities: "6 o'clock visit from the Countess and a friend; feather hanging from her hat, a little girl's dress; arms full of flowers and fruit."[88] But it is in the second version of this portrait (*Noailles II*, 1931, reworked in 1934–1936, New York, Le Frak

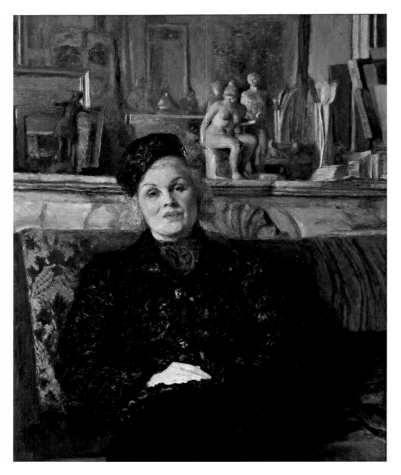

44

Collection, C-S XII.84) that he lets himself go with bloodthirsty delight, employing the most barbaric colours and painting the Countess, who was shortly to die, in an appropriately cadaverous hue. The areas of colour on the canvas are shot through with artful explosions, and the air in the room—a sort of Levantine opium den—seems to have become unbreathable. *Noailles II* is one of the most horrifyingly comic paintings the artist ever made, in an entrancingly lugubrious bad taste that nowadays enthralls us. This is "bad painting" before its time. In these repeated pictorial assaults, Vuillard emerges as a forerunner of portraitists like Alberto Giacometti, Lucian Freud—even Francis Bacon, in whose work the face draws its significance from its own corruption.

In *Yvonne Printemps in an Armchair* (C-S XI.185) Vuillard's subject seems like the epitome of the beautiful flirt, although Sacha Guitry complained that he had married

a real nymphomaniac. The essence of this painting resides in her challenging look and in the mouth outrageously defined in a brilliant shade of lipstick. *Doctor Louis Viau*, triumphant in his office (cat. 293), is surrounded by medical instruments made of lacquered metal, Bakelite, nickel and stainless steel that irresistibly evoke instruments of torture. In his crafty way Vuillard could be seriously ferocious.[89] And he was shameless. The portrait of *Elvire Popesco* (fig. 40) apparently drove Vuillard almost to distraction. The young and beautiful Romanian actress skipped sittings with the artist, he for whom even princesses and ministers managed to be punctual. He took his revenge by aging her, giving her the sullen pose of a brothel madam, with pinched lips and a chalky complexion that suggests a kabuki mask—or even the decrepit actress in *At the Opera* (fig. 41)—gone astray in the Place Vintimille apartment. Far from settling down as time passed, like Michelangelo—who wrote his most profound sonnets at the end of his life— Vuillard retained something of the young man who enjoys lashing out viciously at those around him. With the "Ubu spirit" of his youth still lurking within, he was more savage than ever. His works, though in a radically different style, are occasionally reminiscent of George Grosz's merciless caricatures.

Vuillard was also a cinema enthusiast, and among the films he saw—at the rate of at least two a month—were Pagnol's *Angèle*, Feyder's *La Kermesse héroïque* and Renoir's *La Grande Illusion*. A few days before war was declared in 1939, he painted a portrait of the great American actor Edward G. Robinson (priv. coll., C-S XII.160). If one were looking for a cinematographic equivalent, Vuillard's twilight vision comes somewhere between the pitiless cynicism of Erich von Stroheim in *Foolish Wives* (1922) and the bitter nostalgia at the ending of a world that informs Jean Renoir's *La Règle du jeu* (1939; fig. 42).[90]

While he was indulging in this cruel puppet show, Vuillard realized in the 1930s an aspiration he had never expressed: to be recognized by official institutions. He was given two government commissions: *Comedy* for the new theatre of the Palais de Chaillot, where he was overjoyed to work again alongside his oldest friends, Denis, Bonnard and Roussel;[91] and the huge décor for the assembly hall of the League of Nations in Geneva, which he completed, after a number of technical difficulties, in 1938. The latter commission, an interesting one, gave him the opportunity finally to measure himself against Puvis de Chavannes: *Pax Musarum Nutrix* (Peace, Protector of the Muses; see cats. 294–296) could have been the subject for a great mural by the master who painted the amphitheatre of the Sorbonne—the artist Vuillard had most admired from childhood.[92] But the real masterwork, which demonstrates the interest he took toward the end of his life in becoming a player in the public forum (while still exercising his sense of humour), was *Comedy*, for which he harked back to the marvellously successful decorations he had executed for the Théâtre des Champs-Élysées in 1912 and 1913. He conceived the large square panel as a tribute to the tradition of Molière and Shakespeare. Scapin, Alceste and Célimène meet Titania and Bottom and the exquisite fairies in the friendly woods (modelled on those of the Château des Clayes). Amusingly enough, the notion of turning to Shakespeare's *A Midsummer Night's Dream* came to him from a series of photographs he had taken of Lulu, Lucy Hessel's adopted daughter, as she

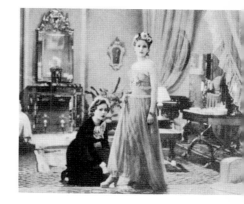

42

Still photograph from Jean Renoir's film *La Règle du jeu*.

assumed various choreographic poses in the park at Les Clayes (fig. 43) and especially in the menagerie, where in several shots she is seen embracing a donkey (fig. 44). In an early version of *Comedy* the artist actually gave Lulu's face, perfectly rendered, to Titania in the creature's embrace (fig. 45): in the face of his model's fury, in which she was supported by her mother, he did as he had so often done[93] and repainted the first version, giving Titania anonymous features (fig. 46). It becomes clear that until the end of his life Vuillard continued to make use of caricature, mockery, elegant exaggeration and remoteness, even with his nearest and dearest. He tirelessly manipulated those around him and, in so doing, his own painting. There is a genuine continuity between the caricatures of his youth, like *The Flirt* (cat. 18) and the hilarious *At the Opera* (fig. 41), in which an aging Messalina makes a comeback in the galleries of the Palais Garnier, and the high-society portraits of his later years, which he varnished with vitriol. It was one of the most endearing sides of his character, and with hindsight seems to us today to have been unusual in the twentieth century. During the 1930s Vuillard tirelessly revisited the Louvre, filled his work with implicit references to his beloved Le Sueur, went again to look at the Villa Barbaro in Maser, at the Mantegnas in the castle at Mantua and the Italian rooms at the National Gallery in London, where he was enchanted by the Uccellos. His goal was to raise his art to an impeccably classical and above all enduring form, built upon the memories of an inexhaustible culture. He was in no hurry. It was an approach shared by certain other painters of the time—one thinks of Derain in particular—but Vuillard was its only convincing exponent. His painting was still and always *cosa mentale*. His creative journey, from Nabism right to the end, followed the same historical curve, *mutatis mutandis*, as the music of Igor Stravinsky.[94] After the "Rimsky-esque" glitter of *The Firebird* (1911) and the primitive, barbaric ecstasies of *The Rite of Spring* (1913), the Russian composer turned after 1918 toward a remote neoclassicism, in which learned —and perverse—references play a pivotal role: thus his *Oedipus Rex*, to a text by Cocteau (a private preview was given at the Polignacs' home in May 1927), is a cold construction—but with a dramatic inevitability—in which Verdi meets Handel in

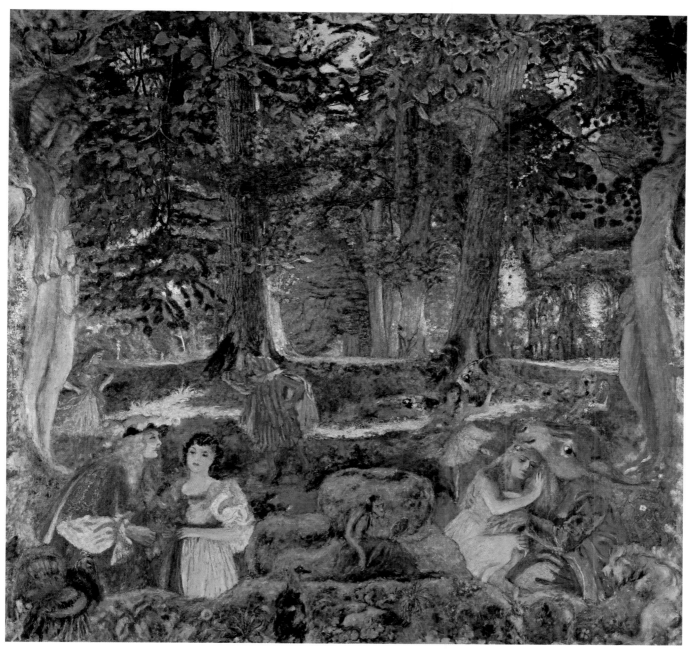

45

(Right) Édouard Vuillard, *Comedy*, 1937, decoration for the Palais de Chaillot, Paris (detail from an earlier version), taken from Claude Roger-Marx's book *Vuillard: His Life and Work*, New York, Éditions de la Maison française, 1946.

46

(Top) Édouard Vuillard, *Comedy*, 1937, decoration for the foyer of the Théâtre du Palais de Chaillot, Paris, C–S XII.134.

imperturbably metronomic rhythms. In the hieratic *Symphony of Psalms* (1928), he succeeded in combining a consistently monodic line with an explosive "vertical" orchestration over which blows a brilliant icy wind. A proper appreciation of the works of Stravinsky and of Vuillard from the 1920s and 1930s requires a real historical perspective. Many who adore *The Suitor* and *The Album* find *Jeanne Lanvin* unappealing: the aging artist, it is assumed, must have grown weary and succumbed to the temptation of facility. The appreciation of Stravinsky's work as a whole has for the past twenty years been a thing accomplished. The time has perhaps come to consider Vuillard's oeuvre, too, as a whole.

1. *Doctor Faustus*, v:2, lines 195–196. Christopher Marlowe, *The Complete Plays*, ed. J. B. Steane (Harmondsworth, England: Penguin, 1969), p. 338.

2. Vuillard, *Journal*, III.(s).1, fol. 23r.

3. Ibid.

4. Dr. Parvu, author of a thesis on cardiovascular syphilis, was Doctor Vaquez's assistant at the Saint-Antoine hospital. He had become the Vuillards' family physician. A small painting of 1922 (priv. coll., United States, c-s xi–158) shows Dr. Parvu treating Alexandre Vuillard (Miquen), the painter's brother.

5. Vuillard, *Journal*, III.(s).1, fol. 23r.

6. Ibid., fol. 24r.

7. All the letters of condolence on Madame Vuillard's death are in the Salomon Archives; they constitute a veritable Who's Who of the period: Paul Valéry, Sacha Guitry, Prince and Princess Bibesco, Countess Anna de Noailles, Jeanne Lanvin, Paul Géraldy, Francis Jourdain, Philippe Berthelot, Albert Sarrault, Tristan Bernard, Léon Blum and so on.

8. Pierre Veber, "Mon Ami Vuillard," *Les Nouvelles Littéraires, Artistiques et Scientifiques*, no. 811 (April 30, 1938), p. 6.

9. Jacques Salomon, *Auprès de Vuillard* (Paris: La Palme, 1953), p. 13.

10. Vuillard, *Journal*, II.2, fol. 12–16.

11. Published in English as *Reminiscences*, in *Kandinsky: Complete Writings on Art*, vol. 1 (1901–1921), ed. Kenneth C. Lindsay and Peter Vergo (Boston: G. K. Hall, 1982).

12. Gaston Bachelard, *L'Eau et les rêves* (Paris: José Corti, 1942), p. 157. This translation taken from *Water and Dreams* (Dallas: The Pegasus Foundation, 1983), p. 116.

13. Romain Coolus, "Édouard Vuillard," *Mercure de France*, vol. 249, no. 853 (January 1, 1934), p. 66.

14. Thadée Natanson, *Peints à leur tour* (Paris: Albin Michel, 1948), p. 364.

15. A quite long article by his friend Pierre Veber, "Une Génération," published in *La Revue de France* between July and August 1936, provides invaluable information about this period.

16. Report books of pupils at the Lycée Condorcet, kindly put at my disposal by the school administration.

17. Ibid.

18. Unpublished note by Jacques Salomon (Paris, Salomon Archives).

19. We absolutely reject the notion, widespread among Vuillard specialists, that he simply ceased writing his diary for a period of twelve years.

20. Vuillard's *Journal* is sometimes hard to decipher. For example, Françoise Alexandre, author of a thesis on the diary ("Édouard Vuillard. Carnets intimes. Édition critique," doctoral diss., Université de Paris 8, 1997–1998), reads "Miquau" for Miquen (Alexandre Vuillard's nickname), "Magne" for (Julien) Magnin, "Dr. Halloua" for Hallona and "Derrien" for décors.

21. Vuillard, *Journal*, I.1, fol. 20 (December 2 , 1888). The Ghirlandaio entered the Louvre in 1886.

22. Vuillard, "Autobiographical notes," *Journal*, II.2, fol. 12r (November 11, 1908).

23. See Otto Rank, *Der Doppelgänger* (Berlin, 1914). Published in English as *The Double: A Psychoanalytic Study* (Chapel Hill: University of North Carolina Press, 1971).

24. Sigmund Freud, "The 'Uncanny'," in *The Standard Edition of the Complete Psychological Works of Sigmund Freud*, trans. James Strachey, vol. 17 (London: Hogarth Press and the Institute of Psychoanalysis, 1955), pp. 234–235.

25. Vuillard, *Journal*, II.2, fol. 12v (November 11, 1908).

26. Salomon records that on his first visit to Denis at Saint-Germain-en-Laye, Vuillard exclaimed, "What odd painting he does!" Jacques Salomon, *Vuillard, témoignage de Jacques Salomon* (Paris: Albin Michel, 1945), p. 19.

27. Maurice Denis, pref. to *L'École de Pont-Aven*, exhib. cat. (Paris: Galerie Parvillée, 1943), n.p.

28. Maurice Denis, in Paul Sérusier, *ABC de la peinture* (Paris: Floury, 1942), p. 67.

29. The Belgian playwright characterized his theatre as follows: "One finds in it essentially the idea of the Christian God combined with the ancient concept of fate, buried deep in nature's impenetrable night, and, from there, pleased to watch, frustrate and cloud the projects, thoughts, feelings and humble happiness of men." Maurice Maeterlinck, pref. to *Théâtre* (New York and Geneva: Slatkine Reprints 1979), p. iv.

30. Quoted from memory.

31. The expression is Jules Lemaître's; it is quoted in Jacques Robichez, *Lugné-Poe* (Paris: L'Arche, 1955), chapter 3.

32. Ibid., pp. 52–53.

33. Maeterlinck, 1979 (see note 29), p. ii.

34. Alfred Sutro, *Celebrities and Simple Souls* (London: Duckworth, 1933), p. 18.

35. "It was the hour when dusk draws in. I returned home with my painting box having finished a study, still dreamy and absorbed in the work I had completed, and suddenly saw an indescribably beautiful picture, pervaded by an inner glow. At first, I stopped short and then quickly approached this mysterious picture, on which I could discern only forms and colors and whose content was incomprehensible. At once, I discovered the key to the puzzle: it was a picture I had painted, standing on its side against the wall. The next day, I tried to re-create my impression of the picture from the previous evening by daylight. I only half succeeded, however; even on its side, I constantly recognized objects, and the fine bloom of dusk was missing. Now I could see clearly that objects harmed my pictures…A terrifying abyss of all kinds of questions, a wealth of responsibilities stretched before me. And most important of all: What is to replace the missing object?" Wassily Kandinsky, in Lindsay and Vergo, 1982 (see note 11), pp. 369–370.

36. Unpublished handwritten note by Édouard Vuillard on Lugné-Poe (Paris, Salomon Archives).

37. Aurélien Lugné-Poe, *La Parade*, II: *Acrobaties. Souvenirs et impressions de théâtre (1894–1902)* (Paris: Gallimard-NRF, 1931), pp. 54–55.

38. Ibid., p. 50; and he adds: "Why aren't our friends also dead of bronchitis?"

39. The great British stage director had this to say: "To speak of a puppet with most men and women is to cause them to giggle. They think at once of the wires; they think of the stiff hands and the jerky movements; they tell me it is a 'funny little doll.' But let me tell them a few things about these puppets. Let me again repeat that they are the descendants of a great and noble family of Images, images which were indeed made 'in the likeness of God;' and that many centuries ago these figures had a rhythmical movement and not a jerky one; had no need for wires to support them, nor did they speak through the nose of the hidden manipulator…Indeed, no! the Puppet had once a more generous form than yourselves." Edward Gordon Craig, "The Actor and the Über-Marionette," in *On the Art of the Theatre* (New York: Theatre Arts Books, 1956), pp. 90–91.

40. Letter from Madame Vuillard to Édouard Vuillard, November 17, 1892 (Paris, Salomon Archives).

41. Letter from Alexandre Vuillard to his brother, June 8, 1893 (Paris, Salomon Archives).

42. In 1898, together with Bonnard, he painted the walls of the auditorium of the Théâtre des Pantins on Rue Ballu (9th arrondissement), established by Alfred Jarry, Claude Terrasse and Franc-Nohain.

43. Vuillard gave it to Vallotton.

44. In Catholic liturgy until the early twentieth century, white was the traditional colour of mourning for dead infants.

45. Weather reports obtained from France's Météorologie nationale.

46. Natanson, 1948 (see note 14) pp. 360–361.

47. Vuillard, *Journal*, I.2, fol. 43v (July 15, 1894).

48. Ibid., fol. 45v (July 23, 1894).

49. Ibid., II.2, fol. 12v (November 11, 1908).

50. Ibid., I.2, fol. 43r (July 13, 1894).

51. André Chastel, *Vuillard 1868–1940* (Paris: Floury, 1946), p. 52.

52. Ibid., pp. 52–53.

53. "Would you be so good as to come tomorrow morning as early as possible that is to say half past nine so we can go to the Bon Marché, where I have just seen a heap of pretty fabrics for the bedroom that I would very much like to have your opinion of." Letter from Misia Natanson to Vuillard, November 22, 1893 (Paris, Salomon Archives).

54. This is the word he used: "It seems to me that there has been a revolution." Letter from Vuillard to Félix Vallotton, September 13, 1899, in Gilbert Guisan and Doris Jakubec (eds.), *Félix Vallotton. Documents pour une biographie et pour l'histoire d'une œuvre*, vol. 1 (1884–1899) (Lausanne and Paris: La Bibliothèque des Arts, 1973), p. 190.

55. Vuillard quoted by Misia Sert, in *Misia and the Muses: The Memoirs of Misia Sert* (New York: John Day, 1953), p. 52.

56. Ibid., p. 53.

57. Chastel, 1946 (see note 51), p. 36.

58. The expression, meaning "tone colour melody," comes from Arnold Schoenberg, the first edition of whose *Treatise on Harmony* was published in 1911. In a piece of music, the same chord or the same motif is repeated throughout by different groups of instruments, thus giving the whole a "shimmering" sonority.

59. Claude Roger-Marx, *Vuillard: His Life and Work* (New York: Éditions de la Maison française, 1946), p. 54.

60. He had known the Hessels since 1895.

61. They were still carrying on an eventful affair in 1900. Unexpectedly, in September 1901, Misia begged him to save her from the horrible millionaire Alfred Edwards, whose attentions had become too insistent; Vuillard joined her in Vienna and later in Rheinfelden, Switzerland, where he painted some superb watercolours. This story shows that the artist was still capable of impulsive romanticism at a time when he appeared to have become thoroughly sensible. Misia was to end up divorcing Thadée in 1904; worse, she married Alfred Edwards in 1905, having left to Vuillard the sordid negotiations over her separation from Thadée.

62. In eighteenth-century Italy, the *cicisbeo* was both a faithful admirer and a noblewoman's lover.

63. Annette Vaillant, in *Le pain polka*, recounts a revealing holiday memory of when she was a child playing on the beach: "I was playing a little behind them, digging a hole. The tone of their lively conversation became angry, and I looked up. The back of Monsieur Vuillard's neck was turning a purplish red. I had never seen a lady and gentleman arguing, and Monsieur Vuillard was certainly in a temper. He was speaking rapidly in a jerky voice that didn't sound like him at all. Madame Hessel kept interrupting him, as if she were very angry too." (Paris: Mercure de France, 1974), pp. 96–97. The artist recorded such lovers' scenes and fits of weeping in his journal.

64. *Ode* by Paul Claudel, published in *L'Occident* in 1905: "Terpsichore, discoverer of the dance! where would the choir be without the dance? who else could bind / The eight wild sisters together, to harvest the outpouring hymn, inventing the inextricable pattern?" This translation taken from Paul Claudel, *Five Great Odes*, trans. Edward Lucie-Smith (London: Rapp and Carroll, 1967), p. 9.

65. Letter from Lucie Belin to Édouard Vuillard, n.d. (Paris, Salomon Archives).

66. Letter from Lucie Belin to Édouard Vuillard, n.d. [1915 ?] (Paris, Salomon Archives).

67. The Salomon Archives contain a superb exchange of letters between Lucy Hessel and Lucie Belin "Ralph" in which, with great dignity, the two reminisce about their lifelong affection for Vuillard. One imagines these two "Vuillard widows" mulling over the past, their black mourning veils barely concealing a torrent of tears.

68. This image has been incorrectly identified as a theatre piece based on Henrik Ibsen's *An Enemy of the People*, for which Vuillard painted the sets (November 10, 1893 at the Bouffes du Nord). The Ibsen play does not deal with an electoral meeting but with a town hall meeting where the people have come to settle accounts with Dr. Stockman, whom they accuse of ruining the town's reputation.

69. Lugné-Poe, 1931 (see note 37), pp. 64-65.

70. Maurice Denis, *Journal*, vol. 1 (1884–1904) (Paris: La Colombe, 1957), p. 150.

71. Vuillard, *Journal*, IV.9, fol. 40r (February 11, 1936): "assault on Léon Blum."

72. Ibid., IV.10, fol. 7v (June 13, 1936).

73. Quoted in Salomon, 1953 (see note 9), p. 93.

74. "Trois artistes refusent le ruban rouge," *Le Temps* (October 26, 1912).

75. Sutro, 1933 (see note 34), p. 26.

76. Vuillard, *Journal*, II.7, fol. 69r (February 1, 1915).

77. Ibid., III.(S).B, fol. 21r (July 24, 1923).

78. In a conversation I had with Daniel Wildenstein (April 2001), who throughout the 1930s had come to know Vuillard very well at the Château des Clayes, he recounted this amusing anecdote: Vuillard had led the young Daniel out onto the terrace while the Hessels were giving a grand dinner party that went on forever and bored the master extremely. He said to the boy, perhaps to scare him: "You see, son, these are all bourgeois. One day it will be the Great Night and the revolution, and then we shall cut their throats."

79. Marie-Blanche de Polignac, "Édouard Vuillard, souvenirs," in *Hommage à Marie Blanche, Comtesse Jean de Polignac* (Monaco: Jaspard, Polus et Cie, 1965), pp. 139–140.

80. Vuillard, *Journal*, IV.10, respectively fol. 45r, 41v, 47r.

81. Quoted in Roger-Marx, 1946 (see note 59), p. 106.

82. Vuillard, *Journal*, IV.9, fol. 4r (August 10, 1935).

83. Handwritten postcard from Vuillard (Paris, Salomon Archives).

84. Handwritten note by Vuillard (Paris, Salomon Archives).

85. Vuillard, *Journal*, III.(S).D, fol. 36r (March 9, 1925).

86. Comedy "chastises the habits of society with laughter." The phrase is from Senteul.

87. Thereafter, his *Journal* is filled with recriminations against Rosengart: "visit from Denis; the latest rudeness, Rosengart." *Journal*, IV.3, fol. 14r (December 20, 1930).

88. Ibid., fol. 73r (August 4, 1931).

89. Daniel Wildenstein told me that "Vuillard, with his white beard, seemed to children like a real Father Christmas...but a Father Christmas who had become wicked."

90. Vuillard, as a friend of his father Auguste, had known Renoir since childhood.

91. On inquiring about the architectural plans so that he could study the layout of the future mural, the artist was answered by an arrogant minister: "By what right do you wish to know the plan?" Quoted in Polignac, 1965 (see note 79), p. 140.

92. In a 1926 interview conducted by Puvis's nephew Henri with Vuillard, the latter's mother interrupted: "I lived in Cuiseaux. I knew your family well; my son has admired Puvis de Chavannes for a very long time: at the Lycée Condorcet in Paris he made friends with Xavier Roussel and the spontaneity of that attachment sprang from the happy surprise felt by the two boys, both artists-to-be, at discovering that they shared the same devotion to the great Puvis..." Henri Puvis de Chavannes, "Un entretien avec M. Édouard Vuillard, contribution à l'histoire de Puvis de Chavannes," *La Renaissance de l'art français et des industries de luxe*, no. 2 (February 1926), p. 3.

93. *Large Interior with Six Figures*; *The Terrasse at Vasouy: Luncheon*; *The Haystack*, etc.

94. By an irony of fate, Stravinsky applied to the Institut, urged on by Paul Valéry, at the same time as Vuillard; he received five votes against Florent Schmitt's twenty-seven. André Boucourechliev, *Igor Stravinsky* (Paris: Fayard, 1982), p. 252.

PERMANENT TRANSGRESSION | *Catalogue* **1–34**

IT MAY BE ARGUED THAT Vuillard the painter existed for a short while before he met the members of the group known as the Nabis. His earliest works, which seem generally to have been inspired by Rixens and Carrière, are often copies of Old Masters in the Louvre (notably the still lifes of Chardin). Having failed the École des Beaux-Arts entrance exam three times, he finally scraped through on July 21, 1887, and with evident pride he signed several nude studies from this period with the words "student of Gérôme, Bouguereau and Robert-Fleury." Something must have happened, then, to prompt this well-behaved product of the Academic system to join forces with his Nabi comrades, barely two years later, as they jeered beneath the windows of the princes of *pompier* art, Bouguereau and Meissonnier. In the early pages of his journal for 1888 and 1889 — the most interesting ones — he makes no mention of the Nabis. The diary is full, however, of picturesque and atmospherically tenebrist sketches. References to those close to him, other than his family, mostly concern his fellow ex-pupils from the Lycée Condorcet, who included the future architect Frédéric Henry, the enigmatic Waroquy, Julien Magnin, the writer Pierre Veber, the musician Pierre Hermant, and Marc Mouclier — a painter evidently very important to Vuillard at the time but today virtually forgotten.

The Nabi group was founded in the summer of 1888, when Paul Sérusier brought back from a trip to Brittany his famous *Talisman*, a landscape ("formless through being synthetically formulated")[1] that was actually a view of the Bois d'Amour, in Pont-Aven. This tiny painting had been executed under instruction from Gauguin, who had advised Sérusier to translate nature in unmixed colours, "as they come out of the tube."[2] Maurice Denis described this critical moment on countless occasions: "Thus, for the first time, in a paradoxical, unforgettable way, was presented the rich concept of the flat surface covered with colours assembled in a certain order. And so we realized that every work of art was a transposition, a caricature, the impassioned equivalent of a sensation experienced."[3] At this time the group consisted of Paul Sérusier, Maurice Denis, Paul Ranson and Pierre Bonnard. Vuillard, part of the "second wave" of Nabis, joined them in 1889, while he was still assiduously attending anatomy classes at the École de Médecine and perfecting his drawing technique in Diogène Maillart's studio. From the outset he was attracted as much by Sérusier's anti-naturalistic provocations as by the philosophical demonstrations that Maurice Denis, the most intellectual of the group, offered the brotherhood for its collective delectation. The lack of cultural refinement of the average Beaux-Arts student shocked Vuillard, and he must have felt naturally drawn to these young artists, bourgeois anarchists for the most part, who were forever quoting Swedenborg, criticizing Carlyle and Schopenhauer, and going into raptures over Wagner and Puvis de Chavannes. Édouard Schuré's recently published *Les Grands Initiés* was handed eagerly around. Each of them strove to be a *primitive* — someone who, as Denis put it, "matches the image of things to the way things look to him"[4] — and they all went out of their way to "act dumb," to use Gauguin's expression. It took them only a few months to reject the principle, peddled by lazy academic teaching methods, of employing modelling to portray things "in the round."

It was Auguste Cazalis,[5] with his sound knowledge of Arabic and Hebrew, who suggested the name "Nabi," which in both languages means "prophet," "inspired," "chosen." And so they became defenders of avant-garde art, waging their revolt in the

studios of the École des Beaux-Arts and the neighbourhood bistros before focusing their activities on Ranson's studio on Boulevard du Montparnasse, which they renamed "The Temple." The Nabis agreed on a number of principles central to the painting revolution that was currently under way: the rhythmic and abstract composition of the painting, the idea that a work of art is an enigma to be deciphered, the importance of non-Western art. On this latter question, the exhibition of Japanese prints and illustrated books held at the Beaux-Arts in April 1890 had roughly the same impact on them as a cataract operation. The paintings from this period, inspired by the *Talisman*, are small works, which slowly but inexorably radiate their own inner sonority. Turning their backs quite quickly on Seurat's pointillist approach, then all the rage in Paris (see cats. 4–5), the Nabis moved resolutely toward an art of *synthesis*. At this period, Vuillard was profoundly influenced by the thinking of Maurice Denis as expressed in his "Définition du néo-traditionnisme," published in August of 1890—the concept of a "flat surface covered with colours assembled in a certain order"[6]—writing that same month in his journal: "The purer the elements employed, the purer the work . . . the more mystical the painters, the more vivid their colours (reds blues yellows) the more materialist the painters the more they employ dark colours (earth tones ochres bituminous blacks)."[7] This was not mere coincidence, but a manifestation of intellectual communion. And more markedly even than in the work of his colleagues, Vuillard's colours became increasingly violent: lemon yellow, teal blue, orange, dense pink.

On the other hand, the esoteric posing of Ranson and Sérusier (who, when Vuillard joined the group, welcomed him as "the new brother sent to us by Yahweh")[8] probably left him rather cold. Vuillard was something of a paradox: although he was by nature solitary and shy, resembling a modern-day but secretive St. François de Sales, his self-assurance increased with time, and his thoughts on art along with his erudition soon earned him the admiration of his friends. Reserved and puritanical, he was also a keen partisan of Parisian nightlife, who saw every show on offer, from cabaret to opera, and not uncommonly made his way home with a hangover.[9] But we suspect that he may have felt a certain reticence about the customs of a brotherhood that threatened his freedom of choice, and he certainly never adopted the ritual expressions that Sérusier and Ransom were in the habit of exchanging, such as "In your Palm, my Word and my Thought." He just about accepted his nickname—the "Zouave" Nabi—awarded in honour of his flamboyantly red beard, clipped in the military manner. Idealism became nevertheless his intellectual compass, and he adopted a language with mystical overtones while at the same time exploring the most provocative possibilities of Cloisonnism: witness the calculated simplification of the bunch of *Lilacs* (cat. 10), the interlocked fields of pure colour in *Octagonal Self-portrait* (cat. 6), and the enigma of the daytime somnolence of *In Bed* (cat. 21). Many of the works produced by the visionary Nabi are mysteries that have to be solved, works whose rhythm and line imposed themselves on his consciousness like a kind of *automatic writing*. As he confided to his journal in November 1888: "A shape, a colour exists only in relation to another. Form alone does not exist. All we can understand is relationships . . . If the brain's mechanism is not in a state to grasp these relationships, to keep them for a moment and transfer them like a sleepwalker onto paper or canvas, it's a waste of time."[10] **Guy Cogeval**

1. Maurice Denis, "L'influence de Paul Gauguin," in Denis 1913, p. 162.

2. Ibid.

3. Ibid.

4. "De la gaucherie des primitifs," in Denis 1913, p. 171.

5. Ranson nicknamed him Nabi "Ben Kallyre" ("of halting speech").

6. Denis 1913, p. 1.

7. A "gueule de bois," as he puts it. Vuillard, *Journal*, 1.2, fol. 74 (August 31, 1890).

8. Letter from Paul Sérusier to Maurice Denis, in Sérusier 1942, p. 48.

9. Vuillard, *Journal*, 1.1, fol. 10r (November 21, 1888).

10. Ibid., fol. 12r–v (November 22, 1888).

So too, when vanished from man's memory
Deep in some dark and sombre chest I lie,
An empty flagon they have cast aside,
Broken and soiled, the dust upon my pride,
I'll be your shroud, beloved pestilence!
The witness of your might and virulence,
Sweet poison mixed by angels; bitter cup
Of life and death my heart has drunken up![2]

In 1889 Vuillard had not yet adopted the unfettered use of colour typical of the Nabis, but we already see his fondness for complex compositions, stacked-up planes, and oddly skewed and shifting scenes whose logic is only obliquely apparent. Here he contrives to show us the action of the eye as it travels across the space, leaving some details in a soft-focus reminiscent of Eugène Carrière, and positively "illuminating" others: for example, the splendid conceits of the foreshortened palette that divides the canvas, the bottle (which we do not immediately notice) and the cigarette, merely glimpsed in an end-on view. The artist leads us across the space on a path of discovery, as if unrolling a parchment, register by register.

It is clear that this painting is a discreetly subtle tribute to *Las Meninas* (1656–1657) by Velázquez, a work of genius, the painting Vuillard admired above all and one that was to influence a number of his later compositions. The Prado painting shows the famous Spanish artist-dandy engaged on a portrait of King Philip IV and Queen Mariana, which was never actually made—it exists only in the painted reflection. "Grandmama's room" has replaced the royal palace, but Vuillard, *optimus pictor*, gives us a measuring look worthy of Velázquez's own. After all, had his Conté drawing of his grandmother, Madame Michaud, not attracted a certain amount of attention at the Salon of 1889?[3] In spite of the almost traditional handling of *Vuillard and Waroquy*, we perceive the future Nabi's highly original effort to link the figures in the same arabesque, committing them to a sort of lyrical gesture not yet explicit. As he notes in his journal in 1890: "not to worry about originality a portrait by Leonardo (drawing) and one by Raphael both have the same decorative aim, the same arabesque drawn by two figures... will produce two different expressions."[4] GC

## 1

VUILLARD AND WAROQUY ·
*Vuillard et Waroquy*

1889, oil on canvas, 92.7 × 72.4
New York, Lent by The Metropolitan Museum of Art, Gift of Alex M. Lewyt, 1955, 55.173

Cogeval-Salomon I.97

*Provenance* Studio—Sam Salz, New York, c. 1952—Alexander M. Lewyt, New York, 1953—Gift of Alex M. Lewyt to the Metropolitan Museum of Art, New York, 1955

*Exhibitions* Basel, Kunsthalle, 1949, no. 35—Cleveland-New York, 1954, p. 100, ill. p. 29—Houston-Washington-Brooklyn, 1989–1990, no. 1, col. ill. p. 6

*Bibliography* Roger-Marx 1946a, p. 83, ill. p. 26—Ciaffa 1985, pp. 91–100, fig. 8—Thomson 1988, p. 16, col. pl. 6—Easton 1989, pp. 13–14—Forgione 1992, pp. 96, 114–116, fig. 50—Groom 1993, p. 8, col. fig. 6

In the relatively precise autobiographical recollections Vuillard entered in his journal in November 1908,[1] he made a point of mentioning this double portrait that for him marked the year 1889: "portrait of Waroquy in grandmama's room." Standing in front of Grandmother Michaud's chest of drawers, Vuillard watches us with a confident look, *à la* De Chirico, which comes to us via the mirrored reflection. He is dressed like an austere clergyman-gardener and his bearing manifests a kind of elegance, although in later life his indifference to clothes was to become proverbial. His friend Waroquy—of whom we know almost nothing—stands behind him in softer focus, smoking a cigarette. Only the bottle at lower right indicates that what we are looking at is a mirror image. This inanimate object, an impassive protagonist in the almost tangible foreground, could well exclaim, like the "Flask" in Baudelaire's *Les Fleurs du Mal*:

1. Vuillard, *Journal*, II.2, fol. 12r.

2. Charles Baudelaire, "Le flacon," in *Les Fleurs du Mal*; trans. in *Charles Baudelaire: The Flowers of Evil*, ed. Marthiel and Jackson Mathews (New York: New Directions, 1989), pp. 61–62.

3. Vuillard, *Journal*, II.2, fol. 12r.

4. Ibid., I.1, fol. 55r.

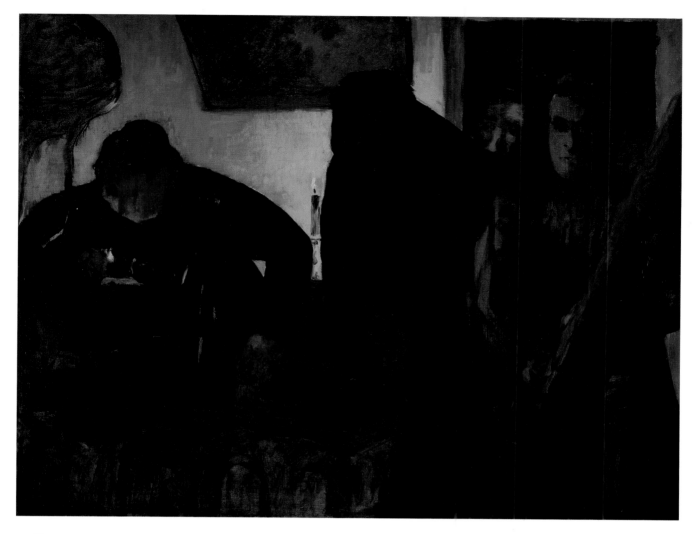

## 2

DINNERTIME · *L'Heure du dîner*

c. 1889, oil on canvas, 71.8 × 92.2
New York, The Museum of Modern Art,
Gift of Mr. and Mrs. Sam Salz and an
anonymous donor, 1961

Cogeval-Salomon IV.2

—

*Provenance* Studio—Sam Salz, New York—
Gift of Mr. and Mrs. Sam Salz and an anony-
mous donor to the Museum of Modern Art,
New York, 1961

*Exhibitions* Toronto-San Francisco-Chicago,
1971–1972, no. 2, ill.—Houston-Washington-
Brooklyn, 1989–1990, no. 36, col. ill.—Lyon-
Barcelona-Nantes, 1990–1991, no. 34, col. ill.
pp. 116–117—Montreal, MMFA, 1998, no. 155,
col. ill. p. 22

*Bibliography* Roger-Marx 1946a, p. 50—
Salomon 1968, p. 42, ill.—Roger-Marx 1968,
p. 20—Russell 1971, pp. 16–17—Mauner
1978, p. 265, fig. 149—Ciaffa 1985, pp. 123–
129, fig. 32—Easton 1989, pp. 58, 60–62—
Cogeval 1990, p. 118—Dumas 1990, p. 63—
Cogeval 1993 and 2002, pp. 39 (2002), 40, 43,
col. ill. pp. 40–41—Easton 1994, p. 16, ill. p. 15

—

We fail to grasp Vuillard's basic nature if we
overlook his savage humour. He could assume
the aloofness of a seminarian at prayer,
remaining mute in the corner of a room as he
watched those present at an evening gather-
ing, but at heart he was akin to those pitiless
caricaturists Vallotton and Toulouse-Lautrec,
or even Yvette Guilbert, capable onstage of
the most outrageous gestural innuendo. Vuil-
lard would encounter Alfred Jarry, wearing
his inevitable cyclist's outfit, in the offices of
the *Revue blanche*, and, like Bonnard, the
"Zouave" Nabi had an Ubuesque sense of
derision and delight in the absurd. This is
apparent in *The Flirt* (cat. 18), *The Demonstra-
tion* (cat. 11), *The Goose* (cat. 35) and certain
sketches in his early journal.

He loved his family, and was unconditionally
adored by them in return. And yet it often
happened that they were the butt of his *vis
comica*. Exerting his charm on every front, he
excelled at manipulating the three female
members of his household in order to create
subjects for his painting. A number of
sketches in the journal of 1888 herald the dark
atmosphere of this astounding canvas—
which we date quite early in his oeuvre. It is,
in fact, along with *Vuillard and Waroquy*, one
of his first masterpieces. And *Dinnertime* is
revealing about the way he saw himself within
the family unit.

The candle sheds a funereal backlight over
the absurdly melodramatic trio, lined up in the
foreground like a row of Aunt Sallys. The
objects on the periphery of our vision are dis-
proportionately large: the chair in the fore-
ground and the hanging lamp on the left seem
enormous and threatening, as if seen through
3-D spectacles. Madame Vuillard is lighting
the lamp on the table, which illuminates her
face from below in a disturbing way. The
widow Michaud is like Erda in *Siegfried*, rising
up from the floor in her black mourning crepe.
Marie, holding a loaf of bread, has a posi-
tively diabolical look on her face. They might
be three witches celebrating a black mass. To
judge from the terrified look on the face of
the artist—who, partly hidden by his grand-
mother, does not dare enter the dining room
—this might well be his own castration cere-
mony. Vuillard loved to present himself as
a victim, and this horrifically comic work is
a masterpiece of black symbolism, a settling of
accounts with himself and his family that has
few counterparts in the history of painting.
It even suggests some of the more terrifying
(and least amusing) works of Edvard Munch,
in which whey-faced souls call us to witness
the chaos of the world. GC

# 3

GRANDMOTHER MICHAUD IN
SILHOUETTE · *La Grand-mère Michaud
à contre-jour*

1890, oil on canvas, 65 × 54
Signed l.r.: *ED. VUILLARD*
Washington, Hirshhorn Museum and
Sculpture Garden, Smithsonian Institution,
Gift of the Marion L. Ring Estate, 1987.32

Cogeval-Salomon II.2

*Provenance* Studio; Marie Roussel; Jacques
Roussel—O'Hana, London, June 1953—
Gustav and Marion Ring, Washington, 1953–
1984; Marion and Gustav Ring Estate, 1984–
1987—Gift of the Marion L. Ring Estate to
the Hirshhorn Museum, Washington, 1987

*Exhibitions* Berne, Kunsthalle, 1946, no. 29—
Brussels, Palais des Beaux-Arts, 1946, no. 51—
London, O'Hana, 1953, no. 43, ill.—Cleve-
land-New York, 1954, p. 101, ill. 52—Wash-
ington, Corcoran Gallery of Art, 1964, n.n.—
New York, Wildenstein, 1964, no. 9, ill.—
Washington, Hirshhorn, 1985–1986, no. 50,
col. ill.—Houston-Washington-Brooklyn,
1989–1990, no. 49, col. ill.—Lyon-Barcelona-
Nantes, 1990–1991, no. 35, col. ill. p. 104—
San Francisco-Dallas-Bilbao, 1999–2000,
no. 402

*Bibliography* Preston 1971, p. 27, fig. 32—
Daniel 1984, pp. 164–165, fig. 61—Ciaffa
1985, pp. 168–169, fig. 59—Easton 1989,
p. 73—Cogeval 1990, p. 122—Forgione
1992, p. 72, fig. 42—Cogeval 1993 and 2002,
p. 65, col. ill. p. 64

To our knowledge, Vuillard never exhibited
this remarkable painting during his lifetime.
He must have thought of it as part of the family
furniture. *Grandmother Michaud in Silhouette*
was not included in the 1941 bequest to the
nation, and must quite understandably have
been kept by Marie as a memento of a differ-
ent age. The work was still listed as being
part of a "private collection, Paris" in its first
recorded exhibition, at the Berne Kunsthalle
in June 1946.

1. Édouard Vuillard, *Grandmother Michaud*, c. 1889, purple ink
on paper, private collection.

When Vuillard's father died, Grandmother
Michaud took over as supreme head of the
household. For the young artist she was a
vital link to the earlier days of a middle-class
dynasty, an old lady who had come of age
under the reign of Louis-Philippe. She, for
her part, turned a blind eye to her grandson's
misdemeanours: it is well known that the
deepest attachments within a traditional fam-
ily often skip a generation.

Here, Madame Michaud wears deep mourn-
ing. She had gone to live with her daughter
Marie in 1888, after the death of her husband,
Prosper-Justinien Michaud, a tradesman.
Vuillard adored her, but sometimes made fun
of her. A previously unpublished caricature
in purple ink that must date from 1888–1889
(fig. 1) shows the profile of a proud and
haughty woman, fiercely preserving a mat-
ronly elegance even in old age. In this oil the
light from the window, filtering through the
drapes in a magical glow, turns the back-
ground into a décor of gold against which the
old lady stands out like a visual sign, rather
like Yvette Guilbert in *At the Divan Japonais*
(cat. 49). An *ombra felice*, she is absorbed, like
a number of Vuillard's protagonists, in the
letter she is reading.

This is not, properly speaking, a Neo-Impres-
sionist painting, but it seems imbued with
Seurat's technique. A drawing from a note-
book dated "1890,"[1] a cursory sketch for
this portrait of his grandmother, enables us
to date Vuillard's first "modern" masterpiece
with some precision. The visual devices are
disquietingly original, and this has led a num-
ber of Vuillard scholars to place it later: 1891,
and even 1894 (although Antoinette Michaud
died in January 1893). The black bulk of the

widow's figure, which takes up the whole fore-
ground, is subtly enlivened with touches of
blue. The bright crimson of the tabletop casts
a rosy light onto her hand. In the centre of
the canvas is a delicate cool accent: the tur-
quoise-blue box. All these elements, skilfully
arranged by the artist, seem straight out of
some Oriental reverie. The small tenebrist
sketches that dot the pages of his journal for
1888–1889 culminated, in 1890, in this mas-
terly avant-garde statement. Vuillard had left
almost all his contemporaries behind, but his
work is strangely akin to Baudelaire's fleeting
visions in *Le Spleen de Paris*. Chapter 13 of
this collection is, in fact, devoted to "Widows":

She was a tall, majestic woman, and so noble in her entire
bearing, that I cannot recall having seen her peer in collec-
tions of aristocratic beauties of the past. A perfume of
haughty virtue emanated from her entire person. Her face,
sad and thinned, was in perfect accord with the formal
mourning in which she was dressed. She, too, like the ple-
beians with whom she mixed without seeing them, watched
the luminous society with knowing eyes, and she listened
while gently nodding her head.[2] GC

1. Salomon Archives, Paris.

2. Charles Baudelaire, *Le Spleen de Paris*; trans. Edward K.
Kaplan, in *The Parisian Prowler* (Athens and London: Univer-
sity of Georgia Press, 1989), p. 26.

3

# 4

GRANDMOTHER AT THE SINK ·
*La Grand-mère à l'évier*

c. 1890, oil on board mounted on panel,
22.5 × 18.3
Paris, private collection, courtesy
Galerie Bellier

Cogeval-Salomon 11.3
—

*Provenance* Studio—Sam Salz, New York;
given to William Goetz, Los Angeles— Goetz
Sale, Christie's, New York, Nov. 14, 1988,
lot 13 (col. ill.); Galerie Bellier, Paris

*Exhibitions* Lyon-Barcelona-Nantes, 1990–
1991, no. 27, col. ill. p. 56—Zurich-Paris,
1993–1994, no. 142, col. ill.—Florence,
Palazzo Corsini, 1998, no. 6, col. ill. p. 45—
Montreal, MMFA, 1998, no. 157, col. ill. p. 26

*Bibliography* Rewald 1956, pp. 418–419,
ill.—Cogeval 1993 and 2002, p. 22, col. ill.—
Cogeval 1998a, p. 180
—

Grandmother Michaud, seen as a ghost in
mourning in the amusing *Dinnertime* (cat. 2),
is involved here in one of Vuillard's most
experimental paintings. Marie Antoinette
Désirée Michaud (1818–1893) was extremely
fond of the young artist, who adored her in
return. After the death of Vuillard's father in
1875, she became the ancestor, the tutelary
goddess of the home, the gentle, tactful incar-
nation of the family *potestas*. In a letter held in
the Salomon Archives, written in the fall of
1892 to her grandson, who was travelling with
Kerr-Xavier Roussel in Holland, she expresses
herself with heartfelt tenderness: "I can't
wait to have your morning and evening kisses
again, but I resign myself with the thought
that what you are doing is good for you, and
that you will make it up to me when you get
home."[1]

Recent research for the Vuillard catalogue
raisonné has brought to light a preparatory
drawing for this little painting in an "1890"
notebook (fig. 1), confirming the generally
accepted dating. Swiftly sketched in Conté
crayon, it focuses on a corner of the kitchen,
where Marie Antoinette Désirée Michaud, rec-
ognizable by her habitual stoop, is washing
dishes under a tap; there is a window above
the sink. This sketch is vital in understanding
Vuillard's approach: close in style to Picasso's
"Barcelona" drawings from around 1900,
tenebrist like the journal sketches from about
1888–1889, it serves as the basis for a painting
that intensifies its avant-garde leanings. In a

work that goes beyond Neo-Impressionism—
where the viewer's eye would ensure the
optical blending of the colours—here we
almost feel that the grandmother is being seen
through a distorting piece of stained glass
or a kaleidoscope. Yet despite the continuous
swirl of atoms that surrounds her, she is rec-
ognizable, busy at the sink. It is not hard to
imagine the apartment on Rue de Miromesnil,
like the one on Rue du Faubourg Saint-
Honoré, permanently invaded by the effluvia
of laundry, cold coffee and soup simmering
on the stove.

Seurat's system was very much in fashion at
the time, and Vuillard has used it here in a
humorous way that verges on the burlesque.
The little window embedded in the image
could be an allusion to the triptych mirror
in Seurat's *Young Woman Powdering Herself*
(itself a caricatural painting), which was
exhibited at the Société des Artistes indépen-
dants in 1890 and which Vuillard undoubtedly
knew. What is more, he owned a Kunisada
print in which a geisha is shown in the same
half-kneeling position as the grandmother
in this work; above her head can be seen a

1. Édouard Vuillard, *Study for "Grandmother at the Sink"* (detail),
1890, Conté crayon on paper, private collection.

kakemono bearing a landscape, the equiva-
lent of the window set in Vuillard's painting
strangely flush to the wall, an artificial open-
ing that subtly draws nature into the space.
This little experimental sketch might be seen
as a "modern" interpretation of the print. GC
—

1. Letter from Marie Michaud to Vuillard, November 13, 1892,
Paris, Salomon Archives.

## 5

THE STEVEDORES · *Les Débardeurs*

c. 1890, oil on canvas, 45 × 61
V. Madrigal Collection

Cogeval-Salomon 11.7

*Provenance* Studio—E. J. Van Wisselingh,
Amsterdam—Arthur G. Altschul, United
States, 1986—Sale, Sotheby's, New York,
Nov. 17–18, 1998, lot 274 (col. ill.)—Private
collection, New York

*Exhibitions* Paris, MNAM, 1955, no. 186—
Milan, Palazzo Reale, 1959, no. 5, ill.—
Toronto-San Francisco-Chicago, 1971–1972,
no. 1, col. ill.

*Bibliography* Salomon 1968, p. 44, col. ill.—
Russell 1971, p. 21—Cogeval 1993 and 2002,
p. 22, col. ill. pp. 24–25 and cover (2002)—
Groom 1993, p. 8, col. fig. 7

—

In this possibly nocturnal scene, stevedores
are loading sacks of sand onto a cart on a quay
beside the Seine. Vuillard's journal for 1888–
1889 includes numerous views of the Parisian
quays, dotted here and there with large heaps
of the gravel used as infill, which were regu-
larly replenished by barge. On December 7,
1888, while on his way to the École de Méde-
cine for an anatomy class, he jotted this note
between two drawings of riverside sand piles:
"on my way to anatomy day clear / splendid;
Monet in the water / small whitecaps / very
small / medley of mauves, reflections of sand
piles."[1] Executed two years later, *The Steve-
dores* displays abstract parallel bands—a
transposition of Monet's shimmering ripples?
—and, at the right, a pile of sand swarming
with "a medley of mauves." Might this brief
note have been the basis for this painting?

MaryAnne Stevens has very aptly compared
this observation of workers along the Seine to
Guillaumin and Signac, attributing Vuillard's
initial contact with Neo-Impressionism to
his friendship with Léo Gosson, who exhibited
with the Nabis at Le Barc de Bouteville in
1891.[2] A "schematic" portrait of Marie Vuillard,
the artist's sister, undoubtedly dates from 1890
(Paris, priv. coll., C-S 11.4), as does the superb
*Grandmother Michaud in Silhouette* (cat. 3).
Both show that the young Nabi was familiar
with the pointillist technique at least by 1889.
However, this Neo-Impressionism is so origi-
nal, so impure—bordering on caricature—
that comparison might be better drawn with
the late Divisionist style that prevailed in
Europe around 1905, especially in Holland
with Sluijters and Mondrian. The chromatic
fragmentation of the suspended particles is
compensated by centripetal involute forms,
rather like those in *Grandmother at the Sink*
(cat. 4), one of Vuillard's most disconcerting
compositions. GC

—

1. Vuillard, *Journal*, I.1, fol. 24v.

2. House and Stevens 1979, p. 147.

**6**

OCTAGONAL SELF-PORTRAIT ·
*Autoportrait octogonal*

c. 1890, oil on board, 36 × 28
Private collection

Cogeval-Salomon II.25

—

*Provenance* Studio—Private collection

*Exhibitions* Cleveland-New York, 1954,
p. 101—Paris, MNAM, 1955, no. 20—Milan,
Palazzo Reale, 1959, no. 8, ill.—Albi, Musée
Toulouse-Lautrec, 1960, no. 9—Munich,
Haus der Kunst, 1968, no. 13, ill.—Paris,
Orangerie, 1968, no. 11, ill.—Brussels,
Musées Royaux des Beaux-Arts de Belgique,
1975, no. 25, ill.—Saint-Germain-en-Laye,
Le Prieuré, 1982–1983, no. 53, col. ill.—
Lyon-Barcelona-Nantes, 1990–1991, no. 7,
col. ill. p. 160—Zurich-Paris, 1993–1994,
no. 143, col. ill.—Florence, Palazzo Corsini,
1998, no. 8, col. ill. p. 47—Montreal, MMFA,
1998, no. 156, col. ill. p. 24

*Bibliography* Salomon 1945, ill. p. 135—
Salomon 1968, pp. 46–47, col. ill.—Russell
1971, p. 22—Thomson 1988, p. 32, col. pl. 20
—Easton 1989, pp. 20–21, col. fig. 7—
Cogeval 1993 and 2002, p. 23, col. ill. (1993)
and cover ill.—Cogeval 1998a, no. 8—
Cogeval 1998b, no. 156

**7**

SELF-PORTRAIT · *Autoportrait*

c. 1887–1888, charcoal on paper, 31.5 × 47.6
Private collection

—

Between 1887 and 1890 Vuillard painted many
self-portraits, which represented opportuni-
ties both to question his own personality and
to conceive variations on masterworks of the
past he particularly admired: his creative
process in these works is based on a series of
subtle quotes. One of the earliest, *Self-portrait
in a Mirror* (1887–1888, Switzerland, priv.
coll., C-S I.77), bears a resemblance to Anto-
nello da Messina's *Christ Blessing*. Another,
*Self-portrait in the Mirror with a Bamboo Frame*
(c. 1890, United States, priv. coll., C-S I.100),
shows Vuillard as a dreaming genius of the
Renaissance, while a third, *Self-portrait in
Silhouette* (c. 1888, United States, priv. coll.,
C-S I.82), may derive from Bellini's *Doge
Leonardo Loredan*. The charcoal drawing

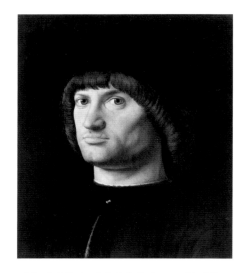

1. Antonello da Messina, *Portrait of a Man* known as *Il Condottiere*,
1475, Paris, Musée du Louvre.

presented here for the first time (the lower part
of which has unfortunately been cut off) pic-
tures him when he was about twenty, a roman-
tic young artist with a dark, intense gaze.

A number of commentators have spoken of
the evident Japanese influence in the bril-
liant *Octagonal Self-portrait*: the strident, flat
colours, the absence of modelling, and the
exceptional boldness of the interlocking
shapes. Plus, of course, the pointillist man-
dorla that provides a setting for the radiant
face. In the diary entry for October 30, 1890
—"the Sérusier year"—Vuillard was oddly
insistent on the need for the work to be homo-
geneous, adding: "for in an art work you can
use yellows or blues, a yellow and a blue
of the same brightness, or a yellow standing
out to some degree against a blue, but these
colours must be homogeneous."[1] It is my view
that the provocative transposition of fifteenth-
century Flemish and Italian models plays a
considerably more important role here than
does *japonisme*. This portrait offers, in combi-
nation, reminiscences of Memling, Van Eyck,
Van der Weyden, Piero della Francesca and
Antonello da Messina. Antonello's famous
*Portrait of a Man* had been hanging in the
Louvre since 1865 (fig.1), and Vuillard would
go and look at it almost weekly. The condot-
tiere's fixed gaze, together with the very
small format of the canvas, in which the face,
against a monochrome ground, fills much
of the pictorial space, must have been deeply
inspiring to Vuillard as he worked on his
greatest self-portrait. In the journal entry for
August 31, 1890, he writes: "dreamed gallery
of Italian paintings in cloisonné style. Lighter
with red areas, beautiful shapes."[2] The infer-
ence is quite clear.

Why did Vuillard employ the octagonal shape?
This religiously significant polygon may well
have been inspired by Ranson and Sérusier.
They would have explained to their "Zouave"
friend that the octagon, inherited from the
baptismal fonts of the early Christian period,
is the miraculous fusion of the circle—con-
taining the Church in its infinite movement—
and the square—which represents the bound-
aries of the empire. In 1890–1891, then, Vuil-
lard did not hesitate to make use of an ancient
symbol of spiritual power and union with God
(see *In Bed*, cat. 21).

A little-known portrait of Vuillard that Bon-
nard painted around the same time, in the
shape of a carpenter's square (see "Backward
Glances," in the present volume, fig. 7),
shows that the stern-looking Zouave's beard
was indeed redder than his ash blond hair. In
fact, it was rare for Vuillard to resort to pure
invention in his painting; he preferred a cari-
catured transposition of reality. A close study
of the octagon reveals that the "solid" colours
are actually composed of a mass of tiny
cross-strokes, which enliven the pictorial sur-
face. The merging of colours into shadow
is equally subtle: chestnut brown for the hair,
dark caramel for the beard. In the yellow
of the illuminated hair there are surreptitious
green shadows. And, delightfully, the ear is
highlighted in pure vermilion.

The flamboyance of the *Octagonal Self-portrait*
has always been interpreted as "heralding
Fauvism." The chromatic range is, however,
much more subtle than the palettes of Derain
or Vlaminck: the pink of the face, with the
dark brown shadow that winds across it, re-
veals a young man beset by doubt. The shrill
orange and yellow that frame his counte-
nance recall the complex kitsch colours and
silk-screen techniques that Pop Art made
commonplace—those used by Andy Warhol
in his portraits of Mao, Marilyn and Liz
Taylor. In the early 1890s, Vuillard was clearly
a brilliant young man eager to surprise his
peers, someone looking forward with con-
fidence to the twentieth century. GC

—

1. Vuillard, *Journal*, I.2, fol. 24v.

2. Ibid., I.2, sheet 71.

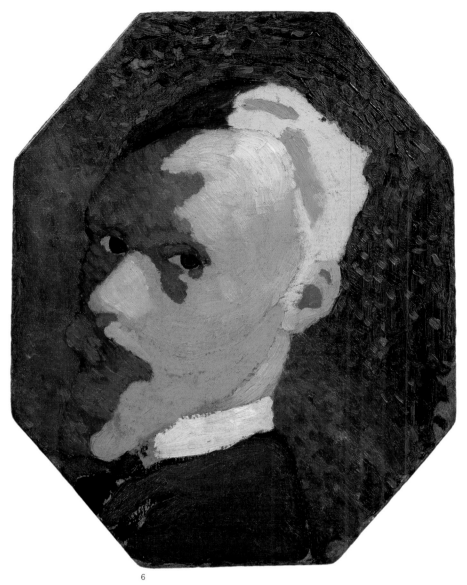

6

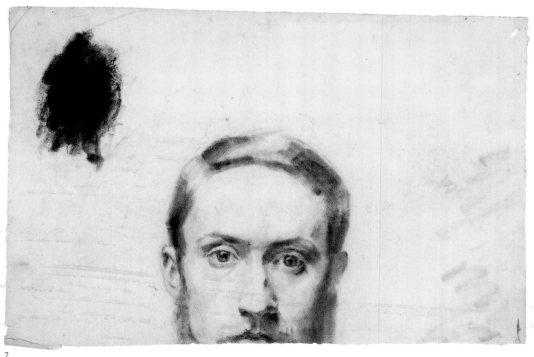

7

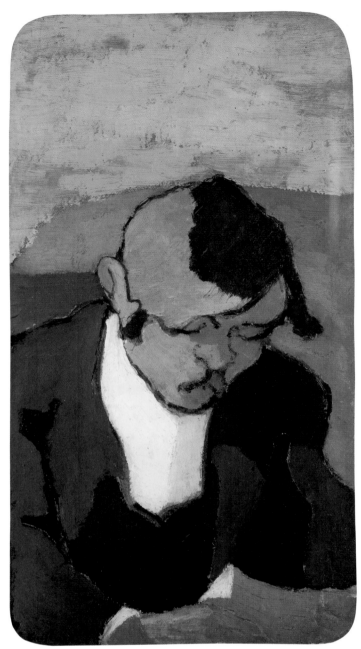

8

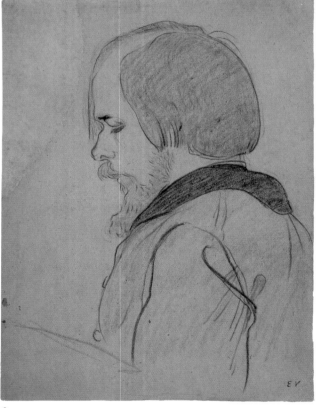

9

## 8

MAN READING · *Le Liseur*

c. 1890, oil on board, 35 × 19
Paris, Musée d'Orsay

Cogeval-Salomon II.19

—

*Provenance* Studio—Acquired through
"dation" by the Musée d'Orsay, Paris, in 1990

*Exhibitions* Munich, Haus der Kunst, 1968,
no. 14, col. ill.—Paris, Orangerie, 1968, no.
12, col. ill.—Zurich-Paris, 1993–1994, no.
145, col. ill.

*Bibliography* Ciaffa 1985, pp. 221–222,
fig. 96—Cogeval 1993 and 2002, col. ill. p. 15

## 9

KERR-XAVIER ROUSSEL ·
*Kerr-Xavier Roussel*

c. 1889, charcoal on brown paper, 32.5 × 24.5
Private collection

—

Several early photos of Kerr-Xavier Roussel
show him in the days before he wore a beard,
when he was a handsome and dreadfully intel-
ligent young dandy (fig. 1). His vast knowl-
edge of art and philosophy had an enormous
influence on Vuillard, who, despite Roussel's
compulsive womanizing, was eager to have
him as a brother-in-law. On a number of
occasions Vuillard portrayed his friend and
fellow Nabi reading, either a book or a letter.
This is the image captured in the fine draw-
ing seen here, datable to around 1889, which
shows Kerr in profile sporting an outfit
reminiscent of those worn in the 1830s by the
group of artists and writers known as the
Jeunes-France. Entirely absorbed in his read-
ing, eyes lowered, he seems to be in a state
of profound meditation.

1. Kerr-Xavier Roussel as a young man, 1887, private collection.

In *Man Reading*, Vuillard has been far more
experimental. Kerr appears against a two-
colour background of ochre and red. His dark
green jacket—like the rest of his elegant attire
—has been rendered in a strictly cloisonnist
style. The detail of his rather romantic locks,
black in the shadow and ochre on the lit side,
is a daring stroke. A masterful blend of Cloi-
sonnism and Synthetism, this work recalls
Gauguin's portrait of *Meyer de Haan*, painted
in 1889; here, as there, we are shown an intel-
lectual absorbed in the reflections inspired by
his reading. Interestingly, Roussel himself
purchased a painting by Gauguin, *Little Girls*,
at the sale held by the master at Hôtel Drouot
in February 1891 (lot 23; now at the Museum
of Fine Arts, Boston).

Roussel's febrile intellect disconcerted even
his closest friends. He thoroughly intimidated
Vuillard, at least until the mid-1890s. Toward
the end of his life, Thadée Natanson remi-
nisced about Roussel in his book *Peints à leur
tour*: "No matter what subject he smilingly
broached, as he warmed up his vocabulary
became more and more abstract and his
thought processes increasingly difficult to fol-
low. As his expression shifted from strain to
enlightenment, even he—despite the help of
numerous hand gestures—was sometimes at
a loss to grasp the sense of his soul-searching.
This is the fate of those who are drawn by
ideas; indeed, part of Plato's genius lies in the

care and myriad precautions with which he
crafted Socrates' dialogues. The more obscure
Kerr Roussel became, the more justified one
would feel in having lost him, unless one pre-
ferred merely to see, in what one no longer
understood, only his goodness in wanting to
convince you, or, simply, when he was bril-
liant, the conviction in his eyes."[1]

Perhaps Vuillard was alluding to this *Man
Reading* when he confided to his journal, on
September 2, 1890: "Crafting a work of art:
this idea began germinating nearly three
months ago; but the mind's habits, naturalistic
ideas though thoroughly criticized, are an
obstacle; working with care a necessity in a
piece like the painting of Roussel: prepare the
colours, the palette, and make sure that the
forms to contain them are exactly right: that
which is on the surface of the canvas, the only
thing visible, is very little indeed (paintings
of the past); but that little must be wholly
<u>conceived</u>, forms and colours (original notion
of <u>intended</u>), the application, the excitement
then becomes a matter of great patience and
care, and that is the sum of a work of art.
Already practised until six months ago."[2] G C

—

1. Natanson 1948, p. 344.

2. Vuillard, *Journal*, I.1, fol. 56v.

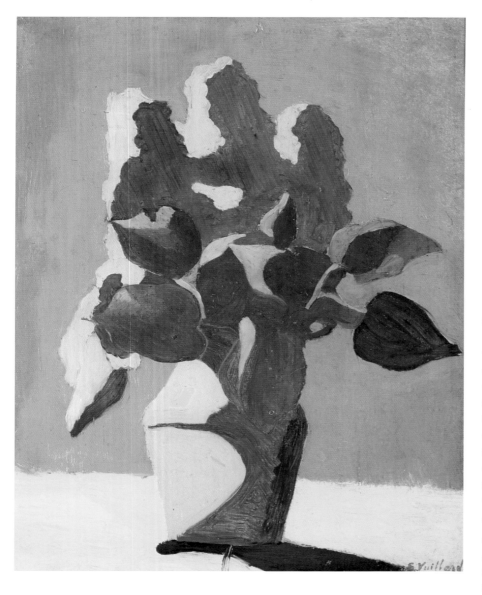

## 10

LILACS · *Les Lilas*

c. 1890, oil on board mounted on cradled
panel, 35.6 × 27.9
New York, Collection William Kelly Simpson

Cogeval-Salomon II.28

*Provenance* Studio [*Le Bouquet schématique*]—
Sam Salz, New York—Donald and Jean
Stralem, New York, 1953—Stralem Sale,
Sotheby's, New York, May 8, 1995, lot 42
(col. ill.)—William Kelly Simpson, New York

*Exhibitions* Cleveland-New York, 1954,
p. 101, col. ill. p. 21—Minneapolis, Institute
of Arts, 1962, p. 149, col. ill.—Toronto-San
Francisco-Chicago, 1971–1972, no. IV, col.
ill.—Lyon-Barcelona-Nantes, 1990–1991,
no. 8, col. ill. p. 169—Montreal, MMFA, 1998,
no. 158, col. ill. p. 26

*Bibliography* Cogeval 1993 and 2002, p. 26,
col. ill.

In his fine essay on Vuillard written in 1946,
André Chastel noted the young artist's pen-
chant for "new exercises" after meeting
Ranson and Sérusier: "The year 1890 was no
doubt a critical time…He was seized by the
lyricism of painting: he gave himself over to
the pleasures of artifice and pure colour…
The tones were laid on with assurance, in their
integral, aggressive quality of red, yellow,
green. Everything was full and sonorous:
there was no emptiness. The pictorial space
was saturated with relations and contrasts
accentuated to the utmost."[1]

Vuillard, it seems, had embraced the manner
of Gauguin and Émile Bernard. In his journal
entry for November 26, 1890, he takes violent
issue with modelling: "The lines of a mod-
elled figure and the lines of the same figure
not yet modelled appear to be of unequal
sizes; learned at the start of a dreadful educa-
tion, the habit of smearing every stroke of
charcoal with the thumb to produce the mod-
elled appearance of something in the round is
a serious hindrance to seeing the form, just the
form, the silhouette; modelling is a shading
off in pictorial art, and the artist must see only
shading off, not something in the round, the
expression of the drawing and of the colour
gradations, not the actual nature of the real
object."[2]

This astonishing "schematic bouquet,"[3] whose
charms were discovered following the Pop
Art vogue of the 1960s, has become more
famous in recent years. The violet shadow on
the yellow field, the stark juxtaposition of the
lit areas with those in shadow, and the sharply
etched profile of the flowers against the uni-
form, abstract background all demonstrate
that Vuillard could have been the true master
of Synthetism. Yet, just months later, he aban-
doned it. GC

1. Chastel 1946, p. 44.

2. Vuillard, *Journal*, I.2, fol. 25v.

3. This was Vuillard's name for it, according to Antoine
Salomon.

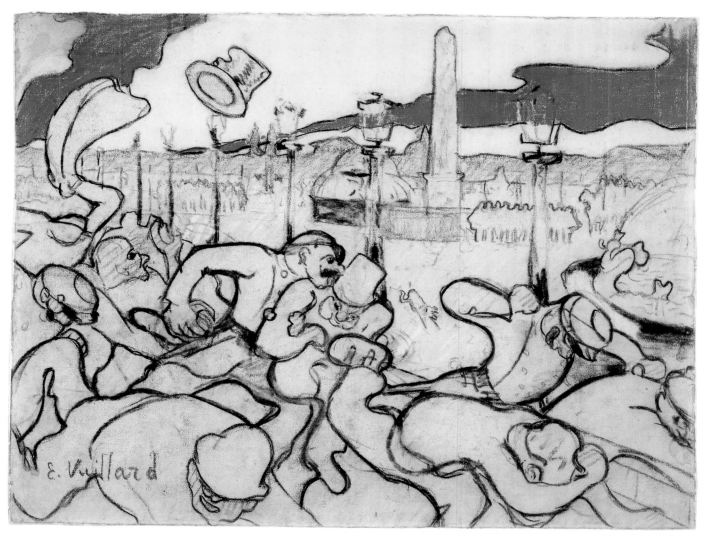

## 11

THE DEMONSTRATION · *La Manifestation*

1890, pastel on paper, 48 × 61.5
Signed l.l.: *E. Vuillard*
Private collection

Cogeval-Salomon II.121

———

*Provenance* Studio—Private collection

*Exhibitions* Basel, Kunsthalle, 1949, no. 244

*Bibliography* Boyer 1988, p. 20, fig. 25

———

This large pastel is easily datable to the
autumn of 1890, for it was preceded by several
drawings in Vuillard's journal for 1890–1891
(I.2, sheet 8v). Visible in these disparate
sketches are the cordons of caped policemen
pictured toward the rear of Place de la Con-
corde. The compact group is joined together
by an endless arabesque; this linking of groups
of passers-by or soldiers in the far background
in a single continuous line was to become a
stylistic commonplace in posters of the 1890s
—but here Vuillard is breaking new ground.
Vallotton, of whom one is irresistibly remind-
ed, had not produced anything similar by 1890.

Place de la Concorde, with its street lamps,
obelisk and fountains, is clearly recognizable;
white clouds span the splendidly blue sky.
Mounted police can be glimpsed in the back-
ground, but the main action is taking place
in the foreground. A top hat flies up in the
air, and the demonstrators run like rabbits to
escape the fists of policemen carried away
by their own violence. As in *The Flirt* (cat. 18),
the bodies gain power through the lines
of tension, carried on the wave of their own
energy. This ferociously humorous compo-
sition is very close in spirit to later posters
and illustrations by Ibels, Hermann-Paul
and Anquetin; it would have been in good

company in Georges Darien's *L'Escarmouche*,
but this anarchist magazine did not appear
until November 1893.

We sense that Vuillard took pleasure in pre-
senting, with devastating irony, a collision
between the two sides—the bourgeois and
the police—in this hunt. The occasion may
have been one of the last clashes between the
monarchists, remnants of Georges Boulanger's
supporters, and the officious agents of the
Republic. On September 30, 1890, General
Boulanger killed himself in Brussels, on the
tomb of his mistress. As usual, the extreme
right wing chose to smell a conspiracy, and
there may have been demonstrations in Paris.
If Vuillard is to be believed, the police reacted
with considerable violence. GC

THE DRESSMAKERS · *Les Couturières*

1890, oil on canvas, 47.5 × 57.5
Private collection

Cogeval-Salomon II.104

———

*Provenance* Studio—Wildenstein, New York
—Mr. and Mrs. Ira Haupt, New York—
Doris Warner Vidor, New York—Richard L.
Feigen Gallery, New York, 1983—Josefowitz
Collection—Private collection

*Exhibitions* Berne, Kunsthalle, 1946, no. 19—
Brussels, Palais des Beaux-Arts, 1946, no. 36,
ill.—London, Wildenstein, 1948, no. 11—
Edinburgh, Royal Scottish Academy, 1948,
no. 63—Paris, Charpentier, 1948, no. 16—
Basel, Kunsthalle, 1949, no. 16 [c. 1898]—
Cleveland-New York, 1954, p. 100, ill. p. 32—
New York, Wildenstein, 1964, no. 4, ill.—
Houston-Washington-Brooklyn, 1989–1990,
no. 8, col. ill.

*Bibliography* Sutton 1948, ill. p. 47—Chastel
1953, p. 39, col. ill.—Ritchie 1954, p. 12—
Thomson 1988, p. 36, col. pl. 17—Easton
1989, pp. 24, 36–37, 39, 166—Frèches-Thory
and Terrasse 1990, pp. 75, 78, ill.—Cousseau
and Ananth 1990, pp. 162, 166–167, col. ill. p.
168—Forgione 1992, p. 96, fig. 52—Terrasse
1992, col. ill. p. 107—Boyle-Turner 1993, col.
ill. pp. 38–39—Cogeval 1993 and 2002, p. 23
(2002), col. ill. p. 57—Ellridge 1993, col. ill.
p. 100

———

1. Édouard Vuillard, *Study for "The Dressmakers": Madame Vuillard*, 1890, charcoal on paper, private collection.

Here, as in *Grandmother at the Sink* (cat. 4),
the artist began with preparatory sketches in
the manner of the Old Masters, only to arrive
at a cloisonnist painting of disconcerting
boldness. A preparatory pastel (1890, New
York, priv. coll.) depicts the scene from fur-
ther away and includes Grandmother Michaud.
The three women of *Dinnertime* (cat. 2) have
lost their troubling aura and become once
again reassuring household deities, busy cut-
ting out fabric, spinning and sewing. Several
drawings in the journal show the women
seated at table, in silhouette. These sketches
amount almost to a plan of action for the pas-
tel, conveying a vivid sense of the silence that
must have reigned in the apartment on Rue
Miromesnil, broken only by the tick-tock of a
grandfather clock and the creaking of a side-
board brought from the Jura. A number of
drawings in an "1890" notebook show the
faces of Madame Vuillard (fig. 1), seen at vari-
ous angles from slightly above, and of Marie
(fig. 2), on whose features the artist has for
once conferred a rare and elegant sweetness.
Standing out in their arabesque-like poses
against the monochrome blue-green back-
ground, the women suddenly seem like veri-
table *emblems* of Cloisonnism. The two Marie
Vuillards look toward the twentieth century,
transformed into the sisters of Yvette Guilbert
as she appears in *At the Divan Japonais* (cat. 49).

The synthetist nature of the painting does
not prevent Vuillard from making a number
of picturesque observations characteristic of
him: the modest blush on Marie's face, for
example, and Madame Vuillard's grey hair in a
chignon very different from Marie's brown,
compact bun. By means of a slight but definite
shift in the viewer's gaze, the mother's black
bodice can be seen in two different downward
views. She has just cut out the red material
that dominates the centre of the painting, and
between the two fields of fabric there is a sort
of narrow stream revealing the worktable, on
which stands a bobbin of thread. The shapes
are locked close together, a series of densely
packed flat masses.

But the gaze of the two women is hidden from
us, as if to signify their total submission to an
immemorial task that has something of both
choreography and butchery—and even of
embalming. Madame Vuillard certainly looks
for all the world as if she has just dissected a
dramatically red slab of meat. Could the cut-
ting up of a piece of fabric and its inevitable
subsequent reassembling be seen, here, as a
metaphor for the act of painting? GC

2. Édouard Vuillard, *Study for "The Dressmakers": Marie Vuillard*, 1890, charcoal on paper, private collection.

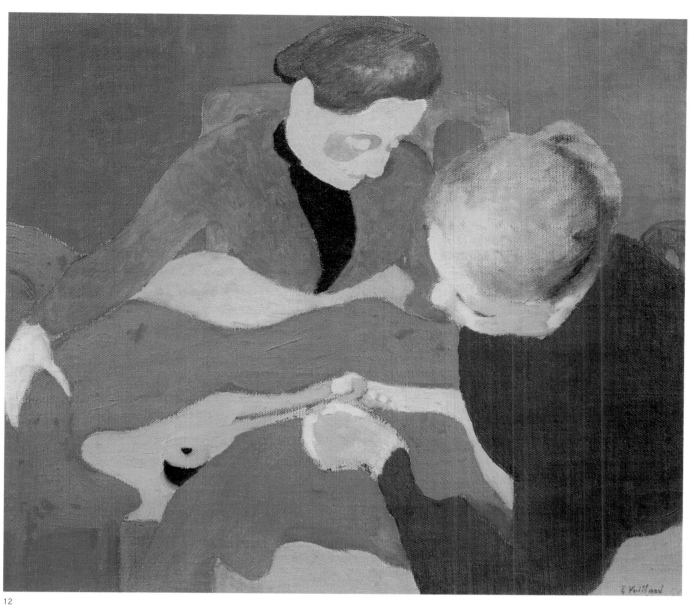

12

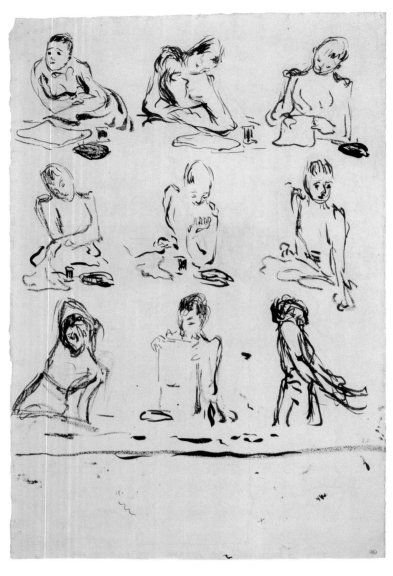

NINE SILHOUETTES OF WOMEN —
STUDIES OF SEAMSTRESSES · *Neuf
silhouettes de femmes—Étude de couturières*

c. 1891, ink wash, 46 × 31
Paris, Musée d'Orsay (on deposit at the
Département des arts graphiques du Musée
du Louvre)

———

There exists a more finished version of these
"nine moments in the life of a seamstress,"
for which—as Ursula Perucchi-Petri has
demonstrated—Vuillard drew considerable
inspiration from the pages of an album of
sketches by the Japanese artist Kitao Masa-
yoshi (1764–1824), which show figures of
dancers and wrestlers in a wide variety of
positions, arranged in sequence.[1] Vuillard is
known to have owned a copy of the album.

This page is symbolic of the freedom with
which Vuillard tackled the problem of depict-
ing the human figure. The amusing postures,
notably the seamstresses' exaggeratedly
jutting hips, are at once an attempt to unravel
the mystery of movement, to capture the
essence of an individual from different angles,
and to offer a subtle variation on the theme of
the figure. In their comic spirit these sketches
are also reminiscent of other drawings pro-
duced around the same time, especially those
published in the magazine *Le Chat noir* by
Théophile Alexandre Steinlen—the famous
*Story of a Cat, a Dog and a Magpie* in eleven
movements, for example (fig. 1). Steinlen,
forerunner of the twentieth century's comic
strip artists, was no doubt influenced by
the same Japanese sources as Vuillard. G C

———

1. Perucchi-Petri 1990, pp. 138, 146.

1. Théophile Alexandre Steinlen, *Story of a Cat, a Dog and a Magpie*,
in *Le Chat noir*, May 17, 1884, Bibliothèque Nationale, Paris.

## 14

THE BOA · *Le Boa*

c. 1890–1891, pastel on paper, 59 × 13
Signed l.l.: *EV*
Private collection

Cogeval-Salomon II.72

———

*Provenance* Ernest Coquelin cadet, Paris—
Bernheim-Jeune, Paris—Henry Bernstein,
Paris, August 31, 1909—Galerie Hopkins-
Thomas-Custot, Paris—Private collection

## 15

HAT WITH GREEN STRIPES ·
*Le Chapeau à côtes vertes*

c. 1890, oil on board, 20.5 × 16.2
Fred Jones Jr. Museum of Art, The University
of Oklahoma, Oklahoma City, Aaron M.
and Clara Weitzenhoffer Bequest, 2000

Cogeval-Salomon II.30

———

*Provenance* Studio—Bela Hein, Paris—
Georges Renand, Paris, 1951—Jean-Pierre
Selz, Paris, 1964—David Findlay, New York
—Aaron M. and Clara Weitzenhoffer, Okla-
homa City, 1979—Weitzenhoffer Bequest to
the Fred Jones Jr. Museum of Art, The Uni-
versity of Oklahoma, Oklahoma City, 2000

*Bibliography* Roger-Marx 1946a, p. 83—
Ciaffa 1985, pp. 297–298, fig. 159

## 16

WOMAN IN PROFILE WEARING
A GREEN HAT · *La Femme de profil au
chapeau vert*

c. 1890–1891, oil on board, 21 × 16
Paris, Musée d'Orsay

Cogeval-Salomon II.79

———

*Provenance* Studio—Acquired through
"dation" by the Musée d'Orsay, Paris, 1990

*Exhibitions* London, Wildenstein, 1954,
no. 114—Paris, MNAM, 1955, no. 187, ill.—
Albi, Musée Toulouse-Lautrec, 1960, no. 8—
Zurich-Paris, 1993–1994, no. 144, col. ill.

*Bibliography* Mauner 1978, p. 221, fig. 57

## 17

FOUR LADIES WITH FANCY HATS ·
*Quatre dames aux chapeaux élégants*

c. 1894, watercolour and graphite on paper,
21.2 × 29.5
Washington, National Gallery of Art, Gift
of Mr. and Mrs. Frank Eyerly, Mr. and Mrs.
Arthur G. Altschul, Malcolm Wiener, and
the Samuel H. Kress Foundation

———

Although won over by the Nabi aesthetic,
Vuillard was still an avid observer of street
life and the evolution of women's fashions.
His journals from 1888 to 1891 are full of
humorous little drawings of women climb-
ing stairs, lifting their skirt hems while negotiat-
ing a puddle or simply displaying themselves
in all their beauty. This was the era when
people on the street and in nightclubs were
singing "I thought I'd die when I saw your
little boot…"

*Hat with Green Stripes* is the most remarkable
and least known of these four compositions.
An elegant woman gazes out at us with a sulky
and rather sheepish expression doubtless
inspired by her hat, which is shaped like the
glass canopy outside a casino on the Nor-
mandy coast. The face and the abstract back-
ground have been laid on with a rough and
vigorous brushstroke.

*The Boa*, the most sophisticated of the four
works, resembles Bonnard's *Peignoir* (1892)—
in its elongated kakemono format if nothing
else. The woman, who turns slightly but is not
really looking at us, wears a coat inspired by
the English fashion of the day, easily identi-
fiable by the characteristic swath of fabric
attached at hip level. This well-dressed lady in
the feather boa stands out against a mono-
chrome orange background, almost a stylized
caricature of the fashion illustrations of the
day. All these Vuillardian images can be seen
as counterparts of the literary caprices of
Mallarmé, who in September-December 1874
published *La Dernière Mode* under several
pen names, not hesitating to sign a pricelessly

funny "Gazette de la Fashion" with the name
"Miss Satin."[1] Vuillard, fascinated by Mal-
larmé's mysterious poetry, borrowed from it
the notion of a disturbingly elegant woman
who passes momentarily by, evoking the
almost imperceptible mark she leaves on the
memory:

Lace sweeps itself aside
In the doubt of the ultimate Game…[2]

*Woman in Profile Wearing a Green Hat* is dis-
tinctly more cloisonnist. The profile stands
out like a head on a medal, against a power-
fully applied background. So often the prudish
Vuillard's girls have faces that elude, a token
of their shyness and quite proper sense of
modesty. They steal furtive looks at us, like
those that in 1900 the painter would start to
capture among his friends and family—with a
camera. With a certain theatricality, he directs
the spotlight onto the threat represented
by the corseted body, a body simultaneously
negated and flaunted. He records all the
impressions of the street and brings them to
life in solid, masterful compositions: "Noth-
ing matters but the state of mind one is in for
successfully subjecting one's thinking to a
sensation thinking about nothing else but that
sensation and finding a way to express it. My
brain is numb now, a while ago when I was
out walking it was so active."[3] We know that
around this time Vuillard did not have the self-
confidence that was later to become habitual,
and his women remained for him objects of
desire that had to be kept at a distance. He
might well have endorsed Baudelaire's won-
derful lines in "L'Amour du mensonge":

But is it not enough your looks prevail
To gladden a heart that flees from verity?[4] G C

———

1. Stéphane Mallarmé, *Oeuvres* (Paris: Gallimard, "La Pléiade,"
1945), pp. 764–766.

2. Ibid., "Autres poèmes et sonnets," p. 74; trans. Henry
Weinfield, in *Collected Poems: Stéphane Mallarmé* (Berkeley,
Los Angeles, London: University of California Press, 1994),
p. 80.

3. Vuillard, *Journal*, I.2, fol. 19v (September 6, 1890).

4. Charles Baudelaire, "L'Amour du mensonge," in *Les Fleurs
du Mal*; trans. in *Charles Baudelaire: The Flowers of Evil*, ed.
Marthiel and Jackson Mathews (New York: New Directions,
1989), p. 125.

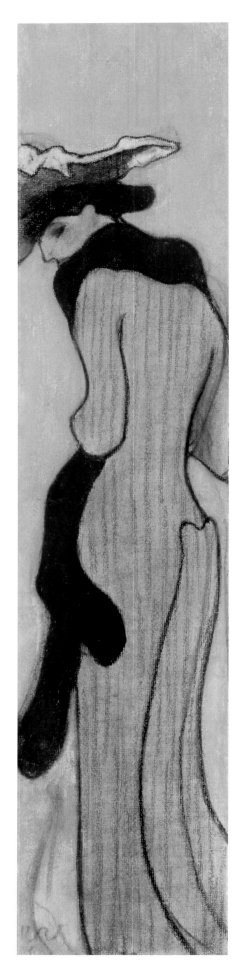

14

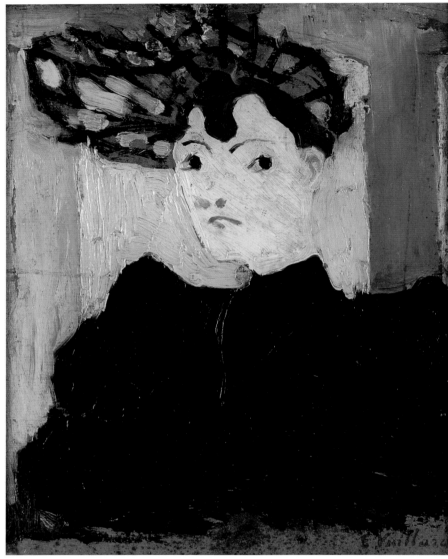

15

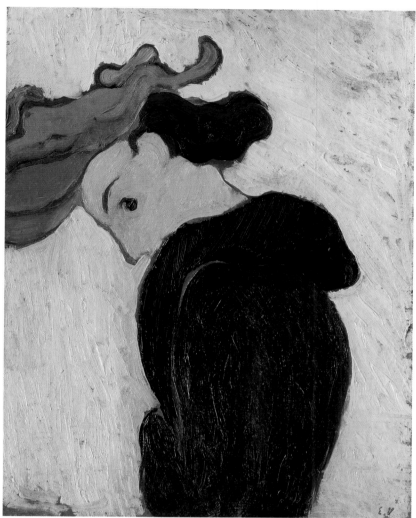

16

17

THE FLIRT · *Le Flirt*

c. 1890–1891, pastel on paper, 24.5 × 20
Private collection

Cogeval-Salomon II.120

*Provenance* Studio—Private collection

*The Flirt*, published here for the first time, points up Vuillard's taste for the *Unheimlich*, that sense of the "uncanny" that haunted Freud throughout his life. In what appears to be a club or a cabaret, a woman stares at her hand, which is in the violent grip of a man whose presence is merely suggested. The effect of surprise is heightened by the woman's staring eyes and huge mouth. Vuillard's startling creation seems like a cross between one of Granville's monsters and Wilder Penfield's somatosensory homunculus. However, his taste was not for the bizarre—unlike Ranson's around this time—but rather for exaggerated derision. Volume I.2 of his journal ("1890") opens with a series of drawings that range from reinterpretations of ladies' fashion plates to close-ups of faces, outrageous caricatures

1. Édouard Vuillard, *Sketch for the Poster "Phonographies Darzens,"* 1890–1891, watercolour and black ink over graphite, private collection.

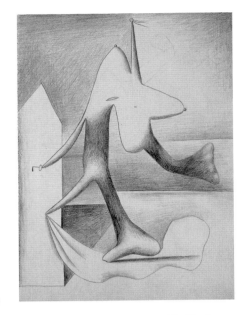

2. Pablo Picasso, *Bather and Cabana*, 1927, graphite stick on Ingres paper, Paris, Musée Picasso.

of a baby, a bearded man in a top hat, a Hokusai cat, and an African Zouave, who, with his fez and enormous smile, bears a striking resemblance to the character that a few years later adorned the Banania cocoa tin. All these experiments, which would have been quite at home in the Arts Incohérents exhibitions, are in the same vein as this pastel.

A woodblock print by the Japanese artist Utagawa Toyokuni II (1777–1835), which was part of Vuillard's collection, could have been the starting point for this strange pick-up scene. In it, a Japanese actor dressed as a woman wears an expression of surprise and horror similar to that of the young woman in *The Flirt*; furthermore, the framing in the lower part of the image cuts off the naked leg and arm of a man holding a pipe, who faces the actor. Beyond the visual similarities, a certain disingenuous sense of obscenity— or *Ungehörigkeit* (impropriety)—could be said to link these two works. But whatever the source of its inspiration, *The Flirt* was a decisive harbinger of the twentieth century, and retains even today its power to shock.

In the early 1890s, Vuillard liked to represent bodies and faces in thrall to what Freud calls an "impulse" or "drive" (*Trieb*); this is the case in *At the Divan Japonais* (cat. 49), in *Miss Helyett* (1890–1891, priv. coll., C-S III.1) and, still more forcefully, in a sketch for *Phonographies*

*Darzens* (fig. 1), an invention by his playwright-inventor friend Rodolphe Darzens that seemed to anticipate the telephone. Vuillard drew several poster designs for him, one of which shows an elf-like figure with an outsized ear listening to the new invention. In these phantasmagorical compositions, the body signals the intended gesture, and the organs are exaggerated to the extreme. In 1888, Vuillard wrote in his journal: "if I concentrate on a single point, losing the sensation of the other images of this body, I lose the relationship between that point and the others, little by little it takes over my mind."[1] There could be no better commentary on *The Flirt*.

In his so-called Surrealist period, Picasso turned again and again to kisses that devour, to bathers—like the *Bather and Cabana* (fig. 2) —whose bodies explode in all directions and recompose according to the viewer's desire, and to sleeping women who slyly observe us through somnolent orifices, eye-mouth-vagina. Jean Clair's reflections on these troubling works by the Spanish artist could almost be transposed to Vuillard, for he, too, "shatters the Platonic sphere, changing the smooth, gentle, binding libido of the Platonic Eros, the union of like with like, into a furious libido that nothing can assuage, the impossible union of two permanently different bodies. The gendered being is both a profusion of forms brought about by the constraints of symmetry and the death of the individual in the name of the safeguarding of the species."[2] G C

1. Vuillard, *Journal*, I.1, fol. 12r (after November 20, 1888).

2. Jean Clair, "The School of Darkness," in *Picasso Érotique*, exhib. cat. (Montreal: The Montreal Museum of Fine Arts; Munich/London/New York: Prestel-Verlag, 2001), p. 23.

18

THE LITTLE DELIVERY BOY ·
*Le Petit Livreur*

c. 1891–1892, oil on board, 40 × 26
Signed l.r. in the 1930s: *E. Vuillard*
Upperville, Virginia, Collection of Mr. and
Mrs. Paul Mellon

Cogeval-Salomon II.130

---

*Provenance* Jos Hessel, Paris—Wildenstein,
New York—Collection of Mr. and Mrs. Paul
Mellon, Upperville, Virginia, 1969

*Exhibitions* Paris, Les Cadres, 1936, no. 70
[*L'Écolier*]—Paris, Musée des Arts décoratifs,
1938, no. 18

*Bibliography* Roger-Marx 1946a, p. 49, ill.
p. 35—Chastel 1946, ill. p. 19—Roger-Marx
1948b, pl. 3—Salomon 1968, p. 51, ill. p. 52—
Groom 1993, p. 215, no. 45

---

Vuillard was often touched, it seems, by the
irruption of children into his family space, and
certainly in his own personality the naughty
little boy and the wise old man always co-
existed. This is apparent in *In Bed* (cat. 21),
which shows a sleeping child, and in a number
of drawings in the journal from 1889–1890.
One of the latter is a sketch of a little boy in a
smock talking to an old lady, who has opened
her window—we glimpse the courtyard of
a Paris apartment building—to listen to the
child's chatter.[1] Rendered in a deliberately

1. Édouard Manet, *A Boy with a Sword*, 1861, New York,
The Metropolitan Museum of Art, Gift of Erwin Davis.

Pont-Aven, synthetist style, it is one of the
most charming sketches in Vuillard's early
journal. In *The Little Delivery Boy* Vuillard
uses the same technique of solid colours
applied in broad brushstrokes seen in *Lugné-
Poe* (cat. 37) and *In Bed*. The range of muted
greens is surprising: it alters as it moves down
from the door frame and rhythmically mottles
the wall in the background, possibly depicting
glass bricks or perhaps a pattern of earthen-
ware tiles.

The boy is proudly carrying a piece of fabric
with the same extreme care displayed by
Manet's *Boy with a Sword* (fig. 1), which, after

a prolonged stay at the Durand-Ruel gallery,
became the first work to enter the Metropoli-
tan's collection. Vuillard may have known
this work from the many prints made of it, or
from a reproduction. The kinship between
the two paintings is striking: in both the legs
are aligned in a kind of frieze, while the upper
body is turned toward the observing artist.
And in both the gracefulness of the child's
arrested movement is miraculous.

Jacques Salomon recounts a charming episode
concerning this canvas: "I happened to be at
Lucy Hessel's one evening when she was posing
for Vuillard. Jos Hessel arrived home and

immediately showed Vuillard a small picture he had just been offered. I can still hear Vuillard's 'Oh!' of surprise and then, in a gentler tone: 'The little delivery boy!' The painting was not signed; Vuillard authenticated it on the spot with the brush he was holding."[2] GC

1. Vuillard, *Journal*, 1.1, fol. 55v (April 25, [1889?]).

2. Salomon 1968, p. 51.

## 20

THE KISS · *Le Baiser*

c. 1891, oil on paper mounted on board,
23 × 16.5
Philadelphia Museum of Art, The Louis E. Stern Collection, 1963, 1963-181-76

Cogeval-Salomon II.21

*Provenance* Studio—Private collection, Paris—Sam Salz, New York—Louis E. Stern, New York, 1955—Gift of Louis E. Stern to the Philadelphia Museum of Art, 1963

*Exhibitions* Brooklyn, Brooklyn Museum, 1962–1963, no. 103—Houston-Washington-Brooklyn, 1989–1990, no. 5, col. ill.

*Bibliography* Philadelphia Museum of Art 1965, p. 69—Barilli 1967b, col. ill. p. 127—Barilli 1967c, ill. p. 97—Negri 1970, p. 22, col. pl. 37—Daniel 1984, pp. 381, 385, fig. 138—Rishel 1989, p. 122, fig. 164—Easton 1989, pp. 14–16—Cogeval 1993 and 2002, col. ill. p. 10—Sidlauskas 1997, p. 97, ill.

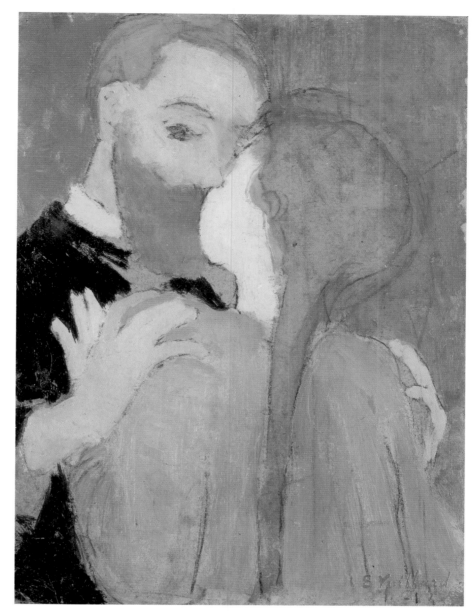

This painting was known for a long time as *Self-portrait of the Artist with His Sister* or *The Brotherly Kiss*. That it seemed impossible to imagine Vuillard kissing anyone other than his sister was doubtless due to a certain prudishness found not infrequently in North American scholarship. In 1891, the probable date of the painting, Vuillard still had a full head of hair, and his red beard blazed. Marie, his sister, was seven years his senior; she was therefore thirty, and since she had unfortunately begun losing her own hair in her late teens, she was obliged to wear it coiled on top of her head.[1] What is more, the artist was the same height as his sister, as some rare contemporary photographs of holidays at Villeneuve-sur-Yonne attest (fig. 1). Here, he is clearly embracing a young girl—slighter and frailer than himself,

1. Photograph by Alfred Natanson of a game of bowls at Villeneuve-sur-Yonne, 1899, detail showing Vuillard and his sister Marie, private collection.

perhaps an apprentice in his mother's workshop—kissing her tenderly while glancing sideways in a mirror. These little apprentices must have been considered "part of the family." They appear in a number of paintings, notably *Young Girls Walking* (cat. 31), *The Apprentices* (c. 1891–1892, priv. coll., C-S IV.9) and *The Drawer* (c. 1892, New York, priv. coll., C-S IV.55). Vuillard has considerably exaggerated the size of his hands as they grasp the young girl's frail shoulders. It is a sign of his psychological reserve that in this image of a kiss he does not portray his mouth. GC

1. I am indebted for this information to Antoine Salomon, Marie Vuillard-Roussel's grandson.

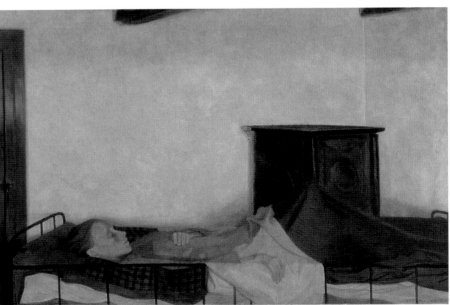

1. Ejnar Nielsen, *The Sick Girl*, 1896, Copenhagen, Statens Museum for Kunst.

1891, oil on canvas, 73 × 92.5
Signed and dated u.l.: *e.vuillard 91*
Paris, Musée d'Orsay, Verbal bequest
of Édouard Vuillard, executed thanks to
M. and Mme Kerr-Xavier Roussel, 1941

Cogeval-Salomon II.123

*Provenance* Studio—M. and Mme K.-X.
Roussel; gift to the French nation in 1941—
Musée national d'art moderne, Paris; Musée
d'Orsay, Paris in 1986

*Exhibitions* Paris, Orangerie, 1941–1942,
no. 18—Paris, MNAM, 1960–1961, no. 733—
Paris, Orangerie, 1968, no. 7, ill.—Zurich-
Paris, 1993–1994, no. 146, col. ill.

*Bibliography* Roger-Marx 1946a, p. 49, ill.
p. 37—Chastel 1946, p. 44, ill. p. 14—
Salomon 1968, p. 45, ill.—Russell 1971, p. 22
—Perucchi-Petri 1976, pp. 98–102, col. fig. 56
—Mauner 1978, pp. 200, 229–230, 233, 255,
fig. 80—Cogeval 1993 and 2002, p. 31, col. ill.
pp. 30–31

Sleeping children are a commonplace of
Symbolism. One need only think of the sick
children portrayed by Edvard Munch or
Ejnar Nielsen, whose *Sick Girl* (fig. 1) offers a
striking parallel to the work seen here; or of
Gustav Mahler's magnificent song cycle on
the death of children entitled *Kindertotenlieder*;
or of Ferdinand Hodler's young subjects
touched by ecstatic grace. In all of these cases,
the children are clearly hearing some mourn-
ful music of the spheres inaudible to adults.
The Symbolist generation did not have to wait
for the writings of Sigmund Freud to under-
stand that sleep is the generating condition
of dreams. And as anyone conversant with
Symbolism knows, dreams are central to that
movement: "For not a week went by without
the publication of some book on dreams or
such related phenomena as hypnosis, som-
nambulism, catalepsy."[1] The eternal recur-
rence of the *slide* into sleep seems to have fired
the imagination of the artists of that period.
Rather than seeing somnolence as a plunge
into the world of enchantment, as Romantics
like Nerval, Dadd or Quincey would have
it, late nineteenth-century culture explored the
lethargic addiction to the suspension of con-
scious activities, focusing on the spiral move-
ment that leads to introversion and solipsistic

2. Winsor McCay, *Little Nemo in Slumberland*, *The New York Herald*,
July 26, 1908. © Ray Monitz.

complexity. And for the father of psycho-
analysis, dreams were the prime site for the
*displacement* of images: "I have given the
name of *dream-work* to the process which,
with the co-operation of the censorship, con-
verts the latent thoughts into the manifest
content of the dream. It consists of a peculiar
way of treating the preconscious material of
thought, so that its component parts become
*condensed*, its mental emphasis becomes *dis-
placed*, and the whole of it is translated into
visual images or *dramatized* and filled out by
a deceptive *secondary elaboration*."[2]

In this extraordinary painting, Vuillard can-
not shake off a certain ambiguity: true to his
Nabi sense of caricature, he is comical (the
knees rising like tent posts beneath the sheet),
yet at the same time inveterately melancholic
(hushed colours with a pale almond dominat-
ing, the cross evoking mourning). André
Chastel spoke brilliantly of "the appearance
of cloisonné enamel, soft stained glass."[3] And
Ursula Perucchi-Petri has, in turn, stressed
the calming forms imposed by the lines of
force: "The soft, full curves of the pillow and
the blanket, constantly striving toward the
reassuring horizontal, are 'plastic equivalents'
that allow the artist to express the repose and
silence that go hand in hand with sleep."[4]
The faint grey highlights conjure a sense of
volume with breathtaking subtlety, but the
composition as a whole is a triumph of spatial
illusion.

Was Vuillard simply depicting the two colours
decorating the background wall, or was he
picturing the cross masked by a semi-transpar-
ent veil or canopy above the sleeping figure?

Hard to tell. This child, who is certainly not
the painter's sister Marie (she was thirty at the
time), seems to be enveloped in a hothouse
atmosphere. The setting is probably not Rue
Miromesnil, where the Vuillards were living
at the time. The painter and his sister often
stayed with their Aunt Saurel in Créteil, then
deep in the countryside, and the subject may
be (although this could never be proved) some
unknown Vuillard cousin. It hardly matters.
Dreaming in full daylight, the little sleeper
appears *transported*, like Psyche by Zephyr in
some lovely early nineteenth-century Neo-
classical drawing by Gagneraux, Flaxman or
Girodet. Closer to Vuillard's day, the Lyon-
nais artist Louis Janmot had depicted children
threatened by nightmare chimeras in his 1854
work *Poem of the Soul*. And with Maeterlinck
the menace intensified: the Belgian play-
wright spoke anxiously of "the infinite, un-
fathomable, hypocritically active presence of
death…preferring to carry off the youngest
and least unhappy, simply because they are
the more disruptive."[5] Like the hero of Win-
sor McCay's *Little Nemo* comic strip (fig. 2),
the child might well exclaim on waking: "I'm
glad I was just dreaming!"

The presence of the cross, finally, is less sur-
prising when we recall that Vuillard, who
had been educated for a time by the Marist
Brothers, frequently alluded in his journal for
1890 to the relationship between the Catholic
faith and creation: "Only intellectuals can
produce and I refuse to be intellectual. But I
am so weak, such a sinner amid sinners, and
why should I elevate myself. God source
of all harmony of all intelligence who every-
where permeates us who surrounds us with
your signs, set me free, defend me in my free-
dom from base and dark ideas, at every
moment reveal yourself to my weak, lowly
intelligence! Prayer alone can save me I
glimpse that peace: no more human arro-
gance, only pride can rightfully participate in
universal harmony, to be a son of God!!"[6] G C

1. Jean Clair, "The Self beyond Recovery," in *Lost Paradise:
Symbolist Europe*, exhib. cat. (Montreal: The Montreal Museum
of Fine Arts, 1995), p. 131.

2. Sigmund Freud, *An Autobiographical Study*, trans. James
Strachey (London: Hogarth Press, 1946), pp. 82–83.

3. Chastel 1946, p. 44.

4. Ursula Perucchi-Petri, in *Nabis 1888–1900*, exhib. cat.
(Paris: Réunion des musées nationaux, 1993), p. 309.

5. Maurice Maeterlinck, pref. to *Théâtre*, vol. 1 (Brussels 1901),
pp. IV–V.

6. Vuillard, *Journal*, I.2, fol. 24r (October 24, 1890).

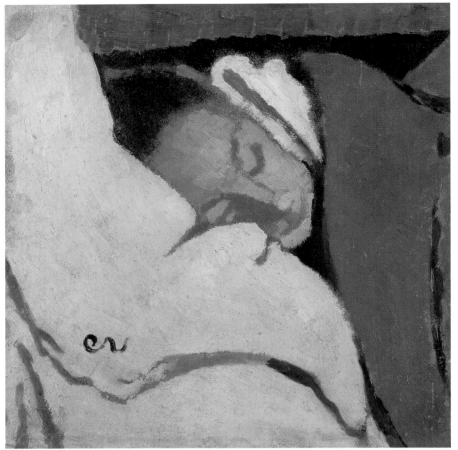

22

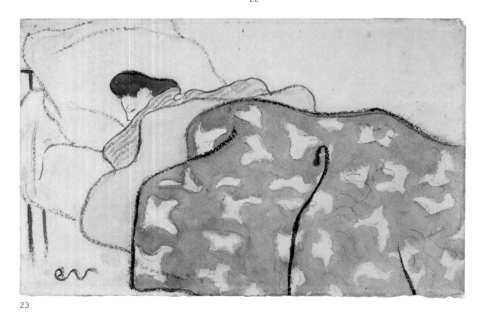

23

## 22

GIRL SLEEPING · *La Dormeuse*

1892, oil on board mounted on cradled panel,
26.8 × 26.8
Signed l.l.: *ev*, dated on verso, possibly in
another hand: *92*
Private collection

Cogeval-Salomon II.125

*Provenance* Alexandre Natanson, Paris—
Alexandre Natanson Sale, Hôtel Drouot,
Paris, May 16, 1929, lot III [*La Femme
endormie*] (ill.)—Jos Hessel, Paris—
Georges Bénard, Paris—Private collection

*Exhibitions* Paris, Bernheim-Jeune, Nov. 1908,
no. 42 [*Dormeuse*]

*Bibliography* Roger-Marx 1946a, ill. p. 37—
Chastel 1946, p. 44, ill. p. 11—Schweicher
1949, p. 107

## 23

WOMAN IN BED · *Femme au lit*

1891, watercolour and charcoal on paper,
14.7 × 22.8
Signed l.l.: *ev*
Washington, National Gallery of Art,
Ailsa Mellon Bruce Collection

*Provenance* Studio—Edward Molyneux,
Paris, by 1952—Ailsa Mellon Bruce, New
York, 1955—Bequest to the National Gallery
of Art, Washington, 1970

*Exhibitions* Washington, NGA, 1966,
no. 245, ill.

*Bibliography Nabis 1888–1890*, exhib. cat.,
Paris, Réunion des musées nationaux, 1993,
p. 310, fig. 146.1

In this *Girl Sleeping*, in marked contrast to
*In Bed* (cat. 21), the face of the artist's sister
Marie is clearly recognizable. Vuillard made
a number of drawings of her in Conté crayon
or charcoal during this period, and here
the broadly arched eyebrows and slightly up-
turned nose are unmistakable. Another
painting, *Sleep*, in the Musée d'Orsay (1892,
C-S II.124), also depicts Marie abandoned to
the luxury of slumber. Vuillard exhibited
this latter oil at the Le Barc de Bouteville in
1892 under the title *Reclining Woman*, and
his severe Cloisonnism earned him a carica-
ture by Yvanhoe Rambosson in *Le Journal*
(November 26, 1892) entitled *Reclining
Woman in Bits*. In *Girl Sleeping* Marie lies in
exactly the same position, but Vuillard has
depicted her at close range, with the tact of a
respectful brother. The way in which the
young woman's skin tones have been gradu-
ally merged into the white of the pillow is
masterly. In contrast to the Cloisonnism of
Émile Bernard, Vuillard's is elegant and
cerebral. This small painting breathes a sort
of happy languor.

The watercolour sketched in charcoal shows
Marie in bed seen slightly from above. Vuil-
lard was clearly haunted by the mystery of
sleep throughout his "Symbolist" years, and
his sister posed, unwittingly, as a dreaming
spirit. The green stripes of her nightgown
partially hide her face. The bedspread seems
almost "punctured" by starry motifs that
recall *Young Girls Walking* (cat. 31) and *Self-
portrait with Cane and Straw Hat* (cat. 28),
which leads us to posit a dating to 1891. GC

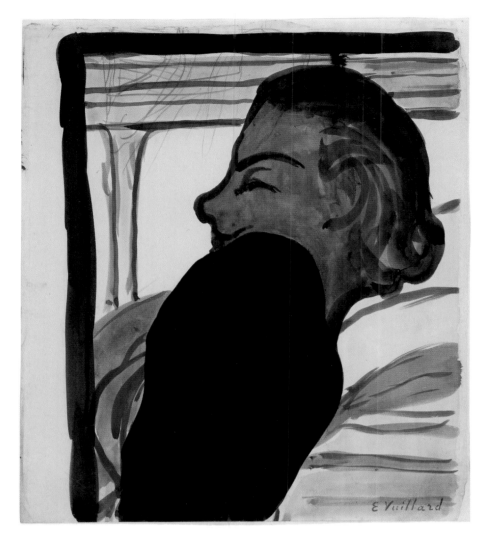

## 24

THE ENIGMATIC SMILE ·
*Le Sourire mystérieux*

c. 1891, watercolour and graphite on rag
paper, 23.6 × 20.5
Washington, National Gallery of Art,
gift of Liane W. Atlas

This powerful watercolour, likely executed
in 1891, unquestionably represents Marie in
profile, shrugging her shoulders at her
brother. The smile she casts in his direction
is at once cartoonish and full of tenderness.
Vuillard was a very keen observer. Photo-
graphs and portraits of him as a young man
show him with dark, melancholy eyes, ever
on the lookout for something new to scruti-
nize. In the family apartment, he must have
been constantly examining his relatives and
the young seamstresses who worked for his
mother with a view to transforming them in-
to subject matter for his art. A delightful
little painting from the same year as this water-
colour, *Young Woman with Her Hand on a
Doorknob* (priv. coll., C-S IV.12), also repre-

sents Marie—there on the point of opening
a door, hunching her shoulders to avoid her
brother's gaze, and again wearing the smile of
some eighteenth-century faun. Later, once
Vuillard had mastered the art of photography,
friends and family were often caught in the
act of avoiding or even frankly fleeing his
inquisitive eyes. GC

red hair is rendered in the same orange Vuillard used for his beard in the self-portraits. The oil on board technique lends itself well to the modelling of the flesh tints, and the shadows reveal the depth of the body; the skin tones are delicately heightened with red, although the unmodelled overall style is close to other paintings of the same period—*In Bed* (cat. 21), *Hat with Green Stripes* (cat. 15) and *Lugné-Poe* (cat. 37). The odd arabesque in the background suggests a theatre flat, like one of the many Vuillard must have created for Lugné-Poe around this time. G C

## 26

LADY OF FASHION · *L'Élégante*

c. 1891–1892, oil on board, 28.4 × 15.3
Private collection

Cogeval-Salomon II.135

*Provenance* Studio—Private collection

*Exhibitions* Paris, MNAM, 1955, no. 183—Milan, Palazzo Reale, 1959, no. 13, ill.—Paris, Orangerie, 1968, no. 30, ill.—Zurich-Paris, 1993–1994, no. 153, col. ill.—Florence, Palazzo Corsini, 1998, no. 10, col. ill. p. 49—Montreal, MMFA, 1998, no. 170, col. ill. p. 28.

*Bibliography* Roger-Marx 1946a, p. 16—Perucchi-Petri 1976, p. 106, fig. 62—Mauner 1978, pp. 227–229, fig. 78—Cogeval 1998a, pp. 180–181—Cogeval 1998b, p. 118

In Vuillard's hands, this utterly banal scene is transformed into a profound metaphysical inquiry. A young woman, no doubt one of Madame Vuillard's clients, is opening a door. She wears the same black sheath skirt the artist would shortly use again for a couple of the women in the Desmarais panels (cats. 103–108). Her bodice of rose-coloured silk is highlighted with touches of white, whose source is the harsh light emanating from the room into which she gazes. Her hat is decked with flowers that seem to burst forth like red fireworks. A mysterious illuminated area forms a Greek *tau* in the second room. "The picture," Mauner noted, "is both real and unreal; motion is potential, not implicit, as the figure contemplates the light to which she is related. The mystery results from the juxtaposition

## 25

SEATED NUDE · *Nu assis*

1891, oil on board, 29 × 22.5
Private collection

Cogeval-Salomon II.108

*Provenance* Studio—Jean-Pierre Selz, Paris —Jan Krugier, Geneva—Sale, Christie's, London, Dec. 2, 1986, lot 318—Private collection

*Exhibitions* Houston-Washington-Brooklyn, 1989–1990, no. 19, ill.—Glasgow-Sheffield-Amsterdam, 1991–1992, no. 15, col. ill. p. 37

*Bibliography* Thomson 1988, p. 32, col. pl. 19 —Easton 1989, p. 37

During his years as a student at the École des Beaux-Arts, Vuillard would undoubtedly have been struck by the iconography of pictures of *Susanna and the Elders* and of *Antiope*, in which a satyr is shown disrobing a beautiful woman while she sleeps. Most of Vuillard's early nudes show tense, curled-up bodies and faces averted from the spectator's gaze. Do these poses have their source in his rather conventional notion of woman as modest, shy and submissive? Was the naked female body in fact linked in his mind with the guilt of original sin?

Here, the sitter was almost certainly a model who came to pose in the studio newly rented by Vuillard and Bonnard on Rue Pigalle. Bonnard, indeed, painted her that same year in exactly the same pose. The piece of fabric on the floor and her clothing lying against the wall tend to support this interpretation. Her

of the natural and the supernatural, and the latter is forced by a confidence in abstraction, not a dependence on pattern."[1]

Vuillard offers us a figure in a state of waiting, or possibly of surprise. She seems gathered in on herself, a modern-day Pandora who has opened the box that holds a gleaming, inexplicable secret. For the Nabi artist, the passage from one room to the other becomes a *transport* from reality toward mystery. With this simple, unpretentious little painting, where someone quite ordinary is about to witness a revelation, Vuillard has created a gem. As he noted in his journal in 1890:

The purer the elements employed, the purer the work. In painting there are two means of expression, form and colour the purer the colours the purer the beauty of the work; this does not mean that a black painting for example will be less beautiful than a yellow painting, it will be so to the same degree if the blacks employed retain their black quality like the yellow painting according to the pureness of the yellow. It is notable that in museums and the history of painting, the more mystical the painters the more vivid their colours (reds blues yellows) the more materialist the painters the more they employ dark colours (earth tones ochres bituminous blacks) I mean to say though that mystics and materialists are also metaphysicians. The need for faith. As for forms the more mystical people are the more their forms become pure arabesques, the more materialist they are the more their forms become complicated, always remaining / both of them / expressive ideaists.[2]

In the early 1890s, Vuillard appears to have succumbed to the charms of the Symbolist sirens, practising the art of the unsaid with conviction and virtuosity. His *Lady of Fashion* is sister to Fernand Khnopff's sibyls (fig. 1), who pose sphinx-like in hushed interiors, awaiting a dénouement that never comes. G C

---

1. Mauner 1978, p. 228.

2. Vuillard, *Journal*, 1.2, sheet 74.

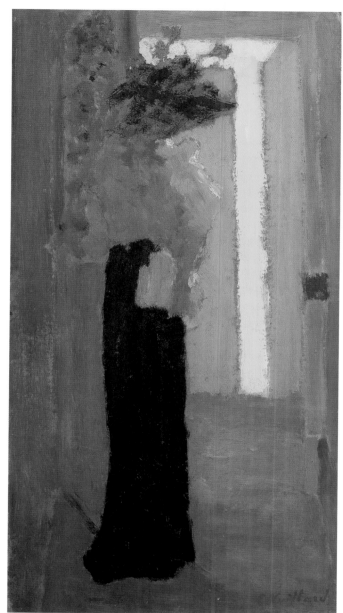

26

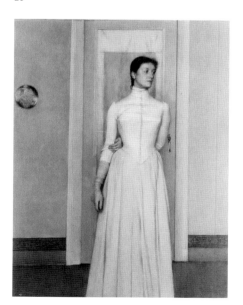

1. Fernand Khnopff, *Portrait of Marguerite*, 1887, Brussels, Fondation du Roi Baudouin, on deposit with the Musées Royaux des Beaux-Arts de Belgique.

MOTHER AND DAUGHTER AGAINST
A RED BACKGROUND · *Mère et fille sur
fond rouge*

c. 1891, oil on board, 18 × 18
Private collection

Cogeval-Salomon II.106

*Provenance* Studio—JPL Fine Arts, London
—Private collection

*Exhibitions* Paris, Parvillée, 1943, no. 73—
London, Wildenstein, 1954, no. 115—Vevey,
Musée Jenisch, 1954, no. 196—Paris, MNAM,
1955, no. 189 [c. 1892]—Glasgow-Sheffield-
Amsterdam, 1991–1992, pp. 19–20, no. 8,
col. ill.

*Bibliography* Mauner 1978, pp. 211–212, 260,
fig. 159

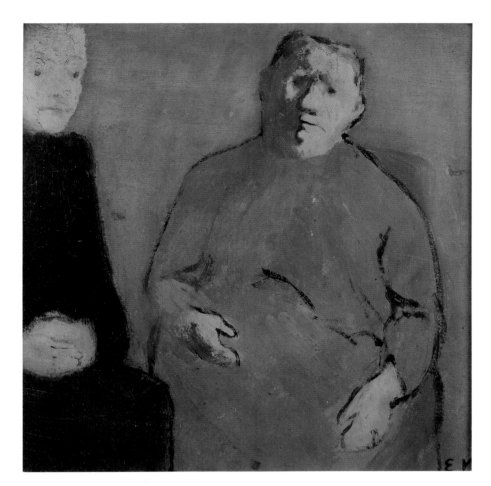

This painting is even more terrifying than
the Washington work called *The Conversation*
(cat. 77) or *Madame Vuillard's Sewing Work-
shop* (c. 1892, United States, priv. coll., C-S
IV.26). Perhaps mother and daughter had
been quarrelling, for reasons as grave as a
boy glanced at in the street or a lost spool of
thread. Vuillard loved family rows; he re-
corded them with a shamelessness peculiarly
his own, and could even provoke them. In
1891 Marie was thirty and still unmarried, an
inevitable source of discord in a turn-of-the-
century *petit-bourgeois* family. Her spinster
status must surely have been the object of
acid comments from her mother, and in 1892–
1893 Vuillard decided to take matters in
hand—unfortunately for his sister.

This little picture is a kind of rehearsal, more
intimate still, for MoMA's *Interior, Mother
and Sister of the Artist* (cat. 85). It is even more
disturbing, because of the red ground that
intensifies the sense of anguish. A sketch from
the "1890" notebook captures Marie sewing
at the window and her mother, seen from
behind in the foreground, lecturing her with
an admonitory finger raised (fig. 1). Fortu-
nately, all these little dramas are offset by a
salutary humour. The style of this small paint-
ing is calm, like that of *In Bed* (cat. 21), at

1. Édouard Vuillard, *Madame Vuillard and Marie* (detail), 1890,
graphite on paper, private collection.

once synthetic and minimal. The mother's
stern look, with her face half in shadow, is
aimed directly at the artist. She wears a brown
dress. Much more disquieting is the figure of
Marie: her round eyes, set in a deathly pale
face, stare straight ahead. Her chalky com-
plexion recalls the absinthe-drinking women
immortalized by Degas—or even a *fin-de-
siècle* drug addict. In fact, the taste for strange-
ness and morbid reverie that permeated the
culture of decadence from Edgar Allan Poe on
was linked to a widespread use of narcotics,
as Jean Clair has so brilliantly reminded us:

"The Symbolist dream is first and foremost an
artificial dream, one that is induced, stimulated
and artificially maintained. The *fin de siècle*
was not only the period that discovered the
virtues of tranquillizers and anaesthetics
(chloroform began to be used in dental sur-
gery towards 1880); there was also the erup-
tion of *paradis artificiels*: hashish, opium, nico-
tine, absinthe, cocaine and morphine. Loved
and feared in turn, pharmacology henceforth
became the bedfellow of creative genius."[1]
Vuillard, who went out almost every evening
and to whom nothing was foreign, was cer-
tainly aware of all this. We may nevertheless
wonder why he went so far in caricaturing his
own family. Perhaps he was determined to
introduce his interest in misfortune, reinforced
by his reading of Maeterlinck and Ibsen, into
his home environment. G C

1. Jean Clair, "The Self beyond Recovery," in *Lost Paradise:
Symbolist Europe*, cat. exhib. (Montreal: The Montreal
Museum of Fine Arts, 1995), p. 132.

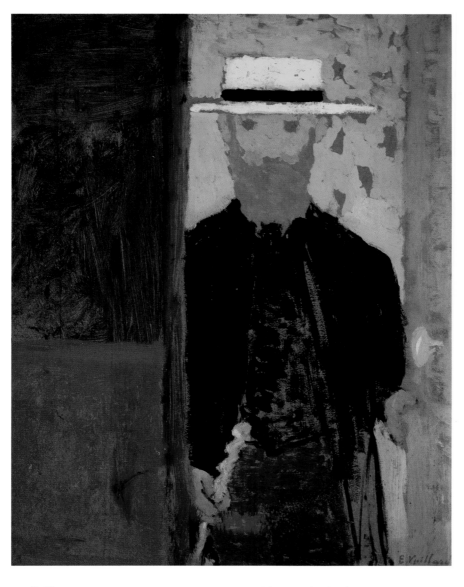

## 28

SELF-PORTRAIT WITH CANE AND
STRAW HAT · *Autoportrait à la canne et
au canotier*

c. 1891, oil on board mounted on canvas,
36 × 28.5
New York, Collection William Kelly Simpson

Cogeval-Salomon II.27

———

*Provenance* Studio—Jacques Roussel—
Sam Salz, New York—Ralph F. Colin, New
York, 1953—E. C. Thaw, New York—
William Kelly Simpson, New York, 1992

*Exhibitions* Cleveland-New York, 1954,
p. 101, ill. p. 40—Toronto-San Francisco-
Chicago, 1971–1972, no. 7, ill.

*Bibliography* Ciaffa 1985, pp. 112–113, fig. 25

———

This self-portrait, one of the artist's most
original, belonged to his nephew Jacques
Roussel after 1940, and later to Sam Salz.
Doubtless for this reason it was never dis-
cussed in the French monographs, notably
those by André Chastel, Claude Roger-Marx
and Jacques Salomon. The work is, in fact,
one of Vuillard's outstanding portraits. It is
almost as if the Nabi artist has incongruously
broken into a painting by Mark Rothko, a
geometric, abstract work in which green, red
and yellow divide the pictorial space into
regular polygons. Empire green and Pompeian
red were colours that typically adorned the
corridors of Paris apartment buildings at the

time, and for many years to come. Behind
the artist we see wallpaper that is almost
"punctured" by a regular pattern.

We are probably in June or July 1891, either
on Rue de Miromesnil or more likely in the
studio on Rue Pigalle, which Vuillard had
been renting since April of that year with
Bonnard and Lugné-Poe. A letter written by
Paul Ranson to Jan Verkade in May 1891 notes
this change in status: "The Nabi Vuillard and
the Nabi Bonnard have taken for themselves
an ergastère [work space] at 28 Rue Pigalle.
These Nebiim are in an ecstasy of joy, serious
in Vuillard's case, exaggerated in Bonnard's."[1]

The citron yellow of the straw hat standing
out against the more muted shade of the wall-
paper behind is very effective, as is the jaunty
angle of the artist's cane. His highly stylized,
almost cartoonish features express a new
quiet composure, and his handsome red beard
makes him look more than ever like a Zouave.
The artist, an elegant young man, is off for a
stroll in the sunny streets of Paris. This can-
vas could be called "Bonjour, Monsieur Vuil-
lard!" for we sense that his self-confidence
has grown by leaps and bounds.

This is actually confirmed by a letter from
Maurice Denis to Paul Sérusier written in 1891:
"Vuillard (whose serenity and lightearted-
ness were such a happy surprise to him after
three years of anxiety and doubt) produces
with ease the loveliest pictures you can imag-
ine, with always an exquisite formal original-
ity."[2] Patricia Ciaffa has pointed most percep-
tively to the artist's fundamental intention in
this fine painting: "Vuillard's emergence from
an open door may represent his willingness
to venture forth and explore new artistic or
personal horizons, or perhaps it expresses his
sense that he was on the verge of an artistic
or personal transformation."[3] GC

———

1. Letter from Paul Ranson to Jan Verkade May 1891, quoted
by Mauner 1978, p. 275.

2. Quoted by Ciaffa 1985, p. 28.

3. Ciaffa 1985, pp. 112–113.

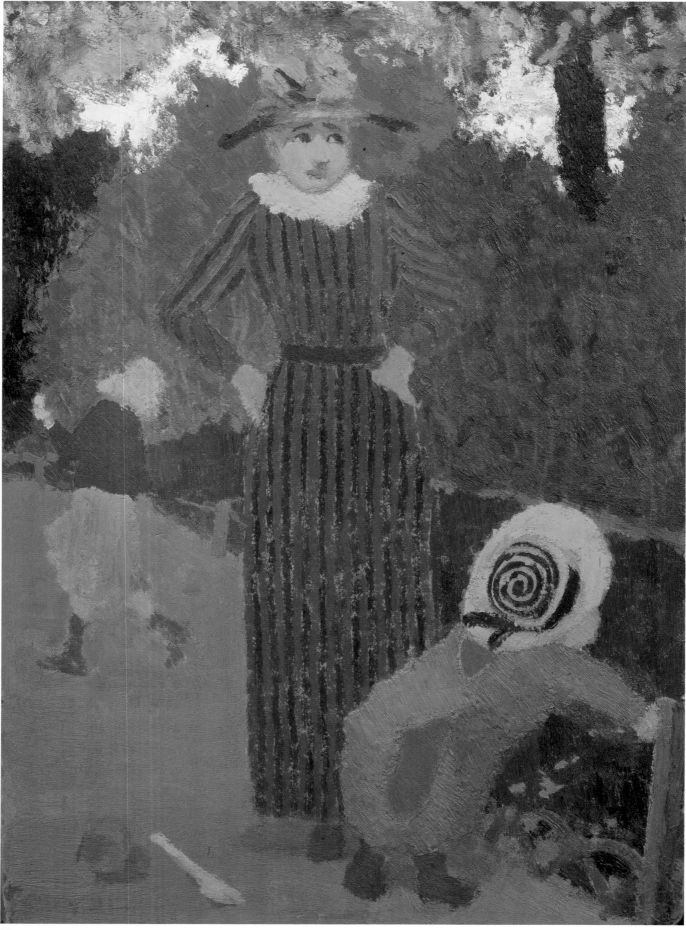

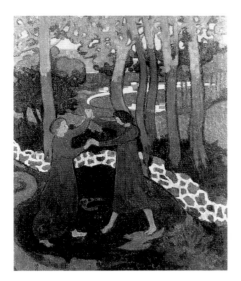

1. Maurice Denis, *Jacob Wrestling with the Angel*, c. 1893, private collection.

## 29

IN THE PUBLIC GARDEN — THE STRAW HAT · *Au jardin public, le chapeau de paille*

1891, oil on board, 32 × 22.5
Signed and dated l.l.: *ev 91*
Private collection

On verso: sketch for a portrait of Dr. Henri Roussel, Kerr-Xavier Roussel's brother, 1891, India ink, pastel and gouache

Cogeval-Salomon V.1

————

*Provenance* Studio — Private collection

## 30

GIRL WITH A HOOP · *Fillette au cerceau*

c. 1891, oil on board, 21.5 × 17.5
Private collection

Cogeval-Salomon v.2

————

*Provenance* Studio — Private collection

*Exhibitions* Paris, Bernheim-Jeune, 1953, no. 63 [*Le Cerceau*]

————

30

These two oil paintings on board, hitherto unpublished, represent the artist's first venture into the world of Paris's public gardens, of which he was to become a brilliant chronicler. He lived within a stone's throw of the Tuileries gardens, and went almost every day to observe its spectacles: pitched battles between gangs of little boys, the mechanical ballet of the nannies, the boats that had to be fetched from the middle of the ponds — this latter scene the subject of a charming and little-known early drawing (*Children around a Pond, Les Tuileries*, c. 1855, pen and brown ink, and graphite on paper, priv. coll.). *The Straw Hat* is deliberately stiff, almost a caricature. The nanny, hands on hips, seems to be losing patience with the naughtiness of the small boy busy ravaging the border at the right-hand side. The vegetation is extremely dense, very different from that in the panels made later for Alexandre Natanson. A child like the one seen catching a ball in the background appears in *A Game of Shuttlecock* (cat. 107), which is one of the Desmarais panels.

*Girl with a Hoop* is much more stylized, almost Olympian in its calm. In the background are trees that could well have grown in the Tuileries. The little girl who gazes at us, leaning on her hoop, is reminiscent of a figure from a Maurice Denis painting: we are reminded of *April* or of *Jacob Wrestling with the Angel* (fig. 1). Vuillard has strengthened his palette of yellows and pinks considerably, almost rivalling the contemporary creations of his friend Denis, the "Nabi of the beautiful icons." GC

YOUNG GIRLS WALKING ·
*Fillettes se promenant*

c. 1891, oil on canvas, 81 × 64.5
Private collection

Cogeval-Salomon v.17

——

*Provenance* Studio—Wildenstein, New York
—Private collection, New York—Sotheby's
Sale, New York, May 17, 1978, lot 47 (col.
ill.)—Josefowitz Collection; on loan to the
National Gallery, London, from 1994 to 1996
—Private collection

*Exhibitions* London, Wildenstein, 1948,
no. 6—Cleveland-New York, 1954, p. 100,
col. ill. p. 17—London, Royal Academy,
1979–1980, no. 233, ill.—Washington, NGA,
1980, no. 145, col. ill.—Zurich-Paris, 1993–
1994, no. 154, col. ill.

*Bibliography* Schweicher 1949, p. 59—
Russell 1971, pl. 5—Cogeval 1993 and 2002,
pp. 26–27, col. ill.

——

Two rather gawky young girls—like those
Madame Vuillard must have employed in her
workshop—are strolling arm in arm along
the path of a small garden. One of them is
wearing a brown smock with dark stripes, the
other a purplish-blue one with regular motifs
not unlike Claude Viallat's "beans." They
wear their hair in single braids, like the little
girl in *The Kiss* (cat. 20). A charming detail:
the striped socks visible above their black
ankle boots. Vuillard delights in capturing the
averted profiles of these shy youngsters and
suggesting their awkward demeanour. In a
number of small paintings he made of his sis-
ter Marie, she too tries to escape her brother's
heavy, insistent, inquisitorial gaze. He also
enjoys combining the radical modernity of the
composition with the touching nature of the
image. The effect of the light gleaming
through the railings is beautiful. We are obvi-
ously not in the Tuileries, here, but a much
smaller Parisian park. The pale yellow area
glimpsed through the railings may be the
façade of an apartment building just beyond
the end of the garden. The fence in a little-
known but exactly contemporary painting,
*Little Girl in Front of Railings* (fig. 1), now in
the museum in Warsaw, presents the same
pattern. The well-behaved little girl in a big
hat playing on the ground is also sketched on
a page of the artist's journal from the spring
of 1891.[1] We believe we can identify Square
Berlioz, with number 10, place Vintimille in
the background, in the Warsaw painting—
and thus by extension in this work. The loca-
tion must therefore be the heavenly oval gar-
den in the 11th arrondissement opposite which
Vuillard was to settle permanently in 1908
and which was to become so important in his
later work. It takes exactly three minutes to
walk from his studio on Rue Pigalle to Place
Vintimille. Whatever the case, here again it
was Vuillard's clear intention to compose
a decisively experimental work that radiates
a deep tenderness. GC

——

1. Vuillard, *Journal*, I.2, fol. 37r.

1. Édouard Vuillard, *Little Girl in Front of Railings*, 1891,
oil on board, Warsaw, Muzeum Narodowe, C-S V.6.

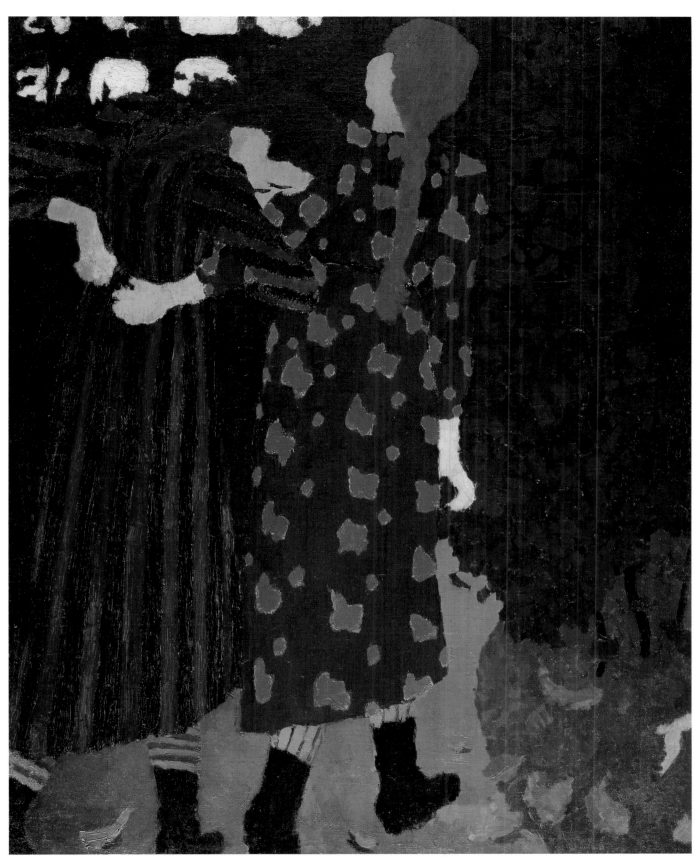

31

GIRL WEARING AN ORANGE SHAWL ·
*La Fillette au châle orange*

c. 1894–1895, oil on board mounted on
cradled panel, 29.2 × 17.5
Signed u.r.: *E Vuillard*
Washington, National Gallery of Art,
Ailsa Mellon Bruce Collection

Cogeval-Salomon v.62

*Provenance* Studio—Edward Molyneux,
Paris, c. 1952—Ailsa Mellon Bruce, New
York, 1955—Bequest to the National Gallery
of Art, Washington, 1970

*Exhibitions* Washington, NGA, 1966, no. 171,
ill.—Washington, NGA, 1978, p. 92, ill. p. 93,
col. ill. p. XVI

*Bibliography* Clay 1971, col. ill. p. 263—
Washington, National Gallery of Art, 1975,
no. 2462, p. 370, ill. p. 371—Daniel 1984,
pp. 119, 121, fig. 39

In the photographs he would later take,
Vuillard rarely risked such radically abrupt
framing as that seen here. The artist offers us
a downward-looking view of a little girl in an
orange shawl walking along the street, delib-
erately choosing to bisect the body of the
man holding her hand. With calculated can-
dour, he shows us the street as the eye first
perceives it, without *mise en scène*, without the
hindsight that reframes everything. This is
one of many Vuillard paintings that reveal
how our vision operates. The little girl's
apparently rather hesitant progress contrasts
with the monolithic mass of the father. The
explosive orange of the shawl introduces a
rare dissonance, like a deliberate overexpo-
sure, in a painting whose tones are predomi-
nantly dark. GC

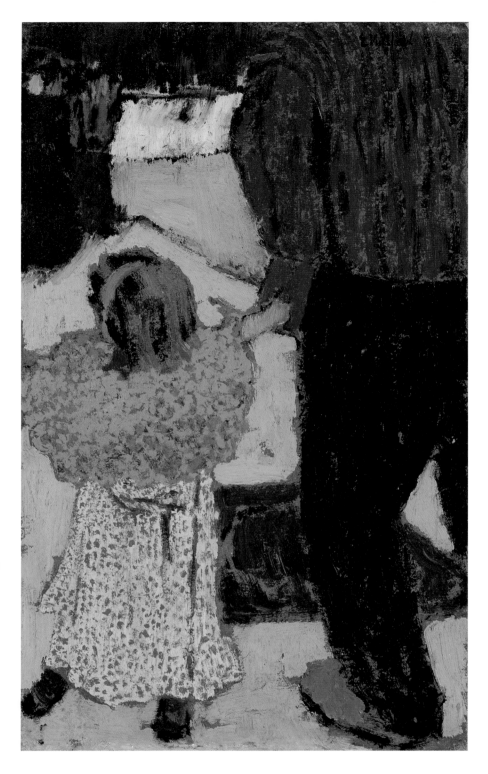

# 33

LANDSCAPE STUDIES · *Étude de paysages*

c. 1890, charcoal on paper, 47.7 × 31.4
Private collection

Strongly reminiscent of the many studies in
perspective—generally night scenes—that
fill Vuillard's journal from 1888 to 1890, the
eight landscapes on this sheet, with their exag-
gerated vanishing traces, seem almost like
exercises in scenography. By the time Vuillard
became a student at the École des Beaux-Arts,
he had likely not travelled much further afield
than his native village of Cuiseaux, in the
Saône-et-Loire region. The marked foreshort-
ening of the landscapes he explores here
can also be seen in several small and relatively
little-known paintings from the 1888–1890
years, whose style shows the already quite
powerful influence of Sérusier and Émile Ber-
nard. In the autobiographical notes he wrote
in 1908, Vuillard actually refers to 1890 as
"the Sérusier year."[1]

In 1889, he did a period of military service in
Lisieux, Normandy. The following year, he
had first-hand experience of the countryside
surrounding Paris when he spent time in
Saint-Maurice, and especially at Créteil, where
he stayed with his Aunt Saurel. Several of
the sketches seen here resulted in paintings:
the narrow window overlooking a tree at
the lower left, for example, which is a pre-
paratory sketch for *Open Window overlooking
the Woods* (1889–1890, Japan, priv. coll.,
c-s 1.70). There is early evidence in all these
works of the artist's penchant for unusual
framing and tightly controlled views. GC

1. Vuillard, *Journal*, II.2, fol. 12r.

## 34

THE FACTORY: THE BIG CHIMNEY
AT NIGHT · *L'Usine : la grande cheminée,
la nuit*

c. 1890 or c. 1895, India ink, pastel and oil
on board, 35 × 34
Inscribed l.r., probably not in the
artist's hand: *97*
Private collection

Cogeval-Salomon v.88

————

*Provenance* Studio—Private collection

————

*The Factory: The Big Chimney at Night* depicts
a relatively rare subject in Vuillard's oeuvre:
a factory at twilight. The painting is inevitably
a sombre one, the palette of violet and brown
in keeping with the nocturnal subject. The
form of the factory itself is heavy and pon-
derous, an effect that is heightened by its posi-
tion in the centre of a square composition and
by the smokestack that rises up and bisects the
picture plane, issuing forth the cloud of dark
smoke seen snaking across the top edge of the
picture. Vuillard accentuates the smoky atmo-
sphere permeating the work by employing
a mixture of media—oil, pastel, India ink—
while leaving portions of the cardboard support
exposed, giving the factory a slightly surreal
appearance. Near the heart of the work is a sin-
gle note of colour in the form of a blue lamp.

Because of the rather unusual subject, it is
difficult to date this painting with absolute cer-
tainty. Cogeval, however, has proposed two
possible datings.[1] The first, circa 1890, is based
on the appearance of the same subject on a
sheet of drawings from around that date,
which is possibly the first idea for this work.
A later date of about 1895 is also plausible,
given that Vuillard painted a number of
nocturnal scenes between 1895 and 1897 (e.g.
*Night*, C-S v.85; *Evening Effect*, C-S v.87;
*Place du Palais-Royal*, C-S v.89).

Vuillard would return to this subject over
twenty years later in a pair of paintings
depicting the interior of munitions factories
in Oullins (*War Factory [Evening]* and *War
Factory [Daytime]*, 1917, Troyes, Musée
d'Art Moderne, on deposit from the Musées
nationaux, C-S X.32-1 and 2), which he
executed during the First World War. K J

————

1. Cogeval-Salomon 2003, no. v.88.

VUILLARD ONSTAGE | *Catalogue* **35–75**

DURING THE TWENTIETH CENTURY it became quite customary for painters to take part in the staging of plays, ballet and opera. After the successful collaboration of Picasso, Cocteau and Satie on the ballet *Parade*—one of the "great leaps forward" in the theatre arts—came Chagall's glorious achievements in the Jewish theatre and the example of Kandinsky, who in 1928 produced the Mussorgsky-Ravel *Pictures from an Exhibition*, designing the costumes and scenery in the purest Bauhaus-style abstraction. There is no doubt, however, that it was the Nabis who had introduced this brand new thread into the tapestry of artistic creation. Their collaboration with Paul Fort's Théâtre d'Art and then with Lugné-Poe's Théâtre de l'Oeuvre (a company of which Vuillard was the co-founder) marked the beginning of a new era that led inexorably to the experiments of the Ballets Russes and of Italian Futurism. Until the end of the nineteenth century, painters and theatre decorators had operated in separate worlds, following paths that did not cross. Vuillard's art took shape at a time when French theatre was being swept by a wind of change, and this reform in the world of the stage was exactly contemporary with new trends in the visual arts: Synthetism and Symbolism flourished in both realms.

What were the main features of these transformations?

• First of all, there was much greater openness to the notions of reverie and suggestion. The "sophisticated" had grown exasperated with the vulgarity of the illusionist techniques employed on the stage in the 1880s and 1890s, which either depended on an excessive use of machinery and clever "tricks" (frequently the case in the opera) or attempted to mimic reality with slavish exactitude. Naturalism: that was the enemy! Zola, with his theory of the "fourth wall," and Antoine, director of the Théâtre-Libre, rapidly came to epitomize the values to be rejected. "Madame" Rachilde—whose terrifying *Araignée de Cristal* (*The Crystal Spider*) was produced by Lugné and Vuillard in February 1894—fulminated against the "pretty, wanton females" who came to the Théâtre-Libre to applaud the "public birthings and abortions"[1] of which the audience in the pit was so fond. The new injunction was to re-endow the "word"—the dramatic poem—with all its power of suggestion. The scenery was not to be accurate or explicit, or even too much in evidence; the artists who painted it were to offer audiences an "excuse to dream."

Among the young writers who provided texts for the idealist theatre, Pierre Quillard played a pivotal role. His *Fille aux mains coupées*, a "mystery" in the medieval sense, was produced by Paul Fort's Théâtre d'Art in March 1891. Sérusier painted a backdrop of praying angels against a gold ground, and the actors performed behind a gauze veil. A short while later, in a letter published in the *Revue d'Art dramatique* under the headline "On the utter uselessness of explicit staging," Quillard expressed ideas that were to have as great an impact as the "Définition du néo-traditionnisme," written by his contemporary Maurice Denis. "The word creates the scenery as it does the rest," wrote Quillard. "The set should be an entirely fictional decoration that completes the illusion through analogies with the drama of colour and line."[2]

• Then, there had to be correspondence among a broad range of sensations. In this striving for a "coalescence" of the arts we see the persistent influence of the myth of "the total work of art," the Wagnerian *Gesamtkunstwerk*. Vuillard collaborated, to some degree at least, on one of the most interesting, and sometimes comical, experiments in *synesthesia* between the arts—Roinart's adaptation of *Le Cantique des cantiques* (*Song of Songs*) presented by the Théâtre d'Art in November 1891. The project was seen by the idealists as a fitting tribute to Baudelaire's "Correspondences." Vuillard took from it one of the finest paintings in this exhibition, *Women in the Garden* (cat. 58), which is based on one of the eight "devices" of this solemn play. During the performances coloured lights were projected and perfumes were sprayed, causing some of the audience to cough. Despite their lack of polish, however, these bold experiments reinforced the predilection of the Nabis and other artists on the fringes of their group (Toulouse-Lautrec, Ibels) for communal work, for ventures in which friendship spurred inspiration. Years later, Maurice Denis would recall this pioneering epoch: "[Sérusier] seized on the opportunity with Lugné and the Théâtre d'Art to satisfy an adolescent passion for stage direction. Interminable discussions around café tables: wonderful plans for revolutionizing the theatre; sackcloth drop scenes painted on the floor; the delight of inexpensively improvised performances; unexpected happenings at dress rehearsals; and the amusing surprise of the reaction of a public who were submissive, scandalized, never indifferent."[3]

• Another change was the development of a more hieratic directing style; movements were slow, individuals became symbols. The leading actors of this new approach—Lugné-Poe, Berthe Bady, Marguerite Moreno—were expert at drawing out their performances and fomenting unease and distress among the audience. Maeterlinck's plays, with their psychologically alienated characters, seemed tailor-made for these performers. During the 1890s, with the development of the theory of the *body-as-symbol,* the actors were often barely visible behind a gauze curtain. In June 1894 Vuillard mounted Henri de Régnier's *La Gardienne* (the same evening as Strindberg's *Créanciers* [*The Creditors*] ): the stage was isolated from the auditorium by a screen of green gauze, and a woman narrator on the proscenium provided a commentary on the actors' movements in a monotonous voice. For the critic Jules Lemaître, despite his relative sympathy for idealist theatre, this was all going too far: "The backcloth showed a dream landscape, blue trees, purple ground, a mauve palace, a Puvis de Chavannes fresco imitated by the unsteady hand of a colour-blind baby—painting in its infancy."[4] As for the Symbolists, they loved it.

• The period was also marked by a new interest in puppets, rhythmic dancing and simplified choreography—this was the era that saw the triumph of Loie Fuller, described by Camille Mauclair as the "sacerdotal priestess of fire"—and even in the man-machine that Alfred Jarry hinted at in *Ubu Roi* and then made central to the *Surmâle*. Maeterlinck would even declare that "[onstage] the absence of man seems to me indispensable."[5]

1. Madame Rachilde, quoted in Bablet 1975, p. 148.

2. Pierre Quillard, "De l'inutilité absolue de la mise en scène exacte," *Revue d'Art dramatique* (May 1, 1891).

3. Maurice Denis, in Sérusier 1942, p. 67.

4. Jules Lemaître, *Journal des débats* (June 24, 1894).

5. Maurice Maeterlinck, in *La Jeune Belgique* (1890), quoted in Robichez 1957, p. 83.

6. Lugné-Poe 1930, p. 193.

And certainly the fragile heroes of his plays seem almost like puppets. The Nabis had a real passion for puppet shows, and two of their matinees became the stuff of legend: a miniature theatre production of Maeterlinck's *Seven Princesses*, to which everyone contributed (including Marie, Vuillard's sister, who sewed the tiny costumes), and the presentation of the medieval *Farce du pâté et de la tarte*, from which two of Vuillard's backcloths remain.

Few painters would become as involved as Vuillard in the creation of theatrical scenery. "The one who from the outset showed the most interest in the theatre and proved the best general adviser was Édouard Vuillard," recalled Lugné-Poe.[6] Between 1891 and 1896, Vuillard's work as a scenographer constituted a sort of "other life." It also enabled him to perfect the technique of painting with distemper, the traditional medium of stage painters, which eventually became his trademark. With Lugné, his friend and ally, Vuillard progressed toward a more "professional," less experimental approach to stage decoration. The 1893–1895 period, during which he created sets for Ibsen's great plays *Rosmersholm*, *An Enemy of the People* and *The Master Builder*, consolidated a reputation that was only further enhanced by the lithographed programs that immortalized those magical evenings. Most importantly, perhaps, this "idealist" repertoire had a profound impact on the singular atmosphere of his "easel" painting. **Guy Cogeval**

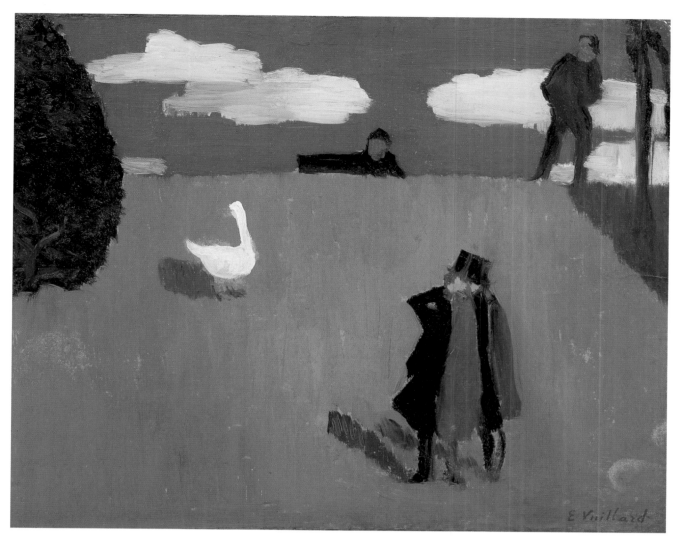

## 35

THE GOOSE · *L'Oie*

c. 1890–1891, oil on board, 22 × 27
Private collection

Cogeval-Salomon III.46

*Provenance*  Studio—Private collection

*Exhibitions*  Milan, Palazzo Reale, 1959, no. 6,
ill.—Albi, Musée Toulouse-Lautrec, 1960,
no. 5—Munich, Haus der Kunst, 1968, no. 16,
ill.—Paris, Orangerie, 1968, no. 13—
Toronto-San Francisco-Chicago, 1971–1972,
no. 4, ill.—Florence, Palazzo Corsini, 1998,
no. 7, col. ill. p. 46—Montreal, MMFA, 1998,
no. 161, col. ill. p. 26

*Bibliography*  Barilli 1967a, p. 104, col. ill.—
Cogeval 1993 and 2002, p. 38, col. ill.—
Cogeval 1998b, no. 161, p. 116

This tiny painting has attracted considerable
attention of late. It reflects the full palette of
Vuillard's seductive artistry: a superb range of
colours, sharply defined planes and a mysteri-
ous iconography, all swept by devastating

humour. Isolated in a field tilted nearly to the
vertical, a rebellious goose taunts two beaters,
profiled against the blue sky, and two violet-
caped, top-hatted hunters, who stand help-
lessly by. This is Vuillard's nod to the spirit of
the Arts Incohérents movement, then at its
peak: he does not hesitate to mobilize four
men to catch one miserable goose.

The planes of this small work are stacked up
like those of a Gothic illumination. One has
the feeling that each mass—the human
beings, the sky, the field, the copse, the goose
—is anchored to the ground like a stage set
and artificially lit by harsh, low-angled light.
Nothing could be less naturalistic than this
hilarious little scene.

It now seems certain that this work, whose
meaning we may never fully grasp, was con-
sciously inspired by the techniques that the
artist developed for the theatre around the
same time. Lugné-Poe's recollections provide
valuable insight into how, between 1890 and
1894, Vuillard literally revolutionized the art
of set design. He makes particular mention
of the staging of Ibsen's *Master Builder*, pre-
sented in April 1894 at the Bouffes du Nord
with sets by Vuillard: "In Act III, the passage
known as 'Mrs. Solness's doll scene' drew
protests. Vuillard, who was as fond of the play

as Maeterlinck, had created an incomparably
brilliant set for this act…Upon seeing it, how-
ever, the spectators reacted like ducks at the
sight of a knife…It was the first time that
anyone in France had dared to erect a raked
stage tilted toward the audience—in this case
to represent the terrace in front of the Solness
home. Autumn foliage hung down over the
actors onstage, but even the movements of
those at the rear could be clearly discerned.
Not a single face was hidden. The actors must
have been uncomfortable, but what did that
matter! They all fussed but to no avail, I held
my ground…In fact, this was the forerunner
of the stage used for the recent revival of
Meyerhold's *Revizor* in Paris."[1]

One would be hard put to prove that *The
Goose* represents a specific scene from the
theatrical repertory of the day. But Vuillard
was a devotee of Rodolphe Salis's Chat Noir
cabaret, and among the shadow theatre plays
(so popular with members of Paris's avant-
garde) presented there was *Les Oies de Javotte*,
a "peasant-piece" by Henri Pille, perform-
ances of which began on January 9, 1891. GC

1. Lugné-Poe 1931, p. 74.

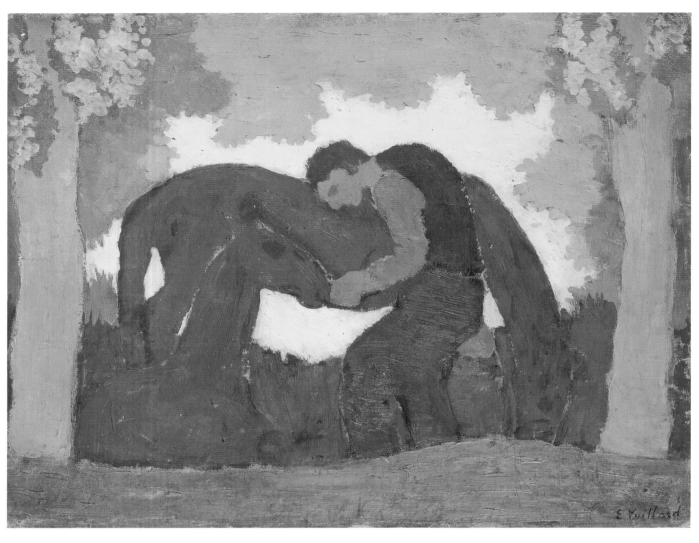

## 36

MAN WITH TWO HORSES · *L'Homme et les deux chevaux*

c. 1890, oil on board, 27.5 × 35
private collection

Cogeval-Salomon III.47

———

*Provenance* Studio—E. J. Van Wisselingh, Amsterdam—Private collection, 1985

*Exhibitions* Paris, MNAM, 1955, no. 185, ill.— Saint-Tropez-Lausanne, 2000–2001, no. 7, col. ill. p. 83

*Bibliography* Thomson 1988, p. 28, col. pl. 1 —Cogeval 1993 and 2002, pp. 38–39, col. ill.

———

This lovely bucolic painting is a harmonious blend of humour, nostalgia for toys and a sort of dreamy awkwardness. The trees that frame the scene are very like those that adorn the ceiling of the church of Saint-Savin-sur-Gartempe. The monochrome background, which lights the entire composition, is framed by festooned foliage in shades of green and

blue, a spatial device that clearly derives from theatrical set techniques, in which light-coloured backdrops are bordered by darker-toned flats anchored to the floor. It appears in several works by Maurice Denis dating from 1890, including *Patches of Sunlight on the Terrace* and *Offering at a Wayside Cross*.

Here, the subjects appear in profile, almost like cardboard cutouts articulated by strings. We know that Claude Debussy, Camille Claudel and Rodolphe Salis were delighted by the Javanese and Siamese shadow puppets they saw at the Paris World's Fair of 1889. These perfectly flat puppets were lit from behind and made to move against a monochrome background as in some of the experiments in shadow theatre being conducted in Paris at the time. Vuillard probably saw them as well. These hypothetical influences aside, the artist was no doubt inspired by Lemercier de Neuville's Théâtre de Pupazzi, rooted in the Sicilian tradition. At the time, the need to revive puppet theatre was felt strongly by the most sophisticated—it was a question of "synthesis"—and one of its most outspoken advocates was Maeterlinck, who, in 1890, declared in *La Jeune Belgique:* "Perhaps all living beings should be banished from the stage."[1]

1. Attributed to René d'Anjou, *Le Cuer d'amours espris*, Vienna, National Library.

This painting remains a touching scene in which Vuillard expresses his nostalgia for humanity's immemorial relationship with nature, represented here by the two docile horses. As with *The Goose* (cat. 35), the iconographical source can be traced to medieval illumination: a famous illustration (fig. 1) from the courtly romance *Le Cuer d'amours espris* (c. 1460) by René d'Anjou (the king was also said to be the author of the illustrations) portrays two horsemen, one asleep and the other solemnly reading an inscription on the

"Spring of Chance." Nearby are two horses. Although the book is kept in Vienna, Maurice Denis and the Nabis undoubtedly knew the image well from reproductions or the facsimiles by Adolphe Braun. Indeed, one of Vuillard's journal entries for December 1888 reads "went to the Bibliothèque, drawings from Vienna"[2]—a reference to an exhibition of drawings from the Albertina collection being held at the Bibliothèque Nationale.

The sense of Romantic melancholy emanating from the scene, the low-angled shadows on the meadow and the powerfully silhouetted greens and blues find subtle echoes in Vuillard's painting. Improbably but successfully, he has "synthesized" puppet theatre and medieval art, humility and his ongoing concern for "fine work." In March 1891 he confided to his journal: "Consider the words that help us: work, working. In bygone days a man's life was spent working, and the result was a work. What is this distinction; working is the part, the work is the whole. The work has but one method, all the actions taken together."[3] G C

---

1. Maurice Maeterlinck, *La Jeune Belgique* (1890), p. 331.

2. Vuillard, *Journal*, I.1, fol. 29.

3. Ibid., I.2, fol. 26.

# 37

LUGNÉ-POE · *Lugné-Poe*

1891, oil on board mounted on board, 22.2 × 26.7
Signed and dated l.l.: *ev 91*
Memorial Art Gallery of the University of Rochester, N.Y., Gift of Fletcher Steele

Cogeval-Salomon III.25

*Provenance* Aurélien Lugné-Poe, Paris— Steele Gift to the Memorial Art Gallery of the University of Rochester, N.Y., 1972

*Exhibitions* Paris, Le Barc de Bouteville, July–Sept. 1893—New York, Wildenstein, 1964, no. 3, ill.—Toronto, 1971–1972, no. 6, ill.—London, Royal Academy, 1979–1980, no. 234, ill.—Washington, N G A, 1980, no. 148, ill.—New Brunswick, N.J., The Jane Voorhees Zimmerli Art Museum, 1985–1986, no. 173—Lyon-Barcelona-Nantes, 1990–1991, no. 33, col. ill. p. 109—Zurich-Paris, 1993–1994, no. 235, col. ill.

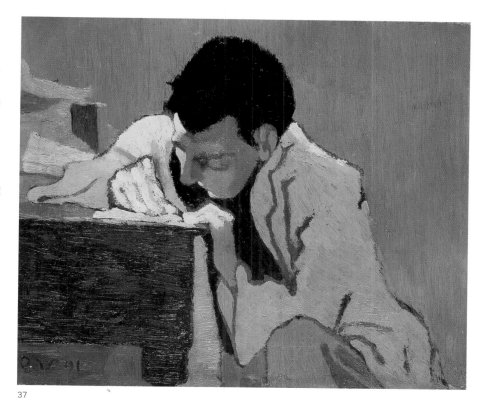

37

*Bibliography* Mauner 1978, pp. 130, 237, 266, fig. 91—Ciaffa 1985, pp. 285–286, fig. 148—Forgione 1992, pp. 96–97, fig. 53—Cogeval 1993 and 2002, col. ill. p. 34

Aurélien Lugné-Poe was one of Vuillard's three or four closest friends, and he stayed loyal to the artist all his life, although the two saw less of each other after 1900. He died, true to his hour, in 1940, a few weeks after Vuillard. Together, they sustained the Théâtre de l'Oeuvre during its "Ibsen years." In the many caricatures he made of Lugné-Poe, Vuillard captured the dark gaze, jet-black hair and outrageous postures of the actor-director, whose numerous roles included Solness, Pastor Rosmer, Golaud in *Pelléas and Mélisande* and Monsieur de Meyrueis in Maurice Beaubourg's *La Vie muette*. Around 1888 he added the surname Poe to his real name of Aurélien Lugné, to suggest a kinship with the American writer, whom he admired above all others. He played a primary role in introducing into France a form of theatre that rejected Zola and realism. Chronically short of funds to stage his productions, tirelessly running from one sponsor to another, forever scribbling his ideas down on the corner of some table— as Vuillard shows him here—he imposed Maeterlinck, Ibsen and Strindberg on Paris society. He was the first person to involve avant-garde painters in the art of scenery, a genuine cultural shift that confirms the notion that the twentieth century began in the 1890s.

Of his actors, he demanded a slow delivery and hypnotic gestures that inevitably prolonged the length of every play to a degree that the critics sometimes found unendurable.

The style of this fine "pseudo-portrait" is that of *In Bed* (cat. 21) and *Woman in Profile Wearing a Green Hat* (cat. 16), a Synthetism of pale colours applied in broad, generous brushstrokes, with surfaces that are clearly divided one from another. The folds of the jacket are defined by lines formed in part by unpainted areas of the cardboard support. The face is lit from the left, and the body's position is rather unbalanced. But the beauty of the lines makes up for this almost caricatural pose. The setting is probably the attic studio on Rue Pigalle that the theatre director had been sharing with Bonnard and Vuillard since 1891. The crampedness of their quarters was a source of endless jokes among the three friends.

This portrait of Lugné-Poe was shown in October 1893 at the Barc de Bouteville Gallery, in an exhibition entitled *Portraits du XXᵉ siècle*. An anonymous writer said of it in *La Plume:* "We see Aurélien Lugné-Poe scribbling in a meticulous manner among his manuscripts, a stern and intelligent clergyman."[1] G C

---

1. Anonymous, "Portraits du Vingtième siècle," *La Plume* (October 1, 1893), p. 415.

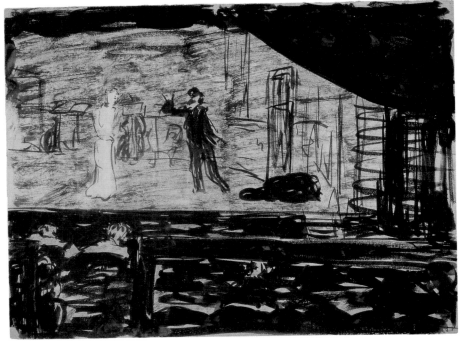

38

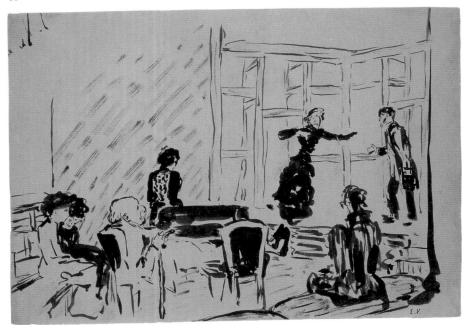

39

## 38

ONSTAGE REHEARSAL · *Répétition sur la scène*

1890–1891, ink wash on paper, traces of graphite, 24 × 31.5
Private collection

———

This ink wash drawing captures the immediacy and conciseness of the artist's vision. The subject is a rehearsal at the theatre, as indicated by the music stands at the back of the stage. Two figures can be made out in the shadows of the orchestra area, and two actors on the stage—a man and a woman. The man's brusque gesture and the woman's restraint as she faces him introduce the exaggeratedly dramatic tone to which Vuillard was so partial (see *Lugné-Poe and Berthe Bady*, cat. 60). GC

## 39

REHEARSAL AT THE CONSERVATORY · *Répétition au Conservatoire*

c. 1890, brush, pen and ink on paper, 19.8 × 27.7
Private collection

———

*Exhibitions* Florence, Palazzo Corsini, 1998, no. 48—Montreal, MMFA, 1998, no. 173

———

Vuillard had an enviable flair for caricature. Here he delightfully details an old gentleman —no doubt a Conservatoire teacher like Gustave Worms, the much-loved master of Lugné-Poe and Marthe Mellot—resting his tired legs on a chair in the auditorium while two young actors perform onstage in front of bare scenery flats. In all likelihood, the young women primly seated off to the side are awaiting their turn on the boards. The fact that everyone is dressed in 1890s attire, coupled with the small size of the stage, confirms the hypothesis that this is the Conservatoire de Musique et de Déclamation. It may have been an afternoon when Vuillard sat in on rehearsals for a competition held at the Conservatoire, which played so important a part in the life of the young Lugné-Poe. In the first volume of his memoirs, entitled *Le Sot du tremplin*, the actor-director recalled these early days with great feeling: "My friends painted while I bored them stiff with talk of the theatre, of the scenes I was rehearsing for the Conservatoire, of lessons I was giving… I should add that of all of them the one who from the outset showed the most interest in the theatre and proved the best general adviser was Édouard Vuillard, who often accompanied me to classes at the Conservatoire."[1] In fact, a watercolour by Vuillard (at the Victoria and Albert Museum) depicts the 1891 declamation competition, where Lugné-Poe interpreted Molière's Harpagon, and Marthe Mellot the title character of Voltaire's *Éryphile*. GC

———

1. Lugné-Poe 1930, pp. 191, 195.

40

**40**

DESIGN FOR A PROGRAM FOR THE
THÉÂTRE-LIBRE: "MONSIEUR BUTE" •
*Projet de programme pour le Théâtre-Libre,
dit "Monsieur Bute"*

1890, pen and ink, and watercolour over
graphite on paper, 20.4 × 18.3
Private collection

———

*Exhibitions* Florence, Palazzo Corsini, 1998,
no. 50—Montreal, MMFA, 1998, no. 167

*Bibliography* Boyer 1998, p. 32

**41**

PROGRAM FOR THE THÉÂTRE-LIBRE •
*Programme pour le Théâtre-Libre*

1890, photo-relief, 21.5 × 39.6
Washington, National Gallery of Art,
Gift of The Atlas Foundation

———

Vuillard designed this program for the Nov-
ember 26, 1890 presentation of three plays at
the Théâtre-Libre: *Monsieur Bute*, *L'Amant de
sa femme* and *La Belle Opération*. A number
of Vuillard scholars have identified the image
as that of Monsieur Bute, a psychopathic
retired executioner who strangled his char-
woman and then wallowed in the blood of the
corpse. This scene would thus portray the
assassin wiping his hands in the garden. How-
ever, we share Patricia Eckert Boyer's reser-
vations about this interpretation, for Maurice
Biollay's play is set indoors, and Vuillard's
subject looks very much like a peasant cutting
vines. Perhaps the artist chose an image—a
peasant at work—that was not directly related
to any of the plays, just as Bonnard would
opt for a labourer rolling up his sleeves as the
logo for the Théâtre de l'Oeuvre. That said,
Vuillard did produce a pen drawing at exactly
the same period—late 1890, early 1891—
that clearly depicts the Monsieur Bute charac-
ter kneeling at the doorstep of his home,
his hands dripping with blood. G C

41

42

## 43

DESIGN FOR A PROGRAM FOR THE
THÉÂTRE-LIBRE · *Projet de programme
pour le Théâtre-Libre*

c. 1891, wash and watercolour on paper,
18.1 × 22.8
Private collection

## 44

RECLINING NUDE · *Nu allongé*

c. 1891, charcoal and watercolour on paper,
11.2 × 34.2
Private collection

Unlike the nudes that Vuillard painted after
1900, which are generally very sensual and
occasionally provocative, those of his "Sym-
bolist" period are synthetist and almost
entirely idealized. It is hard to imagine why
a program cover for the Théâtre-Libre would
feature a nude woman reclining in the grass.
Perhaps all these variations on the female
nude were linked to the "Serpent-Woman"
about whom Maurice Denis spoke in a letter
to Lugné-Poe, away on military duty: "This
week has been devoted to very serious work.
My Reclining Woman (whom you haven't
seen, she's called Nahasch, the Serpent, sym-
bol of universal attraction—still, I'd best
not start explaining things that don't really
interest you). My Reclining Woman is com-
ing along nicely."[1] Oddly enough, the large
version of the serpent-woman is known to us
from a sketch with this title found in Denis's
studio archives. The actual work appears
reflected in the mirror of a much later paint-
ing by Pierre Bonnard, *The Mantelpiece*
(1916). The Maurice Denis painting, so mod-
ern-looking it could easily be confused with
a Matisse, is indeed the *Serpent-Woman* that
Bonnard kept, probably as a souvenir of the
Nabis' early adventures in theatre and Sym-
bolism. All of Vuillard's nudes resemble this
serpent-woman: opulent bodies, presented
prone on the ground, from which they appear
to draw energy. It may be that these creations
were inspired by Symbolist theatre—that
of Remy de Gourmont, for example, author
of the unperformable *Lilith* (1892) and trans-
lator of *Hamartigenia* (The Origin of Sin),
by the fifth-century Christian Latin poet
Prudentius, in which the temptress Eve, in the
guise of a serpent, plays a major role. More-
over, Vuillard's nudes were invariably done
in a horizontal format, which implies a spe-
cific purpose. GC

1. Lugné-Poe 1930, p. 246.

## 42

DESIGN FOR A PROGRAM FOR THE
THÉÂTRE-LIBRE · *Projet de programme
pour le Théâtre-Libre*

c. 1891, watercolour and wash
over graphite on paper, 17.4 × 24.5
Private collection

*Bibliography*  Boyer 1998, p. 34

The inspiration for this lovely design for a
Théâtre-Libre program (which as far as we
know did not result in a lithographed playbill)
is very different from that of the preceding
drawing. Here, a couple in a horse-drawn car-
riage—an elegant lady and a top-hatted gen-
tleman—are being solicited by the street crier
at the far right who is distributing programs,
presumably for the Théâtre-Libre.

Vuillard has created a design to serve as a gen-
eral advertisement for the theatre that con-
tains no mention of a particular play. His sense
of the instantaneity and fluidity of the urban
scene, shared so interestingly with Toulouse-
Lautrec, is in full evidence here. The way the
curved shape of the theatre's name follows
the carriage wheel is delightfully subtle. GC

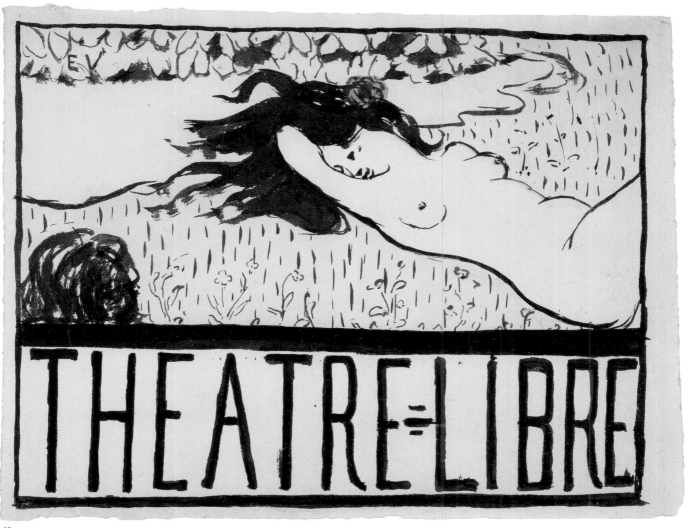

43

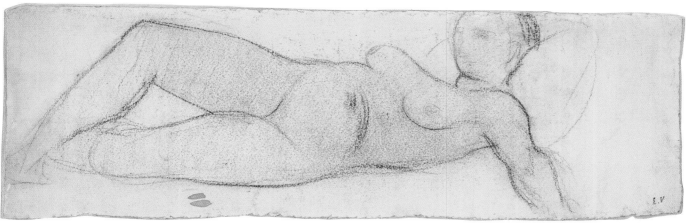

44

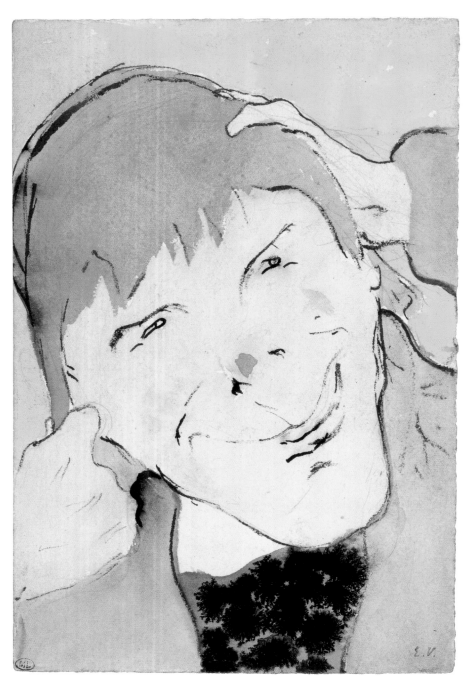

COQUELIN CADET IN "L'AMI FRITZ" ·
*Coquelin-Cadet dans "L'Ami Fritz"*

c. 1890–1891, brush, watercolour, pen
and ink over graphite on paper, 20.3 × 13.3
Paris, Musée d'Orsay (on deposit at the
Département des arts graphiques du Musée
du Louvre)

*Exhibitions* Zurich-Paris, 1993–1994,
no. 236, ill.

The novel *L'Ami Fritz*, published in 1864 by
the popular duo of Erckmann and Chatrian,
had proved a major success. Inspired by
the deeply rooted traditions of Alsace, it was
adapted for the theatre in 1876 and became
part of the repertory of the Comédie-Fran-
çaise. In Italy, Pietro Mascagni turned it into
an opera whose fame all but rivalled that of
his *Cavalleria Rusticana*. The play's success
was no doubt enhanced by the fact that
France had lost Alsace-Lorraine in the Franco-
Prussian War of 1870. The Comédie-Fran-
çaise performed it several times in 1890 with
Coquelin Cadet in the role of Frédéric. He
is portrayed thus by Vuillard in this amusing
watercolour, where the Japanese-inspired
close-up view heightens the cartoonish im-
pact. In all Vuillard's "portraits" of Coquelin
Cadet, he took pleasure in exaggerating the
actor's grotesque expressions and turning
his face into an almost abstract symbol. Two
other watercolours representing Coquelin
Cadet in this role are known to exist. GC

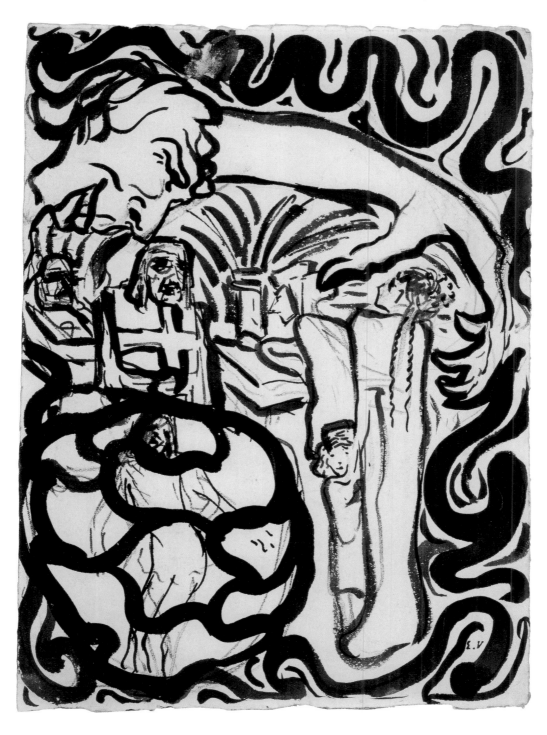

## 46

GRISÉLIDIS · *Grisélidis*

1891, brush, pen and ink, and watercolour
on paper, traces of graphite, 26.5 × 18.5
Private collection

*Bibliography* Boyer 1998, pp. 38—39

This is one of the most delectable of Vuillard's works dealing with the world of the theatre. He has combined his innate fondness for farce with a feel for elegant, Middle Ages-style arabesques in a piece that is clearly a witty attempt to imitate a medieval illumination. The protagonist of the scene is, of course, the actor Coquelin Cadet, portraying the devil in *Grisélidis*, by Armand Silvestre and Eugène Morand. This staged poem premiered at the Comédie-Française on May 15, 1891, with Mademoiselle Barthet in the title role. The Nabi painter has given his actor friend a particularly satanic look in a composition combining Gothic-Revival leanings with Dickensian overtones. The effect is superb, with the devil's claws arching over the figures, threatening patient Griselda and her child. Vuillard loved playing with differences of scale, and has here made Coquelin both monstrous and menacing. The tracery at the lower left, which brings to mind the rose windows of a cathedral, adds a decorative, abstract note. G C

47

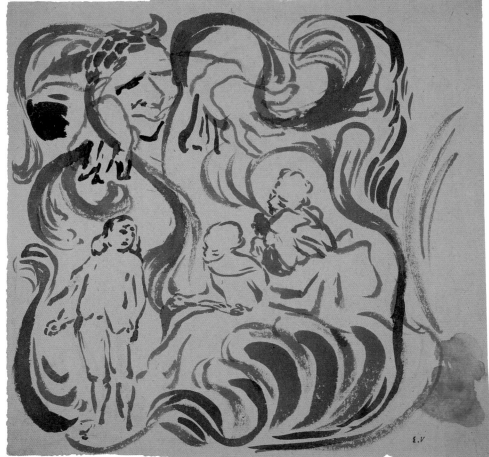

48

## 47

COQUELIN CADET IN THE ROLE
OF LÉRIDON · *Coquelin-Cadet dans le rôle
de Léridon*

1890, wash and watercolour over graphite
on paper, 26.5 × 12.1
Private collection

———

Coquelin Cadet played the role of an elderly
seducer in Henri Meilhac's play *Margot*, pre-
sented at the Comédie-Française in January
1890. GC

## 48

DESIGN FOR A FRONTISPIECE FOR
"THE MARRIAGE OF FIGARO" · *Projet
de frontispice pour "Le Mariage de Figaro"*

1892, wash on brown paper, 24.9 × 25
Private collection

———

There exists a more polished version of this
frontispiece design for the Beaumarchais play.
Vuillard's handling of Coquelin Cadet's pres-
ence here is similar to that employed to por-
tray him as the devil in *Grisélidis* (cat. 46).
The actor, playing Figaro, is hidden in the
curves of the scenery and represented on a
larger scale than the other three characters—
the Countess, Susanna and Cherubino—an
evident allusion to their conversation in the
Countess's room at the opening of Act II.
Coquelin Cadet appears to be manipulating
the action, his fingers once again extended like
those of a puppet-master, his sly gaze taking
in the scene. This production of *The Marriage
of Figaro* premiered at the Comédie-Française
on January 28, 1892. GC

## 49

AT THE DIVAN JAPONAIS ·
*Au Divan Japonais*

c. 1890–1891, oil on panel, 27 × 27
Private collection

———

Cogeval-Salomon III.5

*Provenance* Studio—Girard, Paris, 1950—
Wildenstein, New York—Carroll Carstairs,
New York—Diane Esmond, New York and
Paris, 1955—Sale, Christie's, London, Nov.
30, 1981, lot 18 (col. ill.)—Thomas Gibson
Fine Art, London—Private collection

*Exhibitions* Paris, Parvillée, 1943, no. 74 [*Au
Divan Japonais*]—Paris, Charpentier, 1948,
(hors cat.)—Paris, Charpentier, 1948–1949,
no. 230—Basel, Kunsthalle, 1949, no. 2
[*Le Divan japonais, Yvette Guilbert chantant*]
—Cleveland-New York, 1954, p. 101 [*"Au
Divan Japonais." Profile of Yvette Guilbert*]—
New York, MoMA, 1955, p. 21—London,
Gibson, 1987, p. 18, col. ill.—Lyon-Barce-
lona-Nantes, 1990–1991, no. 25, col. ill. p. 57
—Zurich-Paris 1993–1994, no. 234, col. ill.—
Florence, Palazzo Corsini, 1998, no. 5, col.
ill. p. 44—Montreal, MMFA, 1998, no. 159,
col. ill. p. 25—Saint-Tropez-Lausanne,
2000–2001, no. 8, col. ill. p. 84

*Bibliography* Salomon 1945, ill. p. 134—
Chastel 1946, p. 44, ill. p. 12—Ciaffa 1985,
pp. 299–303, fig. 161—Thomson 1988, p. 28,
col. pl. 16—Dumas 1990, p. 58—Thomson
1991b, p. 204, fig. a—Cogeval 1993 and 2002,
p. 47, col. ill. p. 9

This is unmistakably the face of Yvette Guil-
bert, easily recognizable by her nutcracker
chin and sharp nose, raised imperiously above
the audience in the pit (fig. 1). Among Vuil-
lard's sketches, a sanguine drawing shows the
almost cinematographic stages in the process
that led to the final idea—transforming the
singer into a symbol—starting from an
overhead frontal view of her distinctive face.
Yvette Guilbert was one of the most cele-
brated performers of her day, both witty and
cultivated. As Huisman and Dortu explain,
she was someone "whose success with the
public, and indeed among young writers,

could be compared with that of Greta Garbo
in the 1930s."[1] Wherever she played, it was to
packed houses. Few artists of the 1890s were
so successful in reconciling popular taste and
the sophistications of modernity. Toulouse-
Lautrec discovered her in 1890, but according
to Huisman and Dortu waited four years
before daring to speak to her. Judging by the
number of pastels and sketches Vuillard made
of the famous singer in the 1890–1892 period,
he was not so shy.

He considered portraying her with her red
cheeks fully illuminated, but in the end she
is seen in silhouette—like Grandmother
Michaud in the well-known portrait of the
same period (cat. 3). The face is therefore
quite dark. She is singing, holding a fan in her
left hand. Her black gown is identical to the
very tight-waisted one worn by Jane Avril
in Toulouse Lautrec's famous poster for the
Divan Japonais. Her feathered hat is anchored
by black ribbons running behind her ears.
Beyond her face, in the background, we see
a vague arrangement of multicoloured
"pointillist" scenery.

Guilbert's expression—almost that of some-
one screaming, rather than singing—was
probably accompanied by Japanese-style ges-
tures that no doubt moved the audience to a
mixture of avant-garde shivers and howls of
laughter. Vuillard attended Yvette Guilbert's
performances devotedly; he had only to cross
Rue Saint-Honoré to see her at the Au Nou-
veau Cirque theatre, where she was playing
in *À fond de train*, presented by Gabriel
Astruc—the future director of the Théâtre
des Champs-Élysées—in which she appeared
in a pink dress and mounted on a grey don-
key. Vuillard immortalized this burlesque
scene in a little-known sketch that constitutes
an openly caricatural tribute to the singer
(*Tearing Along*, c. 1891, loc. unkn., C-S. III.18).
The artist, an inveterate nighthawk, was adept
at transforming the popular shows of the era
into disturbing, timeless images. GC

———

1. Philippe Huisman and M. G. Dortu, *Lautrec by Lautrec*
(New York: The Viking Press, 1964), p. 109.

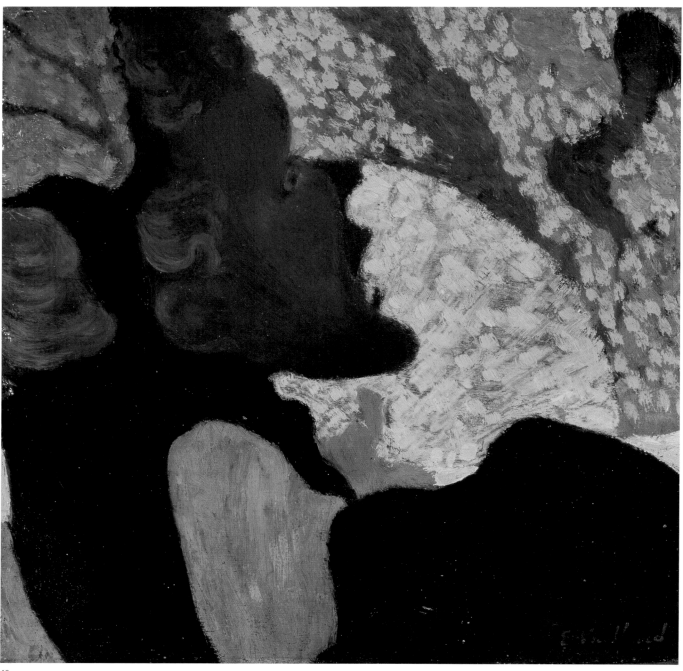

49

1. Photograph of Yvette Guilbert, c. 1890, *Encyclopédie du Théâtre contemporain*, vol. I, Les Publications de France, 1957.

## 50

SCENE FROM "L'ENFANT PRODIGUE":
PIERROT BEGGING HIS FATHER'S
PARDON · *Une scène de "L'Enfant prodigue".
Pierrot demande pardon à son père*

1890, wash and watercolour over graphite
on paper, 16.7 × 28.9
Private collection

———

*Provenance* Studio—Private collection

## 51

"L'ENFANT PRODIGUE": PIERROT
WEEPING · *"L'Enfant prodigue". Pierrot
en pleurs*

1890, pen and ink over graphite on paper,
24.7 × 8.2
Private collection

———

*Provenance* Studio—Private collection

## 52

"L'ENFANT PRODIGUE": PIERROT
AT THE DOOR · *"L'Enfant prodigue".
Pierrot à la porte*

1890, pen and ink over graphite on paper,
13.6 × 10.6
Private collection

———

*Provenance* Studio—Private collection

## 53

DESIGN FOR A FRONTISPIECE
FOR FÉLICIA MALLET IN "L'ENFANT
PRODIGUE" · *Projet de frontispice pour
Félicia Mallet dans "L'Enfant prodigue"*

1890–1891, pen and ink and gouache
over graphite on paper, 30.5 × 21
Waring Hopkins, Paris

———

*Provenance* Studio—Private collection

*Exhibitions* Florence, Palazzo Corsini, 1998,
no. 51, col. ill. p. 85—Montreal, MMFA, 1998,
no. 160, col. ill. p. 23

*Bibliography* Cogeval 2002, p. 35, col. ill.

The fascinating composition featuring Félicia
Mallet (cat. 53) is related to all the other
Pierrot drawings, of which there remained
many in the painter's archives, that focus on
her peculiar talent for mime. An actress and
singer from Bordeaux, Mallet triumphed in the
Soirées funambulesques and became known
for her starring role in *L'Enfant prodigue*, a
Carré-Wormser pantomime performed by
the Cercle funambulesque at the Théâtre des
Bouffes-Parisiens on June 10, 1890.[1] There
was little plot: Pierrot falls in love with the
beautiful Phrynette, played by Biana Duhamel
("I love you to madness. And I lay my heart
at your feet"), but her extravagant tastes drive
him to thievery. Phrynette leaves him for a
wealthy baron ("A necklace!…Oh, Baron!
It's too beautiful!…/ —You are so beautiful!
And I love you so much!"). Pierrot is cursed
by his parents and arrested while robbing the
bourgeois suitor. Finally, he repents and wins
his father's forgiveness.

The play delighted even the severest critics.
It had a profound effect on Vuillard, who,
by some fin-de-siècle *bovarysme*, must have
identified with the impulsive, bohemian Pier-
rot character—a misunderstood son and a
duped lover. He devoted several watercolours
to the subject, which were erroneously
announced for publication in Paul Hugounet's

album *Pierrot et Pierrots*, in 1891. The exag-
gerated lighting effects and precursively
"Expressionist" gestures of the pantomime
no doubt corresponded perfectly with Vuil-
lard's quest for a truly *synthetic* art. Félicia
Mallet's body was made to stand out sharply
against monochrome grounds. In this close-
up of a woman disguised as a young man—
a detail likely troubling to the former Lycée
Condorcet student—he has boldly depicted
her face as a bloodless mask with a diabolical
smile. This Pierrot is truly moonstruck, an
Expressionist icon that predates Schoenberg's
*Pierrot* by some twenty years and intimates
something of the austere Nabi's feverishly
covert sensuality.

The remarkable *Pierrot Weeping* adopts the
narrow vertical format of the kakemono. Vuil-
lard elongates the body of the young thief,
seen beseeching the heavens for an end to his
well-deserved solitude.

Another drawing shows Pierrot, "thin and
shabby," throwing himself at his father's feet
as he begs his pardon. "'Oh! the miserable
wretch!' cried Father Pierrot, his anger rekin-
dling. 'If I catch him here!…Oh!…I'll beat
him with this cane!…' / Mother Pierrot:
'Have pity, dear friend!…' / —'No! No!…
Let him go!…I don't want to see him!'"

*Pierrot at the Door*, finally, serves in a sense as
the tailpiece of the series, for it depicts the
moment when the character takes his leave of
us, with the assurance that "all's well that
ends well." Vuillard portrays Pierrot from the
back, standing partially outlined in a doorway,
hinting at the poetic potential of the passage
from one space to another that he would ex-
ploit so brilliantly in *Lady of Fashion* (cat. 26)
and *The Half-open Door* (c. 1891, The Minne-
apolis Institute of Arts, C-S II.131). G C

———

1. *L'Enfant prodigue*, pantomime in three sketches by Michel
Carré fils and André Wormser, Paris, Bibliothèque de l'Arse-
nal, cote MRO pantomime.

50

51

52

53

54

## 54

DESIGN FOR A PROGRAM FOR THE
THÉÂTRE-LIBRE: "LE CONCILE
FÉERIQUE" · *Projet de programme pour
le Théâtre Libre. "Le Concile féerique"*

1891, graphite and watercolour on paper,
21.5 × 16.4
Private collection

*Provenance* Studio—Private collection

*Bibliography* Boyer 1998, p. 35, no. 16, ill.

## 55

DESIGN FOR A PROGRAM FOR THE
THÉÂTRE-LIBRE: "LE CONCILE
FÉERIQUE" · *Projet de programme pour le
Théâtre Libre. "Le Concile féerique"*

1891, graphite, charcoal and pastel on paper,
18 × 16.8
Private collection

*Provenance* Studio—Private collection

## 56

SKETCH FOR "LE CONCILE
FÉERIQUE" · *Esquisse pour "Le Concile
féerique"*

1891, charcoal on paper, 18 × 17
Private collection

*Provenance* Studio—Private collection

*Exhibitions* Florence, Palazzo Corsini, 1998,
no. 53, col. ill. p. 86—Montreal, MMFA, 1998,
no. 165, col. ill. p. 22

Jules Laforgue's poem *Le Concile féerique* had
been published in *La Vogue* in July 1886. It
was staged by Paul Fort as an "ode with dia-
logue" at the Théatre moderne on December
11, 1891, the same evening as *Les Aveugles*
by Maeterlinck, Napoléon Roinart's adapta-
tion of *Le Cantique des cantiques* and Remy de
Gourmont's *Théodat*. Adolphe Retté, a de-
fender of Symbolism, had this to say: "There
is no plot; the action takes place more or less
wherever you please, and the verses spoken
alternately by the Gentleman and the Lady
are but a singular, painfully intense expression
of love's eternal conflict. A disenchanted but
benevolent chorus, more intimate than the
protagonists, gives meaning to the poem—a
meaning underlined by the coarse observations
of the mocking Echo."[1] Here again, Vuillard
has chosen not to represent a specific passage
from the poem. His image is nevertheless
evocative of certain lines spoken by the chorus:

Touching harmony!
Lovely motif
Decorative,
Before death!
He, anxious,
Bending
To his broad-hipped companion, with her long,
 caressable hair.

The presentation of the two beings linked
by a network of waves is in fact a discreet ref-
erence to Swedenborg's Theosophy, and we
know from various sources that Ranson was
forever quoting from Édouard Schuré's *Les
Grands Initiés*. But in the sketch (cat. 56) it is
hard not to see a gigantic fingerprint projected
behind the silhouette of the two lovers. GC

1. Adolphe Retté, *Théâtre d'Art*, no. 4 (1891), p. 21.

55

56

## 57

THE INTRUDER · *L'Intruse*

1891, oil on board, 27.5 × 60.5
Signed l.r.: *E. Vuillard*
Waring Hopkins, Paris

Cogeval-Salomon III.32

———

*Provenance* Studio—Galerie Berès, Paris,
c. 1956—Lefevre Gallery, London—Private
collection, London, 1963—Sale, Sotheby's,
London, Oct. 26, 1994, lot 5 (col. ill.)—
Whereabouts unknown—Galerie Hopkins-
Thomas-Custot, Paris—Private collection

*Exhibitions* Saint-Germain-en-Laye, Château
national, 1891—Paris, Berès, 1956, no. 91—
London, Lefevre, 1960, no. 33, ill.

*Bibliography* Ciaffa 1985, p. 143, fig. 47

———

Maurice Maeterlinck's *L'Intruse* was per-
formed by the players of Paul Fort's Théâtre
d'Art at the Vaudeville on May 20 and 21,
1891. The show was a benefit performance for
Verlaine and Gauguin. Vuillard painted the
sets. Maurice Denis proffered a superb litho-
graphed frontispiece (fig. 1)—inexplicably
passed over in favour of a banal effort by
Sérusier. Within a few weeks Maeterlinck had
become one of the stars of intellectual Paris.
His brutally simple situations and the slow
intonation of the texts captivated the younger

generation as much as they infuriated the
elder. Death hypocritically insinuates itself
into a family trembling in darkness. It carries
off the mother in the adjoining room, while an
infant wails in the silent darkness. Paul Fort
brilliantly summarized the plot of this short,
violent play: "Among all the words spoken by
the family gathered one evening around the
lamp there intervenes a being of anguish and
terror, the *one*, uninvited, intangible, invisible,
who is diffused in all the gestures and gives a
supernatural tone to the voices."[1]

Vuillard must have been particularly sensitive
to the overwhelming pessimism of the text.
The baby is a "wax doll"; the grandfather,
despite his blindness, is the one who best *sees*
the fate befalling the family, and he has few
illusions about the survival of the new-born:
"I think he will be deaf and perhaps mute…"
Maeterlinck allows himself the luxury of a
laconic Shakespearian phrase to identify the
period of the drama: "The scene in modern
times." Vuillard has respected the main fea-
tures of the Belgian writer's stage directions:
"A rather dark hall in an old mansion. A door
to the right, a door to the left, and a little hid-
den door in a corner. In the background, win-
dows with stained glass, predominantly green,
and French windows opening onto a terrace.
A Flemish standing clock in a corner. A lit
lamp." We can see the stained-glass windows
in the background, the clock, the assembled
characters trembling in a corner of the stage;
in short, an atmosphere—worthy of Edvard
Munch (fig. 2)—that astounded the critics,

1. Maurice Denis, *Frontispiece for the Program of "L'Intruse,"*
1891, lithograph, published in *La Plume* (September 1, 1891), supp.
Bibliothèque Nationale, Paris.

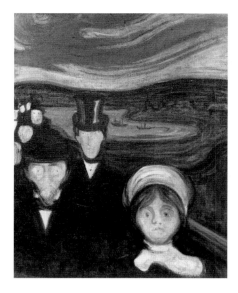

2. Edvard Munch, *Anxiety*, 1894, Oslo, Munchmuseet.

## 58

WOMEN IN THE GARDEN:
"LE CANTIQUE DES CANTIQUES" ·
*Femmes au jardin. "Le Cantique
des cantiques"*

1891, oil on canvas, 74 × 51
Triton Foundation

Cogeval-Salomon III.31

———

*Provenance* Paul Ranson, Paris—Various
private collections—Private collection

*Exhibitions* Mannheim, Kunsthalle, 1963–
1964, no. 173 [Paul Ranson: *Femmes dans un
jardin*]—Florence, Palazzo Corsini, 1998,
no. 29, col. ill. p. 68—Montreal, MMFA, 1998,
no. 172, col. ill. p. 33

*Bibliography* Mauner 1978, pp. 212–213, 246,
fig. 59—Cogeval 1998a, p. 184—Cogeval
1998b, p. 118—Cogeval 2002, p. 32, col. ill.

———

even the hostile ones: "The room is plunged
in darkness and the stage is illuminated only
by a lamp on the table. Three men and three
young women silently approach the table and
sit down. They begin to converse, but in low
tones, so low that from the third row in the pit
where I was sitting, it was impossible to catch
a complete sentence."[2] In fact, Lugné-Poe,
probably on the advice of Vuillard—we think
of the drawings in his 1888 journal in which
he seems obsessed by the effects of street
lights in darkness—had plunged the whole
theatre (the stage and the auditorium) into
blackness. Gradually, the audience realized
that the actors were already on stage, silent,
looking back at them. Thus Lugné-Poe and
Vuillard were anticipating the theatre of the
twentieth century, notably that of Kantor and
Meyerhold. The avant-garde critics (Henri
Bauer in *L'Écho de Paris*, Edmond Stoullig in
*Le National*) were rapturous in their admira-
tion. The last word goes to Jules Lemaître:
"While we listen to the ever more troubling
little phrases of this sad, familiar dialogue,
under the lamp that is slowly dimming, we
too, in truth, feel death pass by."[3] G C

———

1. Paul Fort, *Mes mémoires* (Paris: Flammarion, 1944), p. 33.

2. Anonymous, probably Francisque Sarcey, *Le Temps*
(May 25, 1891).

3. Jules Lemaître, *Les Débats* (May 23, 1891).

This painting is undoubtedly the most impor-
tant recent discovery related to Vuillard's role
as a scene painter and his commitment to the
Symbolist adventure. Mauner rightly reattri-
buted this canvas to Vuillard, whereas it was
previously thought to be by Ranson, having
been in the possession of his heirs for many
years. Some preparatory drawings found
among Vuillard's sketches confirm, if it were
necessary, the intuition of the American expert
on the Nabis. A large pastel sketch places the
bushes and the figures very precisely—only
the cat is missing—and a smaller drawing
captures the woman walking behind the clump
of shrubs in the centre of the canvas, a figure
that could easily have stepped out of a work
by Botticelli or Verrocchio.

When we presented this painting in the exhi-
bition *The Time of the Nabis* in Florence and
Montreal, we felt that it was a work associated
with the theatre, possibly a paraphrase of
Napoléon Roinart's *Cantique des cantiques*, for
which Vuillard created the sets. This hypothe-
sis has since been confirmed.

The evening of December 11, 1891 at the
Théâtre moderne came to be known in the
annals of French theatre as "Symbolism's
Battle of Hernani." Paul Fort had encouraged
Vuillard to become part of this hermetic
experience. King Solomon's "Song of Songs,"
adapted by Roinart, was presented by the
Théâtre d'Art company at the same time as

Maurice Maeterlinck's *Les Aveugles*, Remy
de Gourmont's *Théodat, La Geste du Roy*
by Merrill, Mauclair and Retté, and Jules
Laforgue's *Le Concile féerique*. An onerous
evening! Paul Fort turned to his friends the
Nabi painters for the creation of the sets,
costumes and programs of these plays. *Le
Cantique des cantiques* was presented onstage
in a series of eight "devices," in an atmos-
phere of hieratic medieval mystery—one is
reminded of the later D'Annunzio-Debussy
*Martyre de Saint Sébastien* with its "man-
sions." Each device was composed of a four-
part orchestration involving words, music,
colours and perfumes. The clear influence of
Rimbaud was fused with Wagner's notion of
*Gesamtkunstwerk*, then very much in vogue.
The sixth device, *Solitude*, reveals the distress
of the Queen at being put to the test by the
King: "*Sixth device. Solitude.* In ui lit by the
o; la; pale indigo; lily of the valley. The King,
although strengthened in his love and recog-
nizing the Queen's despair, pretends to be
still angry with her and remains unseen while
watching over her. The Queen, overwhelmed
by her loneliness, laments. Her female com-
panions console her and the men, true to
the King's intention, sing the praises of the
Beloved."[1] Roinart's stage directions are
plain to be seen in Vuillard's painting, and
King Solomon's lines here become a true
poem of ecstasy:

I opened to my beloved,
But my beloved had withdrawn himself,
And was gone:
My soul failed when he spake:
I sought him, but I could not find him;
I called him, but he gave me no answer
. . .
I charge you,
O daughters of Jerusalem,
If ye find my beloved,
That ye tell him
That I am sick with love.

Lighting adapted to each scene was combined
with sprayings of perfume, which only added
to the *succès de scandale* of this avant-garde
experiment. It provided Vuillard with the
excuse for his most extreme foray into the
world of Symbolism.

58

1. Maurice Denis, *The Mystical Grape-Harvest*, 1890–1891, private collection.

This theatrical, idealistic reading of *Women in the Garden* is further confirmed by another consideration. A contemporary painting by Maurice Denis, *The Mystical Grape-Harvest* (fig. 1), shows nuns on a road winding between vineyards, just as in Vuillard's composition; they are gathering Christ's blood.[2] The visual devices of the works are strikingly similar, but, even more significantly, Denis inscribed on his painting lines taken from Solomon's "Song of Songs" (1:14): "BOTRUS CYPRI DILECTUS / MEUS MIHI IN VINEIS / ENGADDI…" ("My beloved is unto me as a cluster of camphire in the vineyards of En-gedi"). In addition to the obvious affinity of spirit, it turns out that the two canvases are exactly the same size (74 × 51 cm), which suggests that they may have been the elements of a decorative diptych on the subject of the *Cantique* kept by Ranson in his studio. In a letter written by Ranson in April 1891 to Denis, the most esoteric of the Nabis confesses his admiration for *The Mystical Grape-Harvest*, which had no doubt just been completed:

Having had to go out to check the shapes of branches on the Champs-Élysées and in the woods, I took the opportunity to drop in on friend Vuillard; alas Vuillard had gone for a chat with his favourite masters at the Louvre, but I gave the fan to Madame Vuillard, and told her what it was for. Didn't you feel like exhibiting the grape harvest in the vineyards of En-gedi? Father Tanguy could stretch the canvas temporarily or mount it provisionally on a wood panel. It really is an outstanding work and despite its small size could well be admired and noticed at the Indépendants.[3]

We might hypothesize that Vuillard, at the request of Ranson, painted a pendant to Denis's painting—already presented to the master of "The Temple"—using as his subject the play presented by Paul Fort. These two works, redolent with Symbolism, were intended to adorn the walls of Ranson's studio on Boulevard du Montparnasse. Less tempted by mysticism than Denis, Vuillard was struck above all by the poem's sensuality. He made his painting a choreography of rapture.

This canvas is certainly remarkable. A boreal shower of gold covers the vegetation. The girls, all in poses of ecstasy as they hide in the enchanted grove, seem like sisters of Maurice Denis's translucent apparitions in *April* and *July*, their exact contemporaries. It is interesting that the Queen and her women are dressed summarily in the style of the period; at most the structured gowns of 1890 seem imbued with a certain medieval, hieratic quality. This rather "timeless" approach could come from the production of Maeterlinck's *L'Intruse* that Vuillard had conceived in May 1891. Some exquisite details could only be his: the cat that turns its back to us and contemplates the Biblical mystery, the woman on the right in the purple robe who exhibits the same rapturous sway of the hips as Bonnard's *Woman with Rabbit*. The atmosphere of *Women in the Garden* is basically comparable to that in *The Croquet Game*, which Bonnard, the "Japanese" Nabi, was to paint in 1892. We also find a melancholy echo of Claude Debussy's *La Demoiselle élue*, written in 1887 and finally performed in 1893: like the Damozel addressing her lover "beyond the golden barrier of the sky," Vuillard's Queen might well sing:

When round his head the aureole clings,
And he is clothed in white,
I'll take his hand and go with him
To the deep wells of light.

This painting suspends us outside of time, in a sort of muted, unreachable sadness. GC

1. Directions for the staging of the *Cantique des cantiques* by Napoléon Roinart, Paris, Bibliothèque de l'Arsenal, Fonds Rondel.

2. I am indebted for this comparison to the wide knowledge of Waring Hopkins.

3. Ranson-Bitker and Genty 1999, p. 395.

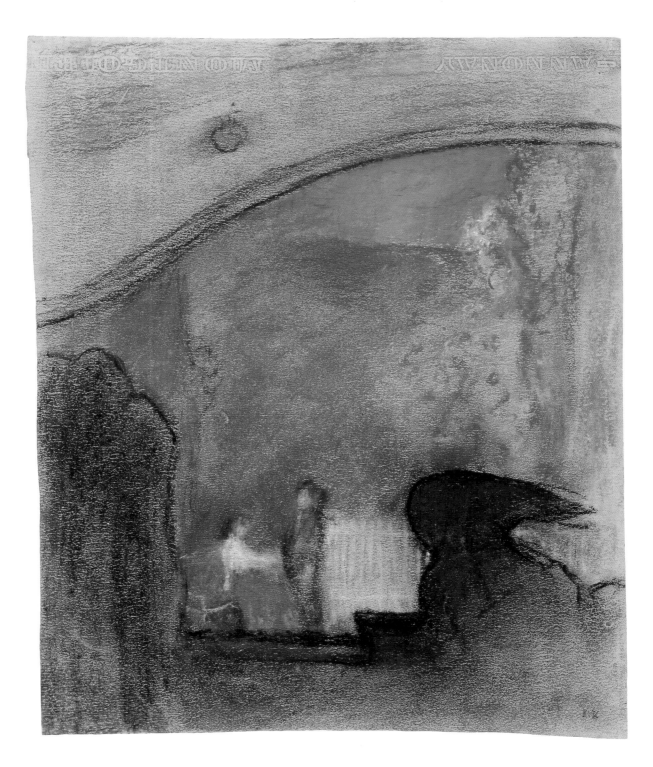

## 59

SCENE FROM A PLAY BY IBSEN •
*Scène du théâtre ibsénien*

1893, pastel on paper, 30 × 25
Private collection

Cogeval-Salomon III.38

———

*Provenance* Studio—Private collection

*Bibliography* Boyer 1998, pp. 101, 103

———

This little-known pastel offers further proof of the interest we know Vuillard took in theatrical set design and especially in the staging of Ibsen. The proscenium arch forming an irregular curve is extremely odd. Behind the actors we glimpse a green curtain hanging from the flies. What immediately evokes Ibsen's plays is the white fence, an inevitable feature of the Scandinavian landscape. Vuillard may have participated to some extent in the staging of *The Lady from the Sea*, performed in December 1892 at the Théâtre moderne with Georgette Camée and Lugné-Poe in the roles of Ellida and Wangel. It was Maurice Denis, however, who designed the handsome frontispiece in a style at once pre-Raphaelite and *japoniste*. This painting

could refer to the last scene (see Boyer), in which Wangel leaves his wife free to follow the Stranger she has loved in the past, whose boat appears at the landing below: "You can choose freely, Ellida, and on your own responsibility." Thus does he induce his wife's immediate return to him.

We are more inclined to link the work to *Rosmersholm*, presented on October 6, 1893 at the Bouffes du Nord. It was Vuillard himself who executed the sets, which Lugné-Poe still remembered with emotion in *Acrobaties*: "Things went as expected. Léopold Lacour staged *Rosmersholm* and *Rosmersholm* was a triumph, thanks largely to the contribution of

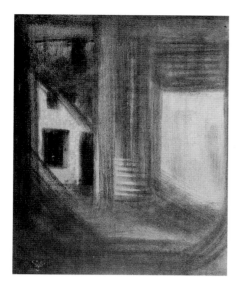

Édouard Vuillard and Herman Bang. Vuillard was marvellous with his economical inventiveness and his flair for creating stage sets and atmosphere. The décor for the second act added distinction and intimacy to our acting. For the first time, Ibsen was being *authentically performed* in Paris. The play was presented with a beautiful lithograph by Vuillard, the first of a series of 'litho-playbills' in which l'Oeuvre took great pride."[1] The winged sphinx in silhouette that stands guard in the foreground—which could have nothing to do with *The Lady from the Sea*—may well stand for the "Horses of Death" that haunt Rosmer and the estate of Rosmersholm from the start of the play. They symbolize the guilt of the pastor, who reproaches himself for the death of his wife, Beata. It is these horses that, at the suicide of Rebecca and Rosmer (played by Berthe Bady and Lugné-Poe) at the end of the play, appear in the sky to carry the two heroic characters beyond death. The style of this *bozzetto* is very different from the program Vuillard lithographed for the Théâtre de l'Oeuvre (cat. 66); it recalls a number of very abstract, stylized décors yet to be created by the English scenographer Edward Gordon Craig, in particular one of those he published in *The Art of the Theatre*, which probably dates from 1907 (fig. 1). It is also very different from the poetic paraphrase of the "Song of Songs" (cat. 58). Here Vuillard indicated to Lugné-Poe the exact placing of the scenery, seen from the auditorium. It was a "stage manager's" project. GC

———

1. Lugné-Poe 1931, pp. 54–55.

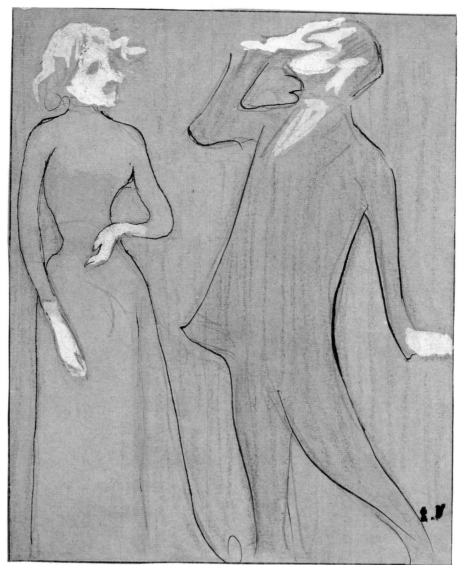

## 60

———

### LUGNÉ-POE AND BERTHE BADY ·
*Lugné-Poe et Berthe Bady*

c. 1893–1894, pen and ink, and watercolour heightened with white gouache, over graphite on paper, 13.4 × 10.4
Private collection

———

No one can rival Vuillard when it comes to capturing high drama in a stunning gesture. Here we recognize the artist's old friend Lugné-Poe, likely confronting actress Berthe Bady, his inevitable partner in nearly all the plays on which Vuillard worked in 1893–1894. This may be a scene from Ibsen's *Rosmersholm*, staged at the Bouffes du Nord by the Théâtre de l'Oeuvre in October 1893. At the beginning of Act III, Pastor Rosmer tells his lover Rebecca of the remorse that haunts his life and makes the future unbearable. But it could also be a scene from Maurice Beaubourg's *La Vie muette*, produced a year later with the same actors in the lead roles. Act III of that play features a horrifying scene in which Monsieur de Meyrueis, who has just tried to kill his own children in the garden, hysterically accuses his wife of life-long betrayal (see cats. 61 and 75).

A third possibility—since scenes of impotent hysteria between Lugné and Bady were standard fare in the Théâtre de l'Oeuvre repertory —is *Beyond our Power* by Bjørnstjerne Bjørnson (Bouffes du Nord, February 13, 1894), for which Toulouse-Lautrec created a lithograph showing the two actors in similar poses. This option may in fact be the most plausible. GC

## 61

SET DESIGN FOR "LA VIE MUETTE"
BY MAURICE BEAUBOURG · *Projet
de décor pour "La Vie muette" de Maurice
Beaubourg*

1894, pen and ink, watercolour and pastel
on paper, 16 × 23.5
Private collection

———

Maurice Beaubourg's long-forgotten play *La
Vie muette* was performed by the Théâtre de
l'Oeuvre troupe at the Nouveau Théâtre on
November 27, 1894. This four-act exercise in
grandiloquence features Georges de Meyrueis,
a jealous, anxiety-ridden, hysterical man con-
vinced that his wife has never been faithful
and that their children are not his. He repeat-
edly attempts to lead the children astray on
the manor grounds, perhaps intending to kill
them. In the final act, his wife steps out of the
shadows and shoots him; realizing the error
of his ways, he dies happy in her arms. Vuil-
lard designed a famous playbill cover for
*La Vie muette* (cat. 75), showing Madame de
Meyrueis protecting her children from her
husband's jealous rage.

This previously unpublished pen and ink
drawing, highlighted with pastel, is a typical
set design, which explains its rather conven-
tional style. Nevertheless, there is an evident
kinship with the more precise, cursive pen
drawings in Vuillard's 1894 and 1895 journals.

The design corresponds almost exactly to the
stage directions for Act I: "In the background,
double glassed doors giving onto a terrace
overlooking the countryside." In fact, at the
back of the room we see a large window
with a view of a wood—critical to the play's
drama—and in the far background, the
greenhouse, where Madame de Meyrueis is
accused of having betrayed her husband.
Vuillard has not introduced the terrace-interior
connection called for in Act I, no doubt be-
cause the Nouveau Théâtre stage was not
large enough to accommodate all of Maurice
Beaubourg's directions. This is not uncom-
mon in the theatre; once production begins,
various scenic elements have to be reduced, or
cut, to make the play technically feasible.
Consequently, the drawing is missing the ter-
race overlooking the manor moat, but it does
include several of the author's stipulations,
such as the windows looking onto the garden
that surrounds the vast drawing room, and the
lounge chair in the foreground, where
Madame de Meyrueis, feeling ill, reclines in
Act I. GC

## 62

THE CONJURING ACT · *Le Numéro
d'illusionniste*

c. 1895, oil on board mounted on cradled
panel, 49 × 39
Signed, l.r.: *E. Vuillard*
Zurich, Foundation E. G. Bührle Collection

Cogeval-Salomon III.50

*Provenance* Sergei Chtchoukine, Moscow—
Bernheim-Jeune, Paris—Édouard Vuillard,
May 3, 1905—Prince Antoine Bibesco,
Paris—Emil Georg Bührle, Zurich, 1955

*Exhibitions* Zurich, Kunsthaus, 1958, no.
266—Munich, Haus der Kunst, 1958–1959,
no. 172—Munich, Haus der Kunst, 1972,
no. 899—E. G. Bührle Collection (trav.
exhib.), 1990–1991, no. 72, col. ill. [*At the
Theatre*]

*Bibliography* Cogeval 1993 and 2002, p. 43,
col. ill.

———

In a previous publication we suggested that
this painting represented not a play as seen
from the theatre, but rather a conjuror's or
magician's act.[1] Research conducted for Vuil-
lard's catalogue raisonné has confirmed this
theory. The setting could be the auditorium
of the Théâtre Robert Oudin or, even more
likely, of the Musée Grévin. The many empty
seats also suggest a matinee performance.
Looking at the stage from the pit was very
much in the spirit of the age; one thinks of
Degas, Toulouse-Lautrec and Beardsley. The
elegant ladies in the audience are wearing
very high Renaissance collars and hats with
feathers, exactly in tune with the fashion of
1895 and its "Queen Margot setting off for the
hunt" look. On the stage we see two figures.
The one in the foreground may be a conjuror
(possibly a woman conjuror dressed as a
man?). On a table near this figure is a top hat,
presumably full of rabbits ready to escape.
At the back, on a rostrum, a woman in a red
tunic encourages the audience to applaud—
as does the magician. The scenery in the back-
ground and the bare-armed woman suggest
either a magic act (she acting as the magician's
foil), the end of a session of hypnosis, or a
conjuring trick (of the woman-sawn-in-half
kind).

Vuillard, keen supporter of the most abstruse
theatrical presentations of the period, scenog-
rapher for plays by Ibsen and Maurice Beau-
bourg, also loved nothing better than to haunt
the city's café-concerts and popular shows,
from which he conceived images of magni-
ficent indecipherability. GC

———

1. Cogeval 2002, p. 43.

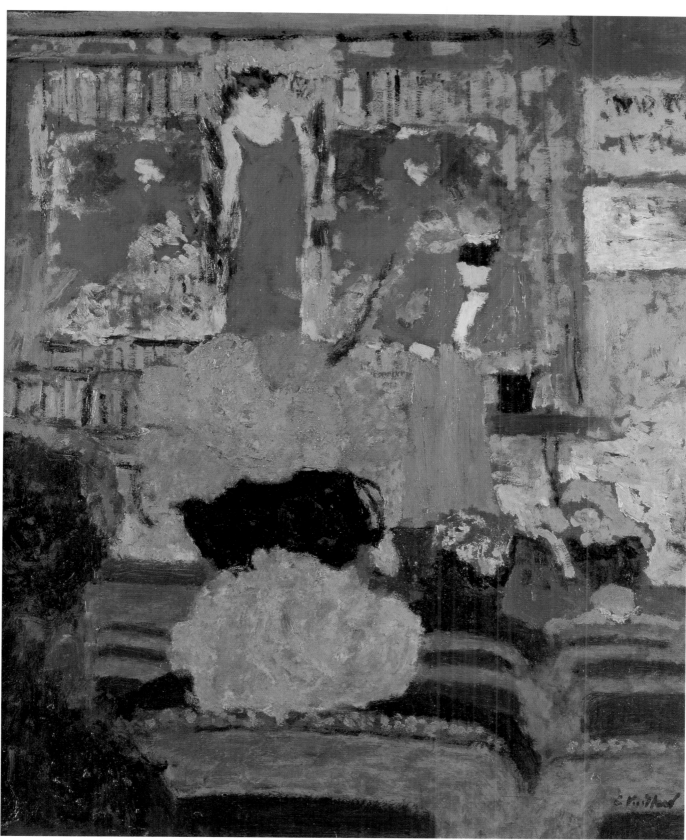

62

## 63

AT THE CAFÉ-CONCERT · *Au café-concert*

c. 1898, watercolour and gouache on paper,
20.3 × 13.9
Paris, Musée d'Orsay (on deposit at the
Département des arts graphiques du Musée
du Louvre)

Cogeval-Salomon v.104

*Provenance* Studio — Claude Roger-Marx,
Paris — Asselain Gift to the Cabinet des
Dessins, Musée du Louvre, Paris, 1978

*Exhibitions* Lyon-Barcelona-Nantes,
1990 – 1991, no. 56, ill. p. 29

*Bibliography* Thomson 1988, pl. 28 —
Cogeval 1993 and 2002, p. 54, col. ill.

## 64

THE GUINGUETTE · *La Guinguette*

c. 1898, oil on board, 33 × 27
Private collection

Cogeval-Salomon v.112

*Provenance* Studio — Galerie Hopkins-
Thomas-Custot, Paris — Private collection

## 65

CAFÉ IN THE BOIS DE BOULOGNE
AT NIGHT — THE GARDEN OF
THE ALCAZAR · *Café au Bois de Boulogne
dans la nuit — Jardins de l'Alcazar*

c. 1898, distemper on paper mounted on
board, 48.5 × 43.5
Signed l.r.: *E. Vuillard*
The Art Institute of Chicago, Gift of Joseph
and Helen Regenstein Foundation

Cogeval-Salomon v.110

*Provenance* Félix Fénéon, Paris — Fénéon
Sale, Hôtel Drouot, Paris, May 30, 1947,
lot 58 (ill.) — Theodore Schempp, Brodhead,
Wis. — Jacques Seligmann, New York —
Roger Darnetal, United States — Thannhauser,
New York — Helen Regenstein, United
States — The Art Institute of Chicago, 1964

*Exhibitions* Paris, Musée des Arts décoratifs
1937, no. 187

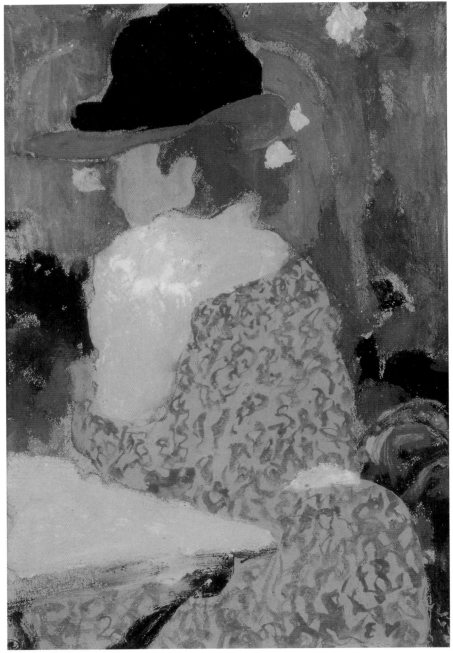

63

Like his friend Bonnard, Vuillard turned his
attention increasingly between 1895 and 1900
to the portrayal of night scenes. During his
Nabi years Vuillard had, of course, produced
a number of images inspired by cabaret shows
and clubs, such as *The Flirt* (cat. 18) and *Miss
Helyett* (c. 1891, priv. coll., c-s iii.1). But in
those days his goal was to capture the absurd-
ity of the scene, and he manipulated daringly
radical viewpoints with the express purpose
of focusing on the energy created by the
dancer performing onstage. After 1895 Vuil-
lard's approach became far more naturalistic,
a more direct mirror of reality. Many of his
evenings were spent in cabarets and the open-
air restaurants or *guinguettes* that abounded in
the area between the Champs-Élysées and the

Bois de Boulogne. Belle Époque society was
deeply committed to enjoying itself into the
small hours, and Vuillard became its observer,
taking advantage of the street lamps and
lanterns to create the very special opaque light
that characterizes these atmospheric nocturnal
views. *At the Café-Concert* is an exquisitely
subtle work. The harmonic relation between
the shimmering mauve of the dress and the
silvery scarf wound around the neck of the
young woman leaning on the marble-topped
table epitomizes the delicacy with which
Vuillard interprets subjects drawn from con-
temporary life. The archways of the café
barely sketched in behind the figure provide
her with an unobtrusive frame.

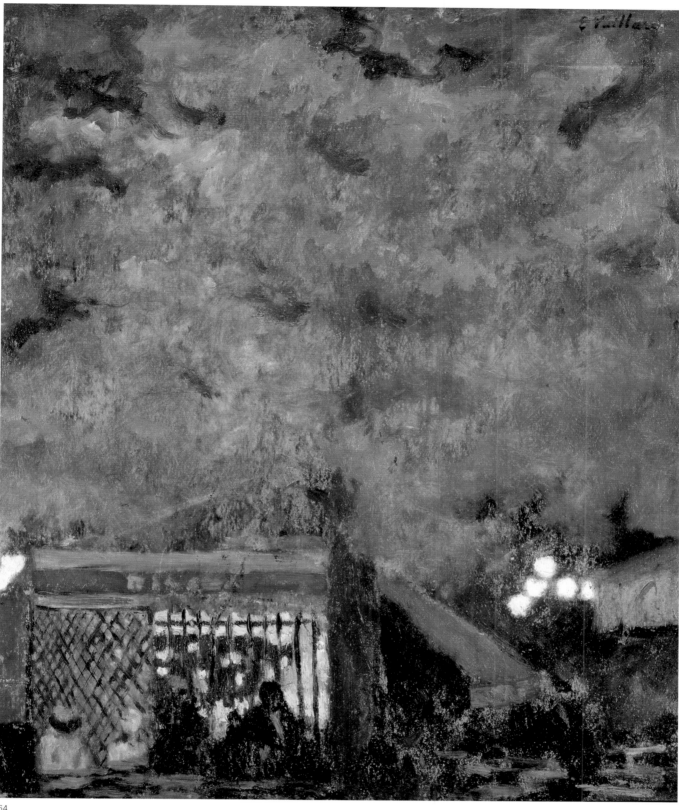

64

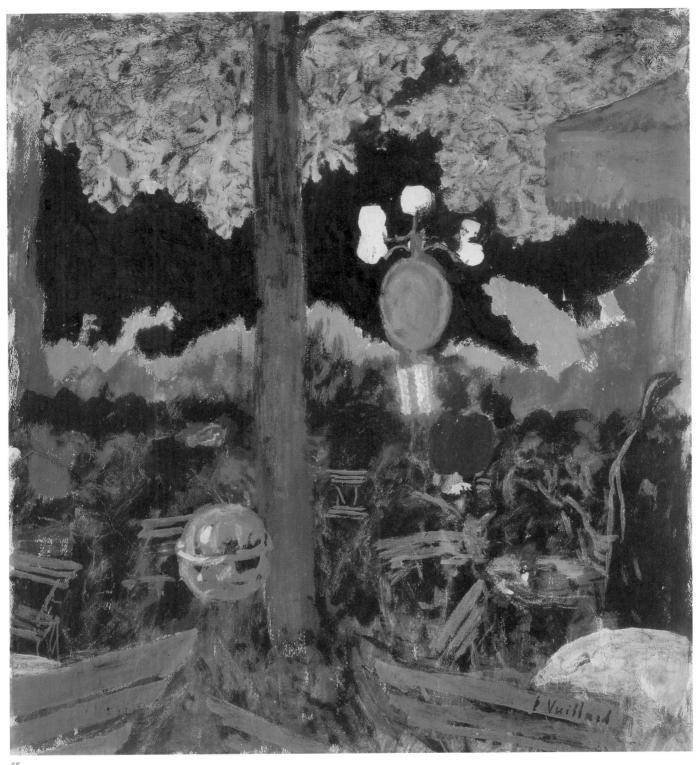

65

There is a clear kinship between *The Guinguette* and *Café in the Bois de Boulogne at Night*—very similar in mood—and other well-known works from the period, such as *The Café in the Bois de Boulogne* (c. 1898, Musée de Besançon, C-S V.111) and *The Blue Vase* (1895–1898, Chicago, priv. coll, C-S v.109), which also offer brilliant snapshots of Parisian nightlife. The chromatic effects in *The Guinguette* are quite remarkable, from the red awning in the foreground, to the bluish darkness enhanced by the lanterns glimpsed behind the restaurant railings and the nocturnal glimmer between the trees that Vuillard has captured in harmonies of intensified ultramarine. GC

## 66

*Rosmersholm*

1893, lithograph in black on light brown paper, 24.4 × 32.6
Washington, National Gallery of Art, Gift of The Atlas Foundation

## 67

*Un ennemi du peuple*

1893, lithograph in black on light brown paper, 24.3 × 32.2
Washington, National Gallery of Art, Gift of The Atlas Foundation

## 68

*Âmes solitaires*

1893, lithograph in black on light brown paper, 32.8 × 48.6
Washington, National Gallery of Art, Gift of The Atlas Foundation

## 69

*Au-dessus des forces humaines; L'Araignée de Cristal*

1894, lithograph in black on light brown paper, 32.9 × 48
Washington, National Gallery of Art, Gift of The Atlas Foundation

66

## 70

*Au-delà des forces humaines*

1897, lithograph in black on paper, 23.9 × 31.9
Washington, National Gallery of Art, Gift of The Atlas Foundation

## 71

*Une nuit d'avril à Céos; L'Image*

1894, lithograph in black on light brown paper, 32.4 × 48.1
Washington, National Gallery of Art, Gift of The Atlas Foundation

## 72

*Solness le Constructeur*

1894, lithograph in black on brown paper, 32.5 × 24.2
Washington, National Gallery of Art, Gift of The Atlas Foundation

## 73

*Les Soutiens de la société*

1896, lithograph in black on light brown paper, 32.4 × 49.9
Washington, National Gallery of Art, Gift of The Atlas Foundation

## 74

*Frères; La Gardienne; Créanciers*

1894, lithograph in black on light brown paper, 48 × 32.4
Washington, National Gallery of Art, Gift of The Atlas Foundation

## 75

*La Vie muette*

1894, lithograph in green-black on paper, 32.9 × 25.1
Washington, National Gallery of Art, Gift of The Atlas Foundation

Vuillard created ten lithographic playbill covers for the Théâtre de l'Oeuvre troupe between 1893 and 1897. Eight appeared in succession between October 1893 and November 1894; the ninth was designed for the June 23, 1896 staging of Ibsen's *Les Soutiens de la société* (*Pillars of Society*) at the Nouveau Théâtre; and the last one was for a new version of Bjørnson's *Au-delà des forces humaines* (*Beyond Our Power*), presented on January 26, 1897. Vuillard's intense collaboration with Lugné-Poe reached its climax in 1893–1894. This was their "Ibsen year," and the Nabi artist's programs reflect the sets and lighting he devised for each of the mostly Nordic plays presented. He was partial to rather gloomy atmospheres *à la* Edvard Munch, and the lithographic medium allowed him to assert both his flair for elliptical expression and his dark disposition.

The program for *Rosmersholm* (October 6, 1893, Bouffes du Nord)—"a very fine lithograph by Vuillard, the first of a series of litho-playbills in which l'Oeuvre took great pride," wrote Lugné-Poe[1]—is a true masterpiece. The entire décor appears to float, and the floral motifs are suspended in space as in paintings such as *Interior, Seated Figure* (1893, Fitzwilliam Museum, C-S IV.94), which shows his sister in mourning after the death of their Grandmother Michaud. The characters are palpably prisoners of their sorrow, and the burden of their destiny is expressed in the overall transparency and in their dematerializing bodies.

One month later, Vuillard created another masterpiece, this one for the opening of *Un ennemi du peuple* (*An Enemy of the People*) on November 10, 1893 at the Bouffes du Nord. He chose the scene from Act IV in which the gullible citizens of the town where Dr. Stockman operates a health spa threaten to lynch him, convinced he is destroying the local economy with talk of contaminated water. This vigorous design recalls the frontispieces of books from the Romantic era (Tony Johanot for Charles Nodier's *Tales*, Victor Hugo for his *Légende des siècles*). Vuillard has given free rein here to the Gothic side of his nature, creating a swelling movement that carries both the letters and the characters and recalls the style of the Théâtre-Libre and *Grisélidis* programs (cats. 42, 46).

The playbill for Ibsen's *Master Builder* (*Solness le Constructeur*, Bouffes du Nord, April 3, 1894) was inspired by his own set designs, which Lugné-Poe described as being of "incomparable brilliance" (see cat. 35). A corner of the raked stage is visible in the lithograph.

All his life—and to our enduring puzzlement—Lugné-Poe held Bjørnson's laborious *Beyond our Power* to be a *chef d'œuvre*.[2] Vuillard's program design shows Clara paralyzed and Pastor Sang attempting to cure her. She dies. The crucifix adds to the leaden atmosphere.

Vuillard created his most troubling—and most inspired—programs for two plays by Maurice Beaubourg: *L'Image* and *La Vie muette*. Taking advantage of the playwright's extreme situations and hysterical characters to unleash his own inner violence, he chose for *L'Image* (Bouffes du Nord, February 27, 1894) the moment when Demenière, a Symbolist novelist, strangles his wife, who has come between him and his ideal image of womanhood. His expression is that of a killer faun, and this savage image is unique in Vuillard's art. For the uneven and strange *La Vie muette* (see cat. 61), the artist sets Madame de Meyrueis in the foreground, her arms protectively enveloping her children, while the lord of the manor, crazed with jealousy and suspicion, fretfully paces the garden path. Romain Coolus instantly lauded this cover in *La Revue blanche*: "The playbill by M. Édouard Vuillard embellishes Maurice Beaubourg's cerebral drama with a synthetic and highly expressive image."[3]

On June 21, 1894, Vuillard proposed a program design for three plays—Herman Bang's *Frères*, Henri de Régnier's *La Gardienne* and Strindberg's *Créanciers* (*The Creditors*)—that were to run simultaneously at the Comédie-Parisienne. It is *La Gardienne*, however, that takes centre stage in his design, with the wraithlike apparition of "universal consciousness." Many years later, in 1953, de Régnier paid tribute in a sonnet to Vuillard's handsome sets, inspired by Puvis de Chavannes:

VUILLARD, hark back! "La Gardienne," the scene,
The Théâtre de l'Oeuvre, where you created,
You, unknown artist, of name unfêted,
The décor where her psychic shade was seen.[4]

And indeed, the phantom glimpsed through a gauzy veil left the audience gasping. GC

---

1. Lugné-Poe 1931, p. 55.

2. Ibid., p. 70.

3. Romain Coolus, "Notes dramatiques," *La Revue blanche* (December 1894), p. 569.

4. Henri de Régnier, "Sonnet to Vuillard," in *Vuillard*, exhib. cat. (Paris: Galerie Bernheim-Jeune, May 1953), n.p.

67

68

69

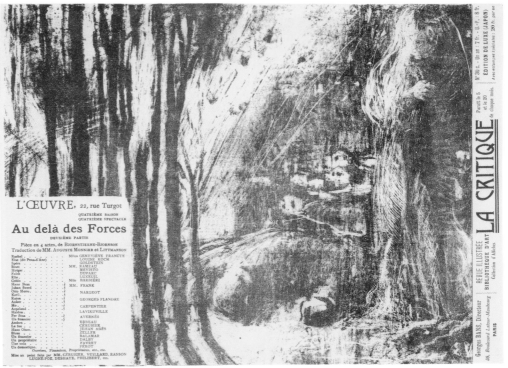

70

71

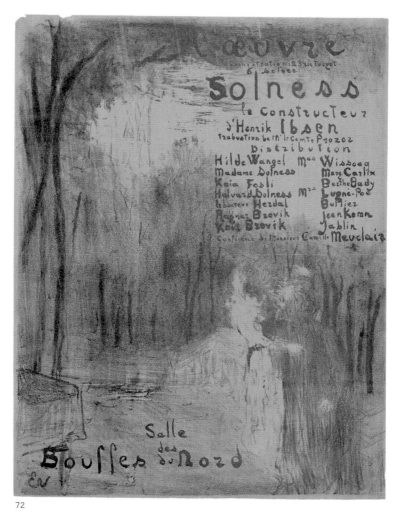

72

73

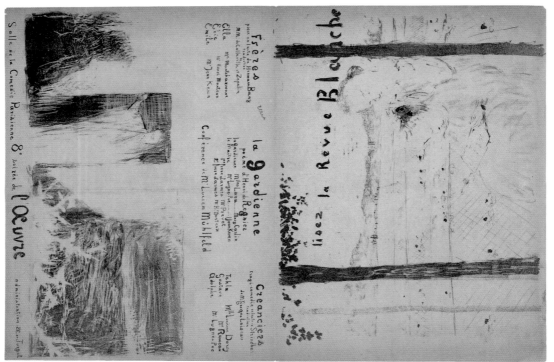

74

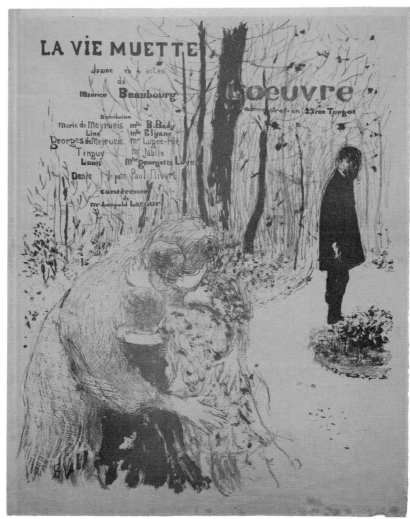

75

BEHIND CLOSED DOORS | *Catalogue* 76–102

ALTHOUGH FASCINATED BY THE formalist theories espoused by Maurice Denis and Paul Sérusier, Vuillard eschewed the more mystical and anti-naturalist aspects of the Nabi aesthetic. Like his friends Pierre Bonnard, Kerr-Xavier Roussel and Félix Vallotton, he preferred to create works based on observation and on exploration of the world around him. For Vuillard, that world was centred on his own home and family. The artist's mother, who was a corset-maker by trade both before and after the death of her husband in 1884, turned the family home into a workshop populated by seamstresses, creating a highly feminized world that she dominated, along with Vuillard's sister Marie and (until her death in 1893) his Grandmother Michaud.[1] Within this world, Vuillard was both resident and intruder, as well as observer. The Vuillard family apartment would serve as backdrop and subject for many of the artist's most compelling works.

From the very beginning of his career Vuillard exhibited paintings of domestic interiors, a central theme in his oeuvre of the 1890s, and they played an instrumental role in establishing his reputation as an artist. In November 1892 he exhibited no fewer than five such paintings at the third *Exposition des peintres impressionnistes et symbolistes*, held at Le Barc de Bouteville (cats. 81, 84). This display earned him the label *intimiste*, for it clearly reflected his penchant for works that were modest in scale and subject, intimate in character and mood.[2] In contrast to the overtly Symbolist works of most of his fellow Nabis, which were greeted with confusion and even derision, Vuillard's *intimiste* visions were—like Bonnard's—widely praised for their perceptiveness and subtlety.

Vuillard's interiors are deeply resonant works, strikingly modern yet steeped in an artistic tradition that stretches back to the seventeenth century. Dutch genre painting, with its modest subjects, often rigorous arrangement of form, and bold contrasts of light and dark, was a key influence on Vuillard. He was especially drawn to the work of Johannes Vermeer, Jan Steen and Gerard Dou, which he knew from his regular visits to the Musée du Louvre and from a trip he made to Belgium, Holland and London in the autumn of 1892.[3] Another potent source of inspiration was the art of Jean-Baptiste-Siméon Chardin, which he admired for its humble subjects and the "pure and simple pleasures" of its tonal harmonies.[4]

Comparisons may also be drawn, in terms of both subject and sources, between Vuillard's interiors and those of contemporary artists Edgar Degas, Édouard Manet, and his friend Henri de Toulouse-Lautrec. The compositional audacity and psychological complexity of Degas's paintings, in particular, set important precedents. Vuillard shared with these artists an admiration for Japanese prints, evident in his use of unusual viewpoints, striking silhouettes and flat planes of unmodulated colour. The nascent art of photography, in which both Degas and Vuillard would experiment, may also be responsible for some of the curious spatial distortions found in a number of these paintings.[5] An even more powerful influence, however, was Vuillard's active engagement during this period in Symbolist theatre, which can be felt in the artist's manipulation of interior space and in his predilection for unconventional lighting effects.

As, over the course of the 1890s, Vuillard's technique became more assured and his eye more sophisticated, his approach to the interior inevitably evolved. While his early experiments in the genre (cats. 76–77) seem to reflect a firm adherence to Nabi precepts regarding the abstract and inherently planar character of pictorial composition, Vuillard never fully rejected the notion of three-dimensional space, subtly employing a number of formal elements—colour, pattern and overlapping forms—to achieve a sense of volume. He also used mirrors (cat. 79) and architectural elements such as doorways (cat. 83) and windows (cat. 89) to heighten the visual tension between figure and ground. In many of these works the integration of form and pattern is complex and profoundly decorative—figures seem not so much to inhabit the spaces as to merge into them (cats. 82, 85, 89).

Vuillard's interiors fall generally into two categories: representations of seamstresses at work and depictions of the more private, intimate world of the Vuillard ménage (although the boundary between the two is often blurred). Vuillard's mother and sister, who inhabited these two domains equally, inevitably feature prominently in these paintings, reflecting their place in the artist's life. But while their figures are easily recognizable, these domestic interiors are not intended as portraits, nor are they genre paintings in the true sense of the term. Rather, they are evocations of the private world of the artist's personal experience. On rare occasions specific events in the lives of the Vuillard family, such as the marriage of the artist's sister Marie to his friend Roussel in 1893 (cats. 89–92) or the couple's estrangement in 1895 as a result of Roussel's infidelities (cats. 95–98), find direct expression in the artist's work, creating an implicit, emotionally charged narrative. In other works Vuillard appears to construct subtle psychological dramas using his family members as the protagonists (cats. 77, 80, 85), a strategy seemingly inspired by Symbolist theatre.

Vuillard's interiors provide a tantalizing view into a cloistered and rarefied world occupied almost exclusively by women. Despite their subject matter, though, these paintings do not titillate, but present a prosaic vision of figures engaged in such quotidian activities as sewing, dining or conversing. Vuillard's women are perpetually absorbed in their occupations and, with only rare exceptions, remain totally unconscious of the presence of the artist and the gaze of the viewer. In these works, intimate by nature and fraught by design, Vuillard succeeds in capturing "the poetry of pleasant interiors, the beauty of an active yet thoughtful life."[6] **Kimberly Jones**

1. Easton 1989, p. 27.

2. Gustave Geffroy, "Chez Le Barc de Bouteville" (November 28, 1892), in *La Vie artistique*, vol. 2 (Paris: E. Dentu, 1893), pp. 381–382.

3. "Afternoon at the Louvre shiny frames calm Shadows light of the Dutch painting." Vuillard, *Journal*, I.1, fol. 21v–22r (December 1888), quoted in Easton 1989, p. 145.

4. Vuillard, *Journal*, I.2, fol. 19v (before September 6, 1890), quoted in Easton 1989, p. 134, note 15.

5. On Vuillard and photography see "The Intentional Snapshot," by Elizabeth Easton, and "Vuillard and His Photographs," both in the present volume.

6. Gustave Geffroy, "Vuillard, Bonnard et Roussel" (October 29, 1893), in *La Vie artistique*, vol. 6 (Paris: E. H. Floury, 1900), p. 296.

format to achieve a sense of intimacy. Unlike these other paintings, however, which place the figure in the foreground, giving it weight and importance, this image shows the solemn figure of the artist's grandmother—easily identifiable by her black garb and distinctive profile—distanced from the viewer, her body seeming to blend with the shadows of the doorway and the gloom of the staircase. The painting has been composed from a restrained, monochromatic palette of browns and blacks whose severity is somewhat lightened by the softer tones of the floor tiles and stairs, and the overall mood is mysterious and nocturnal. The only source of illumination, a thin stripe of warm yellow light emanating from within the apartment, serves to define and detach the silhouette of the grandmother, while casting a bold elongated rectangle of yellow against the wall behind her. The composition is equally stark, consisting of a series of verticals—the doorway, the figure, the patch of light, the staircase banister—that effectively balance the curve of the floor and the sharply truncated spiral staircase dominating the left-hand side of the composition. Although in its strong sense of geometric form and compositional order the work is akin to others of Vuillard's Nabi paintings from this period, its enigmatic and sombre mood anticipates his interiors of the later 1890s, most notably his evocative *Interior, Mystery* (cat. 144), painted five years later. KJ

## 77

THE CONVERSATION · *La Conversation*

c. 1891–1892, oil on canvas, 23.8 × 33.4
Washington, National Gallery of Art, Ailsa Mellon Bruce Collection

Cogeval-Salomon IV.27

———

*Provenance* Studio—Arthur Tooth & Sons, London—Edward Molyneux, Paris, 1947—Ailsa Mellon Bruce, New York, 1955—Bequest to the National Gallery of Art, Washington, 1970

*Exhibitions* Paris, Charpentier, 1948, no. 9—Washington, NGA, 1966, no. 174, ill.—Washington, NGA, 1978, p. 96, ill. p. 97—Houston-Washington-Brooklyn, 1989–1990, p. 88, no. 62, ill.—Florence, Palazzo Corsini, 1998, no. 57, ill. p. 96—Montreal, MMFA, 1998, no. 169, ill. p. 47

*Bibliography* Chastel 1948, pp. 4, 5, col. pl. ii—Ciaffa 1985, pp. 208–210, fig. 90—Cogeval 1998a, p. 188—Cogeval 1998b, p. 118

## 76

THE STAIRCASE LANDING, RUE DE MIROMESNIL · *Le Palier, rue de Miromesnil*

1891, oil on board, 39 × 24
Signed and dated u.r.: *e. vuillard / 91*
Mrs. Margaret Altman

Cogeval-Salomon II.99

———

*Provenance* Louis Carré, Paris—Jacques Dubourg, Paris—Sale, Hôtel Drouot, Paris, May 10, 1950, lot 130—Galerie Gas, Paris—E. J. Van Wisselingh, Amsterdam—Private collection, Canada

*Exhibitions* Toronto-San Francisco-Chicago, 1971–1972, no. 2, col. ill.—London, Royal Academy, 1979–1980, no. 232, ill.—Washington, NGA, 1980, no. 147, ill.—Houston-Washington-Brooklyn, 1989–1990, no. 37, ill.

*Bibliography* Chastel 1946, ill. p. 13—Salomon 1961, pp. 32–34, ill.—Easton 1989, pp. 58, 60, 67

———

*The Staircase Landing, Rue de Miromesnil* is one of several paintings by Vuillard that depict a solitary figure framed by a doorway. In this regard, it is similar to both *The Little Delivery Boy* (cat. 19) and *Lady of Fashion* (cat. 26), utilizing the same narrow, vertical

77

*The Conversation* is one of Vuillard's starkest depictions of the internal drama of family life. In a boldly abstract manner, the artist has flattened and simplified all the forms to their most basic shapes and has adopted an equally minimal palette, comprised of muted shades of ivory, ochre and black. The only hint of colour—the red of the polka dots in the mother's skirt and of the dish on the table— is likewise subdued. With the exception of the tabletop and parts of the figures, the canvas is thinly painted, the weave of the fabric plainly visible, heightening the sense of a scene stripped of extraneous matter in order to expose the raw, unvarnished reality at the heart of domesticity.

The focus of the composition is the interaction between the artist's mother and sister. The two women are presented as a study in contrasts, their portrayal exaggerated to the point of caricature. Standing in the foreground is Madame Vuillard, whose solid, monumental presence fills the right-hand side of the composition. In her left hand she holds what appears to be a letter, and she turns her head toward her daughter as if interrupted

in the middle of her reading. Marie stands on the other side of the table, desperately thin and pale in her severe black dress, her body framed by the sweep of the curtain to the right and by the figure of a seamstress in a boldly checkered dress in the background to her left. Most striking of all is the way Marie seems to hide behind her chair in a pose of profound unease, "as if fending off a maternal assault," as Easton has observed.[1]

Although the figures are clearly identifiable as members of the artist's family, the scene itself is probably not based on reality or is at least not representative of their relationship as a whole. As Easton has noted, Vuillard makes no mention in his diary of any unusual tension between the two women.[2] Ciaffa has observed that in a number of paintings as well as this one, such as *Mother and Daughter at the Table* (cat. 80) and *Interior, Mother and Sister of the Artist* (cat. 85), Vuillard seems to be fabricating a kind of "Symbolist psychodrama" with his family members as the protagonists.[3] Indeed, this painting carries more resonance of Symbolism and Expressionism—both in painting and in theatre—than of the daily life of the Vuillard family. Easton, among others,

has noted that Marie's skeletal features and pallor seem to presage Edvard Munch's paintings of the mid-1890s.[4] She also relates this painting to Vuillard's drawings for the program of Maurice Maeterlinck's play *L'Intruse*, while Cogeval, noting Vuillard's close association with Lugné-Poe at this time, proposes Ibsen as another inspiration for the provocative *mise en scène* that Vuillard constructs in paintings such as this one.[5] KJ

1. Easton 1989, p. 88.

2. Ibid., p. 84.

3. Ciaffa 1985, p. 210.

4. Easton 1989, p. 88.

5. Cogeval in C-S 2003, no. IV.27.

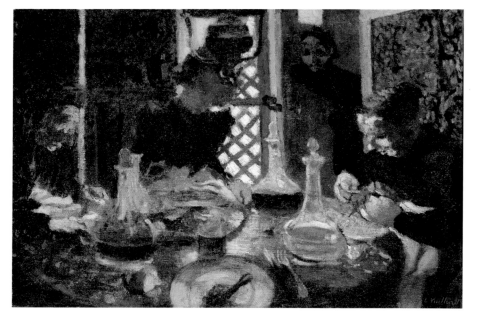

## 78

LUNCHTIME · *À table, le déjeuner*

1892, oil on canvas, 32 × 46
Signed l.r.: *E. Vuillard*
Tom James Company/Oxxford Clothes

Cogeval-Salomon IV.79

*Provenance* Alfred Athis Natanson, Paris—
Sam Salz, New York—Ralph F. Colin, New
York, 1950—Galerie Hopkins-Thomas-Cus-
tot, Paris—Private collection, United States

*Exhibitions* Paris, Bernheim-Jeune, Nov. 1908,
no. 17—Cleveland-New York, 1954, p. 102,
col. ill. p. 43

*Bibliography* Ciaffa 1985, pp. 131–134, fig. 41
—Easton 1989, pp. 62–65, 68–69, col. fig. 41
—Forgione 1992, p. 118, fig. 67

In *Lunchtime*, Vuillard has depicted an ordi-
nary family meal. At the far left is the artist's
grandmother, Madame Michaud, easily
identified by her black bonnet and distinctive
profile. Seated directly across from her is
Vuillard's mother, garbed in a simple brown
dress and white apron. At the centre of the
composition is his sister Marie, her body back-
lit by the light from the window behind her,
her features obscured both by shadow and
by the lamp hanging from the ceiling. She too
is shown in profile, with her head turned to
look at an unidentified woman standing in
the doorway to her left. This woman's body
bends forward toward the dining room, her
deferential manner suggesting that she may be
a servant. In contrast to Marie, the mother

and grandmother remain engrossed in their
meal, as yet unaware of the sudden intrusion.
It is a moment frozen in time, with the figures
caught between awareness and action—a
scene that is all the more compelling for its
potential dynamism.

The cluttered table dominates the foreground,
the trappings of the midday meal spread
across its surface. Most distinctive are the four
carafes, situated like the cardinal points of a
compass, that neatly frame the figures seated
at the table. Although there are only three
people partaking of the meal, a fourth setting
can be seen in the foreground. Together with
the chicken leg that sits somewhat cheerlessly
in the middle of a white plate, the edge of
which is cropped, the utensils, chunk of bread
and glass of wine all indicate the existence of
a fourth diner. The viewer is left to speculate
on his or her identity: is it the woman in the
doorway, the artist himself, or someone else
entirely? We are inclined to believe that it
is the artist, and this evocation of his physical
presence outside the composition simply
adds to the sense of expectation.

In spite of the light coming through the
window at the centre of the composition, the
room remains dark and the figures are in
shadow. Ironically, the lamp so prominently
displayed that it nearly eclipses the face of the
central figure casts no light within the compo-
sition. The darkness of the interior and the
cropping of the figures and the table give the
room an almost oppressive feeling, while the
features of the women—shadowed, abstract
and slightly caricatured—add to the vague
sense of unease that permeates this otherwise
quotidian subject. Although Ciaffa has com-

pared this painting to Paul Signac's *Breakfast*
(1887–1888, Otterlo, Kröller-Müller Museum),[1]
Cogeval has also noted a certain kinship
with Henri Matisse's *The Dessert* (1897, private
collection).[2] *Lunchtime* sits perfectly between
the two works, combining to great effect the
former's wry evocation of bourgeois ritual
with the latter's sly and seductive portrayal of
a mundane still life, all the while maintaining
the subtle pictorial and psychological tension
that is uniquely Vuillard's own. KJ

1. Ciaffa 1985, pp. 133–134.

2. Cogeval in C-S 2003, no. IV.79.

## 79

THE FLOWERED DRESS · *La Robe
à ramages*

1891, oil on canvas, 38 × 46
Signed and dated l.r.: *e. vuillard / 91*
Museu de Arte de São Paulo, Assis
Chateaubriand, São Paulo, Brazil 129/1958

Cogeval-Salomon IV.3

*Provenance* Studio—Wildenstein, New York,
c. 1950—Museu de Arte de São Paulo

*Exhibitions* Saint-Germain-en-Laye, Château
national, 1891, no. 258—Cleveland-New
York, 1954, p. 100, ill. p. 33—Houston-Wash-
ington-Brooklyn, 1989–1990, no. 20, col. ill.
—Zurich-Paris, 1993–1994, no. 149, col. ill.

*Bibliography* Chastel 1946, pp. 46, 61, ill. p. 23
—Salomon 1961, p. 34, ill. p. 35—Perucchi-
Petri 1976, pp. 103, 114, fig. 58—Mauner 1978,
pp. 212, 258, 260, fig. 140—Daniel 1984,
pp. 44, 146, fig. 4—Thomson 1988, p. 166,
pl. 10—Easton 1989, pp. 39–41

Within an oddly lit interior, three seam-
stresses are shown engaged in their labour.
Two of the figures can be identified with some
confidence: Grandmother Michaud, with
her wrinkled features and the black bonnet she
wears in several other paintings by Vuillard
(cats. 3, 76, 78), and the artist's sister Marie,
whose brightly patterned dress can be seen in
another family painting sometimes known as
*The Green Dinner* (see cat. 80, fig. 1). Here it
is the figure of Marie that dominates the com-
position, her colourful dress and standing pose
drawing the eye irresistibly. The setting can
also be identified as the apartment on Rue de
Miromesnil where the Vuillard family resided
between 1889 and 1891.

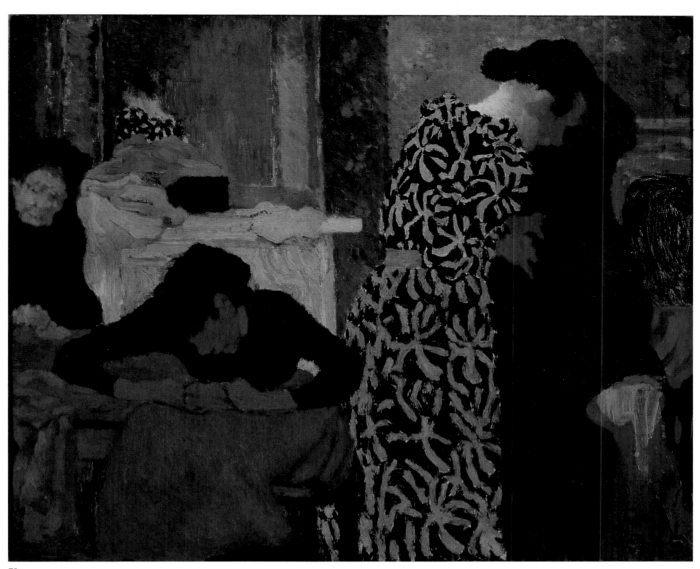

79

In this painting, the tension between the two-dimensional picture plane and the three-dimensional interior space being depicted is particularly fraught. Physically, the figures appear to be assembled in a corner formed by two contrasting planes decorated in flowered wallpaper—one pale green, the other slightly darker—that intersect sharply near the centre of the composition. That these two planes are perpendicular to one another is underscored by the presence of the mirror placed prominently at the left of the composition, which appears to reflect the back of the woman standing to the right—Marie. At the same time, however, Vuillard reasserts the flatness of the pictorial space so effectively that he ultimately undermines the illusion of three-dimensionality. The figures are arrayed across the picture plane in a frieze of silhou-

ettes and undulating curves that seem to interlock, rather than overlap and recede into space. This effect is heightened by the use of stylized form, the juxtaposition of unmodulated, or barely modulated, planes of colour and pattern, and the pervasive use of green and black that, while harmonizing the composition as a whole, renders the relationships between the figures and the background even more ambiguous. Moreover, the positioning of the figures in the very front of the picture plane and the tight focus on the three women further deprive the viewer of a sense of space and scale. The result is an image that is consciously planar and decorative.

The introduction of the mirror, a device Vuillard would use again and again over the years (e.g. cats. 155, 275, 289, 300, 302, 319), is intriguing. By 1891, when this painting was executed, he was evidently already fascinated by the mirror's potential as a pictorial device

capable of presenting multiple viewpoints simultaneously, as well as its ability to both reflect and distort reality. Distortion is certainly apparent in the mirrored reflection in this painting. As Cogeval notes, given Marie's position relative to the mirror, her left shoulder, not her right, should be the one to appear in the reflection.[1] Here, once again, Vuillard manipulates pictorial space, giving precedence to subjective experience and artistic expression over verisimilitude. KJ

---

1. Cogeval in C-S 2003, no. IV.3.

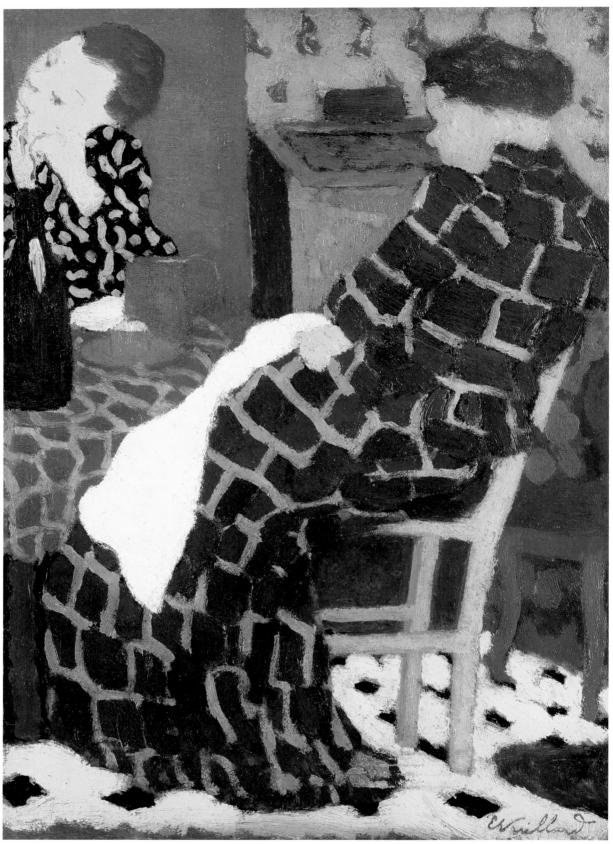

MOTHER AND DAUGHTER AT
THE TABLE · *Mère et fille à table*

c. 1891–1892, oil on panel, 37.5 × 27
Anne Searle Bent

Cogeval-Salomon IV.18

*Provenance* Studio—Wildenstein, New
York—Private collection

*Exhibitions* Japan, 1977–1978 (trav. exhib.),
no. 10, col. ill.—Houston-Washington-
Brooklyn, 1989–1990, no. 35, col. ill.

*Bibliography* Perucchi-Petri 1976, pp. 130–
131, fig. 86—Ciaffa 1985, p. 130, fig. 39—
Easton 1989, p. 60—Sidlauskas 1997,
pp. 99–100, ill.

*Mother and Daughter at the Table* is one of
several paintings in which Vuillard evokes the
complex and even disconcerting energy that
animates the relationship between the two
women who figured most prominently in his
life, his mother and his sister Marie. The
subject, the family meal, is one that Vuillard
explored time and again (see cats. 78, 98),
clearly delighting not only in its intimate and
homely qualities, but also in its potential for
exploring the relationships of the participants.

The painting depicts a conversation that is
presumably occurring after dinner. The meal
itself has been completed and the dishes
removed. All that remains visible is a pitcher,
a bright red teacup and saucer, and, at the far
left, a solitary bottle of wine. As Easton has
noted, *Mother and Daughter at the Table* seems
to draw its inspiration from another painting,
*The Green Dinner* (fig. 1), most notably in
Marie's rather distinctively contemplative
pose.[1] Here, however, the scene has been sim-
plified and condensed. The artist's brother
and grandmother have been expunged, leav-
ing behind the mother and sister, while the
lively exchange depicted in the earlier paint-
ing is replaced by a more intense and subtle
interplay between the two remaining figures.

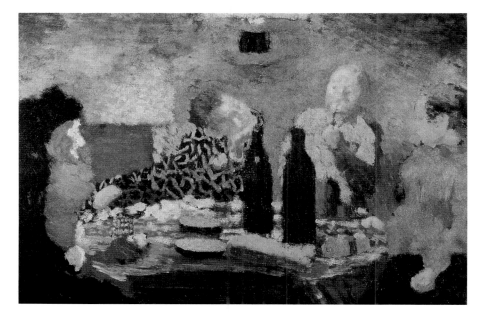

1. Édouard Vuillard, *The Family after Dinner*, also known as *The Green Dinner*, 1891, oil on board, London, private collection, C-S IV.4.

At first glance, the composition is dominated
by the monumental figure of the artist's
mother. Her body spans the composition diag-
onally from upper right to lower left, and
her dress, with its bold pattern of checks, sug-
gests, as Cogeval has wryly observed, "a brick
wall."[2] In contrast, Marie, who is dressed in a
floral frock not unlike the one she wears in
both *The Green Dinner* and *The Flowered Dress*
(cat. 79), is tucked into the left-hand side of
the composition, her upper body compressed
into a space that appears too small to accom-
modate it.

The placement of the two women's bodies in
relation to one another is striking. While
Madame Vuillard leans backward in her chair
away from the table, Marie leans inward to
listen to the conversation taking place just
outside the composition, her torso angled
away from her mother, the empty space a
wedge between them. Although they occupy
the same space, there is no direct interaction
between them, and their physical proximity
only serves to heighten the atmosphere of
emotional distance.

The psychological intensity of this painting is
at odds with the sumptuousness of the picto-
rial surface. Vuillard gives full rein to his love
of vibrant, contrasting patterns throughout
the composition, not only in the dresses of the

two women, but also in the wallpaper, the
tablecloth and even the tiled floor. The pattern
of the floor appears to be the same as the one
in *The Staircase Landing, Rue de Miromesnil*
(cat. 76), which suggests a common location
for the two paintings. As in so many of Vuil-
lard's paintings of this time, the superficial
beauty and the extreme elegance of colour
and form belie the underlying complexity of
the work as a whole. KJ

1. Easton 1989, p. 60.

2. Cogeval in C-S 2003, no. IV.18.

## 81

SEAMSTRESS WITH SCRAPS ·
*La Ravaudeuse aux chiffons*

1893, oil on board, 27.9 × 25.4
Signed and dated l.l.: *ev93*
Indianapolis Museum of Art, Gift of
Blanche Stillson in memory of Caroline
Marmon Fesler

Cogeval-Salomon IV.51

*Provenance* Ernest Coquelin cadet, Paris—
Coquelin cadet Sale, Hôtel Drouot, Paris,
May 26, 1909, lot 56 [*La Couturière*]—Bern-
heim-Jeune, Paris—Alex Reid, Glasgow,
Feb. 23, 1920—Lefevre Gallery, London—
J. M. Sieff, London, Nov. 18, 1932—Lefevre
Gallery, London—Georges Keller, New
York, 1947—Bignou, New York—Mrs.
James W. Fesler, Indianapolis; bequeathed to
Miss Blanche Stillson, Indianapolis, 1960—
Stillson Gift to the Indianapolis Museum of
Art, 1969

*Exhibitions* Paris, Le Barc de Bouteville, 1892,
no. 184 [*Ravaudeuse*]—Glasgow, McLellan,
1920, no. 122—London, Lefevre, 1945,
no. 46—London, Lefevre, 1946, no. 56—
Indianapolis, Museum of Art, 1972, p. 50, ill.
—Indianapolis, Museum of Art, 1976—
Houston-Washington-Brooklyn, 1989–1990,
no. 31, col. ill. [*The Seamstress*]

*Bibliography* Schweicher 1955, pl. 5—*Gazette
des Beaux-Arts*, vol. 77, no. 1225, Feb. 1971, ill.
p. 105—Easton 1989, p. 47—Cogeval 1993
and 2002, p. 54, col. ill.

———

The composition of this painting bears a
strong resemblance to that of *The Stitch*
(cat. 86), another interior executed by Vuillard
in 1893. Both pictures prominently depict a
table placed adjacent to a window, which is on
the right. Both incorporate a seamstress seated
in the foreground with her back to the viewer,
her body partially framed by the window
and softly lit by the light entering through it.
Both paintings juxtapose planes of intricately
patterned wallpaper with more austere walls
of soft grey in order to create a sense of three-
dimensional space.

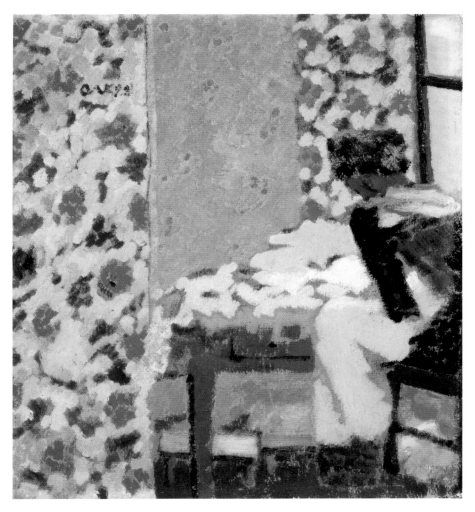

The comparisons end there, however. In con-
trast to the elaborate and lushly painted *The
Stitch*, *Seamstress with Scraps* seems almost
unfinished, an effect that is heightened by the
generous use throughout the painting of
the exposed cardboard support, most notably
in the table and in the apron and dress of the
seamstress. The support appears in the wall-
paper as well, forming a subdued counter-
point to the brightly painted flowers of red,
pink and green. In some areas, such as the
seamstress's back or the wall peeking through
beneath the table, the paint is so thinly applied
that it becomes almost a wash, while in others,
like the seamstress's apron or the fabric piled
on the tabletop, it is opaque and the forms are
curiously bold and abstract.

The most striking—and puzzling—compo-
nent of the painting is the strip of flowered
wallpaper that dominates the left foreground,
with its uncertain relationship to the back-
ground. Easton has suggested that its presence

indicates that the point of view is situated in
another room.[1] Cogeval, however, has pro-
posed that it is a door camouflaged within the
wall. He further identifies it as the very same
door and the same room as those depicted
in *The Mumps* (cat. 83), but shown from a
slightly different angle.[2] As always, Vuillard
uses such visual ambiguity to entice the eye,
leaving the ultimate interpretation of the
room's spatial reality to the viewer's discre-
tion. KJ

———

1. Easton 1989, p. 47.

2. Cogeval in C-S 2003, no. IV.51.

138

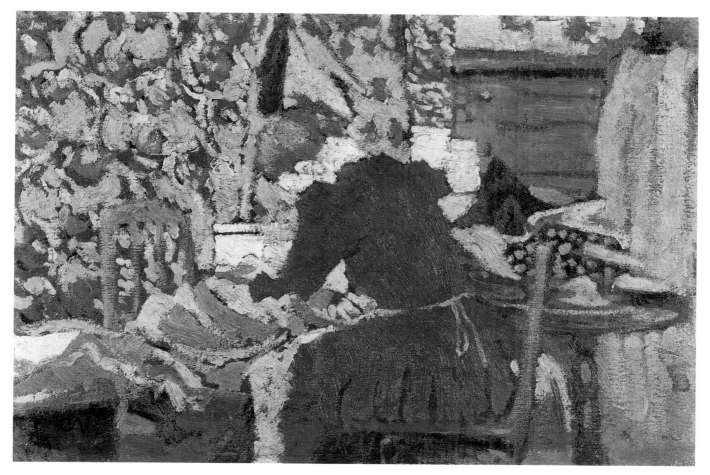

## 82

INTERIOR (MARIE LEANING OVER
HER WORK) · *Marie penchée sur son ouvrage
dans un intérieur*

c. 1892–1893, oil on board mounted on
cradled panel, 23.2 × 34.3
Signed l.l.: *ev*
New Haven, Conn., Yale University Art
Gallery, Bequest of Edith Malvina K.
Wetmore

Cogeval-Salomon IV.48

*Provenance* Bernheim-Jeune, Paris—Georges
Bénard, Paris—Edith Malvina K. Wetmore,
United States—Wetmore Bequest to the Yale
University Art Gallery, New Haven, 1966

*Exhibitions* New York, MoMA, 1930, no. 98
—New York, Seligmann, 1930, no. 21—
Houston-Washington-Brooklyn, 1989–1990,
no. 15, col. ill.

*Bibliography* Easton 1989, p. 33—Cogeval
1993 and 2002, p. 57, col. ill

A seamstress is seated at the centre of the composition, her body turned away from the viewer's gaze, her torso hunched over the sewing spread across her lap. On either side of her is a table upon which bits of brightly coloured fabric are placed haphazardly. Although her features are obscured from view, given the setting and the activity there is no reason to question Cogeval's identification of the woman as Vuillard's sister Marie. The figure is also wearing a simple dark blue dress very similar to the one worn by Marie in *Lunchtime* (cat. 78). Nevertheless it is her vocation, not her identity, that is the focus of this painting.

The surface of this painting is especially lush. Rich colour and sumptuous pattern are juxtaposed throughout, creating an effect comparable to that of a patchwork quilt, at once discordant and subtly harmonious. At the same time, the brushwork, with its dense impasto and repeated use of scumbling, adds texture, giving the painting a strongly tactile quality. The resulting play of pattern and texture renders the spatial relationships all the more ambiguous. Although the figure of Marie is a solid presence in the foreground, the blue of her dress, the brown of her hair and the grey of her apron are echoed throughout the composition, discreetly drawing the background elements toward the foreground. Similarly, the heavy impasto that is used throughout, emphasizing the pictorial surface, gives more weight and presence to objects that are further removed from the viewer. KJ

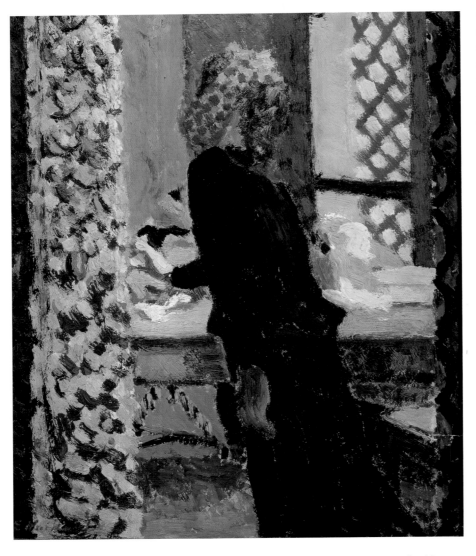

Cogeval has identified the setting as the same room that appears in *Seamstress with Scraps* (cat. 81). In the foreground at the left is the element that he has proposed is a camouflaged door covered in elaborate wallpaper, here described in a series of short, rapid brush-strokes of black, white, red, and the muted blue-grey that appears throughout the composition. The point of view is clearly another room, for the scene is neatly framed on either side by bands of darkly coloured wallpaper in differing patterns. Marie herself stands in the threshold, her hand outstretched, her body angled slightly forward as if in the very act of opening the door, captured forever in a moment of arrested motion. KJ

## 84

IN THE LAMPLIGHT · *Sous la lampe*

1892, oil on canvas mounted on cradled panel, 37.5 × 45.5
Signed and dated l.l.: *ev 92*
Saint-Tropez, Musée de l'Annonciade

Cogeval-Salomon IV.78

———

*Provenance* Bernheim-Jeune, Paris—Georges Grammont, Paris—Bequeathed to the French nation to be placed on deposit at the Musée de l'Annonciade, Saint-Tropez, in 1955

*Exhibitions* Paris, Le Barc de Bouteville, 1892, no. 181—Zurich, Kunsthaus, 1932, no. 127—Berne, Kunsthalle, 1946, no. 42, ill.—Basel, Kunsthalle, 1949, no. 11—Cleveland-New York, 1954, p. 101, ill. p. 38—Milan, Palazzo Reale, 1959, no. 15—Houston-Washington-Brooklyn, 1989–1990, no. 21, col. ill.—Lyon-Barcelona-Nantes, 1990–1991, no. 45, col. ill. p. 120—Zurich-Paris, 1993–1994, no. 160, col. fig. p. 90

*Bibliography* Muhlfeld 1893, pp. 458–459—Schweicher 1949, pp. 6, 33–35, 40, 42, 96–97, 122—Dorival 1957, p. 22, col. ill. p. 18—Cogeval 1986, fig. 334—Thomson 1988, p. 85, fig. 76—Easton 1989, pp. 41–42, 47, 62—Cogeval 1990, p. 118—Dumas 1990, p. 62—Perucchi-Petri 1990, p. 150—Cogeval 1993 and 2002, pp. 43–46, col. ill. pp. 44–45—Groom 1993, p. 28, col. fig. 39—Koella, 1993, p. 94, 102, col. fig. 1

## 83

THE MUMPS · *Les Oreillons*

c. 1892, oil on board, 24 × 20
Private collection

Cogeval-Salomon IV.52

———

*Provenance* Studio—Private collection

*Exhibitions* Berne, Kunsthalle, 1946, no. 17—Brussels, Palais des Beaux-Arts, 1946, no. 31, ill.—Milan, Palazzo Reale, 1959, no. 28, ill.—Hamburg-Frankfurt-Zurich, 1964, no. 20, ill.—Munich, Haus der Kunst, 1968, no. 26, ill.—Paris, Orangerie, 1968, no. 42, ill.

*Bibliography* Schweicher 1949, pp. 32–33, 93, 103

———

In this rather curious painting, Vuillard has depicted a woman standing in the foreground at the centre of the composition, her body partially obscuring a worktable covered with scraps of fabric that occupies the middle ground in the room beyond. Light streams in from the window at the right, brilliantly illuminating the bits of fabric on the table, the edge of the doorway and the woman's extended right hand. Her dark dress is austere in comparison to the ornate wallpaper that surrounds her and contrasts sharply with the soft grey tones of the room she is about to enter. More striking, however, is the polka-dotted scarf wrapped about her face (a response to the "mumps" of the title?), masking it and echoing the flickering patterns of the wallpaper at her left and the window on her right. The woman is almost certainly the artist's sister Marie, who, in a drawing by the artist, is pictured in her sickbed wearing a similar scarf about her head (c. 1892, priv. coll.).

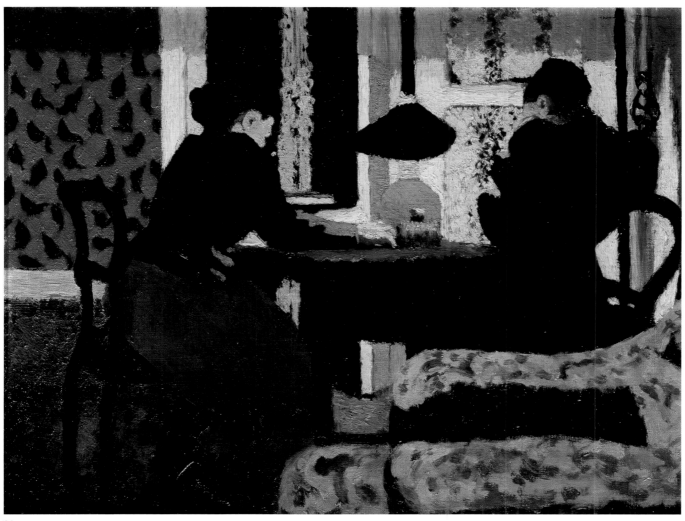

84

*In the Lamplight* is one of a group of paintings that Vuillard executed around 1891–1892 in which he explored the effects of illumination from a single lamp within a darkened interior. In all these works the use of light is highly dramatic and evocative, but in this particular painting light is just one component in an exceptionally tight and carefully constructed image. The progression of verticals across the picture plane (walls, doorway, the legs of the table and the chair, the window) is balanced by a series of horizontals (the chair in the foreground, the table, the rear wall, the window frame) to establish a sense of structure, while the repetition of colour (the red of one wall and the table top, the pale yellow of the other walls and the door and window, the soft, muted greens of the lamp, the chair and shadows, and, most notably, the uncompromising black silhouettes) helps to harmonize the composition overall.

Yet, for all its apparent order, Vuillard has created an image that, subtly undermining traditional tenets of pictorial space, thrives on ambiguity. One technique he uses to achieve this end is a sudden shift in perspective. Although the dominant viewpoint is clearly level with the table and the seated figures, spatial relations have been skewed in the foreground, so that the chair in the lower right-hand corner is viewed not from the side but from above—a physical impossibility. Chastel has attributed Vuillard's use of changing perspective to the influence of the theatre and of the work of Edgar Degas, another artist who explored shifting points of view and spatial ambiguity to great effect.[1] In *In the Lamplight*, Vuillard also sets up a conscious tension between the three-dimensionality of the space inhabited by the women and the flatness of the planes of unmodulated colour —most notably the vividly abstracted red and black wallpaper at the far left and the floor in the foreground—which seems to contradict that spatial reality.

This emphasis upon plane is equally apparent in the depiction of the figures themselves. The silhouettes in this painting are particularly austere and devoid of any modelling or texture. In the case of the woman on the left, her body seems composed of precisely cut shapes of black and brown, the severity of which is barely relieved by the sharply defined patch of pale brown on her sleeve and the twin bands at her waist that indicate the fall of light from the lamp on the table. The figure on the right is even more stark, her black-garbed body completely indistinguishable from the table and the chair upon which she sits, so that her lower body seems to dissolve into the inky darkness. KJ

1. Chastel 1954, p. 47.

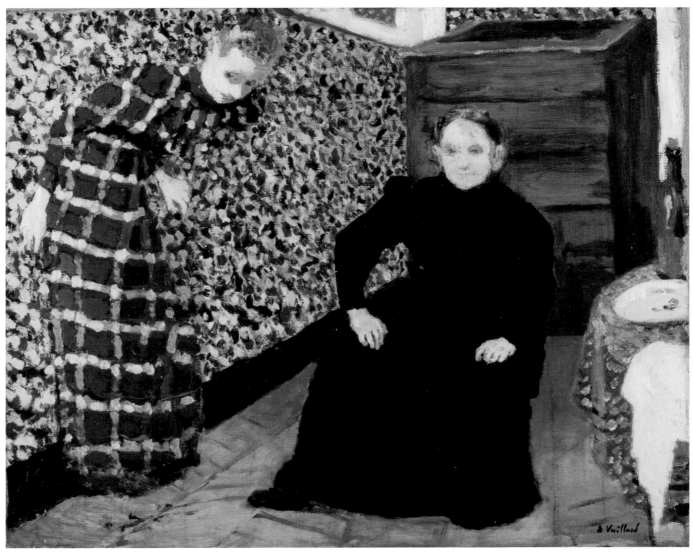

## 85

INTERIOR, MOTHER AND SISTER
OF THE ARTIST · *Intérieur, mère et sœur
de l'artiste*

1893, oil on canvas, 46.3 × 56.5
Signed l.r.: *E. Vuillard*
New York, The Museum of Modern Art,
Gift of Mrs. Saidie A. May, 1934, 141.1934

Cogeval-Salomon IV.112

———

*Provenance* Frédéric Houbron, Paris—
Bernheim-Jeune, Paris—Henry Bernstein,
Paris—Max Rodrigues, Paris, 1914—Max
Kaganovitch, Paris—Mrs. Saidie A. May,
Baltimore, Md., 1933—Gift to the Museum
of Modern Art, New York, 1934

*Exhibitions* Chicago, Art Institute, 1938–1939,
no. 30—Washington, Phillips Memorial
Gallery, 1939, no. 6—Cleveland-New York,
1954, p. 101, col. ill. p. 25—London, Royal
Academy, 1979–1980, no. 236, ill.—Wash-
ington, NGA, 1980, no. 149, ill.—Houston-
Washington-Brooklyn, 1989–1990, no. 55,
col. ill.

*Bibliography* Chastel 1946, p. 47, ill. p. 18—
Perucchi-Petri 1976, pp. 119, 124, 130, fig. 80
–Ciaffa 1985, pp. 204–209, fig. 87—Easton
1989, pp. 74, 83–85—Cogeval 1990, p. 118,
col. ill. p. 121—Perucchi-Petri 1990, pp. 143–
144, ill. p. 145—Cogeval 1993 and 2002, pp. 39
(2002), 51, col. ill. p. 51—U. Perucchi-Petri,
in *Nabis 1888–1900*, exhib. cat. (Paris: Réunion
des musées nationaux, 1993), pp. 332–333,
fig. 165.2—Sidlauskas 1997, pp. 85, 91, 97, 98,
103, 109, 111, ill. p. 86

———

*Interior, Mother and Sister of the Artist* is the
culmination of the dramatic visual confron-
tations between mother and daughter that
Vuillard had explored in earlier paintings
(cats. 77, 80). The psychological tension and

1. Jean Auguste Dominique Ingres, *Louis-François Bertin*,
1832, Paris, Musée du Louvre.

the intimations of maternal domination and filial submission in those earlier works are here made manifest in an image that is ominous and disconcerting in the extreme.

As in the earlier paintings, the composition hinges upon the juxtaposition of the two female protagonists. Vuillard's mother is seated just off centre. Her severe black dress and inscrutable expression give her weight and solidity, while her self-assured posture, with her hands resting lightly upon her knees and her arms akimbo in a surprisingly masculine manner—which a number of authors, Ciaffa[1] and Cogeval[2] among them, trace back to Ingres's masterly portrait of *Monsieur Bertin* (fig. 1) in the Louvre—underscores her authority within her domain.

In contrast to her mother's immutable presence, Marie is but a cipher. She cowers self-consciously against the wall behind her, her hips and hands pressed flat against it while her torso and neck bend downward, as if crushed and stifled by the oppressive weight of the familial roof. Her face and hands are startlingly pale and her eyes seem to flicker nervously to the side as her body cringes away from the viewer. Marie seems to vanish before our very eyes, her dress blending and merging with the wallpaper; she becomes part of the furnishings—decorative, mute, without will or consequence.

As Cogeval has observed, this painting was executed at a time when Vuillard's involvement with Symbolist theatre was at its height, a fact that is readily apparent in the deliberately affected *mise en scène*. Although the setting is once again the familiar Vuillard family apartment, it has been transformed in this painting. The artist dramatically skews the perspective, tilting the floor upward and angling the floorboards sharply toward the vanishing point, while the bottom of the window sill, which appears just above Marie's head, tips sharply downward, so that the walls and the ceiling seem to press increasingly inward. He plays further havoc with the room's perspective by tilting the top of the table up and the top of the sideboard along the back wall down. The room has ceased to be merely the setting of the drama; it has become a real and active participant, and a menacing one at that. KJ

1. Ciaffa 1985, p. 204.

2. Cogeval in C-S 2003, no. IV.112.

## 86

THE STITCH · *L'Aiguillée*

1893, oil on canvas, 42 × 33.5
Signed and dated u.l.: *ev 93*
New Haven, Conn., Yale University Art Gallery, Gift of Mr. and Mrs. Paul Mellon, B.A., 1929

Cogeval-Salomon IV.143

———

*Provenance* Arsène Alexandre, Paris—Paul Rosenberg, Paris—Pierre Goujon, Paris—Wildenstein, New York—Paul Mellon, Upperville, Va., 1969—Gift of Mr. and Mrs. Paul Mellon to the Yale University Art Gallery, New Haven, 1983

*Exhibitions* Paris, Hôtel de la Curiosité, 1924, no. 86 [*Les Ouvrières*]—Paris, Musée des Arts décoratifs, 1938, no. 29—Edinburgh, Royal Scottish Academy, 1948, no. 64—Milan, Palazzo Reale, 1959, no. 27, col. ill.—Munich, Haus der Kunst, 1968, no. 21, ill.—Paris, Orangerie, 1968, no. 40, ill.—Houston-Washington-Brooklyn, 1989–1990, no. 24, col. ill.—Zurich-Paris, 1993–1994, no. 163, col. ill.

*Bibliography* Roger-Marx 1946a, p. 53—Perucchi-Petri 1976, pp. 115–116, 139, fig. 71—Cogeval 1993 and 2002, pp. 54, 57, col. ill. p. 56—Easton 1994, p. 15, ill. p. 14—Kahng 1999, p. 259

———

Painted in 1893, *The Stitch* is perhaps the most striking of all Vuillard's paintings of seamstresses at work. In a brightly lit interior, three seamstresses are absorbed in their labour. The central figure, viewed from the back, is caught in a moment of arrested motion: having pulled her needle away from the fabric she is sewing, she prepares to place the next stitch. This painting is a marriage of contradictions that manages to be simultaneously abstract and intricate. Vuillard has deftly juxtaposed sharply delineated planes of pure, unmodulated colour—the pale wall at the far left, the panes of glass in the window, the chair in the lower left-hand corner, the silhouette of the seamstress seated at the centre—with the sumptuous patterns of the wallpaper, the tablecloth, the mouldings of the picture frame and the disordered pile of fabric that forms a kind of haphazard still life in the foreground at the right.

Unlike so many of Vuillard's paintings on the theme, and despite the vertical format and the lack of space surrounding the figures, this interior feels surprisingly airy. This is due largely to the strong illumination from the

1. Johannes Vermeer, *The Lacemaker*, c. 1669-1670, Paris, Musée du Louvre.

window and the light it casts on the bare wall opposite. The placement of the window, the silvery light that pervades the room and the mood of hushed stillness inevitably call to mind the paintings of Johannes Vermeer, whose work Vuillard knew and admired.[1] Vuillard would have had ample opportunity to view *The Lacemaker* (fig. 1), kept at the Louvre, and perhaps saw other paintings by the Dutch master during his trip to Holland and Belgium in 1892. He may also have known *A Young Woman Standing at a Virginal* (c. 1670, London, National Gallery), a painting belonging to the critic Thoré-Bürger that was sold at auction in Paris in December 1892.

Vermeer is not the only source of inspiration at play in this painting, however. The use of the silhouette, which appears quite often in Vuillard's work of the 1890s, can be traced to a number of artistic sources, most notably—as Perucchi-Petri has noted—Japanese prints and the posters of Toulouse-Lautrec.[2] The flat, black silhouette of the woman's body, the severity of which is lightened by the touches of blue paint on her shoulders and raised arm, stands out in sharp relief against the wallpaper framing her head, and contrasts vividly with the vibrant white, pale lavender and buttery yellow of the scraps of fabric near her back. Easton has also suggested that the influence of Georges Seurat can be seen here, both in the use of silhouette and in the rather hieratic poses of the figures, noting that a retrospective of Seurat's work had recently been shown, first at the Salon des Indépendants in the spring of 1892 and then, later that year, at the offices of *La Revue blanche*.[3]

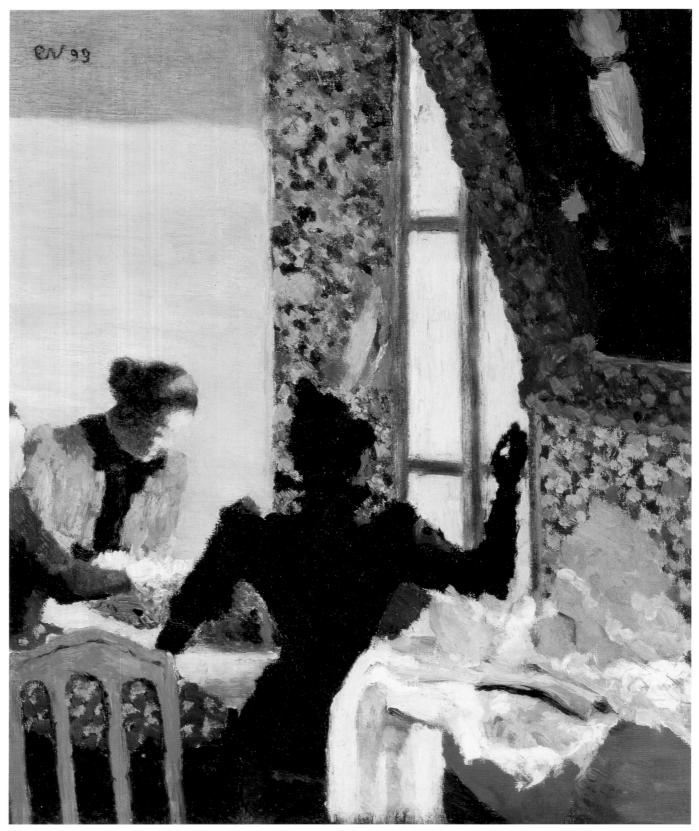

Into the strictly feminine sphere portrayed here Vuillard has introduced a masculine presence in the form of the portrait that hangs out at an angle from the wall on the right. The subject of the painting is unknown, but Cogeval has reasonably suggested that it may be the artist's deceased father, Honoré Vuillard.[4] The presence of the artist's father in what is essentially a domestic and familial setting—it is not difficult to see the features of Vuillard's mother and sister in the two seamstresses at the left—would certainly be fitting. Nevertheless, he remains an unacknowledged and apparently superfluous presence in this domain. The inclusion of the painting is noteworthy, however, for it represents one of the first examples of Vuillard's use of a picture within a picture, a device that would reappear with increasing frequency in the years to follow.

*The Stitch* was originally owned by Arsène Alexandre, the French writer and collector, who was a staunch supporter of modern art and an early admirer of Vuillard. KJ

---

1. On November 24, 1888, Vuillard made a sketch in his journal of *The Lacemaker*, in a cartouche: "Afternoon at the Louvre…"

2. Perucchi-Petri 1976, pp. 115–116.

3. Easton 1989, pp. 44–45.

4. Cogeval in C-S 2003, no. IV.143.

## 87

KERR-XAVIER ROUSSEL READING THE NEWSPAPER · *Kerr-Xavier Roussel lisant le journal*

1893, oil on plywood, 23 × 28
Private collection

Cogeval-Salomon IV.119

---

*Provenance* Studio—Private collection

*Exhibitions* Munich, Haus der Kunst, 1968, no. 25, ill.—Paris, Orangerie, 1968, no. 41, ill.

*Bibliography* Salomon 1945, ill. p. 15—Salomon 1961, p. 42, ill.—Ciaffa 1985, pp. 222–224, fig. 97

---

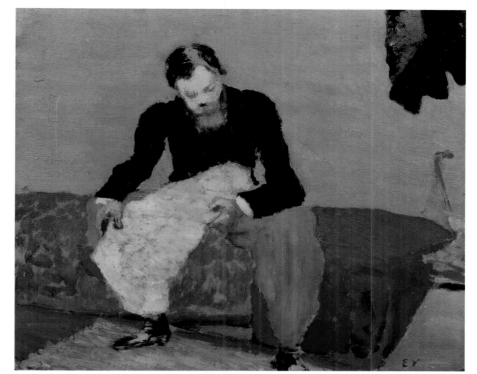

87

Painted in 1893, the year Roussel married Vuillard's sister Marie, *Kerr-Xavier Roussel Reading the Newspaper* is less a portrait of a member of the artist's family than a celebration of a fellow artist and intellectual. Roussel is depicted seated on a low couch in the artist's studio, his dark jacket forming a sharp contrast to the pale grey-green wall behind him. The room is bare except for the couch, a rug, what appears to be an overcoat hanging on the wall in the upper right-hand corner and—somewhat incongruously—a lady's parasol, which possibly serves as a reminder either of Roussel's amorous escapades or of the proximity of Marie. The subject is dressed in "artist's apparel," a morning coat and a pair of "zouave" trousers of tussore silk made for him by Marie. Roussel's apparent absorption in his reading, the choice of the artist's studio as the setting and the lack of domestic trappings, with the exception of the symbolic but highly ambiguous parasol, all seem to indicate that this is, as Cogeval has suggested, Vuillard's final homage to a comrade before he abandons bachelorhood for the married state.[1]

Although the image appears eminently casual, it was in fact planned carefully in advance: in Vuillard's sketchbook from 1893 there is a fairly precise drawing of this composition (fig. 1). With the exception of two minor details—the exact position of the parasol seen at the far right of the composition and what appears to be a picture of some kind hanging

1. Édouard Vuillard, *Study for "Kerr-Xavier Roussel Reading the Newspaper,"* 1893, graphite on paper, private collection.

on the wall over Roussel's right shoulder—the drawing is virtually identical to the final painting, indicating that Vuillard was satisfied with his original conception.

Vuillard's technique here is fluid and assured. The work is painted on plywood, and Vuillard has to great effect left a considerable amount of this support exposed, most notably in Roussel's face and hair and also in the coverlet on the couch, where the bare wood becomes part of the pattern. Most of the sweeping strokes used for the background are horizontal, but others follow the curve of the silhouette, leaving visible in several areas a thin margin of exposed wood between the figure and the ground. KJ

---

1. Cogeval in C-S 2003, no. IV.119.

# 88

MARIE AT THE BALCONY RAILING ·
*Marie accoudée au balcon*

1893, oil on board, 34 × 30
The Beverly Sommer Collection

Cogeval-Salomon IV.122

*Provenance* Studio—Charles Boyer, Los Angeles and Scottsdale, Ariz.—Acquavella, New York—Malcolm Wiener, New York—The Beverly Sommer Collection

*Exhibitions* Houston-Washington-Brooklyn, 1989–1990, no. 76, col. ill.

*Bibliography* Easton 1989, p. 99—Cogeval 1993 and 2002, col. ill. p. 53

In a sketchbook from 1893, Vuillard executed a quick but very precise sketch in preparation for this unpretentious painting of a young woman at a window (fig. 1). Open windows appear quite often in Vuillard's work. Like doorways, another of the artist's favourite motifs, they operate as a convenient architectural device for framing his figures and highlighting their interaction, while also serving to introduce light and a sense of fresh air into his otherwise hermetic and rarefied interiors. In this painting, the artist's sister leans out of an open window, her elbow resting on the railing, her face cradled in her hand in a decidedly contemplative, almost melancholy gesture as she watches the cityscape beneath her. The picture is composed basically of a series of strong verticals—the window, the stone facing of the building, the massive, block-like shapes of the apartment buildings rendered in quick slashes of yellow, white and black paint, the chimneys that punctuate

the brilliant blue sky—and the intersecting diagonals formed by the railing and Marie's body, which draw the eye irresistibly. Strikingly, the composition is divided equally between the apartment interior and the city beyond, the blue-grey edge of the window neatly bisecting the picture vertically, while the figure of Marie spans and unites the two. This emphasis upon the exterior, quite remarkable for an "interior" of this period, anticipates the outdoor scenes of the later 1890s, most notably those painted at the Roussels' home at L'Étang-la-Ville. The pose itself would find its echo some ten years later in Vuillard's photograph of Lucy Hessel reclining against a railing in the artist's apartment on Rue de la Tour (cat. 205). KJ

# 89

INTERIOR WITH WORKTABLE, also known as THE SUITOR · *Intérieur à la table à ouvrage* ou *Le Prétendant*

1893, oil on board, 31.7 × 36.4
Signed and dated l.r.: *ev. 93*
Northampton, Mass., Smith College Museum of Art, purchased with the Drayton Hillyer Fund

Cogeval-Salomon IV.132

*Provenance* Bernheim-Jeune, Paris—Jacques Seligmann, New York—Smith College Museum of Art, Northampton, 1938

*Exhibitions* Paris, Le Barc de Bouteville, Oct.–Nov. 1893, no. 6—London, Tooth & Sons, 1934, no. 35—Chicago, Art Institute, 1938–1939, no. 26, ill.—Cleveland-New York, 1954, p. 101, ill. p. 48—Munich, Haus der Kunst, 1968, no. 20, ill., cov. col. ill.—Paris, Orangerie, 1968, no. 39, col. ill.—Houston-Washington-Brooklyn, 1989–1990, no. 28, col. ill.—Zurich-Paris, 1993–1994, no. 162, col. fig. 19 p. 45

*Bibliography* Roger-Marx 1946a, p. 52, ill. p. 33—Roger-Marx 1948b, pl. 16—Schweicher 1949, pp. 30–35, 46, 91, 104–105—Salomon 1961, p. 40, ill.—Russell 1974, pl. 5—Perucchi-Petri 1976, pp. 106, 110, 112, col. pl. 65—Thomson 1988, pp. 36, 84, col. pl. 49—Easton 1989, pp. 48–50, 52–53, 65, 68–69—Brachlianoff 1990, p. 173—Cogeval 1990, p. 126, ill.—Perucchi-Petri 1990, pp. 151, 154, col. ill. p. 152—Cogeval 1993 and 2002, p. 47, col. ill. pp. 46–47—Perucchi-Petri 1993a, p. 47, col. fig. 19—Sidlauskas 1997, p. 107, ill. p. 108

## 90

INTERIOR WITH RED BED, also known as THE BRIDAL CHAMBER · *Intérieur au lit rouge* ou *La Chambre nuptiale*

1893, oil on board mounted on cradled panel, 32.5 × 53
Signed twice, l.r.: *ev* and *Vuillard*
Private collection

Cogeval-Salomon IV.133

*Provenance* Bernheim-Jeune, Paris—Jacques Seligmann, New York—Jerome Hill, United States and France—Stephen Hahn, New York, with David Findlay, New York, E. V. Thaw, New York, and others—Private collection, California, 1977—David Findlay, New York, 1982—Jay Pritzker, Chicago, c. 1983—Josefowitz Collection—Private collection

*Exhibitions* Paris, Le Barc de Bouteville, Oct.–Nov. 1893, no. 7—Houston-Washington-Brooklyn, 1989–1990, no. 34, col. ill.—Lyon-Barcelona-Nantes, 1990–1991, no. 58, col. ill. pp. 12–13—Montreal, MMFA, 1998, no. 176, col. ill. p. 45

*Bibliography* Roger-Marx 1932, ill. pp. 240–241—Chastel 1954, ill. p. 43—Easton 1989, pp. 53–54—Cogeval 1993 and 2002, pp. 66–67, col. ill.—Cogeval 1998b, p. 119, col. ill. p. 45

## 91

SKETCH FOR "THE SUITOR" AND "THE BRIDAL CHAMBER" · *Esquisse pour "Le Prétendant" et "La Chambre nuptiale"*

1893, charcoal on paper, 33 × 21.3
Private collection

*Interior with Worktable*, also known as *The Suitor*, is justifiably among Vuillard's most famous paintings, for it is a work in which the artist perfectly merges the intimate with the decorative to create an image that is both visually and psychologically rich. With its voluptuous use of pattern, flickering brushwork and distinctive theme—women absorbed in feminine activities within a cloistered interior space—it exemplifies Vuillard's increasingly sophisticated approach to the domestic interior, while presaging two of his most exquisite large-scale decorative projects: the panels executed for Thadée and Misia Natanson (cats. 126–129) and for Dr. Henry Vaquez (cats. 137–140), painted in 1895 and 1896 respectively.

Both the setting—Madame Vuillard's workshop—and the protagonists are familiar. Kerr-Xavier Roussel, whose features are immediately recognizable, peers into the room from behind a camouflaged door, the austerity of his black suit contrasting sharply with the bright colours and vigorous patterns in which the room is described. Standing in the left foreground, manoeuvring a length of blue fabric across the surface of the worktable, the artist's sister Marie raises her head at the sudden interruption to gaze at the intruder. As the two figures become aware of one another's presence, the seamstress on the right remains oblivious to their interaction: it is a moment frozen in time, fraught with possibilities.

1. Announcement of the marriage between Marie Vuillard and Kerr-Xavier Roussel, 1893, private collection.

It was Salomon who astutely assigned the title *The Suitor* to the Smith College painting, seeing a connection between the "idyllic character" of this work and the marriage between Roussel and Marie, which took place the year it was executed.[1] Cogeval has taken this suggestion one step further, moreover, arguing quite persuasively that this painting and its companion piece, *Interior with Red Bed*, are directly linked to the wedding of Marie and Roussel and form a kind of diptych that depicts "the wedding march of the bachelor Nabi."[2]

Cogeval's interpretation is supported by the existence of a preparatory drawing (cat. 91), which he first published in 1998[3] and which reveals the hitherto unknown connection between the two paintings. As he has noted, the relative size of the two images in the drawing differs considerably from that of the final products. Although *Interior with Red Bed* is the larger of the two and is almost identical in height to *Interior with Worktable*, in the preparatory drawing the former is much smaller than the latter and its placement on the page, just below the *Interior with Worktable* sketch, gives it the appearance of a predella to the larger image.[4] Nevertheless, the proximity of the sketches leaves little doubt that the two paintings were conceived as a pair, while the date of 1893 (which can now also be assigned to *Interior with Red Bed*) and the identity of the figures inevitably link both paintings to the year's most significant event in Vuillard's personal life: the marriage of Marie and Roussel.

Unhappy with his friend Roussel's numerous amorous adventures, one of which had necessitated a precipitous journey to Belgium and Holland late in the autumn of 1892, Vuillard appears to have encouraged Roussel to begin keeping company with his sister Marie in the hope that he would settle down. Vuillard's strategy proved fruitful and on July 20, 1893, the couple were married (fig. 1). The two were, however, woefully ill-matched. Roussel, charming, handsome and intellectual, had little in common with the rather plain and diffident Marie, who was seven years his senior. Unfortunately, the family remained blind to this incompatibility, though it would eventually result in much heartache and several periods of estrangement.

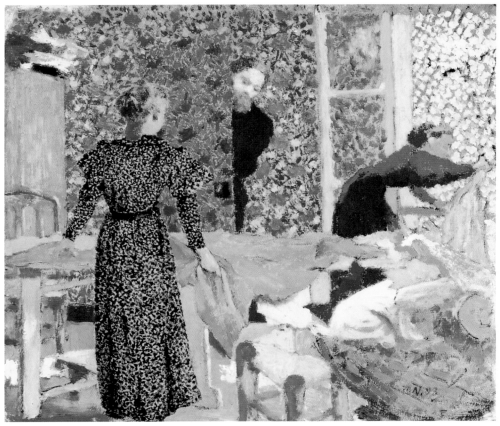

89

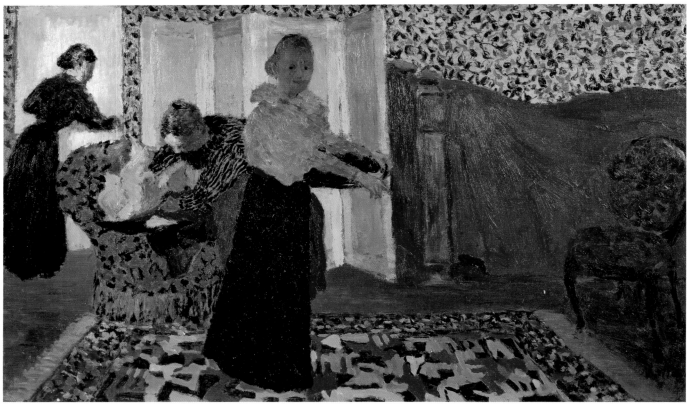

90

91

Marie is the dominant figure in both paintings, and Vuillard has endowed his sister with a sensuousness and an elegance absent in most of his other depictions of her. In *Interior with Worktable* Marie is described in a series of rounded lines, from the curve of her cheekbone, to the full sleeves of her dress, to the graceful sweep of her skirt. Although her features are hidden from the viewer by the artist's use of a *profil perdu*, he has emphasized other characteristics, notably the line of her neck and the chignon of hair above it, that accentuate her femininity rather than her skill as a seamstress.

In *Interior with Red Bed* Vuillard shows Marie as an ebullient fiancée, preparing the home that she and Roussel will share following their wedding. Once again, Vuillard has depicted three figures within an interior: Marie, her mother and a third woman whose svelte figure and dark dress suggest that she is the anonymous seamstress who also appears in the other painting. The mood of this work is optimistic. Marie stands near the centre of the composition, smiling contentedly at the viewer. The room is filled with bright, warm tones and vibrant patterns (the wallpaper, the rug, the chair) juxtaposed with planes of solid colour (the door, the folding screen, the coverlet), which gives the painting a greater sense of space and order than that found in its pendant.

While the mood of *Interior with Worktable* is almost flirtatious, *Interior with Red Bed*, by contrast, is stately, a distinction that is reflected in the artist's sources of inspiration. In relation to the former, Cogeval notes Vuillard's fascination with marionette shows, comparing Roussel's pose to that of a puppet appearing from behind a curtain. Even more intriguing, however, is this author's comparison of the interaction between Marie and Roussel with an image from the courtship of Arlequin and Colombine in a show called *Pauvre Pierrot*, which was part of Émile Reynaud's "Pantomimes lumineuses" (1892). Given Vuillard's well-known fascination with the theme of Pierrot (see cats. 50–53) and the novelty of Reynaud's invention—a predecessor of the cinematograph—the artist could hardly fail to have been interested.[5]

In *Interior with Red Bed*, Vuillard exploits more traditional sources, from both East and West. The composition seems to be drawn at least in part from the Japanese print, in particular a work by Utagawa Kunisada, casting Marie in the role of a geisha standing before a folding screen. Her actual pose, on the other hand, appears to be borrowed from ancient Roman depictions of figures carrying offerings.[6]

Both paintings were among a group of eleven works that Vuillard exhibited at Le Barc de Bouteville in October 1893, which were well received in the press. Thadée Natanson praised them for "the depth of the compositions' easy charm, the particularly intense appeal of the tonalities and colours";[7] Maurice Cremnitz admired the "profoundly impassioned soul" of Vuillard's figures;[8] and Gustave Geffroy perceptively observed that the paintings "remind one of the woolly reverse side of a tapestry,"[9] perhaps recognizing a manifestation of the decorative impulse that would play an even greater role in the years to come. KJ

1. Salomon 1961, p. 40.

2. Cogeval in C-S 2003, nos. IV.132, IV.133.

3. Cogeval 1998b, p. 119.

4. Cogeval in C-S 2003, nos. IV.132, IV.133.

5. Ibid.

6. Ibid.

7. Thadée Natanson, "Expositions. Un Groupe de peintres. MM. Maurice Denis, Marc Mouclier, K. X. Roussel, Édouard Vuillard, P. Ranson, P. Sérusier, F. Vallotton, Pierre Bonnard, I.G. Ibels," *La Revue blanche*, vol. 5, no. 25 (November 1893), p. 339.

8. Maurice Cremnitz, "Exposition de quelques peintures chez le Barc de Bouteville," *Essais d'art libre* (December 1893), pp. 231–232.

9. Gustave Geffroy, "Vuillard, Bonnard et Roussel" (October 29, 1893), in *La Vie artistique*, vol. 6 (Paris: E.H. Floury, 1900), p. 296.

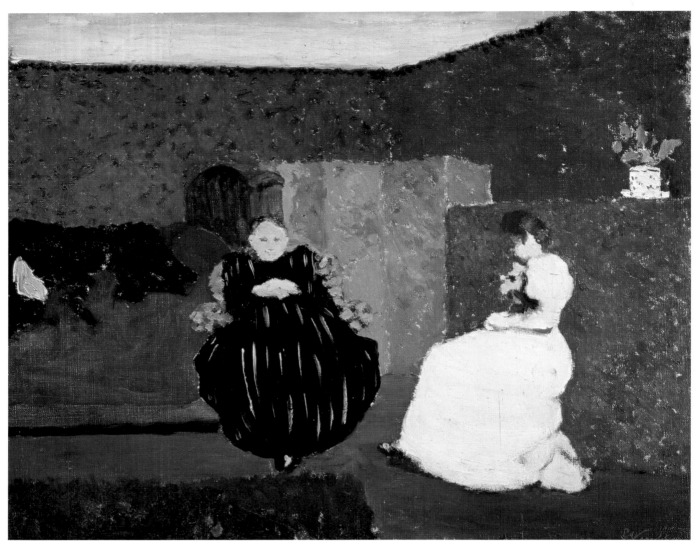

## 92

THE CHAT, also known as THE BRIDE ·
*La Causette* ou *La Mariée*

1893, oil on canvas, 32.4 × 41.3
Edinburgh, Scottish National Gallery of
Modern Art, Presented by Sir Alexander
Maitland, in memory of his wife, Rosalind,
1960

Cogeval-Salomon IV.134

———

*Provenance* Studio—Marcel Hendricks-
Masurel, Paris—A. de Lampe—Arthur
Tooth & Sons, London—Sir Alexander
Maitland, Great Britain, 1950—Maitland
Gift to the National Gallery of Scotland,
Edinburgh, 1960; transferred to the Scottish
National Gallery of Modern Art, Edin-
burgh, 1984

*Exhibitions* Houston-Washington-Brooklyn,
1989–1990, no. 57, col. ill.

*Bibliography* Mauner 1978, p. 260—Thomson
1988, col. pl. 67—Easton 1989, pp. 83–84—
Cogeval 1993 and 2002, pp. 50–51, col. ill.—
Sidlauskas 1997, p. 93, ill.

———

Cogeval has affirmed that the inspiration for
this painting was the wedding of Vuillard's
sister Marie to the painter Kerr-Xavier Rous-
sel on July 20, 1893.[1] Rather than the wedding
ceremony, however, Vuillard has elected
to paint an event prior to it: Madame Vuillard
imparting words of wisdom to her daughter
in preparation for the nuptials. The setting, a
sombre and unprepossessing interior painted
in muted shades of brown, is designed to
serve as a neutral backdrop for the subtle
interaction between the two women. Madame
Vuillard is almost at the centre of the compo-
sition. Dressed in a black gown with pale pink
stripes—a departure from the strict conven-
tions of mourning—she is a solid, immutable
presence, and her placid expression and serene
smile bespeak her satisfaction with the pro-
ceedings. Seated to her left and viewed in
profile is Marie, dressed in her white wedding
gown. The younger woman's posture, head
bowed, face in shadow and hands folded
demurely in her lap, is quintessentially that of
the obedient and dutiful daughter receiving
words of maternal advice immediately before
her wedding. This depiction of the two
women is a study in contrasts: frontal view
and profile, black and white, maturity and
youth. Physically separate, the two figures are
nonetheless intimately linked, each serving
as a foil for the other and helping to establish
the provocative dynamic that energizes this
otherwise mundane scene. KJ

———

1. Cogeval in C-S 2003, no. IV.134.

## 93

THE BLUE SLEEVE · *La Manche bleue*

1893, oil on board mounted on cradled panel,
26.6 × 22.3
Signed and dated u.r.: *ev 93*
New York, Collection Malcom Wiener

Cogeval-Salomon IV.147

———

*Provenance* Acquired from the artist by
Ambroise Vollard, Paris—Wildenstein, New
York—Doris Warner Vidor, New York—
Private collection, New York

*Exhibitions* Paris, Le Barc de Bouteville, Oct.–Nov. 1893, no. 2—Cleveland-New York, 1954, p. 101, ill. p. 42—Houston-Washington-Brooklyn, 1989–1990, no. 58, col. ill.

*Bibliography* Ciaffa 1985, pp. 177–180, 272, fig. 64—Easton 1989, pp. 82–83—Easton 1994, pp. 9–16

The setting for this unusual painting is a familiar one. It is a corner of the dining room of the family apartment on Rue Saint-Honoré, identifiable by the densely patterned wallpaper and the strip of windows above. It is the same space that Vuillard depicted from a more distant point of view in *Interior* (fig. 1), right down to the details of the hanging lamp, the table and the high-backed slatted chair.

For all the seeming familiarity of the setting, *The Blue Sleeve* is a rather striking departure from Vuillard's other depictions of seamstresses at work, in that its emphasis is on the figure rather than the act in which she is engaged. The subject is once again the artist's sister Marie, who is shown pausing in her work, a newspaper held in her outstretched hand. She turns to look at the artist, her body twisted toward him, her elbow and lower arm resting upon the chair back. The sense of anonymity and absorption that we find in Vuillard's other paintings of seamstresses has been replaced by an acute awareness on the part of the sitter, who engages the artist—and consequently the viewer—in a remarkably direct manner. Marie's attentiveness contrasts with the preoccupation of the seamstress seated in the background, who continues to work, oblivious to, or uninterested in, the intrusion of the artist. Yet, even as Marie gazes outward, to a certain degree she is inscrutable as well. Forgione has noted her "masklike impenetrability," an effect created by sharp contrasts of light and dark, as well as the "blank opacity" of her eyes, which makes it impossible to truly connect with her.[1] She remains, in the end, another compelling but ultimately ambivalent cipher.

Both Easton and Cogeval have remarked upon the strongly photographic quality of this image. While Easton comments on the spatial distortions similar to those caused by the photographic apparatus of the time,[2] noting the curious disjunction between the monumental form of Marie in the foreground and the much smaller figure in the background, Cogeval emphasizes the contrast between the sharp delineation of Marie and the blurred and almost unreadable form of the other woman.[3]

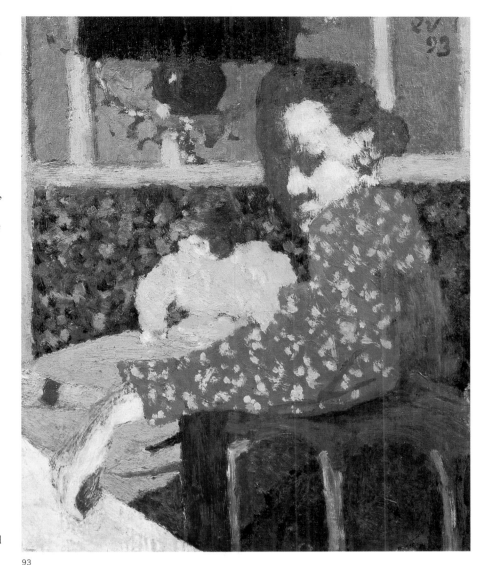

93

1. Édouard Vuillard, *Interior*, 1894, oil on board mounted on canvas, Washington, The Phillips Collection.

Such curious inconsistencies appear throughout the painting, most notably in the way the relation of Marie's figure to the chair back seems to place her above the seat rather than on it, and in the gross disproportion between her lower arm, from elbow to wrist, and the rest of her body. The result is an image that is both potent and strangely disconcerting. KJ

1. Forgione 1992, pp. 117–118.

2. Easton, 1994, pp. 9–17.

3. Cogeval in C-S 2003, no. IV.147.

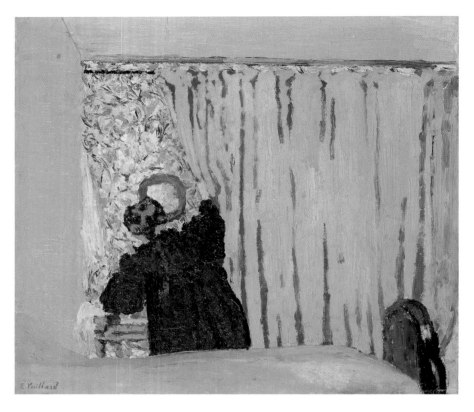

## 94

THE YELLOW CURTAIN · *Le Rideau jaune*

c. 1893, oil on canvas, 35 × 39
Washington, National Gallery of Art,
Ailsa Mellon Bruce Collection

Cogeval-Salomon IV.160

*Provenance* Studio—Edward Molyneux,
Paris, c. 1952—Mrs. Ailsa Mellon Bruce, New
York, 1955—Mellon Bruce Bequest to the
National Gallery of Art, Washington, 1970

*Exhibitions* Paris, Charpentier, 1948, no. 6—
Houston-Washington-Brooklyn, 1989–1990,
no. 46, col. ill.—Florence, Palazzo Corsini,
1998, no. 9, col. ill. p. 48—Montreal, MMFA,
1998, no. 177, col. ill. p. 26

*Bibliography* Easton 1989, p. 66—Sidlauskas
1997, ill. p. 94—Cogeval 1998a, p. 180—
Cogeval 1998b, p. 120

This painting presumably depicts the bedroom
of Vuillard's mother in the family residence
at 346, rue Saint-Honoré, where they lived
between 1891 and 1896. The titular curtain,
which dominates much of the composition,
separates the bedroom proper from the dress-
ing room, a common practice in bourgeois
domiciles of the time. Madame Vuillard,
wearing a dressing gown, her braided hair
trailing down her back, pulls the curtain aside,
offering a tantalizing glimpse of her dressing
room, which is decorated in brightly patterned
wallpaper and furnished with a dressing table
and a small round mirror. Her gesture, her
apparel and her informal coiffure all indicate
that she has been captured just as she is about
to dress for the day.

The composition of *The Yellow Curtain* is
striking in both its simplicity and its con-
straint. The space within the picture is tightly
condensed. The figure of Madame Vuillard
is trapped between the solid form of the yellow-
draped bed, which extends across the fore-
ground, and the curtain, which clearly sepa-
rates the space she occupies from the area
beyond. The muted colours and unadorned
surfaces of the bedroom—the walls, the bed,
the curtain, even the robe of Madame Vuillard
herself—contrast sharply with the ornate
décor of the dressing room, which draws the
viewer's eye toward it, just as it draws the
figure.

As Cogeval notes, in this painting we are in
effect voyeurs, given a surreptitious and fleet-
ing glimpse into an intimate scene from which
we are about to be excluded.[1] The subject, a
woman at her *toilette*, had considerable cur-
rency among artists of the nineteenth century,
including Manet, Degas and Bonnard, all of
whom explored it to great effect. Despite the
potentially provocative subject, there is noth-
ing prurient or sensual about Vuillard's de-
piction. On the contrary, the image bespeaks
stateliness and modesty, even as it hints at
the hidden mysteries of the feminine realm.

Forgione has seen a connection between
Madame Vuillard's gesture, as she draws back
her bedroom curtain, and Vuillard's associa-
tion with the theatre, proposing the rehearsals
that the artist observed at the Conservatoire
de Musique et de Déclamation as a possible
inspiration for the pose, while also citing the
use of the motif in his theatre programs for
both *Rosmersholm* (cat. 66) and *Les Soutiens
de la société* (cat. 73).[2] Whether or not Vuillard
intended such overt allusions, the gesture is
inherently theatrical and revelatory. KJ

1. Cogeval in C-S 2003, no. IV.160.

2. Forgione 1992, p. 146.

## 95

WOMAN IN BLUE · *La Dame en bleu*

1895, oil on board, 49 × 58
Private collection

Cogeval-Salomon IV.213

*Provenance* Studio—Private collection

*Exhibitions* Paris, MNAM, 1955, no. 35—
Milan, Palazzo Reale, 1959, no. 9, ill.—Ham-
burg-Frankfurt-Zurich, 1964, no. 11, ill.—
Paris, Orangerie, 1968, no. 111, ill.—Toronto-
San Francisco-Chicago, 1971–1972, p. 227,
col. pl. V—Zurich-Paris, 1993–1994, no. 170,
col. ill.—Florence, Palazzo Corsini, 1998,
no. 61, col. ill. p. 100—Montreal, MMFA,
1998, no. 181, col. ill. p. 46

*Bibliography* Salomon 1945, ill. p. 21—
Chastel 1948, col. pl. VI—Chastel 1954, p. 52,
col. ill.—Russell 1971, p. 24—Cogeval
1998a, p. 189

*Woman in Blue* is an unusual work in Vuil-
lard's oeuvre of the mid-1890s. Although its
subject—figures seated in a domestic interior
—is a familiar one, the location portrayed is
less so. Here the artist departs from his long-
standing predilection for depicting the inti-
mate confines of the Vuillard family apartment
and turns his attention instead to the salon of
the Ranson home, located on the first floor at
25, boulevard du Montparnasse. A founding
member of the Nabi circle, Paul Ranson was
known within the group as "the Nabi who is
more Japanese than the Japanese Nabi [Bon-
nard]," while his studio, located on the fourth
floor, became known as "The Temple" and
served as the meeting place for the group. Both
his studio and his salon became the setting for
passionate debates on subjects ranging from
art and theatre to religion and philosophy.

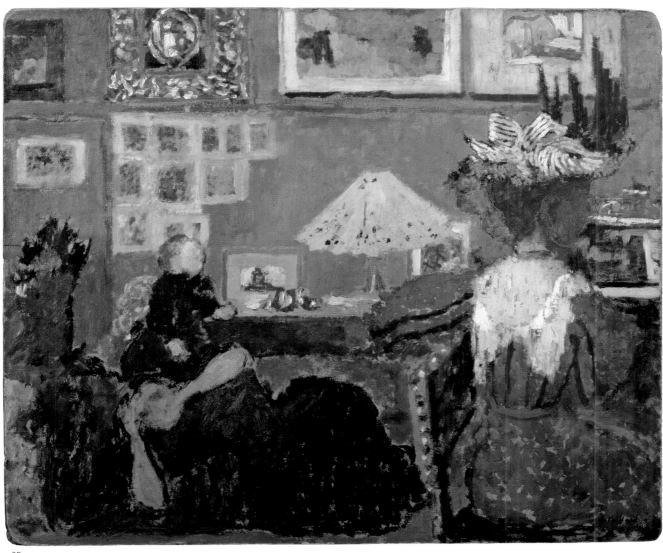

95

In this painting, Vuillard brings to bear the same sense of wry observation that is so apparent in his depictions of his own family's apartment. In keeping with the vocation of its residents, the Ranson salon is filled with paintings of various shapes and sizes, irresistibly drawing the viewer's eye into the work. Covering the rear wall are paintings by fellow Nabi artists, several of which have been identified: Jan Verkade's *Red Apples* (1891, private collection) in the upper left, a gift from the artist to Madame Ranson;[1] Paul Sérusier's *Paul Ranson in Nabi Costume* (1890, private collection) in the large gilded frame in the upper right-hand corner; and Sérusier's *Stonecutters* (1890, Ottawa, National Gallery of Canada), which hangs directly beside it in the simple white frame.[2]

Within this rarefied and artistic framework, Vuillard depicts a group of women in the midst of a social call. Salomon has readily identified three of them.[3] Reclining on a cushion in the foreground is France, Paul Ranson's much-admired wife, who was accorded the honorary title "Light of the Temple" by the members of the Nabi circle. Seated demurely behind her at the table is her mother, Ida Rousseau. Both women are dressed in mourning in tribute to France's father, who died early in 1895. The inclusion of this detail supports the dating of the painting to 1895, rather than the earlier date of 1890 first proposed by Salomon.[4]

The most striking figure of the group is the titular visitor seated at the far right, whose vivid blue dress and outrageously beribboned and befeathered hat contrasts dramatically with the sombre attire of the other women. This figure has been identified as Mademoiselle Fornachon, a regular at the Ranson home.[5] She is perched on a chair with her back to the viewer, her torso twisted to the side and her arm resting on the chair back in a pose reminiscent of that used by the artist in his earlier painting *The Blue Sleeve* (cat. 93). It is a casual gesture that betrays a sense of intimacy and of long familiarity with the household.

In addition to these three women, there is a fourth, shadowy figure at the far left who is little more than a vague silhouette. Cogeval describes her as a "visiting ghost,"[6] a spectral presence within the painting whose impact is more evocative and caricatural than realist. Given the date of the painting, his reference to the scandalous romance between France's sister Germaine and Kerr-Xavier Roussel, husband of Vuillard's sister Marie, seems pertinent. The sordid affair casts a pall, both literal and figurative, over the room's inhabitants, isolating the figures from one another in an unpleasant atmosphere of family drama. KJ

1. Humbert 1954, p. 52; Boyle-Turner 1989, p. 52.

2. Cogeval 1998b, no. 124, p. 109.

3. Salomon 1961, p. 34.

4. Salomon 1945, p. 21.

5. *Pierre Bonnard, Vuillard et les Nabis, 1888–1903*, exhib. cat. (Paris: Musée national d'art moderne, 1955), no. 35.

6. Cogeval in c-s 2003, no. IV.213.

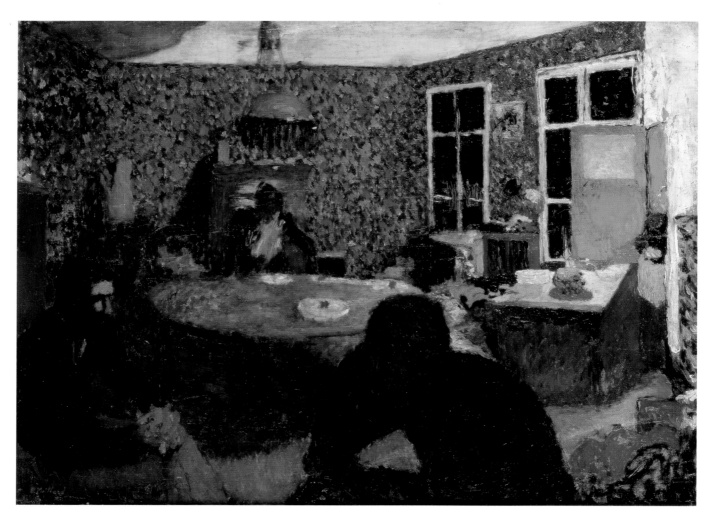

## 96

A FAMILY EVENING · *Soirée familiale*

1895, oil on canvas, 48 × 65
Private collection

Cogeval-Salomon IV.211

*Provenance* Studio—De Hauke, Paris—
Knoedler, New York—Doris Warner Vidor,
New York—Richard L. Feigen, New York—
Josefowitz Collection—Sale, Christie's,
New York, May 7, 2002, lot 10 (col. ill.)—
Private collection

*Exhibitions* Basel, Kunsthalle, 1949, no. 181
[dated 1905]—Houston-Washington-Brook-
lyn, 1989–1990, no. 69, col. ill.

*Bibliography* Ciaffa 1985, pp. 138–142, fig. 46
—Easton 1989, p. 97—Sidlauskas 1997, p. 109,
ill. p. 110

As Cogeval has remarked, *A Family Evening*
is among the most autobiographical of all of
Vuillard's paintings.[1] Drawing upon Vuillard's
journal and other documents in the Salomon
Archives, he has reconstructed the sequence
of events that led up to the crisis within the
Roussel ménage that Vuillard evokes in this
painting.

In his chronology for 1895, Vuillard records
"complications in the Roussel household," an
oblique reference to the tumultuous events in
which the family was embroiled at that time.
The marriage between Kerr-Xavier Roussel
and Vuillard's sister Marie had been less than
solid from the outset, marred by Roussel's
ongoing affair with Germaine Rousseau that
had begun in 1891. Marie's miscarriage in
December 1894 led to a marked deterioration
of the marriage, and Roussel's increas-
ing absences and ill humour further estranged
him from the Vuillards. By July 1895, the
situation had become so acrimonious that
Roussel abandoned Marie and took up resi-
dence with his mother. Although mutual
friends attempted to intervene discreetly in
the hope of putting an end to the increasingly
scandalous situation, their efforts met with
little apparent success. Faced with widespread
disapprobation, however, Roussel and
Germaine eventually broke off their affair,
and by the end of 1895 or early in 1896 the
situation had more or less settled down.

In this disquieting and psychologically
charged picture, Vuillard plays out the family
drama. Both Ciaffa and Easton have remarked
upon the mood of melancholy and malaise
that suffuses the scene, and Easton has percep-
tively seen it as evidence that "all was not

happy with the Roussels at first."[2] The picture
portrays an evening meal during the increas-
ingly tense months prior to Roussel's depar-
ture from the Vuillard family home in July
1895. The familiar interior of the apartment
on Rue Saint-Honoré that appears in so many
of the artist's paintings of the early 1890s has
been transformed, and the luminous work-
room occupied by industrious seamstresses
has been replaced by a gloomy, nocturnal in-
terior reminiscent of a stage set for a Symbol-
ist play. Ciaffa in particular notes the strong
similarity between this painting and the final
scene of *Intérieur*, a one-act play by Maurice
Maeterlinck performed at the Théâtre de
l'Oeuvre on March 15, 1895, with Lugné-Poe
and Sérusier in the leading roles.[3] The scene
is moodily lit, not by the hanging lamp at the
centre of the room but by a small oil lamp
placed on the sideboard, which brightly illu-
minates the right side of the room while leav-
ing the opposite side and its occupants veiled
in shadow. Although it is unlikely that this
painting was specifically intended as a re-
creation of the final scene from Maeterlinck's
text, the sense of foreboding that permeates it
is certainly in keeping with the atmosphere of

the play. Vuillard's predilection—so evident here—for sombre, nocturnal scenes would be further explored to great effect in the coming years (cats. 144–145).

The mood of the scene is unrelentingly solemn, the space airless and claustrophobic, hemmed in by opaque windows and the figures themselves, who seem to block every possible route of escape. Seated at the left is Frédéric Henry, an architect and friend of both Vuillard and Roussel, while Roussel himself is the shadowed figure occupying the centre foreground, his body hunched over in a pose of some dejection. Marie stands behind the table, head bowed, situated at the furthest possible point from her husband, her figure small and insubstantial compared to his. Madame Vuillard appears on the right in the open doorway, standing on the threshold as if reluctant to enter the room itself. Each of the figures remains isolated and distant from his or her companions, and the tension between them is almost palpable. Vuillard records it all with the unflinching candour of a disinterested observer, rather than as an active participant who had in fact been the orchestrator of the ill-starred marriage. K J

1. Cogeval in C-S 2003, no. IV.211.

2. Ciaffa 1985, p. 138; Easton 1989, p. 97.

3. Ciaffa 1985, pp. 139–142.

# 97

WOMAN SEATED IN A DARK ROOM ·
*Femme assise dans une pièce sombre*

c. 1895, oil on board mounted on panel,
36.7 × 26.3
The Montreal Museum of Fine Arts,
purchase, 1988–1993 Museum Campaign
Fund, inv. 296-2001

Cogeval-Salomon IV.205

*Provenance* Studio—Sam Salz, New York—
Gift to Ralph F. Colin, New York, 1951—
Galerie Bellier, Paris—Private collection—
Acquired by The Montreal Museum of Fine
Arts, 2001

*Exhibitions* Florence, Palazzo Corsini, 1998,
no. 58, col. ill. p. 97—Montreal, MMFA, 1998,
no. 183, col. ill. p. 46

*Bibliography* Cogeval 1998a, pp. 188–189—
Cogeval 1998b, p. 121

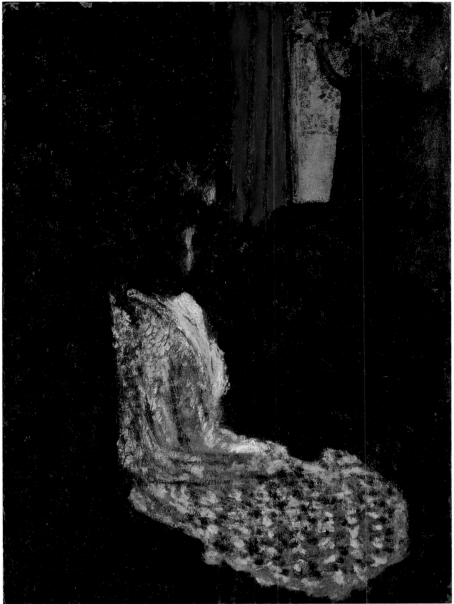

97

Within a darkened interior, a solitary female figure is seated, her features obscured by shadow. Although her body is viewed in profile, she turns her gaze toward what appears to be a window or an open doorway, the only source of illumination in the tenebrous interior. The mood of this painting is mysterious and mildly unsettling, calling to mind Vuillard's other experiments in the depiction of oddly lit, nocturnal interiors of this time such as *A Family Evening* (cat. 96) and *Interior, Mystery* (cat. 144). The woman is sketchily painted, her form rapidly defined by the pale slash of paint in her bodice and the flickering touches that suggest the polka-dotted pattern of her dress. The figure stands out in stark contrast to the dark cushions on which she is seated and the shadowy confines of the room around her, whose gloom is alleviated only by the faint illumination provided by the window or doorway and the vibrant red drapes beside it.

In view of the intimate quality of Vuillard's work in general and, in particular, the autobiographical elements that began to emerge around this time—*A Family Evening* being the primary example of the development of this aspect of his art—it is tempting to interpret this painting in an equally personal manner. His sister Marie, who had long been a favourite model, is almost certainly the figure depicted in this painting. The gloomy setting is an appropriate one for the portrayal of a young woman abandoned by her charismatic but unfaithful husband. In this regard, the painting seems to presage the more directly autobiographical painting *Married Life: The Absence* (1896, priv. coll., C-S IV.217), which evokes the same mood of melancholy and depicts Marie in an almost identical pose. K J

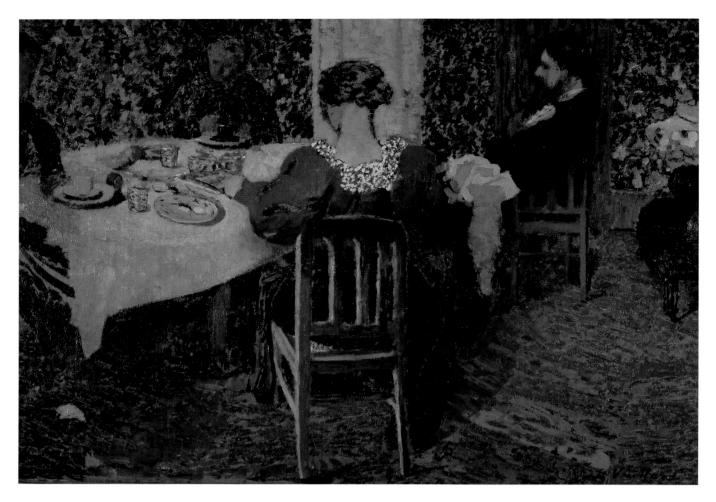

## 98

THE TABLE: END OF A LUNCH
AT THE VUILLARD HOME · *La Table,
la fin du déjeuner chez madame Vuillard*

c. 1895, oil on board mounted on cradled
panel, 49.5 × 68.5
Signed l.r.: *E. Vuillard*
Private collection

Cogeval-Salomon IV.212

*Provenance* Jos Hessel, Paris—Louis Carré,
Paris—Alfred Daber, Paris—Charpentier,
Paris—Private collection, New York

*Exhibitions* Paris, Bernheim-Jeune, Nov. 1908,
no. 31—Zurich, Kunsthaus, 1932, no. 129—
Paris, Musée des Arts décoratifs, 1938, no. 48
—Cleveland-New York, 1954, p. 102, col.
ill. p. 58

*Bibliography* Chastel 1946, ill. p. 46—Roger-
Marx 1946a, pp. 55, 79, ill. p. 36—Ciaffa 1985,
pp. 154–156, fig. 49

Seated at the table after a meal are the mem-
bers of the artist's family: his sister Marie in
the foreground, her husband Kerr-Xavier
Roussel to her right, the artist's mother at

the far side of the table and a fourth figure,
barely visible at the far left, who is presum-
ably Vuillard himself. *The Table* recalls similar
paintings by the artist, in particular *Lunchtime*
(cat. 78), which likewise depicts four mem-
bers of the Vuillard family sharing a meal,
including the artist—there, as here, a spectral
presence.

In contrast to that earlier, rather congenial
scene, *The Table* is an understated and highly
disconcerting study of a family under stress.
Although it has been assigned various dates
over the years, ranging from as early as
1893–1895 to as late as 1899, it can reason-
ably be dated to about 1895, the very time
(as Cogeval has astutely ascertained) that the
Roussel marriage was undergoing a crisis
because of Roussel's continuing infidelities.[1]
The tensions within the family are palpable
throughout this composition. The figures do
not appear to interact with one another, and
the lively conversation apparent in such earlier
paintings as *The Green Dinner* (1891, Lon-
don, priv. coll., C-S IV.4; see cat. 80, fig. 1) is
markedly absent. Roussel, who is viewed in
profile, stares fixedly ahead, his manner and
posture aloof. In contrast, both the artist and
his mother remain vague and insubstantial.
Vuillard is but a shadow at the far left and his
mother, usually a solid presence, seems almost
to vanish into the wallpaper behind her.

The focus of the painting is the artist's sister
Marie, who serves as the fulcrum upon which
the composition is balanced. She is viewed
from behind, her body placed at the centre.
Directly beyond her is what appears to be a
door, its white rectangle framing her head and
neck and accentuating her form, even as it
helps to introduce a strong vertical presence
that is picked up and continued by the chair
back and legs, effectively bisecting the picture
from top to bottom. Like the family itself, the
composition is divided in two, with Vuillard
and his mother on one side and Roussel on the
other, while the unfortunate Marie remains
trapped in between.

Whether from sympathy or from his innate
love of elegant form, the artist appears to
have taken great delight in emphasizing the
various aspects of Marie's appearance, from
the rounded sleeves of her vivid red blouse
and the delicate polka-dotted collar, up
through the smooth, pale flesh of her impos-
sibly elongated neck. As Cogeval has noted,
Vuillard's fascination with this part of the
female anatomy would later be confirmed in
*The Nape of Misia's Neck* (cat. 149), a subtle
and sensual homage to the female body.[2] KJ

1. Cogeval in C-S 2003, no. IV.212.

2. Ibid.

156

## 99

1893 SKETCHBOOK

5.9 × 10.8
Private collection

## 100

1894–1895 SKETCHBOOK

8 × 11.5
Private collection

## 101

DAYBOOK

1896, 8.1 × 5.5
Private collection

## 102

"ÉTINCELLES" SKETCHBOOK

1902, 10.8 × 17
Private collection

Vuillard likely placed little value on these small sketchbooks from the most gloriously creative period of his life, as they no doubt served the same purpose as the *aide-mémoire* photos he took in later years, after acquiring his first Kodak (see "Vuillard and His Photographs," in the present volume). But it is astonishing to discover that nearly all of his Nabi works, which appear to have been done without preparation, were in fact preceded by scrupulously accurate drawings that lay out the final composition. The 1893 sketchbook, the most interesting of the four, contains the main outlines of such important paintings as *Kerr-Xavier Roussel Reading the Newspaper* (cat. 87), *Marie at the Balcony Railing* (cat. 88) and *Madame Vuillard Sewing* (New York, priv. coll., c-s IV.138). It includes all the familiar figures that people his paintings—his mother, his friends, his sister—brought to life with great compassion and the same sense of caricature that can be detected throughout Vuillard's oeuvre, whatever the period.

Some of these tiny scenes are also "abandoned ideas." An extraordinary double page shows the artist himself strolling in the countryside against a backdrop of poplars that impose a rhythm on the space. And just above, another frame contains a sardonically humorous image: Marie visiting Kerr-Xavier Roussel at home, or possibly the two of them meeting at the Rue Pigalle studio—Vuillard did all he could to encourage the young couple's engagement—or perhaps visiting Aunt Saurel in Créteil. The composition is certainly comical; in just a few pencil strokes, Vuillard has captured Marie's bemusement and Roussel's profound boredom. Already, we feel, they have nothing to say to each other.

Leafing through this sketchbook, one senses that Vuillard knew exactly what he wanted, even when sketching theatre sets. Several pages show different elements of a set design that may have been for *Rosmersholm*, which was staged at the Bouffes du Nord in October 1893.

The 1894–1895 sketchbook is less remarkable, with the exception of a lovely drawing for *The Chestnut Trees* (cat. 125), the stained-glass window that Vuillard created for the exhibition held at Siegfried Bing's Maison de l'Art Nouveau in 1895.

The 1896 daybook might well be called the "Valvins diary." The Natansons were renting a house called La Grangette in Valvins that year, and Vuillard visited them twice, once in the summer and again in the fall. Returning from a trip to Switzerland in September, he passed through his native village of Cuiseaux —the times of the trains from Geneva and the connections are noted in this diary. One particularly touching image shows "Petit-Jean," the baby born to Kerr-Xavier Roussel and Marie on August 26 who was to die on November 6. Vuillard apparently made most of the daybook sketches on his second trip, from October 20 to December 20, since the landscapes are those of autumn. There is an exterior view of La Grangette, a drawing of Cipa Godebski—Misia's brother—asleep, and one of Misia writing. On the page for February 23, the artist jotted down a few interesting thoughts: "For the litho think of the pencil on stone, of the quality, subject of secondary importance to me apart from that."

When, after 1900, Vuillard began spending extended periods in the country, he always carried a sketchbook and his camera. For the summer of 1902, the Hessels rented a villa called Les Étincelles, in Criquebœuf (Léon Blum would succeed them the following summer). During his stay there Vuillard began using larger sketchbooks, which allowed him to enhance some of his drawings of the Normandy landscape with watercolour. GC

1893 sketchbook, fol. 10v–11r, *Marie Vuillard / Landscapes*,
graphite on paper.

1893 sketchbook, fol. 19v–20r, *Kerr-Xavier and Marie / Vuillard Taking
a Walk*, graphite on paper.

1894–1895 sketchbook, fol. 7r–8v, *Sketch for "The Chestnut Trees"* / *Madame Vuillard*, graphite on paper.

1894–1895 sketchbook, fol. 12v–13r, *The Table* / *The Square*, graphite on paper.

Daybook, 1896, May 2–3, *Cipa Asleep*, graphite on paper.

Daybook, 1896, May 10–11, *Petit-Jean*, graphite on paper.

Daybook, 1896, July 6–7, *Mallarmé's House at Valvins*, graphite on paper.

Daybook, 1896, July 10–11, *Misia Writing at La Grangette in Valvins*, graphite on paper.

"Étincelles" sketchbook, 1902, fol. 20r, *Landscape at Criquebœuf*, graphite and watercolour on paper.

"Étincelles" sketchbook, 1902, fol. 13r, *Landscape at Criquebœuf*, graphite and watercolour on paper.

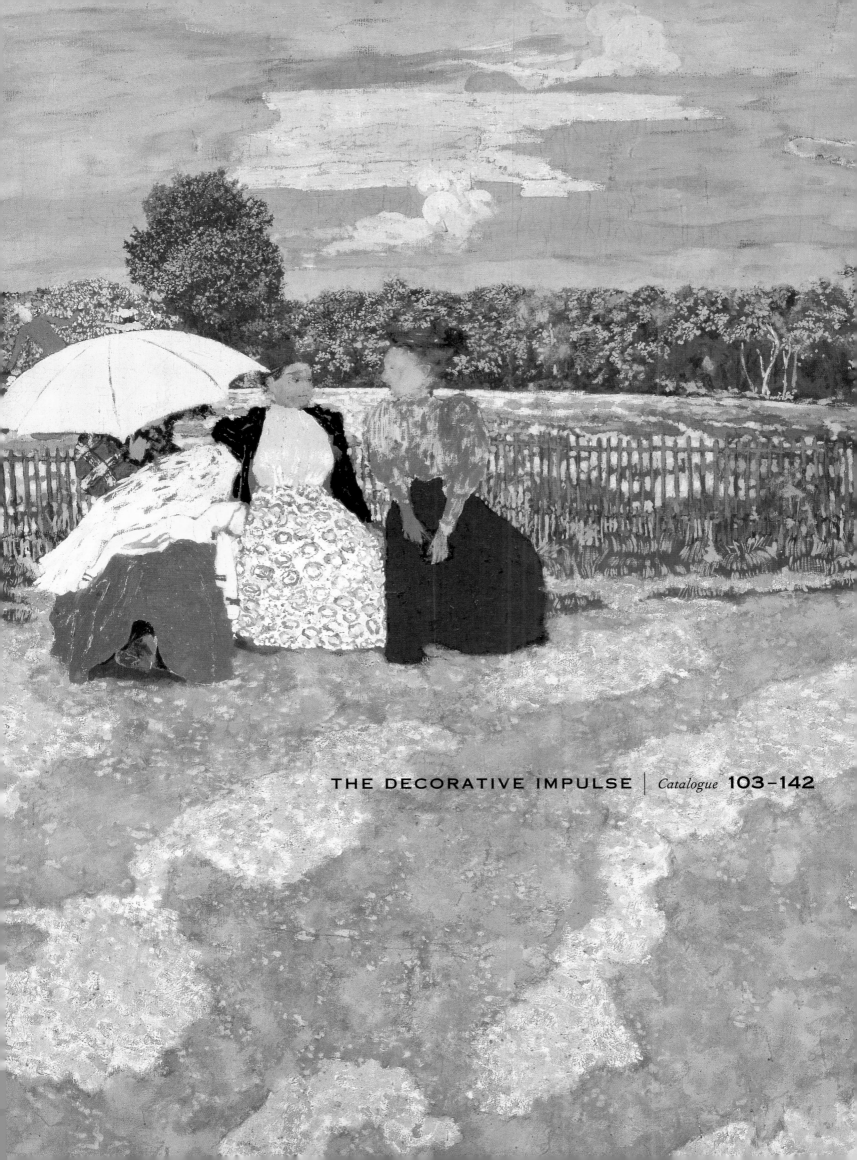

THE DECORATIVE IMPULSE | *Catalogue* **103–142**

THE CONCEPTS OF DECORATION and the decorative that were intrinsic to the
Nabi aesthetic during the 1890s reflected the group's conscious rejection of academic
tradition and of the longstanding division between the fine and the decorative arts. Like
Paul Gauguin and his followers, the young Nabis eschewed pictorial illusionism—or,
as in the case of Vuillard, the literal transcription of reality—in all their work, reaffirm-
ing the two-dimensional picture plane instead. Their position was later summed up by
the Dutch painter Jan Verkade, a one-time member of the Nabi group: "No more easel
painting! Down with useless furnishings!…Down with perspective! The wall must
remain a surface, must not be breached by the representation of infinite horizons. There
are no pictures, there are only decorations!"[1]

In their quest to reinvigorate traditional art, the Nabis drew inspiration from
a variety of sources—the Arts and Crafts movement in Britain and the murals of
Pierre Puvis de Chavannes, as well as more "primitive" art forms such as Japanese art,
medieval tapestries and Italian Trecento painting. They also extolled the virtues of
harmony in colour, form and arabesque, both as a way of achieving visual equilibrium
and as a means of expressing a moral or spiritual component, of transcending the mun-
dane reality of the world around them.

For Vuillard, the creation of decorations was a logical and perhaps even
inevitable outgrowth of the work he was producing for the theatre. Early in their careers,
Vuillard and his fellow Nabis worked on decorative projects for several avant-garde
theatres, designing sets, posters and programs. It was through his work for the theatre
that Vuillard was introduced to the technique of distemper (*détrempe*), also known as
*peinture à la colle*, which would become his medium of choice for decorative paintings
and eventually his preferred medium for painting in general. This technique involved
mixing dry pigments with rabbit glue (or size) and then using heat to liquefy the mixture.
Unlike oil paint, this fast-drying material allowed the artist to work—and rework—
a surface rapidly. It also produced a very distinctive paint surface, smooth and matte,
or heavy and scumbled in areas that had been reworked and built up.

Vuillard's career as a painter-decorator began in 1892 with a commission to
produce a suite of six overdoors for the salon of the Desmarais residence (cats. 103–
108). He quickly carved a niche for himself as a creator of decorative panels designed
to adorn the private homes of the Parisian intelligentsia. Unlike many of his colleagues,
including Pierre Bonnard and Maurice Denis, who initially produced works designed
in accordance with decorative precepts without envisaging any specific environment,
Vuillard always worked by commission, creating pieces that were planned with a parti-
cular client and almost invariably a precise locale in mind. Vuillard's keen awareness
of the site-specific nature of his decorations was such that he actually altered or adapted
certain projects in order to accommodate their reinstallation in a new setting (cats. 111–118,
263–264). The number of such works by Vuillard clearly attests to his keen abilities in
the genre. Between 1892 and 1899 he completed no fewer than eight different decorative
projects, comprising more than thirty separate pieces.[2]

Although Vuillard's experience in the theatre and his espousal of the decorative aesthetic defended by the Nabis both played a central role in fostering his interest in this domain, credit must also be given to the Natansons, who actively supported Vuillard's early career as a painter of domestic decorations. In fact, many of Vuillard's key decorative projects were commissioned by various members of the Natanson family. Alexandre, the eldest of the three Natanson brothers and a co-founder of *La Revue blanche*, commissioned *The Public Gardens* (cats. 111–118, 123–124). His brother and sister-in-law, Thadée and Misia, commissioned a suite of five panels (cats. 126–129). A cousin, Stéphane Natanson, commissioned the decorative screen *Figures in an Interior* (cat. 141) and was instrumental in helping Vuillard to obtain a commission for the suite of overdoors (cats. 103–108) and a folding screen for his brother-in-law, the industrialist Paul Desmarais. In 1899 Adam Natanson, the patriarch of the Natanson clan, commissioned a pair of paintings to decorate his library (see cat. 142). Several other works were commissioned by people with whom Vuillard came into contact as a result of his involvement in *La Revue blanche*, among them the writer Jean Schopfer (cats. 131–136, 263–264). Not only did these patrons within the Natanson circle prove to be discerning, they also allowed the young artist an extraordinary degree of latitude in the subjects he depicted and the manner in which he completed the commissions.

Always open to experimentation, Vuillard frequently adopted unconventional formats and techniques and explored a variety of media, producing not only large decorative panels and overdoors, but folding screens and ceramics as well. He also enjoyed a brief association with the impresario Siegfried Bing, for whom he executed a design for a stained-glass window (cat. 125) and in whose gallery, the Maison de l'Art Nouveau, he exhibited several works in 1895 (cats. 126–129, 131–136).

The relationship between Vuillard's decorations and his easel paintings, which drew upon and echoed the same sources of inspiration, was a fluid one. The result, in both realms, is a complex marriage between tradition and modernity. In their subject matter, his decorations consistently reveal the artist's celebration of the world around him: workshops filled with industrious seamstresses, public gardens populated by children and their nannies, country homes inhabited by friends and family, rarefied and ornate interiors—the very subjects that dominate the easel paintings of the 1890s, simply translated into a grander scale. As in his smaller works, Vuillard fashioned richly animated surfaces, consciously emulating and merging sources as varied as Japanese woodblock prints, Persian miniatures and, above all, tapestries.

Rarely exhibited and virtually unknown to the public at large during Vuillard's lifetime, the decorations are among the artist's most personal works. Expressly designed to be experienced within the intimate confines of a private interior space, they are, like the small-scale pictures of domestic interiors, a sumptuous manifestation of Vuillard's *intimiste* inclinations. **Kimberly Jones**

1. Willibrod [Jan] Verkade, *Le Tourment de Dieu; étapes d'un moine peintre* (Paris: Librairie de l'art Catholique, 1926), p. 94. This translation taken from Cogeval 1998b, p. 42.

2. Segard 1914, pp. 320–321.

## Six Overdoors for Monsieur and Madame Paul Desmarais · *Six dessus-de-porte pour M. et Mme Paul Desmarais* (103–108)

Cogeval-Salomon v.28

*Joint Provenance*  Paul Desmarais, Paris – Private collection

*Joint Exhibitions*  Milan, Palazzo Reale, 1959, nos. 18 and 19 (cats. 103–104), ill.—Munich, Haus der Kunst, 1968, nos. 66–71, ill.—Paris, Orangerie, 1968, nos. 32–37, ill.—Lyon-Barcelona-Nantes, 1990–1991, no. 41—Zurich-Paris, 1993–1994, p. 45, no. 158, col. ill.

*Joint Bibliography*  Marx 1892a, 1892b, 1892c—Segard 1914, p. 289, no. 1, p. 320—Salomon 1945, p. 41—Roger-Marx 1946a, pp. 120–121, ill. p. 33—Russell 1971, pp. 30–31, 51, 224, ill. pp. 34–35—Perucchi-Petri 1976, pp. 110–111, 120, 125–126, 129, col. figs. 68, 79—Mauner 1978, pp. 97, 104, 246, 301, no. 3—Perucchi-Petri 1990, pp. 138, 143, 154—Cogeval 1993 and 2002, pp. 30–31, 72 (2002) col. ill.—Groom 1993, pp. 3, 19–34, 36–41, 45, 46, 49, 50, 85, 90, col. figs. 24–29—Groom 2001, pp. 118–119, col. ill. p. 119

## 103

THE DRESSMAKING STUDIO—I · *L'Atelier de couture — I*

1892, oil on canvas, 48 × 117
Private collection

Cogeval-Salomon v.28-1

## 104

THE DRESSMAKING STUDIO—II · *L'Atelier de couture — II*

1892, oil on canvas, 48 × 117
Private collection

Cogeval-Salomon v.28-2

## 105

STROKING THE DOG · *La Caresse au chien*

1892, oil on canvas, 48 × 117
Private collection

Cogeval-Salomon v.28-3

## 106

GARDENING · *Le Jardinage*

1892, oil on canvas, 48 × 117
Private collection

Cogeval-Salomon v.28-4

## 107

A GAME OF SHUTTLECOCK · *La Partie de volant*

1892, oil on canvas, 48 × 117
Private collection

Cogeval-Salomon v.28-5

## 108

NURSEMAIDS AND CHILDREN IN A PUBLIC PARK · *Nourrices et enfants dans un jardin public*

1892, oil on canvas, 48 × 117
Private collection

Cogeval-Salomon v.28-6

## 109

SKETCH FOR THE "DESMARAIS PANELS" · *Esquisse pour les "Panneaux Desmarais"*

1892, pastel and charcoal on brown paper, 44.5 × 31.2
Private collection

## 110

SKETCH FOR THE "DESMARAIS PANELS" · *Esquisse pour les "Panneaux Desmarais"*

1892, pastel and charcoal on brown paper, 55.7 × 39.8
Private collection

This suite of panels marks Vuillard's debut as a painter of decorative works produced for the homes of private clients. Like most of the artist's decorative projects of the 1890s, this one can be traced directly to his association with *La Revue blanche* and the Natanson circle. In this case, the credit goes to Stéphane Natanson, a cousin of the Natanson brothers. An architect trained at the École des Beaux-Arts, Stéphane apparently encouraged his sister Léonie and her new husband, the wealthy industrialist Paul Desmarais, to commission Vuillard to execute six decorative panels for the salon of their town house at 43, rue de Lisbonne, in the Parc Monceau district.

The first known reference to the panels appears in a letter from Paul Ranson to Jan Verkade, dated June 1892: "Vuillard is decorating a very chic salon with overdoors."[1] Another letter, this one from Stéphane Natanson to Vuillard and dated November 18, 1892, confirms that the commission had been completed and that the artist received a total of two thousand francs for his efforts. Stéphane goes on to say that while Paul Desmarais was "somewhat astonished initially," he would "get used to them and end up liking them as we do. There is already one panel, the one with the dog, that he admires very much."[2]

Historically there has been a great deal of confusion about the installation of these paintings. The frequently repeated assertion that the panels were created specifically to be fitted into mahogany woodwork in the dressing room of the Desmarais mansion is incorrect,[3] since, as Groom has pointed out, the Desmarais mansion on Avenue de Malakoff did not yet exist, and the couple was living on Rue de Lisbonne when the panels were commissioned.[4]

Even more complicated is the question of the precise arrangement of the panels themselves. As Ranson's letter indicates, the Desmarais panels were always intended to serve as overdoors. Indeed, the width of each picture—117 centimetres—corresponds roughly to the width of a door, suggesting that each panel was intended to hang above a separate doorway. Cogeval, however, has brought to light a pair of pastel drawings (cats. 109–110) that, along with a study in oil,[5] reveal how the panels were originally installed. The two pastels clearly indicate that the decorations were designed to be hung in two groups of three panels each, stacked one over the other above two separate doors. (The top of a door frame is visible at the bottom of each pastel.)

The format of the panels and their unusual arrangement was clearly a direct response to the architecture of the salon itself, which had not only two doors but also, as Cogeval has noted, a ceiling some 4.3 metres high.[6] The effect of this installation is of two vertical panels, each nearly two metres in height and comprising three separate registers. Segard, writing in 1914, described the works as "two overdoors for Mme Desmarais,"[7] further confirming that the panels were intended to form two discrete, self-contained parts that functioned as approximate mirror images of one another.

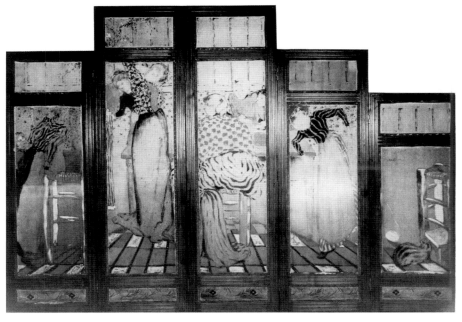

1. Contemporary photograph of the Desmarais screen, showing the five vertical panels and five upper panels in the original frame (now lost), Paris, private collection.

In subject the Desmarais panels portray themes that were increasingly familiar in Vuillard's work of the early 1890s: women engaged in dressmaking, intimate scenes of family life, nurses watching over children at play. The arrangement of the individual panels marks a physical progression of sorts from a cloistered interior at the top (cats. 103–104), via the terrace at the centre (cats. 105–106), to the open spaces of a public garden below (cats. 107–108). At the same time there is a visual progression as the eye is led from the densely patterned panel at the top, through the less elaborate middle register decorated with a few isolated areas of pattern such as the tiles on the ground and the vine-covered walls, down to the flat, unembellished planes of colour in the bottom register.

For all their differences, Vuillard achieves a subtle harmony among the six panels by skillfully exploiting the arabesque, by imposing alternating rhythms of calm and motion, void and active space, and through his use of colour. The panels are woven through with shades of yellow and ochre, while accents of bright red also serve to unify the suite as a whole.

For this, his first decorative project, Vuillard seems to have been drawing upon a number of sources of inspiration. Forgione has noted a connection to shadow theatre in the way Vuillard has deployed the figures across a narrow ledge-like space that calls to mind the shallow layered planes used for such productions.[8] Both Thomson and Cogeval have remarked upon the influence of Italian Trecento paint-ing. The former has compared the overdoors to early Italian predella panels—especially, in the case of the outdoor scenes, those of Fra Angelico—while the latter has suggested the inspiration of the frescoes depicting the *Allegory of Good Government* painted by Ambrogio Lorenzetti for the Palazzo Pubblico in Siena.[9]

Nor were these the only sources of inspiration. Thomson and Perucchi-Petri have both noted the influence of Japanese woodblock prints, especially in regard to the two sewing workroom scenes (cats. 103–104). Perucchi-Petri has argued that they evoke mid-nineteenth-century Japanese prints, such as those by Utagawa Kunisada, in their variety and juxtaposition of motif, their vivid, luminous colours and their lively wallpaper.[10]

In this mingling of influences from East and West, Vuillard was giving expression to the theories of Roger Marx on the proper nature of Symbolist decorative art: "The lessons of the Orient, ancient and modern, seemed in no way to contradict those offered by Romanesque and Gothic art...Never has there been greater appreciation than today of the expressive value of the outline, the power of solid colours, of flat tints, the significance of harmonies—and there is no doubt that the roots of this close understanding lie in the parallels between the aesthetics of the Orient and the Middle Ages."[11] It is little wonder that Marx, the first to write about the Desmarais works, declared them to be "six pieces of the freshest inspiration and the highest ornamental originality."[12]

As well as the suite of panels, the Desmarais commissioned another element of decoration, a five-panel screen depicting seamstresses at work (fig. 1), which was regrettably dismantled and dispersed sometime after its sale in 1945 (various priv. colls.). The screen, which was executed later (the fifth panel bears the date "93"), echoes the theme of seamstresses at work depicted in the topmost panels of the overdoors, thus interjecting into the decoration of the room a strongly vertical element that both harmonized with and played against the arrangement of the overdoors.

In 1903 the Desmarais moved to their new home, the elegant three-storey mansion at 98, avenue Malakoff (now Avenue Raymond Poincaré) designed by Stéphane Natanson for his sister and brother-in-law. The panels were reinstalled in Madame Desmarais's dressing room and were now arranged horizontally, either as a frieze over the cornice or as overdoors; the original arrangement of the panels had ceased to exist.[13]

Never exhibited during the artist's lifetime and rarely commented on in contemporary literature, the Desmarais panels remained relatively unknown for decades, so much so that in 1946 Roger-Marx asked: "What has become of the six panels and the screen executed for Madame Desmarais in 1892, that year of feverish groping? We know of them thanks only to an article in *Voltaire* and to the rough sketches, vigorous in tone, which the artist was careful to preserve."[14] It was not until 1968 that the entire suite of panels was shown together publicly for the first time. KJ

1. Quoted in Mauner 1978, p. 280.

2. Letter from Stéphane Natanson to Édouard Vuillard, November 18, 1892, doc. no. 23, quoted in Cogeval-Salomon 2003, no. V.28.

3. See in particular Bacou 1964, p. 193; Dugdale 1965, p. 96; Frèches-Thory and Terrasse 1990, p. 102.

4. Groom 1993, pp. 36–37.

5. See catalogue of the sale at Christie's, New York, November 9, 1999, no. 272.

6. Cogeval in C-S 2003, no. V.28.

7. Segard 1914, p. 289, note 1.

8. Forgione 1992, p. 73.

9. Thomson 1988, p. 36; Cogeval in C-S 2003, no. V.28.

10. Perucchi-Petri 1976, p. 111.

11. Marx 1892a. Quoted in C-S 2003, no. V.28.

12. Marx 1892b. Quoted in Roger-Marx 1946, p. 205, note 7.

13. Groom 1993, pp. 36–40.

14. Roger-Marx 1946, p. 120.

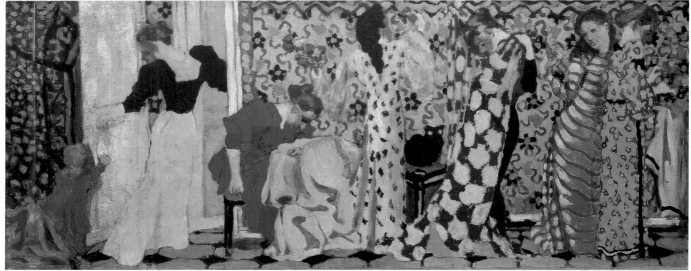

103

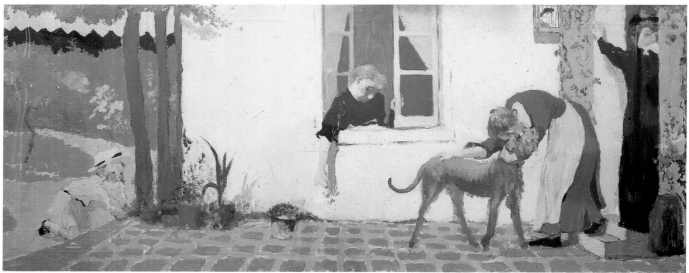

105

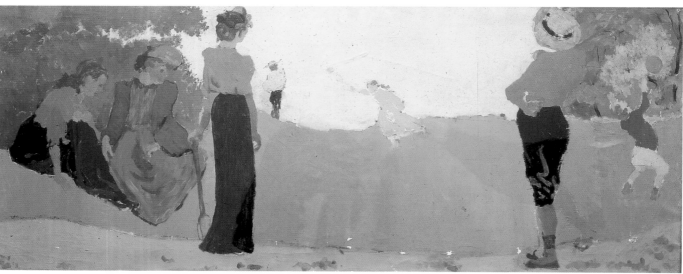

107

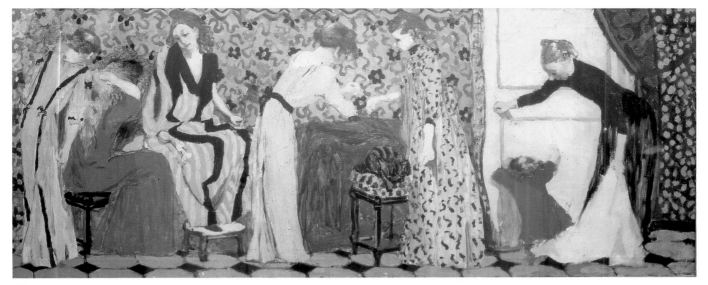

104

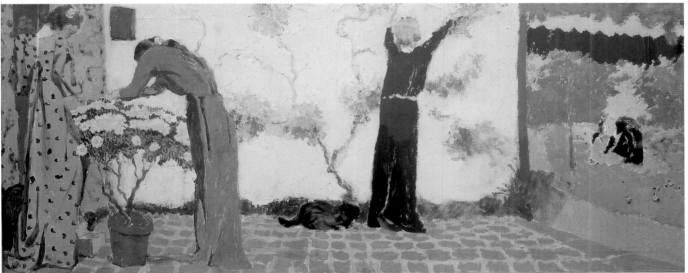

106

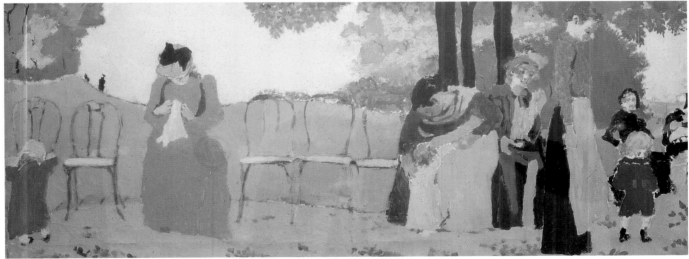

108

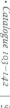

109

110

**The Public Gardens · *Les Jardins publics*
(111–118)**

Cogeval-Salomon v.39

*Joint provenance* Commissioned from Vuillard by Alexandre Natanson, Paris, in January 1894

*Joint exhibitions* Paris, Bernheim-Jeune, 1906, no. 26 ["Neuf panneaux décoratifs"]

*Joint bibliography* Segard 1914, pp. 253, 289–291—Dorival 1943, p. 127—Salomon 1945, pp. 37–40, ill. p. 36—Chastel 1946, pp. 53, 115, ill. p. 29—Roger-Marx 1946a, pp. 53, 83, 121–123, 188, ill. pp. 129, 130—Schweicher 1949, pp. 57–68, 74, 76, 79–82, 92–93, 102, 105, 112–117, 124–130—Salomon 1953, pp. 25–26—Russell 1971, pp. 49–53, 225, ill. pp. 36–39—Perucchi-Petri 1976, pp. 124, 143–147, fig. 94—Frèches-Thory 1979, pp. 305–312, ill.—Cogeval 1990, p. 118—Dumas 1990, p. 74, col. ill. pp. 72–73—Cogeval 1993 and 2002, pp. 72–73, col. ill. pp. 72, 74–77—Groom 1993, pp. 1, 3, 47–65, 67, 69, 77, 89, 101, 124, 128, 150, 158, 160, 206, col. figs. 77–82, 85–86—Groom 2001, pp. 120–124

## 111

THE PUBLIC GARDENS: YOUNG GIRLS PLAYING · *Les Jardins publics. Fillettes jouant*

1894, distemper on canvas, 214.5 × 88
Signed and dated l.r.: *E. Vuillard 94*
Paris, Musée d'Orsay, Bequest of Mme Alexandre Radot, 1978

Cogeval-Salomon v.39-1

*Provenance* [see *Joint provenance*] M. Level, Paris—Mme Knessler, Paris—Mme Edith-May Hirschler (Mme Alexandre Radot)—Mme Alexandre Radot Bequest, 1978; Musée d'Orsay, Paris, 1986

*Exhibitions* [see *Joint exhibitions*] Zurich-Paris, 1993–1994, no. 167d, col. ill.

*Bibliography* [see *Joint bibliography*] Perucchi-Petri 1993b, p. 86, col. fig. 22 (p. 88)

## 112

THE PUBLIC GARDENS: THE QUESTIONING · *Les Jardins publics. L'Interrogatoire*

1894, distemper on canvas, 214.5 × 92
Signed and dated l.r.: *E. Vuillard 94*
Paris, Musée d'Orsay, Bequest of Mme Alexandre Radot, 1978

Cogeval-Salomon v.39-2

*Provenance* [see *Joint provenance*] Alexandre Natanson Sale, Hôtel Drouot, Paris, May 16, 1929, lot 124 (ill.)—M. Level, Paris—Mme Knessler, Paris—Mme Edith-May Hirschler (Mme Alexandre Radot)—Mme Alexandre Radot Bequest, 1978; Musée d'Orsay, Paris, 1986

*Exhibitions* [see *Joint exhibitions*] Zurich-Paris, 1993–1994, no. 167e, col. ill.

*Bibliography* [see *Joint bibliography*] Perucchi-Petri 1993b, p. 86, col. fig. 22 (p. 88)

## 113

THE PUBLIC GARDENS: THE NURSEMAIDS · *Les Jardins publics. Les Nourrices*

1894, reworked in 1936, distemper on canvas, 213.5 × 73
Signed and dated l.r.: *E. Vuillard 94*
Paris, Musée d'Orsay

Cogeval-Salomon v.39-3

*Provenance* [see *Joint provenance*] Alexandre Natanson Sale, Hôtel Drouot, Paris, May 16, 1929, lot 118 (ill.)—Acquired by the French nation; Musée d'Orsay, Paris, 1986

*Exhibitions* [see *Joint exhibitions*] Paris, Musée des Arts décoratifs, 1938, no. 32c—Paris, MNAM, 1955, no. 216—Paris, Orangerie, 1968, no. 53, ill.—Zurich-Paris, 1993–1994, no. 167b, col. ill.

*Bibliography* [see *Joint bibliography*] Rosenblum 1989, col. ill. p. 610—Perucchi-Petri 1993b, p. 86, col. fig. 22 (p. 89)

## 114

THE PUBLIC GARDENS: THE CONVERSATION · *Les Jardins publics. La Conversation*

1894, reworked in 1936, distemper on canvas, 213 × 154
Signed and dated l.r.: *E. Vuillard 94*
Paris, Musée d'Orsay

Cogeval-Salomon v.39-4

*Provenance* [see *Joint provenance*] Alexandre Natanson Sale, Hôtel Drouot, Paris, May 16, 1929, lot 125 (ill.)—Acquired by the French nation; Musée d'Orsay, Paris, 1986

*Exhibitions* [see *Joint exhibitions*] Paris, Musée des Arts décoratifs, 1938, no. 32a—Paris, MNAM, 1955, no. 217—Paris, Orangerie, 1968, no. 51, ill.—Zurich-Paris, 1993–1994, no. 167a, col. ill.

*Bibliography* [see *Joint bibliography*] Rosenblum 1989, col. ill. p. 610—Perucchi-Petri 1993b, p. 86, col. fig. 22 (p. 89)

## 115

THE PUBLIC GARDENS: THE RED PARASOL · *Les Jardins publics. L'Ombrelle rouge*

1894, reworked in 1936, distemper on canvas, 214 × 81
Signed and dated l.r.: [illegible]
Paris, Musée d'Orsay

Cogeval-Salomon v.39-5

*Provenance* [see *Joint provenance*] Alexandre Natanson Sale, Hôtel Drouot, Paris, May 16, 1929, lot 117 (ill.)—Acquired by the French nation; Musée d'Orsay, Paris, 1986

*Exhibitions* [see *Joint exhibitions*] Paris, Musée des Arts décoratifs, 1938, no. 32b—Paris, MNAM, 1955, no. 218—Paris, Orangerie, 1968, no. 52, ill.—Zurich-Paris, 1993–1994, no. 167c, col. ill.

*Bibliography* [see *Joint bibliography*] Rosenblum 1989, col. ill. p. 610—Perucchi-Petri 1993b, p. 86, col. fig. 22 (p. 89)

## 116

THE PUBLIC GARDENS: FIRST STEPS ·
*Les Jardins publics. Les Premiers Pas*

1894, distemper on canvas, 213.4 × 68.5
Signed and dated l.r.: *E. Vuillard 94*
United States, Tom James Company /
Oxxford Clothes

Cogeval-Salomon v.39-7

————

*Provenance* [see *Joint provenance*] Alexandre
Natanson Sale, Hôtel Drouot, Paris, May 16,
1929, lot 119 (ill.)—M. Kleinmann, Paris—
Gaston Gemmendinger, Paris—Seized by the
Nazis during the Occupation; restitution—
Private collection—Tom James Co./Oxxford
Clothes, United States

*Exhibitions* [see *Joint exhibitions*] Chicago-
New York, 2001, no. 32, col. ill. p. 121

## 117

THE PUBLIC GARDENS: THE TWO
SCHOOLBOYS · *Les Jardins publics.
Les Deux Écoliers*

1894, distemper on canvas, 214 × 98
Signed and dated l.r.: *E. Vuillard 94*
Brussels, Musées royaux des Beaux-Arts
de Belgique, inv. 6681

Cogeval-Salomon v.39-8

————

*Provenance* [see *Joint provenance*] Alexandre
Natanson Sale, Hôtel Drouot, Paris, May 16,
1929, lot 123 (ill.)—Princess Bassiano, Paris
—Private collection, Paris—Musées royaux
des Beaux-Arts de Belgique, Brussels, 1953

*Exhibitions* [see *Joint exhibitions*] Paris,
Musée des Arts décoratifs, 1938, no. 33—Paris,
MNAM, 1955, no. 219, ill.—Milan, Palazzo
Reale, 1959, no. 22, ill.—Hamburg-Frank-
furt-Zurich, 1964, no. 87, ill.—Munich, Haus
der Kunst, 1968, no. 72, col. ill.—Paris,
Orangerie, 1968, no. 54, col. ill.—Brussels,
Musées Royaux des Beaux-Arts, 1975, no. 28,
ill.—Zurich-Paris, 1993–1994, no. 167f,
col. ill.

## 118

THE PUBLIC GARDENS: UNDER THE
TREES · *Les Jardins publics. Sous les arbres*

1894, distemper on canvas, 214.6 × 97.7
Signed and dated l.r.: *E. Vuillard 94*
Cleveland, Ohio, The Cleveland Museum
of Art, Gift of the Hanna Fund, 1953.212

Cogeval-Salomon v.39-9

————

*Provenance* [see *Joint provenance*] Alexandre
Natanson Sale, Hôtel Drouot, Paris, May 16,
1929, lot 122 (ill.)—Georges Bénard, Paris—
Henri Blum, Paris—Gift of the Hanna Fund
to the Cleveland Museum of Art, 1953

*Exhibitions* [see *Joint exhibitions*] Paris, Musée
des Arts décoratifs, 1938, no. 34b—Cleve-
land-New York, 1954, p. 101, col. ill. p. 34—
Chicago-New York, 2001, no. 33, ill. p. 121

## 119

STUDY FOR "THE PUBLIC GARDENS":
THE SQUARE · *Étude pour "Les Jardins
publics". Le Square*

1894, brush and ink on brown paper,
64.6 × 50
Washington, National Gallery of Art,
Collection of Mr. and Mrs. Paul Mellon

## 120

STUDY FOR "THE PUBLIC GARDENS"
WITH LAYOUT OF THE ROOM ·
*Étude pour "Les Jardins publics" avec le
plan de la pièce*

1894, brush and ink, and black pencil height-
ened with pastel on paper, 25 × 31.8
Paris, Musée d'Orsay (on deposit at the
Département des arts graphiques du Musée
du Louvre)

## 121

STUDY FOR THE TRIPTYCH IN
"THE PUBLIC GARDENS" · *Étude pour
le triptyque des "Jardins publics"*

1894, charcoal and pastel on paper, 25 × 32
Paris, Musée d'Orsay (on deposit at the
Département des arts graphiques du Musée
du Louvre)

## 122

STUDY FOR FOUR PANELS IN
"THE PUBLIC GARDENS" · *Étude pour
quatre panneaux des "Jardins publics"*

1894, charcoal and pastel on paper,
24.8 × 32
Paris, Musée d'Orsay (on deposit at the
Département des arts graphiques du Musée
du Louvre)

## 123

THE PUBLIC GARDENS:
OVERDOOR—I · *Les Jardins publics.
Dessus-de-porte—I*

1894, distemper on canvas, 40 × 149
Paris, Françoise Marquet Collection

Cogeval-Salomon v.39-10

————

*Provenance* Alexandre Natanson, Paris—
Zao Wou-Ki, Paris—Private collection, Paris

*Bibliography* Groom 1993, p. 64, col.
fig. 110a-b

## 124

THE PUBLIC GARDENS:
OVERDOOR—II · *Les Jardins publics.
Dessus-de-porte—II*

1894, distemper on canvas, 40 × 149
Paris, Françoise Marquet Collection

Cogeval-Salomon v.39-11

————

*Provenance* Alexandre Natanson, Paris—
Zao Wou-Ki, Paris—Private collection, Paris

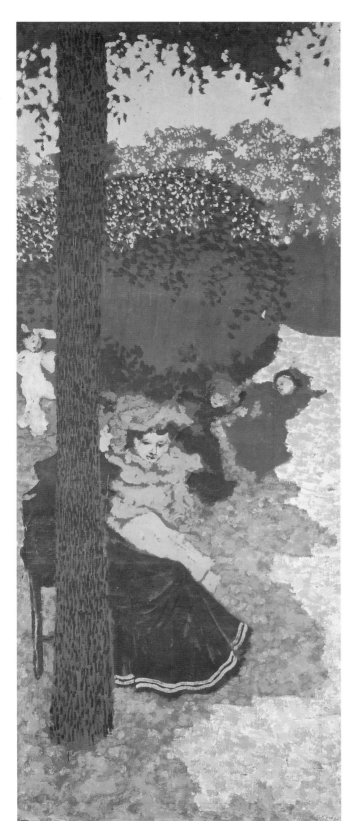

111

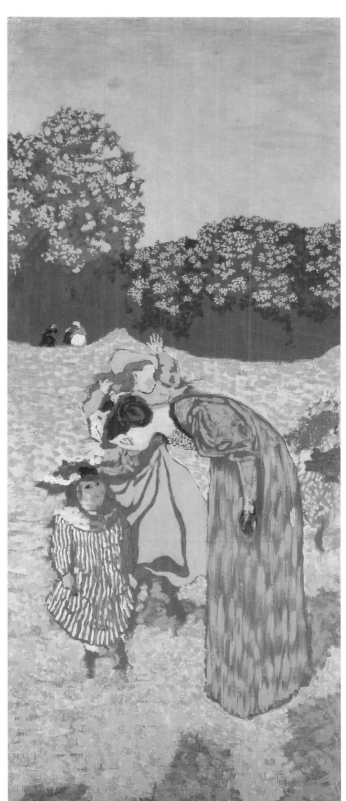

112

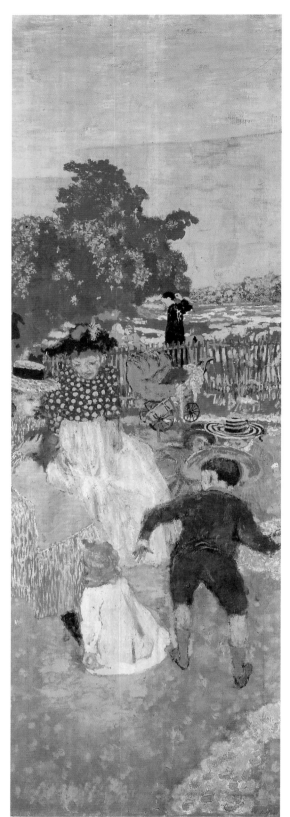

113

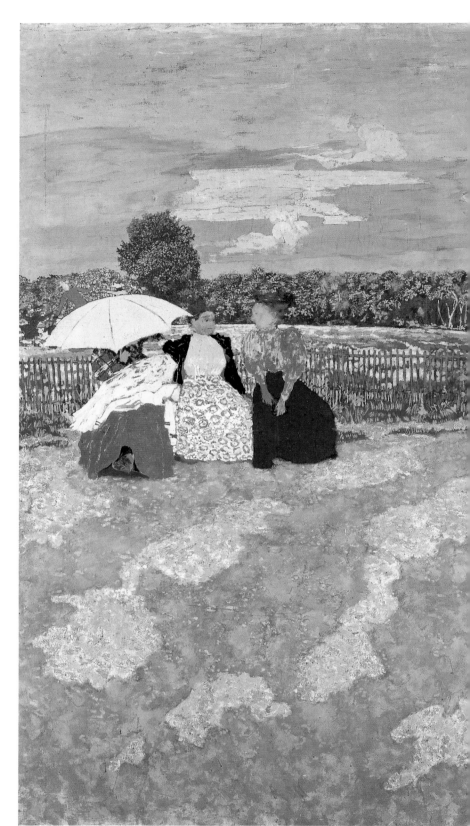

114

115

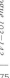

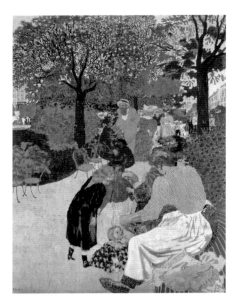

1. Édouard Vuillard, *Study for "The Public Gardens": Square de la Trinité*, also known as *The Square*, 1894 (reworked 1908), distemper on canvas, private collection. C-S V.37.

*The Public Gardens* is indisputably the grandest and most complex of Vuillard's decorative projects of the 1890s, as well as the most famous. Commissioned by Alexandre Natanson, director of *La Revue blanche* and eldest of the three Natanson brothers, it was created to decorate the salon of his residence on Avenue du Bois (now Avenue Foch). The first reference to the commission appears in Vuillard's journal in January 1894: "Offer for a decoration, to do what I want. Why not attempt it, why avoid these vague desires, why not have confidence in these dreams which are, which will become reality for others as soon as I give them precedence…"[1]

Initially, Vuillard seems to have struggled to find a direction. Although it is clear that he had received this commission by January of 1894, he does not appear to have begun to work in earnest on the project until the summer, and there is no further reference to it in his journal until July. However, he seems to have experienced a sort of revelation following a visit to the Musée de Cluny that helped solidify previously nebulous ideas regarding the art of decoration. Profoundly influenced by the art he saw, especially the tapestries, Vuillard observed: "In the tapestries I think that by purely and simply enlarging my little panel it would become the subject for a decoration. How modest are the subjects of these decorations at the Cluny! Expression of an intimate subject on a larger surface, that's all. The same thing as a Chardin, for example."[2]

The notes for that day are accompanied by pen and ink sketches of parks filled with trees and figures that seem to presage *The Public Gardens*. A number of subsequent journal entries indicate that Vuillard was spending a good deal of time in the park observing both the setting and the figures that inhabited it.[3] The artist had found his direction at last.

Vuillard produced a large number of preparatory sketches, in his journal and elsewhere, that shed light on the evolution of this project as he tried to establish both the subject and format of the paintings. Cogeval has drawn attention to a number of these, including a sheet filled with sketches of various scenes of urban life—carriages, omnibuses, figures— some of which are enclosed in rectangular panels not unlike those eventually used for the work in its final form,[4] and two previously unpublished sketches that appear to be prelim-

inary ideas for the suite—one showing a series of nine vertical panels depicting female figures arrayed in two registers (1894, priv. coll.), and a second (cat. 130) showing a group of irregularly shaped panels that anticipate the Natanson panels (cats. 126–129) of the following year in their format but that depict scenes set in gardens.[5] Most significant of all are a trio of drawings heightened with pastel in which the artist depicts the panels in their final stage, providing invaluable information about not only the palette and the relationship between the panels, but also their intended installation (cats. 120–122).

As the general title indicates, the subject selected by Vuillard is the public gardens of Paris. Originally, the artist was thinking of incorporating a number of parks around the city, among them Square de la Trinité, a small park located just a few minutes away from the studio at 28, rue de Pigalle that he was sharing at the time with Bonnard and Lugné-Poe, which can also be seen in a large pen and ink drawing (cat. 119) and in his monumental painting *The Square* (fig. 1).[6]

Cogeval has argued quite convincingly that *The Square* was the first version of the central panel of this suite but was subsequently abandoned in favour of *The Conversation* (cat. 114).[7] Nor is this the only painting that the artist appears to have rejected. Groom has noted that two separate panels of comparable scale seem to depict the Luxembourg Gardens and Parc Monceau respectively.[8] In the end, however, Vuillard elected to limit the suite to two parks, the Tuileries Gardens and the Bois de Boulogne, both of which were larger and therefore better suited to the expansive, panoramic program he envisioned for the Natanson decoration. The former, distinguished by the rich foliage formed by the neat rows of chestnut trees, which is the setting for two of the panels (cats. 117–118), was located just a few blocks from the apartment on Rue Saint-Honoré where the Vuillard family resided between 1893 and 1898, while the latter, which provided the setting for the seven remaining panels (cats. 111–116, fig. 2), was situated near the Natansons' home at the end of the avenue bearing the same name.[9] Vuillard's decision may also have been driven by a desire to avoid overt references to specific sites, in order to create a decorative

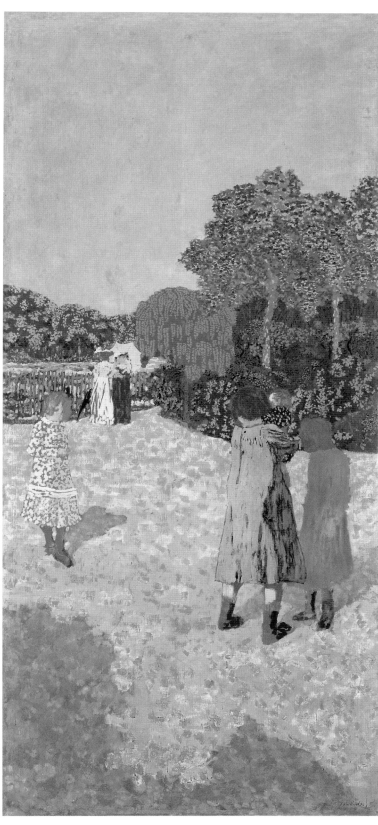

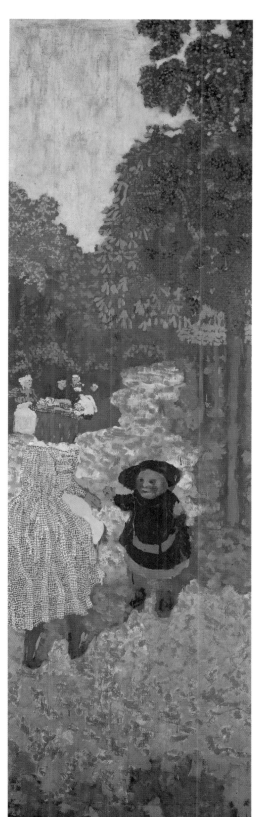

116

2. Édouard Vuillard, *The Public Gardens: The Promenade*, 1894, distemper on canvas, Museum of Fine Arts, Houston; The Robert Lee Blaffer Memorial Collection, gift of Mr. and Mrs. Kenneth Dale Owen, C–S V.39–6.

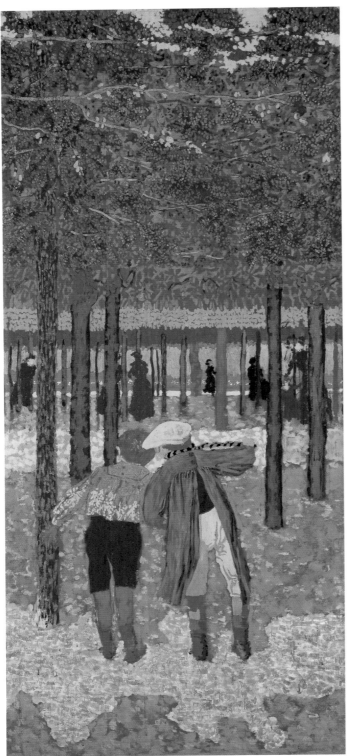

117

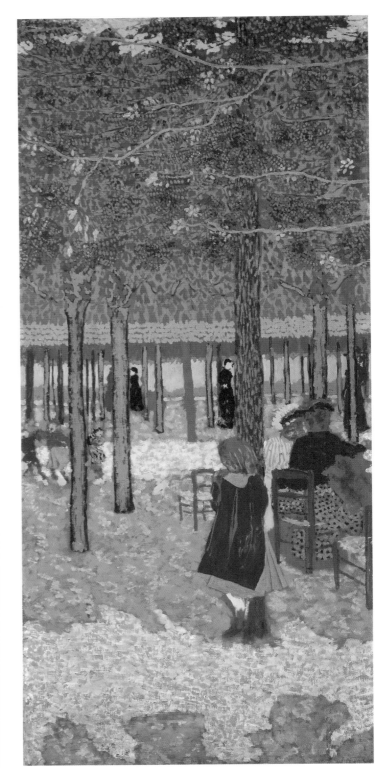

118

program that was more general and emblematic than documentary. In his journal, Vuillard reflected: "Really, for apartment decoration a subject that is objectively too exact would easily become intolerable…The imagination always generalizes."[10]

Depictions of nurses and children in the parks and other public spaces of Paris enjoyed a certain popularity among the Nabis. Roussel, Vallotton and Bonnard all produced paintings on the subject.[11] In particular, Bonnard's four-panel screen *Promenade of the Nursemaids: A Frieze of Fiacres* (priv. coll.), painted in 1894, provides an interesting counterpart to Vuillard's more ambitious project in terms of both subject and function.[12] Vuillard, however, seemed exceptionally drawn to the subject, having already used it in a pair of the Desmarais overdoors (cats. 107–108) as well as a number of other paintings of the 1890s.[13] Like the paintings of seamstresses at work that were so common in his oeuvre of the early to mid-1890s, these paintings portray a world that, devoid of the masculine presence, bears a distinctly feminine imprimatur.

In the case of the Natanson panels, however, the subject, with its celebration of childhood, would have held considerable appeal for the patron as well as the artist. By 1894, when the paintings were commissioned, Alexandre and his wife Olga had three young daughters, Evelyn, Bolette and Georgette, and, as Groom notes, it is not unreasonable to assume that Vuillard designed the project to appeal to both generations of the Natanson family.[14] Emily Ballew has proposed an even more directly biographical element, suggesting that the figures in the painting *The Questioning* (cat. 112) are Olga Natanson and one of her daughters.[15]

The sources from which Vuillard may have drawn inspiration are numerous and varied. In addition to the Cluny tapestries, Vuillard's journal also indicates that the artist was thinking about the work of Jean-Antoine Watteau, in particular his painting *Gathering in a Park*, which Vuillard knew intimately from his frequent pilgrimages to the Louvre and which provides a thematic precedent for this painting.[16] Cogeval has also noted the similarity of these panels to the romantic idylls by Fragonard and his contemporaries depicting amorous dalliances in verdant gardens, many of which were created as decorations for domestic interiors.[17] In addition, he has sug-

gested the influence of Flemish painting, which Vuillard had long admired at the Louvre and had encountered during his trip to Belgium and Holland in 1892. The format of the central panels of *The Public Gardens* does indeed call to mind triptychs the artist would have seen.[18] Among more modern references, works by the Impressionists, with their images of middle-class leisure, provide the most obvious precedent, though other sources of inspiration have been proposed, including Georges Seurat's monumental canvas *A Sunday on La Grande Jatte*,[19] the work of Pierre Puvis de Chavannes,[20] and even three-dimensional works such as Hendrik Willem Mesdag's *Maritime Panorama*.[21]

*The Public Gardens* marks a departure for the artist in terms not only of scale and complexity, but medium as well. For these panels the artist abandoned oil in favour of distemper, or *peinture à la colle*, which he had previously used on scenery backdrops for the Théâtre de l'Oeuvre in 1893–1894 but had never employed for a work of such importance or permanence, with the exception of *The Square*, the original centrepiece of the suite. Although difficult and time-consuming to utilize, distemper allowed for the creation of a matte, non-reflective surface reminiscent of fresco painting and therefore uniquely suited to decoration. Distemper would become a favourite medium of Vuillard's and would be used in many of his decorative works of the 1890s and later.[22]

On August 21, 1894, Vuillard received eight hundred francs from Alexandre Natanson, which enabled him to purchase the canvas necessary for the project, although he continued to struggle with the suite as a whole.[23] The panels were finally completed and installed by the end of 1894, and in February 1895 they were inaugurated with a lavish soirée attended by some three hundred guests.[24]

The panels, according to the available evidence, were installed on the ground floor in a space that served as a combination dining room and salon.[25] The precise arrangement of the panels themselves is known, thanks to an annotated sketch of the room in the artist's hand that appears in the upper corner of one

119

120

121

122

123

124

of his drawings (cat. 120). The annotations, which correspond to the dimensions of each of the nine panels, reveal that the central triptych (cats. 113–115) was hung along one of the long walls of the rectangular room. Facing it was the pair of panels set in the Tuileries Gardens (cats. 117–118), while a pair of panels occupied each of the two short walls—one pair (cats. 111–112) to the left of the triptych, the other pair (fig. 2, cat. 116) to the right.[26]

While the configuration of the nine panels is known, more problematic is the matter of the pair of overdoors that Vuillard produced to accompany the suite. Completed in November, these overdoors have long defied identification.[27] Groom has suggested that a pair of panels now in the collection of the Musée des Beaux-Arts of Rouen are possible candidates and has called into evidence a photograph by the artist that she identifies as representing the original installation of the panels prior to their reinstallation in 1908.[28] Cogeval favours another pair of horizontal panels (cats. 123–124), filled with dense foliage comparable to that of the chestnut trees found in *The Two Schoolboys* (cat. 117) and *Under the Trees* (cat. 118), which he believes were returned to the artist in 1908—which would explain their absence from the sale of the Natanson collection in 1929.[29]

The suite of panels was reinstalled twice, first in 1908 when the Natansons moved to a new residence on the nearby Avenue des Champs Élysées, and again in 1914 when they moved to Rue de Courcelles near Parc Monceau. Vuillard himself was called in to supervise the reinstallation of the suite in 1908, at which time he also removed the two original overdoors and created new ones in their stead.[30] The second installation was completed by December 1908, and Vuillard, who attended a dinner party at the new Natanson residence on December 15, noted the "good effect" of his paintings.[31] Vuillard makes no reference in his journal to the 1914 reinstallation, which suggests that the artist was not directly involved in the process.

*The Public Gardens* has appeared publicly in its entirety only once, at an exhibition held at the Bernheim-Jeune Gallery in Paris in 1906. The suite of panels remained in the Natanson collection until 1929, when they were dispersed at auction. The three central panels (cats. 113–115) were purchased at the sale by the French government for the Musée du Louvre and initially housed at the Musée du Luxembourg, while the other panels were acquired by private collectors. In 1953, three of the other panels entered public collections in Brussels (cat. 117), Cleveland (cat. 118) and Houston (fig. 2) respectively. In 1978, two additional panels (cats. 111–112) were

bequeathed to the Louvre. The ninth panel (cat. 116), which had long been presumed destroyed, had in fact been confiscated during the Nazi Occupation in 1940. Restituted to the rightful owner Gaston Hemmendinger in 1948, it quickly disappeared from view yet again, finally resurfacing in 1999, bringing the suite to its full complement once more.[32] KJ

1. Vuillard, *Journal*, I.2, fol. 66r. Quoted in c-s 2003, no. v.39.

2. Vuillard, *Journal*, I.2, fol. 44v (July 16, 1894). Quoted in Groom 1993, p. 220, note 101.

3. "I went down to the square. The same woman as yesterday came and sat on my bench…Weather overcast. Foliage in the area denser than I had thought. Purplish blue flowers. Impression." Vuillard, *Journal*, I.2, fol. 45v (July 24, 1894). Quoted in Groom 1993, p. 219, note 84.

4. See in particular the sheet of drawings first brought to light by Cogeval and exhibited in Florence 1998, no. 77, and Montreal 1998, no. 179.

5. Cogeval in c-s 2003, no. v.39.

6. Ibid., no. v.37.

7. Ibid.

8. Groom 1993, p. 52.

9. Groom 2001, p. 120.

10. Vuillard, *Journal*, I.2, fol. 47v (August 2, 1894). Quoted in Groom 1993, p. 220, note 100.

11. See Groom 1993, pp. 55–56.

12. Bonnard's screen was so popular that two years later he produced a colour-lithographed version, of which forty examples were mounted as screens. *The Folding Image: Screens by Western Artists of the Nineteenth and Twentieth Centuries*, exhib. cat. (New Haven: Yale University Art Gallery/Washington, DC: National Gallery of Art, 1984), p. 143.

13. *The Tuileries Gardens*, Paris, 1897, Yale University Art Gallery, c-s VII.3; *The Nursemaids, Square Vintimille*, c. 1895, priv. coll., c-s v.58; *The Bench*, 1895, priv. coll., c-s v.54. See also Vuillard's colour lithograph *The Tuileries Gardens*, 1896.

14. Groom 2001, p. 123.

15. Ballew 1990, p. 38.

16. Vuillard, *Journal*, I.2, fol. 43r (July 13, 1894) and fol. 47v (August 3, 1894). Cited by Ursula Perucchi-Petri in *Nabis 1888–1900*, exhib. cat. (Paris: Réunion des musées nationaux, 1993), p. 336, note 10.

17. Cogeval in c-s 2003, no. v.39.

18. Ibid.

19. Thomson 1988, p. 40; Groom 1993, p. 59.

20. Bacou 1964, p. 195; Thomson 1988, p. 40; Groom 1993, p. 59.

21. Robinson 1992, p. 121.

22. Groom 1993, p. 44.

23. "Received money from Alex. Canvas 9 metres 50 by 2 metres 40 at 3.80 = 36.10. fixative 1.10. India ink 0.60. total 37 francs 80." Vuillard, *Journal*, I.2, fol. 48v (August 21, 1894). Quoted in Groom 2001, p. 266, note 11.

24. In a letter to Olga Natanson dated December 15, 1894 (priv. coll.), Vuillard mentions that he is hoping to see Alexandre in two or three days time to discuss "the completion of our little decoration." This letter is quoted in Groom 1993, p. 220, note 107. On the inauguration, see Bernier 1983, pp. 28–33.

25. Groom 1993, pp. 61–62.

26. Frèches-Thory was the first to reconstruct this installation. See Frèches-Thory 1979, pp. 306–310.

27. "work all morning finish two overdoors." Vuillard, *Journal*, I.2, fol. 55r (November 9, 1894). Quoted in Groom 1993, p. 221, note 127.

28. Groom 1993, p. 64. The photograph is reproduced on p. 63.

29. Cogeval in c-s 2003, no. v.39. Groom, too, has speculated that these panels might be the overdoors in question. Groom 1993, p. 64.

30. Vuillard recounts that he went to the Natanson residence to "take measurements for the overdoors." *Journal*, II.1, fol. 37r (April 6, 1908). Quoted in Bareau 1986, p. 44, note 4.

31. Vuillard, *Journal*, II.2, fol. 23r (December 15, 1908). Quoted in Groom 1993, p. 221, note 139.

32. On the restitution, see U.S. National Archives/RG 260/Ardelia Hall Collection/ Munich Central Collection Point records, box 520.

## 125

THE CHESTNUT TREES: PROJECT
FOR A STAINED-GLASS WINDOW ·
*Les Marronniers, projet de vitrail*

1894–1895, distemper on board mounted
on canvas, 110 × 70
Private collection

Cogeval-Salomon v.95

———

*Provenance* Siegfried Bing, Paris—Bern-
heim-Jeune, Paris—Galerie Percier, Paris—
Galerie Berri-Lardy, Paris, c. 1979—Jose-
fowitz Collection—Private collection

*Exhibitions* Paris, MNAM, 1955, no. 220—
Lyon-Barcelona-Nantes, 1990–1991, no. 59,
col. ill. p. 68—Zurich-Paris, 1993–1994,
no. 218, col. ill.—Chicago-New York, 2001,
no. 34, col. ill. p. 125

*Bibliography* Mauner 1978, pp. 159, 176,
fig. 40—Thomson 1988, p. 32, col. pl. 23—
Groom 1993, p. 75, fig. 125—*Nabis 1888–
1900*, exhib. cat., Paris, Réunion des musées
nationaux, 1993, p. 396—Groom 2001,
p. 124, col. ill. p. 125

———

This painting is one of several designs com-
missioned by Siegfried Bing for reproduction
as stained-glass windows utilizing the innova-
tive technique developed by Louis Comfort
Tiffany. Bing, an entrepreneur and expert on
Japanese art, first encountered Tiffany's work
during a visit to the United States from Feb-
ruary to May 1894. Upon his return to France,
Bing, through the intermediary of the artist
Henry Ibels, commissioned several artists
of the Nabi circle, Vuillard among them, to
produce cartoons for this medium. In a letter
of May 1894 to his friend Maurice Denis,[1]
Vuillard enthusiastically endorsed the idea
of asking "artist-decorators" to produce
maquettes for stained glass and invited Denis

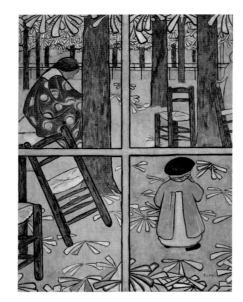

1. Kerr-Xavier Roussel, *Garden*, 1894, oil on board, Pittsburgh,
Carnegie Museum of Art; gift of Mr. and Mrs. John F. Walton.

to come to his studio the following Friday
afternoon to view samples of Tiffany glass,
believing that of all the artists in the group
Denis, along with Bonnard, would be most
interested.

By the end of October 1894, most of the
designs had been submitted. Tiffany would
eventually execute thirteen stained-glass win-
dows from designs by eleven different French
artists, eight of whom were Nabis: Bonnard,
Denis, Ibels, Ranson, Roussel, Sérusier,
Vallotton and Vuillard. The finished stained-
glass windows were exhibited at the Salon de
la Société nationale des Beaux-Arts in April
1895 and were also shown later that same year
at Bing's Maison de l'Art Nouveau.

For his design, Vuillard chose to depict a
street scene viewed from above. The rather
dramatic bird's-eye perspective is relatively
rare in Vuillard's work of the period, though
it would become a favourite device in several
of his later decorative paintings (cats. 269–
271). The subject itself, on the other hand,
with its women and children in a street or
courtyard surrounded by trees, is a familiar
one that calls to mind *The Public Gardens*
(cats. 111–118), another decorative project he
was working on at this time, which may also
have inspired Roussel's stained-glass design,
*Garden* (fig. 1).

In its abstraction and stylization of forms and
its juxtaposition of flattened planes of vibrant,
unmodulated colour, *The Chestnut Trees* is
stylistically similar to Vuillard's synthetist
paintings of around 1890–1891. Here, how-
ever, the artist has altered his approach in sig-
nificant ways to accommodate the particular
requirements of the stained-glass medium.
His rather painterly technique has of necessity
been restrained and there is a strong sense of
linearity. This is most apparent in the thick
black lines that inscribe and define the individ-
ual forms, which recall the cloisonnist tech-
nique of Émile Bernard and Paul Gauguin
but which also have the more practical func-
tion of serving as a guide for the glass cutters
and the person who would pour the lead used
to solder the pieces together. The result, as
Groom has noted, is an image that is crude
and "primitive" in comparison to Vuillard's
generally more naturalistic style.[2]

Unfortunately, the window based upon Vuil-
lard's design is now lost—only the windows
designed by Bonnard, Roussel and Toulouse-
Lautrec still exist—but given the generally
enthusiastic critical response to the stained-
glass windows at the Salon of 1895, it is
reasonable to assume that Vuillard's final prod-
uct was a relative success. Nevertheless,
*The Chestnut Trees* was to be Vuillard's one
and only foray into the realm of stained-glass
window design. KJ

———

1. Groom 2001, p. 115.

2. Ibid., p. 124.

125

**Five Panels for Thadée Natanson** also known
as **The Album** · *Cinq panneaux pour Thadée
Natanson* dits également *L'Album* (126–129)

————

Cogeval-Salomon v.96

————

*Joint provenance* Commissioned from Vuillard
by Thadée Natanson, Paris, by 1895

*Joint exhibitions* Paris, Maison de l'Art Nou-
veau, 1895–1896, no. 210 — Berlin, Ausstel-
lundshaus am Kurfürstendamm, 1906, no. 296

*Joint bibliography* Segard 1914, p. 320 —
Chastel 1946, pp. 53, 115, ill. pp. 24, 25 —
Roger-Marx 1946a, pp. 53–54, 78, 126, ill.
p. 133 — Easton 1989, pp. 117–118 — Frèches-
Thory and Terrasse 1990, pp. 122, 126, ill.
p. 123, col. ills. pp. 124–125 — Groom
1993, pp. 3, 67–90, 101, 104, 141, 145, 164,
205–206, fig. 115, col. figs. 114, 116, 117,
118 — Groom 2001, pp. 126–131, col. ills.
pp. 126–130

————

## 126

THE STRIPED BLOUSE · *Le Corsage rayé*

1895, oil on canvas, 65.7 × 58.7
Signed l.r.: *E. Vuillard*
Washington, National Gallery of Art,
Collection of Mr. and Mrs. Paul Mellon

Cogeval-Salomon v.96-1

————

*Provenance* [see *Joint provenance*] Thadée
Natanson Sale, Hôtel Drouot, Paris, June 13,
1908, lot 55 (ill.) — M. Escher — Georg Her-
bert Dietze, Frankfurt — Wildenstein, New
York, c. 1965 — Paul Mellon, Upperville,
Virginia — National Gallery of Art, Wash-
ington, 1983

*Exhibitions* [see *Joint exhibitions*] Munich,
Gabäude am Königsplatz, 1911, no. 202 —
Leipzig, Stadtgeschichtliches Museum, 1922
— Hamburg-Frankfurt-Zurich, 1964, no. 26,
ill. — Houston-Washington-Brooklyn, 1989–
1990, no. 87, col. ill. — Zurich-Paris, 1993–
1994, no. 172, col. ill. — Chicago-New York,
2001, no. 39, col. ill. p. 130

*Bibliography* [see *Joint bibliography*] Cogeval
1993 and 2002, p. 58, col. ill.

## 127

THE TAPESTRY · *La Tapisserie*

1895, oil on canvas, 177.7 × 65.6
Signed l.r.: *E. Vuillard*
New York, The Museum of Modern Art,
Estate of John Hay Whitney, 1983, 294.193

Cogeval-Salomon v.96-3

————

*Provenance* [see *Joint provenance*] Thadée
Natanson Sale, Hôtel Drouot, Paris, June 13,
1908, lot 54 — Bernheim-Jeune, Paris —
Jacques-Émile Blanche, Paris, Feb. 15, 1909 —
Leicester Gallery, London — M. Lecaron,
Paris — Hector Brame, Paris, 1958 — De
Haucke, Paris — John Hay Whitney, New
York — Museum of Modern Art, New
York, 1983

*Exhibitions* [see *Joint exhibitions*] Zurich-
Paris, 1993-1994, no. 171, col. ill. — Montreal,
MMFA, 1998, no. 182, col. ill. p. 58 — Chicago-
New York, 2001, no. 36, col. ill. p. 127

## 128

THE DRESSING TABLE · *La Table
de toilette*

1895, oil on canvas, 65 × 116
Signed l.r.: *E. Vuillard*
Private collection

Cogeval-Salomon v.96-4

————

*Provenance* [see *Joint provenance*] Thadée
Natanson Sale, Hôtel Drouot, Paris, June 13,
1908, lot 53 — Jos Hessel, Paris — Sale,
Christie's, New York, Nov. 14, 1989, lot 55
(col. ill.) — Private collection

*Exhibitions* [see *Joint exhibitions*] Zurich,
Kunsthaus, 1932, no. 124 — Paris, Musée des
Arts décoratifs, 1938, no. 37a — Chicago-
New York, 2001, no. 38, col. ill. p. 129

## 129

THE STONEWARE POT · *Le Pot de grès*

1895, oil on canvas, 65 × 116
Signed l.l.: *E. Vuillard*
Private collection, courtesy Nancy Whyte
Fine Arts, Inc.

Cogeval-Salomon v.96-5

————

*Provenance* [see *Joint provenance*] Thadée
Natanson Sale, Hôtel Drouot, Paris, June 13,
1908, lot 52 (ill.) — Jos Hessel, Paris — Private
collection — Sale, Christie's, New York, Nov.
18, 1998, lot 38 (col. ill.) — Private collection

*Exhibitions* [see *Joint exhibitions*] Munich,
Secession, 1908 — Zurich, Kunsthaus, 1932,
no. 123 — Paris, Musée des Arts décoratifs,
1938, no. 37b — Chicago-New York, 2001,
no. 37, col. ill. p. 128

## 130

PRELIMINARY SKETCH FOR THE
"NATANSON PANELS" · *Première idée
pour les "Panneaux Natanson"*

1894–1895, pen and ink, and pastel on
paper, 20.2 × 31
Private collection

————

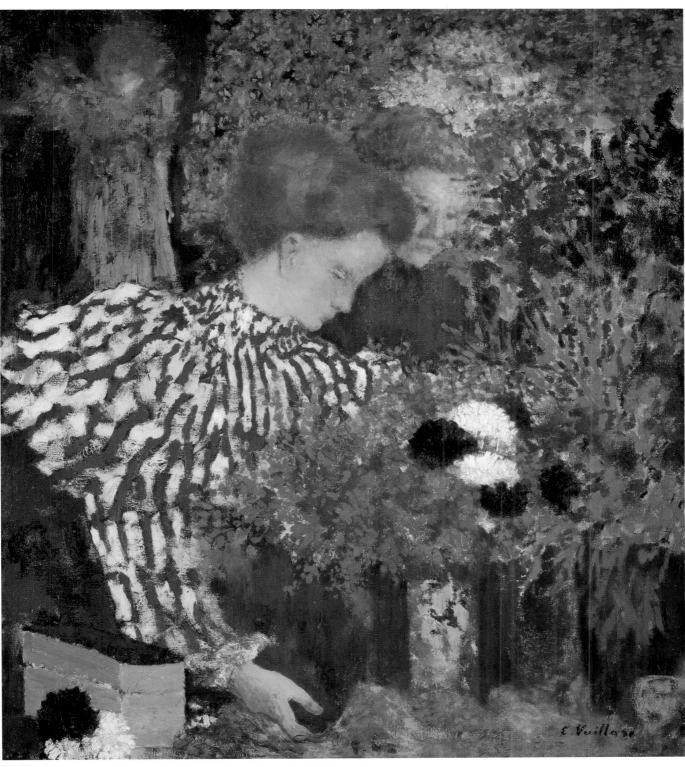

126

In 1895, Vuillard painted a group of five panels for Thadée Natanson and his wife Misia, to adorn their apartment on Rue Saint-Florentin. In many respects these paintings are typical of Vuillard's oeuvre of this period. In their subject—the depiction of elegant young women in hermetic, well-appointed, flower-laden interiors engaged in everyday activities such as embroidery, reading and conversation— these paintings echo the thematic concerns of many of the intimate interior scenes he was painting around this time, while presaging the suite of four decorative panels he would paint for Dr. Vaquez the following year (cats. 137– 140). Similarly, the dense pictorial surface, with its rich patterning, flickering impasto and warm, burnished palette of reds, browns and ivory, can also be found in a number of Vuillard's works from the early to mid-1890s.

It is in their designated function as decorative panels, however, that these works diverge from the norm and assert their rather unconventional character. Although conceived and executed as a suite, the five pictures are uniform in neither size nor format. While *The Striped Blouse* (cat. 126) and *The Tapestry* (cat. 127) are vertical in orientation, the remaining three, *The Dressing Table* (cat. 128), *The Stoneware Pot* (cat. 129) and *The Album* (fig. 1) are strongly horizontal, and only two of the panels, *The Stoneware Pot* and *The Dressing Table*, share the same dimensions. The one point of direct correspondence is the common height of the four smaller panels— 65 centimetres—which allows them to be arranged to form a kind of continuous horizontal frieze, with *The Tapestry* as the single vertical accent. Vuillard was clearly intrigued by the decorative possibilities presented by the use of diverse formats, as evidenced by a preliminary drawing (cat. 130) depicting a group of five panels that are unified in theme but disparate in size and orientation. Although this drawing may have been created with *The Public Gardens* (cats. 111–118) in mind, it constitutes a definite precedent for this decorative program.

The disparity in scale between the different elements is largely counterbalanced by the unity of subject and palette, as well as by Vuillard's adoption of a stippled technique that reproduces the visual effects of a tapestry. This imitation of tapestry, with its complex surface and its interweaving of stylized form and arabesque, pervades Vuillard's decorative works of the 1890s, reappearing in the Vaquez panels before finding its fullest expression in the pair of paintings he produced for Adam Natanson in 1899 (cat. 142). In the case of these five panels, however, the emulation of tapestry represented more than simply the conscious evocation of another traditional decorative medium: it was undoubtedly used as a way of harmonizing them within the eclectic décor of the Natanson apartment, which was filled with exotic textiles, oriental rugs, Renaissance tapestries and English-style floral wallpaper (see cats. 156–157).

The story behind the execution of these paintings is not entirely clear. The only reference to them in Vuillard's journal occurs in a summary of the year 1895 that the artist wrote later, which includes an entry that mentions simply "panels for Thadée November."[1] Although Vuillard's journal provides no further information concerning either the circumstances of the commission or the evolution of the project, paintings and photographs made by the artist between 1896 and 1899 give a fair indication of the manner in which they were displayed. *The Stoneware Pot*, for example, is clearly visible in the background of *Misia and Vallotton at Villeneuve* (cat. 147), while *The Album* appears in the background of *Misia Playing the Piano for Cipa* (1897–1898, Staatliche Kunsthalle, Karlsruhe, C-S VI.38). More striking, however, is the fact—evidenced by contemporary photographs—that the paintings did not remain permanently in situ at the Rue Saint-Florentin apartment, but accompanied the Natansons to their country homes, first at Valvins and later at Villeneuve-sur-Yonne.

The flexibility of the series is further underscored by the panels' inclusion in the inaugural exhibition of Siegfried Bing's Maison de l'Art Nouveau, held in December 1895. Determined to transform his gallery into a showcase for the "new art," Bing had invited several

artists to collaborate on the interior decoration of the space. Unlike his friends Denis and Ranson, however, Vuillard did not design new wall decorations, but sent the panels created for Thadée and Misia, under the title "'Decoration in Five Panels' Belonging to Madame Thadée Natanson." In view of the timing— the panels were completed in November and included in the Bing installation the following month—it seems highly probable that Vuillard conceived the suite with both the Natanson apartment and the Maison de l'Art Nouveau gallery in mind.

Response to the suite of panels when they were exhibited in 1895 was mixed. Arsène Alexandre described them as "harmonious and discreet,"[2] while Edmond Cousturier, writing in *La Revue blanche* in January 1896, had this to say: "Mr. Vuillard is a rare harmonist; he is sensitive to the charm of privacy, the enigma that every solitary being seems to inhabit. He vocalizes in a minor key; his tones are neutral and muted, his combinations subtle."[3] More critical, and perhaps more perceptive, was Camille Mauclair, who noted that Vuillard had exhibited "several disconnected panels that bear no relation to the lighting of the room."[4]

Mauclair's observation that the panels failed to harmonize with their setting in the Bing installation seems justified. The presence of this suite of paintings in part or *in toto* in the Natansons' Paris apartment and in their two successive country homes, the unusual and inconsistent dimensions of the panels themselves, and their seemingly haphazard installation all suggest that Vuillard may have designed the suite for the Natansons not to fit a specific site, but as a kind of portable decoration whose elements could be separated and arranged according to their owners' whim. If such was the case, then the relationship of the panels to their setting was of secondary importance.

While the setting for these paintings was fairly inconsequential, however, the same cannot be said of their audience. These panels were created specifically with the Natansons and their circle in mind. More than in Vuillard's

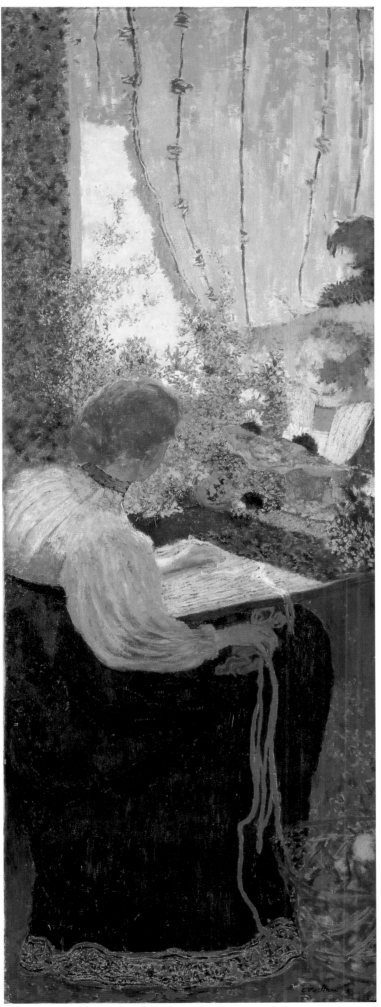

127

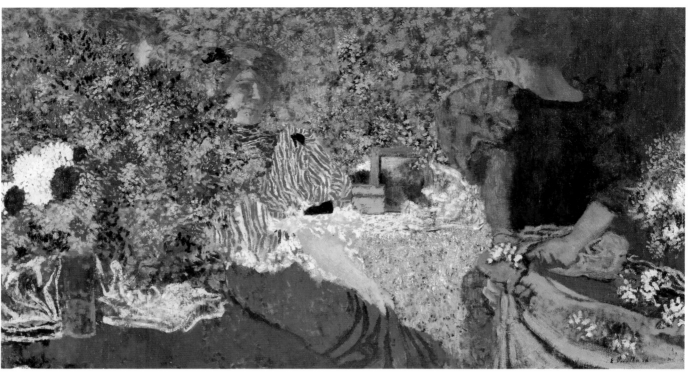

128

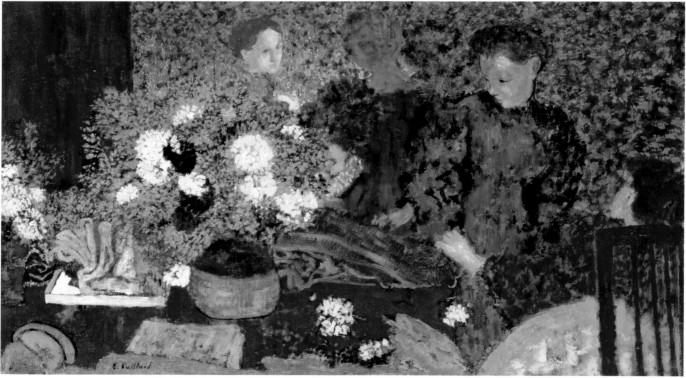

129

130

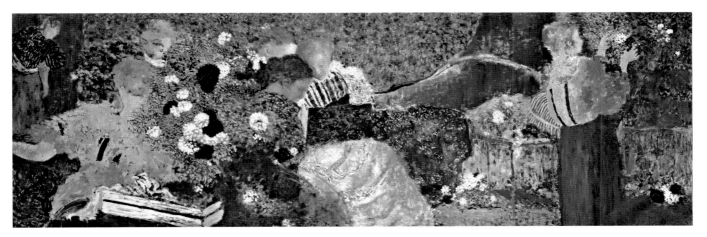

1. Édouard Vuillard, *The Album*, 1895, oil on canvas, New York, The Metropolitan Museum of Art, The Walter H. and Leonore Annenberg Collection, partial gift of Walter and Leonore Annenberg, 2000, 2000.93.2

earlier decorative works, these paintings reflect a strong interest in Symbolist thought, and what Segard referred to as "confused analogies between strict truth and that which is beyond truth."[5] Roger-Marx also noted the evocative mood of the paintings, which, he said, "are once again steeped in symbolism."[6] The mood of the panels is languorous, subdued and highly sensual. The spatial ambiguity —the tension between the two-dimensional picture plane and the illusory three-dimensional interior space—that marks so many of

the artist's domestic interiors from this period is particularly pronounced here, further intensifying the rarefied atmosphere of domestic calm and mystery that pervades the suite as a whole. This is especially evident in the horizontal panels, notably *The Stoneware Pot*, where even the women themselves seem to blend into their surroundings, their features vague, their forms simply another ornamental element in the elaborately patterned picture. KJ

1. Vuillard, *Journal*, 11.2, fol. 12r-v.

2. *Le Figaro* (December 28, 1895), p. 1; reprinted in Victor Champier, "Les expositions de l' 'Art Nouveau'," *Revue des arts décoratifs*, vol. 16 (January 1896), p. 5.

3. "Galerie S. Bing: Le Mobilier," *La Revue blanche*, vol. 10, no. 63 (January 15, 1896), p. 93.

4. "Choses d'art," *Mercure de France*, vol. 17, no. 74 (February 1896), p. 268.

5. Segard 1914, p. 250.

6. Roger-Marx 1946a, p. 54.

**Table Service Commissioned by Jean Schopfer ·**
***Service de table commandé par Jean Schopfer***
**(131 – 136)**

————

1895, porcelain
Mark on verso: *H & CO L* (Haviland and Co.
[Limoges])
Josefowitz Collection

————

*Provenance* Commissioned by Jean Schopfer,
1895 — Galerie Druet, Paris, by 1938 (?) —
Private collection [Josefowitz Collection]

*Exhibitions* Paris, Maison de l'Art Nouveau,
1895–1896 (hors. cat.) — Paris, Musée des
Arts décoratifs, 1938, no. 321 [Pièces d'un
service en porcelaine décoré par E. Vuillard,
1898. À la Galerie Druet] — Zurich-Paris,
1993–1994, no. 219 (cats. 131, 132)

*Bibliography* Schopfer 1897, pp. 252–255, ill.
pp. 248–254 — Segard 1914, p. 288, n. 1 —
Salomon 1953, p. 33 — Troy 1984, pp. 58, 59 —
Weisberg 1986, ill. pp. 69, 94–95 — Frèches-
Thory and Terrasse 1990, pp. 190–192, ill. —
Troy 1991, p. 24, ill. 25, pl. 3 — *Nabis 1888–
1900*, exhib. cat., Paris, Réunion des musées
nationaux, 1993, pp. 397–398, ill. — Groom
1993, pp. 71, 74–76, 99, 100, ill. pp. 74, 75, 76

## 131

Red-headed woman in a polka-dotted blouse
with a checked apron and a skirt with a border
at the hem, wearing a hat (diam.: 24)

## 132

Woman in a long-sleeved checked blouse
and a plain skirt, wearing a hat, viewed from
behind (diam.: 24.5)

## 133 *not pictured*

Seated woman wearing a spotted blouse and a
checked skirt with a yellow sash (diam.: 24)

## 134

Woman in a striped blouse and a plain skirt
decorated with a double border at the hem
(diam.: 24)

## 135

Woman in a feathered hat, wearing a striped
blouse and a plain skirt (diam.: 21)

## 136

Woman arranging flowers (diam.: 24.5)

————

In 1895, Vuillard executed a suite of water-
colours destined to decorate an extensive table
service in porcelain. This foray into the realm
of porcelain decoration, although apparently
unique in Vuillard's career, is not without
precedent or parallel. All of the members of
the Nabi group dabbled to some extent in the
decorative arts, including ceramics, no doubt
drawing inspiration from their idol Gauguin,
who had begun making ceramics in 1886. In
the mid-1890s, several of Vuillard's contem-
poraries, including Bonnard and József Rippl-
Rónai, also began trying their hand at painting
porcelain plates.

The history behind this particular project
remains rather sketchy, though Gloria Groom
has clarified it considerably. The project ori-
ginated as a commission from Jean Schopfer
(whose pen name was Claude Anet), who
would subsequently commission a pair of
large-scale decorative panels from Vuillard in
1898 and a companion piece in 1901 (cats.
263–264). Schopfer wrote to Vuillard in May
1895[1] informing him that he was ready to
move ahead with plans for the decorated table
service, which, according to an entry in Vuil-
lard's journal dated October 30, 1895, was
completed four months later: "To fix date.
September the Schopfer service."[2] There is a
second reference in the journal of November
1908, in which the artist records his major
projects of the previous years. In a note near
the end of this chronology, the "Schopfer
table service" is listed as one of his achieve-
ments for 1895.

According to Groom, the commission
included ninety-six pieces, for which Vuillard
was required to produce eight groups of
watercolours, although Schopfer specifically
states that each pattern included a "dozen
plates, seven in all."[3] Vuillard's designs were
then transferred onto plates, platters, saucers
and gravy boats by the painter and ceramicist
Georges Rasetti.[4] Salomon has attributed the
execution to the atelier of the ceramicist
André Méthey, who worked with a number of
artists (among them Bonnard, Denis and
Roussel) at the behest of Ambroise Vollard.[5]
It should be noted, however, that Vollard him-
self made no mention of Vuillard as being
among those who made use of Méthey's serv-
ices.[6] The verso of the plates bears the mark
*H & CO L*, which Frèches-Thory has identified
as belonging to Haviland & Co., a porcelain
firm in Limoges that provided the plates to
be decorated.[7]

Despite the number of patterns required, the
designs are consistent in theme. Each piece
depicts an elegant young woman shown in a
half- or full-length pose, her body framed by
exuberant borders filled with arabesques and
floral motifs. The designs inevitably call to
mind the suite of five decorative panels that
Vuillard was painting for Thadée and Misia
Natanson around this time (cats. 126–129),
which in similar fashion use women and
flowers as ornamental components.

At least part of the Schopfer service was first
shown in December 1895 at the inaugural
exhibition of Siegfried Bing's gallery, the
Maison de l'Art Nouveau, which also show-
cased Vuillard's design for a stained-glass
window commissioned by Bing (see cat. 125)
and the decorative panels for the Natansons.
The table settings were put on display in the
dining room designed by the architect Henry
van de Velde. While there is no mention of
the service in the catalogue of either the first
or second exhibition at Bing's gallery, its pres-
ence is nevertheless confirmed by a contem-
porary photograph of the installation at the
gallery's opening.[8]

131

135

132

136

134

1. Édouard Vuillard, *Design for a Plate for Siegfried Bing*, c. 1895, brush and blue ink, and graphite on paper, private collection.

2. Édouard Vuillard, *Design for a Plate for Siegfried Bing*, c. 1895, watercolour and graphite on paper, private collection.

In 1897, Schopfer published an invaluable article on the subject of modern decoration that discussed the table service at some length, providing insight into the project and its goals. Not surprisingly, the author is quite laudatory about the service as a whole, praising Vuillard for the simplicity of his palette (composed exclusively of three colours—reddish brown, green and blue) and his ingenious and varied use of it. He also admires the decorative program itself: "For the central motive of the decoration he has taken women—not Louis XVII [sic] shepherdesses, but women of the present day. He has, however, been careful not to treat them as might have done a portrait painter or a designer of fashion plates. He has only taken so much of them as can be taken for decorative purposes." [9]

Although these plates are generally considered to be part of the service executed for Schopfer, this assumption has been questioned in recent years by both Frèches-Thory[10] and Groom.[11] Groom has noted the inclusion of a porcelain service in the Vuillard retrospective held at the Musée des arts décoratifs in 1938. No mention was made of Schopfer's name in conjunction with this service; furthermore, it was dated 1898, not 1895. While this may be an error, it has raised speculation as to the possible existence of a second porcelain service.

There is no reference in Vuillard's journal to a second commission for a table service; there are, however, three drawings in the Salomon Archives that are clearly designs for plates. This is evident in their circular format and the inclusion of a prominent decorative border, as well as their dimensions, which in the case of two of the three drawings are identical to those of existing plates—24.5 centimetres in diameter. One of the drawings, a watercolour that employs the same palette as that used for the Schopfer plates, is largely abstract, composed purely of floral patterns.[12] In contrast, each of the other two drawings depicts a pair of figures placed in what appears to be a

garden setting (figs. 1, 2), one showing two children at play and the other, two women, one of whom is seated, with her head and torso framed by foliage. Whether these drawings were produced as possible but ultimately unused designs for the Schopfer service or were sketches for another project that was never executed is uncertain. Their subject, however, recalls *The Public Gardens* (cats. 111 –118), Vuillard's primary decorative project of 1894, which would suggest that they were an earlier rather than a later experiment in porcelain design.

If a second service was indeed produced, then it almost certainly made use of the designs created by Vuillard in 1895. If that is the case, then the extant plates may very well be part of the later service rather than the original one commissioned by Schopfer. K J

1. Salomon Archives, Paris. Quoted in Groom 1993, p. 222, note 29.

2. Vuillard, *Journal*, I.2, fol. 57r (probably October 30, 1895).

3. Groom 1993, p. 74; Schopfer 1897, p. 254.

4. Groom 1993, p. 74.

5. Salomon 1953, p. 33.

6. Vollard 1957, p. 190.

7. Claire Frèches-Thory, in *Nabis 1888–1900*, exhib. cat. (Paris: Réunion des musées nationaux, 1993), p. 397.

8. Reproduced in Weisberg 1986, p. 59.

9. Schopfer 1897, p. 254.

10. Frèches-Thory (see note 7), p. 397.

11. Groom 1993, p. 71.

12. Reproduced in Cogeval 1998a, no. 100, p. 136 and Cogeval 1998b, no. 180, p. 55.

**The Vaquez Panels: Figures in an Interior ·**
***Les Panneaux Vaquez. Personnages dans un***
***intérieur* (137 – 140)**

Cogeval-Salomon V.97

*Joint provenance* Commissioned from Vuillard
by Dr. Henri Vaquez—Vaquez Bequest to the
Musée du Petit Palais, Paris, 1936

*Joint exhibitions* Paris, Grand Palais, 1905,
nos. 1597–1600—Paris, Musée des Arts déco-
ratifs, 1938, no. 45—Basel, Kunsthalle, 1949,
nos. 233–236—Paris, Orangerie, 1968,
nos. 60–63, ill.

*Joint bibliography* Natanson 1896, p. 518—
Segard 1914, pp. 266–274, 320, ill. pp. 265, 272
—Huyghe 1939, pp. 41–42, pl. 15—Salomon
1945, p. 40, ill. p. 39—Chastel 1946, pp. 53–
54, 58, 115, ill. pp. 32–33, 35—Roger-Marx
1946a, pp. 52–54, 124–126, 184, ill. pp. 134–
136—Perucchi-Petri 1976, pp. 147–149,
fig. 95—Mauner 1978, p. 196—Frèches-
Thory 1979, p. 310—Thomson 1988, pp. 49,
72–73, pls. 42–43—Frèches-Thory and
Terrasse 1990, pp. 126–127, ill. p. 127, col.
ills. pp. 128–129—Dumas 1990, p. 74, ill.
pp. 34–35—Cogeval 1993 and 2002, pp. 60,
69, 73, col. ill. p. 68—Groom 1993, pp. 1,
90–96, 101, 104, 126, 137, 145, 164, 206, col.
figs. 154–155, 157–158

## 137

FIGURES IN AN INTERIOR: WORK ·
*Personnages dans un intérieur. Le Travail*

1896, distemper on canvas, 212 × 77.3
Signed and dated l.l.: *Edouard Vuillard 96*
Paris, Musée du Petit Palais, inv. PPP02442

Cogeval-Salomon V.97-1

## 138

FIGURES IN AN INTERIOR:
CHOOSING A BOOK · *Personnages dans
un intérieur. Le Choix des livres*

1896, distemper on canvas, 212 × 77
Signed and dated l.l.: *Edouard Vuillard 96*
Paris, Musée du Petit Palais, inv. PPP02441

Cogeval-Salomon V.97-2

## 139

FIGURES IN AN INTERIOR:
INTIMACY · *Personnages dans un intérieur.
L'Intimité*

1896, distemper on canvas, 212.5 × 154.5
Signed and dated l.r.: *Edouard Vuillard 96*
Paris, Musée du Petit Palais, inv. PPP02439

Cogeval-Salomon V.97-3

## 140

FIGURES IN AN INTERIOR: MUSIC ·
*Personnages dans un intérieur. La Musique*

1896, distemper on canvas, 212.5 × 154
Signed and dated l.l.: *Edouard Vuillard 96*
Paris, Musée du Petit Palais, inv. PPP02440

Cogeval-Salomon V.97-4

In 1896, Dr. Henri Vaquez, a renowned cardi-
ologist, commissioned Vuillard to produce a
suite of four panels to decorate the library of
his Paris apartment at 27, rue du Général Foy.
Over the years, these paintings have been
assigned various titles, all of them descriptive
in nature. Vuillard, in his typically reticent
manner, referred to the paintings in his jour-
nal simply as the "Vaquez project," with no
reference to the subjects of the panels them-
selves. Similarly, when they were first exhibited,

in 1905, they appeared under the generic title
"decorative panels," a designation that directs
attention to their function rather than their
subject or the owner who commissioned them.
It was not until 1914, when Segard assigned
the paintings their current names, that the
panels acquired individual titles.[1]

This suite of panels inevitably and perhaps
even intentionally calls to mind the decora-
tions executed for Thadée and Misia Natanson
some eight months earlier (cats. 126–129).
Once again, Vuillard chose to explore the
theme of women engaged in feminine occupa-
tions within an elaborate and charmingly clut-
tered bourgeois interior. The women are
depicted absorbed in leisure activities: sewing,
reading, playing and listening to music. The
atmosphere of the panels is rarefied, the mood
decorous. The highly feminized world that
Vuillard has chosen to depict is striking, given
that the works were created to hang in the
apartment of a thirty-six year old bachelor.
Although it has been suggested that the inte-
rior portrayed in the panels is that of the
Vaquez library itself, Vuillard has taken cer-
tain liberties, creating an environment that
appears to harmonize with, rather than recon-
struct, the intended setting. Vuillard's one nod
to the masculine environment that the panels
were to inhabit is the inclusion in *Work* (cat.
137) of a man seated at the table, engrossed
in his reading and as oblivious of his female
companion as she is of him.

The relationship with tapestry evident in the
Natanson panels is all the more apparent in
the panels produced for Dr. Vaquez. The ex-
tremely precious *mille-fleur* wallpaper, which
Segard likened to "fine and minutely detailed"
Persian miniatures,[2] clearly evokes the fif-
teenth-century tapestries that, as Groom has
noted,[3] Vuillard knew well from his visits
to the Musée de Cluny. Vuillard's contempo-
raries immediately grasped the resemblance
of these paintings to tapestries, in both func-
tion and style. Charles Morice recognized
the similarity in the "generally harmonious
motifs, which accord with the objects,"[4] while
Maurice Denis described them as "sumptuous
wall hangings reminiscent of antique tapes-
tries."[5]

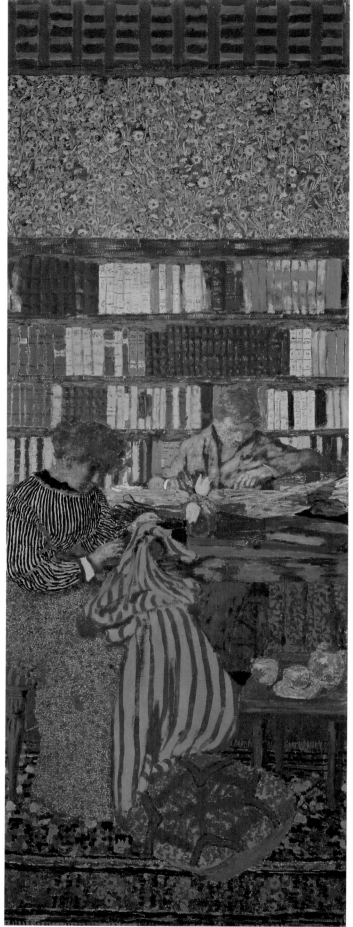

137

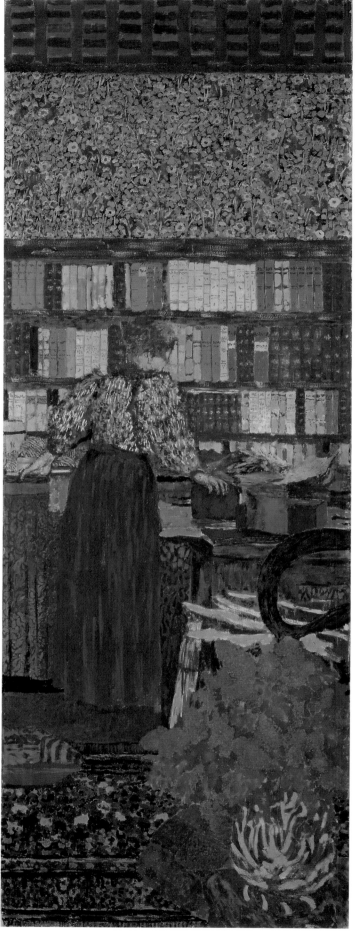

138

Despite the similarities with the Natanson panels, which constitute an obvious precedent for this suite, the Vaquez works differ from the earlier paintings in several ways, including technique. *Figures in an Interior* marks a return to the medium of distemper, which Vuillard had used previously for *The Public Gardens* and which would eventually become his medium of choice for decorative panels. The blond tonalities and dry, non-reflective surface of *peinture à la colle* were especially well suited to the emulation of tapestry the artist was seeking to achieve in these panels.

These paintings also differ from the Natanson series in their powerful unity of both subject and format, which is in keeping with their intended role as site-specific decorations. The suite is composed of two pairs of panels, one narrow and unequivocally vertical, the other more square in format. All four panels are the same height, 212 centimetres, and share the same scintillating wallpaper, whose colours—shades of pink, fuchsia, beige, green and teal—are deftly woven throughout all four panels. Most distinctive of all is the depiction of the wood-beamed ceiling that runs like a band across the top of the four paintings, serving to unify the suite.

There is also a greater sense of physical space in these paintings than in the Natanson panels. The scale of the figures in relation to their setting and the use of repoussoir elements in the foreground of each of the canvases—a cushion, a vase of lilacs, the edge of a sofa, a table covered with fabric—serve to situate the figures firmly within the picture plane, while the overlapping of forms creates an illusion of spatial recession. Nevertheless, this intimation of three-dimensional space is undermined by

the treatment of the picture surface. The figures themselves, whose features are vague and often cast in shadow, lack weight and solidity. Although their forms are more clearly defined than those of their counterparts in the Natanson panels, they remain resolutely two-dimensional, their brightly garbed bodies placed against the canvas and displayed, as Cogeval has so astutely remarked, like butterflies in a specimen case.[6]

The relationship between foreground and background is equally complex. As in so many of Vuillard's interiors of the 1890s, there is an emphasis upon pattern over form. Virtually every available surface within these panels is decorated with vibrant and contrasting patterns—the wallpaper, the carpets, the books lining the shelves, the cushions and couches, the dresses of the women—all competing with one another visually and transforming the entire pictorial surface into an elaborate two-dimensional patchwork that advances toward the picture plane. The only elements that create a breach in the overall flatness are the open doorway on the right-hand side of *Intimacy* (cat. 139), which provides a glimpse into another room beyond the cloistered interior of the library, and the rectangular mirror that flanks it, which reflects and expands the pictorial space.

We do not know precisely how the panels were installed, although a preparatory drawing in the Salomon Archives indicates that *Work* was intended to be hung to the left of *Choosing a Book* (cat. 138). One intriguing feature is the difference in the ground colour used for the four panels. While *Intimacy* and *Music* (cat. 140) were painted upon a blue-green ground, *Work* and *Choosing a Book* utilize an ochre ground. This change in colour, which subtly affects the paint surface, was no doubt deliberate, intended to compensate for the lower light levels further away from the windows and thus to maintain a consistent tonality throughout the suite.

The Vaquez panels were first exhibited, some nine years after their creation, at the Salon d'Automne of 1905, where they drew much praise for their exquisite and subtle colouring and their discreet charm. Vuillard was applauded for his skill as a painter of decorative panels: Roger-Marx praised him for his ability to be a "decorator without being an *intimiste*,"[7] while Gustave Geffroy affirmed that the artist had "perfectly understood how to decorate modern apartments."[8] André Gide was especially flattering, saying "I know few works where the dialogue with the artist is more direct,"[9] and Camille Mauclair declared, "I know of no more gifted decorator."[10] KJ

1. Segard 1914, p. 266.

2. Ibid., p. 267.

3. Groom 1993, p. 93.

4. Charles Morice, *Mercure de France*, vol. 58, no. 203 (December 1, 1905), p. 385.

5. Maurice Denis, "Le Salon d'Automne" (1905), reprinted in Maurice Denis, *Théories, 1890–1910. Du symbolisme et de Gauguin vers un nouvel ordre classique*, 4th ed. (Paris: L. Rouart and A. J. Watelin, 1920), p. 206. Also published in Denis 1913.

6. Cogeval in C-S 2003, no. V.97.

7. R. M. [Roger Marx], "Le vernissage du Salon d'Automne," *La Chronique des arts et de la curiosité*, no. 32 (October 21, 1905), pp. 267–268.

8. "Le Salon d'Automne : La Peinture," *Le Journal* (October 22, 1905), n.p.

9. "Promenade au Salon d'Automne," *Gazette des Beaux-Arts*, vol. 34, no. 582 (December 1, 1905), p. 480.

10. "Le Salon d'Automne," *Revue bleue*, vol. 4, no. 17 (October 21, 1905), p. 523.

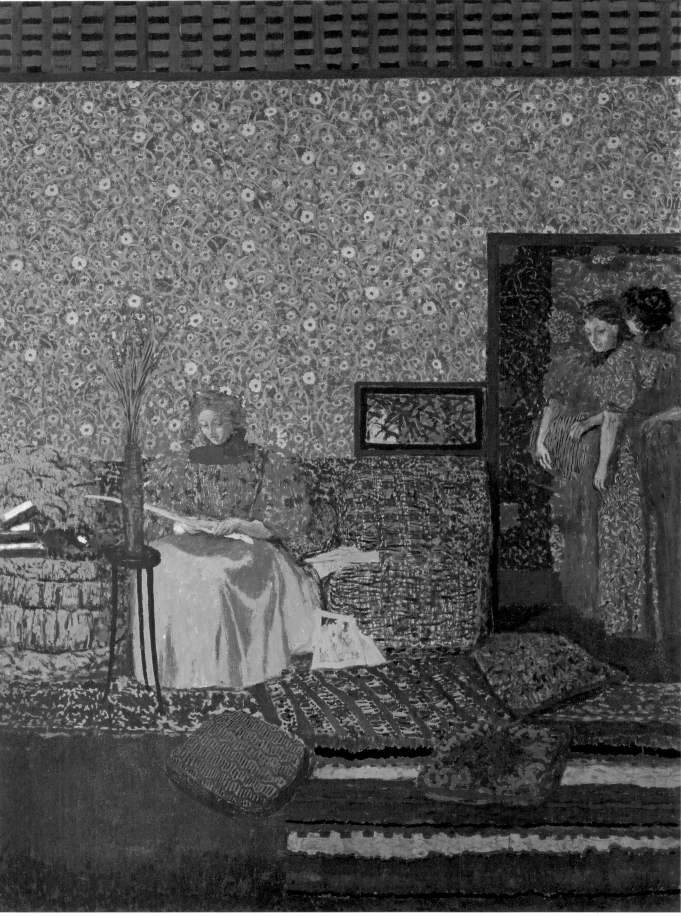

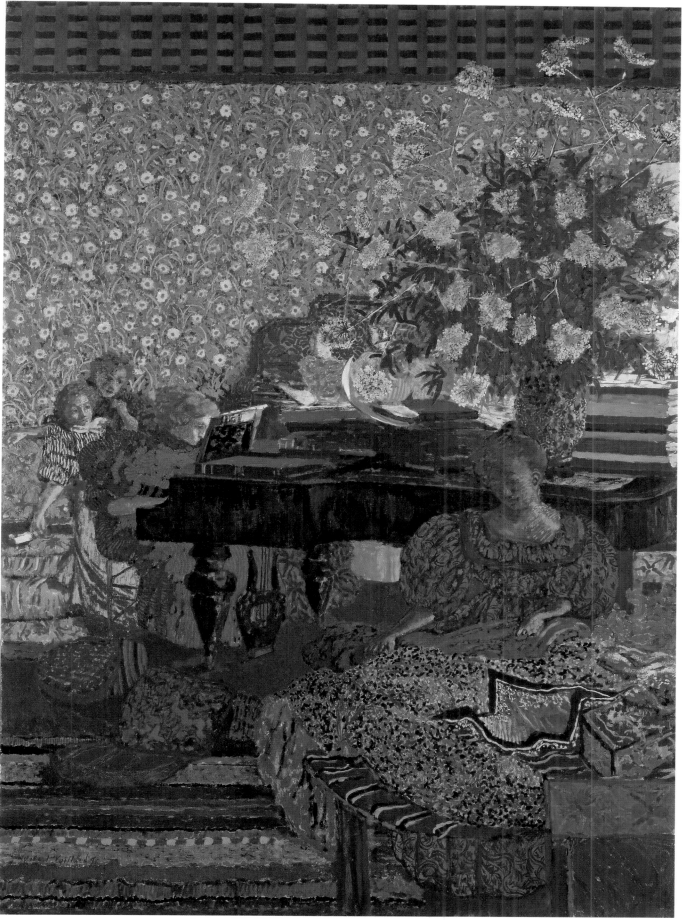

# 141

SCREEN FOR STÉPHANE NATANSON:
FIGURES IN AN INTERIOR · *Paravent de
Stéphane Natanson. Figures dans un intérieur*

1898, distemper on linen mounted on
canvas (remounted as a wall painting),
129 × 170 (present state)
Private collection

Cogeval-Salomon VI.101

*Provenance* Stéphane Natanson, Paris, 1898;
Louis Natanson, 1905—Maurice Laffaille,
Paris—Lefevre, London, 1959—Private
collection, London

*Exhibitions* Washington-New Haven, 1984—
1985, no. 7, col. ill.

*Bibliography* Segard 1914, p. 321—Groom
1993, p. 41, fig. 62

Painted decorative screens held a particular
allure for Vuillard and his fellow Nabi artists.
These objects embodied the harmonious
merging of the aesthetic and the functional
so admired by the group, and it is hardly sur-
prising that between the years 1890 and 1910
Bonnard, Denis, Ranson, Seguin, Roussel
and Vuillard all designed or executed one or
more such screens.[1] Vuillard is known to
have painted three folding screens during his
career. The first of these, *The Seamstresses*
(see cat. 103–108, fig. 1), was a five-panel
screen depicting seamstresses at work, com-
missioned by Paul Desmarais at the encour-
agement of his brother-in-law, Stéphane
Natanson, to accompany the suite of six
overdoors (cats. 103–108) produced for his
home. Natanson himself went on to com-
mission this, the second of Vuillard's decora-
tive screens, in 1898.

The work's primary influence was the Japan-
ese folding screens that were becoming in-
creasingly familiar to contemporary Parisian
audiences as a result of exhibitions like the
one held by Louis Gonse on Rue de Sèze in
1883, together with publications like Siegfried
Bing's *Le Japon artistique*, which first appeared
in 1888. In *Screen for Stéphane Natanson:
Figures in an Interior* the influence of Japanese
art is immediately apparent, not only in its
format, but in a number of stylistic elements.
Particularly noteworthy are the striking
bird's-eye view and wildly tilted surfaces, the
off-centre composition, and the casual array

of cropped forms, all regular features of the
Japanese print. Vuillard has here once again
opted to use distemper rather than oil, and has
chosen a linen support in a pale beige colour
that is left exposed throughout much of the
composition, giving it an open, airy quality
that increases the sense of spatial ambiguity
created by the sloping floor and the vaguely
defined walls. Many sections of the work are
thinly painted, notably the tablecloth, the
patterned carpet in the right foreground and
Misia Natanson's dress, which appears almost
translucent. In contrast, other sections are
dark and solid, including the figure of
Stéphane Natanson, the black floor tiles, and
the door and sideboard in the background.

While the figures depicted on the screen are
readily identifiable as Misia and Stéphane
Natanson, the dating of the work has proved
more problematic. Segard correctly dated
the screen to 1898, but mistakenly attributed
its ownership to Madame Desmarais.[2] More
recently it has been assigned the erroneous
date of 1895.[3] There can be no doubt that the
work was executed later, since it depicts Les
Relais, the house purchased by Thadée and
Misia Natanson in 1897. This is confirmed by
a photograph taken by Vuillard at Les Relais
that shows Misia descending a staircase
(cat. 177) and Romain Coolus seated in the
foyer. As Cogeval has noted, the setting por-
trayed in this screen is easily identifiable by
its tiled floor, woven rug and round table.[4]
In fact, Vuillard appears almost to have taken
the scene represented in the photograph,
shifted the position of the figures and then
portrayed them from the top of the stair-
case—thus achieving the startling viewpoint.

The screen's four panels were remounted at
some point to form a wall painting. In the
work's original form, however, the four panels
would have been individually framed, and
articulated in a way that allowed them to be
moved and folded. Although Vuillard con-
tinued to execute decorative panels, a dozen
years would pass before he undertook his
third and final folding screen (cat. 271). KJ

1. Komanecky 1984, p. 71.

2. Segard 1914, p. 321.

3. Frèches-Thory and Terrasse 1990, p. 170; Michael Koma-
necky, in *The Folding Image: Screens by Western Artists
of the Nineteenth and Twentieth Centuries*, exhib. cat. (New
Haven: Yale University Art Gallery, 1984), p. 147.

4. Cogeval in C-S 2003, no. VI.101.

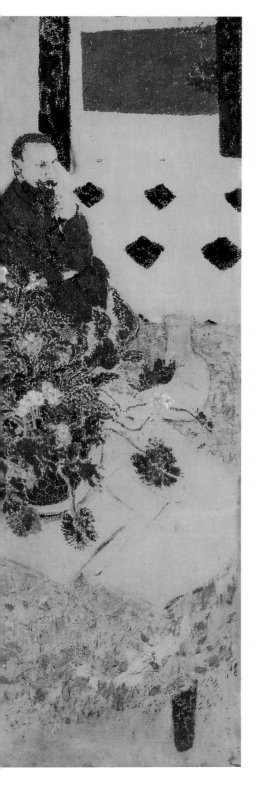

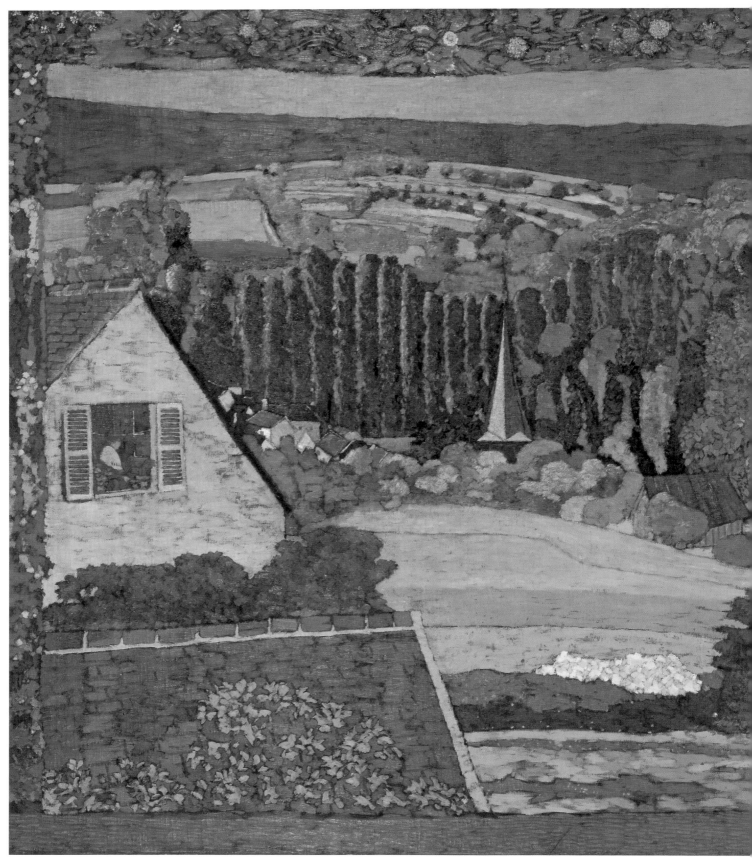

ÎLE-DE-FRANCE LANDSCAPE:
THE WINDOW OVERLOOKING THE
WOODS · *Paysage de l'Île-de-France.*
*La Fenêtre sur les bois*

1899, oil on canvas, 249.2 × 378.5
Signed and dated l.r.: *E. Vuillard 99*
The Art Institute of Chicago, L. L. and A.S.
Coburn Fund, Martha E. Leverone Fund,
Charles Norton Owen Fund, and anonymous
restricted gift, 1981.77

Cogeval-Salomon VII.64

———

*Provenance* Commissioned from Vuillard by
Adam Natanson, Paris, by 1899—Robert
Blum, Paris, 1950—Knoedler, New York—
Reader's Digest Association, New York—
John S. Samuels III, New York—Shickman
Gallery, New York—Art Institute of Chicago

*Exhibitions* Paris, Grand Palais, 1904, no. 1287
or 1288—Paris, Musée des Arts décoratifs,
1938, no. 69—Basel, Kunsthalle, 1949, no. 230
—Paris, MNAM, 1955, no. 221—Chicago-
New York, 2001, no. 41, col. ill. p. 135

*Bibliography* Segard 1914, pp. 253, 256–266—
Chastel 1946, pp. 53, 115—Roger-Marx 1946a,
pp. 138–139—Cogeval 1993 and 2002, pp. 78
–79, col. ill.—Groom 1993, pp. 65, 121–134,
145, 164, col. figs. 196–197—Groom 2001,
pp. 135–137, col. ill. p. 135

———

1. Édouard Vuillard, *Île-de-France Landscape: The First Fruits*, 1899, oil on canvas, Pasadena, Norton Simon Museum of Art, C-S VII.63.

*The Window overlooking the Woods*, also known as *Verdure*, the title under which it was first exhibited in 1904, is one of a pair of paintings: this work and its pendant, *The First Fruits* (fig. 1), were commissioned from the artist by Adam Natanson, the patriarch of the Natanson clan, to decorate the library of his Paris *hôtel particulier* at 85, rue Jouffroy. Executed in 1899, these paintings had as their subject and source of inspiration the landscape surrounding L'Étang-la-Ville (fig. 2), a village outside Paris where the Roussel family had recently rented a house and where Vuillard spent much of that summer. In a letter to Vallotton written in July, Vuillard says that he is greatly preoccupied with the paintings for "Rue Jouffroy" and that after a week filled with long promenades in the countryside he thinks he has "found some exploitable material."[1] Here, Vuillard has portrayed an idyllic countryside, dominated by rolling hills and lush foliage and punctuated throughout with gentle reminders of human habitation: the houses in the foreground, the tiny figures of men and a horse, the church steeple nestled among the trees in the middle ground. It is a pastoral scene that offers no intimation of the proximity of a bustling metropolis.

2. Photograph by Vuillard of the landscape at L'Étang-la-Ville, c. 1899. Salomon Archives.

Interestingly, but not at all uncommonly for Vuillard, the subject for this decoration was not dictated by the person who commissioned it but selected by the artist himself, from his own personal experience. It is perhaps an indication of the exceptional latitude accorded Vuillard within his relatively intimate circle of friends and patrons. The decision of the elder Natanson to commission the panels is, however, quite surprising and can only be attributed to the influence of his sons, in particular Thadée, who was living with Misia in the Rue Jouffroy apartment at this time. As Groom has pointed out, Natanson, a retired banker, was conservative by nature and had fairly conventional tastes, much preferring the art of eighteenth-century masters like Hubert Robert to works by contemporary artists such as Vuillard.[2]

Vuillard seems to have taken Natanson's tastes into account when creating these paintings, deliberately emulating tapestries of the seventeenth and eighteenth centuries. Adam Natanson owned several *verdures*—tapestries depicting wooded landscapes—some of which appear in Vuillard's paintings and photographs of Thadée and Misia's apartment on Rue Saint-Florentin (see cat. 156).[3] Although Vuillard had explored the visual effects of tapestry in a number of his previous decorations (cats. 126–127, 129, 137–140), experimenting with elaborate pattern, flattened form and flickering touches of interwoven colour, here he takes these experiments to their logical conclusion. He has represented a panoramic landscape by using a number of tapestry techniques, including creating the illusion of depth by stacking a succession of planes of colour one upon the other, so that they seem to recede and diminish into the distance. He has also abstracted the forms, eschewing detail and chiaroscuro and relying instead upon the juxtaposition of shapes and colours to describe his subject. Most striking is the brushwork itself. The paint has been applied in careful horizontal strokes that seem almost to mimic the coloured threads woven through the warp on a loom. The overall effect is completed by the decorative border of floral motifs, which could only have its source in tapestries from earlier centuries. KJ

1. Guisan and Jakubec 1973, p. 15.

2. Groom 1990, pp. 154–155.

3. Ibid., p. 159.

THE TURNING POINT | *Catalogue* **143–165**

THE PERIOD FROM AROUND 1896 to the turn of the century was a transitional one in Vuillard's artistic career. Domestic interiors, which had been a dominant theme in his work of the early 1890s, remained central to his art. In his typically oblique manner, Vuillard recorded the events affecting his own family—sometimes tragic, as in the death of his sister's baby son (cat. 144), sometimes joyous, as in the subsequent birth of his niece Annette (cats. 158–159), but more often than not perfectly mundane or even humorous (cats. 153–154). By the second half of the 1890s, however, Vuillard's world began to expand, both literally and figuratively, due largely to his growing association with the avant-garde journal *La Revue blanche*, its founders Alfred, Alexandre and Thadée Natanson, and, most importantly, Thadée's wife, the exuberant Misia.

In her unofficial role as the muse of *La Revue blanche*, Misia drew together a vibrant intellectual circle that included the poet Stéphane Mallarmé (cats. 163–164), the writer Romain Coolus (cat. 160) and a number of painters—her "*vernisseurs*"—who included Henri de Toulouse-Lautrec (cat. 162), Pierre Bonnard (cat. 161), Félix Vallotton (cats. 147, 152) and, of course, Vuillard. Vuillard's association with Misia and her circle played an important role in his career at this crucial juncture, providing a stimulating intellectual environment both in Paris and in the country, while allowing the young artist to cultivate patronage among the Natansons and their friends (see "The Decorative Impulse," in the present volume). As Vuillard's perennial muse and the object of his unrequited passion, Misia inevitably became a favourite subject, and Vuillard seems to have taken great pleasure in depicting her in a range of settings, within the confines of the tastefully eclectic Parisian apartment she and Thadée occupied on Rue Saint-Florentin (cats. 148, 156–157) or in the more relaxed environment of their country houses, first at Valvins (cats. 145–146) and later at Villeneuve-sur-Yonne (cats. 147, 150–151), where Vuillard experienced his first *villégiatures*.

Vuillard's *villégiatures*, those extended excursions into the countryside that were inaugurated with a visit to Misia and Thadée Natanson's country retreat at Valvins in 1896 and continued at Les Relais, their property at Villeneuve-sur-Yonne (see "Vuillard and the *Villégiature*," in the present volume), opened up new artistic possibilities. They offered novel themes—figures presented in more informal poses and situations (cat. 147), landscapes (cat. 254), figures within a landscape (cat. 150)—but more importantly these country sojourns offered the artist many direct experiences of natural light, and he began increasingly to explore its potential, both as a component within his compositions and as a vehicle for introducing a greater spatial and formal realism.

Artificial light, cast by judiciously placed lamps (see cats. 143, 156) or injected dramatically into an interior through an open door (see cat. 144), continued to feature in his work during this period, no doubt reflecting his ongoing involvement with Lugné-Poe's symbolist Théâtre de l'Oeuvre (see "Vuillard Onstage," in the present volume). However, natural light began to appear as a compositional element with growing frequency in his interiors (cat. 154), or as the mechanism for undermining the radical two-dimensionality that was the hallmark of his Nabi work (see "Permanent Transgression" and "Behind Closed Doors," both in the present volume). In paintings such as *The Widow's*

*Visit (The Conversation)* (cat. 153), various objects cast shadows—a visual device as yet relatively unexploited in Vuillard's work—thus creating an unprecedented sense of depth and introducing a slight but perceptible separation between figure and ground. In a number of other paintings created around 1900 natural light is employed, along with other pictorial elements, to establish a sense of volume and to differentiate figures from their decorative environment (see cats. 155, 159).

This period of transition was also marked by a consolidation of Vuillard's creative process and the introduction in 1897 of an additional visual resource in the construction of his compositions: the camera (see "The Intentional Snapshot," in the present volume). The product of a traditional artistic training, Vuillard habitually used quick, thumbnail pencil sketches during the 1890s as an initial stage in his creative process. To these were now added photographs. However, there was a systematic dependence upon neither sketch nor snapshot. Rather, they served as general sources for compositional ideas, which would then be mediated onto the canvas through the process of memory and recall. Maurice Denis, in his 1899 analysis of the two different strands he perceived as coexisting within the Nabi group, asserted that Vuillard's work—together with that of Bonnard and Vallotton—could be distinguished by the fact that it was created "from life" and yet made "from memory, without models."[1] Such a procedure implies an inevitable distancing from the motif that Vuillard's approach shared with the pictorial Symbolism of Gauguin.

In the spring of 1897, Vuillard and his fellow Nabis were being hailed by Roger Marx as successors to the Impressionists, talents that could not be dismissed,[2] while André Fontainas was applauding their audacity and innovation: "Daring explorers…their works, all more or less unusual, all appealing in their fresh boldness, their markedly original style."[3] But by the turn of the century the stylistic differences between the Nabis were being increasingly noted, and certain of their number, including Denis and Sérusier, were the object of growing negative criticism. Vuillard, however, although his work was seen to be changing, still commanded the praise and support of the majority of the critics: "M. Édouard Vuillard is among the few whom we sense to be moving toward something better, something new. He is a truly natural painter…"[4] This evaluation augured well for Vuillard's entry into the twentieth century. **MaryAnne Stevens and Kimberly Jones**

1. Denis 1957a, p. 150 (journal entry, made after March 15, 1899).

2. "Les Salons de 1897," *Le Voltaire* (April 20, 1897).

3. "Art : Les Dix," *Mercure de France*, vol. 22, no. 89 (May 1897), pp. 411–412.

4. Ivanhoé Rambosson, "Les Symbolistes et les Néo-impressionnistes chez Durand-Ruel," *La Plume*, no. 243 (June 1, 1899), p. 383.

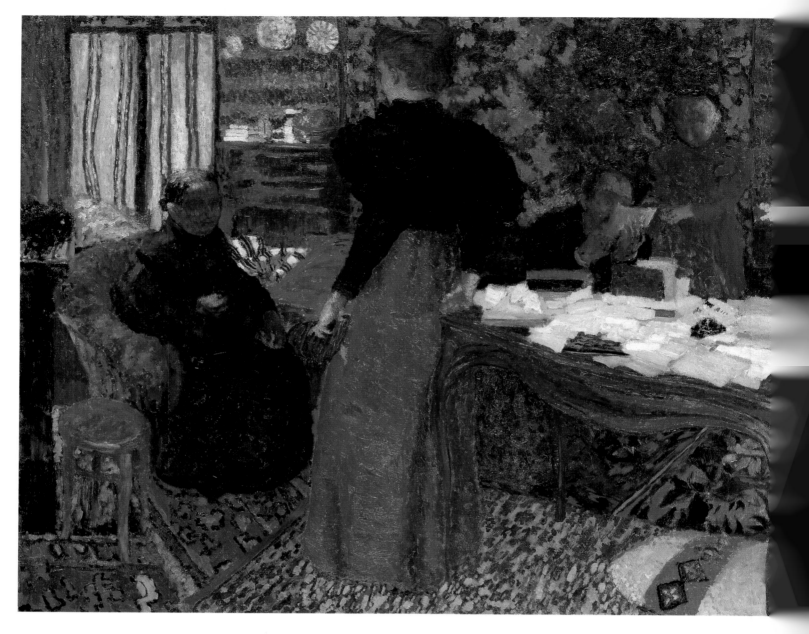

## 143

LARGE INTERIOR WITH SIX FIGURES ·
*Le Grand Intérieur aux six personnages*

1897, oil on canvas, 90 × 194.5
Signed and dated l.l.: *E. Vuillard 97*
Kunsthaus Zurich, Inv. 1966/13

Cogeval-Salomon IV.215

———

*Provenance* Félix Vallotton, Paris, c. 1898 —
Galeries Paul Vallotton, Lausanne —
Kunsthaus, Zurich

*Exhibitions* Paris, Vollard, 1897 — Zurich,
Kunsthaus, 1932, no. 133, ill. — Zurich-Paris,
1993 – 1994, no. 174, col. ill.

*Bibliography* Roger-Marx 1948b, pl. 7 —
Russell 1971, p. 59 — Perucchi-Petri 1976,
p. 139, fig. 93 — Cogeval 1990, pp. 118, 126,
ill. p. 155, col. ill. pp. 204 – 205 — Cogeval
1993 and 2002, pp. 49, 60 – 61, col. ill. —
Groom 1993, pp. 86, 96 – 97, col. fig. 162

———

In terms of both its scale and its visual com-
plexity, *Large Interior with Six Figures* repre-
sents a new direction in Vuillard's art, mark-
ing the transition from the tightly contained,
claustrophobic interiors typical of his oeuvre
of the early to mid-1890s to a more expansive,
space-oriented approach to picture-making.

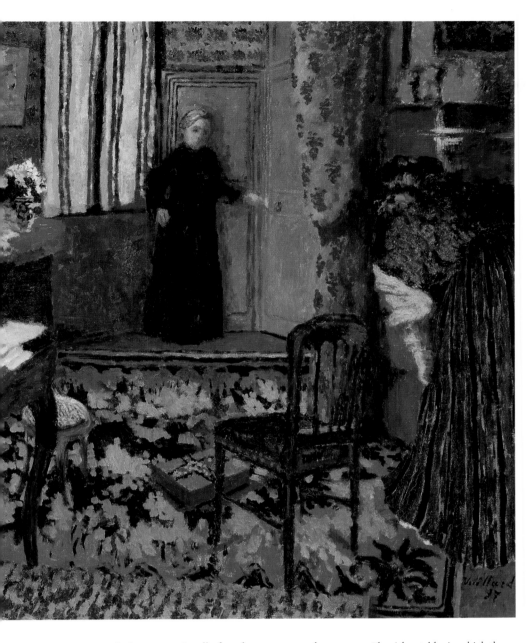

*Large Interior* is an exceptionally fraught painting, visually and psychologically. Its surface is sumptuous, filled with competing patterns—in the rugs scattered across the floor at varying angles, the drapery, and even the papers covering the table's surface—all interwoven with vibrant shades of red. Composed of a series of concave and convex curves, the picture compels the viewer's eye to shift rhythmically from foreground to background, as if (as noted by Émilie Daniel)[1] it were a five-panel screen folded upon itself or (as observed by Cogeval)[2] the product of a series of mirrors arranged in a zigzag pattern reflecting "a reality divided between several different viewpoints." Cogeval has also likened the painting's pictorial organization to a polyptych, or even a Flemish retable, in which the narrative registers are collapsed and conflated by anamorphosis into a kind of weightless reality.[3] Given the ambitious scale of the work and its strong decorative quality, Groom has suggested that it may have been executed as a decoration for a specific interior, but that either the project was cancelled or the painting rejected.[4]

Unlike most of Vuillard's earlier interiors, whose settings and protagonists are easily recognizable, here precise identifications have remained elusive. François Daulte has suggested that the setting is Odilon Redon's apartment at 32, avenue de Wagram, identifying the seated man as Redon and the woman standing on the left as Vuillard's sister Marie.[5] The identification of Redon, however, has largely been refuted.[6] Thomson likewise sees Marie in the standing woman, and suggests that the seated man could be Mallarmé and the woman standing next to him Misia.[7] Baumann and Perucchi-Petri have identified the seated man as Roussel and the standing woman as Marie, but the latter also mentions Salomon's hypothesis that the two figures may be Paul Ranson and his sister-in-law, Germaine Rousseau.[8]

Cogeval has finally resolved the issue, noting that according to Kerr-Xavier Roussel the scene is set in the Ranson apartment on Boulevard de Montparnasse, also depicted in Vuillard's earlier painting, *Woman in Blue* (cat. 95),[9] and its protagonists are therefore members of the Ranson family. The most striking figure is that of Germaine Rousseau, who dominates the composition on the left and whose identity is corroborated by contemporary photographs. Also present is the artist Paul Ranson, who is seated at the table, and Ida Rousseau, the mother of Germaine and France Ranson, depicted standing in the doorway to the rear of the picture.[10] Seated at the far left is Madame Vuillard, the one figure whose identity has never been questioned.

Cogeval believes that this painting, like *Woman in Blue*, and in a more oblique fashion *A Family Evening* (cat. 96) and *Woman Seated in a Dark Room* (cat. 97), alludes to the scandalous romance between Roussel and Germaine —and its repercussions. This affair, which shocked both the Vuillard and the Ranson families, as well as their circle, finally reached a crisis point in October 1895. In a letter to her son dated October 6, 1895 Madame Vuillard recounts a visit to the Ransons that may have provided the inspiration for this painting: "I didn't answer you yesterday afternoon because we were to see the Ransons in the evening and I thought I might have some news to give you; but there are no developments on that front, we spent a nice and very friendly evening, speaking hardly at all about the Young Lady, who, it seems, is getting over it quite quickly and wishes to hear no more about it. As for Kerr, he's as stubborn as ever."[11]

1. Félix Vallotton, *Woman in a Purple Dress by Lamplight*, 1898, Winterthur, private collection.

There is an almost palpable sense of strain in this painting that centres on the confrontation between the seated figure of Madame Vuillard and the standing Germaine, at the left side of the composition. This mood of disquiet infuses the picture, resonating in the awkward poses of the figures and their strange lack of interaction, but also in the tension between the picture surface and the somewhat incoherent recession into space.

Vuillard gave this painting to his friend Félix Vallotton, probably around the time of the exhibition held at the Vollard gallery in April 1897, where it was exhibited *hors catalogue*.[12] Its presence in Vallotton's collection is confirmed by its appearance in two separate paintings by him: *Woman in a Purple Dress by Lamplight* (fig. 1) and *The Red Room* (1898, Lausanne, Musée cantonal des Beaux-Arts). In the former, as Cogeval notes, *Large Interior* is clearly visible on the wall of Vallotton's apartment, though there is one notable modification: the figure of Ida Rousseau opening the door is absent and in her stead is a man shown turning away from the room's other inhabitants, in a pose precisely the same as that chosen by Vuillard for his depiction of Monsieur de Meyrueis in his theatre program

for Maurice de Beaubourg's play, *La Vie muette* (cat. 75).[13] In *The Red Room*, Vuillard's *Large Interior* can be seen reflected in a mirror hanging over the fireplace, although there the scale is reduced and the image has been reversed to present the painting as it appears in reality. In this work however, the figure of Ida Rousseau is clearly present once more.

Cogeval puts forward a compelling hypothesis to account for this curious discrepancy: he suggests that Vuillard gave the painting to Vallotton in its original form, but then altered it in 1897, the date that appears in the lower right-hand corner of the painting. The original male figure was in all likelihood none other than Roussel himself, shown turning his back on his lover in a gesture that epitomized the tumultuous drama being portrayed but that also made "the allusion to the family situation in the fall of 1895…too obvious."[14] Wishing to play down this domestic crisis, Vuillard effaced the male figure and replaced it with a more innocuous player, Ida Rousseau. Although the explosive personage of Roussel has been removed, however, and with him much of the original narrative subtext, the potent mood of unease with which Vuillard imbued the work remains intact. KJ

1. Daniel 1984, pp. 187–190.

2. Cogeval in C-S 2003, no. IV-215.

3. Ibid.

4. Groom 1993, p. 97.

5. Daulte 1964, no. 154.

6. See Baumann 1966, p. 63.

7. Thomson 1988, p. 44.

8. Baumann 1966, p. 61; Perucchi-Petri 1972, p. 25. Ursula Perrucchi-Petri in *Nabis, 1888–1900*, exhib. cat. (Paris: Réunion des musées nationaux, 1993), no. 174.

9. See Cogeval in C-S 2003, no. IV-215.

10. Ibid.

11. Letter from Madame Vuillard to Vuillard, October 12, 1895 (Salomon Archives), quoted by Cogeval in C-S 2003, no. IV-215.

12. Baumann states specifically that Vuillard gave it to Vallotton after the close of the exhibition "in gratitude for his sincere enthusiasm." Baumann 1966, p. 61.

13. Cogeval in C-S 2003, no. IV-215.

14. Ibid.

## 144

INTERIOR, also known as INTERIOR, MYSTERY · *Scène d'intérieur*, dit *Intérieur, Mystère*

1896, oil on board, 35.8 × 38.1
V. Madrigal Collection

Cogeval-Salomon IV.218

*Provenance* Acquired from the artist by Bernheim-Jeune, Paris—Carroll Carstairs, New York—John Koch, New York, c. 1968 —Galerie Bellier, Paris—Jan Krugier, Geneva, c. 1993—Private collection, New York

*Exhibitions* Paris, Durand-Ruel, 1899— Cleveland-New York, 1954, p. 102, ill. p. 57— Houston-Washington-Brooklyn, 1989–1990 (hors cat.)—Lyon-Barcelona-Nantes, 1990– 1991, no. 53, col. ill. p. 113—Montreal, MMFA, 1995, no. 461, p. 162

*Bibliography* Roger-Marx 1946a, p. 50— Perucchi-Petri 1976, p. 101, fig. 57—Mauner 1978, pp. 255–256, fig. 130—Cogeval 1993, p. 62, col. ill. p. 63—Groom 1993, pp. 12, 77, col. fig. 16

This enigmatic painting is pivotal in Vuillard's oeuvre: it simultaneously harks back to his work of the early 1890s, with its overtly charged symbolist content, and asserts a radical reassessment of the role of natural light— initially within interiors (see cat. 156) and subsequently outdoors in the world of urban and rural landscapes (see cats. 255–256). It also connects laterally to Vuillard's involvement with the avant-garde theatre and to his experiments in colour lithography (the room that forms the subject of the painting was also the model for four colour lithographs from the album *Landscapes and Interiors*, published by Ambroise Vollard in 1899: *Interior with Hanging Lamp* [fig. 1] and *Interior with Pink Wallpaper I, II* and *III*).[1]

The shafts of light that penetrate—not entirely logically—this room in Vuillard's apartment at 342, rue Saint-Honoré establish a spatial ambiguity while reinforcing the overall tonal harmony. Intense light pierces the interior from the right, reflecting off the brass oil lamp and its white shade behind, which in turn throws a segmented beam onto the wall above the half-open door. The left-hand side of the composition, by contrast, is in deep shadow, with most of the detail obscured; there is only the most summary reference to the lamp suspended from the ceiling in a dense area of the same tones of brown, grey and muted red that dominate the entire composition.

Despite the intrusion of light, the image emits a heavy, evocative atmosphere that has led certain authors, notably George Mauner, to read into it a strong symbolist message. Mauner links the atmosphere of the painting to such dramatically lit, emotionally charged early works as *Dinnertime* (cat. 2); but he also deduces from the Greek *tau* shape created by the spotlighting of a section of the panelling at the top of the far wall that the painting possesses a theosophical significance similar to the one he also discerns in *In Bed* (cat. 21) and *Lady of Fashion* (cat. 26):

In *Mystère*, the beams themselves create the cross, as it is picked out by a stray spot of light of undescribed origin. In the sign, the Theosophic symbol of the Absolute, as an integral part of the room, Vuillard restates the mood and meaning of the entire painting. The tau form of the cross refers to the androgyne; to the unity of opposing forces.[2]

So specific a symbolist interpretation of the painting is, however, undermined by a number of considerations. First, as Cogeval has argued, the painting derives its subject matter from direct observation.[3] A drawing exists (priv. coll.) that not only plots the various constituent elements of the composition (from

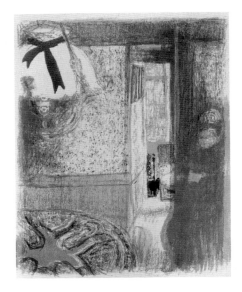

1. Édouard Vuillard, *Interior with Hanging Lamp*, 1899, colour lithograph, Washington, National Gallery of Art, Rosenwald Collection.

the suspended light fixture to the brass oil lamp and the half-open door), but also indicates the precise fall of light onto the upper wall of the room and the "T" shape created by the illuminated intersection of vertical and horizontal sections of the panelling. Furthermore, when *Interior, Mystery* was exhibited for the first time in 1899 at the Durand-Ruel gallery with three other works, under the collective title "Interior Scenes," it did not provoke any symbolist readings from the critics. Maurice Denis, reflecting upon the exhibition in a journal entry written sometime after March 15, 1899, actually made a clear distinction between the "large symbolic paintings" of Ranson, Sérusier and himself and the "small pictures…from life…made from memory, without models" by Bonnard, Vallotton and Vuillard.[4] And although Gustave Geffroy perceived "the most unusual impression of modern life" in the four "Interior Scenes," he also noted that this unique atmosphere was achieved by ennobling everyday objects and experiences through the discreet and precise placing of coloured marks upon the canvas, thus creating "works full of delicacy, where colour flowers so subtly and form so elegantly."[5]

Although not explicitly symbolist, however, the painting contains a definite emotional resonance. The use of intense spotlighting and the corresponding areas of suggestive shadow may well owe their inspiration to Vuillard's continued work for Lugné-Poe's Symbolist theatre company, the Théâtre de l'Oeuvre, as a designer of both sets and theatre programs (see cat. 57). Vuillard's particular involvement with the work of the Scandinavian dramatists Ibsen and Björnson, which explored contemporary domestic life in terms of social and ethical mores and extreme emotional states, is no doubt especially relevant here. It seems in fact possible that the painting, with its absence of figures and its half-open door, may be the highly personal expression of a family still mourning the death the previous November of Petit-Jean, the baby son of Vuillard's sister, Marie Roussel.[6] The extent to which the tragedy affected them all is intimated in a comment made by Vuillard in a letter to Félix Vallotton dated August 5, 1897: "I hope to be able to get her [Madame Vuillard] away for a while from these surroundings, where she is becoming obsessed by dreadful thoughts."[7] It is possibly because the painting recorded so painful a personal tragedy that Vuillard not only bought it back from Bernheim four days after he sold it to the dealer on February 16, 1907, but also excluded it from his major retrospective exhibition, held at the Musée des Arts décoratifs in 1938—and indeed from all other exhibitions held during his lifetime.
MAS

1. Cogeval in C-S 2003, no. IV.218.

2. Mauner 1978, pp. 255–256.

3. See Cogeval in C-S 2003, no. IV.218.

4. Denis 1957a, p. 150.

5. Gustave Geffroy, *Le Journal* (March 15, 1899).

6. Cogeval in C-S 2003, nos. IV.217 and IV.218.

7. Guisan and Jakubec 1973, p. 160.

## 145

THE ATTIC OF LA GRANGETTE
AT VALVINS · *Le Grenier de La Grangette
à Valvins*

1896, oil on board mounted on cradled panel,
44.5 × 64
Signed and dated u.r.: *Vuillard 96*
Private collection

Cogeval-Salomon VI.12

—————

*Provenance* Acquired from the artist by
Ambroise Vollard, Paris, c. 1899—Private
collection

*Exhibitions* Cleveland-New York 1954, p. 102,
col. ill.—Toronto-San Francisco-Chicago,
1971–1972, no. 43, ill.

*Bibliography* Preston 1971, p. 94, col. ill. p. 95
—Ciaffa 1985, pp. 252–253, fig. 118

## 146

THE ATTIC OF LA GRANGETTE
AT VALVINS · *Le Grenier de La Grangette
à Valvins*

1896, graphite, pen and coloured pencils
on paper, 8.2 × 10.1
Private collection

—————

This painting depicts the attic of La Grangette,
the small country house where Thadée Natan-
son and his wife Misia spent their summers.
Located in Valvins, not far from Fontainebleau
and just a few doors away from the home of
the poet Stéphane Mallarmé, La Grangette
became a sanctuary for Vuillard, who along
with Bonnard was a frequent visitor.

Vuillard has portrayed the attic in a manner
more evocative than descriptive. The wooden
beams that criss-cross the composition at dif-
ferent angles—the room's most prominent
feature—give it a misshapen but charmingly
quirky appearance. The sole source of light,
a small oil lamp resting on the table, casts its
light upward so that the beams throw heavy
shadows across the cool blue ceiling, leaving
the rest of the room softly veiled in shadow.
Here and in several other paintings executed
around this time (cats. 96, 144) Vuillard seems
to have taken great pleasure in exploring noctur-
nal effects, utilizing discrete light sources that
provide minimal illumination in order to create
mysterious and richly atmospheric interiors.

The room itself reflects the somewhat bo-
hemian personalities of its inhabitants. It is
crowded, cluttered with furniture and other
possessions. Misia's piano is given pride of
place in the left foreground, a vase of flowers
on top; directly behind it, a chair with cush-
ions covered in a rich red brocade seems dis-
proportionately large in relation to the piano.
Other pieces of furniture are scattered about
the small attic, leaving virtually no bare space.
That Vuillard has subtly manipulated the
space for expressive purposes becomes appar-
ent when we compare this painting to the
drawing of the same attic room (cat. 146).
Many of the details are present in both ver-
sions: the picture frame hanging near the win-
dow, the piano, the chair. In the drawing,
however, the attic looks open and airy, in con-
trast to the densely packed interior space of

the painting. But despite the clutter and
Vuillard's ingenious compression of the space,
the room does not seem claustrophobic, but
rather cozy and inviting. This is due largely to
the presence of Thadée and Misia themselves:
the two are seated opposite one another at the
table, engaged in their intellectual pursuits—
Misia reading, Thadée writing. Although their
features are vague and largely hidden from
view, their identity is obvious, as is the affec-
tion that the artist feels for them both, which
transforms *The Attic of La Grangette at Val-
vins* into an understated homage to a valued
friendship. K J

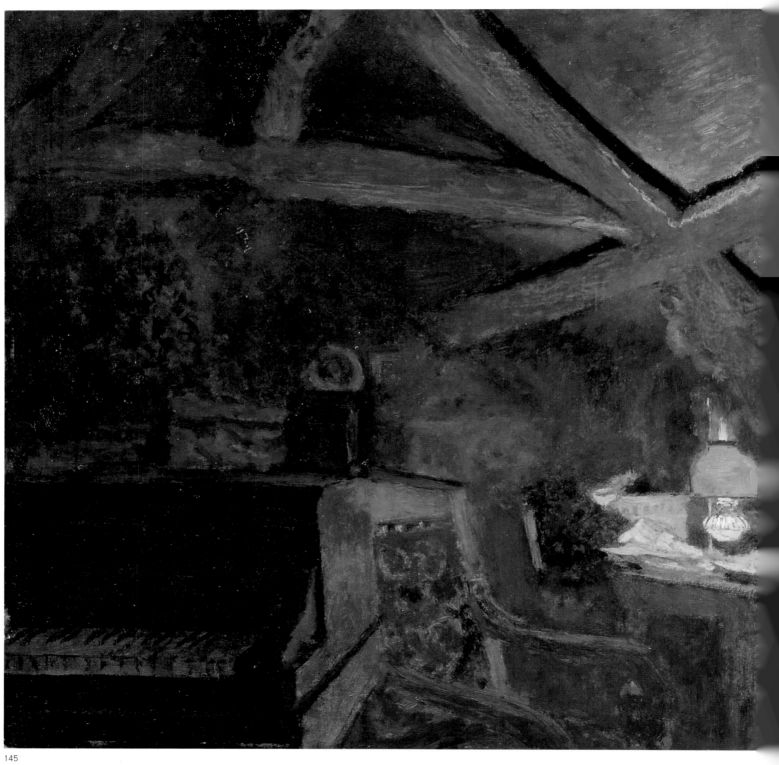

145

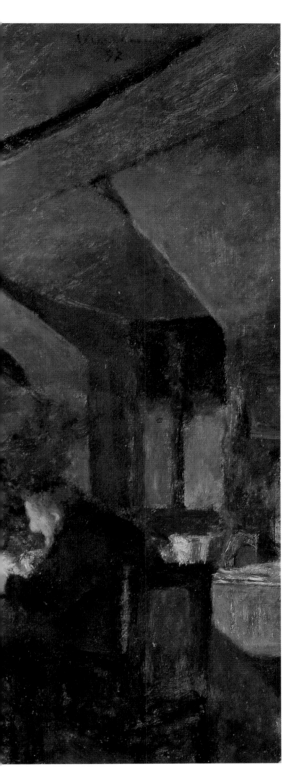

146

## 147

MISIA AND VALLOTTON AT
VILLENEUVE · *Misia et Vallotton
à Villeneuve*

1899, oil on board, 72 × 53
Signed and dated u.r.: *E Vuillard 99*
New York, Collection William Kelly Simpson

Cogeval-Salomon VI.71

———

*Provenance* Rosenberg, Paris—Bernheim-
Jeune, Paris—Mme Emile Mayrisch, Colpach
—Wildenstein, New York—William Kelly
Simpson, New York

*Exhibitions* London, New Gallery, 1905,
no. 263 [Intérieur et personnages]—Munich,
Haus der Kunst, 1968, no. 54, ill.—Paris,
Orangerie, 1968, no. 104, ill.—Houston-
Washington-Brooklyn, 1989–1990, no. 92,
col. ill.

*Bibliography* Escholier 1937, ill. p. 18—
Roger-Marx 1946a, p. 84, ill. p. 87—Chastel
1946, ill. p. 43—Salomon 1968, p. 72, col. ill.
p. 73—Easton 1989, pp. 118, 125—Cogeval
1993 and 2002, p. 52, col. ill.—Groom 1993,
pp. 85–86, col. fig. 144

———

The informality with which *Misia and Vallot-
ton at Villeneuve* is composed suggests that its
origins could lie in a snapshot. It is rather as
if a camera lens had been pointed more or less
randomly to capture Misia seated at a table,
Félix Vallotton moving away from the centre
of the image and Thadée Natanson cut off on
the extreme left by what could be the arbitrary
constraints of the photographic frame. How-
ever, the conspicuous isolation of each of
the protagonists within the composition might
equally be a hint that the painting is actually
concerned with exploring a complex set of
personal relationships marked by an absence
of communication. Misia's back is turned
pointedly toward her husband, whose minimal
presence implies that he has only a limited
significance in his wife's emotional world.
Misia is also disengaged from Vallotton, and
their simultaneous proximity and lack of
communication suggests an ambiguity in their
relationship.

Given the presence both of the stylized floral
wallpaper that covered the walls of the salon-
music room of the Natansons' Rue Saint-
Florentin apartment (see cats. 156–157) and
of the painting *The Stoneware Pot* (cat. 129)—
one of the set of five decorative panels that
the Natansons had commissioned from
Vuillard in 1895 (cats. 126–129)—it has been
assumed that the setting of this painting
must have been the Natansons' Paris residence.
However, the informality of Misia's dress,
complete with yellow neckerchief, and the
glimpse of blue sky through the almost-covered
window in the background, together with
the fact that the Rue Saint-Florentin wallpaper
had also been used at their country house,
Les Relais, and that paintings were commonly
moved from Paris to Les Relais to decorate
the walls suggest, as Guy Cogeval has pointed
out, that the subject originated at Villeneuve-
sur-Yonne.[1] The summer and autumn of 1899,
during which Vuillard was a house guest of
the Natansons at Villeneuve-sur-Yonne, actu-
ally seems to have been a highly productive
season for the artist, despite characteristic
bouts of depression and inactivity. In a letter
to Félix Vallotton, Vuillard described his
activities in the country with a certain degree
of satisfaction: "I'm actually doing a lot of
painting and in spite of moments of despair,
misgiving and annoyance, I think I shall be
able to bring back a few pictures—or I must
resign myself to simply doing my best, which
is a little humiliating for my spiritual, intel-
lectual and other pretensions."[2]

No specific photograph provided the compo-
sitional material for this painting, but Vuillard
had acquired a camera two summers earlier
and made consistent use of it during his
*villégiatures* at Villeneuve-sur-Yonne, taking
several snaps of Misia, in a variety of relaxed
poses, wearing her characteristically casual,
checked Liberty-style smocks (see cats. 167,
177–179). A drawing also exists (priv. coll.)
that plots the disposition of the figures with-
in the composition in some detail and even
indicates the presence of *The Stoneware Pot*
on the wall.

The relationship between Misia and Félix
Vallotton was as playful and flirtatious as her
relationship with Vuillard or with Romain
Coolus. Vuillard certainly recognized that her
affections were divided, commenting to Val-
lotton in a letter dated November 27, 1897:
"You know her, she likes you very much and
asked me to tell you so; what a kind and good
woman."[3] The position was little different

when Vuillard wrote to Vallotton toward the
end of the 1899 *villégiature* at Les Relais, dur-
ing which *Misia and Vallotton at Villeneuve*
was painted: "Misia tells me that you are one
of the very rare individuals of whom she
thinks without rage. That's her latest word."[4]

This painting was first exhibited in London
in 1905, where it appeared with *The White
Salon* (1904, priv. coll., C-S VII.332) at the
fifth exhibition of the International Society of
Sculptors, Painters and Engravers. Given
that the masters of Impressionism were still
receiving responses ranging from lukewarm
to completely dismissive from most British
critics and the exhibition-going public—Roger
Fry's exhibition *Manet and the Post-Impres-
sionists* was still five years off—it is not sur-
prising that Vuillard's uncompromisingly
two-dimensional composition met with a com-
bination of disregard and distaste, attenuated
only a little by one critic's acknowledgement
that "the picture has several beauties of colour
and of tone."[5] Vuillard's "little flat picture,"
"to which a character of silliness is undoubt-
edly attached," provoked another commenta-
tor to detect confusion in his artistic intentions:
"It may be a jest, an expression of ill-temper
or indigestion, a mere fly-blow on canvas, or
it may be the normal work of a man in whose
talent extraordinary assurance and extraor-
dinary feebleness go hand-in-hand."[6] Regret-
fully, the critic of the *Pall Mall Gazette* was
forced to conclude that "there is no fresh
lesson to be taken from France…For the time
being the experiments have all been made."[7]
MAS

———

1. Cogeval in C-S 2003, no. VI.7.

2. Letter from Vuillard to Félix Vallotton, dated November 27,
1899, in Guisan and Jakubec 1973, p. 191.

3. Guisan and Jakubec 1973, p. 170.

4. Ibid., p. 191.

5. Mrs. Meynell, "'The International': New Gallery,"
*The Ladies' Field* (January 21, 1905), p. 274.

6. A.M., "The International," *Pall Mall Gazette*
(January 9, 1905).

7. Ibid.

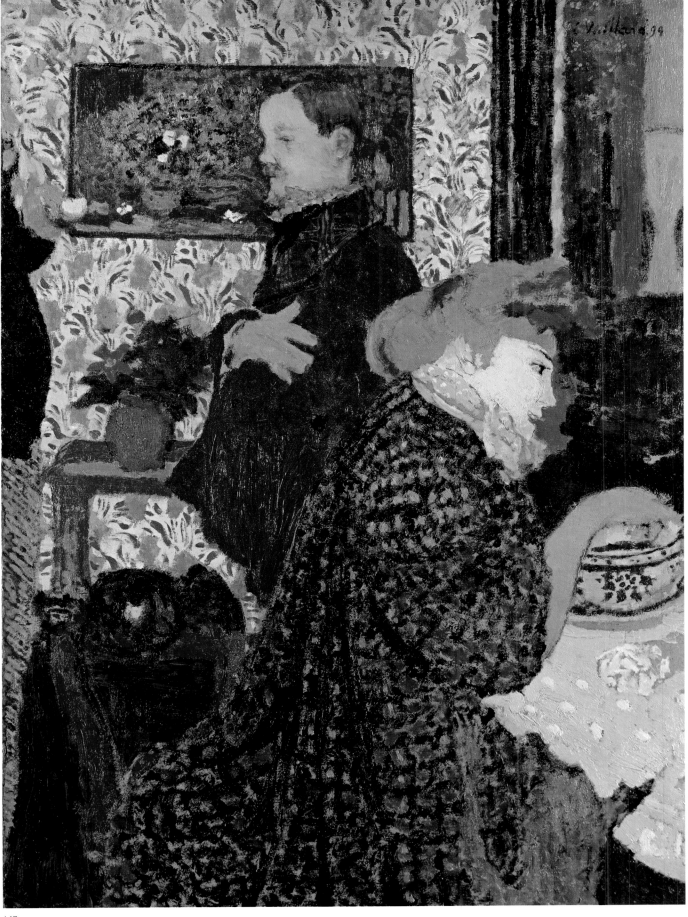

147

# 148

WOMAN SEATED IN A CHAIR ·
*La Femme au fauteuil*

1896, oil on paper mounted on canvas,
105 × 74
Signed l.r., possibly by another hand:
*E. Vuillard*
Private collection

Cogeval-Salomon VI.34

———

*Provenance* Bernheim-Jeune, Paris—Sam
Salz, New York, after 1948—Nate B. Spin-
gold, New York—Gift to the Museum of
Modern Art, New York, 1957—Sale, 1987—
E. V. Thaw, New York—Private collection

*Exhibitions* Paris, Bernheim-Jeune, 1913
(hors cat.)—Paris, Petit Palais, 1937, no. 24
—Cleveland-New York, 1954, p. 102, col.
ill. p. 51

*Bibliography* Roger-Marx 1968, col. pl. 6—
Preston 1971, p. 92, col. ill. p. 93—Groom
1993, p. 94, col. fig. 161—Easton 1994, p. 15,
ill. p. 11

———

This painting, illuminated by the white of
the sitter's dress, is set in the Natanson home
on Rue Saint-Florentin. The apartment was
decorated with stylized floral wallpaper—
immediately recognizable—and included a
grand piano (see cat. 157). Misia Godebska,
the gifted musical wife of Thadée Natanson,
is seated in front of the grand piano, which
is draped in a richly-coloured Spanish shawl.
Behind her on the right, barely discernible,
stands the ruminative figure of her husband,
while near her chair lingers a dog—or pos-
sibly two. The composition is based on a pre-
liminary drawing (priv. coll.) that includes
neither Thadée Natanson nor the dog and
presents Misia's face in firm profile rather
than—as in the final painting—almost
frontally and tilted slightly to the side. Here,
she appears to be totally absorbed in the con-
templation of a musical experience being
provided by an invisible and possibly imagi-
nary pianist.

The white striped dress subtly tinted with
pink, which can also be seen in the Natanson
screen (cat. 141), helps to cast Misia in the
timeless role of muse. The allure she exerted
over most of the male members of the Natan-
son circle, in Paris, at Valvins and later at
Villeneuve-sur-Yonne, is well documented.
Vuillard, writing to Félix Vallotton from
Villeneuve-sur-Yonne on October 23, 1897,
noted: "Misia is, as ever, charming and kind,
she wears violent colours, which you would
love, as I do."[1] A somewhat cooler assess-
ment of her power over the opposite sex was
offered some years later by Annette Vaillant:
"A dangerous fairy, she could both create and
destroy. Pretty, but in a slightly coarse way,
despite her classical profile... Musical, irresis-
tible, adored, devoted, she bewitched all
the young men, but was not content to reign
benevolently: she was soon to be the cause
of considerable suffering."[2]

The image of an individual enveloped in a
private world of musical experience was quite
common in Symbolist art during the last
two decades of the nineteenth century. James
Ensor, for example, had represented a man
caught in rapt appreciation of a woman's
playing in *Russian Music* (1881, Musées Roy-
aux des Beaux-Arts de Belgique). But closer
in spirit to Vuillard's *Woman Seated in a Chair*
is the work by Fernand Khnopff entitled
*Listening to Schumann* (1883, Musées Royaux
des Beaux-Arts de Belgique), where the
pianist has been virtually excluded from the
composition and the entire focus is on a seated
woman, isolated within a bourgeois interior,
her head bowed as the music she hears pro-
vokes private thoughts and reveries. Deriv-
ing their inspiration from Charles Baudelaire,
the Symbolists sought in music—the most
non-mimetic of arts—the power to lift the
reader or spectator from the realist world of
literal description into one of pure, abstract
ideas and emotions. By making Misia utterly
unaware of either Thadée within the painting
or the spectator beyond, and by replacing
realistic description with non-naturalist pattern,
Vuillard seems to have sought to establish a
close link between art and music. Vuillard's
own art was in fact often described in musical
terms, notably as the pictorial equivalent of
the music of Claude Debussy. In June 1902,

when reviewing a group exhibition of Bon-
nard, Maurice Denis, Maillol, Roussel, Vallot-
ton and Vuillard at the Galerie Bernheim-
Jeune, the critic Félicien Fagus saw a specific
connection between the *intimiste* poetry of
Baudelaire and the *intimiste* paintings of
Vuillard, which he interpreted as the direct
equivalents of the tonal reflections of Debussy:
"But Baudelaire also created *intimiste* poetry,
music about intimate things. Like Vuillard.
The amazing symphony of juxtaposed
colours, which is so precisely similar to the
harmonic iridescences of the composer
Debussy, is at the same time and above all a
symphony of substances."[3] MAS

———

1. Guisan and Jakubec 1973, p. 164.

2. Vaillant 1956, p. 31, quoted in Guisan and Jakubec 1973,
p. 165, note b.

3. Félicien Fagus, "Gazette d'art : Bonnard, Maurice Denis,
Maillol, Roussel, Vallotton, Vuillard," *La Revue blanche*,
vol. 28, no. 216 (June 1, 1902), pp. 215–216.

## 149

THE NAPE OF MISIA'S NECK ·
*La Nuque de Misia*

1897–1899, oil on board mounted on
cradled panel, 13.5 × 33
Signed l.r.: *E. Vuillard*
Private collection

Cogeval-Salomon VI.61

*Provenance* Sacha Guitry, Paris—José Maria
Sert y Badia, Spain—Private collection

*Exhibitions* Montreal-Paris, 2000–2001, ill.
p. 276

*Bibliography* Guitry 1952, ill. p. 101

This small, relatively little-known painting is
a masterpiece of lover's reserve. Misia Natan-
son, Vuillard's perennial muse, seen time
and again in the paintings executed between
1895 and 1900, was his great secret love. She
enabled him to transcend the barriers of a
rather furtive, ironic, juvenile sensuality. In
her memoirs, published after her death, Misia
relates—no doubt truthfully—an episode
that vividly reveals the painter's impulsive
shyness:

The echoes of this agitation [the Dreyfus affair] reached
me at Villeneuve, and I decided to leave for Paris earlier
than usual. Vuillard then said he wanted to take a last
walk along the banks of the Yonne, and we started at
dusk. Looking dreamy and grave, he led me beside the
river amongst the tall birches with their silvery trunks.
He moved slowly over the yellowing grass, and I fell
in with his mood; we did not speak. The day was closing
in rapidly, so we took a shortcut across a beetroot field.
Our silhouettes were insubstantial shadows against a
pale sky. The ground was rough, I tripped on a root and
almost fell; Vuillard stopped abruptly to help me regain
my balance. Our eyes met. In the deepening shadows
I could see the sad gleam of his glance. He burst into
sobs. It was the most beautiful declaration of love ever
made to me.[1]

Almost certainly painted at Les Relais, the
Natanson's country house—as witness
Misia's summer dress and relaxed pose—this
unusually shaped picture reveals a power-
fully sensual aspect of Vuillard's personality.
The lock of hair that hides Misia's face and
the delicate shadow caressing her cheek have
a disturbing effect; most striking, though, is
the way she exposes her neck, transforming
it into an object of erotic fixation (no doubt
much appreciated by the work's successive
owners—Sacha Guitry and José-Maria Sert,
Misia's third husband). The simplicity of
the statement parallels the gaze cast ideally
upon the object of love, with an elegant cool-
ness reminiscent of Utamaro's images of
courtesans. Within the confines of this small
work, Vuillard succeeds in conveying a range
of sensations: the torpor of a fine summer's
afternoon in the country, the spectacle of
light embracing the contours of a body—
in a word, a particular form of voluptuous
pleasure. GC

1. Sert 1953, p. 52.

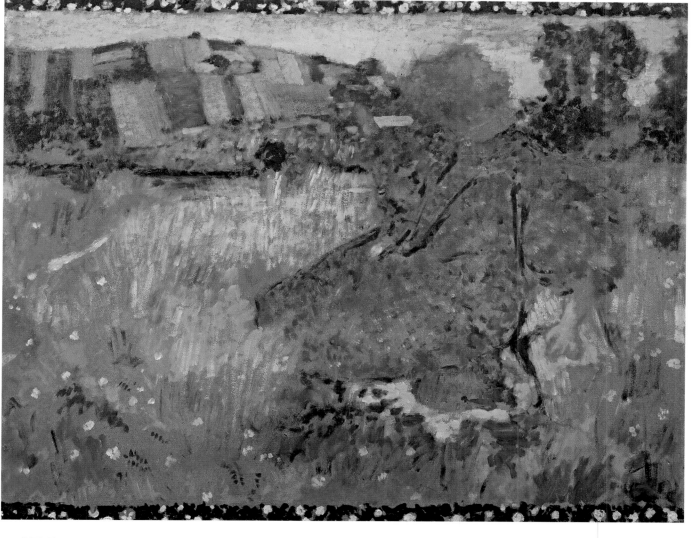

## 150

WOMAN IN THE COUNTRYSIDE ·
*La Dame aux champs*

1897–1899, oil on board, 54 × 67
Signed l.r.: *E. Vuillard*
Private collection

Cogeval-Salomon VI.93

———

*Provenance* Thadée Natanson, Paris—
Louis Bernard—Bernheim-Jeune, Paris—
Private collection

*Exhibitions* Brussels, La Libre Esthétique,
1910, no. 191—Milan, Palazzo Reale, 1959,
no. 36, ill.—Toronto-San Francisco-Chicago,
1971–1972, no. 42, ill.—Japan, 1977–1978
(trav. exhib.), no. 19, col. ill.

*Bibliography* Chastel 1946, pp. 63–64—
Groom 1993, pp. 139, 152, col. fig. 221

———

This work almost certainly shows Misia
Natanson in the countryside surrounding Les
Relais, the property at Villeneuve-sur-Yonne
that she and her husband Thadée had acquired
in 1897. It was here that Vuillard was to pass
three *villégiatures*, from 1897 to 1899, as part
of the circle that gravitated around the Natan-
sons and *La Revue blanche*.

In view of the decorative border that appears
at the top and bottom of the canvas, the char-
acteristic integration of the figure with the
surrounding natural elements, the absence of
spatial recession, and the disregard for any
logical scale linking its constituent parts, the
painting, despite its relatively modest dimen-
sions, should be seen within the context of
Vuillard's decorative work. Indeed, André
Chastel specifically referred to the work as a
"decorative panel."[1]

If we discount his use of outdoor settings as
the framework for the 1894 series *The Public
Gardens* (cats. 111–118), Vuillard only be-
gan to seriously exploit the potential of the
landscape as a source for decorative panels
after his initiation to the countryside, first at
Valvins in 1896, and then at Villeneuve-sur-
Yonne from 1897 to 1899 and at L'Étang-la-
Ville. In 1898 he commenced work on the
first two Schopfer panels, *Woman Reading on
a Bench* and *Woman Seated in an Armchair*
(1898, priv. coll., C-S VI.99-1 and C-S VI.99-2),
both of which picture the Natanson property
at Villeneuve-sur-Yonne. The following year,
the house of his sister Marie and her husband
Kerr-Xavier Roussel, at L'Étang-la-Ville,
provided the more purely landscape subject
matter for the two panels created for Adam
Natanson (see cat. 142). And, contemporane-
ously, Vuillard executed another work inspired
by Villeneuve-sur-Yonne—the decorative
panel entitled *Promenade in the Vineyard*
(cat. 151).

LE REPOS

1. Pierre Puvis de Chavannes, *Rest*, c. 1863, Washington, National Gallery of Art, Widener Collection.

PROMENADE IN THE VINEYARD ·
*Promenade dans les vignes*

1900, oil on canvas, 260.4 × 248.9
Los Angeles County Museum of Art,
Gift of Hans de Schulthess, 59.75

Cogeval-Salomon VI.103

*Provenance* Jack Aghion, Paris—Jos Hessel,
Paris—Henry van de Velde for Karl Ernst
Osthaus, Hagen—Hans de Schulthess,
United States—Gift to the Los Angeles
County Museum of Art

*Exhibitions* Paris, Bernheim-Jeune, 1900,
no. 3—Toronto-San Francisco-Chicago,
1971–1972, no. 28, ill.—Chicago-New York,
2001, no. 42, col. ill. p. 139

*Bibliography* Segard 1914, p. 321—Groom
1993, pp. 3, 134–143, 145, 151, col. fig. 214—
Groom 2001, p. 138, col. ill. p. 139

Both of these latter decorative commissions can be related to the work shown here. As Gloria Groom has pointed out, the sketchy treatment of Misia's checked "duster" dress is echoed in the handling of her green and orange blouse in *Promenade in the Vineyard*.[2] Likewise, the position that Misia adopts in *Woman in the Countryside* is recorded in a photograph (see cat. 151, fig. 1), taken by Vuillard in about 1898 during an excursion party in the countryside around Villeneuve-sur-Yonne, that served as visual source material for *Promenade in the Vineyard*. In this decorative panel a view of Misia seen from behind (an imaginative reversal of her photo image) is inserted into the top centre of the composition; her pose in *Woman in the Countryside* is, with a slight variation, that of the woman standing behind her in the photo.

It is the decorative border suggested at the top and bottom of *Woman in the Countryside* that links the work to *The First Fruits* (cat. 142, fig. 1) and *The Window overlooking the Woods* (cat. 142). In both these panels, a decorative border of foliage and flowers frames the image on three sides, while on the fourth, at the base of the composition, the border is composed of a sequence of short, horizontally striated brushstrokes, possibly intended to suggest the sill of the window through which Vuillard invites the spectator to view

the landscapes beyond. Although *Woman in the Countryside* is not completely framed by a decorative edging, the fact that its two borders consist primarily of flowers relates it to a study for *The First Fruits*, whose decorative border is also summarily suggestive of flowers. The inclusion of such borders encouraged viewers to read the decorative panels as if they were tapestries. Gloria Groom[3] has pointed to possible prototypes for such framing devices in the floral borders used by Maurice Denis in his pair of decorative panels of 1894, *Forest in Spring* and *Forest in Autumn* (New York, priv. coll.), and in the procedure adopted by Puvis de Chavannes when he exhibited reduced versions of his decorative schemes as easel paintings at the Paris Salons (see fig. 1). By implying an association with tapestries, Vuillard was stressing the works' primarily decorative (rather than descriptive) objectives, especially in cases where the panels drew inspiration from the external world rather than the carefully controlled, more intensely patterned interiors that were the settings for his Vaquez panels and *The Album* (see cats. 137–140 and 126–129). MAS

1. Chastel 1946, p. 64.

2. Groom 1993, p. 139.

3. Ibid., pp. 128–129.

Relatively little is known about *Promenade in the Vineyard*, by far the least familiar of all Vuillard's large-scale decorations, although Gloria Groom has succeeded in reconstructing much of its history.[1] The painting was commissioned by Jack Aghion, a somewhat peripheral figure in the *Revue blanche* circle who amassed an important collection of modern paintings that included works by the Impressionists, Van Gogh and the Nabis, among them Vuillard.

The precise date of the commission is not known. The first reference to the "Aghion panel" appears in an entry in Vuillard's journal of April 1900.[2] Within three months the work had been completed and installed, as we learn from a letter Vuillard wrote to his friend Vallotton on July 9, 1900: "We have installed Aghion's panels and you know there is question of inviting you and Ranson to make decorations for each end of the room."[3] This letter is important, for it implies not only that Vuillard produced at least one additional—although still unidentified—panel for the same room, but also that the work was ideally intended as one component of a larger joint artistic venture.

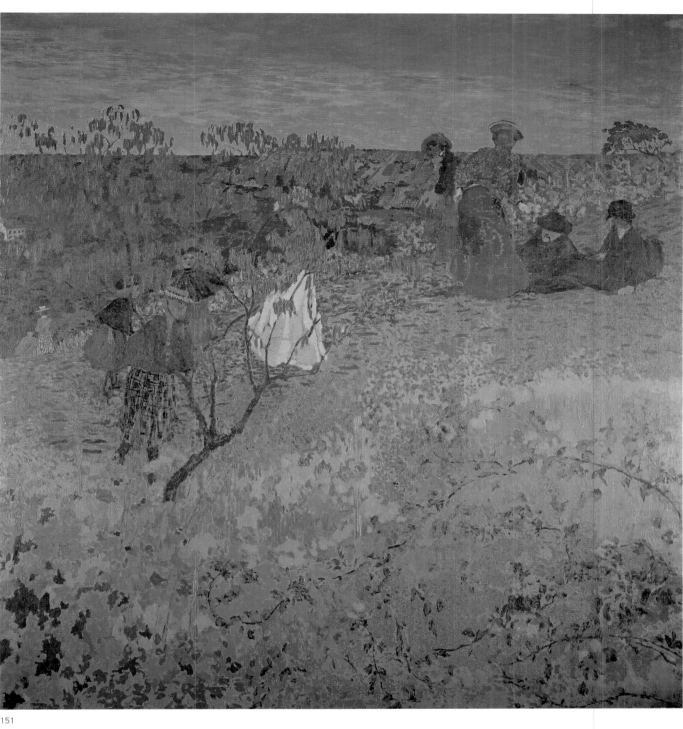

151

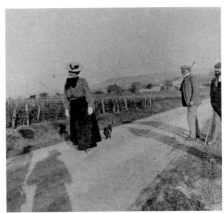

1. Photographs by Vuillard of an excursion party in the hills around Villeneuve-sur-Yonne, c. 1898, Paris, Salomon Archives.

*The Promenade* is something of an anomaly among Vuillard's decorations. It is one of the last to be executed in oil rather than distemper, which was to become the artist's medium of choice, but it also stands out because of its rather sombre, earthy palette and low tonal contrast. Groom conjectures that this somewhat restricted palette was chosen expressly to harmonize with the room where it was to be hung.[4]

The painting depicts a familiar locale—the vineyards surrounding the Natansons' property at Villeneuve-sur-Yonne, where Vuillard was a regular guest. The warm palette, composed of browns, olives, ochres and mauves, and the bareness of the tree in the middle ground suggest that the scene was inspired by an autumn outing, possibly during the fall of 1899 when Vuillard was enjoying "a real holiday" with his friends the Natansons.[5]

Groom has noted the existence of photographs taken by the artist at Villeneuve-sur-Yonne in either 1898 or 1899 (fig. 1), which he subsequently drew upon to create this painting.[6] This was a far from uncommon practice with Vuillard, who often used photographs as *aide-mémoire* to compose paintings after the fact (see cats. 221–224, 266). Typically, Vuillard's use of such photographs was fluid rather than literal. While certain figures, such as the girl with the braid standing in the left middle ground and the woman in the pale skirt, are drawn directly from the photographs, others, including the two men seated on the right, are invented. The most striking transformation is in the easily recognizable figure of Misia, who is seen in one

of the photographs (fig. 1, left) facing the camera and is depicted in the very same pose on the right-hand side of the painting, but viewed from behind. Apart from Misia, it is difficult to establish the identities of the figures. The three young girls, for example, could be the daughters of Thadée's brother Alexandre, or those of Aghion himself; the bearded figure on the far right may very well be Vuillard.[7] Ultimately, however, it hardly matters: Vuillard once again subordinates the specificity of portraiture to more general decorative and aesthetic concerns.

Despite a promising beginning, Vuillard's association with Aghion was short-lived. By 1908 Aghion had gone bankrupt and was forced to sell part of his collection, including this painting, which was acquired by Jos Hessel of the Galerie Bernheim-Jeune. It was subsequently purchased by the Belgian architect Henry van de Velde, who incorporated it into the decorative scheme he was creating for Hohenhof, the home of the collector Karl Ernst Osthaus at Hagen, Westphalia, in western Germany. There it was given a new life as the centrepiece of the *Salonkultur*, or music room, where it remained until Osthaus's death in 1921. KJ

1. See Groom 1993, pp. 134–143.

2. Vuillard, *Journal*, II.2, fol. 12r. Cited in Easton 1989, p. 144.

3. Guisan and Jakubec 1974, p. 42.

4. Groom 2001, p. 138.

5. Letter from Vuillard to Félix Vallotton, November 27, 1899, in Guisan and Jakubec 1973, p. 191.

6. Groom 1993, pp. 137–138.

7. Ibid., p. 139.

FÉLIX VALLOTTON IN HIS STUDIO ·
*Félix Vallotton dans son atelier*

c. 1900, oil on board mounted on cradled
panel, 63 × 49.5
Signed l.r.: *E. Vuillard*; inscribed on
the verso: *Félix Vallotton dans son atelier,
6, rue de Milan, 1900*
Paris, Musée d'Orsay, R.F. 1977-390

Cogeval-Salomon VI.104

———

*Provenance* Emile Mayrisch, Colpach—
Rodrigues-Henriques, Paris—Carle Dreyfus,
Paris—Dreyfus Bequest to the Musée
national d'art moderne, Paris, 1953; Musée
d'Orsay, Paris

*Exhibitions* Paris, Musée des Arts décoratifs,
1938, no. 75—Basel, Kunsthalle, 1949, no. 6
—Paris, MNAM, 1955, no. 22—Milan, Palazzo
Reale, 1959, no. 40, ill.—Toronto-San Fran-
cisco-Chicago, 1971–1972, no. 53, ill.—Lyon-
Barcelona-Nantes, 1990–1991, no. 89, ill. p. 66
—Zurich-Paris, 1993–1994, no. 179, col. ill.

*Bibliography* Salomon 1961, p. 70, ill.—
Rosenblum 1989, col. ill. p. 580

———

The thirty-six-year-old Félix Vallotton, Nabi
painter and woodblock printmaker, is shown
here seated on a small table in the corner
of his new Paris studio at 6, rue de Milan, in
a pose that seems entirely in tune with the
description of his personality given by Annette
Vaillant in *Le pain polka*: "This reserved gentle-
man, whose corrosive humour was nonethe-
less to be feared, this loner among friends…
this Vaudois mandarin enveloped in puritan
garb, armour of his strange personality."[1]

The painting marks a moment of change in
the relationship between Vallotton and Vuillard
that the latter registers both iconographically
and technically, in the construction of the
painting itself. In 1899 Félix Vallotton married
Gabrielle Rodrigues-Henriques, a young
widow with three children who was the sister
of Gaston and Josse Bernheim. Vuillard
seems to have been alluding to this event in

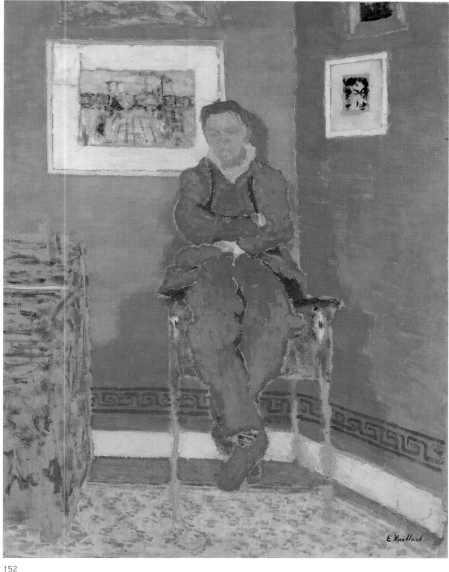

152

1898, oil on paper mounted on panel, 50 × 63
Signed u.r.: *E Vuillard*
Toronto, Art Gallery of Ontario,
Purchase 1937

Cogeval-Salomon VII.13

*Provenance* Acquired from the artist by
Bernheim-Jeune, Paris—Arthur Tooth &
Sons, London—Art Gallery of Ontario,
Toronto, 1937

*Exhibitions* Paris, Vollard, 1898, no. 57—
Cleveland-New York, 1954, p. 101, ill. p. 44—
Milan, Palazzo Reale, 1959, no. 17, ill.—
Munich, Haus der Kunst, 1968, no. 41, ill.—
Paris, Orangerie, 1968, no. 82, ill.—Toronto-
San Francisco-Chicago, 1971–1972, no. VIII,
col. ill.—Montreal, MBAM, 1998, no. 184,
col. ill. p. 44

*Bibliography* Salomon 1961, p. 68, ill.—
Cogeval 1998b, no. 184, col. ill. p. 44

The period during which this painting was
made can be identified quite precisely. It is set
in the Rue des Batignolles apartment to which
Vuillard and his mother had moved from
Rue Saint-Honoré in November 1897, and it
appeared in a group exhibition at the Galerie
Vollard that opened on March 27, 1898.[1]

The visit of a widow to Vuillard's mother and
his sister Marie, seated on the right, has been
depicted not as a sorrowful event but as
one tinged with ironic humour. In the artist's
earlier *intimiste* works the presentation of
simplified figures, often in silhouette, added
an element of caricature to his portrayal of
actions and emotions that is still in evidence
here. Madame Vuillard's air of resignation,
suggesting tolerance of too lengthy a dis-
quisition, and Marie's pointedly engaged pose
suggest that their visitor, sporting an exag-
gerated widow's bonnet, has outstayed her
welcome.

The painting is based on two preliminary
sketches—on the recto and verso of a single
sheet—both of which position the figures
within the room and indicate the location of
the inanimate objects, such as the piano, the

his depiction on the wall behind Vallotton of
a Chinese painting on silk from his collection
that shows a wedding ceremony.[2] According
to Vallotton himself, Vuillard, a confirmed
bachelor, had reacted badly to the news of his
wedding: "He was staggered by the news
of my marriage; it will take him a few days to
grasp it properly."[3] The marriage would cer-
tainly alter relations between the two artists,
and the technique of this painting suggests
that Vuillard was reviewing the path the two
had travelled together during the "heroic"
Nabi years. On the one hand, the flat blocks of
colour used to portray the wall, the be-suited
sitter and even his red shoes, as well as the
areas left unpainted, are reminiscent of the
extreme schematization found in such early
Nabi works by Vuillard as *Lugné-Poe* (cat. 37)
and *In Bed* (cat. 21). However, the artist has

at the same time sought to achieve a greater
degree of naturalism, not only by providing a
clearly defined architectural setting but also
in the more precise designation of the facial
features, which have been incised descriptively
into the paint surface with the handle of a
brush. This portrait of Vallotton was preceded
by a preliminary study (priv. coll.) that care-
fully plots out all the picture's constituent
parts, including the Chinese painting on the
wall behind the sitter's head. MAS

1. Vaillant 1974, p. 80.

2. Ralf Beil, in *Nabis, 1888–1900*, exhib. cat. (Paris: Réunion
des musées nationaux, 1993), no. 179.

3. Letter from Félix Vallotton to his brother Paul, 1899, in
Guisan and Jakubec 1973, p. 188.

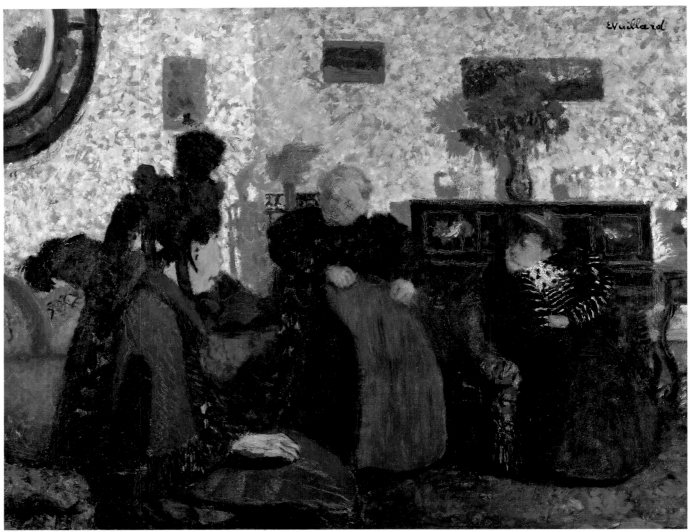

153

1. Édouard Vuillard, *Sketch for "The Widow's Visit,"* 1898, graphite on paper, private collection.

vase of flowers and the circular mirror on the left-hand wall. One of the drawings (fig. 1) bears two annotations: "decorative motif / elegant motif." It may be this close dependence upon preliminary studies that accounts for the figures' retaining greater weight and individual identity within the overall composition than in Vuillard's earlier *intimiste* paintings.

More striking, however, is the way the composition has been given an enhanced sense of depth by the introduction of shadows cast by such objects as the vase of flowers on the piano and the étagère behind Madame Vuillard. Both are illuminated by a single, intense light that enters the room from the right. This move toward a slight disengagement of the figure and the object from the background was noted as an indication of a stylistic shift by Thadée Natanson, when he reviewed the 1898 Galerie Vollard exhibition: "It may be that we shall observe this year a notable development in his talent; he is still the most delightful and refined of sensual analysts, but we can see that he is striving to give greater generality and scope to the expression of his ideas."[2] MAS

1. Vuillard showed eight works in the exhibition (nos. 57–63).

2. Thadée Natanson, "Petite Gazette d'art," *La Revue blanche*, vol. 15, no. 117 (April 15, 1898), p. 618.

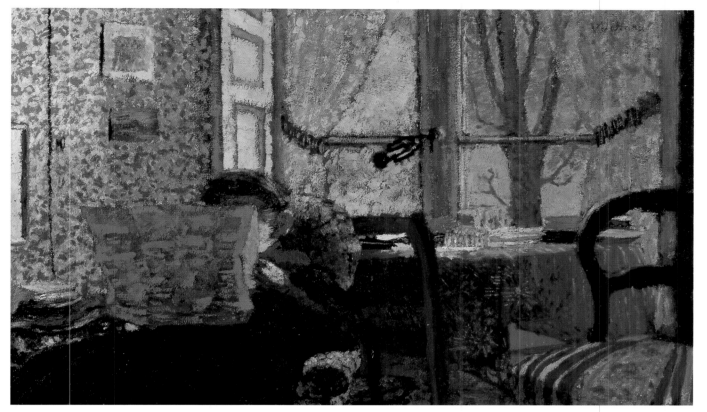

## 154

MADAME VUILLARD READING THE
NEWSPAPER · *Madame Vuillard lisant
le journal*

1898, oil on board mounted on cradled panel,
32.2 × 53.3
Signed u.r.: *Vuillard*
Washington, The Phillips Collection

Cogeval-Salomon VII.21

———

*Provenance* Jos Hessel, Paris—Félix Fénéon,
Paris—Phillips Collection, Washington

*Exhibitions* Paris, Bernheim-Jeune, Nov. 1908,
no. 33—Cleveland-New York, 1954, p. 102,
ill. p. 69—Paris, Orangerie, 1968, no. 84, ill.
—Houston-Washington-Brooklyn, 1989–
1990, no. 73, col. ill.

*Bibliography* Roger-Marx 1946a, p. 66—
Easton 1989, p. 98

———

This painting indicates the direction Vuillard's work would take over the succeeding four decades. Unlike his earlier treatment of Kerr-Xavier Roussel reading a newspaper (cat. 87), where the colour is laid on with broad flat sweeps of the brush in a way that reinforces the work's uncompromisingly two-dimensional character, in this picture, created five years later, the paint has been applied in short, stabbing brushstrokes that articulate the composition's various components and locate them within a more realistically defined pictorial space. The unambiguously direct reference to the external world of nature and natural light also sets the painting apart from the tightly enclosed interiors of Vuillard's earlier *intimiste* work. Even in a painting like *The Stitch*, from 1893 (cat. 86), which is illuminated by light entering through a window, the quality of that light is closer to the artificiality of theatrical spotlighting than to natural daylight. And despite the slight visual confusion caused here by the fact that Madame Vuillard's newspaper is on a plane parallel to the rear wall, and the merging of the newsprint with the patterned wallpaper that results, the painting demonstrates Vuillard's new interest in the close observation of specific details. In particular, the crockery and glasses that sit on the red-clothed table have been carefully described, presaging his renewed interest after 1900 in the still life genre.

By asserting so boldly the presence of external nature, albeit observed through the window, Vuillard was announcing in this work his cautious but deliberate move away from the claustrophobic interior world of his family and the Natanson circle and toward the open, exteriorizing world of rooms lit with natural light flooding in through open windows and doors—and ultimately toward landscape. Explored initially in such works as *Boating* (cat. 254) and the first two Schopfer panels (1898, priv. coll., C-S VI.99-1 and C-S VI.99-2), the lure of the natural world was answered from 1900 onward in landscape paintings (see cats. 255–262) and in large-scale decorative panels (see cats. 266 and 274–275).

There exists a study of Madame Vuillard reading a newspaper in front of a window that may have served as a point of departure for the present painting (priv. coll.), although there are several differences: in the sketch, as here, the chair with the curved back figures on the right, but in the drawing the table is located to the left of Madame Vuillard, who herself is seen at an angle to the picture plane, her face clearly visible as she reads the newspaper she holds in her hand.

It was images such as the one captured here—a characteristic bourgeois interior shown at a quiet moment in the routine of daily life—that prompted critics to try to analyze and define the meaning of *intimisme* in Vuillard's oeuvre. When this painting was exhibited in the retrospective exhibition of his work held at the Galerie Bernheim-Jeune in November 1908, Pierre Hepp recognized that Vuillard's concern to "correspond precisely to his era" led the artist to accord equal weight to every item in a given scene, in true *intimiste* fashion: "Moving from modest interiors to luxurious apartments, he feasted his eyes on everything, eager to exercise his perceptive genius. Not one of the ravishing motifs harboured by the panelling, the chairs, the tablecloths escaped his keen-eyed cataloguing. And he recorded them with extraordinary subtlety in the fifteen years that led him to fame."[1] MAS

1. Pierre Hepp, "Les Expositions : Édouard Vuillard," *La Grande Revue* (December 1908), p. 604.

# 155

WOMAN ARRANGING HER HAIR •
*La Coiffure*

1900, oil on board, 49.5 × 35.5
Signed l.l.: *E Vuillard*
The Trustees of the Barber Institute of
Fine Arts, The University of Birmingham

Cogeval-Salomon VII.173

———

*Provenance* Acquired from the artist by Bernheim-Jeune, Paris—Arthur Tooth & Sons, London—Odo Cross, London, 1943—Barber Institute of Fine Arts, University of Birmingham

*Exhibitions* Brussels, La Libre Esthétique, 1901, no. 524—London, Wildenstein, 1948, no. 20—Edinburgh, Royal Scottish Academy, 1948, no. 76—Glasgow-Sheffield-Amsterdam, 1991–1992, no. 60, ill. p. 22

*Bibliography* Thomson 1988, col. pl. 2—Cogeval 1993, ill. p. 135

———

Vuillard had already pictured his mother doing her hair in *The Comb* (1898, loc. unkn., c-s IV.15), but here, in keeping with his growing interest in pictorial depth, he has placed her in front of a mirror—a device that both throws her image back into the composition and opens up another spatial dimension. In contrast to the primarily decorative role the mirror had played in works made earlier in the 1890s—a notable exception being *The Flowered Dress* of 1891 (cat. 79)—in *Woman Arranging Her Hair* it takes on the dual function of pushing the interpretation toward a greater naturalism and creating new zones of spatial recession. Vuillard was to explore the mirror's rich potential in a number of works made after 1900, most notably and daringly in *At La Divette, Cabourg; Annette Natanson, Lucy Hessel and Miche Savoir at Breakfast,* from 1913 (cat. 275).

Together with three others by Vuillard, this painting was exhibited in Brussels in 1901, at the annual exhibition of the Belgian avant-garde exhibition society La Libre Esthétique. Vuillard had originally been invited to show at the 1900 Libre Esthétique, but had refused on the grounds that he had only a few minor works available because of his recent engagement by the Galerie Bernheim-Jeune and the demands of an impending exhibition.[1] In December 1900, in response to a second invitation, Vuillard wrote: "I am not at all opposed in principle to exhibiting at La Libre Esthétique this year, if the Bernheims are in agreement with you."[2] His offering was plainly well received by the press. *L'Art Moderne* mentioned "the four interiors, of truly exquisite colouring, by Vuillard,"[3] and Julien Leclercq commented: "Édouard Vuillard contributes with beautifully harmonious interiors of powerfully intimate feeling."[4] Vuillard exhibited again with La Libre Esthétique in 1904, 1908, 1909, 1910 (when his submission included *Woman in the Countryside,* cat. 150) and 1911.[5] MAS

———

1. Gisèle Ollinger-Zinque (ed.), *Les XX—La Libre Esthétique : Cent Ans Après*, exhib. cat. (Brussels: Musée Royaux des Beaux-Arts de Belgique, 1993), p. 105.

2. Quoted in ibid., p. 111.

3. Quoted in ibid., p. 113.

4. Julien Leclercq, "Correspondance de Belgique : Salon de la Libre esthétique," *La Chronique des arts et de la curiosité,* no. 147 (April 6, 1901), p. 109.

5. Donald E. Gordon, *Modern Art Exhibitions 1900–1916* (Munich: Prestel-Verlag, 1974), vol. 2, pp. 91, 251, 319, 383, 465.

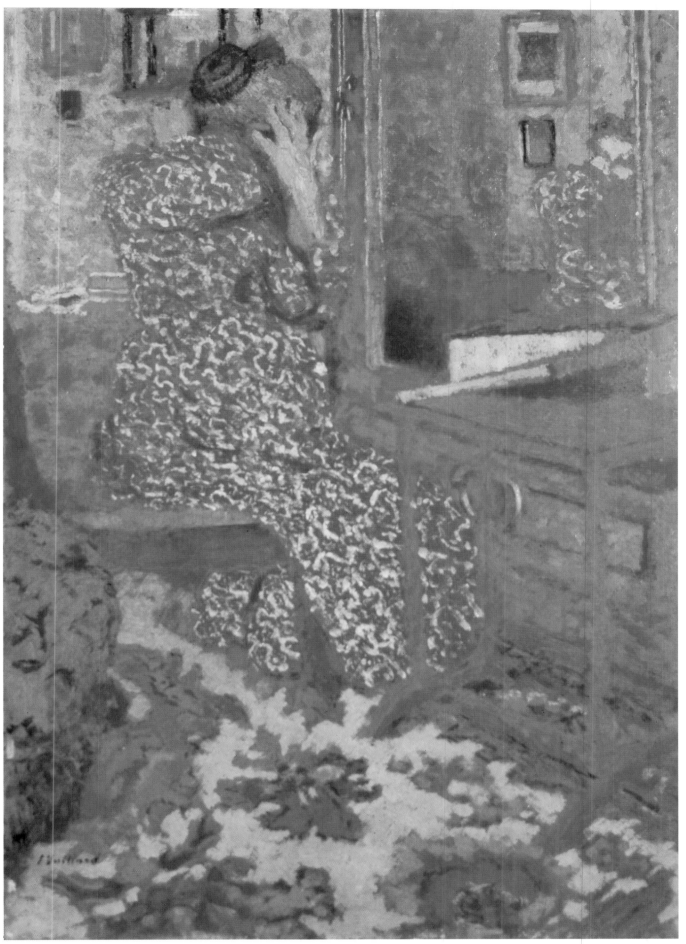

155

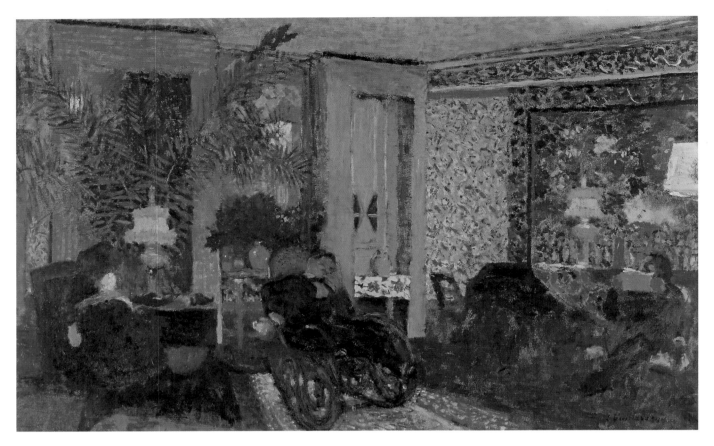

## 156

INTERIOR, THE SALON WITH THREE
LAMPS, RUE SAINT-FLORENTIN •
*Intérieur. Le Salon aux trois lampes, rue
Saint Florentin*

1899, distemper on paper mounted on canvas,
59 × 95
Signed and dated l.l.: *E Vuillard 99*
Paris, Musée d'Orsay, private collection.
Gift to the French nation (with life interest
retained), 2000

Cogeval-Salomon VI.44

*Provenance* Acquired from the artist by Bern-
heim-Jeune, Paris—Gustav Zumsteg, Zurich
—Private collection—Musée d'Orsay, Paris

*Exhibitions* Berlin, Secession. VII, 1903, no.
200—Basel, Kunsthalle, 1949, no. 219—
Paris, MNAM, 1955, no. 196—Munich, Haus
der Kunst, 1968, no. 44—Paris, Orangerie,
1968, no. 72, ill.—Toronto-San Francisco-
Chicago, 1971–1972, no. VI, col. ill.—Hous-
ton-Washington-Brooklyn, 1989–1990, col. ill.

*Bibliography* Dorival 1957, col. ill. p. 21—
Salomon 1961, p. 60, col. ill.—Russell 1971,
pp. 32, 49, 55—Easton 1989, pp. 109, 125–126
—Cogeval 1993 and 2002, p. 59—Groom
1993, pp. 81, 83, 89, 90, col. fig. 134

This work pictures the apartment of Thadée
and Misia Natanson, which served as the un-
official second office of the Natanson broth-
ers' avant-garde periodical, *La Revue blanche*.
Located in an eighteenth-century property
on Rue Saint-Florentin, near Place de la Con-
corde, the apartment consisted essentially of
one very large room that served as informal
gathering place, salon and music room. It had
been decorated by Misia and Thadée in the
somewhat claustrophobic, highly-patterned
style of the 1890s that drew its primary inspi-
ration from the visions of William Morris,
Walter Crane and the English Arts and Crafts
Movement. The painting gives a clear impres-
sion of the scale, decoration and furnishing
of the salon-music room. Looking diagonally
across the space past three seated figures—
Misia, her friend Romain Coolus (in a bent-
wood rocking chair) and Thadée Natanson
absorbed in his reading—we can make out
Misia's grand piano, draped in a Spanish shawl
and standing in front of a tapestry set within
a floral frame. The yellow, green and black
flowered wallpaper that serves as the tapes-
try's backdrop is topped with a frieze of foliage
running along the wall at cornice height.

Characteristically, Vuillard has capitalized on
the rich variety of patterned surfaces and tex-
tures that the scene presents, from the wallpaper
and tapestry to the carpets and the Spanish
shawl. Even the foliage of the outsized potted
palm on the left provides an additional deco-
rative and textural note. This positive riot of
detail is skilfully held in control by the limited

tonal range Vuillard has adopted for the paint-
ing. As in many of his *intimiste* works from the
1890s, Vuillard has used this strategy to create
a many-threaded but unifying rhythm that
runs across the entire surface of the canvas.

The atmosphere of the room is hushed,
muted. Each protagonist, whether sewing,
reading or thinking, is rapt in his or her own
world. Both the subject and execution of this
acutely observed turn-of-the-century bour-
geois interior seem to comply with Raymond
Cogniat's definition of the "painter of inti-
macy," which he gave in his review of Vuil-
lard's retrospective exhibition held in 1938
at the Musée des Arts décoratifs, in Paris:

No one has expressed better than he [Vuillard] the intimacy
of comfortable interiors...no one has placed figures more
successfully than he within these silent interiors, muffled
with curtains and carpets. He conjures a secluded world, of
women sewing by lamplight...of friends chatting quietly
in rather cluttered living rooms, full of overstuffed furniture.
Bourgeois intimacies, slippered elegance and silence. Man,
in all these paintings, is generally no more important than
the vase of flowers or the table...The very materials Vuillard
employs reinforce the atmosphere of silence so characteristic
of his work. Not only do the tones all harmonize in a palette
invariably dominated by a single colour—either yellow or
red—but the whole possesses the smooth quality of velvet.
The outlines of the forms sometimes seem indistinct, so
close are the tones.[1] MAS

1. Raymond Cogniat, "Vuillard au Musée des Arts décoratifs :
Du tableau de chevalet aux grandes compositions," *Beaux-
Arts*, vol. 75, no. 278 (April 29, 1938), p. 3.

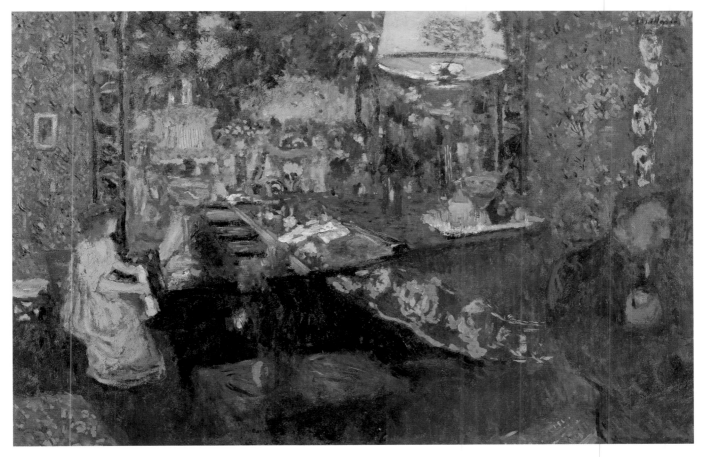

## 157

MISIA AT THE PIANO · *Misia au piano*

1899, oil on board, 55 × 80
Signed u.r.: *E. Vuillard*
Private collection

Cogeval-Salomon VI.45

———

*Provenance* Acquired from the artist by
Bernheim-Jeune, Paris—Jos Hessel, Paris—
Dr. Jacques Soubies, Paris—Josefowitz
Collection, 1990—Private collection

*Exhibitions* Edinburgh, Royal Scottish Academy, 1948, no. 65—Munich, Haus der
Kunst, 1968, no. 43, ill.—Glasgow-Sheffield-
Amsterdam, 1991–1992, no. 49, col. ill.

*Bibliography* Groom 1993, pp. 83, 89, col.
fig. 139

———

In contrast to the more compositionally conventional *Interior: The Salon with Three Lamps,
Rue Saint-Florentin* (cat. 156), this painting
contains spatial ambiguities and exaggerated
perspectival distortions that contribute to
its highly charged, suggestive atmosphere.
The subject of the two paintings is the same,
but in *Misia at the Piano* it is as if the room
has been rotated through an angle of ninety
degrees. Misia, seated at her instrument, has
been radically reduced in size and pushed back

into the depths of the composition. The lamp
on the piano, on the other hand, has been
made dramatically larger, as if the piano tail
had been swung round toward the spectator.
In the right foreground, in a scale logically
related neither to the figure of his wife nor to
the lamp, sits Thadée Natanson, smoking a
pipe with his back turned to Misia. As in many
works from the period, Vuillard has established a dominant colour key—in this case a
complex mix of yellow, green, blue and red
that suffuses the entire composition.

The deliberate disregard in this work for the
realistic spatial recession seen in *The Salon
with Three Lamps*, and the slightly looser
brushwork, which reduces realistic detail and
emphasizes pattern, imbue it with a definite
tension. By 1899, the relationship between
Thadée Natanson and his wife was in fact
showing signs of strain, caused in part by
Thadée's lengthy and increasingly frequent
absences from Paris. The deliberate non-
naturalism of the painting allows it to convey
meaning that goes beyond the mere description of an intimate evening in a bourgeois
domestic interior. While never overtly symbolic, as was the work of Maurice Denis,
Paul Ranson and Paul Sérusier during the
1890s, Vuillard's interiors from the same
decade often use distortion to draw attention
to a scene's emotional dynamics. The technique employed here calls to mind a similar
disjunction of scale found in Vuillard's earlier

painting *A Family Evening* (cat. 96), which
also seems to suggest marital discord—in that
case, the tension between the artist's sister and
her husband. It was this suggestive component
of his work that excited many critics. Henri
Ghéon sensed its significance in a review published in 1899:

Vuillard has the same instinct for intimacy as Chardin, he
penetrates the obscure life of rooms and of objects; he
imbues them with meaning simply by creating an atmosphere. In all his canvases there is something floating,
something immaterial, every one of his rooms is full of
"air." We feel it, we almost see it, and the intimate scenes
he evokes are wonderfully enveloped in both light and
shadow.[1]

A year later, when confronted with this painting at a group exhibition held at the Galerie
Bernheim-Jeune, André Fontainas detected a
sequence of suggestive meanings hidden
within the work: "Evenings in a gently closed-
in living room, lit by mellow lamplight, whilst
people listen, among the softness of the cushions, to the dream conjured from the piano by
the brilliant fingers of a young woman, or to
friendly, unhurried talk, or to the silence that
binds even closer."[2] MAS

1. Henri Ghéon, "Lettres d'Angèle," *L'Ermitage*, vol. 18,
no. 4 (April 1899), pp. 314–315.

2. André Fontainas, "Revue du mois," *Mercure de France*,
vol. 34, no. 124 (May 1900), p. 545.

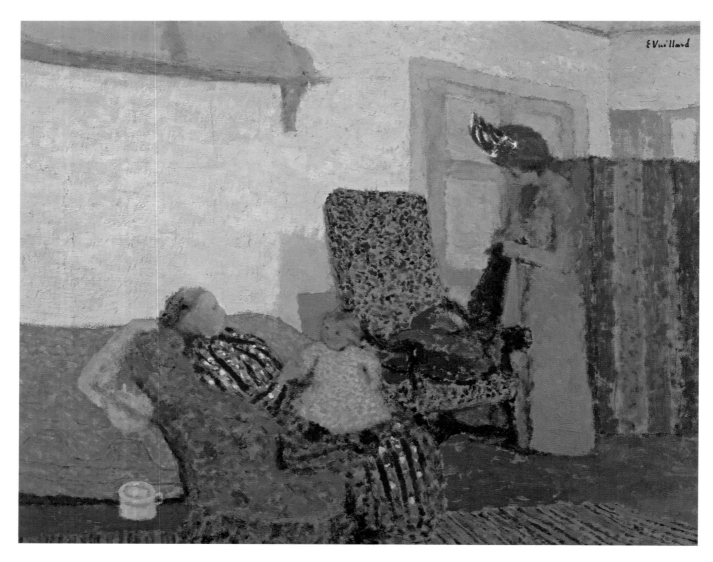

## 158

THE WHITE ROOM · *La Chambre blanche*

1899, oil on board, 46 × 57.8
Signed u.r.: *E Vuillard*
Private collection

Cogeval-Salomon VII.55

———

*Provenance* Acquired from the artist by
Bernheim-Jeune, Paris—Frantz Jourdain,
Paris—Private collection

*Exhibitions* Paris, Bernheim-Jeune, 1900,
no. 11—Paris, Bernheim-Jeune, Nov. 1908,
no. 40—Paris, Petit Palais, 1937 (hors cat.)—
Hamburg-Frankfurt-Zurich, 1964, no. 43, col.
ill.—Munich, Haus der Kunst, 1968, no. 58,
col. ill.—Paris, Orangerie, 1968, no. 102, ill.

*Bibliography* Salomon 1961, p. 80, ill.

———

Madame Vuillard is shown here seated in a
chair with a small child on her knees. Given
that the painting was shown at the Galerie
Bernheim-Jeune in April 1900, the child, pre-
viously identified as Jacques, son of Marie
Vuillard and Kerr-Xavier Roussel, must in
fact be their daughter Annette (see cats. 172–
174), since Jacques was not born until June
1901. The woman on the right has not been
identified, but the setting is definitely the
room in the Vuillards' new apartment on Rue
Truffaut that the artist would soon begin
using as his studio.[1]

Several elements in the painting are reitera-
tions of Vuillard's approach to subject matter
and technique during the 1890s. The use of a
carefully controlled palette based upon brown,
blue-grey, black and white effectively encom-
passes all the pictorial elements within a single
plane. Similarly, the red bedspread covering
an object devoid of three-dimensionality sil-
houettes the figure of Madame Vuillard, her

chair and the child like paper cutouts. And the wry humour that often marked works from previous years can be detected here in the slightly absurd black and white feathered hat worn by the standing woman and the white chamber pot tucked behind Madame Vuillard's armchair.

As with other paintings created during the closing years of the 1890s, however, *The White Room* betrays a greater sense of naturalism, notably in the illusion of depth created by the shadow cast onto the wall by the Louis XIII-style chair. When this painting was exhibited at the Galerie Bernheim-Jeune in 1900, together with ten other relatively recent works, the shift toward a greater degree of naturalism evident in the group was observed and commented upon, generally favourably, by the critics. Louis Dausset, for example, having expressed regret that in Vuillard's interiors from the earlier 1890s "he did not concern himself with atmosphere or perspective," was relieved to note that the artist had now remedied these defects: "It still happens frequently that his rooms are filled with elements set askew, but a preoccupation with atmosphere has made its appearance in his pictures, and there is on this point nothing more to say."[2] MAS

1. Cogeval in C-S 2003, no. VII.55.

2. Louis Dausset, "Choses d'art," *Le Temps* (April 13, 1900).

# 159

CHILD PLAYING: ANNETTE IN FRONT OF THE RAIL-BACKED CHAIR · *Enfant jouant : Annette devant la chaise à barreaux*

1900, oil on board mounted on cradled panel, 38 × 53.5
Signed u.r.: *E Vuillard*
The Art Institute of Chicago, Mr. and Mrs. Martin A. Ryerson Collection

Cogeval-Salomon VII.123

*Provenance* Acquired from the artist by Bernheim-Jeune, Paris—Georges Feydeau, Paris—Baron Bruno Caccamisi, Paris—Mme Blanche Marchesi, Paris—Martin A. Ryerson, Chicago—Ryerson Gift to the Art Institute of Chicago

*Exhibitions* Brussels, La Libre Esthétique, 1901, no. 525—Cleveland-New York, 1954, p. 102, ill.—Munich, Haus der Kunst, 1968, no. 57, ill.—Paris, Orangerie, 1968, no. 101, ill.—Toronto-San Francisco-Chicago, 1971–1972, no. x, col. ill.—Houston-Washington-Brooklyn, 1989-1990, no. 71, col. ill.

*Bibliography* Salomon 1968, p. 92, ill.—Ciaffa 1985, p. 183, fig. 70—Easton 1989, p. 98, col. ill.

The little girl playing so absorbedly in front of a slightly decrepit bedroom chair is Annette Roussel, the daughter of Vuillard's sister Marie and Kerr-Xavier Roussel (see cats. 172–174, 200, 209–210). While the depiction of depth seems more decisive here than in such nearly contemporaneous works as *Madame Vuillard Reading the Newspaper* (cat. 154) and *The White Room* (cat. 158), *Child Playing* shares with both these paintings its insistence on a dominant chromatic key. But it also introduces a dialogue between two somewhat strident areas of blue-grey (one

on either side of the composition) that, although inhabiting different planes, seem jointly to threaten the spatial recession established by the perspectival plunge of the child's iron bedstead. The resulting tension between two- and three-dimensional space creates a highly idiosyncratic representation of depth, which was described some six years later by Arsène Alexandre: "Vuillard has an individual approach to draftsmanship and perspective, which are neither the draftsmanship of the studio nor the perspective of architects."[1]

Despite marking an important step along the route toward greater naturalism, this painting, when shown at the annual Libre Esthétique exhibition in Brussels in the spring of 1901, compelled the Belgian Symbolist poet and critic Émile Verhaeren to summarize Vuillard's artistic achievements to date. Recognizing the artist as an innovator, he celebrated Vuillard's novel colour harmonies, his unprecedented, almost childlike technique—which turned his canvases into a kind of embroidery—his strange compositional procedures and the deftness of his draftsman's hand:

It is in the marriage of practically unknown colours, in the choice of special pinks, marvellous oranges, unusual blues and purples; it is in the virtually reinvented technique that seems at first almost childlike, it is in the strange yet unaffected compositions that all M. Vuillard's instinctive gifts assert themselves. His taste is absolutely impeccable. He seems to embroider his canvases with gloriously old-fashioned wools. His draftsmanship is skilful and delicate, never heavy. He floats in the atmospheres of his closed, intimate, familiar rooms.[2] MAS

1. Arsène Alexandre, "Vie artistique : Petites expositions," *Le Figaro* (May 29, 1906).

2. Émile Verhaeren, "La Libre Esthétique," *L'Art moderne* (March 17, 1901), reprinted in É. Verhaeren, *Écrits sur l'art*, vol. 2 *(1893–1916)*, ed. Paul Aron (Brussels: Labor, 1997), p. 800.

159

## 160

ROMAIN COOLUS · *Romain Coolus*

c. 1897, pen and ink on paper, 9.9 × 13.2
Private collection

## 161

PIERRE BONNARD · *Pierre Bonnard*

c. 1920, graphite on paper, 17.7 × 10.8
Private collection

## 162

HENRI DE TOULOUSE-LAUTREC ·
*Henri de Toulouse-Lautrec*

1897–1898, graphite on paper, 13.8 × 10.9
Private collection

## 163

STÉPHANE MALLARMÉ ·
*Stéphane Mallarmé*

1896, pen and brown ink on paper, 13.9 × 10.9
Private collection

## 164

STÉPHANE MALLARMÉ ·
*Stéphane Mallarmé*

1896, graphite on paper, 13.9 × 10.9
Private collection

## 165

LÉON BLUM · *Léon Blum*

1920–1925, graphite on paper, 20.6 × 11.6
Private collection

This group of sketches pays homage to the friendships that Vuillard developed in the 1890s through his association with the avant-garde journal *La Revue blanche*. Founded in Belgium in 1889 by Alfred, the youngest of the Natanson brothers, *La Revue blanche* moved to Paris in 1891 and soon became one of the most daring and eclectic periodicals of the *fin-de-siècle* period. Over the course of its fourteen-year existence, it chronicled current social, literary and artistic developments with an openness and intelligence that led Stéphane Mallarmé to describe it as the "friendly, ready-for-anyone *Revue blanche*."[1]

International in scope, the journal published the work of prominent writers from around the world—many of them appearing in French for the first time—including Leo Tolstoy, Henrik Ibsen, Oscar Wilde and Mark Twain. They joined a number of French authors, some of them older and established, such as the Symbolist poets Mallarmé (cats. 163–164) and Paul Verlaine, and some promising new-comers, such as Marcel Proust and André Gide. *La Revue blanche* also counted many of the most creative minds of the day among its regular contributors—such figures as Octave Mirbeau, Claude Anet (Jean Schopfer, see cats. 263–264), the playwrights Romain Coolus (cat. 160) and Tristan Bernard (cat. 231), the art critic Félix Fénéon, the composer Claude Debussy (who wrote music reviews under the pseudonym "Monsieur Croche"), and Léon Blum, the future premier of France, who wrote literature, theatre and sports reviews (cat. 165). In 1893, *La Revue blanche* began to commission and reproduce original works of art, and Bonnard (cat. 161), Toulouse-Lautrec (cat. 162), Vallotton (cats. 147, 152) and Vuillard were among those who contributed prints and designed posters promoting the journal (fig. 1).

*La Revue blanche* undoubtedly played a central role in Vuillard's early career and beyond. His association with the journal dated from 1891, when Pierre Veber introduced him to Thadée Natanson, one of its co-editors. It was in the offices of *La Revue blanche*, that same

1. Pierre Bonnard, *Poster for "La Revue blanche,"* 1894, colour lithograph, Washington, National Gallery of Art.

year, that Vuillard was to hold his first one-man exhibition. Through his involvement with the journal Vuillard gained entry into the vibrant and intellectually brilliant circle that centred on it and its muse, "the radiant and enigmatic Misia Natanson."[2] He also benefited from greater visibility in the Paris art world and significant patronage from members of the Natanson family and their friends (see "The Decorative Impulse," in the present volume). Perhaps most importantly, however, he forged a number of close friendships, many of which lasted for decades—as the drawings of Bonnard and Blum shown here attest. Long after *La Revue blanche* ceased publication in 1903, these ties would remain for Vuillard a source of inspiration and comfort. KJ

1. Quoted in Arthur Gold and Robert Fitzdale, *Misia: The Life of Misia Sert* (New York: Vintage Books, [1980] 1992), p. 47.

2. Lugné-Poe 1933, p. 33.

160

161

162

163

164

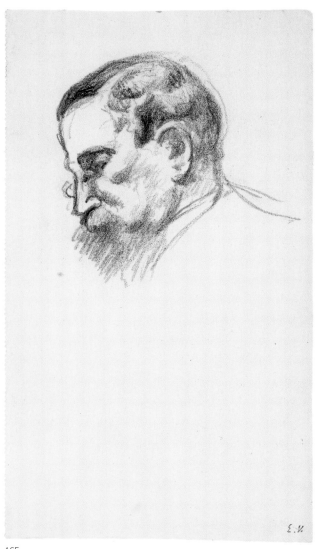

165

VUILLARD AND HIS PHOTOGRAPHS | *Catalogue* **166-253**

TWENTY OR THIRTY YEARS from now, when all the 1,750 photographs in Vuillard's studio archives are housed in some great heritage institution—or distributed among various museums and private collections—one of our deepest satisfactions[2] will be to have worked on this collection before it was hospitalized and mummified, under conditions very like those enjoyed by Vuillard's immediate "heirs," Jacques Salomon and Annette Vaillant. These old photos are actually still kept today rather like a family album —as is only fitting. The disarming simplicity of Vuillard's attitude to his photographic work is integral to the triumphant mechanism of his creative genius. It is its obvious strategy. Its supreme imperative.

It is touching to think of Annette Vaillant preparing for the exhibition *Vuillard et son kodak*, held at the Galerie L'Oeil in April and May of 1963—a trail-blazing project at the time—discovering documents that took her back to her own childhood and to her comical, caustic, Proustian take on the memories she shared with "Monsieur Vuillard": "Discoloured or faded, like the flowers of an herbarium, frozen, precise but soulless, these amateur's photographs take me back in time, where the memory of what I had heard is my only guide."[3] They evoke the vague procession of beaches, the villas filled with hordes of children, the devoted if dim-witted nursemaids, the lazy wet-nosed dogs belonging to "cousin Lucy"; and, too, the sponging guests, the indolence of Normandy afternoons and bodies snoring in the shade, the wheezing motorcars. "Vuillard-the-silent" would remain in the corner of the room observing his fellows. His melancholy gaze, to be seen in many photographs, is intensely searching (cats. 183, 236). "Sometimes, during a conversation," recalled Jacques Salomon, "Vuillard would go to get [his Kodak] and resting it on some furniture or even the back of a chair, oblivious of its view finder, would point the lens in the direction of the image he wished to record: he would then give a brief warning, 'Hold it, please' and we would hear the clic…clac of the time exposure."[4] It should be said at the outset that photography accompanied the radical change in Vuillard's painting that began to take place between 1897 and 1899. It enabled him to exorcize his early penchant for stifling interiors and the Expressionist scenes of 1892–1897—which nevertheless delight us. Whereas *In the Lamplight* (cat. 84) and *Interior, Mother and Sister of the Artist* (cat. 85) employ false perspectives that abolish notions of near and far, the photographs restore depth of field, the tastes and scents of the moment. They are also for Vuillard the corollary of a "face-value" acceptance of sexuality. A simpler and sunnier sexuality.

AMONG THE SELECTION of photographs presented here, one taken at La Jacanette[5] in 1908 (cat. 238) is interesting for a number of reasons. It demonstrates the artist's continued interest in the "Pirandellian" arrangement of figures in a room. Since Vuillard is included in the image, it was most probably Kerr-Xavier Roussel who released the shutter: Jacques Salomon, Roussel's son-in-law, suggests this in regard to a different shot.[6] But it seems extraordinarily evident that it was Vuillard who *wanted* and *fixed* the scene. Bonnard is seen from behind, in exactly the same pose as many figures in Vuillard's paintings of the time (for example, *Café Scene*, c. 1908–1910, Munich, Neue Pinakotheck, c-s VII.544). The overbearing Marthe Bonnard stares at the lens with her beautiful mad

grey eyes—and there we have what Vuillard thinks of her, without words. Annette Roussel, as so often in her uncle's paintings, seems entirely detached from the proceedings. And the artist is in the background, silent and intense, *drawing to himself* the deep meaning of this inspired shot.

Similarly, in the fine composition (cat. 167) where he poses with Misia at Villeneuve in about 1897–1899—the period when he was deeply in love with Thadée Natanson's wife—we sense that no element of the framing escaped his eye. They seem to have been returning from a walk along the banks of the Yonne, which was where, according to Misia's memoirs, he made his "declaration": "Our eyes met. In the deepening shadows I could see the sad gleam of his glance. He burst into sobs."[7] We guess that as they walked back to the villa, the smiles returned.

Vuillard bought his Kodak in about 1897. From that point on he took one snapshot after another during all the holidays he spent in the country, undoubtedly learning a number of technical details from Alfred Natanson, who was more expert than he at "artistic photography" (the men can be seen together in cat. 166). Once again Annette Vaillant—Alfred Natanson's daughter—describes with charming humour (appropriate in an eyewitness who was also a gifted writer) the manner, empirical to say the least, in which the two friends used the medium:

Monsieur Vuillard and my father both had an identical camera. An ordinary Kodak, covered in black gritty leather, rounded at the angles. The inside was dark red and opened like an accordion. Sometimes, I was allowed to look into the little square of frosted glass which was protected by a small metal screen. In it, the people upside down, turned into Lilliputians, moved in a blurred world. On the window sills of our country houses, sometimes even in Paris, on a bright wintry morning on the balcony, the negatives in their frames, exposed to the sun light, would release their images, carefully watched by someone. Later, floating in little square white dishes, my sister and her nanny would appear together on the excursion to Cap Fréhel, Tristan Bernard, Monsieur Vuillard, Madame Hessel, my mother, my friends Jacques and Annette Roussel, and all the people who came visiting us from Trouville, Dinard or somewhere else, depending on where we had been on holiday that year.[8]

Between 1900 and 1914, Vuillard's "bachelor machine" operated within this perfect triangle: holiday-photography-memory.

VUILLARD WOULD BE astonished at the attention being paid his photographs today. For him they were, like his journal, "memoranda"[9] that helped him define the paintings he wanted to make and fix the faces of the individuals who would be their protagonists. His photos recaptured for him, over the distance of years, the flavour of an atmosphere, the truth of a moment. They restored the *this-is-the-way-it-was* inherent to unpretentious snapshots. But at the same time, Vuillard had mistrusted photography since his youth— a love-hate attitude encountered often among nineteenth-century painters. An eloquent passage in his journal from 1890 makes his feelings clear: "The head of a woman has just roused in me a certain emotion, this emotion alone should suffice me and I should not try to remember the nose or the ear, that is of no importance; let's look at what I do the nose and the ear that I make but let's not try to remember anything but the emotion very complex thing in these cases; the expressive techniques of painting are capable of conveying

1. Vuillard, *Journal*, IV.13, fol. 33r (October 13, 1939).

2. I speak here for all the curators of this exhibition. We cannot thank the Salomon family enough for the access they have so generously allowed us.

3. Salomon and Vaillant 1963, p. 18.

4. Ibid., p. 2.

5. The Roussels' house at L'Étang-la-Ville, built by Vuillard's architect friend Frédéric Henry in 1908. Its name came from those of the two Roussel children, Jacques and Annette.

6. "It was probably Roussel who released the shutter to record the arrival of his brother-in-law at L'Étang-la-Ville." Salomon and Vaillant 1963 (French edition), p. 4.

7. Sert 1953, p. 67.

8. Salomon and Vaillant 1963, pp. 16-18.

9. This well-chosen expression is from Annette Vaillant, ibid., p. 18.

an analogy but not an impossible photograph of a moment. How different are the snapshot and the Image!"[10] Vuillard was therefore a subtle, critical, "distanced" user of photography, not compulsive and hypocritical like Fernand Khnopff, who at his death left thousands of photographs in his studio drawers, certainly employed as aids to his painting, and yet in 1899 had published in the British *Magazine of Art* an article in which he slyly wondered, "Is Photography among the Fine Arts?"[11]

The private, family nature of Vuillard's photography becomes even more evident when we learn that he printed the pictures himself—or, better yet, had his mother do it. Like Pierre Bonnard—although much more inspired—he was something of a Sunday photographer. Around 1900 these two shared their interest in the magic of the black box with another Nabi, Maurice Denis. The latter, however, took carefully composed photographs of family visits to Italy, showing a marked preference for chiaroscuros reminiscent of English Pictorialism and entrusting the printing of his negatives to the famous firm of Druet. In Vuillard's use of the medium we find no modernist effulgences, like Heinrich Kühn's solar effects or Henry Emerson's inspired mists, and certainly none of Lewis Hine's accusatory observations. His photography is a vision made up of small touches, fleeting notes, somewhere between Count Primoli and Jacques-Henri Lartigue; several of his snapshots are comparable to the first "family" films made by the Lumière brothers, which he used to go and see with Lucy Hessel.[12] We find in them the same palpable humanity, the same unreasoning confederacy with the family-dominated world inhabited by the French *petite bourgeoisie* around the turn of the century. One thinks, for example, of the astonishing image of Kerr-Xavier Roussel holding a cat (cat. 197)—a shot designed to capture movement that seems clearly inspired by early experiments in cinematography. Other holiday photographs combine humour, the celebration of friendship and an inimitable elegance of composition: thus Tristan Bernard's lover, Marcelle Aron, brushing her Medusa-like hair at Amfreville with the empty gaze of a Bellini sleepwalker (cat. 219). In fact, in his photographic work Vuillard accomplished a remarkable task of exhuming the past, of "looking back," exploiting what Freud called the "memory trace" and identified with the involuntary activation of memory.

Vuillard made extensive use of his photographs from the 1905–1908 period on; when reworking certain of his major decorations, he would dig snapshots out of the shoeboxes where they were kept. After he had executed *The Haystack* (cat. 266) and *The Alley* (1907, Paris, Musée d'Orsay, C-S VIII.226), commissioned by the Bibesco princes, the artist was far from happy with the results of his work. These two panels depict scenes from the summer holiday of 1907, at Amfreville, and he began work on them in November 1907. In a journal entry dated November 10, he writes: "delighted with these photos that awaken a host of memories."[13] Some time later, on January 22, 1908, he speaks of the extraordinary and paradoxical feeling that the *colours* come back to him when he looks at his black and white prints: "go to the studio for a moment violet of the dress (the mauve of nature recurs in imagination as I look at the photo)"[14] (cats. 222–224). *The Alley* is in fact one of the most monumental portraits of his lover Lucy Hessel, a proclamation of the illicit affair that no one mentioned but everyone in

Paris society knew about. So Vuillard hesitated, reworking and retouching this painting, drawing on the pitiless testimony of the photographs. Again and again in the journal the word *photo* is linked to the word *memory*—proof of the extent to which these *memoranda* formed in his mind an archipelago of love remembered. For each photograph was like a piece of his own truth, a vain attempt to reassemble the fragmented puzzle of his inner life. One is reminded of a passage in Barthes's *Camera Lucida*, where the author puts his finger on this secret mechanism:

What I want, in short, is that my (mobile) image, buffeted among a thousand shifting photographs, altering with situation and age, should always coincide with my (profound) self; but it is the contrary that must be said: "myself" never coincides with my image; for it is the image which is heavy, motionless, stubborn (which is why society sustains it), and "myself" which is light, divided, dispersed; like a bottle-imp, "myself" doesn't hold still, jiggling in my jar: if only Photography could give me a neutral, anatomic body, a body which signifies nothing! Alas, I am doomed by (well-meaning) Photography always to have an expression: my body never finds its zero degree, no one can give it to me (perhaps only my mother? . . .)[15]

After 1897 Vuillard's own mother was certainly deeply involved in the painter-photographer's empirical migrations (cats. 169–170), for she whom he called his "true muse" seemed naturally to trigger reverberations in the mysteries of passing time. But in 1939, more than thirty years after painting the first versions of *The Haystack* and *The Alley*, the artist went back to them, and in a journal entry speculated in a very revealing way:

. . . photographs Haystack and alley, justification of this aid on what conditions (return from Viau's place), rapid succession of characters necessary, awareness of them only in the intervals, all past linked to the present (lampshade brick tones of the alley of the Haystack), torment of the lie; Valéry: it is clear that the "Good" and the "Beautiful" are out of fashion—As for the "True," photography has shown its nature and its limits: the recording of phenomena by a pure effect of themselves, demanding the <u>least possible of Man</u>, such is our "True." This is what I realize . . . definite greater importance of the feeling of the coloured sensation subject that encompasses everything, instead of the idea of drawn form (document), pencil or other element of understanding; notion of *trompe-l'œil* after, barren or at least limited.[16]

This meditation of his later years seems astonishingly like a continuation of one of the painter's first declarations, recorded in an early journal entry (November 22, 1888), where he advocates the combination of a thought-out, carefully sketched composition with a kind of automatic writing, where the artist operates "like a sleepwalker," almost in a state of controlled catalepsy.[17] Photography thus allowed Vuillard to seek *his* truth, in Valéry's sense, and to permit himself this revision of memory, serving as the guarantee of what might be called his creative recollection of things past. Photography was Vuillard's quest of Isis.

10. Vuillard, *Journal*, I.2, fol. 20v (September 6, 1890).

11. *The Magazine of Art*, vol. 22 (1899), p. 156.

12. Vuillard, *Journal*, II.1, fol. 52r (June 25, 1908): "Hatred of Lucie we go to the cinematograph," and II.1, fol. 68v (September 29, 1908): "Return dinner at Lucy's we go to the cinematograph."

13. Ibid., II.1, fol. 5r (November 10, 1907).

14. Ibid., fol. 21v (January 22, 1908).

15. Roland Barthes, *Camera Lucida: Reflections on Photography* (New York: Hill and Wang, 1981), p. 12.

16. Vuillard, *Journal*, IV.12, fol. 47r-v (January 15, 1939).

17. Ibid., I.1, fol. 12r-v. The complete passage is as follows: "Practical necessity of working above all from memory, and always to see as a whole the masses the air etc. If the brain's mechanism is not in a state to grasp these relationships, to keep them for a moment and transfer them like a sleepwalker onto paper or canvas, it's a waste of time."

AGAIN, WHEN HE BEGAN reworking *The Terrace at Vasouy* (cats. 263–264)—an immense panel that the widow of Claude Anet (Jean Schopfer) had asked to have cut in half—he noted on October 5, 1935: "examine photos with magnifying glass for Claude Anet."[18] He completely reconstructed the scene, combining snapshots from 1901, identifying the objects on the checked tablecloth with his magnifying glass, erasing certain figures (Léon Blum)—in short, *reinventing history* with all the authority of a stage director. Vuillard had continued to employ his camera during the war: in March 1917, during his preparations for Lazare Lévy's panels (1917, C-S X.32a–b)—painted in the munitions factories at Oullins, then run by Thadée Natanson—his excitement at exploring an industrial world that he found fascinating sent him back to the photographic medium: "immense interest photos of shapes of the machines now that I have an idea of them";[19] "world of engineers of active ambitious figures passionate conflicts; visit to the factory flux of terrifically interesting sensations confused feverish."[20] But above all the war— with Paris emptied of its young men, all away at the front—gave him the opportunity to make more female conquests. While Madame Hessel was conveniently busy attending to her blind soldiers, gassed in the trenches, he met and fell in love with Lucie Belin, a ravishing dressmaker's assistant who dreamed of becoming an actress. Pictured in her little room, she is the subject of one of his finest photographic portraits, on a par with works by Brassaï (cat. 247).[21] Photography, in this case, became the supreme *medium of love*, for the work is even more convincing than her painted portrait, *Lucie Belin Smiling* (cat. 307). In the ongoing dialogue of passion—and it was reciprocal—the new Lucie photographed Vuillard sitting in his studio, no doubt carefully following the master's instructions. And, of course, we should not forget the last photographs of his mother, who died in 1928. An emaciated phantom, a shade already waiting on the bank of the Styx, she still found the strength to pose patiently before the lens of her cherished son, the love of her life (cats. 251–252).

The transformation of the past was also radical in the case of one of the masterpieces of Vuillard's last period, the Metropolitan Museum's *The Garden of the Clos Cézanne at Vaucresson* (C-S XI.52). A large decorative panel, painted for himself and as a tribute to the decorative painting of Odilon Redon, this picture of the enchanted garden at the Clos Cézanne presided over the salon of the Château des Clayes, the Hessels' home. However, the artist reworked it frequently. On May 31, 1926 he wrote: "exhume painting of the Clos Cézanne";[22] and a while later, on September 22, 1926: "sort out old sketches photos."[23] In fact, instead of adjusting the age and features of the models as he retouched the painting, as might have been expected, he actually made Marcelle Aron and Lucy Hessel—his two great friends, who pose in glory among the decorative tracery of the painting—seem younger. Thus did he exorcize the intolerable onslaught of time, against which nothing is proof.

We may be permitted, perhaps, one last example, where triumphs the miraculous fusion of Vuillard's wit, his love of the theatre and his wide cultivation. It was his snapshots of the beautiful Lulu Hessel[24] (Lucy's adopted daughter), taken at random in the garden at Les Clayes, that in 1937 gave Vuillard the idea for the subject of *Comedy*, the great painted décor for the Palais de Chaillot. Walking in the park menagerie, he had chosen, among a range of possibilities, to photograph Lulu kissing a donkey on the nose. The flash of inspiration came, and the connection with Shakespeare's *Midsummer Night's Dream* struck him at once—hence the delightful image in the foreground of the panel of Titania in Bottom's arms. As so often in Vuillard's oeuvre, it was the immediate experience of a personal reality that enabled him to create a work of art whose impact was ultimately universal. His little Nabi paintings can sometimes take our breath away. His great decorative works dazzle us. His photography seems calculated to awaken in us an immediate feeling of kinship. **Guy Cogeval**

18. Ibid., IV.9, fol. 16r.

19. Ibid., III.1, fol. 51v (March 23, 1917).

20. Ibid., fol. 51r (March 17, 1917).

21. To our knowledge there exist eight photographs of Lucie Belin, but only cat. 247 is an original print.

22. Vuillard, *Journal*, III.(S).E, fol. 20r (May 31, 1926).

23. Ibid., fol. 59v (September 22, 1926).

24. It was she who posed for the nine muses of the Geneva decoration (1938), in a Greek chiton in the studio on Place Vintimille (see cat. 253 and cats. 294–296, fig. 2).

## 166

Vuillard and Alfred Natanson in front of
Les Relais, in Villeneuve-sur-Yonne

c. 1897–1899, original gelatin silver print,
7.8 × 8.5
Private collection

## 167

Vuillard and Misia Natanson in the park
of Les Relais, in Villeneuve-sur-Yonne

c. 1897–1899, original gelatin silver print,
8.8 × 9.1
Private collection

## 168

Misia Natanson seated on a chaise lounge,
Rue Saint-Florentin

1899, original gelatin silver print, 8.4 × 8.6
Private collection

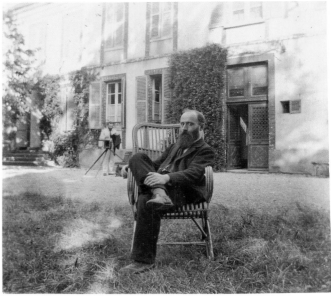

166

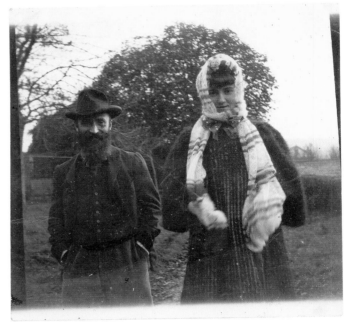

167

168

169

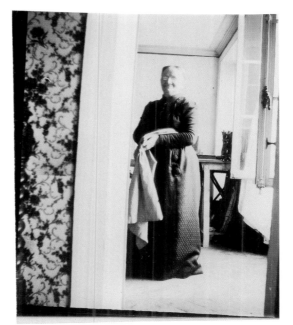

170

## 169

Madame Vuillard cooking,
Rue des Batignolles

1897, original gelatin silver print, 9 × 9
Private collection

## 170

Madame Vuillard, Rue Truffaut

1899–1904, original gelatin silver print,
8.5 × 7.1
Private collection

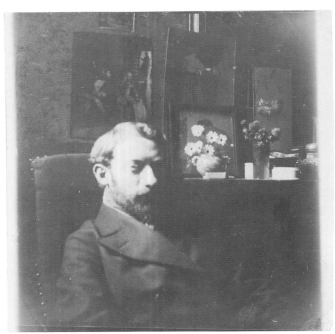

171

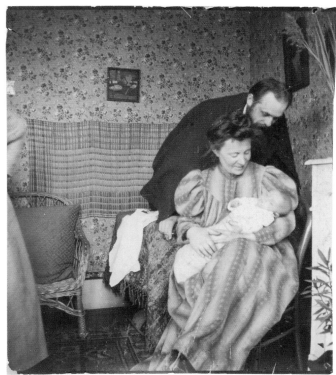

172

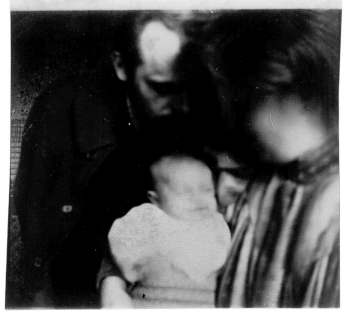

173

## 171

Pierre Bonnard, Rue des Batignolles

1897–1899, original gelatin silver print,
8.9 × 8.8
Private collection

## 172

Kerr-Xavier, Marie and Annette Roussel
in Levallois

1898, original gelatin silver print, 8.8 × 7.7
Private collection

## 173

Kerr-Xavier, Annette and Marie Roussel
in Levallois

1898, original gelatin silver print, 8.6 × 8.9
Private collection

## 174

Kerr-Xavier and Annette Roussel in Levallois

1898, original gelatin silver print, 8.7 × 8.9
Private collection

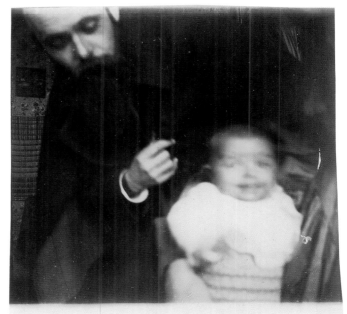

174

## 175

Misia Natanson in front of the credenza,
Rue Saint-Florentin

1899, original gelatin silver print, 9.1 × 8.9
Private collection

## 176

Misia Natanson and Romain Coolus,
Rue Saint-Florentin

1899, original gelatin silver print, 8.9 × 8.9
Private collection

## 177

Romain Coolus and Misia Natanson
descending the stairs at Les Relais, in
Villeneuve-sur-Yonne

1898, original gelatin silver print, 9 × 8.9
Private collection

## 178

Suzanne Avril, Misia Natanson and Vuillard
in Misia's room at Les Relais, in Villeneuve-
sur-Yonne

1899, original gelatin silver print, 8.4 × 9
Private collection

## 179

Misia Natanson in the salon of Les Relais,
in Villeneuve-sur-Yonne

1899, original gelatin silver print, 9 × 9
Private collection

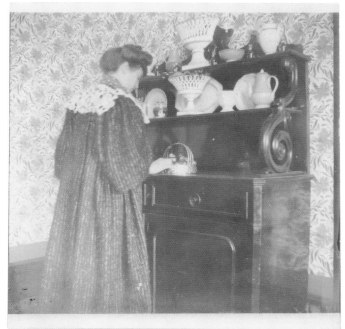

175

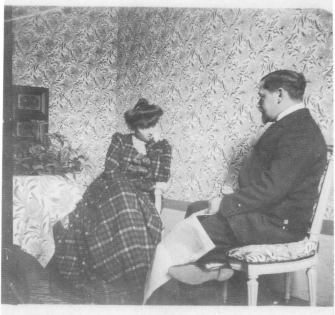

176

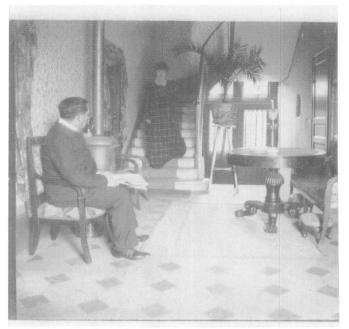

177

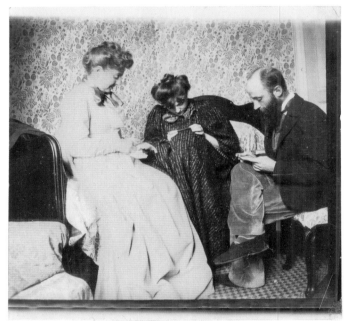

178

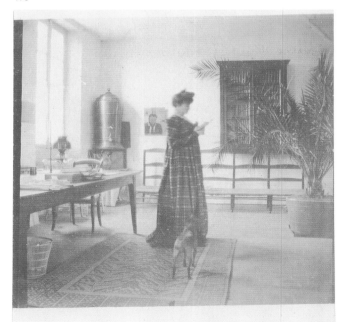

179

180

181

## 180

Kerr-Xavier Roussel in the dining room,
Rue Truffaut

c. 1900, original gelatin silver print, 9 × 9.1
Private collection

## 181

Marie Roussel in an armchair in the
dining room, Rue Truffaut

c. 1900, original gelatin silver print, 9 × 9
Private collection

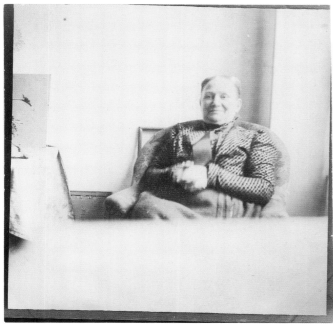

## 182

Madame Vuillard in an armchair in the
dining room, Rue Truffaut

c. 1900, original gelatin silver print, 9 × 8.9
Private collection

## 183

Vuillard in an armchair in the dining
room, Rue Truffaut

c. 1900, original gelatin silver print, 9 × 9.1
Private collection

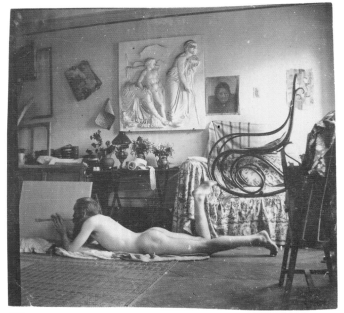

184

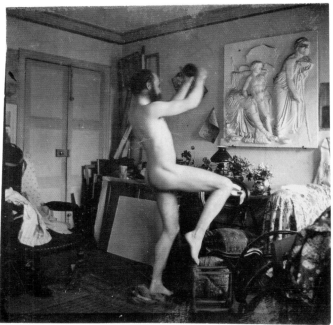

185

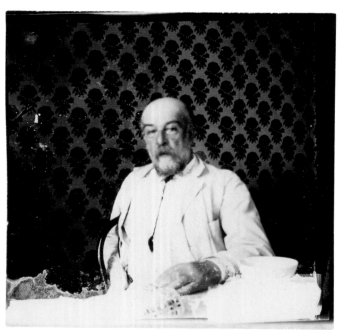

186

**184**

Kerr-Xavier Roussel nude, Rue Truffaut

c. 1900, original gelatin silver print, 8.5 × 8.7
Private collection

**185**

Kerr-Xavier Roussel dancing nude,
Rue Truffaut

c. 1900, original gelatin silver print, 8.7 × 8.5
Private collection

**186**

Odilon Redon in Saint-Georges de Didonne

1901, original gelatin silver print, 8.9 × 9.1
Private collection

**187**

Vuillard at the window in Venice

1899, original gelatin silver print, 9 × 8.9
Private collection

**188**

Pierre Bonnard and Kerr-Xavier Roussel
at the window in Venice

1899, original gelatin silver print, 9 × 8.9
Private collection

187

188

## 189

The road from Grenada to Cadiz seen
from a horse-drawn carriage

1901, original gelatin silver print, 6.6 × 9.7
Private collection

## 190

Vuillard and Antoine Bibesco on a train
in Spain

1901, original gelatin silver print, 6.6 × 9.2
Private collection

## 191

Pierre Bonnard and Emmanuel Bibesco at
the Hotel Inglès in Madrid

1901, original gelatin silver print, 8.9 × 9
Private collection

189

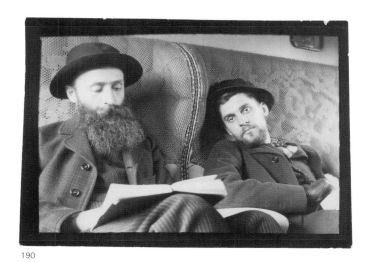

190

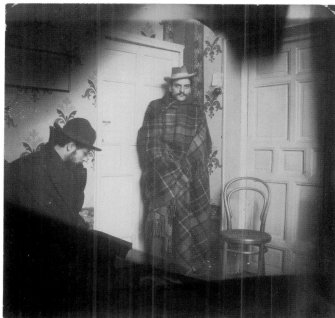

191

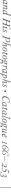

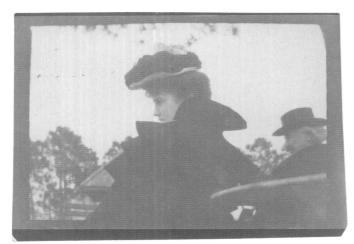

192

193

194

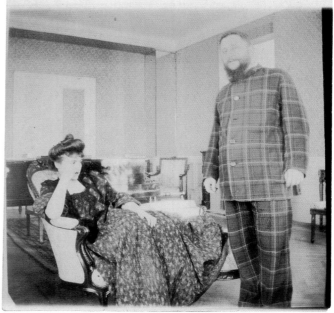

195

196

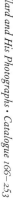
## 192

Misia Natanson seen in profile in a carriage in Cannes

1901, original gelatin silver print, 6.7 × 9.4
Private collection

## 193

Misia Natanson on the steps of La Croix des Gardes, in Cannes

1901, original gelatin silver print, 9.5 × 6.6
Private collection

## 194

Misia Natanson in a rattan chair at La Croix des Gardes, in Cannes

1901, original gelatin silver print, 6.5 × 9.5
Private collection

## 195

Misia and Thadée Natanson in the salon of La Croix des Gardes, in Cannes

1901, original gelatin silver print, 8.9 × 9
Private collection

## 196

Paul Élie Ranson, Félix Vallotton, Pierre Bonnard, Maximilien Luce, Paul Sérusier and Vuillard at La Montagne, in L'Étang-la-Ville

1901, original gelatin silver print, 9.1 × 9
Private collection

## 197

Kerr-Xavier Roussel and his sister-in-law
Louise at La Montagne

1900–1902, original gelatin silver print,
6.7 × 9.5
Private collection

## 198

Maurice and Marthe Denis at La Montagne

1900–1903, original gelatin silver print,
6.7 × 9.6
Private collection

## 199

Marthe Denis with a dove at La Montagne

1900–1903, original gelatin silver print,
6.5 × 9.5
Private collection

197

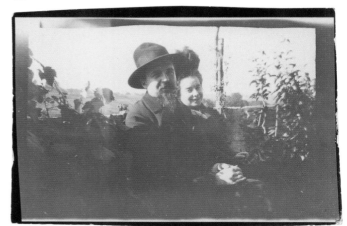

198

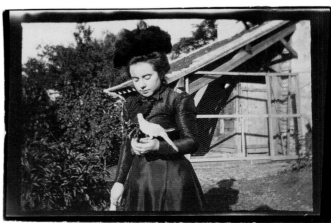

199

200

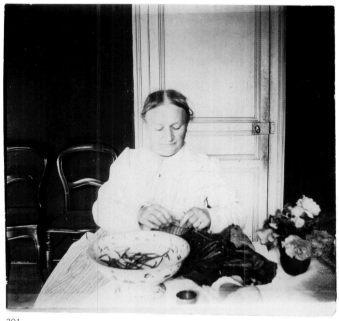

201

## 200

Jacques and Annette Roussel at La Montagne

1904, original gelatin silver print, 9.3 × 9.2
Private collection

## 201

Madame Vuillard cleaning green beans
at Myosotis, in Villerville

1902, original gelatin silver print, 8.5 × 8.7
Private collection

202

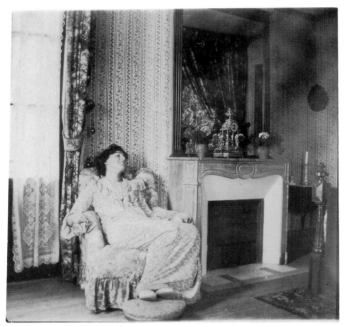

203

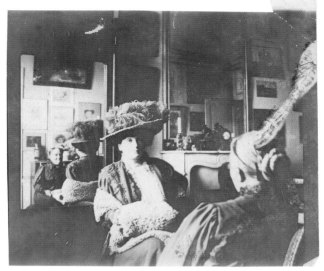

204

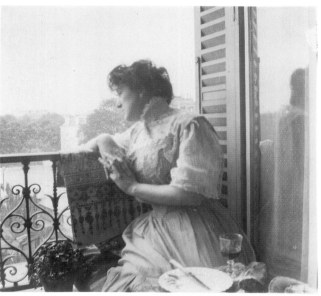

205

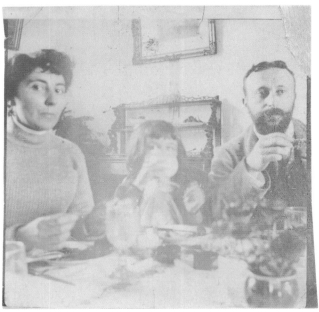

206

## 202

Madame Vuillard doing her hair,
Rue Truffaut

c. 1902–1904, original gelatin silver print,
9 × 8.9
Private collection

## 203

Lucy Hessel seated in the salon of
La Terrasse, in Vasouy

1904, original gelatin silver print, 8.4 × 8.6
Private collection

## 204

Lucy Hessel visiting Madame Vuillard,
Rue de la Tour

1904–1908, original gelatin silver print,
8.5 × 9.4
Private collection

## 205

Lucy Hessel at the window, Rue de la Tour

c. 1905, original gelatin silver print, 8.1 × 8.6
Private collection

## 206

Marthe Mellot, Annette Natanson and
Alfred "Athis" Natanson

1904, original gelatin silver print, 8.8 × 8.8
Private collection

207

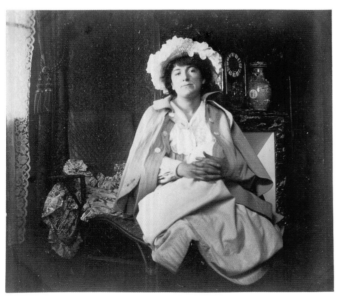

208

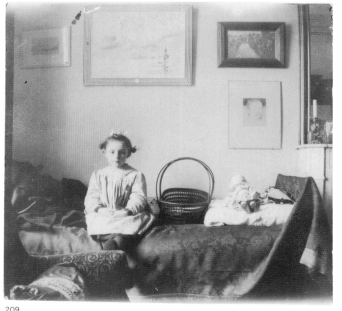

209

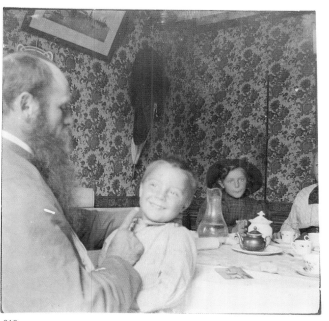

210

## 209

Annette Roussel seated on a bed,
Rue de la Tour

1906, original gelatin silver print, 8.3 × 8.8
Private collection

## 210

Kerr-Xavier, Jacques and Annette Roussel
in Salenelles

1905, original gelatin silver print, 8.5 × 8.5
Private collection

211

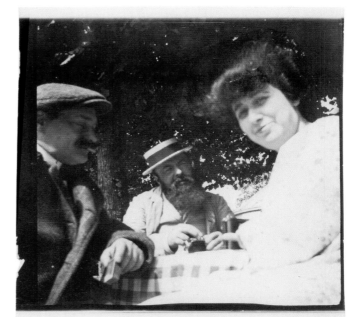

212

213

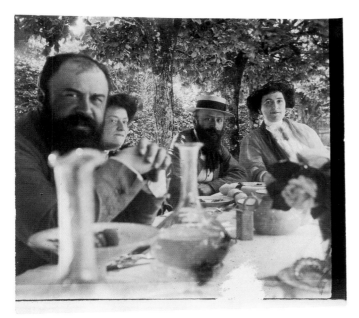

214

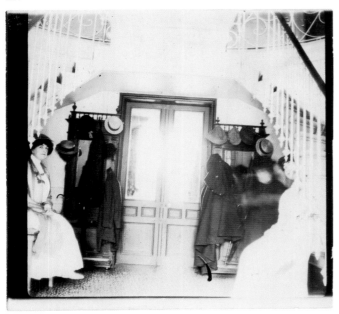

215

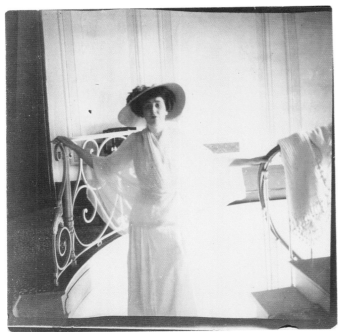

216

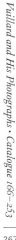
## 211

Cattle in front of the car in Brittany

1906, original gelatin silver print, 10.2 × 10.2
Private collection

## 212

Romain Coolus, Tristan Bernard and Marcelle
Aron in the garden of the Château-Rouge,
in Amfreville

1905, original gelatin silver print, 8.7 × 9.1
Private collection

## 213

Romain Coolus, Lucy Hessel and an
unidentified woman in the garden of the
Château-Rouge, in Amfreville

1905, original gelatin silver print, 8.7 × 8.8
Private collection

## 214

Tristan Bernard, Louise Hessel, Vuillard
and Lucy Hessel at the Château-Rouge, in
Amfreville

1905, original gelatin silver print, 8 × 8.3
Private collection

## 215

Lucy Hessel and Marcelle Aron beneath
the staircase of the Château-Rouge, in
Amfreville

1905, original gelatin silver print, 8.9 × 9.4
Private collection

## 216

Marcelle Aron ascending the stairs of the
Château-Rouge, in Amfreville

1905, original gelatin silver print, 9 × 9
Private collection

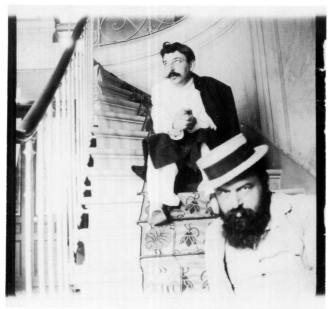

217

218

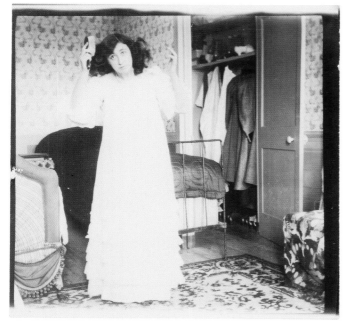

219

220

221

**217**

Tristan Bernard and André Picard on the stairs of the Château-Rouge, in Amfreville

1905, original gelatin silver print, 8.9 × 9
Private collection

**218**

Marcelle Aron reclining on the stairs of the Château-Rouge, in Amfreville

1905, original gelatin silver print, 8.9 × 9.3
Private collection

**219**

Marcelle Aron brushing her hair in her room at the Château-Rouge, in Amfreville

1907, original gelatin silver print, 8.9 × 9.1
Private collection

**220**

Vuillard on the beach at Mereville-Franceville

1907, original gelatin silver print, 8.1 × 8.6
Private collection

**221**

Vuillard and Lucy Hessel in Amfreville

1907, original gelatin silver print, 8.5 × 8.5
Private collection

222

## 222

Lucy Hessel and Marcelle Aron in front
of a haystack in Amfreville

1907, original gelatin silver print, 8.8 × 8.7
Private collection

## 223

Lucy Hessel leaning against a haystack
in Amfreville

1907, original gelatin silver print, 8.8 × 8.8
Private collection

## 224

Lucy Hessel laughing, leaning against a
haystack in Amfreville

1907, original gelatin silver print, 8.8 × 8.9
Private collection

## 225

Lucy Hessel reclining on the grass
in Amfreville

1907, original gelatin silver print, 8.8 × 8.9
Private collection

## 226

Lucy Hessel in a meadow in Amfreville

1907, original gelatin silver print, 8.9 × 9.1
Private collection

## 227

Romain Coolus and Lucy Hessel in Amfreville

1907, original gelatin silver print, 9 × 8.8
Private collection

223

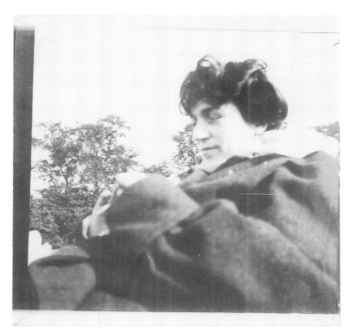

226

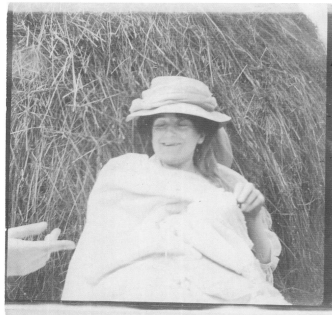

224

225

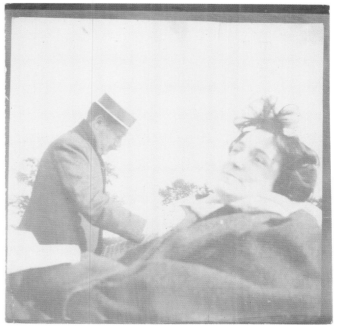

227

228

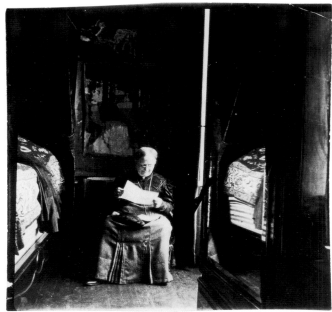

229

## 228

Madame Vuillard and her daughter-
in-law Marie in Vuillard's salon-studio,
Rue de la Tour

c. 1907, original gelatin silver print, 8.1 × 8.5
Private collection

## 229

Madame Vuillard in her room in Salenelles

1907, original gelatin silver print, 8.4 × 8.5
Private collection

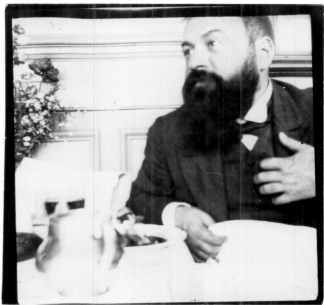

230

231

## 230

Marcelle Aron in a restaurant in Normandy

1907, original gelatin silver print, 8.8 × 9.4
Private collection

## 231

Tristan Bernard in a restaurant in Normandy

1907, original gelatin silver print, 8.9 × 9.1
Private collection

232

233

234

235

236

## 232

Lucy Hessel in a restaurant in Normandy

1907, original gelatin silver print, 8.9 × 8.9
Private collection

## 233

Romain Coolus in a restaurant in Normandy

1907, original gelatin silver print, 8.9 × 8.7
Private collection

## 234

Lucy Hessel and the Bernheim ladies at the
Château-Rouge, in Amfreville

1905, original gelatin silver print, 8.8 × 8.8
Private collection

## 235

Paul Sérusier leaning against the mantel-
piece and Madame Vuillard's shadow, Rue
de la Tour

1907, original gelatin silver print, 8.2 × 8.7
Private collection

## 236

Vuillard seated at the dining-room table,
Rue de la Tour

1908, original gelatin silver print, 8.9 × 8.8
Private collection

237

238

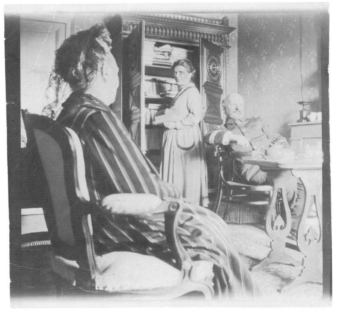

239

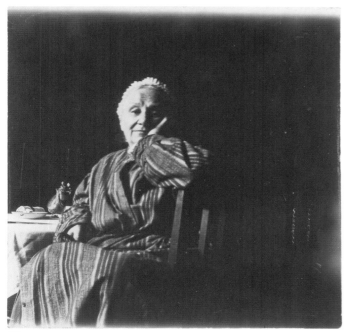

240

## 237

Kerr-Xavier, Jacques and Annette Roussel,
Lucy Hessel and Pierre Bonnard walking
in the vicinity of La Jacanette, in L'Étang-
la-Ville

1908, original gelatin silver print, 8.9 × 9.5
Private collection

## 238

Madame Roussel mère, Marthe Bonnard,
Vuillard, Annette Roussel and Pierre Bonnard
around the table at Kerr-Xavier Roussel's
house, La Jacanette

1908, original gelatin silver print, 8.4 × 8.6
Private collection

## 239

Madame Vuillard, her son Alexandre and
his wife, Marie, in Lorient

1911, original gelatin silver print, 9 × 9.2
Private collection

## 240

Madame Vuillard seated, Rue de la Tour

1908, original gelatin silver print, 8.7 × 8.8
Private collection

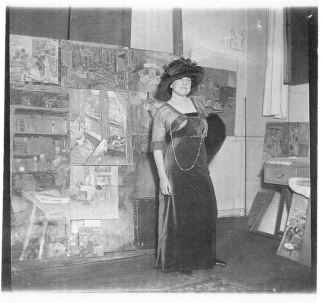

241

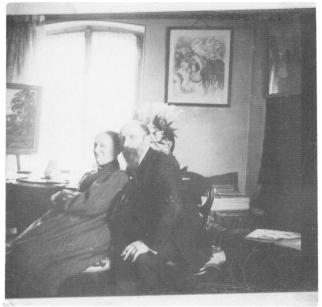

242

## 241

Lucy Hessel in the studio on Boulevard
Malesherbes

1911–1912, original gelatin silver print,
8.7 × 9
Private collection

## 242

Vuillard and his mother, Rue de Calais

1910, original gelatin silver print, 9 × 8.8
Private collection

243

244

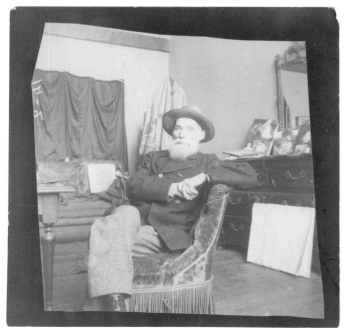

245

## 243

Annette and Kerr-Xavier Roussel and
Madame Vuillard, Rue de Calais

1912, original gelatin silver print, 8.6 × 8.8
Private collection

## 244

Lucy Hessel at Coadigou in Loctudy,
next to one of the decorations for Bois-
Lurette

1912, original gelatin silver print, 8.1 × 8.6
Private collection

## 245

Auguste Renoir in his studio

1912, original gelatin silver print, 9 × 9
Private collection

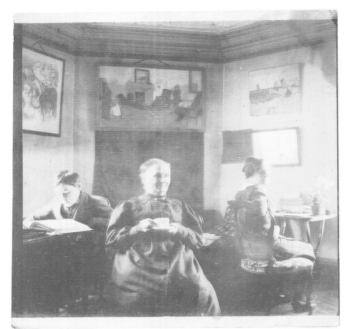

246

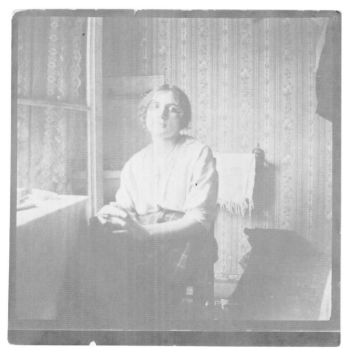

247

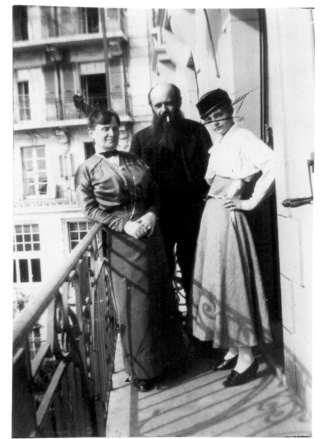

248

## 246

Jacques Roussel, Madame Vuillard and
Annette Roussel in the salon, Rue de Calais

1913, original gelatin silver print, 8.9 × 8.8
Private collection

## 247

Lucie Belin at home

1917, original gelatin silver print, 9.4 × 9
Private collection

## 248

Marie, Kerr-Xavier and Annette Roussel
in Lausanne

1916, original gelatin silver print, 8.2 × 5.6
Private collection

## 249

Lucy Hessel and Alfred "Athis" Natanson
at the Clos Cézanne, in Vaucresson

1920, original gelatin silver print, 8.8 × 9.2
Private collection

## 250

Lucy Hessel and Madame Vuillard on the
avenue in the park of the Château des Clayes

c. 1927, original gelatin silver print,
9.2 × 9.2
Private collection

## 251

Madame Vuillard at her toilet,
Place Vintimille

1928, original gelatin silver print, 7.5 × 6.9
Private collection

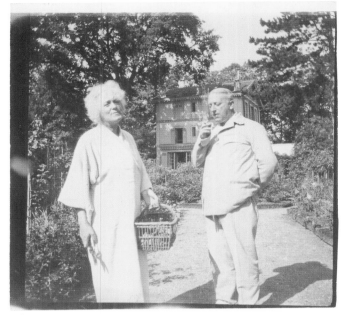

249

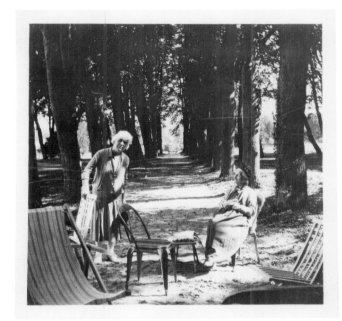

250

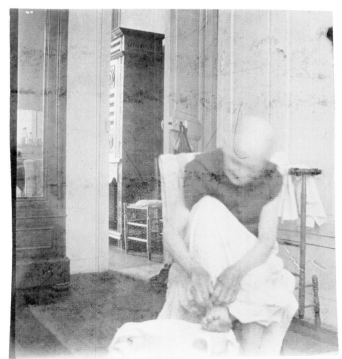

251

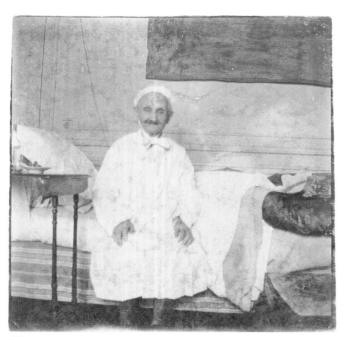

252

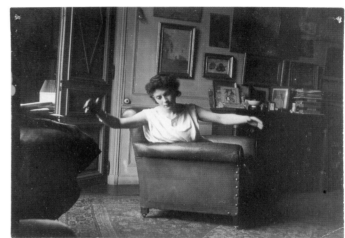

253

## 252

Madame Vuillard seated on her bed,
Place Vintimille

1928, original gelatin silver print, 8.7 × 8.7
Private collection

## 253

Lulu Hessel posing for "Peace,
Protector of the Muses," Place Vintimille

1937, original gelatin silver print,
6.4 × 8.9
Private collection

THE TRIUMPH OF LIGHT | *Catalogue* **254-276**

VUILLARD'S POST-NABI PERIOD, which ran from about 1900 until his death in 1940, has generally been viewed as one in which the avant-garde artist who had developed an uncompromisingly radical form of non-naturalism during the 1890s retreated into a modified form of naturalism that excluded him from the "modern" mainstream. Around 1900 Vuillard certainly moved away from the claustrophobic interiors that had provided the settings for his *intimiste* paintings of the early 1890s and began to explore the world beyond. At the same time, a more direct observation of the subject and a reassessment of the articulation of space through light prompted him to eschew the simplification of forms and the disregard for three-dimensional space that had characterized his works of the previous decade.

Much of this transformation can be tied to the artist's discovery of landscape. Vuillard's familiarization with landscape as a subject in its own right was a gradual process. During the first half of the 1890s his art remained resolutely focused on the interior, a notable exception being *The Public Gardens*, the major series of decorative panels he created in 1894 (cats. 111–118). Beginning in 1896, however, Vuillard adopted the habit of making regular visits to the country homes of close friends and family (see "Vuillard and the 'Villégiature'," in the present volume). Although his initial response to the inevitable confrontation with nature remained cautious, it did lead to his first serious attempts to introduce landscape as something more than an appealing and largely schematic backdrop. The move is evident in easel paintings, such as *Boating* (cat. 254), large-scale decorations, such as the *Île-de-France* panels (see cat. 142), and even prints, such as *Across the Fields*—one of the suite of twelve colour lithographs entitled *Landscapes and Interiors* published in 1899 by Ambroise Vollard.

The summer and early autumn of 1900 saw a radical shift in Vuillard's engagement with landscape. On August 10, while staying with the Roussels at L'Étang-la-Ville, a suburb west of Paris, he wrote to Félix Vallotton describing his discovery of the beauty of external nature and its changing aspects: "But I'm discovering some great things, marvellous spectacles, I really enjoy being in the country, I'm able to admire without being reminded of paintings. I'm astonished to see the sky, by turns blue, grey, green, and that the clouds come in all sorts of different shapes and colours, and that without bending over backwards to find subtleties there is much pleasure to be had from understanding things in simple terms."[1] It was this revelation that Vuillard carried with him on his trip to Switzerland the following month and to Cannes in the winter of 1900–1901, where he would create some of his first pure landscapes (cats. 255–258, 261–262). The Cannes works, following on from Signac but some ten years before Bonnard, exquisitely capture the very particular quality of southern light.

In the years that followed, Vuillard travelled regularly in the company of friends, although now it was Lucy Hessel and her "society" circle who dominated, rather than Misia Natanson and her more bohemian crowd. In the company of Lucy, her husband Jos and their friends, Vuillard enjoyed *villégiatures* at a variety of locales throughout Normandy and Brittany, and in the countryside around Paris, each of which provided him with new vistas to explore and new lessons to be mastered.

The impact of these changes was threefold. The most obvious, of course, was the introduction of new subject matter. In addition to landscapes per se (cats. 267–268), Vuillard produced a number of paintings celebrating the life and activities he experienced during these country sojourns, including a number of large-scale decorations produced for an ever-broadening circle of patrons (cats. 263–264, 266, 274–275). Nor was his growing fascination with the world around him limited to the countryside: he also began to explore the vibrant cityscape of Paris, casting his painter's eye over its familiar streets and squares. Among the most striking results of this new appreciation are the depictions of Place Vintimille (cats. 269–272), where Vuillard combined keen observation, daring perspective and vigorous brushwork to create a thoroughly modern vision of the world as glimpsed from an apartment window.

Second, a greater concern for direct observation brought with it a new commitment to the potential properties of natural light as a dynamic and unifying force within a composition. While Vuillard had already begun to incorporate natural light into his paintings of the late 1890s—albeit sparingly—as a way of achieving a greater illusion of depth (cats. 153, 158), in interiors and landscapes made after 1900 he accorded it greater prominence as a formal component. The result in the interiors is an unprecedented sense of space, especially in those works inspired by his *villégiatures*, which are suffused with a tantalizing quality of warmth and atmosphere (cats. 273–276).

Finally, the artist's direct confrontation with nature and reappraisal of light led to a reconsideration of both colour and painting technique. Although vibrant colour had been a hallmark of much of Vuillard's art from the early 1890s on, after 1900 he displayed a new exuberance in its use, as colours came to be applied in a richer and more varied handling. The most notable change in Vuillard's technique was a result of his increasing predilection for the medium of *peinture à la colle*, or distemper. He had discovered the medium through his early theatrical work and used it subsequently for decorative panels, but from around 1907 on Vuillard began to explore all the limits and potential of this unconventional medium, working on both paper and canvas. In his small landscape paintings (cats. 267–268) he experimented with broad sweeps of *peinture à la colle*, creating boldly abstract images that are both evocative and surprisingly modern in their effect. In his large decorative panels, on the other hand, striving to balance the dual exigencies of observation and evocation, he adopted a different approach, applying the paint in short, bold dabs across the entire surface of the panel (in a manner reminiscent of tapestry or mosaic) to create a greater sense of unity and luminosity.

Vuillard's efforts did not go unacknowledged. By November 1908, during the course of his second major solo exhibition to be held that year at the Galerie Bernheim-Jeune, at which a significant number of landscapes were shown, critics were hailing Vuillard's return to nature as the consecration of a great artist whose work represented "a delightful protest against systematic distortions."[2] François Thiébault-Sisson, writing of his work the following year, observed perceptively that Vuillard was "a synthetist, but a synthetist preoccupied solely with effects of light and colour."[3]

**MaryAnne Stevens and Kimberly Jones**

1. Guisan and Jakubec 1974, pp. 47-48.

2. Arsène Alexandre, "La Vie artistique : Exposition Vuillard," *Le Figaro* (November 12, 1908); see also Jean-Louis Vaudoyer, "Petites Expositions : Édouard Vuillard (Galerie Bernheim)," *La Chronique des arts et de la curiosité*, no. 36 (November 21, 1908), p. 370, and Pierre Hepp, "Les Expositions : Édouard Vuillard," *La Grande Revue* (December 1908), p. 604.

3. Thiébault-Sisson, "Choses d'Art," *Le Temps* (November 10, 1909).

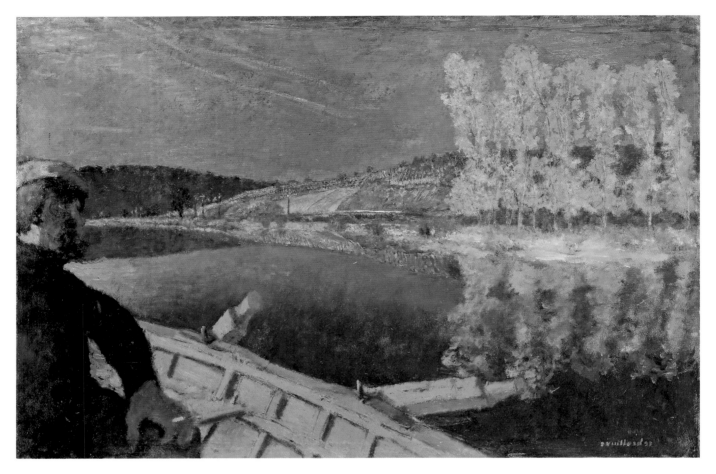

## 254

BOATING, also known as "THE FERRY-MAN" · *En barque (Le passeur)*

1897, oil on board mounted on cradled panel, 51 × 74.5
Signed and dated l.r.: *E Vuillard 97*
Paris, Musée d'Orsay, Gift of Mme Abreu, 1948

Cogeval-Salomon VI.92

———

*Provenance* Maurice Fabre, Paris—Bernheim-Jeune, Paris—Alexandre Natanson, Paris, 1908—Alexandre Natanson Sale, Hôtel Drouot, Paris, May 16, 1929, lot 113 (ill.)—Albert Sancholle-Henraux, Paris—Mme Sanchez Abreu, Paris—Gift to the Musée national d'art moderne, Paris; Musée d'Orsay, Paris

*Exhibitions* Paris, Bernheim-Jeune, Nov. 1908, no. 43 [*Automne*]—Paris, Musée des Arts décoratifs, 1938, no. 49—Cleveland-New York, 1954, p. 102, ill. p. 61—Milan, Palazzo Reale, 1959, no. 35—Lyon-Barcelona-Nantes, 1990–1991, no. 70, p. 83, ill.

*Bibliography* Roger-Marx 1946a, p. 158—Dorival 1961, p. 36—Salomon 1961, p. 57, ill.

———

1. Gustave Caillebotte, *Skiffs*, 1877, Washington, National Gallery of Art, Collection of Mr. and Mrs. Paul Mellon.

This work represents one of Vuillard's earliest essays in the landscape genre. It shows Cipa Godebski, Misia Natanson's brother, in a boat on the River Yonne, beneath a threatening autumnal sky. It was painted toward the end of the first *villégiature* that Vuillard spent at Misia and Thadée Natanson's house Les Relais, at Villeneuve-sur-Yonne, a location that was to stimulate his exploration of the landscape as subject matter—primarily in large-scale decorative panels such as *Woman in the Countryside* (cat. 150) and the first two Schopfer panels of 1898, *Woman Reading on a Bench* and *Woman Seated in an Armchair* (see "Vuillard and the 'Villégiature'," in the present volume, figs. 2–3).

Both compositionally and chromatically, *Boating* is striking. The radical truncation of the figure of Cipa on the far left and the eccentric eruption of the oar handles in the centre, above the edge of the boat, suggest, on the one hand, the influence of Japanese prints and a careful study of some of Degas's more extreme compositional devices. But it was in 1897 that Vuillard acquired his Kodak camera, and such bold procedures may have been generated by the artist's appreciation of the random visual "accidents" of instant photography. His use of a dramatically plunging perspective may also have been informed by Japanese prints, no doubt combined with the memory of Gustave Caillebotte's daring 1870s compositions (see fig. 1), together with the more recent influence of Théo van Rysselberhge's *Man at the Helm* (1892, Paris, Musée d'Orsay) and Félix Vallotton's woodcut prints from the 1890s. A preliminary drawing related to the painting (priv. coll.) plots out the entire composition, including the bold perspective, with precision, but it excludes the vertical pattern created by the reflection in the water of the poplar trees that line the far bank of the river.

The application of the complementary colours of blue-grey and orange suggests that, for this early foray into the natural world, Vuillard had recourse to the colour theories of Michel-Eugène Chevreul, which had underpinned the Impressionists' and Neo-Impressionists' understanding of the translation of light into colour. However, naturalism has not been unequivocally embraced in *Boating*. Just as Cipa Godebski's cut-off figure, though located outdoors, repeats a compositional device that Vuillard had used frequently in his *intimiste* interiors of the 1890s (see cats. 78–80), so does the choice of blue-grey and orange as the composition's dominant tones reflect the tendency throughout his *intimiste* years to select a small gamut of colours for each subject and to apply it across the entire surface of the picture, thus creating a decorative rather than a descriptive effect. It seems, in fact, that Vuillard paid little attention to scientific theories of colour—a point made by Maurice Denis in October 1906, when he noted in his journal that the dismissal of colour theory by the current younger generation derived from the example set initially by Vuillard.[1]

When Vuillard first exhibited landscape paintings in 1901, at the Salon des Indépendants, they were favourably received. Several years later, in November 1908, he showed a significant number of landscapes at his one-man exhibition at the Galerie Bernheim-Jeune, among them *Boating* and a group of nine Brittany landscapes. And once again, the shift in his interest from smaller-scale interiors to the external world of landscape and street scenes (see cats. 267, 268, 269–272) was acclaimed by several commentators, including Arsène Alexandre[2] and Pierre Hepp.[3] MAS

---

1. Denis 1957b, p. 47.

2. Arsène Alexandre, "La Vie artistique : Exposition Vuillard," *Le Figaro* (November 12, 1908).

3. Pierre Hepp, "Les Expositions : Édouard Vuillard," *La Grande Revue* (December 1908), p. 604.

## 255

SWISS LANDSCAPE · *Paysage de Suisse*

1900, oil on board mounted on panel, 40.6 × 81.9
Signed l.l.: *E. Vuillard*
Memphis, Tennessee, Memphis Brooks Museum of Art, Gift of Mr. and Mrs. Hugo N. Dixon

Cogeval-Salomon VIII.5

---

*Provenance* Acquired from the artist by Bernheim-Jeune, Paris—Louis Bernard, Paris—Paul Gallimard, Paris, and Eugène Lami—Paul Cassirer, Berlin, 1929—Georges Lévy, Paris—Israel Collection, New York—Wildenstein, New York, 1955—Mr. and Mrs. Hugo Dixon, Memphis, 1955—Dixon Gift (with life interest retained) to the Memphis Park Commission for Memphis Brooks Museum of Art, 1955; on loan to the Dixon Gallery and Gardens, Memphis, Jan. 1976–Jan. 1977; Memphis Brooks Museum of Art, Memphis

*Exhibitions* Cleveland-New York, 1954, p. 102, col. ill. p. 80—New York, Wildenstein, 1964, no. 24, ill.

*Bibliography* Chastel 1953, col. ill. p. 28

## 256

LANDSCAPE AT ROMANEL · *Paysage à Romanel*

1900, oil on board, 36.9 × 35.8
Signed l.l.: *E Vuillard*
Richmond, Virginia, Virginia Museum of Fine Arts, Collection of Mr. and Mrs. Paul Mellon

Cogeval-Salomon VIII.3

---

*Provenance* Acquired from the artist by the Galerie Paul Vallotton, Lausanne—Paul Mellon, Upperville, Virginia—Virginia Museum of Fine Arts, Richmond

*Exhibitions* Basel, Kunsthalle, 1949, no. 5—Paris, MNAM, 1955, no. 40

## 257

THE BLUE HILLS · *Les Collines bleues*

1900, oil on board, 42.5 × 68
Signed and dated l.r.: *E Vuillard 1900*
Kunsthaus, Zurich, Inv. Nr. 1412

Cogeval-Salomon VIII.2

---

*Provenance* Druet, Paris—Bernheim-Jeune, Paris—Paul Vallotton, Lausanne—Dr. Hans Schuler—Schuler Bequest to the Kunsthaus, Zurich

*Exhibitions* Milan, Palazzo Reale, 1959, no. 43, ill.—Munich, Haus der Kunst, 1968, no. 64, ill.—Paris, Orangerie, 1968, no. 107, ill.—Lyon-Barcelona-Nantes, 1990–1991, no. 92, col. ill. p. 196—Zurich-Paris, 1993–1994, no. 181, col. ill.

## 258

LANDSCAPE AT ROMANEL · *Paysage à Romanel*

1900, graphite, coloured pencil and watercolour on paper, 8.5 × 11.8
Private collection

## 259

LANDSCAPE AT RHEINFELDEN · *Paysage à Rheinfelden*

1904, watercolour and graphite on paper, 17.1 × 10.3
Private collection

## 260

SWISS LANDSCAPE · *Paysage de Suisse*

c. 1904, watercolour and graphite on paper, 16.5 × 10.6
Private collection

---

In August and September 1900, Vuillard visited his friend Félix Vallotton, who had been staying for the summer and autumn at the Château de La Naz at Romanel, outside Lausanne. Invigorated by his sojourn in L'Étang-la-Ville the previous month, which had sparked a new awareness of the countryside and the potential of landscape, Vuillard created a group of landscapes, including the three paintings and the drawing shown here (cats. 255–258). It was during a second journey to Switzerland four years later that he created the two watercolours, *Landscape at Rheinfelden* and *Swiss Landscape* (cats. 259–260).

In all these landscapes, the artist, while maintaining a sense of naturalism, has simplified to some degree the constituent elements. In *The Blue Hills* (cat. 257), the recession into depth has been treated as a series of flat planes, each differentiated by a clear spatial demarcation and the relatively uniform application of varying shades of green, green-blue and blue, punctuated only by the presence of the red roofs in the middle plane. In *Landscape at Romanel* (cat. 256), whose highly schematized construction has prompted Cogeval to liken it to a stage set,[1] the simplification has been exaggerated to create a pattern of alternating green and beige horizontal zones. The same process of reduction is evident in *Swiss Landscape* (cat. 255), where the outlines of tree, branch and foliage establish a sequence of abstract patterns that brings the overall effect closer to the rigorous, almost poster-like outlines and flat colour infill of the two 1904 watercolours. This condensing of natural forms parallels similar developments in Félix Vallotton's approach to landscape around 1900. Having reconsidered the landscape compositions of the seventeenth-century master Nicolas Poussin, Vallotton aimed to use flat, simple colour and hard outline to create an idealized, composite record of specific landscapes, a "composed" landscape (e.g. *Clouds over Romanel*, 1900, Lausanne, Musée cantonal des Beaux-Arts). Another influence on Vuillard's development as a landscapist,

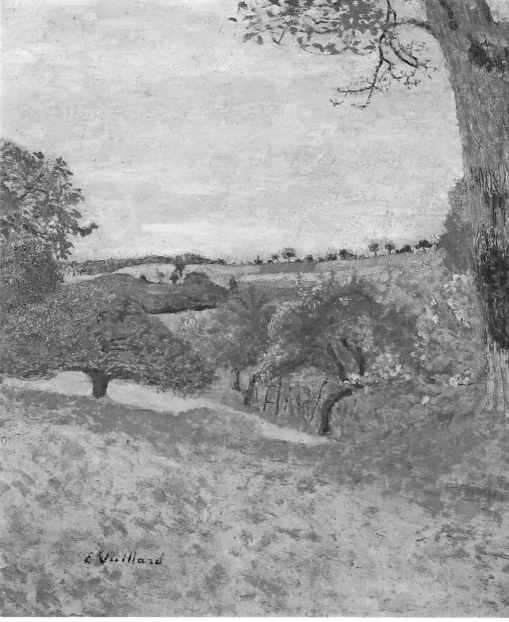

255

as Belinda Thomson has suggested, may well have been his recognition of the simplification of forms in Corot's Italian landscapes of 1825 –1828.[2] Vuillard had expressed admiration for the work of this precursor of Impressionism in journal entries for 1888 and 1890. He could have seen the major Corot retrospective exhibition shown in Paris in 1895 and may also have familiarized himself with the artist's work in Henri Rouart's important collection. In the particular case of *Landscape at Romanel* (cat. 256), the manipulation of space—the composition reads as a view from above Lake

Geneva, which is placed at the top rather than the bottom of the canvas—recalls the radical treatment of views of the same lake from Chexbres created by Ferdinand Hodler in the mid-1890s (such as *Genfersee von Chexbres*, c. 1900, Zurich, Kunsthaus). Yet for all their abstraction, these works are firmly rooted in observation. In the watercolour *Landscape at Romanel* (cat. 258), for example, Vuillard deftly captures a view of the surrounding countryside glimpsed from a terrace (complete

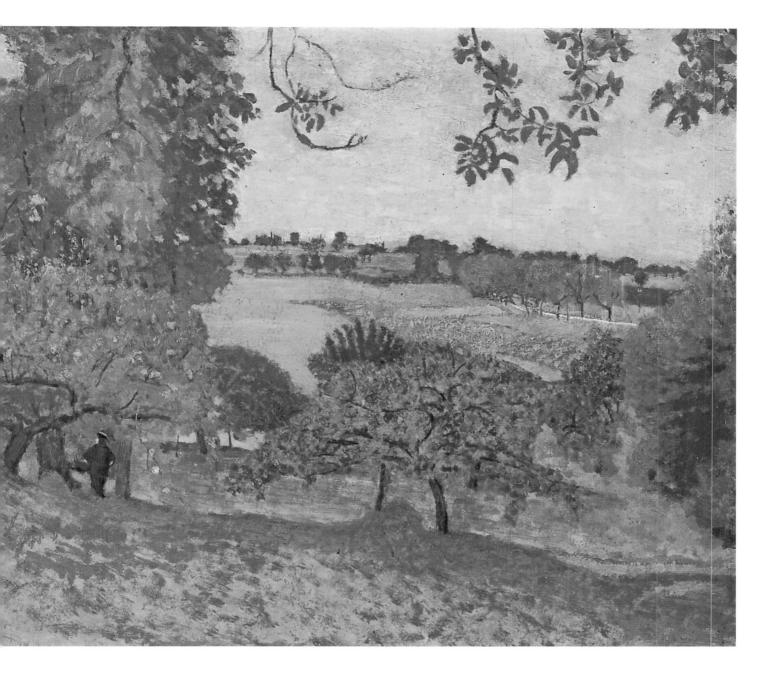

with the trappings of what is perhaps the art-ist's breakfast). The fluid lines of the artist's pencil and the simple washes of colour across the surface bespeak an image quickly drawn in situ. What is most striking, however, is its composition, which utilizes the same perspec-tive and the same reliance upon horizontal bands of colour stacked one upon the other to create an illusion of depth as found in the painting (cat. 256). That the watercolour may have been a forerunner of the painting is not at all unlikely. In addition, Vuillard also pro-duced a small, finely drawn sketch (priv. coll.)

in which he indicates not only the colours "green and blue-grey" but the presence of the cows in their pasture.[3] As in his interiors from around this time, observation remains the cornerstone of his method. MAS/KJ

---

1. Cogeval in C-S 2003, no. VIII.3.

2. Thomson 1991a, p. 77.

3. Cogeval in C-S 2003, no. VIII.3.

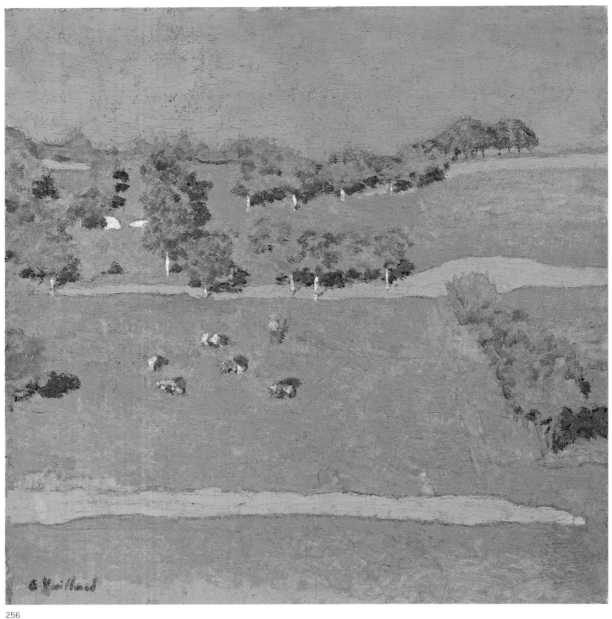

256

257

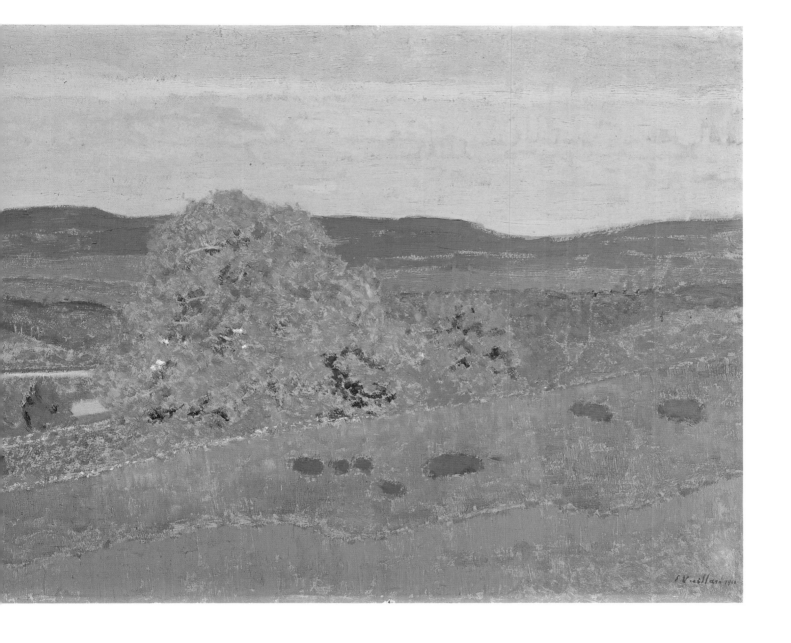

258

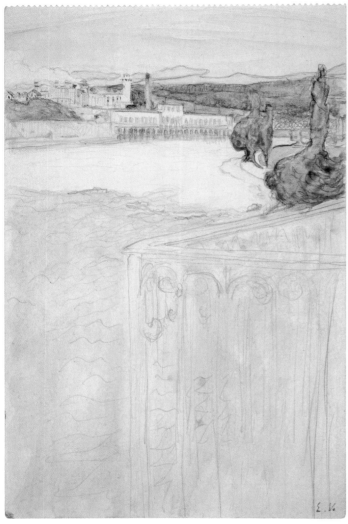

259

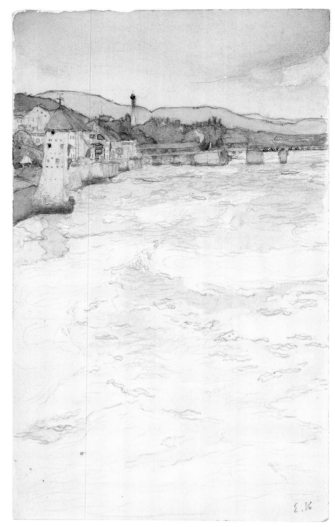

260

## 261

CANNES, GARDEN ON THE
MEDITERRANEAN · *Cannes, jardin
au bord de la Méditerranée*

1901, oil on board mounted on panel, 28 × 33.5
Signed l.r.: *E. Vuillard*
Pittsburgh, Pennsylvania, Carnegie Museum
of Art, purchased with funds contributed
through the generosity of Mrs. Alan M. Scaife
and Family, 1965

Cogeval-Salomon VIII.18

*Provenance* Ernest Coquelin Cadet, Paris,
1901—Gaston Bernheim de Villers, Paris—
Knoedler, New York—The Carnegie Institute
Museum of Art, Pittsburgh, Pennsylvania

*Exhibitions* Paris, Exposition universelle,
1901, no. 991 [*Dans le Midi*]—Paris, Musée
des Arts décoratifs, 1938, no. 78

*Bibliography* Chastel 1946, p. 30—Roger-
Marx 1946a, pp. 64, 158

## 262

THE BAY OF CANNES, SEEN FROM
THE TERRACE · *La Baie de Cannes, vue de
la terrasse*

1901, oil on board, 20 × 30
Signed l.r.: *E Vuillard*
Private collection, courtesy Galerie Bern-
heim-Jeune, Paris

Cogeval-Salomon VIII.23

*Provenance* Josse Bernheim, Paris—Private
collection, Paris

*Exhibitions* Paris, Musée des Arts décoratifs,
1938, no. 77

*Bibliography* Roger-Marx 1946a, pp. 64, 158

In 1900–1901 Vuillard wintered in Cannes
as the guest of Thadée and Misia Natanson.
Photographs taken by the artist record the
villa—La Croix des Gardes—its mistress
and guests, and its daily activities (see cats.
192–195).

The two paintings shown here represent views
from the villa, one across the luxuriant veg-
etation separating it from the Mediterranean
beyond, the other looking from the terrace
toward the town of Cannes and showing the
Tour du Mont Chevalier and the campanile
of Notre-Dame de l'Espérance (a view also
recorded in a postcard sent by Vuillard to his
mother on January 17, 1901).[1]

The selection of a domestic location as the
viewpoint from which to paint a landscape
was not unprecedented: Vuillard had already
utilized such a viewpoint in his two *Île-de-
France* panels of 1899 (see cat. 142), as well
as in other paintings such as *The Red Roof,
L'Étang-la-Ville* (1900, London, Tate,
C-S VII.91) and *Lake Geneva, Seen from a
Window* (1900, Zurich, Walter Feilchenfeldt,
C-S VIII.8). According to Thomson, "without
going so far as to define Vuillard as an arm-
chair landscapist," it is clear that in his approach
to landscape he was prepared neither to "battle
with the elements after the heroic example of
an artist like Monet" nor to stalk his motifs.[2]
On the contrary, he seemed to subject his
landscape motifs to the same process of famil-
iarization that he applied to his *intimiste*
compositions featuring family and friends.

The winter trip of 1900–1901 was Vuillard's
first visit to the South. At the time, the south
coast of France was regarded as a region
where visitors could experience the benefits of
a mild winter climate—particularly sufferers
from tuberculosis, whose favoured destination
was Menton, near the Italian border. It was
only after 1918 that the phenomenon of "sun
worship" transformed the Côte d'Azur into
a summer resort. Since it was his first experi-
ence of the region, it is hardly surprising that
Vuillard was affected by the particular quali-
ties of the southern winter light. Unlike its
summer counterpart, which bleaches colour
from the landscape, the winter light tends to
heighten local colour—as had been recog-
nized some two decades earlier by both Monet

and Renoir. Vuillard's response to this new
visual experience is evident both in his palette
and in his articulation of forms. Chromati-
cally, it can be seen in the rich blue of the sea
set against the pale terracotta of the terrace
tiles in *The Bay of Cannes* and in the intensity
of the green foliage in *Cannes: Garden on the
Mediterranean*. Formally, the sharpened con-
trasts between light and shade result in the
latter work in a simplified interlocking of the
façades of the villas on the right, and in the
former in the near abstraction of the bold,
wedge-shaped shadow cast by the balustrade
across the tiles. And as in the Romanel land-
scapes, executed the previous autumn (see
cats. 256–258, 260), the tendency toward
abstraction observable in these two Cannes
paintings may owe something to Corot's sim-
plification of forms in his Italian landscapes
from 1825–1828.

*Cannes: Garden on the Mediterranean* was
one of at least four landscapes among the nine
works Vuillard exhibited at the Salon des
Indépendants during April and May of 1901.
The novelty of Vuillard's presenting land-
scapes in a public exhibition was noted by
the critics—and provoked positive responses.
Thadée Natanson, writing in *La Revue blanche*,
referred to the Cannes landscape as "a de-
lightful rarity" and commented on the impor-
tance of the artist's works in the genre within
the context of his continued development:
"M. Vuillard does not cease to change and to
enchant…all his landscapes are perfumed
with the charm of an ingenious tenderness we
have not seen expressed before."[3] MAS

1. Identified by Cogeval in C-S 2003, no. VIII.23.

2. Thomson 1991a, p. 76.

3. Thadée Natanson, "Gazette d'art. Les Artistes indépendants.
XVIIe exposition," *La Revue blanche*, vol. 25, no. 190 (May 1,
1901), p. 54.

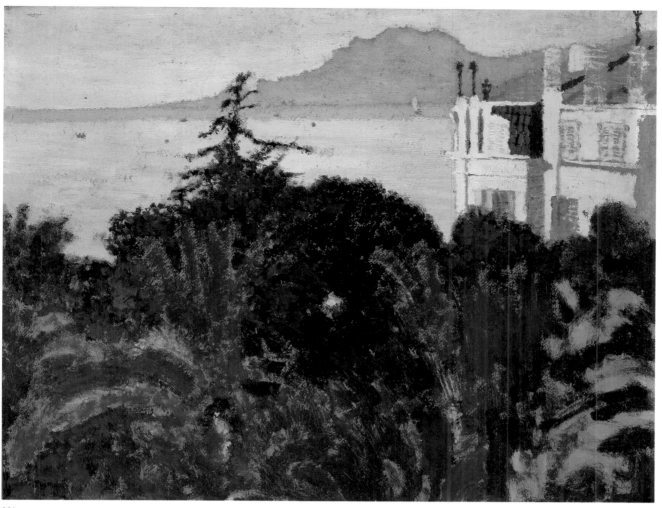

261

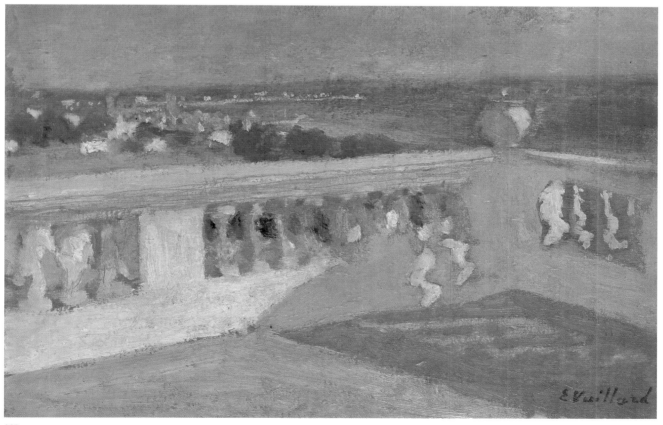

262

**Third Decorative Panel for Jean Schopfer ·**
*Troisième panneau décoratif pour Jean Schopfer* (263 – 264)

# 263

THE TERRACE AT VASOUY:
THE GARDEN · *La Terrasse à Vasouy.*
*Le Jardin*

1901, reworked in 1935–1936, distemper
on canvas, 218 × 182
Signed l.l.: *E. Vuillard*
London, Tate Gallery, Lent by the National
Gallery, acquired with assistance from
Grant-in-Aid and the Temple West Fund

Cogeval-Salomon VIII.37

*Provenance* Jean Schopfer, Paris; Clarisse
Langlois Schopfer, Paris, 1931—Raphaël
Gérard, Paris—Georges Renand, Paris—
Pierre Berès, Paris, 1961—Galerie Beyeler,
Basel—Major E. Allnatt, Great Britain, 1966
—On loan to the National Gallery, London,
1966–1970—Acquired by the National
Gallery, London, in 1970; on deposit at the
Tate Gallery

*Exhibitions* Paris, Musée des Arts décoratifs,
1938, no. 54a

*Bibliography* Segard 1914, pp. 279–282, 320
—Chastel 1946, p. 106—Roger-Marx 1946a,
pp. 137–138, ill. p. 145—Salomon 1953, pp. 32
–33, 84—Groom 1993, pp. 3, 108, 119, 124,
126, 150–151, 152, 159, figs. 177–178

# 264

THE TERRACE AT VASOUY:
LUNCHEON · *La Terrasse à Vasouy.*
*Le Déjeuner*

1901, reworked in 1935–1936, distemper
on canvas, 218 × 190
Signed l.r.: *E. Vuillard*
London, Tate Gallery, Lent by the National
Gallery, 1997, L01902

Cogeval-Salomon VIII.38

*Provenance* Jean Schopfer, Paris; Clarisse
Langlois Schopfer, Paris, 1931—Raphaël
Gérard, Paris—Alfred Daber, Paris—De
Hauke, Paris—National Gallery, London,
1966; on deposit at the Tate Gallery

*Exhibitions* Paris, Musée des Arts décoratifs,
1938, no. 54b

*Bibliography* Salomon 1945, p. 55, ill. p. 56—
Roger-Marx 1946b, ill. p. 373—Roger-Marx
1948b, pl. 28—Cogeval 1993 and 2002, col.
ill. p. 86—Groom 1993, pp. 3, 108, 119, 124,
126, 150–151, 152, 159, figs. 177–178

As Gloria Groom has shown, the history of
these two paintings is complex. They were
originally commissioned as a single decorative
panel in 1901 by Jean Schopfer, the dramatist
and critic who worked under the pseudonym
Claude Anet. The work was to join two other
decorative panels, *Woman Reading on a Bench*
and *Woman Seated in an Armchair* (see "Vuil-
lard and the 'Villégiature'," in the present
volume, figs. 2–3), commissioned by Schopfer
three years earlier. These panels had been
made at Les Relais, in Villeneuve-sur-Yonne,
the summer house of Thadée and Misia Nat-
anson. The setting for the later panel (cats.
263–264) has been correctly identified as the
terrace and garden of the villa rented by Lucy
and Jos Hessel at Vasouy, a small resort a few
kilometres southwest along the coast from
Honfleur, where Vuillard spent the summer
of 1901.

As a single panel, *The Terrace at Vasouy* was
completed and installed in Schopfer's Paris
apartment on Avenue Victor Hugo by De-
cember 18, 1901. Jean Schopfer's subsequent
divorce from his American-born wife Alice
Wetherbee Schopfer, which occurred in 1903,
precipitated a painful division of their estate;
the two 1898 panels went to her, and the
single 1901 panel remained with Schopfer,
who, when he had to leave the apartment,
asked Vuillard to store the work temporarily.
The single panel appears in photographs
(Salomon Archives)[1] taken prior to the work's
return to Schopfer's new apartment on Rue
Chaillot, sometime between 1908 and 1910.
After his marriage to Clarisse Langlois, it was
moved to the dining room of the couple's
ground-floor apartment on Rue du Bac, where
it was displayed alongside the plates Schopfer
had commissioned from Vuillard in 1895
(see cats. 131–136), three decorative panels by
Kerr-Xavier Roussel, and two works by Pierre

Bonnard (including his 1910 portrait of the
second Madame Schopfer). In about 1934, the
recently widowed Clarisse Langlois Schopfer
asked Vuillard to divide the original panel.
He worked on the project throughout 1935,
and eventually returned *The Terrace at Vasouy*
to her as two separate panels.[2]

There is evidence of Vuillard's growing dis-
satisfaction with the first version of the work.
Early in 1919 he made a couple of remarks
in his journal that reveal his disquiet. In one,
dated February 28, a comparison between the
panel and the works by Bonnard and Roussel
also hanging in the Schopfer dining room led
him to declare: "Good impression of Roussel's
paintings…poor effect of my painting before
the Bonnard portrait."[3] Seven years later he
appears to have been even less happy with the
work: "leave early for lunch at Claude Anet's;
my gloomy old panel."[4] It is hardly surpris-
ing, in light of these sentiments, that Vuillard
willingly acceded to the request to rework
the panel.

He cut the panel in two and, to assist in the
reworking, returned to the sketches, prelimi-
nary studies and photographs from which the
original panel had been created, recasting
some of the figures in both of the newly cre-
ated panels. In *The Garden* (cat. 263), deriv-
ing the image from earlier photographs,[5] he
inserted the figure of Lucy Hessel (wearing a
white dress) behind the nurse and the two
Schopfer children, Hélène and Anne, daugh-
ters of Louis (Jean's brother) and Jean res-
pectively. In *Luncheon* (cat. 264), reading
from left to right, he retained Bonnard, Alice
Schopfer, Jean Schopfer, Romain Coolus and
Misia Natanson, removed Léon and Lise Blum
(replacing them with Lucy Hessel), and left
Louis Schopfer, his wife "Bob" and Tristan
Bernard. The latter acquired a somewhat in-
sistent companion in the form of Basto, Lucy
Hessel's collie dog. The inclusion of Lucy
Hessel in both panels may be explained by
Vuillard's ongoing relationship with her and
by the fact that she had been mistress of the
villa at Vasouy that had served as the setting
for the original 1901 panel. No other changes
were made to the participants, despite the
passage of more than thirty years, apart from
the transformation of Alice Schopfer's radiant
expression into one tinged with wistfulness.

To reinforce the new compositions, Vuillard inserted a wedge of grey paint in the lower left- and right-hand corners of *Luncheon* and *The Garden* respectively—possibly a way of establishing a more trenchant division between the worlds of adults and children—and added elements to the still life on the table. Finally, possibly in an attempt to impose a new unity on the two separated parts, Vuillard applied large touches of rich blue paint to the tree trunk and plants in the foreground of *The Garden*, and to areas of the background foliage in *Luncheon*.

The relationship between *The Terrace at Vasouy* and its nineteenth-century precedents has been extensively discussed by Gloria Groom. She has also pointed out the disparity between it and a more contemporaneous treatment of a similar subject: Bonnard's *Bourgeois Afternoon* (1900, Paris, Musée d'Orsay), whose essentially critical, caricatural approach contrasts sharply with Vuillard's sympathetic representation of his immediate circle of close friends.[6] Direct prototypes for the subject of figures grouped around a dinner table laden with the usual paraphernalia of a meal can be found, on a smaller scale and set within intimate interiors, throughout Vuillard's own work of the previous decade (see cats. 78, 98). An exterior model is *People in a Garden, Romanel* (1900, Stuttgart, Staatsgalerie, c-s VIII.10), which Vuillard created in 1900 and which shows, seated at a table out-of-doors, such identifiable sitters as Félix Vallotton, his new wife Gabrielle, and Lucy Hessel.

The third Schopfer panel raises an issue that became increasingly significant in Vuillard's work after 1900: the nature of the tripartite relationship between genre, portraiture and decoration. The decorative panels of the mid-1890s—such as those made for Vaquez (cats. 137–140) and for Thadée Natanson (cats. 126–129), and the two Schopfer panels from 1898—integrate figures into their environments to create two-dimensional, decorative compositions. It was this figure-ground fusion that, even as late as 1900, critics like Louis Dausset found disturbing: "The figures are still to far too great a degree simply vague forms...The trouble is that the backgrounds, the incidental objects are infinitely more precise than the figures."[7] The figures in both versions of *The Terrace at Vasouy* are, by contrast, identifiable contemporary individuals, endowed with markedly enhanced volume. They are none-theless presented within a composition unified by foliage and by the application across the entire pictorial surface of a limited palette of greens, greys, beiges, blues, whites and reds. Still determined to maintain the commitment to recording contemporary life that had underpinned his *intimiste* works of the 1890s, Vuillard made a definite move toward greater realism in the representation of his subjects after 1900. This shift in his vision, combined with his new interest in portraiture—the physical description of an identifiable sitter—could have constituted a threat to the decorative objectives of the 1901 Schopfer panel but is tempered by Vuillard's creation of a pictorial unity that depends not only on the use of a consciously limited gamut of colours but also on the application of a network of small, uniform brushstrokes by which he built up the surface of the painting and described its forms. MAS/KJ

---

1. Reproduced in Groom 1993, pp. 109, 117.

2. Ibid., pp. 108–119; see also Cogeval in c-s 2003, nos. VIII.37 and 38.

3. Vuillard, *Journal*, III.4, fol. 39r.

4. Ibid., III.(S).E, fol.55v (August 26, 1926).

5. First brought to light by Cogeval in c-s 2003, no. VIII.37 and 38.

6. Groom 1993, pp. 112–113.

7. Louis Dausset, "Choses d'art," *Le Temps* (April 13, 1900).

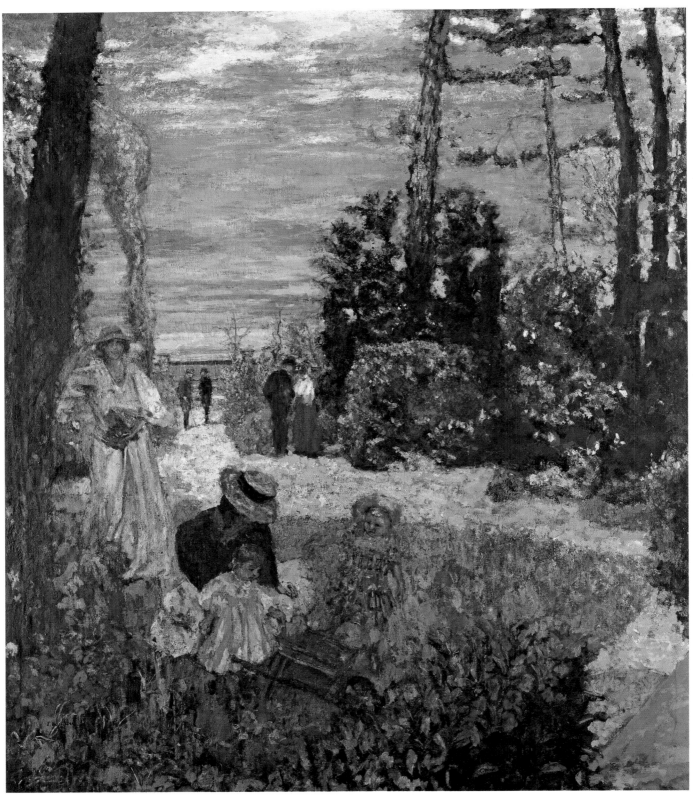

263

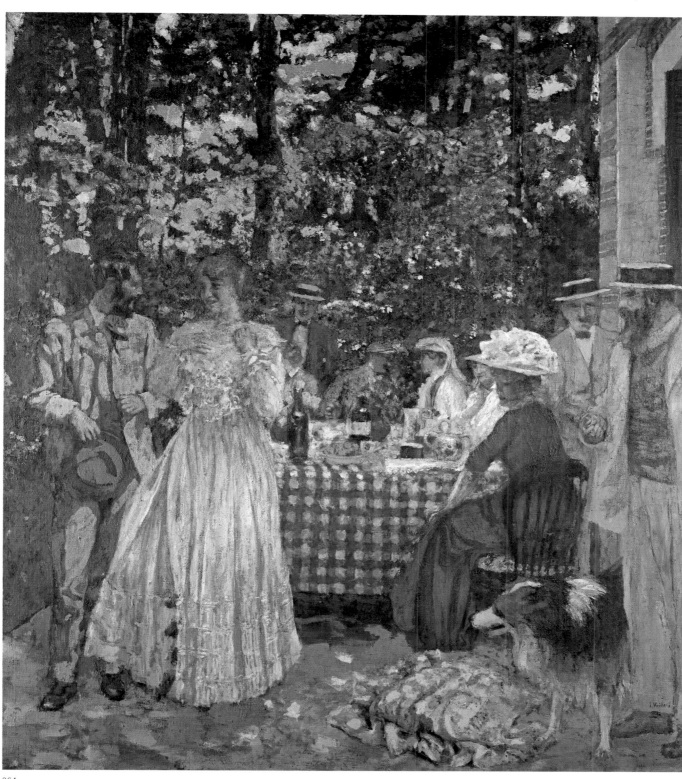

264

# 265

ANNETTE ON THE BEACH AT
VILLERVILLE · *Annette sur la plage de
Villerville*

1910, distemper on paper mounted
on canvas, 172 × 124
Private collection

Cogeval-Salomon VIII.393

————

*Provenance* Studio—Prince Antoine Bibesco,
c. 1940–1951—Private collection

*Exhibitions* Paris, Charpentier, 1948 (hors
cat.)—Cleveland-New York, 1954, p. 103—
Milan, Palazzo Reale, 1959, no. 73, ill.—Ham-
burg-Frankfurt-Zurich, 1964, no. 61, ill.—
Paris, Orangerie, 1968 (hors cat.)—Toronto-
San Francisco-Chicago, 1971-1972, no. XIV,
col. ill.—Florence, Palazzo Corsini, 1998, no.
126, col. ill. p. 164—Montreal, MMFA, 1998,
no. 186, col. ill. p. 88

*Bibliography* Salomon 1961, p. 107, col. ill.—
Cogeval 1993, pp. 96, 97, col. ill.—Cogeval
1998a, no. 126, p. 198, col. ill. p. 164—
Cogeval 1998b, no. 186, p. 122, col. ill. p. 88

————

This painting shows Annette, the daughter
of the Roussel ménage, at the age of eleven.
She is standing somewhat nonchalantly on
the beach below Criquebœuf, the small sea-
side resort some two kilometres northeast
of Villerville, in Normandy, where Lucy and
Jos Hessel had rented a villa, Les Pavillons,
for the summer of 1910.

The genesis of the work lay in a series of
summary sketches made on the beach in
August 1910, which served as the basis for the
"large sketch" that he undertook in his studio
at Les Pavillons: "met Annette on the beach.
Did quick sketches of rocks…went up to
the attic made large sketch that exhilarates
me."[1] Following a process of creation by this
time well established, Vuillard supported and
amplified these sketches with a sequence of
photographs picturing Annette on the beach
in more informal poses than the one ulti-
mately adopted for the painting.

The scale of the painting is ambitious: it is
neither a decorative panel nor a portrait in
which the sitter dominates the picture space.
As a depiction of a figure in its environment,
the work clearly relates to such portraits
as *Claude Bernheim de Villers* (cat. 298) and
*Henry and Marcel Kapferer* (cat. 305), but it
can also be linked to Vuillard's decorative
panels made after 1898, for which he moved
out of the claustrophobic Parisian interiors
into landscapes populated by figures. In
these works, as here, the figures take on a new
gravitas and a greater articulation of form,
yet still "belong" within the landscape set-
ting—as was pointed out as early as 1904 by
André Fontainas: "The human figure, sur-
rounded by familiar things, is no longer the
centre. It is the environment in which it is usu-
ally situated that is depicted, and to the figure
itself are given the place and the importance
it demands."[2] In the work shown here, that
environment—beach, sea and sky—is con-
veyed through subtly graduated shades of
blue, white and sand, their key echoed in the
colours of Annette's figure. There is no
attempt to translate light into the colours of
the spectrum, according to either Impression-
ist or Neo-Impressionist principles. This
disregard for both systems freed Vuillard to
record this beach scene (one more embodi-
ment of contemporary life) using a chromatic
system that involved the juxtaposition of two
colours of close tonal value, rather than two
contrasting colours, to convey the iridescent
light filling the sky and bouncing off the
damp sand and the water beyond.

*Annette on the Beach at Villerville* was never
sold during Vuillard's lifetime. One of a
sequence of images that recorded his niece
from infancy to adulthood, it served as a
repository of precious memories. MAS

————

1. Vuillard, *Journal*, II.4, fol. 35v (August 7, 1910).

2. André Fontainas, "Le Salon d'Automne (troisième article),"
*L'Art Moderne*, no. 45 (November 6, 1904), pp. 359–360.

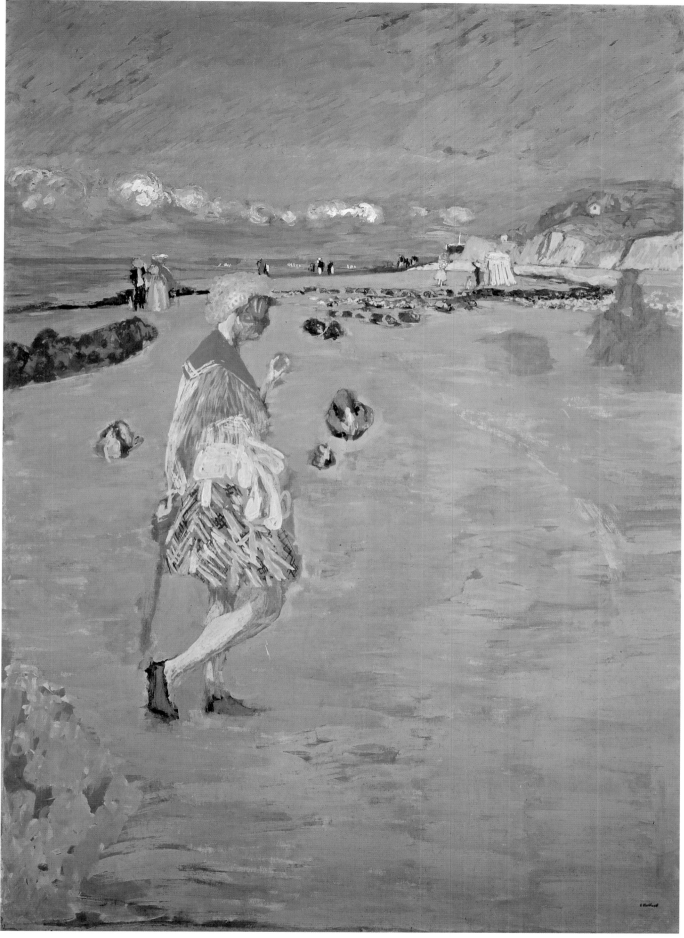

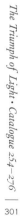

265

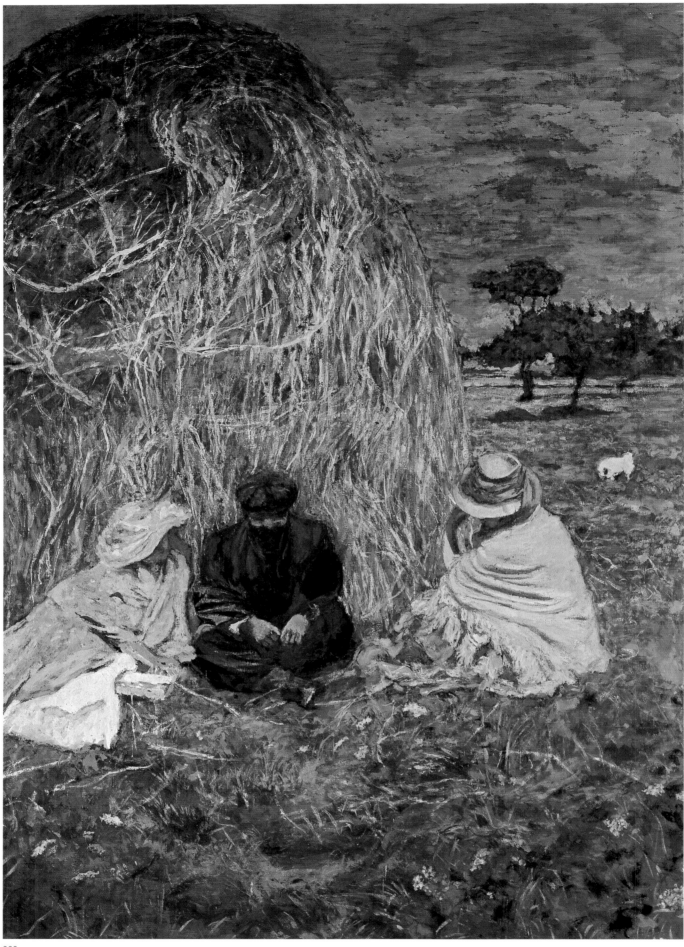

PANEL FOR PRINCE EMMANUEL
BIBESCO: THE HAYSTACK · *Panneau
pour le prince Emmanuel Bibesco, La Meule*

1907–1908, reworked in 1938, distemper on
canvas, 230 × 164
Musée des Beaux-Arts, Dijon, Inv. 3813

Cogeval-Salomon VIII.226-2

*Provenance*  Commissioned from the artist
by Prince Emmanuel Bibesco, Paris, Nov.
[1907 ?]—Édouard Vuillard, Paris, 1918;
M. and Mme K.-X. Roussel, 1940—Gift to
the French nation, 1941; Musée des Beaux-
Arts de Dijon, 1949

*Exhibitions*  Paris, Bernheim-Jeune, Feb. 1908,
no. 2—Paris, Musée des Arts décoratifs, 1938,
nos. 74a–b—Lyon-Barcelona-Nantes, 1990–
1991, p. 87, no. 117, col. ill. p. 88

*Bibliography*  Segard 1914, pp. 286, 321—
Dorival 1943, p. 159—Salomon 1945, p. 71—
Chastel 1946, pp. 90, 106—Roger-Marx
1946a, pp. 139–140, ill. p. 147—Thomson
1988, pp. 97, 108, 110, col. pl. 79—Cogeval
1993 and 2002, pp. 79 (2002), 93—Groom
1993, pp. 148, 152–159, 162–164, 170, 172,
185, 189, col. fig. 243, fig. 244

This work, together with *The Alley* (1907–
1908, Paris, Musée d'Orsay, c-s VIII.226-1)
and *The Lilacs* (1899–1900, priv. coll.,
c-s VI.102), was first shown at Vuillard's one-
man exhibition at the Galerie Bernheim-Jeune
in February 1908 under the collective heading
"decorative panels" (nos. 1–3). In fact, the
works never constituted a unified three-panel
decorative scheme resulting from a single
commission. *The Haystack* and *The Alley* had
been commissioned in November 1907 by
Emmanuel and Antoine Bibesco to complete a
group of five decorative panels; two of these
were the 1898 Jean Schopfer panels, which the
Bibescos had acquired from Louise Wetherbee
Schopfer sometime between 1903 and 1906,
and the third was *The Lilacs*, which they had
bought from Vuillard shortly after its comple-
tion in 1900 and which Vuillard retouched at
their request in 1908 in order to integrate it
more fully with the two new panels.[1]

*The Haystack* and *The Alley* were Vuillard's
first commission for large-scale decorative
panels since his completion of the third Schop-
fer panel, *The Terrace at Vasouy* (cats. 263–
264), in 1901. The subject of both panels

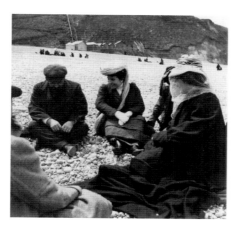

1. Photograph by Vuillard of Tristan Bernard and, on the right,
Lucy Hessel, Normandy, 1907, private collection.

was drawn from Vuillard's *villégiatures* be-
tween 1905 and 1907 at the Château-Rouge, in
Amfreville, the summer retreat of Lucy
and Jos Hessel (see cats. 212–219). Both cele-
brate Lucy Hessel as muse and companion—
alone, in *The Alley*, and, in *The Haystack*, with
Tristan Bernard (seated Buddha-like in the
centre) and his future wife Marcelle Aron,
Lucy Hessel's cousin (seated on the left). The
making of the two panels is exceptionally
well-documented, both in Vuillard's journal,
which he resumed in March 1907 after an
eleven-year gap, and in a series of extensive
preliminary studies in pencil, chalk and pastel,
together with, in the case of *The Alley*, a fully
worked representation of the avenue that
forms the backdrop to the figure of Lucy Hes-
sel (1907–1908, distemper on paper, Paris,
Musée d'Orsay, c-s VIII.195). Most important,
however, was Vuillard's explicit dependence
upon photographs for establishing both the
compositional structure of each panel and the
poses of the figures. While a single photo-
graph taken by Vuillard provides the visual
source material for *The Alley* (1907, Paris,
Bibliothèque de l'Institut de France), in the
case of *The Haystack* Vuillard merged two
photographs taken on different occasions and
in different locations. A photograph taken in
the fields near Amfreville in 1907 establishes
the form and position of the haystack and
of Lucy and Marcelle Aron (see cat. 222). A
group photograph taken on the beach in the
summer of 1907 (fig. 1) provides the pose for
Tristan Bernard, who was inserted, collage-
like, between the two women in the finished
panel. It has been suggested that his pose may
be a meditative one, like the figure of Her-
cules at the crossroads, caught between Virtue

(Lucy) and Vice (Marcelle).[2] The work itself
was created with broad, fluent brushwork,
possibly newly liberated by Vuillard's recent
adoption of distemper for landscape paintings.
The subject matter of both the panels may
reflect the influence of the work of an older
modern master, Claude Monet, to which Vuil-
lard was to return in late 1909 in relation to
his Place Vintimille paintings (see cats. 269–
272). The haystack articulated by the play of
sunlight recalls the "Grainstack" series that
Monet had exhibited in 1891, while *The Alley*
seems to demonstrate a familiarity with the
sun-dappled path captured in Monet's views
of the main garden at Giverny, executed in
the early years of the new century.[3]

Vuillard received the commission for the two
panels from the wealthy Romanian princes,
Emmanuel and Antoine Bibesco, on Novem-
ber 5, 1907.[4] He had been introduced to the
princes in 1895 at the inauguration of his nine-
panel decorative scheme, *The Public Gardens*
(cats. 111–118), in the home of Alexandre
and Olga Natanson. The Bibescos were famil-
iars of the *Revue blanche* circle, and their
interests encompassed the avant-garde theatre,
literature and visual arts of Paris. They
became patrons of, among others, Aristide
Maillol, Pierre Bonnard and Vuillard, travel-
ling with the latter two to Spain and Portugal
in February 1901. According to Vuillard's
journal, his enthusiasm about embarking upon
a new decorative scheme ensured that pro-
gress was swift. *The Alley* was completed by
January 14, 1908, and *The Haystack* in early
February. Vuillard received the final pay-
ment from Emmanuel Bibesco on Febru-
ary 6, 1908.[5] Following their exhibition at
the Galerie Bernheim-Jeune, the panels were
initially installed at the brothers' home in
Rue Commandant-Marchand before being
removed to their newly-constructed *hôtel
particulier* in Rue Vineuse in 1914. After
Emmanuel's suicide in 1917 and Antoine's
move to a seventeenth-century property on
Île Saint-Louis two years later, *The Haystack*
and *The Alley* were both returned to Vuillard.
Already uneasy with the two panels as early
as 1912,[6] Vuillard expressed profound dis-
satisfaction with them immediately after their
return to his studio: "Studio bring out old
Bibesco panels, awful; some lucidity at first,
then collapse."[7] He eventually reworked the
panels in March and April of 1938, in pre-
paration for their inclusion in his major retro-
spective exhibition at the Musée des Arts
décoratifs from May to July.

Vuillard's growing dissatisfaction with *The Haystack* and *The Alley*—in which he was not alone—may have stemmed from an awareness of the inherent conflict between the decorative function of the paintings and the shift toward greater naturalism apparent in his work after 1900. Although a number of his earlier decorations combined elements of genre, portraiture and landscape, most notably the Schopfer panels of 1898 and *Promenade in the Vineyard* (cat. 151), realism was firmly subordinated to the decorative impulse. Not so in this painting, in which Vuillard seems to have been unwilling—or unable—to subdue the realist element beneath tonal veils of repeated colour. He had apparently forgotten his own observations made in 1894, while planning the *The Public Gardens*: "Really, for apartment decoration a subject that is objectively too exact would easily become intolerable...The imagination always generalizes."[8] The less than felicitous result was remarked upon in 1908 by a number of critics. Some simply saw the panels as indicative of a change in Vuillard's style. Charles Morice, however, felt obliged to analyze them within the context of a wider discussion of the state of contemporary decorative art, in which, he felt, *intimiste* subjects—the product of the "illustrator of life"—could play no role: "In larger-scale works, I think it is our right to demand that the painter make an attempt at spiritual or emotional transposition, the pushing of the plastic aspects toward an ideal of simplification, required most compellingly by the use of the human figure. *The Alley*, *The Haystack*, *The Lilacs* do not satisfy this requirement, this need, at all, and this is no doubt why these three panels...create more of an impression of exaggerated easel paintings than decorative compositions."[9]
MAS/KJ

1. Bareau 1986, pp. 41–42.

2. See Cogeval in c-s 2003, nos. VIII.226-1 and 2.

3. See Groom 1993, p. 157.

4. Vuillard, *Journal*, II.1, fol. 4r.

5. Ibid., II.1, fol. 25v.

6. Ibid., II.6, fol. 40r.

7. Ibid., III.5, fol. 13r.

8. Ibid., I.2, fol. 47v (August 2, 1894).

9. Charles Morice, "Art Moderne : Exposition Vuillard (chez Bernheim-Jeune, 15 rue Richepanse)," *Mercure de France*, vol. 72, no. 258 (March 16, 1908), p. 358.

## 267

TWILIGHT AT LE POULIGUEN ·
*Le Crépuscule au Pouliguen*

1908, distemper on paper mounted on canvas, 78 × 148
Private collection

Cogeval-Salomon VIII.245

*Provenance* Studio—Private collection

## 268

LANDSCAPE AT SAINT-JACUT ·
*Paysage à Saint-Jacut*

1909, distemper on paper mounted on canvas, 86.5 × 194
London, Neffe Degandt Fine Arts

Cogeval-Salomon VIII.320

*Provenance* Studio—Private collection—Neffe Degandt Fine Arts, London

*Exhibitions* Glasgow-Sheffield-Amsterdam, 1991–1992, no. 76, col. ill. p. 85

Vuillard spent the summer of 1908 in Brittany, staying as a guest of the Hessels at Le Pouliguen, on the south coast near La Baule. He visited them again the following summer, at Saint-Jacut de la Mer, on the north coast. Brittany afforded Vuillard the opportunity to address new themes encompassed by the landscape genre: seascapes and coastal views, such as the two works shown here, and views of fishing boats and port scenes, such as *Promenade at the Port, Le Pouliguen* (see "Vuillard and the 'Villégiature'," in the present volume, fig. 8). He exhibited nine Breton works at the Galerie Bernheim in November 1908, and a large number of landscapes and coastal scenes, "works of the past season,"[1] at the same gallery almost precisely a year later.

*Twilight at Le Pouliguen* was probably made toward the end of August 1908, since Vuillard notes in his journal for August 25 that he had created a "large sketch with figures."[2] It shows four of his friends, Lucy and Jos Hessel and two others (possibly Tristan Bernard and Marthe Mellot), seated in front of a parapet that may have been the wall surrounding the Villa Kerr-Panurge.[3] *Landscape at Saint-Jacut* dates from the following summer, when

the Hessels rented two villas on the northern coast. This panorama, which shows an inlet of the sea, a village of slate-roofed houses and a stretch of surrounding countryside, is typical of the views of coast and country that both villas afforded their visitors. Vuillard certainly explored the full range of possible motifs, developing an extensive repertoire of scenes that he executed in oil, pastel and sometimes—as in the two works seen here—*peinture à la colle*, or distemper.

Vuillard had already made use of distemper for his decorative panels of the 1890s (see cats. 111–118, 137–140), and he appears to have adopted the technique for smaller-scale works in 1907 (see, for example, *Portait of Thadée Natanson*, 1906, Paris, Musée d'Orsay, Paris, c-s VII.404). Although it is almost impossible to use this complicated technique out-of-doors (see "The Decorative Impulse," in the present volume), Vuillard adopted it to transform sketches into more ambitiously scaled works, such as these two landscapes and the equally bold *Breakfast at Saint-Jacut* (1909, priv. coll., c-s VIII.276). As is evident in both the Pouliguen and the Saint-Jacut works, the technique demanded that the colours be laid on quite quickly, with broad sweeps of the brush; the overall matte effect was achieved through the absorbency of the paper, which was used as the primary support and subsequently mounted on canvas or panel.

When Vuillard exhibited his works from the 1909 summer in Brittany at the Bernheim gallery, critics noted with approval the deceptively "unpolished" look of those created in *peinture à la colle*: "There is nothing on view but delicate pastels, which are nonetheless powerful, and paintings in distemper, which possess at once the tonal freshness of watercolour and the velvetiness of pastel."[4] But the simplification of form resulting from the speed of execution required by the technique also provoked further considerations about the relationship between naturalism and nonnaturalism in Vuillard's work. Thiébault-Sisson, in *Le Temps*, asserted that nature could be interpreted either analytically or synthetically. While the analytical approach lay at the basis of all artistic procedures and merely involved "sustained and patient observation,"

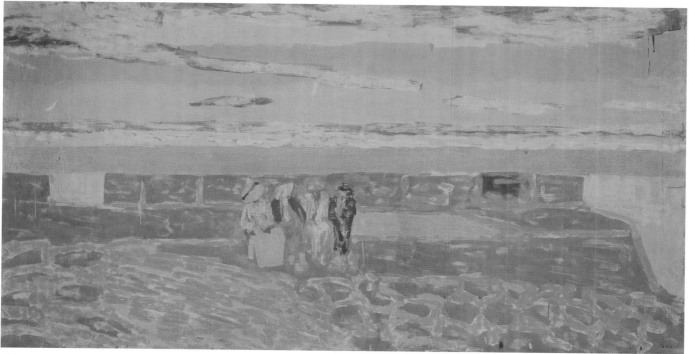

267

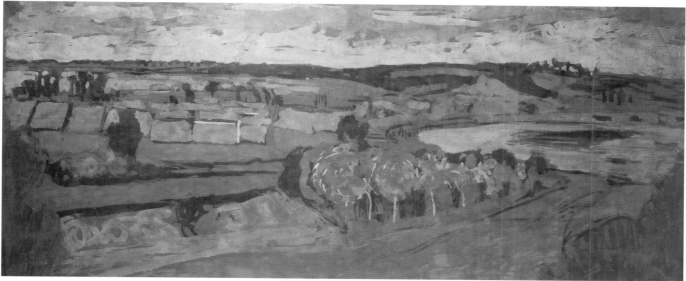

268

with no discrimination between details and generalities, the synthetic approach selected the dominant effect, transmitting this to the spectator through the artist's personal interpretation of a given motif. It is the latter procedure that Vuillard followed, conveying the synthesis of his motifs through the effects of light and colour "with a smoothness and refinement" that "enchanted."[5] J.-F. Schnerb pursued this line of discussion further, recognizing the novelty of the technique and its aesthetic effects: "M. Vuillard's new works are quite large distempers executed with a rapidity

that is not carelessness, and with a singular understanding of the medium's potential." He then focused on the relationship between the technique used to describe the "summer landscapes, beaches, interiors" that Vuillard was showing at Bernheim and his earlier large-scale decorations, where naturalistic detail had been subsumed by the decorative imperative. Vuillard's transcription of nature, Schnerb concluded, inevitably involved creating an allusion to—rather than producing a direct transcription of—reality. His process was thus the visual equivalent of the poet Stéphane Mallarmé's allusive procedures:

The motifs are simply pretexts for more delicate arrangements, where the elements taken from life have no other reason for figuring in the panel than to decorate it. M. Vuillard, however, in thus submitting forms to his decorative vision, respects and admires them sufficiently, and his earlier studies have endowed him with sufficient expressive skill, for us to sense that in these light impressions precision has been deliberately attenuated. 'I have never proceeded except by allusion,' said Mallarmé.[6]

This connection between Vuillard's approach to natural motifs and literary Symbolism, resonant in both the works shown here, recalls that the roots of the Nabi aesthetic lay in the pictorial Symbolism forged by Paul Gauguin and Émile Bernard in Brittany between 1886 and 1889. While the simplification in *Land-scape at Saint-Jacut* evokes the overt outlines and flat colour that were the hallmarks of pictorial Symbolism, Vuillard eschews its insistent blue or black outlines and non-naturalist colours, creating formal separations through the divisions established automatically when different-coloured areas of his medium are juxtaposed, and adopting a tonal range of greens, greys and buffs suggested naturally by the motif itself. Yet even as these paintings evoke the work of Gauguin and Bernard as well as Vuillard's own experiments in synthetism of the early 1890s, they also look forward to the vibrant canvases of Sam Francis as well as the highly abstract and lushly coloured paintings that Bonnard was to undertake at Le Cannet thirty years later.[7] MAS/KJ

---

1. A. Alexandre, "La Vie artistique : Petites Expositions," *Le Figaro* (November 5, 1909).

2. Vuillard, *Journal*, II.1, fol. 62r (August 25, 1908).

3. Cogeval in C-S 2003, no. VIII.245.

4. Thiébault-Sisson, "Choses d'art," *Le Temps* (November 10, 1909).

5. Ibid.

6. J.-F. Schnerb, "Petites Expositions : Exposition Vuillard (Galerie Bernheim)," *La Chronique des arts et de la curiosité*, no. 35 (November 30, 1909), p. 281.

7. Cogeval in C-S 2003, no. VIII.245.

## 269

STUDY FOR "PLACE VINTIMILLE" · *Étude pour "La Place Vintimille"*

1910, distemper on paper mounted on canvas, 196 × 69
Bremen / Berlin, Kunsthandel Wolfgang Werner, and Munich, Kunsthandel Sabine Helms

Cogeval-Salomon VII.514-8

---

*Provenance* Studio—Private collection—Kunsthandel Wolfgang Werner, Bremen / Berlin, and Kunsthandel Sabine Helms, Munich

*Exhibitions* Paris, Charpentier, 1948, no. 61—Milan, Palazzo Reale, 1959, no. 69, ill.—Hamburg-Frankfurt-Zurich, 1964, no. 90, col. ill.—Munich, Haus der Kunst, 1968, no. 147, ill.—Paris, Orangerie, 1968, no. 138, ill.—Toronto-San Francisco-Chicago, 1971–1972, no. 68, ill.—Lyon-Barcelona-Nantes, 1990–1991, no. 120, col. ill. p. 44—Chicago, Art Institute, 2001, no. 77, col. ill. p. 234

*Bibliography* Chastel 1990, p. 42, ill. p. 44—Groom 2001, pp. 233–237, col. ill. p. 234

## 270

STUDY FOR "PLACE VINTIMILLE" · *Étude pour "La Place Vintimille"*

1910, distemper on paper mounted on canvas, 196 × 69
Bremen / Berlin, Kunsthandel Wolfgang Werner, and Munich, Kunsthandel Sabine Helms

Cogeval-Salomon VII.514-7

---

*Provenance* Studio—Private collection—Kunsthandel Wolfgang Werner, Bremen / Berlin, and Kunsthandel Sabine Helms, Munich

*Exhibitions* Paris, Charpentier, 1948, no. 60—Milan, Palazzo Reale, 1959, no. 68, ill.—Hamburg-Frankfurt-Zurich, 1964, no. 89, col. ill.—Munich, Haus der Kunst, 1968, no. 146, ill.—Paris, Orangerie, 1968, no. 137, ill.—Toronto-San Francisco-Chicago, 1971–1972, no. 67, ill.—Lyon-Barcelona-Nantes, 1990–1991, no. 120, col. ill. p. 44—Chicago, Art Institute, 2001, no. 76, col. ill. p. 234

*Bibliography* Chastel 1990, p. 42, ill. p. 44—Groom 2001, pp. 233–237, col. ill. p. 234

The works shown here offer views from a window of Vuillard's home at 26, rue de Calais. Early in 1908 he had moved with his mother from 123, rue de la Tour, in Passy, where he had been resident since 1904, to this address near Place Clichy in the more modest Batignolles district. He was to remain at 26, rue de Calais for nearly twenty years, living initially on the fourth floor and then, in October 1913, moving to the second floor, before eventually being forced to relocate in 1927 to 6, place Vintimille when the Rue de Calais property was demolished.

The two works are full-size sketches in distemper for two (figs. 1–2) of the four panels Vuillard completed in 1910 for Henry Bernstein, the author of such theatrical successes as *La Griffe* (1906), *La Lutte* (1908), and *L'Israël*, (1908)—a *succès de scandale*. At the close of Vuillard's exhibition at the Bernheim-Jeune gallery in November 1908, Henry Bernstein had acquired four panels by him depicting the streets of the Passy district of Paris.[1] The following year Bernstein commissioned four more panels; three were high-angle views of Place Vintimille and the remaining one a precipitous view along Rue de Vintimille (priv. coll., C-S VII.516-1 to 4). The two studies shown here look down onto Place Vintimille (now Place Adolphe-Max) from the fourth-floor window of Vuillard's apartment, one indicating Rue de Bruxelles (cat. 269) and the other Rue de Douai (cat. 270). Although they broadly map in the salient features of the finished panels, they exclude the details of people and animals that animate the final versions. Almost certainly created during the winter of 1909–1910 (to judge from the denuded trees and leaden skies in the right-hand panel), the two sketches, like the finished works, intentionally record a variety of weather conditions. The right-hand panel (cat. 270) represents Place Vintimille under rain, and the left-hand one (cat. 269) suggests a moment after the sun has broken through clouds to catch the façades of the houses on the far side of the square. The remaining *Place Vintimille* panel (priv. coll., C-S VII.516-2) captures the scene under an overcast sky. It is known that Vuillard and Bonnard visited Claude Monet at Giverny in December 1909, and it appears that Vuillard decided to explore in a current work the principles behind the older master's series paintings—a central motif seen under changing conditions of weather and light—many examples of which he could have seen assembled at Giverny.[2] In fact,

269

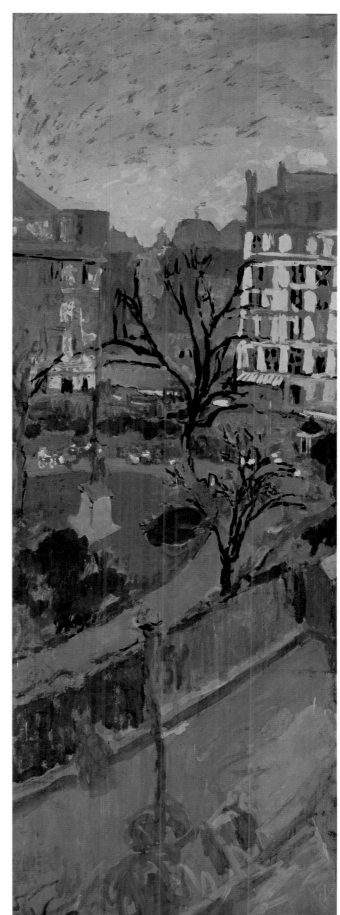

270

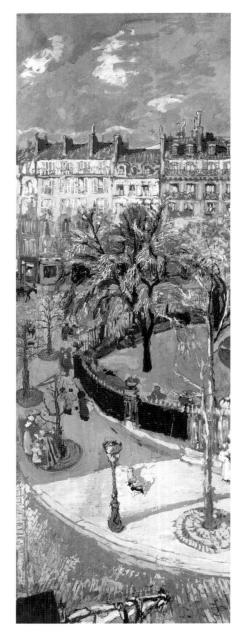

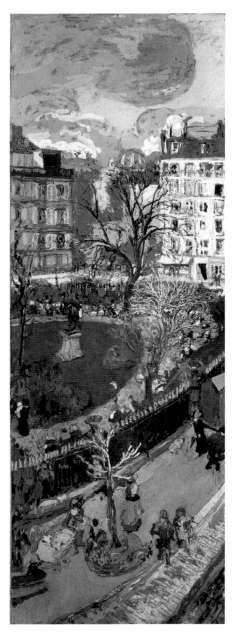

panels, in terms both of the atmospheric effects represented and the slightly differing viewpoints, that undermines any attempt to read them as a unified whole. As Cogeval has noted, the four panels were intended to function as pairs, in much the same way as the original four Bernstein panels. Vuillard, who was well aware of the manner in which Bernstein had installed the earlier panels, using them to decorate two pairs of doors, would have kept their likely disposition in mind and designed them accordingly. His journal entry for November 15, 1909 offers evidence of this: "go to lunch at Bernstein's 1.15. Measure the panels. Quite pleasant chat about painting."[5] Cogeval's suggestion that the two Guggenheim panels were probably hung on a pair of doors separated by a narrowish space seems logical and is supported by Roger-Marx, who described them as "one picture cut into two leaves."[6] The creative process that resulted in the Place Vintimille group was long-drawn-out and painful, but the four panels were finally delivered in March 1910 to Henry Bernstein's bachelor apartment at 157, boulevard Haussmann, where they joined the four he had purchased in 1908 and became part of a décor described as "in good taste, beige silk on the walls, thick curtains, English furniture of Chinese lacquer, Cormandel screens…"[7]

The Bernstein commission generated a number of subsequent works, all decorative in intent. These included *Place Vintimille: Five-panel Screen for Miss Marguerite Chapin* (cat. 271), *Berlioz Square* (see cat. 272) and a set of four panels commissioned in 1917 by Georges Bernheim (Paris, priv. coll., c-s VII.515-1 to 4). MAS/KJ

1. Édouard Vuillard, *Place Vintimille* (left panel), 1908, distemper on board mounted on canvas, New York, Solomon R. Guggenheim Museum, Thannhauser Collection, gift of Justin K. Thannhauser, 1978.

2. Édouard Vuillard, *Place Vintimille* (right panel), 1908, distemper on board mounted on canvas, New York, Solomon R. Guggenheim Museum, Thannhauser Collection, gift of Justin K. Thannhauser, 1978.

1. These works, painted between May and July 1908 while Vuillard was still residing on Rue de la Tour, drew their material from the wealthy milieu of Passy. The *Paris Streets* series consists of *The Water Cart, Child Playing in the Gutter, The Eiffel Tower* and *The Street* (c-s VII.515-1 to 4).

2. Groom 2001, p. 235.

3. Vuillard, *Journal*, II.3, fol. 47r.

4. Cogeval in c-s 2003, no. VII.514.

5. Vuillard, *Journal*, II.3, fol. 42r.

6. Cogeval in c-s 2003, no. VII.514; Roger-Marx 1946a, p. 156.

7. Georges Bernstein Gruber and Gilbert Maurin, *Bernstein le Magnifique : cinquante ans de théâtre, de passions et de vie parisienne* (Paris: J. C. Lattés, 1988), p. 158; quoted in Groom 1993, p. 176.

Vuillard wrote in his journal on December 5: "Plans for the Bernstein panels. Memories of Monet general ideas . . ."[3] Monet, however was not Vuillard's only source of inspiration. As Cogeval notes, the artist was also thinking of Japanese prints, especially those of Hiroshige and Hokusai.[4] Their influence is certainly apparent in the bird's-eye perspective, radically cropped forms and sharply tilted planes.

The Bernstein commission—as was becoming typical—was preceded by a number of preliminary works. These included drawings, a sequence of photographs, full-size pastels of the three Place Vintimille views (Dallas, priv. coll., c-s VII.514-5, 7, 8), a large distemper sketch of the Rue de Calais view and these two full-size distemper sketches (no such sketch appears to have existed, or to have survived, for the third view of the square). Although it is tempting to view the three Place Vintimille panels as a form of triptych, they were never intended as such. There is a distinct lack of harmony among the three

FIVE-PANEL SCREEN FOR MISS
MARGUERITE CHAPIN: PLACE
VINTIMILLE · *Paravent à cinq feuilles
pour Miss Marguerite Chapin : La Place
Vintimille*

1911, distemper on paper mounted on canvas,
230 × 60 (each panel)
Signed in 1933, on the far-right panel, l.r.:
*E Vuillard*
Washington, National Gallery of Art,
Gift of Enid A. Haupt, 1998.47.1

Cogeval-Salomon IX.165

*Provenance* Commissioned from the artist by
Marguerite Chapin, Paris, May 1911—Albert
Sancholle Henraux, Paris—Wildenstein,
New York—Enid A. Haupt, New York—
National Gallery of Art, Washington, 1998

*Exhibitions* Paris, Bernheim-Jeune, 1912,
no. 29 [*Le Square, paravent*]—Paris, Musée
des Arts décoratifs, 1938, no. 135—Chicago-
New York, 2001, no. 80, col. ill. p. 238

*Bibliography* Segard 1914, p. 321—Salomon
1945, pp. 57, 108—Roger-Marx 1946a, pp. 68,
121, 140, 155, 188—Chastel 1946, p. 90—
Thomson 1988, pp. 93, 104, 114, col. pl. 71—
Groom 1993, pp. 177, 179, 196–197, 201, 206,
col. fig. 282—Groom 2001, pp. 237–239, col.
ill. p. 238

The *Screen for Miss Marguerite Chapin* is per-
haps Vuillard's most breathtaking depiction
of Place Vintimille. Commissioned from the
artist in early May 1911, it was completed by
the end of the following month. Although
using the same viewpoint as the three *Place
Vintimille* panels of the Bernstein group, it
adopts a tighter angle of vision, thus eliminat-
ing, laterally, the neighbouring streets, and,
vertically, virtually all reference to the range
of houses on the far side of the square. In
further contrast, it represents a sunlit day in
the blossoming of early summer. This has
allowed the artist to use the rich foliage of the
trees in the square to weave a tapestry of var-

1. Photograph by Vuillard of Place Vintimille, viewed from the
fourth floor of the Rue de Calais, 1910, private collection.

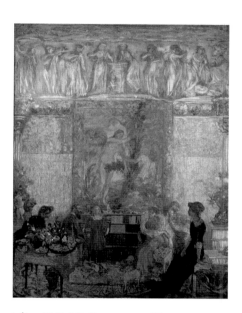

2. Édouard Vuillard, *The Library*, 1910–1911, distemper on canvas,
Paris, Musée d'Orsay, C-S IX.164.

ied greens across the surface of the composi-
tion and to treat the shadows cast by the trees
and lampposts in the foreground as abstract
patterns overlaying the pavements (fig. 1).

Marguerite Gilbert Chapin was a wealthy
American who had arrived in Paris in 1900 to
study singing with Jean de Reske, the brother
of Caruso. She quickly established herself
within a circle of literary and artistic friends
and associates that not only led to her intro-
duction to Vuillard on March 11, 1910 in the
company of Emmanuel Bibesco and Pierre
Bonnard (who had already executed her
portrait), but also, after 1918, enabled her to
gather in her Versailles home a cultured

coterie that included André Gide, Paul
Claudel, Francis Jammes, Max Jacob and Paul
Valéry. Her meeting with Vuillard led imme-
diately to two major commissions: the paint-
ing *Woman with a Dog* (1910, Cambridge,
Fitzwilliam Museum, C-S IX.162) and the mon-
umental decorative panel, *The Library* (fig.
2).[1] It was on completion of the latter, one of
the most artistically and emotionally fraught
creations of his entire career, and its instal-
lation in the spring of 1911 in Marguerite
Chapin's apartment on Rue de l'Université,
that Vuillard received the commission for
the screen.

Both *The Library* and the Chapin screen were
included in Vuillard's one-man exhibition
at the Galerie Bernheim-Jeune in April 1912,
where their presence was remarked upon
favourably—and with considerable relief—
by Louis Vauxcelles. Contrasting the artist
with "all the virtuous hypocrites of the
'Société Nationale'," he especially admired
Vuillard for his eye, "the most refined that
the school—the real school—of contem-
porary painting has to offer," which had pro-
duced the decorative artist Vauxcelles saw
as "the most unpredictable, the richest, the
most worthy of being compared to the great
Japanese masters of decoration."[2] Vaux-
celles's comparison to Japanese art was cer-
tainly apposite. The formal construction of
this work owes much to Japanese prints:
the dramatic bird's-eye perspective, the un-
centred composition, the use of cropping and
the simplified forms. But it is in the format—
that of a folding screen—that Vuillard's
debt to Japanese art is most apparent. He had
already experimented with this form in the
1890s (see cat. 141), and his decision to return
to it more than a decade later suggests that he
was, at least on some level, re-examining his
origins as a painter of decorations, perhaps
in response to the mixed reception of his dec-
orative works after 1900. MAS/KJ

1. Groom 1993, pp. 181–199.

2. Louis Vauxcelles, "Les Arts : Exposition Vuillard,"
*Gils Blas* (April 16, 1912).

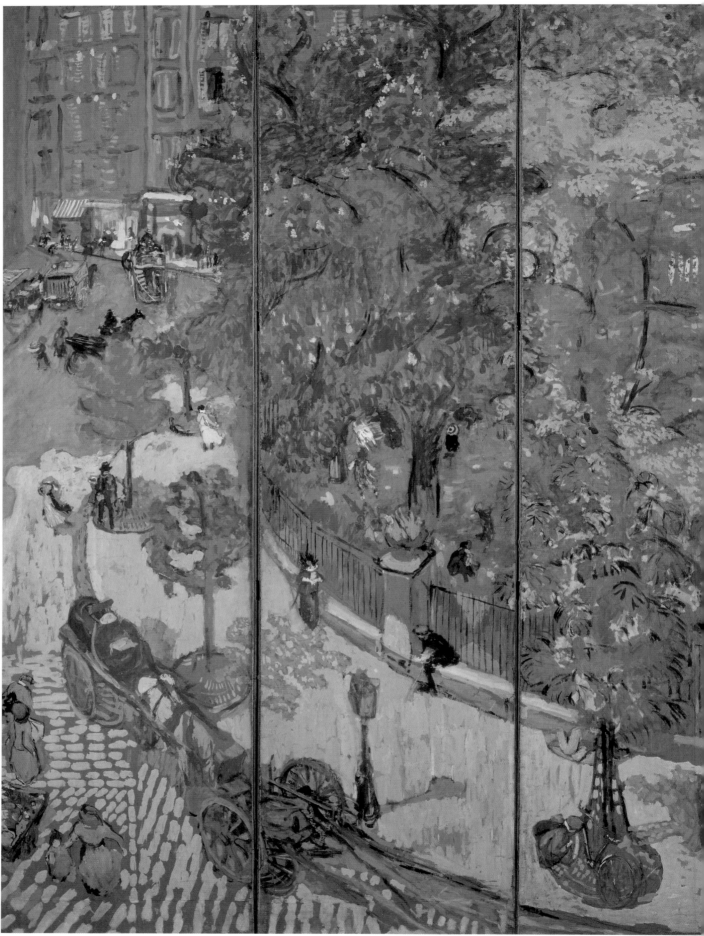

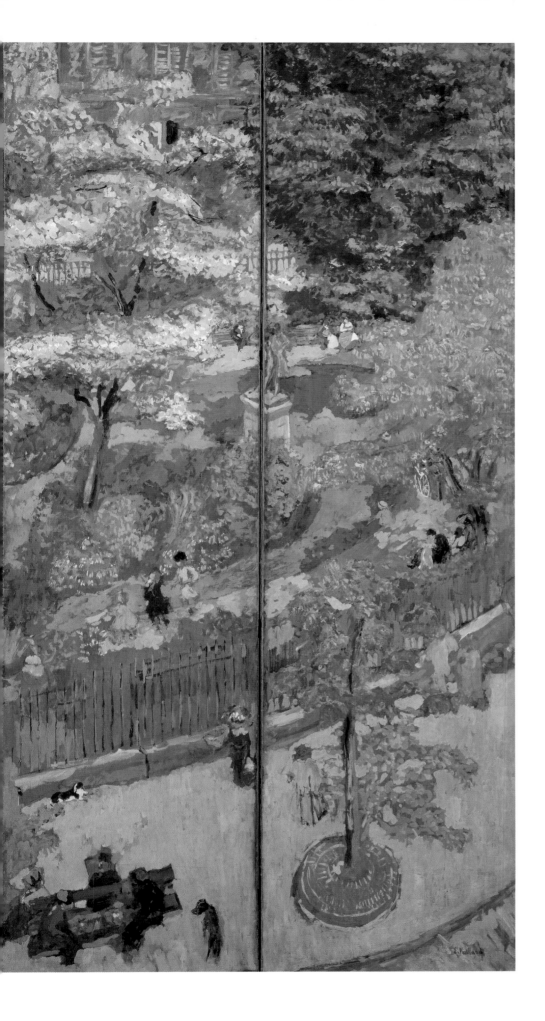

BERLIOZ SQUARE (SKETCH) ·
*Le Square Berlioz (esquisse)*

1915, distemper on paper mounted on canvas,
160 × 230
Metz, Musées de la Cour d'Or

Cogeval-Salomon X.101

___

*Provenance* Studio—Jacques Salomon, Paris
—Gift of Jacques Salomon to the Musées
nationaux, Paris, 1946; La Cour d'Or, Musées
de Metz

___

In June 1915, four years after completing the
Chapin screen, Vuillard embarked at the
behest of Emile Lévy upon another "portrait"
of Place Vintimille, which was destined to
hang in Lévy's office at 73, rue Claude-
Bernard (fig. 1). The apparently anomalous
title under which it was first exhibited in 1916,
*Berlioz Square*, is in fact historically accurate.
The square was renamed in 1905 in com-
memoration of the composer Hector Berlioz,
who had died nearby at 4, rue de Calais and
whose monument, erected on the central
island in 1886, can be glimpsed in several of
Vuillard's paintings (cats. 270–272) and pho-
tographs (fig. 2). The original bronze statue
by Alexandre Lenoir was destroyed around
1942 and replaced in 1948 with a stone version
by Georges Saupique.[1] Although the name
of the square had been changed, and would
be changed again in 1940 to the current
designation, Square Adolphe-Max, the popu-
lar name—Place or Square Vintimille—
remained in common usage.

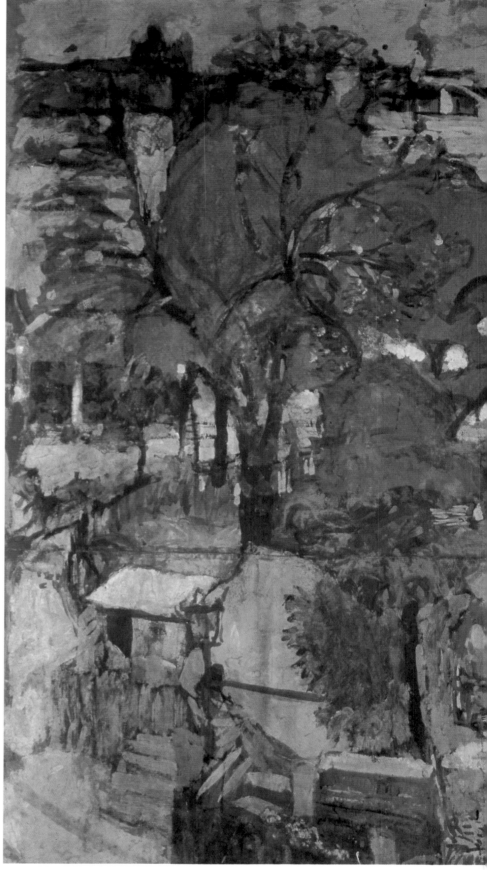

272

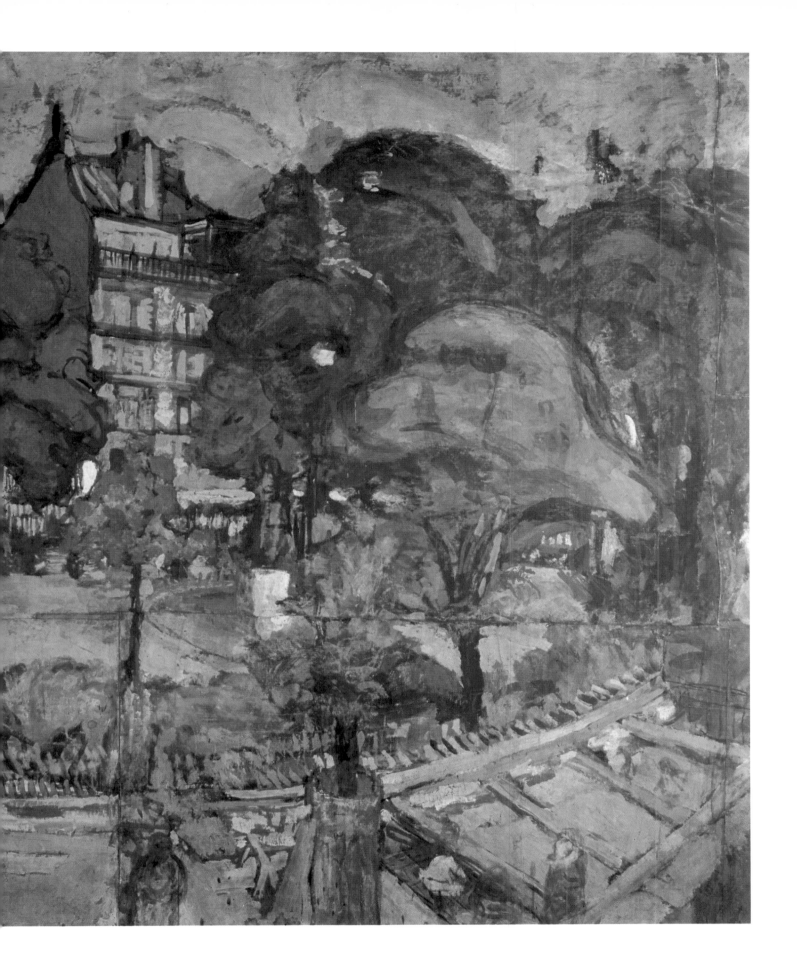

1. Édouard Vuillard, *Place Vintimille* or *Berlioz Square*, 1915–1916, reworked 1923, distemper on canvas, New York, The Metropolitan Museum of Art, promised gift of an anonymous donor, C–S X.102.

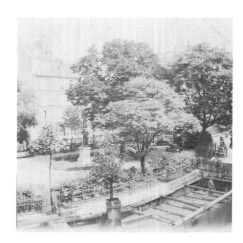

2. Photograph by Vuillard of Place Vintimille undergoing construction work, c. 1915, private collection.

Initially working at great speed, making use of photographs (fig. 2) and a series of preliminary drawings, Vuillard had completed both a pastel maquette and the full-scale distemper sketch shown here by the end of the second week of July 1915. Painted from the window of his second apartment at 26, rue de Calais, located on the second floor, both the distemper sketch and the finished decorative panel inevitably adopt a less vertiginous angle of vision than that employed in either the Bernstein panels of 1909–1910 (see cats. 269–270) or the Chapin screen (cat. 271). As a result, the artist has devoted more attention to the extensive foreground, in which major road works are being undertaken. The sketch hints at this dimension of the subject in the workman's hut and the loosely brushed-in wooden palings on the lower left and the wooden structural supports on the lower right, but in the finished panel Vuillard added workmen, tools and building materials contained within a clearly demarcated space, their labours acting as a foil to the leisure activities of the children and adults in the square beyond the iron

railings. Given that the panel was created during the height of the First World War, it has been suggested that Vuillard, too old for active service, might have intended the gash on Place Vintimille to be read as "a kind of open-air trench in the heart of the Batignolles district."[2] This seems unconvincing on three counts. First, the artist was returning to a subject he had already addressed on two occasions prior to the outbreak of the war. Second, Vuillard was, by this stage in his artistic evolution, committed to recording details of contemporary life—in this case, Place Vintimille undergoing road renovations—whenever they presented themselves. And third, by 1915 he had already decisively shifted his focus on modern life from the domestic settings that marked his work of the 1890s to exterior rural and urban locations.

The final version of *Berlioz Square* seems not to have pleased its commissioner, Emile Lévy, when he saw the work in September 1915,[3] and when, on January 23, 1916, he suddenly died, the panel was left unfinished and homeless. By March 1916, however, it had been completed and was shown at the Galerie Georges Petit. It was eventually sold to Marcel Kapferer in 1923, and hung in 1929 in the newly reopened Musée du Luxembourg. MAS/KJ

1. June Hargrove, *The Statues of Paris, an Open-air Pantheon* (Antwerp: Mercatorfonds, 1989), p. 342.

2. Groom 2001, p. 245.

3. Vuillard, *Journal*, II.8, fol. 50r (September 9, 1915).

# 273

BEFORE THE DOOR · *Devant la porte*

1910, reworked in 1915–1916, distemper on
paper mounted on canvas, 179.9 × 95.9
Signed l.r.: *E. Vuillard*
Washington, National Gallery of Art, Collec-
tion of Mr. and Mrs. Paul Mellon, 1985.64.43

Cogeval-Salomon VIII.395

————

*Provenance* Acquired from the artist by Bern-
heim-Jeune, Paris—Galerie Georges Petit,
Paris—Auguste Pellerin, Paris—Mme René
Lecomte, Paris—Knoedler, New York—
Paul Mellon, Upperville, Virginia, June 1964
—Gift to the National Gallery of Art,
Washington, 1985

*Exhibitions* Paris, Bernheim-Jeune, 1913,
no. 11—Paris, Charpentier, 1948 (hors cat.)
—Washington, NGA, 1966, no. 190, ill.

*Bibliography* Segard 1914, p. 322

————

Painted during the artist's sojourn at Crique-
bœuf in the summer of 1910, *Before the Door*
reflects a more prosaic side of the *villégiature*.
Vuillard has depicted his mother seated before
an open door in her room at the Hotel de
Paris et Bellevue, her granddaughter Annette
at her side, both of them engrossed in their
sewing.[1] Although Madame Vuillard regularly
accompanied her son on his summer sojourns,
she did not generally stay with the Hessels
but preferred to reside in more modest accom-
modation nearby. Images such as this one,
showing the artist's mother engaged in sew-
ing, either alone or in the company of other
women, are a constant in the artist's work.
One thing that does distinguish this painting
from so many of its predecessors is its setting,
which is far removed from the more familiar
Parisian locales.

Of even greater interest, however, is the
painting's composition. A door opens inward
into the room, allowing a wedge-shaped beam
of sunlight to cut across the foreground. The
soft yellow of the sunlight alternates with a
pattern of pale blue-violet shapes—presum-
ably the shadow cast by a balustrade. The
door itself introduces a strong perpendicular
element that reinforces the painting's vertical
format and echoes the striped wallpaper, yet

remains subtly balanced by the play of diag-
onals that criss-cross the composition. The
palette—dominated by whites, pale yellows,
ochre and blues, contrasted with vibrant
accents of red and pink—is restrained, as is
the handling of the *peinture à la colle*. The
paint surface is largely smooth and uncompli-
cated, resulting in simple planes of colour
(most notably in the wall and floor) that con-
trast with the deft patterning in Madame
Vuillard's skirt and the delicate lace curtain.
The effect is both understated and thoroughly
charming.

Like *Annette on the Beach at Villerville* (cat.
265), another large-scale picture executed dur-
ing the same summer, this work seems to blur
the line between easel painting and decora-
tion—something acknowledged by Segard as
early as 1914, when he identified it as a "deco-
rative panel" made without a specific location
in mind.[2] Early in August 1910, Vuillard wrote
in his journal: "attempt a large panel after a
sketch of Annette with Mama. Recall Alexan-
dre's panels."[3] While this panel recalls *The
Public Gardens* suite in its scale and its tech-
nique—the increasingly ubiquitous *peinture
à la colle*—it is much closer in spirit to the
series of canvases the artist would undertake
the following year to decorate Bois-Lurette,
the summer villa of the Bernheim family (see
cats. 274–275). This painting in fact appears
to be a forerunner of that series and may
well have served as the inspiration, if not the
prototype, for *At the Ducs de Normandie
Hotel: At the Window (Madame Vuillard)*
(C-S IX.159-10), painted three years later in a
similar hotel room on the Normandy coast.

*Before the Door* was shown at the Galerie
Bernheim-Jeune in 1913, along with five of
the paintings produced for Bois-Lurette,
including *At the Window (Madame Vuillard)*.
A contemporary photograph reveals that it
was even hung alongside one of them,
*The Riverbank* (C-S IX.159-12), further under-
scoring the tacit connection between this
painting and the later works.[4] K J

————

1. Cogeval in C-S 2003, no. VIII.395.

2. Segard 1914, pp. 321–322.

3. Vuillard, *Journal*, II.4, fol. 35v (August 5–6, 1910).

4. Reproduced in Groom 2001, p. 244.

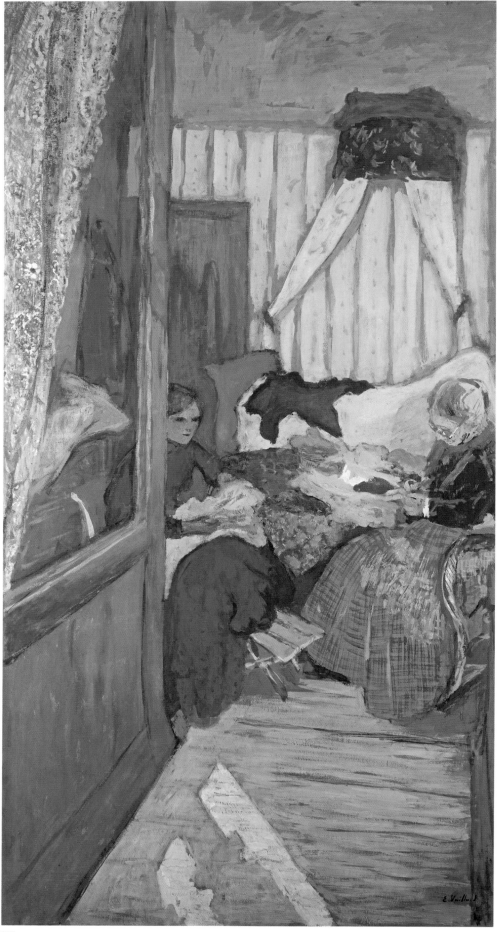

**Decoration for Bois-Lurette, the Bernheim Villa at Villers-sur-Mer, Normandy · *Décoration pour Bois-Lurette, la villa de MM. Bernheim à Villers-sur-Mer (Normandie)* (274 – 275)**

## 274

DECORATION FOR BOIS-LURETTE. THE VERANDA AT LE COADIGOU IN LOCTUDY: LUCY HESSEL AND DENISE NATANSON (surround for door II, left portion) · *Décoration pour Bois-Lurette. La Véranda du Coadigou à Loctudy, Lucy Hessel et Denise Natanson* (encadrement de porte II, partie gauche)

1912, reworked in 1934, distemper on canvas, 200 × 115
Private collection

Cogeval-Salomon IX.159-6

———

*Provenance* Commissioned from the artist by Josse and Gaston Bernheim de Villers for their villa, Bois-Lurette, in Villers-sur-Mer; painted by Vuillard during the summers of 1911, 1912 and 1913; dismantled 1933; reworked in 1934 —Galerie Urban, Paris—Sale, Galerie Charpentier, Paris, June 16, 1955, lot 95 (ill.)—Galerie Katia Granoff, Paris—Galerie Bellier, Paris—Private collection, 1984

*Exhibitions* Paris, Petit Palais, 1937, gallery 15, no. 20—Paris, Musée des Arts décoratifs, 1938, no. 159f

*Bibliography* Segard 1914, p. 321—Salomon 1945, p. 64—Roger-Marx 1946a, pp. 140, 142–143, 188—Chastel 1946, p. 90—Thomson 1988, p. 119, pl. 91—Groom 1993, p. 208

## 275

DECORATION FOR BOIS-LURETTE. AT LA DIVETTE, CABOURG: ANNETTE NATANSON, LUCY HESSEL AND MICHE SAVOIR AT BREAKFAST · *Décoration pour Bois-Lurette. À la Divette, Cabourg, Annette Natanson, Lucy Hessel et Miche Savoir au déjeuner du matin*

1913, reworked in 1934, distemper on canvas, 184 × 109
Signed l.l.: *E. Vuillard*
Private collection

Cogeval-Salomon IX.159.13

———

*Provenance* Commissioned from the artist by Josse and Gaston Bernheim de Villers for their villa, Bois-Lurette, at Villers-sur-Mer; painted by Vuillard during the summers of 1911, 1912 and 1913; dismantled 1933; reworked in 1934 —Jeanne Lanvin, Paris; Comtesse Jean de Polignac, Paris—Private collection

*Exhibitions* Paris, Bernheim-Jeune, 1913, no. 3—Paris, Petit Palais, 1937, gallery 15, no. 20—Paris, Musée des Arts décoratifs, 1938, no. 149e

*Bibliography* Roger-Marx 1946a, pp. 79, 143, ill. p. 150—Groom 1993, p. 208

These two decorative panels formed part of a multi-panel commission that Vuillard received from his dealers, Josse and Gaston Bernheim, in 1911. The works were to be installed in the brothers' summer villa, Bois-Lurette, at Villers-sur-Mer, a seaside resort on the Normandy coast between the fashionable centres of Trouville and Deauville, and Cabourg. The villa itself, situated in a prominent position overlooking the sea, was neo-Gothic in style and housed works by Bonnard and Matisse, among others, from the Bernheims' collection.[1] When the villa was sold in 1933, the decorative panels were dismantled. They were reworked by Vuillard during the following year and were subsequently dispersed.

As Cogeval has shown, the decorative scheme, made up of at least thirteen panels, comprising three distinct commissions, was created over a period of three years, from 1911 to 1913. It consisted of two pairs of panels framing a first door, with an overdoor panel, and a further pair of framing panels for a second door, also with an overdoor panel, plus five other panels, three vertical and two of irregular format. Their subject matter was drawn from the artist's personal experiences during those years, with their locations and sitters reflecting the pattern of his own summer vacations, or *villégiatures*. In 1911, Vuillard was staying with Lucy and Jos Hessel at their summer villa, Les Pavillons, at Criquebœuf, a seaside settlement some two kilometres northeast of Villerville. It was here that he

embarked upon the first two panels framing door I, *At Les Pavillons, Criquebœuf: The Park* (priv. coll., C-S IX.159-1) and *At Les Pavillons, Criquebœuf: In Front of the House* (priv. coll., C-S IX.159-2), together with the overdoor panel *At Les Pavillons, Criquebœuf: Mosaic* (priv. coll., C-S IX.159-3) and two subsidiary left and right framing panels, both entitled *Verdure* (locs. unkn., C-S IX.159-4, 5). The following summer, when Vuillard was staying at Loctudy in southern Brittany, he worked on the two panels, *The Veranda at Coadigou in Loctudy: Lucy Hessel and Denise Natanson* (cat. 274) and *The Veranda at Coadigou in Loctudy: Marcelle Aron and Marthe Mellot* (Paris, Musée d'Orsay, C-S IX.159-7), that were destined to frame the second door; they were linked by an overdoor panel that continued the motif of the trellis-like glazing of the conservatory (priv. coll., C-S IX.159-8). The last five panels were commissioned on July 20, 1913 and executed during that summer. Four record scenes in Cabourg, a resort of Proustian renown some ten kilometres southwest of Villers-sur-Mer—*At La Divette, Cabourg: The Open Door* (priv. coll., C-S IX.159-9), *At the Ducs de Normandie Hotel: At the Window (Madame Vuillard)* (priv. coll., C-S IX.159-10), *At La Divette, Cabourg: Annette Natanson, Lucy Hessel and Miche Savoir at Breakfast* (cat. 275) and *At La Divette, Cabourg: The Riverbank* (priv. coll., C-S IX.159-12)—and one shows the *Terrace at Bois-Lurette (Mmes Josse and Gaston Berheim)* (priv. coll., C-S IX.159-11) (see "Vuillard and the 'Villégiature'," in the present volume, fig. 10).

The initial commission for these panels appears to date from August 10, 1911, when Vuillard lunched with the Bernheims at their villa while he was vacationing at Criquebœuf. Within days he was at work on the first group of paintings, and on September 10, just one month after receiving the commission, he recounted in his journal: "At Villers Bois Lurette installation of my decoration retouches quite nice effect."[2] Vuillard kept to his now standard practice of undertaking a rigorous preparation, producing small sketches in charcoal and pastel prior to attacking the large-scale work in distemper. Unlike so many of his earlier decorations, which were constructed in the studio from sketches and photographs—*The Haystack* (cat. 266) being a prime example of this practice—the Bois Lurette canvases were executed on site, a fact

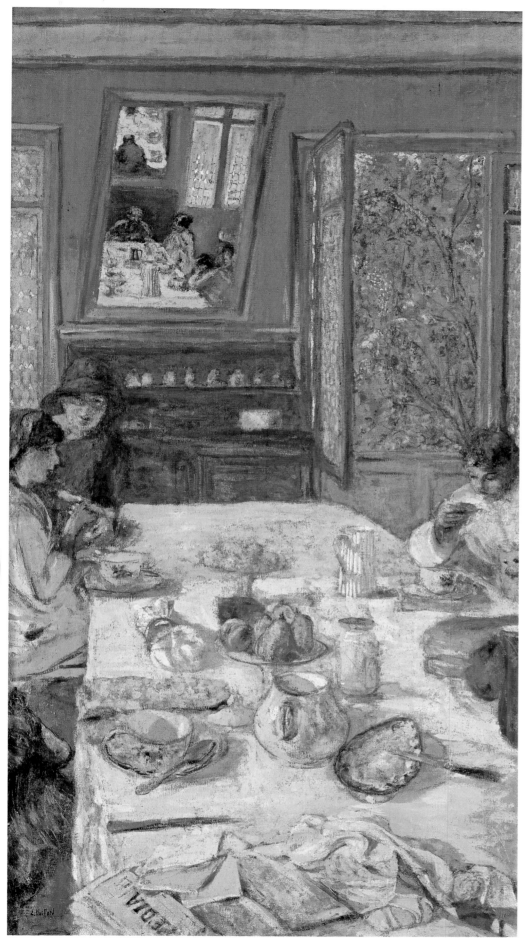

275

that is evidenced by contemporary photographs (see cat. 244). As Cogeval notes, this suite posed a further challenge for the artist: for the first time he was confronted with the necessity of adhering to a precise architectural framework, which had not been the case in his earlier decorative projects, where he retained a certain degree of latitude vis-à-vis the exact setting. The experience would prove invaluable for his next decorative project, a commission to decorate the foyer of the Théâtre des Champs-Élysées, which he received in May 1912.[3]

The set of panels demonstrates a continuity of subject matter within Vuillard's oeuvre, but also reveals significant developments in his compositional procedures, his appreciation of the role of light and his definition of "decoration." The subject of each panel had an autobiographical reference for the artist. As in his works of the 1890s, where family and friends (then centred around Thadée and Misia Natanson) constituted the dramatis personae, there is a persistent visual engagement with the personalities at the centre of his personal and creative life. The Bois-Lurette panels record familiar figures from the early days—his mother at the window of the Ducs de Normandie Hotel in Cabourg, Marthe Mellot, wife of Thadée Natanson's brother Alfred, and two Natanson children, Denise and Annette—but they also register the presence of a new social group, with which Vuillard had become acquainted around 1900: the families of Josse and Gaston Bernheim and, most importantly, Lucy Hessel, wife of Jos Hessel and cousin of Marcelle Aron.

But the Bois-Lurette panels also confirm the marked development that had taken place in Vuillard's work since 1900. Although they share a preoccupation with natural light—and, in a couple of cases, with landscape—with early decorative schemes such as *The Public Gardens* of 1894 (see cats. 111–118) and the Schopfer panels of 1898 and 1901 (see cats. 263–264), which had already explored the world beyond the claustrophobic interiors of the 1890s, the Bois-Lurette scheme relates more specifically, in compositional terms, to the gradual reassessment from about 1900 of the role of light (both natural and artificial)

as a dynamic and unifying force. In several of the panels, including *The Veranda at Le Coadigou in Loctudy: Lucy Hessel and Denise Natanson* (cat. 274), the compositions are centred upon figures silhouetted against strong sources of natural light—a device Vuillard had already explored with some consistency after 1900 in a sequence of chromatically charged interiors. One panel, *At La Divette, Cabourg: Annette Natanson, Lucy Hessel and Miche Savoir at Breakfast* (cat. 275), is even more inventive in its exploration of the penetration of natural light into an interior. In a dramatically constructed composition, where the plunge of the table with its still life objects is thrown back into the interior by its reflection in the mirror on the far wall, light enters the room through the open window but is amplified both by the reflection of another window opposite and by the brilliant white of the tablecloth.

Five of the Bois-Lurette panels were exhibited in December 1913 at the Galerie Bernheim, as part of a selection of recent works that included elements from two other decorative schemes and a first version of *The Surgeons* (see cat. 306). The paintings provided critics with an opportunity to evaluate not only Vuillard's embracing of naturalism but also, by extension, his interpretation of "decoration." Gustave Kahn, erstwhile Symbolist writer and critic, correctly understood that Vuillard did not achieve the unification of subject, albeit with a naturalist slant, required of a large-scale decoration through a simplification of form. He achieved it through colour. However, Vuillard's colour was not "non-natural" in a Symbolist sense, but rather represented "a reproduction of real colour" through which he gave "to the appearance of things an inner harmony."[4] It was this use of colour as the translator of real light that Louis Hautecœur identified in his remarks specific to the five Bois-Lurette panels: *At La Divette* (cat. 275) he sees as recording "the morning light," while *On the Terrace* describes "light filtered through a yellow blind," and all five panels demonstrate a remarkable facility to "envelop objects in light."[5] According to Arsène Alexandre, both the translation of light and the observation of the real world in a non-literal sense lay at the heart of Vuillard's distinct contribution to decoration: "Applied to Vuillard's work, decoration means: a view of light and of life, not through a literal account, but through an interpretation, an almost musical transposition, of atmosphere and objects."[6] Adolphe Dervaux,

in *La Plume*, summarized Vuillard's recent achievements as a master of decoration, but also hailed him as a great modern painter: "…as Monsieur Vuillard is one of the most complete and best representatives of modern art, the air, the light, the joy of the clear, evanescent atmosphere, the liveliness of the light, flamboyant colours, fill his decorations… and are immensely pleasing."[7] MAS/KJ

1. Thomson 1988, p. 117.

2. Vuillard, *Journal*, II.5, fol. 29v (September 10, 1911).

3. Cogeval in C-S 2003, no. IX.159.

4. Gustave Kahn, "Art : Exposition Vuillard," *Mercure de France*, vol. 107, no. 397 (January 1, 1914), p. 209.

5. Louis Hautecœur, "Petites Expositions : Exposition Vuillard," *La Chronique des arts et de la curiosité*, no. 39 (December 27, 1913), p. 307.

6. Arsène Alexandre, "La Vie artistique : Peintures d'Édouard Vuillard," *Le Figaro* (December 21, 1913); see also A. Alexandre, "Deux Harmonistes. Deuxième partie. Édouard Vuillard," *Comoedia* (December 27, 1913).

7. Adolphe Dervaux, "Notes sur l'Art," *La Plume*, vol. 26, no. 426 (January 1, 1914), p. 291.

## 276

SUNLIT INTERIOR: MADAME VUILLARD'S ROOM AT LA CLOSERIE DES GENÊTS · *Intérieur ensoleillé, la chambre de Madame Vuillard à la Closerie des Genêts*

1921–1922, distemper on paper mounted on canvas, 83.2 × 63.8
Signed l.r.: *E. Vuillard*
London, Tate Gallery, bequeathed by the Hon. Mrs. A. E. Pleydell-Bouverie through the Friends of the Tate Gallery, 1968

Cogeval-Salomon XI.41

*Provenance* Acquired from the artist by Jos Hessel and Bernheim-Jeune, Paris—Sir Alfred Chester Beatty, London—Arthur Tooth & Sons, London—Mrs. A. E. Pleydell-Bouverie, London, 1961—Pleydell-Bouverie Bequest to the Tate Gallery, 1968

*Exhibitions* Glasgow-Sheffield-Amsterdam, 1991–1992, no. 94, col. ill. p. 33

276

E. Vuillard

Lucy and Jos Hessel had taken the Villa Anna, their first villa at Vaucresson, west of Paris, in 1917. The following year Vuillard rented an apartment in the Closerie des Genêts nearby, where he and his mother stayed regularly for the next seven years. The Hessels moved to the Clos Cézanne, Vaucresson, in 1920 before finally acquiring the Château des Clayes, near Versailles, in 1925 (see cat. 334). *Sunlit Interior*, painted from the adjacent dining room, shows his mother standing in her bedroom at the Closerie des Genêts, the light streaming in from the window that opens onto a screen of verdant growth beyond.

In keeping with the artist's enhanced concern for naturalism, the integrity of the individual constituents of the bedroom—table, chair, wardrobe, bed, carpet and deck chair—has been respected, and the deep spatial recession recorded. However, so apparently direct a representation of a modest domestic interior (as evidenced by photographs taken by the artist) is undermined by two elements within the painting. The overall tonality of the work has been created through a dialogue between pristine yellows, grey-greens and varying tones of creams, such that their alternating rhythms across the surface of the composition tend to attenuate their descriptive function. Secondly, as in works dating from the 1890s, and increasingly after 1900, the presence of mirrors complicates the otherwise logical recession into the depth of the room. Vuillard was to employ both these pictorial tools in his larger and more ambitious portrait of Countess Marie-Blanche de Polignac, made in 1928–1932 (cat. 320). MAS

TRADITION, GENRE, MODERNITY | *Catalogue* **277–296**

AROUND 1900, WHEN THE NABIS' collective enterprise had run its course and Vuillard's work as a decorator had given him a glimpse of new horizons, the artist threw himself into a genuine re-invention of his painting. This necessary and inevitable change of direction was to be endeavoured by all the former Nabis, according to the goals and means afforded by their various temperaments. As avant-garde movements succeeded one another at an accelerating rate, Vuillard based the painting of his maturity on a personal freedom that had as both its price and its limit a distancing from most of the controversies that shook the art world during the remainder of his career. But although it must be admitted that Vuillard's artistic path was thereafter somewhat marginal, we must also recognize that his contribution to twentieth-century painting was grounded in this classicizing, versatile and many-faceted exploration.

Maurice Denis, as we know, played a pivotal role in theorizing the developments that went beyond the radical notions first formulated by the Nabis in the early 1890s. In the decade separating his crucial journey to Rome with André Gide in 1898 and his article "De Gauguin et de Van Gogh au Classicisme," published in 1909,[2] Denis pursued his quest for "a new classical order." But while Vuillard was part of this precocious "return to order," he did not, unlike Bonnard and Roussel, adopt the iconography of a revisited Arcadia. Thus, and most significantly, his contribution to the decoration of the Théâtre des Champs-Élysées (1912–1913) is a tribute to various aspects of theatrical history (Molière's *Le Malade imaginaire*, Debussy's *Pelléas et Mélisande*, Goethe's *Faust* and Tristan Bernard's *Le Petit Café*), which, encompassing both the classical and the ultra-modern, offers an eclectic range of cultural references that contrasts sharply with Denis's Antique-style ceiling. Only at the very end of his career, in his work for the League of Nations building (cats. 294–296), did Vuillard come closer to the classical ideal formulated by Puvis de Chavannes, the artist who probably exerted the most persistent influence on his oeuvre.[3]

Vuillard was fond of using the background paintings or objects portrayed in his own work as artistic "quotes," and this practice, which over time became a real leitmotif, is essential to an understanding of his relationship to the art of the past. The works he cites are not present simply as decorative elements or reflections of a taste, or a personality. They form an ongoing inventory whose full meaning lies in its close connection to contemporary reality (see *Self-portrait in the Dressing-Room Mirror*, cat. 289). These references sometimes take over a portrait to the extent diverting it from its primary function, as in *Madame Val-Synave* (1917–1920, distemper on canvas, priv. coll., C-S X.233), where the sitter, presented as the formal and spiritual double of a cast of the *Venus de Milo*, serves primarily as the excuse for a reflection on the fragility of human ambition and the timelessness of classical beauty.

The permanence of the contents of Vuillard's private museum, in which paintings by Le Sueur, Vouet, Chardin and Watteau recur as regularly as classical antiquities from the Louvre, is confirmed by every period of the journal, from his pre-Nabi youth to the final years of the 1930s. He sought through these exemplary works both to define his own approach and to reaffirm the continuity of a French tradition. In this movement back and forth between the art of past and present, it is not surprising that the celebration

of the nation's artistic heritage became more vehement during the Great War (*The Chapel at the Château de Versailles*, cat. 283), reaching its height in the early 1920s with the reopening of the Louvre and the Bauer decorations (cats. 284–288)—the very period when a younger generation, feeling in its turn torn between "Order and Adventure," as Apollinaire put it, was going back to the museums.

André Chastel focused specifically on Vuillard's relationship with the past when he wrote: "His art is easier to relate to traditional images than that of Bonnard. Not that Vuillard went looking for inspiration in museums: we cannot cite any work that, as often happens with Manet, springs directly from the study of an Old Master. At most, we sense an echo of Degas, or sometimes of Manet himself. But Vuillard is one of those painters who is perhaps best understood when we think of those who went before him rather than those who followed."[4] In fact, it was a still recent past, Impressionism and its beginnings, that made itself most strongly felt in Vuillard's painting around the turn of the century. As with Bonnard, this link was probably tightened by his new relationship with the Bernheim-Jeune gallery. In any case, the influence was markedly evident in the radical changes in his approach to space and light that occurred between 1900 and 1910. Vuillard's debt to the Impressionist legacy (for which Denis reproached him, seeing it as too dependent on simple "feeling") is mainly evident in the decorative work, the landscapes and the urban scenes (see "The Triumph of Light," in the present volume). Although in the mid-nineteenth century a split had arisen between tradition and modernity on the question of genre, around 1910 Vuillard began exploring this rich and ambiguous problem anew. The complete or partial dissolution of genres in the contemporary subject is actually the central issue of his portraits (see *The Surgeons,* cat. 306; *Doctor Louis Viau*, cat. 293). It is also at the core of a singular and marvellous group of works inspired by the war. Like Vallotton, but on subjects much less directly related to the conflict, Vuillard conjured this traumatic and painful episode with a totally new expressive power (*Interrogation of the Prisoner*, cat. 282; *War Factories*, 1917, Troyes, Musée d'Art Moderne, C-S X.32-1 and 2).

Through these successive redefinitions, Vuillard was questioning not only the history of painting but also its techniques and its practice. The tireless documentation of reality on which his creative alchemy was based also informed his simplest, perhaps most traditional aims in the many canvases devoted to the studio, the nude and the still life (see cats. 277–281). The desire to bring together the intellectual, emotional and technical dimensions of painting that persisted in Vuillard was, of course, primarily a search for identity, a need to find his place in history. He arrived at an indirect conclusion to this inquiry in the early 1930s, when he assembled in the "Anabaptists" series his four ex-Nabi friends, Bonnard (cat. 291), Denis (cat. 292), Maillol and Roussel. In picturing them in their studios, in attesting forcefully yet dispassionately to their continued practice of their art, more than forty years after the extraordinarily creative audacities of their youth, Vuillard confirmed and celebrated a journey that had also been his own. Time had done its work, the transition was complete, moderns had become classics. **Laurence des Cars**

1. Roger-Marx 1946a, p. 190.

2. Maurice Denis, "De Gauguin et de Van Gogh au Classicisme," *L'Occident*, no. 90 (May 1909), pp. 187–202.

3. On this subject, see Puvis de Chavannes 1926, the interview Vuillard gave to Puvis de Chavannes's nephew.

4. Chastel 1946, pp. 83–84.

## 277

NUDE IN THE STUDIO · *Nu dans l'atelier*

1902–1903, oil on canvas, 72 × 60
Private collection, courtesy Kunsthandel
Sabine Helms, Munich

Cogeval-Salomon VII.244

———

*Provenance* Studio—Private collection,
Germany

*Exhibitions* Japan, 1977–1978 (trav. exhib.),
no. 31, col. ill.

## 278

NUDE SEATED IN AN ARMCHAIR ·
*Nu au fauteuil*

c. 1900, oil on board, 47 × 54
Sally Engelhard Pingree

Cogeval-Salomon VII.250

———

*Provenance* Studio—JPL Fine Arts, London
—Private collection, United States

*Exhibitions* Japan, 1977–1978 (trav. exhib.),
no. 20, col. ill.

## 279

TWO NUDE FIGURE STUDIES ·
*Deux études de femmes nues*

1900–1905(?), charcoal on paper, 52 × 40.5
Washington, National Gallery of Art,
Rosenwald Collection, 1964.8.1712

## 280

NUDE WITH RAISED ARMS (CLAIRE
CALA) · *Nu aux bras levés (Claire Cala)*

1905–1907, graphite on paper, 20 × 12.1
Private collection

———

While the direction of Vuillard's work during
the period of Nabi experimentation generated
only the occasional image of the nude—
except in his programs for the Théâtre-Libre
(cats. 43–44)—the subject was to re-enter the
artist's vocabulary and punctuate his oeuvre
throughout his later career. This renewed
interest may have been due in part to a libera-
tion in his emotional life, but it was perhaps
also a response to the increasing engagement
with the nude that his fellow Nabi, Pierre
Bonnard, had effectively announced with such
paintings as *Woman Lying on a Bed* (1899,
Paris, Musée d'Orsay).

Unlike Bonnard's nudes, however, which
were intended for public exhibition and domi-
nate the domestic settings in which they are
portrayed, Vuillard's remain essentially pri-
vate studies set resolutely within the context
of the creative environment, the artist's stu-
dio. Seated, as in the case of the two paintings
seen here, in relaxed poses, as in the two
nude figure studies, or standing, naked or half-
dressed, as in many other paintings, they
relate to a larger, ongoing enterprise: a visual
investigation of the "life of the studio." *Nude
Seated in an Armchair* and *Nude in the Studio*
thus belong to a group of paintings that ex-
plore sitters in the artist's various work spaces,
which include such pictures as *Madame
Val-Synave* (1917, 1919–1920, distemper on
canvas, priv. coll., C-S X.233), who stands
before the mirror in the Rue de Calais studio,
framed by the artist's studio props, and
*Madame Vuillard Lighting the Stove* (cat. 290).
Similarly, Vuillard created images of artists
at work in their own studios, as in the "Anaba-
ptists" series (see cats. 291–292), and took
photographs showing different members of
his circle—Lucy Hessel, for example (c. 1909,
Paris, priv. coll.)—in his studio.

The studio is further explored as a still-life
subject in paintings such as *The Mantelpiece*
(cat. 281) and in numerous photographs taken
throughout the artist's career. Both paintings
and photographs reveal the sources of Vuillard's
creative inspiration and endeavour, which
encompass reproductions of masterpieces
from both the Western and oriental traditions,
casts after the Antique, examples of his own
work, small-scale sculptures by colleagues
such as Aristide Maillol, and sometimes the
physical presence of one or other of his vari-
ous "muses."

Vuillard's approach to the studio world, par-
ticularly when inhabited by the nude, must
have been noted by Walter Sickert, the English
artist, collector and critic, for he observed that
in drawing from the live model lessons could
be learned from "such heirs of the Impres-
sionist school as Vuillard [and] Bonnard" who
stressed the primacy of domestic settings and
natural lighting over a formal studio setting
bathed in unmodulated light: "Drawing must
be made more interesting by substituting
figures and objects in the definite light and
shade of an ordinary room for the blank
monotony of the nude on a platform, with its
diffused illumination of studio light."[1] MAS

———

1. Walter Sickert, "On the Conduct of a Talent" (1914),
reprinted in Walter Sickert, *A Free House, or The Artist as
Craftsman* (London: Macmillan, 1947), pp. 329–330.

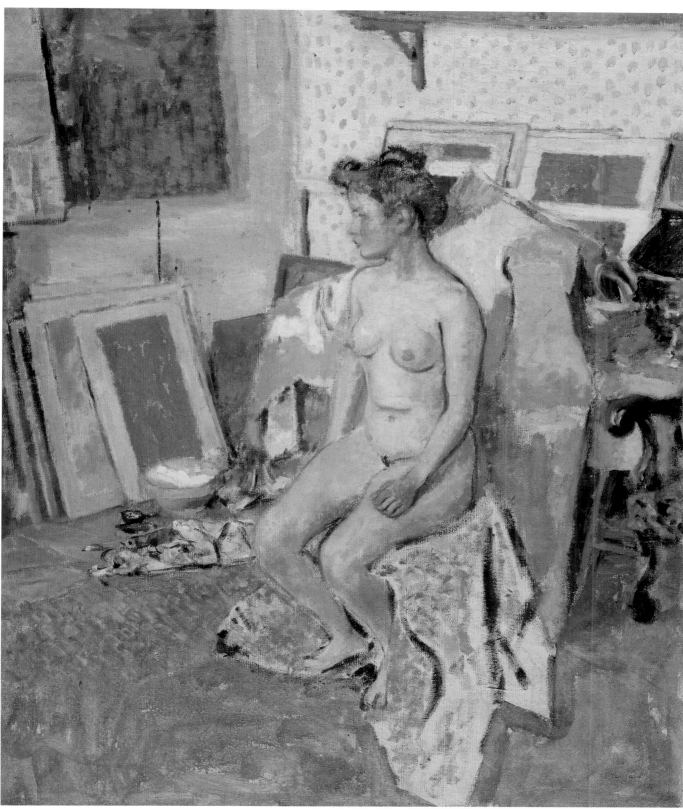

277

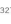

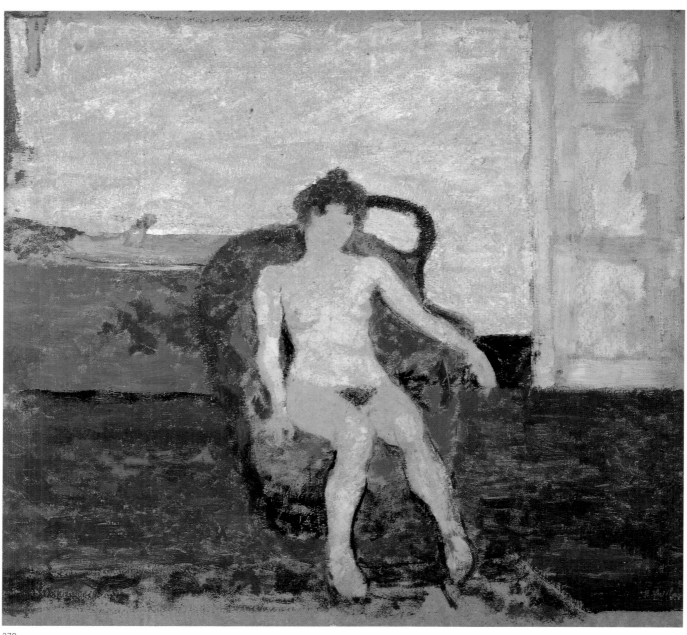

278

280

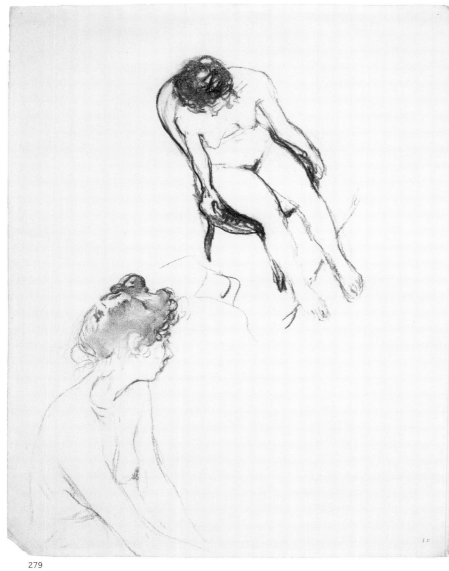

279

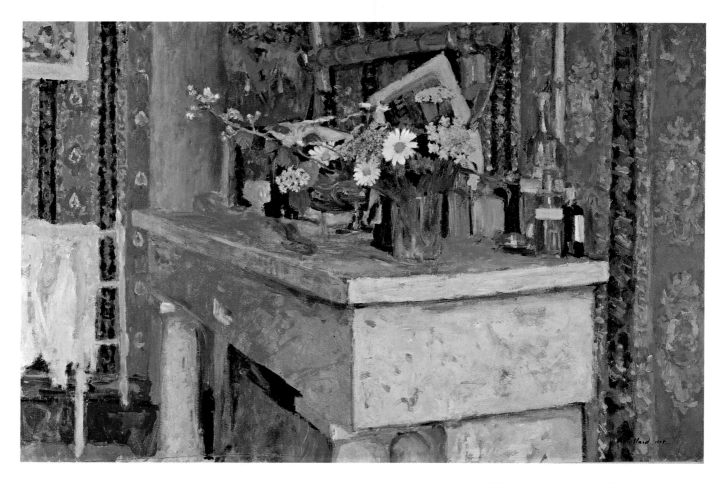

# 281

THE MANTELPIECE · *La Cheminée*

1905, oil on board, 53.5 × 78.5
Signed and dated l.r.: *E. Vuillard 1905*
London, The National Gallery

Cogeval-Salomon VIII.126

*Provenance* Acquired from the artist by Bernheim-Jeune, Paris—Sir Hugh Percy Lane, Chelsea—Lane's Conditional Gift of Continental Pictures to the British nation; Municipal Art Gallery, Dublin, 1908–1913; Lane Bequest to the National Gallery, London, 1917; Tate Gallery, London, 1917; transferred to the National Gallery, London, 1959, NG3271; on loan to the Municipal Art Gallery, Dublin, 1966; on loan to the Tate Gallery, 1997

*Exhibitions* Paris, Bernheim-Jeune, 1906, no. 8—London, Wildenstein, 1948, no. 26, ill.—Edinburgh, Royal Scottish Academy, 1948, no. 85—Munich, Haus der Kunst, 1968, no. 136, ill.—Paris, Orangerie, 1968, no. 120, ill.—Lyon-Barcelona-Nantes, 1990, p. 83, no. 109, col. ill. p. 37—Glasgow-Sheffield-Amsterdam, 1991–1992, no. 67, ill. p. 66

*Bibliography* Denis 1959, p. 153—Cogeval 1993 and 2002, p. 95, col. ill. p. 96

This work shows the marble mantelpiece in Vuillard's room at the Château-Rouge, Amfreville, a property rented on three consecutive summers, from 1905 to 1907, by Jos and Lucy Hessel. Apart from the posy of wild flowers, the objects allude to the profession of the room's occupant. The painting rags hanging in the background, the motley array of bottles on the mantelpiece, and the works of art propped up behind the flowers and pinned on the far wall accord with the description of Vuillard's working environment during the summer of 1905 that the artist himself gave in a letter to Félix Vallotton: "…postcards of paintings at the Louvre. This collection and another picture by Daumier decorate my room and meet, for the moment, the demands of old idolatries."[1] The painting was shown at Vuillard's first significant one-man exhibition, mounted at the Bernheim-Jeune gallery from May 19 to June 2, 1906. The exhibition, which comprised thirty-two works, included at least four still lifes: *Flowers on a Mantelpiece* (no. 5), *Flowers* (no. 9), *Fruit* (no. 30) and the picture seen here (no. 8).

From about 1900, however, while never entirely abandoning references to the space the still-life elements inhabited, Vuillard began to narrow his angle of vision and to make them his central focus.

There is much in this work to suggest that it represents a relatively new departure for Vuillard. In other still-life paintings created over the preceding five years, such as *The Candlestick* (1900, C-S VII.125) and *Pot of Flowers, Rue Truffaut* (c. 1902–1903, C-S VII.260), both now at the Scottish National Gallery of Modern Art, in Edinburgh, Vuillard had continued to blur any logical relationship between surface and depth. Here, the angle at which the marble mantelpiece plunges into the heart of the composition establishes a more stridently naturalistic account of the interior space. The issue of the balance between two-dimensional "decoration" and three-dimensional "representation" had been discussed in relation to Vuillard's art from around the turn of the century. In 1902, for example, the critic Georges Dralin deplored the artist's halting reassertion of naturalism,[2] while two years later Roger Marx[3] and Raymond Boyer recorded a significant shift in this direction in the nine works shown at the Salon d'Automne. Boyer wrote: "A thoroughly French glimmer is emerging from the chaos of the modern: here is Vuillard, an *intimiste* and a decorator, already recovering in 1903 and now, in 1904, making a vibrant effort; less formless but still pleasing, it appears that he wishes to banish the neurasthenic and the spineless; his painter's eye seems to have freed itself of those overly-Japanese arrangements and Byzantine tapestries; his bright red flowers and wine-coloured still life against an azure brocade fit for a marquise retain a sketch-like flavour while accentuating the graphic."[4] By 1906, this negotiation between the radical spatial descriptions of the 1890s and a return to greater naturalism was seen to have been settled in favour of the latter.

Despite this move on the part of certain critics to nominate Vuillard as the champion of a sane French art in the face of artistic anarchy,[5] his handling of colour and composition in *The Mantelpiece* manifests a continuity within the context both of his own work and that of a longer tradition. Although each component of the composition has been more clearly articulated than in earlier works, and the overall organization allows for a less ambiguous description of depth, both strategies retain a distinctly personal character. Speaking generally, Arsène Alexandre made the point in his review of the 1906 exhibition: "Vuillard has an individual approach to draftsmanship and perspective, which are neither the draftsmanship of the studios nor the perspective of architects."[6] And these strategies, combined with the persistent assertion of dominant tonalities within a composition—in this case the greys and reds that unify the diverse objects and planes—not only ensured that Vuillard's still lifes were seen as part of the French tradition that included Chardin[7] and Manet,[8] but also permitted them to communicate profound ideas and emotions: "M. Vuillard… showed us how skilfully he composes his interiors, portrays the familiar scenes behind his flowers, all the while observing like a Dutch painter the play of light and the recession of planes, how he imbues his painting with the charm of subtlety and wit."[9] MAS

---

1. Letter from Vuillard to Félix Vallotton, July 29, 1905, in Guisan and Jakubec 1974, p. 93.

2. Georges Dralin, "Chronique de peinture. Galerie Bernheim jeune : exposition d'œuvres nouvelles par Bonnard, Maurice Denis, Maillol, Roussel, Vallotton et Vuillard," *L'Occident*, no. 7 (June 1902), p. 397.

3. Roger Marx, "Le Salon d'Automne," *Revue universelle*, no. 120 (October 1904), p. 642.

4. Raymond Boyer, "Le Procès de l'art moderne au Salon d'Automne," *Revue bleue* (November 5, 1904), p. 605.

5. See also André Gide, "Promenade au Salon d'Automne," *Gazette des Beaux-Arts*, vol. 34, no. 582 (December 1, 1905), pp. 479–481.

6. Arsène Alexandre, "Vie artistique : Petites expositions," *Le Figaro* (May 29, 1906).

7. Chardin's name is regularly invoked in relation to Vuillard; see, for example, Henri Ghéon, "Lettre d'Angèle," *L'Ermitage*, vol. 18, no. 4 (April 1899), pp. 314–315, and Camille Mauclair, *Les Maîtres de l'impressionnisme* ([Paris: Georges Lecomte, 1903] Paris: Ollendorff, n.d. [1924]), p. 194.

8. See A.M., "The International," *Pall Mall Gazette* (January 9, 1905).

9. J.F. Schnerb, "Les Expositions. Chez MM. Bernheim-Jeune : Fleurs et natures mortes," *La Grande Revue* (December 10, 1907), p. 584.

## 282

INTERROGATION OF THE PRISONER ·
*Interrogatoire du prisonnier*

1917, distemper on paper mounted on canvas,
110 × 75
Signed l.l.: *E. Vuillard*
Paris, Musée d'Histoire Contemporaine,
Or. PE 16

Cogeval-Salomon X.24

*Provenance* Acquired from the artist by the
French government; Musée d'histoire contem-
poraine, Hôtel National des Invalides, Paris

*Exhibitions* Paris, Musée des Arts décoratifs,
1920—Lyon-Barcelona-Nantes, 1990—1991,
no. 134, col. ill. p. 94

*Bibliography* Salomon 1945, p. 61—Roger-
Marx 1946a, p. 79—Cogeval 1993 and 2002,
pp. 93—94, col. ill.

Vuillard was involved in the First World War
first as a participant and later as an observer.
When war broke out he was forty-six, too
old for active service, but he was mobilized in
August 1914 as a railway patrolman at Con-
flans-Sainte-Honorine and served in that
capacity until his release the following De-
cember. Two years later he found himself
again faced with the war, but this time as an
artist. In November 1916 the Ministry of War
and the government department responsible
for the fine arts approached a number of art-
ists with the proposal that they travel to the
front as observers to record the historic events
taking place. Bonnard, Denis, René Piot,
Henri Lebasque and Vallotton thus became
"Army painters" for some weeks, although
Jacques-Émile Blanche refused, feeling they
would be given the same welcome as "rich
ladies…when they set out on works of charity
in the slums."[1] Vuillard himself received his
orders on January 25, 1917, and on February 4
arrived in Gérardmer in the Vosges. He spent
three weeks at the front with his colleague
Paul Baignères. From the start he carefully
noted down all his impressions: "soldiers Sun-
day crowd; go to the casino, soldiers' room,
night-club songs. Concert by soldiers; the tal-
ent; go back to hotel, feel suddenly depressed,
go and see cap. Baignères again around six
o'clock, soldiers' café, grey crowd, go to bed
straight after dinner, sleep at 11."[2] In spite of
the uneasiness, even hostility, aroused by
his presence, Vuillard was allowed to witness
the interrogation of German prisoners. He
felt a "violent interest of all kinds" and imme-
diately found the subject he was looking for,
beginning work on it as soon as he got back to
Paris on February 23: "try to execute scene
of prisoner" (February 26, 1917).[3]

In a compositional device that would recur
often in his work, the slightly elevated view-
point accelerates the perspective, thereby
offering a glimpse at the lower right of the
officer conducting the interrogation. In the
centre, the gaunt figure of the German soldier
is counterbalanced by the stove, whose pipe
lends structure to a receding, totally non-
objective space. Looking on are two men of
the Alpine light infantry, swiftly sketched sil-
houettes one of which remains featureless.
The violence at the heart of this wretched yet
banal act of war, evoked by the distorted per-
ception of space and the dehumanized nature
of the action, is as much visual as moral—
all the faces are actually reduced to little more
than masks. The predominantly blue-grey
tones emphasize the icy atmosphere—literal
and figurative—of the scene. Claude Roger-
Marx clearly recognized the power of this
untypical work: "The change in the soldiers'
uniform from red to blue brought the war
within Vuillard's range of colour. The green-
ish discoloured spectre dragged into the sor-
did guard-house—the mean objects set
out on a bench (poor relics stripped from the
living and the dead) are full of misery."[4]
Guy Cogeval likens the violent pessimism of
*The Interrogation of the Prisoner* to the spirit
of German Expressionism.[5] It is certainly
true that while not reaching the extremes of
anguish conveyed by artists like Otto Dix,
Max Beckmann or Ernst Ludwig Kirchner,
this officially commissioned painting cannot
be classified as visual propaganda. In its des-
peration and dignity, it is the picture of a
spectral humanity defeated by History. LC

1. Quoted in Thomson 1988, p. 122.

2. Vuillard, *Journal*, III.1, fol. 45r.

3. Ibid., fol. 49r.

4. Roger-Marx 1946a, p. 79 (trans. slightly modified).

5. Cogeval in C-S 2003, no. X.24.

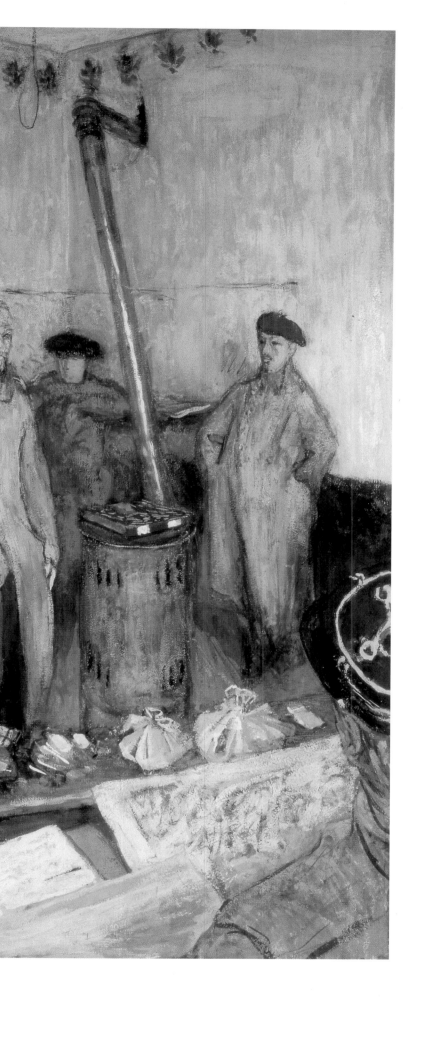

282

1. Édouard Vuillard, *Study for "The Chapel at the Château de Versailles,"* 1917, graphite on paper, private collection.

2. Édouard Vuillard, *Study for "The Chapel at the Château de Versailles,"* 1917, graphite on paper, private collection.

# 283

### THE CHAPEL AT THE CHÂTEAU DE VERSAILLES · *La Chapelle du château de Versailles*

1917, 1919, reworked in 1926–1928, distemper on paper mounted on canvas, 96 × 66
Signed l.r.: *E Vuillard*
Paris, Musée d'Orsay, Jacques Laroche donation (with life interest retained), 1947. Entered museum in 1976

Cogeval-Salomon x.187

———

*Provenance* Acquired from the artist by Jos Hessel and Bernheim-Jeune, Paris—Jean Laroche, Paris—Laroche Donation to the Musées nationaux, 1947—Musée d'Orsay, Paris

*Exhibitions* Paris, Musée des Arts décoratifs, 1938, no. 164, ill.—Paris, Charpentier, 1948, no. 71bis—Milan, Palazzo Reale, 1959, no. 84, ill.—Hamburg-Frankfurt-Zurich, 1964, no. 71, ill.—Munich, Haus der Kunst, 1968, no. 112, col. ill.—Paris, Orangerie, 1968, no. 150, col. ill.

*Bibliography* Salomon 1945, p. 61, ill. p. 63—Chastel 1946, p. 104—Roger-Marx 1946a, p. 80, ill. p. 69—Thomson 1988, p. 123, col. pl. 113—Rosenblum 1989, col. ill. p. 611

———

Paradoxically, this calm and peaceful painting emerged from a world war. In the midst of the turmoil, Vuillard found in this tribute to the classicism of Versailles—also much studied by Maurice Denis—a way of exorcising the misery of the times and situating his own work within the continuity of a specifically French kind of sensibility. In this painting, the chapel at Versailles plays a role comparable to that of the galleries of the Louvre in the Bauer decoration (cats. 287–288), undertaken after the war was over, although here the mood of nationalism is more pronounced—it was at Versailles that the German Empire had been proclaimed in 1871. The precise subject of the work was provided by a concert organized by the Société des Amis des Cathédrales that Vuillard attended on June 29, 1917: "go to Versailles to the chapel; the public in the train; delighted interest of the chapel; the paintings; the decoration...straight lines."[1] Among the works performed were Henry Du Mont's *Dialogus de anima*, Michel de Lalande's *Miserere* and Jean-Philippe Rameau's *In Convertendo*. It was clearly the memory of the perfect congruity between music and architecture that the painter wished to celebrate. He left nothing to chance, sketching on his concert program[2] elements of the architectural and sculptural decoration visible from the gallery and drawing Claude Poirier's relief of *The Presentation of Jesus in the Temple* in particular detail (figs. 1 and 2). This celebration would not have been complete without a female presence. It is incarnated here in the figure of a young woman seen from behind, her astonishing red-gold hair spreading out across the blue of her dress and enlivening the grey-mauve tones of the background. At the far right of the composition another blue—the sky blue of an infantry uniform—recalls the value of such tranquil moments in the midst of a shattered world. LC

———

1. Vuillard, *Journal*, III.2, fol. 19v.

2. This program is held at the Salomon Archives.

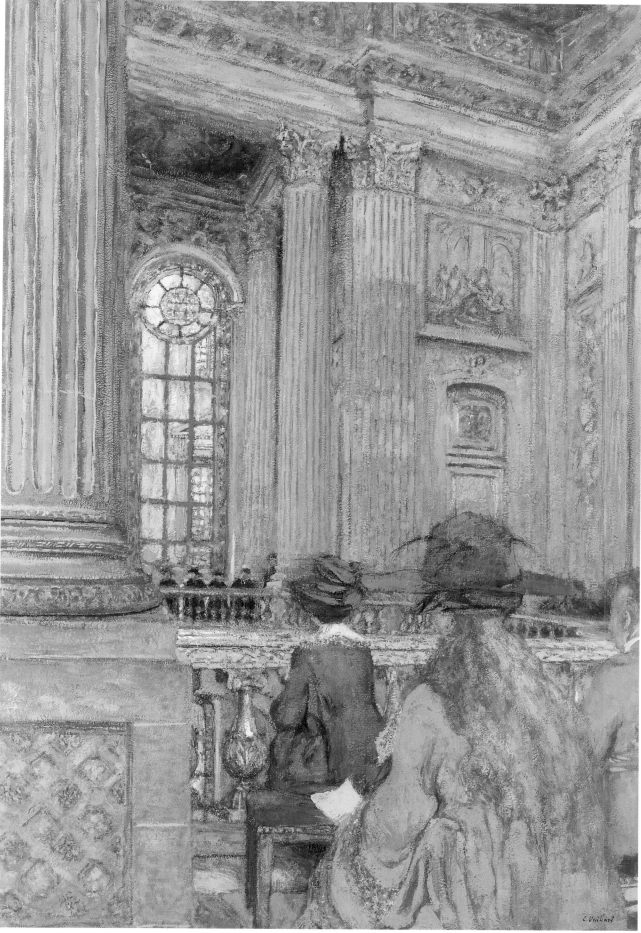

283

284

285

Cogeval-Salomon XI.179

## 284

VUILLARD'S MANTELPIECE
(OVERDOOR I) · *La Cheminée de
Vuillard. (dessus-de-porte I)*

1922, distemper on canvas, 45 × 115
Signed and dated l.r.: *E. Vuillard 1922*
Collection of Hans-Peter Bauer

Cogeval-Salomon XI.179-5

*Provenance* Commissioned from the artist
by Camille Bauer, Basel—Bauer Collection,
Switzerland—Sale, Sotheby's, London,
Dec. 5, 1990, lot 127 (col. ill.)—Private
collection

*Exhibitions* Munich, Haus der Kunst 1968,
no. 154, ill.—Paris, Orangerie, 1968,
no. 159, ill.

*Bibliography* Salomon 1945, pp. 64, 101

## 285

VUILLARD'S MANTELPIECE
(OVERDOOR II) · *La Cheminée de
Vuillard. (dessus-de-porte II)*

1922, distemper on canvas, 45 × 115
Signed and dated l.r.: *E. Vuillard 1922*
Collection of Hans-Peter Bauer

Cogeval-Salomon XI.179-6

*Provenance* Commissioned from the artist by
Camille Bauer, Basel—Bauer Collection,
Switzerland—Sale, Sotheby's, London, Dec.
5, 1990, lot 128 (col. ill.)—Private collection

*Exhibitions* Munich, Haus der Kunst, 1968,
no. 153, ill.—Paris, Orangerie, 1968,
no. 158, ill.

*Bibliography* Salomon 1945, pp. 64, 101

## 286

THE MEDIEVAL GALLERY AT THE
MUSÉE DES ARTS DÉCORATIFS · *La
Salle du Moyen Âge au Musée des Arts
décoratifs*

1922, distemper on canvas, 97 × 115
Signed and dated l.r.: *E. Vuillard 22*
Private collection

Cogeval-Salomon XI.179-4

*Provenance* Commissioned from the artist
by Camille Bauer, Basel—Bauer Collection,
Switzerland—Sale, Sotheby's, London,
Dec. 5, 1990, lot 126 (col. ill.)—Private
collection

*Exhibitions* Hamburg-Frankfurt-Zurich,
1964, no. 75, ill.—Munich, Haus der Kunst,
1968, no. 156, ill.—Paris, Orangerie, 1968,
no. 155, ill.

*Bibliography* Salomon 1945, pp. 64, 101—
Cogeval 1993 and 2002, pp. 81–83

## 287

THE SALLE LA CAZE AT THE
LOUVRE · *La Salle La Caze au Louvre*

1921, distemper on canvas, 157 × 137
Signed and dated l.r.: *E. Vuillard 21*
Collection of Albert Bauer

Cogeval-Salomon XI.179-1

*Provenance* Commissioned from the artist
by Camille Bauer, Basel—Bauer Collection,
Switzerland—Sale, Sotheby's, London,
Dec. 8, 1997, lot 7 (col. ill.), withdrawn—
Private collection

*Exhibitions* Munich, Haus der Kunst, 1968,
no. 157, ill.—Paris, Orangerie, 1968,
no. 156, ill.

*Bibliography* Salomon 1961, col. ill. p. 141—
Thomson 1988, p. 138, col. ill. no. 127—
Cogeval 1993 and 2002, pp. 81–83, col. ill.
p. 83

## 288

THE SALLE DES CARIATIDES AT
THE LOUVRE · *La Salle des Cariatides
au Louvre*

1921, distemper on canvas, 167 × 138
Signed and dated l.l.: *E. Vuillard 21*
Collection of Hans-Peter Bauer

Cogeval-Salomon XI.179-2

*Provenance* Commissioned from the artist
by Camille Bauer, Basel—Private collection

*Exhibitions* Munich, Haus der Kunst,
1968, no. 155, ill.—Paris, Orangerie, 1968,
no. 154, ill.

*Bibliography* Salomon 1961, col. ill. p. 138

This decorative ensemble constitutes the most
ambitious and most personal of Vuillard's
tributes to the art of museums. This medita-
tion on the artistic and humanist legacy of
France cannot be fully appreciated without
taking into account the circumstances of the
commission. Jacques Salomon tells us that
Vuillard met Judlin, a representative of the
Swiss industrialist and collector Camille
Bauer, at Conflans-Sainte-Honorine in 1914,
while the painter was doing his military serv-
ice.[1] Vuillard was, it appears, free to choose
the specific subjects for the various works.
The complete decorative ensemble, which
consisted of two pairs of panels installed
facing one another, and two overdoors, re-
mained in Camille Bauer's home in Basel
until the 1960s.[2] The commission was carried
out in two stages. Vuillard first delivered
*The Salle des Cariatides* and *The Salle La Caze*,
which he worked on between January 1920
and May 1921. The Louvre had recently re-
opened, and Vuillard began to visit it almost
daily, combining work with the endless
pleasure of re-exploring its treasures after a
lengthy period of privation. A compulsive
draftsman, he revelled in these sessions,
absorbing and recording every detail of the
objects, furniture, architecture and picture
frames. For example, he produced extremely
thorough studies of some of the antiquities in

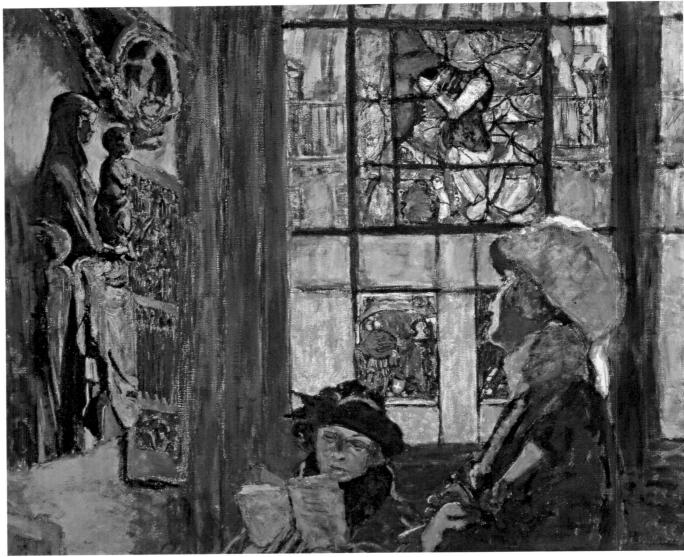

286

the Salle des Cariatides: the *Richelieu Bacchus*, the *Mercury Tying His Sandal* and the Borghese vase. This last became the subject of one of the first two panels, where it is portrayed in a particularly striking close-up view (cat. 288). The paintings of the La Caze collection, donated to the Louvre in 1869, were also carefully analyzed. Vuillard plainly declared his love of eighteenth-century French painting by copying Fragonard's *Study*, a *Pastorale* now attributed to Norblin de la Gourdaine, Watteau's *Nymph and Satyr*, Chardin's *Olive Jar* and a *Portrait of a Man* by Largillière.[3]

From Vuillard's first two Bauer canvases it becomes clear that the central object of the series is a celebration of the human gaze, represented by the recurrent presence of Annette Roussel and her fiancé Jacques Salomon, our doubles and our guides. Of course, this recreation of a museum visit, broken down in this case into independent sequences, had

1. Edgar Degas, *At the Louvre: The Etruscan Gallery*, c. 1879, etching, varnish, aquatint and drypoint, Washington, National Gallery of Art, Rosenwald Collection.

a famous precedent that did not escape the painter. The connections to Degas's prints, *At the Louvre: The Etruscan Gallery* and *At the Louvre: The Paintings Gallery* (figs. 1–2), were in Vuillard's mind from the start: "Louvre with Annette, sketch, unusual subject, suddenly think of analogies Degas" (May 4, 1920).[4]

After seeing the first two panels installed in their Basel home in December 1921, Vuillard began to work on the second part of the commission, which he executed between January and July 1922. This consisted of *The Salle Clarac* (fig. 3), *The Medieval Gallery at the Musée des Arts décoratifs* and the overdoors representing Vuillard's mantelpiece. Although the artist was greatly concerned with the decorative coherence of the suite of panels, this second part nevertheless shows slight differences of approach. The vision is perhaps less broad than in the first panels, but the compositions are more intricate and we find some of

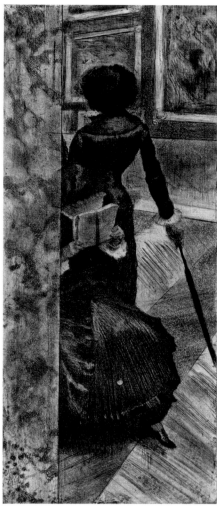

2. Edgar Degas, *At the Louvre: The Paintings Gallery*, c. 1879, etching, varnish, aquatint and drypoint, Washington, National Gallery of Art, Rosenwald Collection.

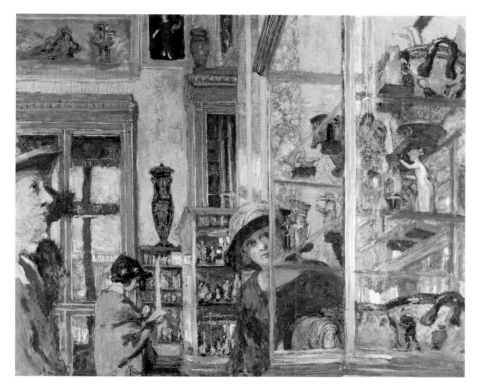

3. Édouard Vuillard, *The Salle Clarac*, 1922, distemper on canvas, Toledo Museum of Art, Purchased with funds from the Libbey Endowment, Gift of Edward Drummond Libbey 1999.2, C-S XI.179-3.

the artist's favourite stylistic devices. These include the spatial amplification created by the reflections of the glass doors, the windows and the showcase full of Greek ceramics in *The Salle Clarac*, and the transparency effects of the stained-glass window in *The Medieval Gallery*, over which the painter took some care. The two overdoors were based on a "'true' still-life arrangement" (April 19, 1922), "the kind of unadventurous but meticulous work of my youth" (May 8, 1922). The mantelpiece of the apartment on Rue de Calais was loaded down with a model of the *Venus de Milo's* torso, Tanagra figurines also seen in the portrait of *Madame Val-Synave* (1917, 1919–1920, distemper on canvas, priv. coll., c-s x.233) and a small plaster of the *Apollo Belvedere*, together with "Japanese prints, a cashmere shawl and parrot tulips" (May 12,

1922).[5] This purely decorative stylistic exercise brought Vuillard back to his earliest paintings, still lifes strongly marked by the influence of Chardin. This work, a seemingly more modest counterpoint to the ambitious vision of the Louvre galleries, nonetheless prompted him to reflect on painting: "session overdoor panel; letters hierarchy of values, pleasure when one understands it; older ways of understanding agree with the new (Delacroix, colourists (!!) of my youth and now Bonnard, Monet, Corot)" (May 22, 1922). The reflection continues a while later, after another visit to the museum: "Louvre…tour of the galleries, the Sabine women, Ingres; the pearl, Delacroix, go back to the ceramics; Matisse, the magnificent Courbet; question arises while looking at the Ingres" (June 30, 1922).[6] It is actually the sense we have of a personal meditation on the art of the past and on creation that relieves the decoration as a whole of the solemnity that the subject and the overwhelming historical context might easily have imposed. The artist's need to infuse this meditation with an emotional dimension through the inclusion of people close to him is in itself most revealing. Unlike Degas, who explored the nature of the human

gaze from an ironic distance, according little importance to the works, Vuillard adopts an approach that is entirely unambiguous. The works in the Louvre and the objects in his home on Rue de Calais constitute a private inventory selected for the joy of it, but also chosen—and more significantly—from a need to come to terms with an inheritance. Vuillard cannot help seeing either a masterpiece or a simple plaster as a source of both doubt and encouragement. LC

1. Salomon 1961, p. 137.

2. See the disposition of the works presented in c-s 2003, no. XI.179.

3. For a complete identification of the works, see entries by Marie-Anne Dupuy in *Copier Créer. De Turner à Picasso : 300 œuvres inspirées par les maîtres du Louvre*, exhib. cat. (Paris: Réunion des musées nationaux, 1993), pp. 68–71.

4. Vuillard, *Journal*, III.6, fol. 30v.

5. Ibid., III.8, fol. 24v, 31r, 32r.

6. Ibid., III.8, fol. 35r, 46r.

287

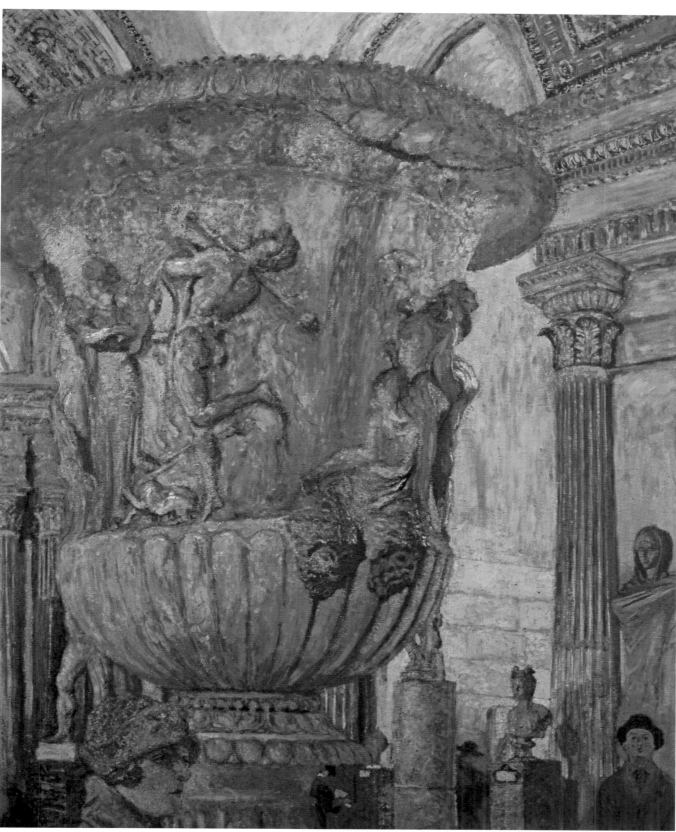

288

289

SELF-PORTRAIT IN THE DRESSING-
ROOM MIRROR · *Autoportrait dans le miroir
du cabinet de toilette*

1923–1924, oil on board, 81 × 67
New York, Dian Woodner and Andrea
Woodner

Cogeval-Salomon XI.167

———

*Provenance* Studio—Sam Salz, New York—
Woodner Family Collection—Dian Woodner
and Andrea Woodner, New York

*Exhibitions* Paris, Charpentier, 1948, no. 89—
Toronto-San Francisco-Chicago, 1971–1972,
no. 88, ill.—Lyon-Barcelona-Nantes, 1990–
1991, no. 144, col. ill. p. 52—Glasgow-
Sheffield-Amsterdam, 1991–1992, no. 97, ill.
p. 32

*Bibliography* Salomon 1961, p. 163, ill.—
Thomson 1988, p. 139, col. pl. 118—Cogeval
1993 and 2002, pp. 107, 110, col. ill. p. 111

———

Around this image of his aging self, Vuillard
assembles a kaleidoscope of works that have
inspired him. These copies and reproductions
form an inventory that is virtually an aesthetic
survey, ranging from the world of antiquity,
represented by the Stabiae *Flora*, to Michel-
angelo's *Zacharias*, and from the French clas-
sicism of Le Sueur's *Raymond Diocrès* and
Poussin's drawing of *Moses and the Daughters
of Jethro* to a print by Hiroshige from the
"One Hundred Views of Edo" series. The
artist's reflected image, a picture within a pic-
ture, adds to these allusions by including his
own works, the paintings that, in the midst
of the ordinary studio paraphernalia, cover
every inch of the wall. Vuillard's face and
body show his age, but it is the blind-looking
eyes that betray it most cruelly. Guy Cogeval
compares this painting to work by Edvard
Munch, especially his *Self-portrait between
Clock and Bed* (fig.1), which presents a similar
picture of anguish amid the familiar surround-
ings of past works.[1] Closer to Vuillard's time,
we are inevitably reminded also of Bonnard's
astounding late self-portraits (fig. 2), which,
like this painting, demonstrate the bitter vic-
tory of lucidity over age. LC

———

1. Cogeval in C-S 2003, no. XI.167.

1. Edvard Munch, *Self-portrait between Clock and Bed*, 1940–1944,
Oslo, Munch Museet.

2. Pierre Bonnard, *Self-portrait*, 1945, Toulouse, Fondation Bemberg.

MADAME VUILLARD LIGHTING THE
STOVE · *Madame Vuillard allumant le mirus*

1924, oil on paper mounted on canvas,
63.5 × 74.3
Signed l.r.: *E. Vuillard*
Flint Institute of Arts, Michigan, Gift
of The Whiting Foundation through Mr.
and Mrs. Donald E. Johnson, 1971.12

Cogeval-Salomon XI.128

———

*Provenance* Jos Hessel, Paris—Arthur Tooth
& Sons, London—Edward Le Bas, London,
1937—Norton Simon, Los Angeles, 1962—
Simon Sale, Sotheby's, New York, May 5,
1971, lot 69 (col. ill.)—Flint Institute of Arts,
gift of The Whiting Foundation, 1971

*Exhibitions* Paris, Musée des Arts décoratifs,
1938, no. 189—London, Wildenstein, 1948,
no. 53—Edinburgh, Royal Scottish Academy,
1948, no. 111, ill.—Munich, Haus der Kunst,
1968, no. 110, ill.—Paris, Orangerie, 1968,
no. 152, ill.—Toronto-San Francisco-
Chicago, 1971–1972, no. 89, ill.

*Bibliography* Roger-Marx 1946a, p. 81, ill.
p. 70—Salomon 1961, p. 147, ill.

———

This painting shows Madame Vuillard, com-
plete with her characteristic little white cap,
kneeling awkwardly toward the stove in
Vuillard's studio on the second floor of their
Rue de Calais home. The work was executed
between February and April 1924, four years
before Madame Vuillard's death.[1]

Iconographically, the painting relates to the
extensive group of studio interiors made after
1900, which are populated by nude models
(see cats. 277–280), sitters and fellow artists
(see cats. 291–292), or treated as still-life
subjects (see cat. 281). Here, pictures and
prints adorn the walls, while the mantelpiece
supports such atelier props as the plaster cast
of the head and torso of the *Venus de Milo*,
alongside an array of smaller maquettes. An
easel closes off the left-hand edge of the com-
position. Despite an enhanced clarity in the
articulation of space and in individual descrip-
tion, these elements, together with the figure
of the artist's mother, are characteristically

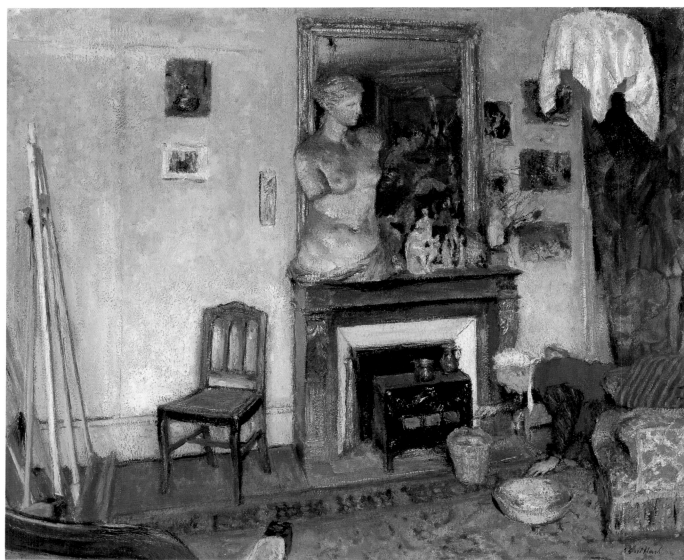

290

rendered in the muted beiges and greys that set the overall tonality of the work. In this the painting conforms to Vuillard's *intimiste* approach to interiors, in which no single element is permitted a primacy that might threaten to introduce an anecdotal note into what remains essentially an exercise in tonal harmonies, textures and atmosphere. It was this objective, consistent throughout his work as a *peintre d'intimisme*, that Raymond Cogniat identified in his review of the major retrospective exhibition of Vuillard's work held in 1938 at the Musée des Arts décoratifs, in Paris: "Man, in all these paintings [of interiors], is generally no more important than the vase of flowers or the table."[2]

While the finished painting may suggest a desire to avoid overt naturalism, the story of its genesis, as recalled by Jacques Salomon, nonetheless serves to underline the importance for Vuillard of an initial contact with reality in the creative process: "Arriving at Vuillard's house one morning, I came upon this scene… of course, she [Madame Vuillard] was happy to pose for her son, she was used to it, but her expression indicated that this time he'd gone too far. When Vuillard, while continuing to sketch, told her it was…nearly over, Madame Vuillard sighed discreetly. Playful remonstrations about the well-known cruelty of artists toward their models soon petered out, and before long, rubbing her knees, she was in her son's arms, as he helped her up and gave her a kiss, pleading forgiveness for having been so hard on his elderly Mama."[3] In fact, Vuillard took a photograph of this exact framing and obviously used it to execute the painting.[4] MAS

1. A letter from Juliette Weil to Vuillard dated March 8, 1924 makes reference to "the little painting of your Mama tending the fire like a vestal virgin." Paris, Salomon Archives.

2. Raymond Cogniat, "Vuillard au Musée des Arts décoratifs : Du tableau de chevalet aux grandes compositions," *Beaux-Arts*, vol. 75, no. 278 (April 29, 1938), p. 3.

3. Salomon 1968, p. 157.

4. See Cogeval in C-S 2003, no. XI.128.

**The Anabaptists: Bonnard, Denis, Maillol, Roussel · *Les Anabaptistes: Bonnard, Denis, Maillol, Roussel* (291–292)**

Cogeval-Salomon XI.120

*Joint provenance* Acquired from the artist by the City of Paris for the Musée du Petit Palais, Paris, 1937; Musée d'Art Moderne de la Ville de Paris

*Joint exhibitions* Paris, Musée des Arts décoratifs, 1938, nos. 184–187—Brussels, Palais des Beaux-Arts, 1946, nos. 1–4—Basel, Kunsthalle, 1949, nos. 225 (Bonnard), 238 (Denis) and 224 (Maillol)

*Joint bibliography* Escholier 1937, p. 22—Roger-Marx 1945, pp. 112–113—Salomon 1945, p. 135, ill. p. 129 (Bonnard), 138 (Maillol)—Roger-Marx 1946a, pp. 95–96, 105, ill. p. 113 (Roussel), 114 (Bonnard, Denis), 115 (Maillol)—Thomson 1988, pp. 126, 150, col. pl. 119 (Roussel), pl. 121 (Maillol)

# 291

THE ANABAPTISTS: PIERRE BONNARD · *Les Anabaptistes. Pierre Bonnard*

1931–1934, reworked in 1936–1937, distemper on canvas, 114.5 × 146.5
Signed l.r.: *E. Vuillard*
Musée d'Art Moderne de la Ville de Paris, AMVP 2557

Cogeval-Salomon XI.120-3

*Exhibitions* [see *Joint exhibitions*] London, Wildenstein, 1948, no. 50—Paris, Charpentier, 1948, no. 84

# 292

THE ANABAPTISTS: MAURICE DENIS · *Les Anabaptistes. Maurice Denis*

1931–1934, reworked in 1936–1937, distemper on canvas, 116 × 140.6
Signed, l.r.: *E. Vuillard*
Musée d'Art Moderne de la Ville de Paris, AMVP 2558

Cogeval-Salomon XI.120-4

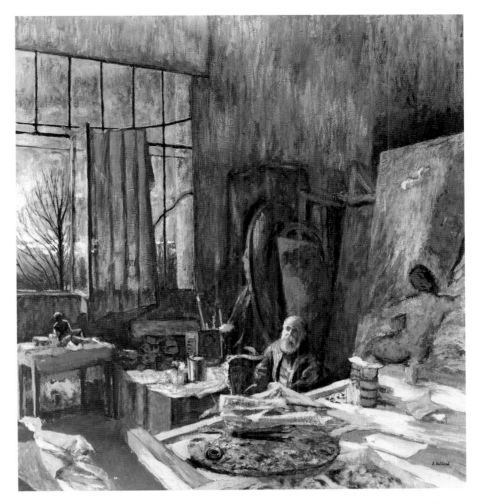

1. Édouard Vuillard, *The Anabaptists: Kerr-Xavier Roussel*, 1931–1934, reworked in 1935–1937, distemper on canvas, Paris, Musée d'Art Moderne de la Ville de Paris, C-S XI.120-2.

These two works belong to a series of four portraits that Vuillard devoted to his friends Maillol, Roussel, Bonnard and Denis, all former Nabis. In fact, the series was not initially conceived as a whole and only came together gradually, first in the form of maquettes, then as finished works, which were united definitively upon their entry into the collections of the City of Paris. In August 1936, Vuillard was approached by the curator of the Musée du Petit Palais, Raymond Escholier, who wanted to acquire the four paintings, which, meanwhile, had been sent twice (in 1934 and 1937) to the Venice Biennale, along with the four sketches initially promised to Albert Henraux. The somewhat disconcerting title, *The Anabaptists*, apparently stemmed from a joke made by Roussel, but Vuillard adopted it in his journal in November 1935. Less anecdotal than it might seem, this reference to a "second baptism" at maturity was both a tribute to and a reflection on the work of the artist, at a time when some of the friends of Vuillard's youth had already died: Vallotton in 1925, Sérusier in 1927.

Vuillard conceived of his *Roussel* (fig. 1) as a complement to his portrait of *Maillol* (fig. 2)—"seeking pendant to the Maillol"—which he had begun in the summer of 1923.[1] The works did not advance beyond the state of "maquettes" (Vuillard's expression) until 1928, when the idea of a third composition took shape with the *Bonnard*: "go at 11 o'clock to Bonnard's first Rue Tourlaque then to Batignolles, chat, sketch silhouette picture; question of his first prints…worked all day oil sketch of Bonnard from morning drawing, with great enthusiasm, pleasure" (December 9, 1928).[2]

In his Parisian *pied-à-terre* at 48, boulevard des Batignolles, Bonnard was observed by Vuillard, in an atmosphere of silent affinity, as he contemplated his recent *Panoramic View of Le Cannet* (1928, priv. coll.), tacked to the wall. The brilliant conceit of the painter's shadow, from which the form of his basset hound, Pouce, emerges like a punctuation

mark, conveys something of the great affection Vuillard felt toward his friend's world. Indeed, this painting says much about the lengthy, reserved and mutually respectful friendship that linked the artists to the end of their lives. The journal contains numerous references to Bonnard's visits, which Vuillard looked forward to with both eagerness and trepidation, so much did Bonnard's judgment count in his eyes. Here the situation is reversed: the focus is on a dialogue between the artist and his own creation, and it is Vuillard's turn to look at and interpret Bonnard's work. Neither the studio nor the spectacular landscape disturb the intimate and dreamy character of the image. A few elements—the open

box of paints, the tones borrowed from Bonnard (the tender greens and pinks of the walls and ceiling)—are enough to conjure the painter's work.

In May 1930, Vuillard began the fourth painting, which depicts Maurice Denis decorating the apse of the Franciscan chapel at Rouen: "Thursday 8 get up early, train 8 am Rouen, sleep in the train; derailment delay; Denis at the station; running as if 20 years old; breathless Rue Joyeuse, chapel, scaffolding; curtains, planks, trestle, light bulbs; trucks, brushes; Denis in blue overalls; violets greens; light; blues browns; lights on the forehead, rosy hands; stairs to the right, clothing, interest figure, pinks of Elizabeth, St. Francis; the student on the ladder" (May 8, 1930).[3] Denis is the only one of the four "Anabaptists" who

2. Édouard Vuillard, *The Anabaptists: Aristide Maillol*, 1931–1934, reworked in 1935–1937, distemper on canvas, Paris, Musée d'Art Moderne de la Ville de Paris, C-S XI.120-1.

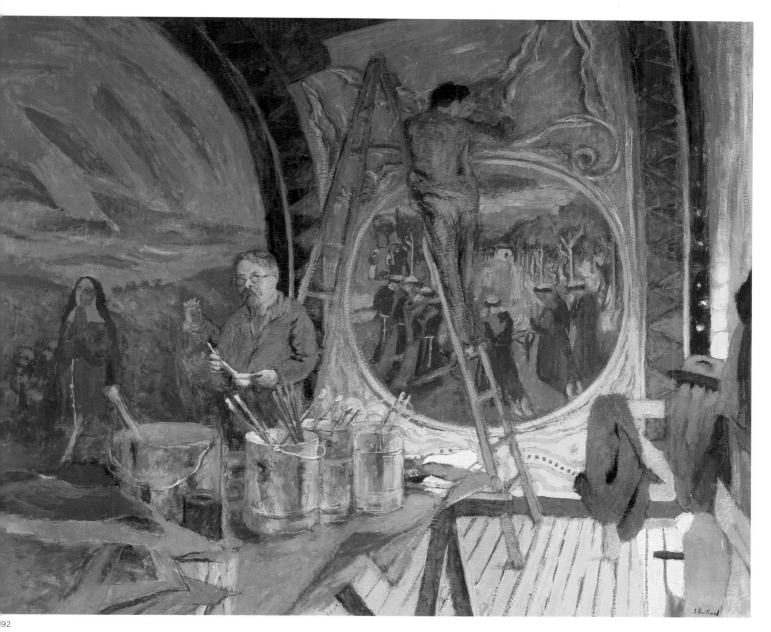

looks directly at the viewer, a basic feature
of the traditional portrait form not shared by
the pendant works. Under the curve of the
chapel's vault, the discreetly placed figure of
Denis, set back a little, is nonetheless the cen-
tre of a broad circular movement that brings
together all the stages of his work, from the
paint jars to the ongoing decoration. The live-
liness of the pink of the tondo border and of
the blue indentations recall the most violent
audacities of Denis's own palette. More spec-
tacular than the image of Bonnard, this por-
trait also evokes the (often frustrated) public
decoration ambitions of a whole generation.
Denis had, moreover, perfectly understood
how Vuillard's undertaking was the fruit of a
friendship in which, confronted by the passage
of time, differences had been suppressed:

"Vuillard wrote me that he wants to do some-
thing with me on my scaffolding. He came
Thursday and took an hour to make his
sketches…I find him aged…Our reunion was
full of joy, trust, complete harmony about
what has united us, painting. But how many
of life's essential things we reciprocally set
aside, not out of discretion but out of a fear
of putting our feelings to the test."[4] LC

1. As first pointed out by Cogeval in c-s 2003, no. XI.120.
Vuillard, *Journal*, III.(S).B, fol. 38r (August 26, 1923).

2. Ibid., III.(S).I, fol. 20r .

3. Ibid., IV.1, fol. 104v .

4. Denis 1959, p. 122.

1. Édouard Vuillard, *Doctor Georges Viau in His Dental Office*, 1914, oil on canvas, Paris, Museé d'Orsay, C-S IX.234.

## 293

DOCTOR LOUIS VIAU · *Le Docteur Louis Viau*

1936–1937, distemper on canvas, 88 × 81
Signed l.r.: *E. Vuillard*
Paris, Musée d'Orsay, Saint-Germain-en-Laye, Musée du Prieuré (on deposit from the Musée d'Orsay)

Cogeval-Salomon XII.129

---

*Provenance* Commissioned from the artist by Dr. Louis Viau, Paris—Réunion des musées nationaux, 1955; placed on deposit at the Musée départemental Maurice Denis "Le Prieuré," Saint-Germain-en-Laye, 1980

*Exhibitions* Paris, Musée des Arts décoratifs, 1938, no. 216—Basel, Kunsthalle, 1949, no. 216, ill.—Cleveland-New York, 1954, p. 104, ill. p. 89

*Bibliography* Salomon 1945, p. 66—Roger-Marx 1946a, pp. 79, 117–118, 158, ill. p. 116—Schweicher 1949, pp. 75, 99, 104—Cogeval 1993 and 2002, p. 107, col. ill.

---

In this, the last of Vuillard's medical portraits, Dr. Louis Viau (1868–1940) is not shown actually engaged in the practice of his profession. This fact distinguishes it from the portraits of *Doctor Georges Viau in His Dental Office* (fig. 1) featuring the sitter's uncle, *Doctors Vaquez and Parvu at Saint-Antoine Hospital* (c-s XI.250) and *Doctor Vaquez at Saint-Antoine Hospital* (c-s X.211), and from the masterpiece of the series, *The Surgeons* (cat. 306). Here, the dental surgeon poses in the middle of his office with an air of self-assurance that is somewhat contradicted by his unimposing figure, which seems almost lost in the luxurious interior of his Boulevard Haussman apartment. There are, in fact, two "characters" in the painting: the doctor himself and, perhaps more striking, the ensemble composed of his medical-dental equipment and the empty patient's chair. The incongruous intrusion of these items—probably very up-to-date for the time—into the classical setting is actually as important as the presence of the doctor. In his preparatory sketches, Vuillard made detailed renderings of these odd and vaguely threatening shapes, and of the play of light on the modern materials. Claude Roger-Marx noted that "the unity of the colouring is assured by the tender Paris light, which coming through a window caresses twenty surfaces of nickel, glass, aluminium and white lacquer."[1] In the modernist spirit of the 1930s, Vuillard presents here the very picture of technical medicine, but the elderly painter is clearly more amused than intimidated. LC

---

1. Roger-Marx 1946a, p. 118.

1. Édouard Vuillard, *Peace, Protector of the Muses*, 1938, distemper on canvas, C-S XII.134. Photograph of the decoration in situ, in Roger-Marx 1946a, p. 167.

## 294

PEACE, PROTECTOR OF THE MUSES:
DECORATION FOR THE PALAIS DE LA
SOCIÉTÉ DES NATIONS, GENEVA
(FIRST SKETCH) · *La Paix protectrice des
Muses. Décoration pour le Palais de la Société
des Nations, Genève (première esquisse)*

1937–1938, pastel on paper, 108 × 69
Private collection

Cogeval-Salomon XII.141

## 295

PEACE, PROTECTOR OF THE MUSES:
DECORATION FOR THE PALAIS DE LA
SOCIÉTÉ DES NATIONS, GENEVA
(SECOND SKETCH) · *La Paix protectrice
des Muses. Décoration pour le Palais de la
Société des Nations, Genève (deuxième
esquisse)*

1937–1938, pastel on paper, 109 × 70
Private collection

Cogeval-Salomon (hors. cat.)

## 296

PEACE, PROTECTOR OF THE MUSES:
DECORATION FOR THE PALAIS DE LA
SOCIÉTÉ DES NATIONS, GENEVA
(THIRD SKETCH) · *La Paix protectrice des
Muses. Décoration pour le Palais de la Société
des Nations, Genève (troisième esquisse)*

1937–1938, pastel on paper, 108 × 69
Private collection

Cogeval-Salomon (hors. cat.)

---

During the second half of the 1930s Vuillard received official recognition in several ways. His admission to the Institut de France in 1937 in fact coincided with the only two government commissions he was ever granted, a panel for the Palais de Chaillot and his part in the decoration for the debating chamber of the League of Nations in Geneva, the gigantic scale of which made it the largest decoration the painter ever undertook (fig. 1). Initially, the four commissioned works for the debating chamber—a gift from France to the League of Nations—were to be executed by Vuillard, Bonnard, Denis and Roussel. The first

mention of the project is found in a letter from Vuillard to Bonnard, dated March 1935: "These fifteen-metre-high bands only start six metres from the floor and run up to the ceiling …This all quite extraordinary. Will it ever come to anything? In any case we can dream about these unusual surfaces and the way in which they might be filled; this is why I decided to write to you, though it isn't very easy and raises a lot of objections."[1] Bonnard, appalled by the scale of the undertaking, finally resigned and was replaced by Roger Chastel.

Vuillard had always longed to confront the challenge of large public art, thus following in the footsteps of Puvis de Chavannes. His old admiration for the creator of the décor of the Musée d'Amiens, *Peace* and *Ave Picardia Nutrix* (1861–1865), and that of the Musée de Lyon, *Sacred Wood Dear to the Arts and Muses* (1884–1886)—so similar in theme to the League of Nations project—never faltered. In 1926, in an interview he granted to Puvis's nephew, he reiterated the reasons for this deep respect: "Like all geniuses, Puvis de Chavannes was ahead of his contemporaries. The experiments in stylization and expressive synthesis typical of today's painting I see clearly in his art. At the beginning he was prone to very contradictory tendencies. How did he manage to choose among so many demands, to unleash his powerful personality, control his astonishing imagination that sometimes spilled over into absurdity? It would be interesting and extremely useful to show and demonstrate the answers to these questions . . ."[2] The model of Puvis thus guided Vuillard's studies for this ambitious project. Indeed, among his notes and sketches for the decoration (priv. coll.) we find Mallarmé's tribute to Puvis de Chavannes (1895), copied out like a talisman by the painter.[3]

After a certain amount of debate, an iconographic program on the virtues of Peace was decided upon, and Vuillard was allotted the subject of *Pax Musarum Nutrix*. Although the example of Puvis and his humanist legacy provided the underpinning for his creation of the décor, Vuillard's artistic solutions also owed a debt to the great Roman models.[4] The vertical format—covering eleven metres of

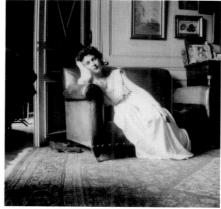

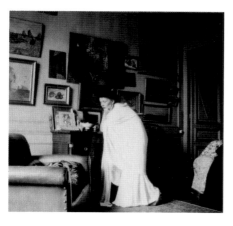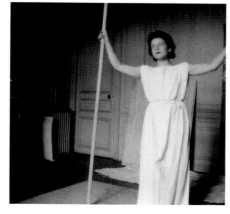

2. Photographs by Vuillard of Lulu Hessel posing for Peace and the Muses, c. 1937, private collection.

wall!—naturally called for a series of registers, which we see clearly worked out in the large preparatory pastels. These works are also indicative of the artist's various hesitations about the final path to take. The pastel technique was clearly of particular help to Vuillard in enabling him to grasp his composition in all its plastic and chromatic breadth. Finally, to clarify his plans, he wrote the program out carefully on a page of his sketchbook:

Peace, protector of the muses
At the top peace parting the clouds
Below in a ravine under woods the nine muses:
In the left foreground Urania muse of astronomy
On the right Clio muse of history
Behind Urania, Polymnia muse of epic poetry
In the centre Melpomene muse of tragedy
bends over a manuscript, to the right Thalia
muse of comedy leaning on an altar
In front of which are the tragic and comic masks
Between them Calliope writing
In the background from left to right
Terpsichore muse of the dance
Erato muse of love poetry
Euterpe muse of music[5]

To compose the various figures of the Muses, Vuillard drew on the art of the past: "after lunch to the Louvre, the Sueurs, Prud'hon (for the League of Nations project)" (February 12, 1937),[6] but also had recourse to photography and one of his favourite models. The amusing series of snapshots discovered by Guy Cogeval in which Lulu Hessel poses as Peace and the various Muses in turn (cat. 253 and fig. 2) offers evidence of a refreshing personal and emotional involvement that at least partially saves the project from the mood of bloodless and stereotypical symbolism that threatens it.

The installation of the canvases took place in August 1938, and Vuillard then undertook the final retouching in situ. The décor was perfectly in tune with the various efforts made during the 1930s to revive the art of the mural. But in terms of Vuillard's own career, this seems less significant than the elderly painter's rather poignant struggle with a larger-than-life project, and his realization of an old dream in the context of a somewhat superfluous palace. LC

1. Letter from Vuillard to Pierre Bonnard, March 25, 1935, published in Bonnard / Vuillard Correspondance, ed. Antoine Terrasse (Paris: Gallimard, 2001), pp. 80–81.

2. Puvis de Chavannes 1926.

3. See Cogeval in c-s 2003, XII.142.

4. Ibid.

5. Sketchbook, private collection.

6. Vuillard, Journal, IV.11, fol 5r.

294

295

296

"I DON'T PAINT PORTRAITS" | *Catalogue* **297–334**

"I DON'T PAINT PORTRAITS, I paint people in their homes."[1] Vuillard did not consider himself a portraitist. Yet not the least of the paradoxes posed by this rich facet of his oeuvre is that the portraits made a decisive contribution toward confirming his status among twentieth-century critics. In 1928 an exhibition entitled *Portraits d'aujourd'hui*, organized by Claude Roger-Marx and held at the Galerie Bernier, stirred up old disputes between the champions of the realistic, descriptive tradition as a source of inspiration in portraiture and the proponents of new artistic approaches, among them Cubism. Recalling the event in his 1946 monograph on the painter, André Chastel noted: "Vuillard had quite unwittingly been drawn into what could be called 'the portrait dispute.'"[2] Indeed, one can easily imagine that the "mutual challenge"[3] represented by the confrontation of Picasso's *Young Philosopher* and the painting of *Jean Giraudoux* by Vuillard (see fig. 12 of "Vuillard between Two Centuries," in the present volume) sprang from a theoretical, even ideological, battle that was not at all to the latter's taste. With age and experience on his side, Vuillard undoubtedly allowed a distance to insert itself between his work and the aesthetic debates of the time. The portraits were inevitably affected by this situation. For all that, the artist's almost atemporal autonomy had its source above all in the logic of the oeuvre, and one wonders whether the adjective "late," applied so often to this group of works, has not ultimately eclipsed the questions of real interest by compressing into one final chapter an exploration that spanned many years.

Vuillard actually began to be interested in portraiture as such around 1905, so his earliest works in the field obviously cannot be seen as a meditation of his declining years. Before the First World War he had already painted several of his portrait masterpieces: *Claude Bernheim de Villers* (cat. 298), *Gaston and Josse Bernheim* (cat. 299), *Mademoiselle Jacqueline Fontaine* (cat. 301), *Sacha Guitry in His Dressing Room* (cat. 302), *Théodore Duret in His Study* (cat. 304) and *Portrait of Henry and Marcel Kapferer* (cat. 305). Portraits focus principally on models, and thus on encounters and surroundings. Vuillard's new interest in the genre was clearly linked to the radical changes then taking place in his professional and social life. After signing a contract with the Galerie Bernheim-Jeune he found his social circle expanding, and he was soon mixing with the wealthy *grande bourgeoisie* and frequenting the world of *théâtre de boulevard*. What Vuillard was experiencing during these years was far from a sensitive retreat into himself: it was an opening up to the world and to others, one that is magnificently apparent in the early portraits. On seeing *Claude Bernheim de Villers* at the Salon d'Automne of 1906, Paul Jamot noted the "interesting development...toward a broader style and a more in-depth, portrait-like approach to the human figure."[4] The portraits were, moreover, an integral part of the revolution in light and space taking place in Vuillard's work at the turn of the century. We would therefore do well to emulate Vuillard's rejection of the overly narrow definitions inevitably suggested by the assigning of works to a specific genre. On the other hand, although the laconic and prosaic Vuillard claimed to be simply "painting people in their homes," it seems evident that his reflections on the new developments in an expressive form as codified as the portrait were rooted in the essentially modern tradition, dominated by Ingres and Degas. The portrait of *Théodore Duret* bears especially clear witness to this debt.

**Degas, Duranty, Duret** | IN A LETTER TO MARCEL Guérin written around 1930, Vuillard mentions a copy he has made of Edmond Duranty's text *La Nouvelle peinture* (1876) and says how important he considers it. In 1932 he recommended the same essay to Maurice Denis.[5] The reference should not surprise us, for certain passages of this militant, Degas-inspired text resonate powerfully in Vuillard's portraits of the time. The following description could apply to almost any of them: "And since we stick closely to nature, we no longer separate the figure from the background of the apartment or of the street. The figure would never appear to us, in real life, against a neutral, empty, vague background. But around and behind it there is furniture, mantelpieces, wall hangings, a backdrop that speaks of the subject's wealth, class, profession."[6] We are reminded of certain photographs of Marie-Blanche de Polignac's apartment (priv. coll.) when we read: "The message of the empty apartment should be clear enough for us to deduce the personality and habits of the person who lives there." Romain Coolus expresses the same idea when he discusses Vuillard's work in words that mirror Duranty's: "The artist directs a special beam onto the individual depicted; but that individual is for him just another object among all those that make up the life the individual belongs to. The subject is refracted in everything around him; his tastes and preferences are written in the furniture familiar to him and in all the details of the setting in which his life is spent."[7]

Vuillard's portraiture was based, then, on a rejection of hierarchy that sprang both from the edicts of an earlier generation of artists and from his own experience as a creator of decorative works. The painter's main goal was to avoid selection, to place his sitters and their surroundings at the same level. By blurring boundaries, by not reducing the portrait to a simple problem of physical resemblance but rather envisaging an ambitious and incredibly detailed *geography* of the subject, Vuillard found himself freer to question the traditional benchmarks of taste—those of his patrons, but also those of the critics and the public at large. It was these shifts, often combined with a formal approach full of references—to Ingres and Degas in particular—that allowed the artist to reveal, for example, the boredom underlying a feeling of harmony (*Perfect Harmony*, cat. 324) or to make vulgarity and dissonance fascinating (*Portrait of Marcelle Aron*, cat. 300; *Jane Renouardt*, cat. 319). It hardly needs pointing out that while these effects (with the historical perspective we bring to them) enchant us today, they counted against the painter for many years. André Lhote was clearly infuriated by the portrait of *Anna de Noailles* (cat. 322): "The vulgarity of the colours, the overstressing of the features, the accumulation of facial details, the blinding realism of the roses and the fabrics represent a triumph of the bad taste that each of us anxiously watches out for, ready to curb its wildest outbursts."[8]

The other result of the naturalist underpinnings of Vuillard's portraiture was his ability to meld these influences in an exercise of social typology unique in French painting of the time. Although archival documents and the artist's own journal suggest that his patrons had complete confidence in him, Vuillard, scrupulously mindful of the tacit restrictions of his commissions and of his material obligation to accept them, was sometimes obliged to submit to the role of hired portrait painter. The business could prove to be drawn out and strained, and ended on at least one occasion—*Lucien Rosengart*

1. Vuillard quoted in Chastel 1946, p. 94.

2. Chastel 1946, p. 102.

3. André Lhote, "Portraits d'aujourd'hui" (1928), reprinted in Lhote 1933, p. 151.

4. Jamot 1906, p. 473.

5. Quoted in Ciaffa 1985, p. 7.

6. Duranty 1876, p. 27.

7. Romain Coolus, "Édouard Vuillard," *Mercure de France*, vol. 249, no. 853 (January 1, 1934), p. 68.

8. Lhote 1956, p. 148.

9. Hector de Callias, "Salon de 1864," *L'Artiste* (June 1, 1864), p. 243.

10. Vuillard, *Journal*, IX.1, fol. 29r (September 13, 1929).

*at His Desk* (cat. 321)—in more or less open conflict. During the last fifteen years of his work in the genre, when he painted some of his best portraits, we sense that Vuillard often slipped from typological observation to the creation of a gallery of *characters*. There was a moralist lurking beneath the acuteness of his psychological and emotional insights.

"It is not simply a matter of making a portrait, but of making a painting,"[9] wrote one critic in the early days of the "new painting," and this was basically Vuillard's view of the question. But what he contributed to this enterprise over a period of thirty years is a fascinating and hitherto little-explored attempt to capture time, which at its best perfectly embodies one facet of the era's anxious humanism. It may well be that the profound ambivalence born of the tension between painting and observing represents the artist's final liberation. In September 1929, Vuillard, anxious as ever about the opinion of his friend Bonnard, wrote in his journal: "see Bonnard through the window; wave to him to come up; his instructive silence in front of Mmes Bénard and Polignac; gently indicates preference, regret about Polignac sketch, says to keep it; disconcerts me a bit; the rule of pleasure. Renoir at the end of his life, at last I'm doing what I want."[10] **Laurence des Cars**

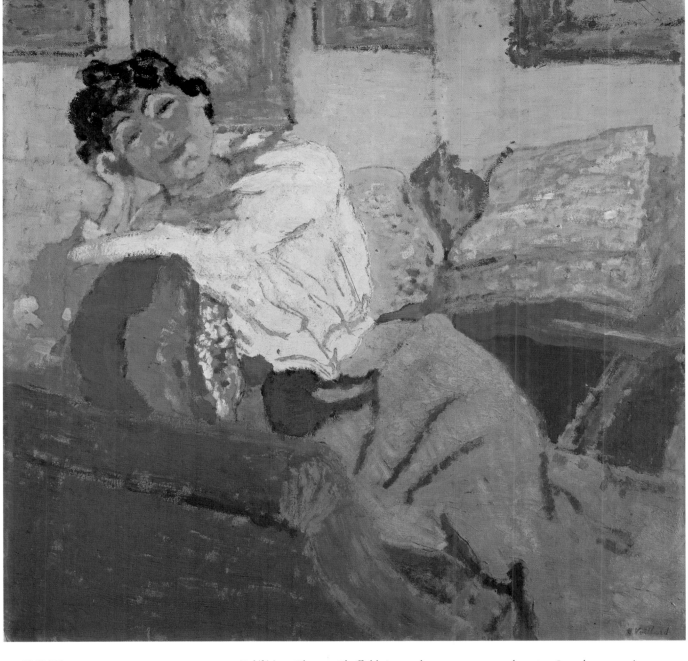

## 297

MADAME HESSEL IN HER
BOUDOIR— II • *Madame Hessel
dans son boudoir—II*

c. 1905, oil on board, 54.6 × 54.6
Liverpool, Walker Art Gallery, WAG 6217

Cogeval-Salomon VII.346

*Provenance* Studio—Hanover Gallery,
London—Odo Cross, London, 1947—
Walker Art Gallery, Liverpool, 1964

*Exhibitions* Glasgow-Sheffield-Amsterdam,
1991–1992, no. 59, col. ill. p. 57

*Bibliography* Thomson 1991b, p. 57

It was in the summer of 1900, during a stay
with Vallotton in Romanel, Switzerland, that
Vuillard became better acquainted with Lucy
Hessel, whom he had met only briefly before.
She was the wife of Jos Hessel—a cousin of
Gaston and Josse Bernheim and director
of the gallery the two had just taken over on
the retirement of their father, Alexandre.
The relationship that began to develop at this
period between Vuillard and Lucy lasted until
the artist's death. Friend, lover, confidante,

muse and mentor, Lucy became—in a more
profound and enduring way than Misia—
the most important woman in Vuillard's life.
She was a seductive, domineering character
(Tristan Bernard nicknamed her "The Dra-
gon" after the heroine of *Le Dragon de Villars*,
a popular comic opera of the time) who never
ceased to inspire in the artist the most com-
plex emotions. Vuillard's extreme reserve when
writing in his journal (not forgetting, of
course, that no diaries from the early years of
the century have come down to us) nonethe-
less allows glimpses of the constant swing in
his feelings for Lucy, from adoring fascination

to exasperation at her demanding possessiveness. Still, Vuillard and Lucy would grow old together, forming a real couple that coexisted with the Hessels' more official union. Jos, for his part, seems to have had little trouble accepting a situation that afforded him the freedom of which he was so fond. This painting is one of the artist's first attempts to capture the intelligence and charm of Lucy's personality. It is actually a slightly enlarged copy of an earlier version that bears the dedication "To my friend Lucie Hessel. E. Vuillard" (c. 1905, Pasadena, Norton Simon Museum, c-s vii.345).[1] The setting is identical—the small salon in the Hessels' apartment on Rue de Rivoli, which, with its frequent rotation of art works, was often featured in Vuillard's sketches and paintings. The model's relaxed pose is also the same, but here the framing is tighter and the treatment more frankly caricatural. While in the earlier work the face is rendered with an impassive gentleness, here Vuillard has with merciless irony left it in shadow and hardened its features by means of a theatrical lighting effect. Traces of the daring, subjective vision of the Nabi years linger on in this almost burlesque portrait, which Belinda Thomson has also likened to portraits by Matisse and the Fauves.[2] The freedom of approach vividly reflects the ambivalent lucidity of Vuillard's sentiments regarding Lucy Hessel. For one brief moment, we are permitted to see beneath the mask—the artificiality—of the self-confident seductress. LC

1. Her name was spelled alternatively "Lucy" or "Lucie."

2. Thomson 1991a, p. 57.

# 298

CLAUDE BERNHEIM DE VILLERS ·
*Claude Bernheim de Villers*

1905–1906, reworked in 1908, oil on paper mounted on plywood, 68 × 96
Paris, Musée d'Orsay, Gift of M. and Mme Gaston Bernheim de Villers on the occasion of their fiftieth wedding anniversary, 1951

Cogeval-Salomon vii.391

*Provenance* Gaston Bernheim de Villers, Paris—Gift of Bernheim de Villers, in honour of his 50th wedding anniversary, to the Musée national d'art moderne, Paris, 1951; Musée d'Orsay, Paris, 1986

*Exhibitions* Paris, Bernheim-Jeune, 1906, no. 14—Paris, Grand Palais, 1906, no. 1744—Munich, Haus der Kunst, 1968, no. 118, ill.—Paris, Orangerie, 1968, no. 123, ill.—Lyon-Barcelona-Nantes, 1990–1991, no. 113, pp. 178, 182, col. ill. p. 188

*Bibliography* Jamot 1906, p. 473—Groom 1993, p. 160, col. fig. 255

This double portrait of the son and wife of Gaston Bernheim, at that time (along with his brother Josse) Vuillard's dealer, is one of the major works from the first decade of the century in which Vuillard gives early intimations of a new style. This broader manner plays skilfully upon the perception of space by exploring all the structural and framing possibilities offered by a given environment, particularly its decorative elements and its furniture. It in fact enabled Vuillard to place the stamp of originality on his nascent career as a portraitist and to assign this inherently more conventional and traditional genre a central place in his mature work. On seeing this painting at the 1906 Salon d'Automne, Paul Jamot spoke of the "interesting development, already revealed in a recent exhibition [at the Bernheim-Jeune gallery from May to June, 1906], toward a broader style and a more in-depth,

portrait-like approach to the human figure."[1] However, unlike the small *Michel Feydeau on a Carpet* (fig. 1), the child here is not alone, left to his own devices as he explores the world around him. The completely decentred composition shows the young Claude, somewhat lost in one corner of the couch, looking questioningly at his mother, whose truncated profile and figure we perceive only gradually. This masterly device plays on the commingling and progressive separation of two different decorative components. The texture of the pink and cream dress gradually stands out against the Aubusson tapestry of the couch, allowing the curved and enveloping gesture, so eminently feminine and maternal, to anchor the composition. The child's interrogative look thus becomes the central point of a dialogue with his mother. The psychological and emotional subtlety that emanates from this composition reflects how successfully Vuillard has enriched this portrait with the tender, serious questions that arise between mothers and children. LC

1. Jamot 1906, p. 473.

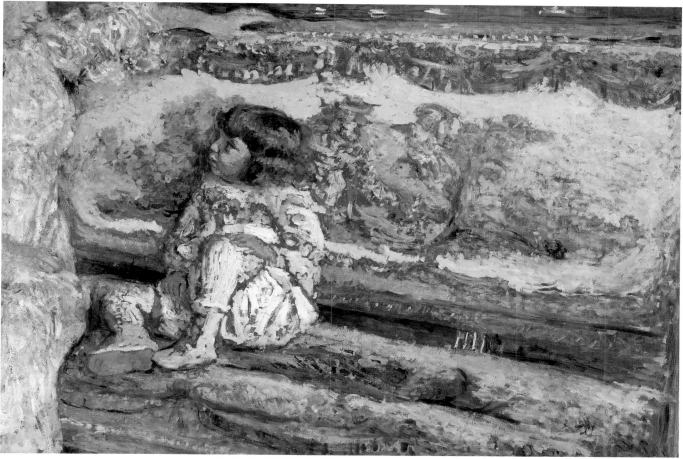

298

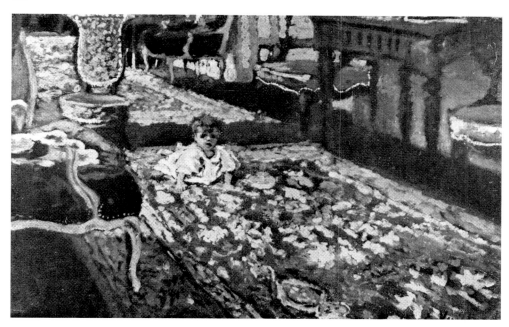

1. Édouard Vuillard, *Michel Feydeau on a Carpet*, 1901, oil on panel, Glasgow, Kelvingrove Art Gallery and Museum, C-S VII.297.

# 299

GASTON AND JOSSE BERNHEIM
(SKETCH), also known as THE
ART DEALERS (THE BERNHEIM
BROTHERS) · *Gaston et Josse Bernheim
(projet)*

1912, oil on board mounted on canvas,
73.2 × 66
The Saint Louis Art Museum, Gift of
Mr. and Mrs. Richard K. Weil

Cogeval-Salomon IX.201

---

*Provenance* Studio—Lefevre Gallery, Lon-
don, 1950—Sam Salz, New York, 1952—
Mr. and Mrs. Richard K. Weil, St. Louis,
Missouri—Gift of Mr. and Mrs. Richard K.
Weil to the Saint Louis Art Museum, 1953

*Exhibitions* Cleveland-New York, 1954,
p. 103, ill. p. 85—Toronto-San Francisco-
Chicago, 1971–1972, no. 71, ill.

*Bibliography* Preston 1971, p. 130, col. ill.
p. 131

---

The role played by the Bernheim brothers in
bringing Vuillard's work to public attention
was considerable. Following a group exhibi-
tion held in April 1900 at the Bernheim-Jeune
gallery, then located at 8, rue Lafitte, Vuillard
signed a contract that was to bind him to the
two art dealers for twelve years. The agree-
ment not only gave the painter a certain finan-
cial security but also allowed him to exhibit
regularly in group and solo exhibitions, and
to reach a wider clientele. But his relationship
with the Bernheims was not always an easy
one, as can be learned from his journal after
1908. Vuillard, approaching forty, wondered
about his artistic and financial independence:
"Question of my work relations, or rather of
my concerns and relations with the public.
dealers and others. Agony of not finding the
discipline I need. health and independence.
Earning one's living as one should. Not
satisfied with the present arrangement. Fun-
damental compromises that expose me to
all sorts of misfortunes despite appearances.
Need to take good care of one's financial
affairs" (May 22, 1908). These concerns led to
a difficult confrontation between the artist
and his dealers, and a falling-out was only
narrowly avoided: "Decide to go to the Bern-
heims' to have it out with them affectionate
side of their offers. I say everything that's on
my mind. Proposals to make an end of it.

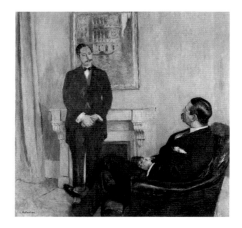

1. Édouard Vuillard, *Jos Hessel and Gaston Bernheim in Their
Office on Boulevard de la Madeleine*, 1912, oil on canvas, Paris,
Galerie Bernheim-Jeune, C-S IX.202.

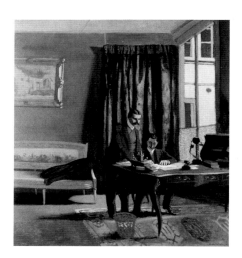

2. Félix Vallotton, *The Bernheim Brothers in Their Office*, 1901,
Paris, Galerie Bernheim-Jeune.

Basic reason for my longing for freedom risk
and its demands forcing me to produce. my
laziness. their kindness and their regret. the
conversation moves on to Thadée's sale I go
down with Fénéon [the critic had joined the
gallery in 1906], suggest to him a short tryout
of the new arrangement" (July 3, 1908). But
the arrangement did not last, and four years
later, urged on by Lucy Hessel, Vuillard left
the Bernheim brothers for good and joined up
with their cousin Jos Hessel: "write to Fénéon
to stop the monthly payments take letter and
cheque" (October 5, 1912).[1]

Although this decision did not permanently
damage friendly relations between the three
men, it was nevertheless in the tense atmos-
phere that preceded it that, in May and June
1912, Vuillard painted the portrait of the two
brothers held at the Marion Koogler McNay
Art Museum in San Antonio, for which this
was a preparatory sketch. In both cases the
almost caricatural approach is rendered in

an energetic style that still resonates with the
subjective boldness of Vuillard's Nabi period.
It is the very opposite of the precise, neutral
treatment seen in the exactly contemporary
portrait of Jos Hessel and Gaston Bernheim
(fig. 1). Here the element of caricature is light
and charming, although just as unmistakably
present as in the bittersweet journal entries.
The composition is intriguingly reminiscent
of the portrait painted by Vallotton some
years earlier (fig. 2). Whether a simple stylis-
tic exercise or an overt tribute, the similarity
is odd, for the setting looks identical despite
the fact that the gallery had moved in 1907 to
25, boulevard de la Madeleine. It is amusing
to note that much of this same setting reap-
pears in the portrait of the Bernheims painted
by Bonnard some years later (1920, Paris,
Musée d'Orsay).

In the foreground, awaiting the client and
incidentally the viewer, is the stark silhouette
—"all in angles"[2]—of Gaston, the dandy,
perched elegantly on the arm of his chair,
while Josse, in the middle ground, is busy at
his desk. The poses of the two brothers were
thoroughly worked out in a series of prepara-
tory sketches, illustrating how cleverly the
swift, spontaneous treatment of the work con-
ceals its carefully conceived objectives. Gloria
Groom has astutely pointed out a third figure
present only in the sketch, a client or collabo-
rator being roundly ignored by the two broth-
ers, who is leafing through the cabinet con-
taining prints—the gallery's most inexpensive
commodities.[3] In the final work the format
is more vertical, with a tighter focus on the
figure of Gaston Bernheim, who seems like a
predator lying in wait for his prey. But in both
versions Vuillard emphasizes the vertical bank
of spotlights used to illuminate and enhance
the paintings we cannot see. This ironic touch
is clear evidence of the cold eye Vuillard
brings to bear on his dealers. Implacably, he
reminds us of the commercial fate of the
works and the artifices of the sales ritual, over
which Gaston Bernheim, despite the studied
nonchalance of his pose and the "sense of
propriety in dress"[4] the artist so perfectly cap-
tures, is triumphantly presiding. LC

---

1. Vuillard, *Journal*, II.1, fol. 43v–44r, 55r; II.6, fol. 33v.

2. Roger-Marx 1946a, p. 89.

3. Groom 1993, p. 166.

4. Roger-Marx 1946a, p. 89.

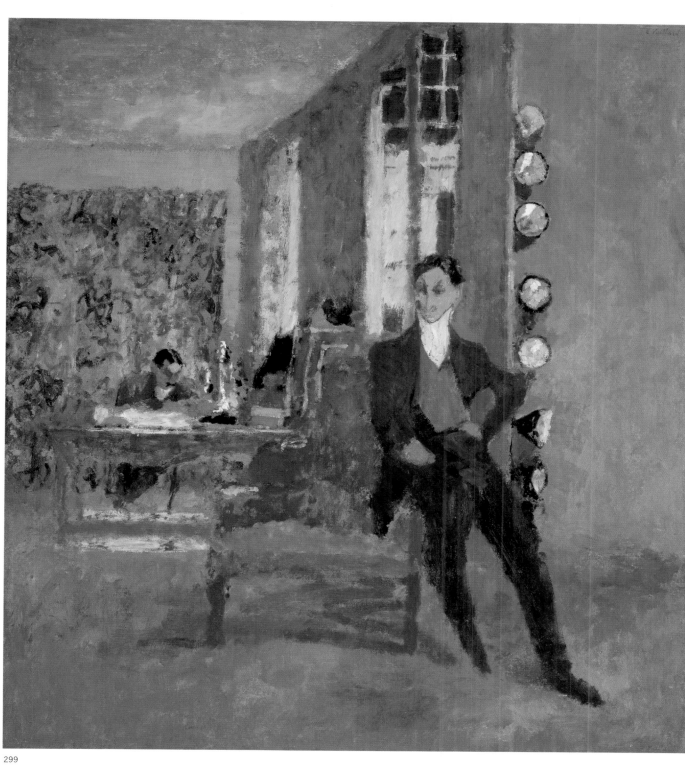

299

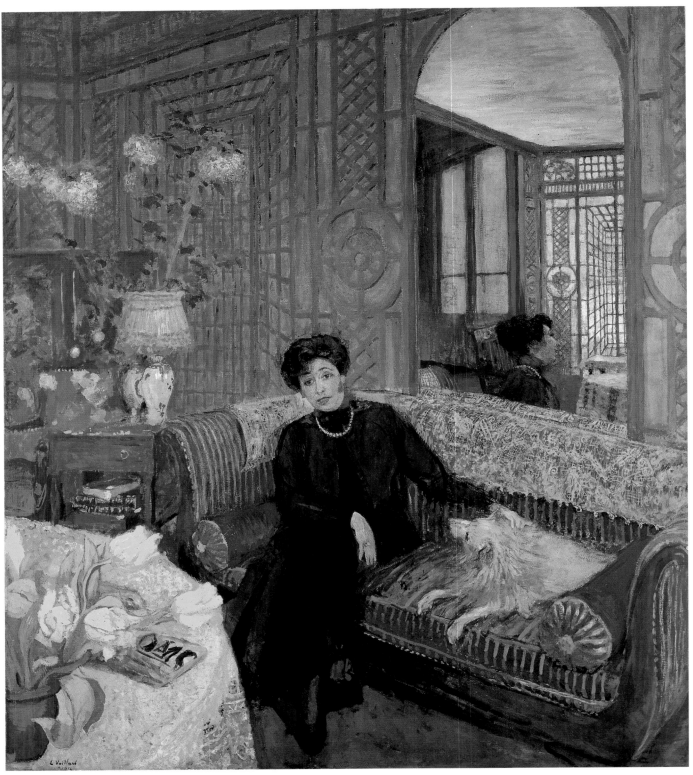

## 300

PORTRAIT OF MARCELLE ARON ·
*Portrait de Marcelle Aron*

1913–1914, distemper on canvas, 181.3 × 156.5
Signed and dated l.l.: *E Vuillard 1914*
The Museum of Fine Arts, Houston, Gift
of Alice C. Simkins in memory of Alice N.
Hanszen, 95.222

Cogeval-Salomon IX.233

———

*Provenance* Commissioned from the artist by
Marcelle Aron and Tristan Bernard, Paris—
Édouard Jonas, Paris, c. 1950—E. J. Van Wis-
selingh, Amsterdam, 1955—Knoedler, New
York, after 1958—Huntington Hartford (The
Gallery of Modern Art), New York, 1964—
Alice Hanszen, Houston; Gift of Alice C.
Simkins to the Museum of Fine Arts, Hous-
ton, 1995

*Exhibitions* Paris, Musée des Arts décoratifs,
1938, no. 153

*Bibliography* Chastel 1946, p. 116—Roger-
Marx 1946a, pp. 91, 188

———

Claude Roger-Marx considered this painting
the first great portrait by Vuillard in distem-
per. The second Madame Tristan Bernard
sat for the artist in the conservatory of her
ground-floor apartment at 167, boulevard
Malesherbes. The many preparatory sketches
reveal Vuillard's indecision as to the exact
placement of the sitter against a background
made even more complex by his emphasis on
the spatial expansion created by the mirrored
reflection. With its geometric motifs, the trellis
of the window artificially enhances the feeling
of depth by accelerating the perspective and
gives a phantasmagorical aspect to this interior
of an apartment in the Plaine Monceau neigh-
bourhood. Marcelle Aron's pose was also the
subject of many studies, in which the painter
concentrated particularly on the position of
the hands. The question was finally resolved
by the choice of the broad, relaxed gesture
with which Marcelle Aron fondles her Pom-
eranian. The lapdog, absent from the sketches,
was invited for the final painting to sit on the
sofa, providing a somewhat comic counter-
point to the sitter. Around this group Vuil-
lard's palette is at its most pungent: the mauve

and green of the walls next to the blue of the
sofa, the yellow tulips partially hiding an issue
of the magazine *Comoedia*, the vivid pink
of Marcelle Aron's cheeks. Most significantly,
though, the painting may be read as a first
variation on the Ingres model. As would be
the case some years later with *Jane Renouardt*
(cat. 319), the legacy so plainly announced
has here been wittily distorted. The painter's
ironic lucidity manages to push the harmonic
restraint of *Madame de Senonnes* into total and
gaudy disarray.[1] This version has all the marks
of a game of displacement based clearly on
an appreciation of kitsch. It may well be that
the work, more than simply a portrait, is actu-
ally a brilliant inquiry into taste. LC

———

1. Cogeval in C-S 2003, no. IX.233.

## 301

MADEMOISELLE JACQUELINE
FONTAINE · *Mademoiselle Jacqueline
Fontaine*

1911–1912, oil on canvas, 179 × 129
Tom James Company / Oxxford Clothes

Cogeval-Salomon IX.171

———

*Provenance* Commissioned from the artist
by the sitter's father, Arthur Fontaine, Paris—
Private collection

*Exhibitions* Paris, Bernheim-Jeune, 1912,
no. 13—Paris, Musée des Arts décoratifs,
1938, no. 144

*Bibliography* Salomon 1968, p. 25

———

Jacqueline Fontaine was the daughter of
Arthur Fontaine, a mining engineer who be-
came a politician and president of the Bureau
International du Travail, and Marie Escudier,
whose sisters had married Henry Lerolle and
Ernest Chausson. Like both his brothers-
in-law, Arthur Fontaine was one of the earliest
admirers of Maurice Denis, having commis-
sioned *The Muses* (1893, Paris, Musée d'Orsay)
and several family portraits, including one
of Jacqueline as a child (1895). It was through
Denis that Vuillard, in 1897 or thereabouts,
became part of the circle of intellectuals and
musicians that gravitated around the Fon-
taines, executing a number of commissions
for them (*Chat at the Fontaines*, 1904, priv.
coll., C-S VII.310). After the couple's divorce
in 1905 and Arthur Fontaine's remarriage,
Denis seems to have kept aloof from his

admirer, whereas Vuillard remained friendly
with him, receiving the commission for this
portrait while Jacqueline was living with her
father at 54, avenue de Saxe. This little-known
painting is fascinating in many respects for
the study of Vuillard's work as a portraitist,
which underwent an unprecedented develop-
ment in the years 1911–1912. The full-length
portrait was a format the artist was scarcely
ever to use again, and the full frontal pose
suggests a spontaneity of approach in keeping
with the sitter's age. The creation of the work
presented some difficulty for Vuillard, who
began as usual with a series of preliminary
sketches and pastels but found himself brought
up short when he started on the painting itself:
"mental confusion about Jacqueline, don't
know how to go about it, letter from Fontaine,
lunch with Mother, unable to hide my desper-
ation. nervous" (January 18, 1912). Abandon-
ing the attempt to recompose the work in his
studio, he decided to set up his easel in Arthur
Fontaine's apartment and to paint straight
from life: "to Fontaine's place, long important
sitting, all the lower part, armchair, carpet,
table and roses. link up a bit with books. fairly
happy with effect; tired, sweaty. see Jacque-
line again" (January 22, 1912).[1] This last entry
underlines the fact that this canvas is one of
the first in which the obsessive attention to
detail and the astonishing rendering of tex-
tures so characteristic of Vuillard's portraits
appear with the authority of a statement of
principle. Moreover, the subtlety of psycho-
logical perception that led the artist to firmly
stamp the face with the slightly sulky dreami-
ness of adolescence has already resulted in the
freedom and the accuracy of tone that subse-
quently proved almost unerring. But in addi-
tion to these initial formulations, what makes
this painting so outstanding is its echo of a
sensibility rooted in the late nineteenth cen-
tury. In a crude light very like that of a pho-
tographer's magnesium lamp, which pins the
girl against her father's bookcase, Vuillard
captures the final gleams of a naturalism that
was for him a necessary stage in the appro-
priation of beings and objects. LC

———

1. Vuillard, *Journal*, II.5, fol. 59r, 60r

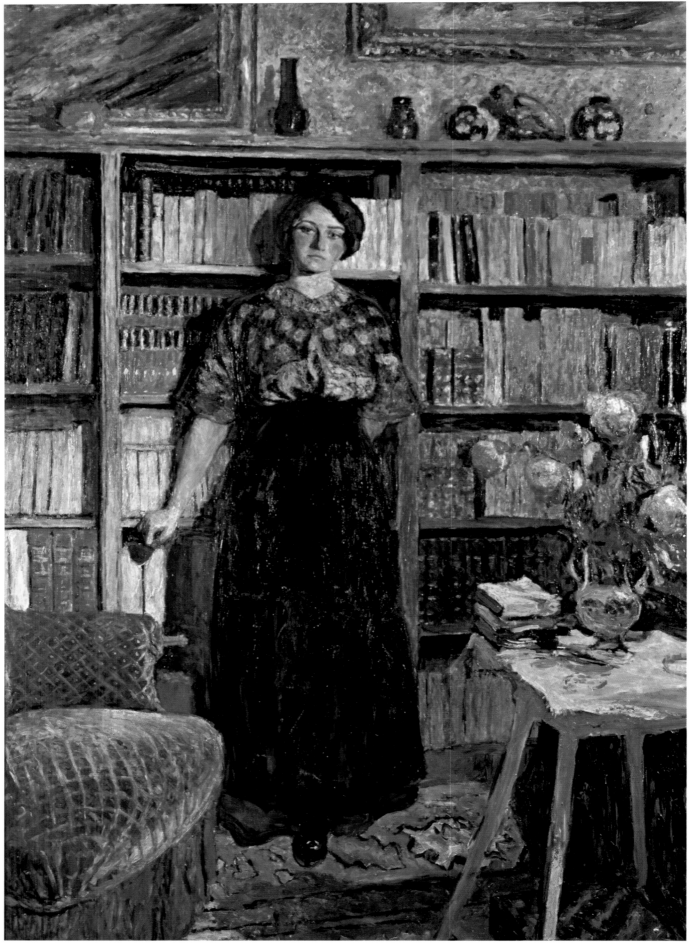

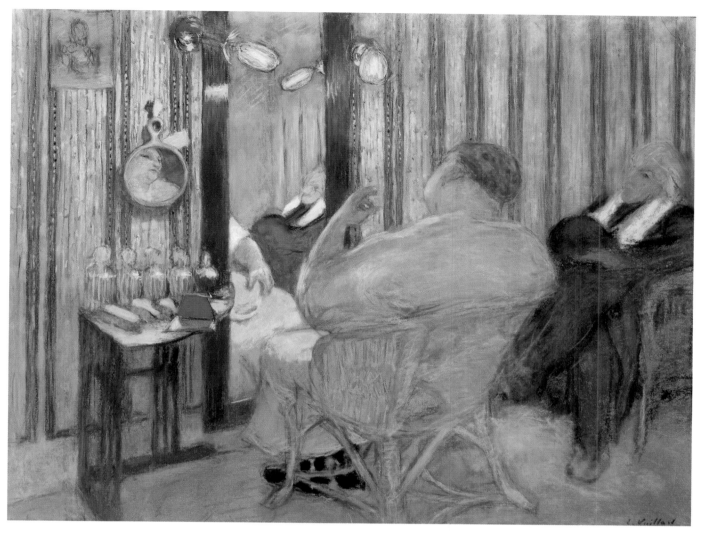

## 302

SACHA GUITRY IN HIS DRESSING
ROOM · *Sacha Guitry dans la loge*

1911–1912, pastel on paper, 75 × 98
Signed l.r.: *E. Vuillard*
Sir Sean and Lady Connery

Cogeval-Salomon IX.173

———

*Provenance* Commissioned from the artist by
Sacha Guitry and Charlotte Lysès, Paris—
Pierre Berès, Paris—The Collection of Sir
Sean and Lady Connery, London

*Exhibitions* Paris, Musée des Arts décoratifs,
1938, no. 228

*Bibliography* Roger-Marx 1946a, p. 186

———

In December 1911, Sacha Guitry commis-
sioned Vuillard to execute his own portrait
and that of his first wife, the actress Charlotte
Lysès, which the painter also executed in
pastel (1911–1912, Albi, Musée Toulouse-
Lautrec, C-S IX.174). At the age of twenty-six,
Guitry had recently achieved celebrity as the

result of his first great success as playwright
and actor, *Le Veilleur de nuit*, written in Feb-
ruary 1911. In October 1911 he had also exhib-
ited his paintings and cut-out silhouettes at the
Bernheim-Jeune gallery, and it may have been
through his close friendship with Gaston and
Josse Bernheim that Guitry met Vuillard.

Guitry's personality, and especially the chosen
setting—the actor's dressing room—obvi-
ously awakened Vuillard's enthusiasm: "In
the evening, went to see the Sachas in their
dressing room, much struck by the look of
the background, the makeup, picturesque, re-
markable" (December 16, 1911). A few days
later he wrote, "Afternoon unable to resist
urge to work on the Sachas' dressing room
very enthusiastic" (December 21, 1911).[1] This
is one of Vuillard's most potently expressive
works, where he gives almost outrageously
free rein to his talent, but in a way that is
particularly appropriate, as it is in complete
accord with the subject. The surroundings are
as vital as the figures in capturing the inti-
macy and strange alchemy of the moment.
The blue-striped wallpaper, the mirror with
its two bracket lamps that light up the actor's

dressing gown, the dressing table with its
rows of bottles and brushes, make of the room
a visually charged and chromatically dense
space. The complex spatial construction is
based on a skilful use of mirrors. Vuillard
plays upon an almost complete duplication
of the figure of the actor Louis Baron (1838–
1920), whose "extraordinary" presence he
noted in his journal (December 20, 1911).[2]
But Guitry's imposing presence, accented by
his famous pose—cigarette held carelessly
in the tips of his fingers—and well rendered
in a preparatory drawing, is literally frag-
mented by the two mirrors. The face reflected
in the circular looking glass appears almost
feminized, travestied by makeup. These fic-
tional features are the most tangible indication
of the performance that has been or is about
to be given. Vuillard conveys magnificently
the actor's ritual face-to-face encounter with
himself, as he appraises his own haughty but
derisive narcissism. LC

———

1. Vuillard, *Journal*, II.5, fol. 53v, 57r.

2. Ibid., fol. 53v.

# 303

LUCIEN GUITRY · *Lucien Guitry*

1921, pastel on paper, 151 × 94
Signed l.r.: *E Vuillard*
Private collection

Cogeval-Salomon XI.204

*Provenance* Commissioned from the artist by
Sacha Guitry, Paris, 1921—Private collection

*Bibliography* Salomon 1945, p. 66—Guitry
1952, ill. p. 10—Salomon 1968, p. 26

When Sacha Guitry commissioned a portrait of his father from Vuillard, he had just written *Le Comédien* for the elder Guitry. The play opened at the Théâtre Édouard VII on January 21, 1921. After *Pasteur* (January–April 1919, Théâtre du Vaudeville) and *Mon père avait raison* (October 1919–January 1920, Théâtre des Mathurins), this play was Sacha Guitry's most personal tribute to his father, that giant of the French theatre. Lucien Guitry had trained alongside Sarah Bernhardt, with whom he shared a triumph in *L'Aiglon*, returning to Rostand for the creation of *Chanteclerc*. He was also director of the Théâtre de la Renaissance, and joined the Comédie-Française in 1901. Around 1903–1904 he fell out with his son as a result of the latter's affair with Charlotte Lysès, who had previously been Guitry senior's mistress. The two men were not reconciled until 1918, shortly before Sacha's marriage to Yvonne Printemps. *Le Comédien*, a grandiloquent and frank portrait of an actor made to measure for Lucien, failed and was replaced in April 1921 by the Guitry-Guitry-Printemps trio in *Le Grand-Duc*.

Vuillard evidently worked very quickly on this large pastel: according to his diary, the whole work was completed in under two weeks, between January 10 and January 22, 1921. Lucien Guitry was rehearsing his son's play at the time, and Vuillard went to the Théâtre Édouard VII for the sittings: "preliminary sketch at 1 o'clock with Lucien Guitry, just the two of us in the theatre for a moment, a handsome man, very overexcited."[1] In a few preparatory sketches Vuillard dwelt on the actor's face, spent time on the position of the hands in the pockets and drew the folds in the suit in some detail. But the final composition is simple and strong, dominated by verticals to accommodate the sitter's frontal pose, and the handling is lively. Vuillard's treatment is not fussy; it is as though his model's physical presence, blossoming fully only in an empty set, imposed a curb on details and accessories. Lucien Guitry, lit by the theatre lights, commands the stage with vigour and ease, and assumes his role as the great actor at the threshold of his world. LC

1. Vuillard, *Journal*, III.7, fol. 40v (January 11, 1921).

## 304

THÉODORE DURET IN HIS STUDY ·
*Théodore Duret dans son cabinet de travail*

1912, oil on board mounted on cradled
panel, 95 × 74.5
Signed and dated l.l.: *E Vuillard 1912*
Washington, National Gallery of Art,
Chester Dale Collection

Cogeval-Salomon IX.199

*Provenance* Commissioned from the artist
by Théodore Duret, May 7, 1912—Reid and
Lefevre, London—Étienne Bignou, Paris—
Chester Dale, New York, 1929; Chester Dale
Gift to the National Gallery of Art, Washington, 1962

*Bibliography* Chastel 1946, p. 90—Roger-
Marx 1946a, p. 91, ill. p. 99—Thomson 1988,
pp. 126, 130, col. pl. 115—Cogeval 1993 and
2002, col. ill. p. 98—Groom 1993, p. 195

The name of Théodore Duret (1838–1927) is
linked to the defence and history of Impressionism. His study *Les Peintres impressionnistes*
(1878) was the first major text devoted to the
nascent movement, at the time much maligned
by critics. An art lover and great collector,
Duret was important both as a participant and
as a witness during the early years of struggle.
But after publishing his *Critique d'avant-garde*
(1885), a collection of his principal texts devoted to the "new painting," he exchanged his
role of critic for that of historian. Seeing the
issues he defended gradually gaining acceptance among critics and public alike, he adopted
a more objective and scholarly approach in his
important *Histoire de la peinture impressionniste*
(1906) and in his many monographs, notably
on Manet, Whistler, Courbet and Renoir. The
elderly man—he was seventy-four—who in
1912 commissioned his portrait from Vuillard
embodied a whole era in the history of modern French painting. The artist was undoubtedly well aware of the historical significance
of the project, and deeply touched by it.

1. Edgar Degas, *Edmond Duranty*, 1879, pastel and tempera on
canvas, Glasgow Museums: The Burrell Collection.

The slightly raised viewpoint and angled
perspective allowed Vuillard to give greater
breadth and energy to what is essentially a
quietly meditative painting. Duret, seated at
his work table in his Paris apartment, surrounded by his art collection, his books and
his papers, appears somewhat distant as he
absentmindedly strokes his cat. Vuillard seems
to have deliberately exploited the contrast
between the cat's keen gaze and the writer's
tired old eyes, which had particularly struck
him: "Session at Duret's place, reworked the
head, opened the eyes."[1] But seizing on the
historical aspect of the painting, the artist
placed it from the outset in the modern tradition. The Duret portrait encompasses all the
distinctive, almost typological, signs common
to a series of tribute-portraits featuring avant-
garde critics. Claude Roger-Marx noted the
link with enthusiasm, speaking of this "masterpiece, *Théodore Duret* (1912)...worthy
of inclusion with the great portraits of writers
at work—with the Zola of Manet, the
Duranty of Degas, and the Gustave Geffroy
of Cézanne."[2] The affinity with Degas (fig. 1)
is perhaps the closest, if only because of
the tipped perspective that enhances the visual
impact of the papers and books, which are
actually mentioned in Vuillard's first diary
entry about the painting: "three o'clock went
to see Duret, a Balzac-like interior Cousin
Pons heap of books."[3] As a reflection on
painting, the work is also a painter's tribute to
his art. On the wall we recognize Ingres's
sketch *The Muse of Lyric Poetry* (c. 1842), an

Orpheus (?) by Gustave Moreau and, most
particularly, in the distance of the mirror's
reflection (clearly suggesting the mirror of the
past), Whistler's *Arrangement in Flesh Colour
and Black: Portrait of Theodore Duret* (1883–
1884, New York, The Metropolitan Museum
of Art), this latter a marvellous echo of
Duret's brilliant youth, when he dictated contemporary taste with the elegance—in
Manet's words—of "the last of the dandies."
Duret himself confirmed this inevitable
distancing in a statement made in later life:
"I don't know the present-day painters. At
my age you don't dare assess works; one
has loved the art of one period too much not
to be unfair to the art that follows. One must
know how to grow old, to stop judging. And
besides, I have such wonderful memories."[4]
In 1912, when Vuillard was devoting himself
increasingly to portraiture, his tribute to
Duret had the status of a statement of intent,
a work whose acknowledgement of the
passage of time could also be seen as a declaration of fidelity to himself. From this point
on, to paint would also be to remember. LC

1. Vuillard, *Journal*, II.6, fol. 15r (May 31, 1912).

2. Roger-Marx 1946a, p. 91.

3. Vuillard, *Journal*, II.6, fol. 10v (May 4, 1912).

4. Quoted in Fels 1925, p. 28.

## 305

PORTRAIT OF HENRY AND MARCEL
KAPFERER · *Portrait d'Henry et Marcel
Kapferer*

1912, oil on canvas, 72.4 × 99.2
Signed and dated l.r.: *E Vuillard 1912*
Private collection

Cogeval-Salomon IX.205

———

*Provenance* Marcel Kapferer, Paris—
Private collection

*Exhibitions* Paris, Musée des Arts décoratifs,
1937, no. 190—Paris, Charpentier, 1948,
no. 67—New York, Wildenstein, 1964,
no. 62, ill.

———

When Vuillard first met them, the two Kap-
ferer brothers, still unmarried, shared a large
apartment at 26, avenue de Clichy. Henry
(1870–1958), the elder, a civil engineer, in-
ventor and aviator, had in 1910 founded the
Compagnie Générale Transaérienne, later to
become Air France. Marcel (1872–1966)
made his fortune in the petroleum business,
working for Royal Dutch and Shell Oil. Mar-
cel Kapferer was a great collector, with a par-
ticular liking for the work of Redon, Bonnard,
Cézanne, Renoir and especially Van Gogh.
He also admired Maurice Denis—his collec-
tion contained the six panels of the *History of
Nausicaa* (1914)—and the later decorative
work of Vuillard. He owned the latter's *Place
Vintimille* (see cat. 272, fig. 1), and in 1923
commissioned from the painter a frieze for
his apartment on Avenue Henri-Martin.

Surrounded by their growing collections
(Henry was fond of Dufy, Utrillo and La
Fresnaye), the two brothers are shown seated
at the table reading the newspaper. The
morning light shining through the window
illuminates the deep red of the carpet and
the bright yellow tablecloth. But despite the
unusually emphatic colouring of the work,
the tone is a familiar one. Both men are in
dressing gown and slippers, and in this com-
bined dining room and office the separation
between private and professional life is non-
existent. An accessory, the impressive tele-
phone in the middle of the table, both unites
and separates the brothers. Its presence under-
lined by the striking two-tone cord, whose
coils draw the eye, the instrument constitutes
the link between the daily domestic ritual of
breakfast and the outside world of business
and the stock exchange. The telephone, a
standard theme of modernity and a recurring
motif in Proust's work, seems to have fas-
cinated Vuillard, whose portraits record
with humour its gradual invasion of people's
homes (e.g. *Léon Gaboriaud*, *Madame
Bénard*, *Madame Vaquez*). LC

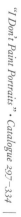

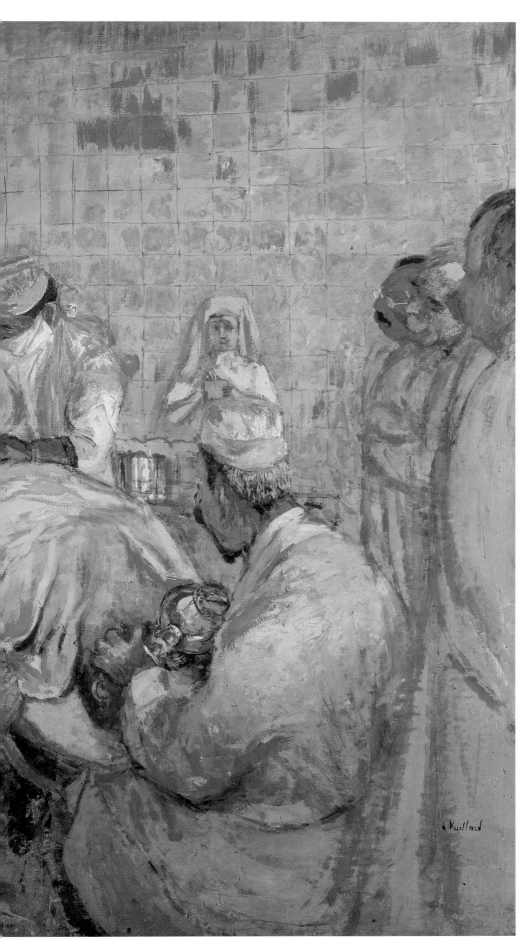

## 306

THE SURGEONS · *Les Chirurgiens*

1912–1914, reworked in 1925 and 1937,
distemper, heightened with pastel,
on paper mounted on canvas, 158 × 227
Signed l.r.: *E. Vuillard*
Private collection

Cogeval-Salomon IX.226

*Provenance* Private collection, United States
—Private collection

*Exhibitions* Paris, Bernheim-Jeune, 1913,
no. 12—London, Wildenstein, 1948, no. 35—
Edinburgh, Royal Scottish Academy, 1948,
no. 96—Paris, Charpentier, 1948, no. 74—
Cleveland-New York, 1954, p. 103, ill. p. 88

*Bibliography* Salomon 1945, p. 66, ill. p. 65—
Roger-Marx 1946a, pp. 79–80, ill. p. 164—
Cogeval 1993 and 2002, p. 107

The central figure in this painting is Dr.
Antonin Gosset (1872–1944), a surgeon and
urologist elected to the Académie de sciences
in 1934. This eminent doctor, highly renowned
in his time, was painted by Marie Laurencin
and sculpted by Duchamp-Villon. Vuillard
immortalizes him in the midst of an operation
at the clinic he set up on Rue Antoine-Chantin.
The painter began work on his composition
in 1912, eventually making two versions. Vuil-
lard was greatly inspired by the intensity of
the scene—captured only rarely in painting
—played out in an operating room: "Dr.
Gosset took me to the hospital. Gosset operat-
ing. very strong impression" (May 15, 1912);
"morning hospital Gosset. Enormous world
operating room" (June 19, 1912).[1] The painter
was able to observe at his leisure the precise
and ritualized procedure of an operation and
to record in detail the highly specific context
in which it occurs. Taking up the project again
a year later, he clearly defined his subject:
"at Gosset's Chantin, decide upon my subject
the three large figures maybe one more with
the transportation of the patient. study in
studio, enlarge subject action to left of women."[2]
Most of the canvas's protagonists can be
clearly identified from a photograph published

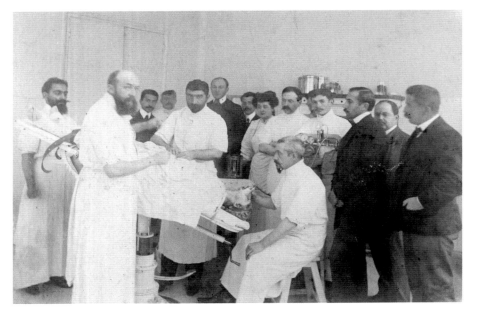

1. Dr. Gosset operating, c. 1912, private collection.

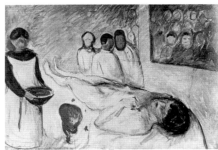

3. Edvard Munch, *The Operation*, 1902, Oslo, Munch Museet.

by Guy Cogeval (fig. 1),[3] which shows Dr. Gosset and his team, notably the anaesthetist Bourreau, also seated in the painting, and Dr. Jean Berger, in the left foreground of the photograph but seen from behind in the painting. While the painting was composed—in keeping with Dr. Gosset's request—according to the principles governing the traditional group portrait, these constraints are barely evident in this inspired interpretation of a thoroughly modern situation, and the work is more closely related to the two *War Factory* paintings from 1917 (C-S X.32-1 and 2) than to the exactly contemporaneous *Théodore Duret in His Study* (cat. 304).

The picture's theme picks up the thread of a well-established realist pictorial tradition, running from Rembrandt to Thomas Eakins, that proposes a clear analogy between the activities of surgery and painting, merging scalpel and brush to reveal truths about humanity and the world. Yet this impressive work is not precisely an anatomy lesson: it is as if, at the dawn of the twentieth century, such a painting could no longer take the form of a brilliant demonstration but had to record the surgical act itself, in all its grandeur and banality. It was a truly modern subject, then, one that had earlier been tackled by Toulouse-Lautrec in his work *An Operation by Dr. Péan at the Hôpital international* (fig. 2), which in many respects prefigures Vuillard's canvas. Moreover, it is by demythologizing the healing act and making it part of the visual culture of

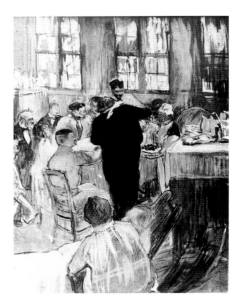

2. Henri de Toulouse-Lautrec, *An Operation by Dr. Péan at the Hôpital international*, 1891, Albi, Musée Toulouse-Lautrec.

"modern life" that this canvas becomes the masterpiece of the medical subjects that are, finally, quite common in Vuillard's oeuvre. Having opted for a conventional anonymity that undercuts the very concept of the portrait, Vuillard could adopt a dispassionate and even cold approach, which is not that of either the phantasmagorical *Doctor Louis Viau* in his dental office (cat. 293) or the compassionate *Doctors Vaquez and Parvu at the Saint-Antoine Hospital* (1926, pastel and distemper mounted on canvas, Paris, Musée de L'Assistance publique, C-S XI.250). In *The Surgeons* Vuillard brings to bear a masterly theatricality that skilfully exploits the almost voyeuristic fasci-

nation this theme invariably inspires in viewers. We are disconcerted by the dramatized and subjective space of this operating room, whose perspective has been exaggerated to the point of distortion. In the second version a basin has been added to the foreground, serving as an entry point into the composition and edging aside the trolley that, parallel to the patient's body, accentuates the lines of perspective. The tones of white, grey and yellow heighten the feeling of tension and coldness that seems to permeate the atmosphere. With this lavish spectacle of a helpless body at the mercy of science, Vuillard gives voice to a lucid objectivity that lies somewhere between Munch's interpretation of his own experience (fig. 3)—using a spatial structure very like that of *The Surgeons*—and the glacial irony of Christian Schad's *Operation* (1929), which Guy Cogeval has likened to this painting.[4] Claude Roger-Marx, a critic always sensitive to Vuillard's contemporary proclivities, perfectly grasped the essentially dramatic nature of the work: "What most attracted Vuillard was the precious relations between so many shades of white: head-dresses, blouses, cloths, walls varnished with Ripolin, nickeled instruments; the lightness of the shadows, the character of hands and faces saturated with an aseptic atmosphere. Nurses, operator, and assistants are so many draped statues. A great white silence prevails, shot through with a sense of tragedy; but death and blood do not come into the picture, as they do in Rembrandt's."[5] LC

1. Vuillard, *Journal*, II.6, fol. 11v, 18v.

2. Ibid., II.6, fol. 67v (May 16, 1913).

3. Cogeval in C-S 2003, no. IX.226.

4. Ibid.

5. Roger-Marx 1946a, pp. 79–80.

LUCIE BELIN SMILING · *Le Sourire de Lucie Belin*

1915, distemper on paper mounted on canvas, 130 × 101
Private collection

Cogeval-Salomon x.45

*Provenance* Studio—Private collection

*Exhibitions* New York, Knoedler, 1916—Japan, 1977–1978 (trav. exhib.), no. 39, col. ill.—Lyon-Barcelona-Nantes, 1990–1991, no. 131, col. ill. p. 185

In 1914 Vuillard met Lucie Belin, a young dressmaker who hoped to become an actress, using the stage name Lucie Ralph. She became his model, and they were soon involved in a passionate affair, to which this spontaneously brilliant canvas bears witness. Guy Cogeval has stressed the importance of this love affair,[1] a delightful and somewhat unruly interlude that for a while disturbed the more settled, bourgeois relationship the painter had established with Lucy Hessel. The attachment

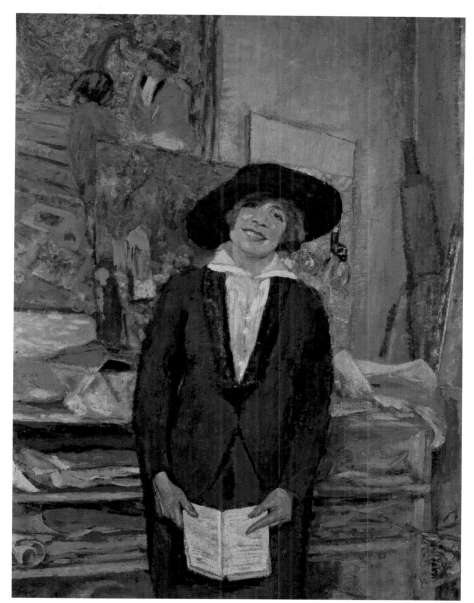

1. Photograph by Vuillard of Lucie Belin, c. 1915, private collection.

between the two is apparent from the many references to Lucie in the painter's diary, the letters she sent him (Salomon Archives) and the photographs that Vuillard took of her in 1915 and 1916 (see cat. 247). There is actually something of the spontaneity of a snapshot in this portrait painted in 1915, at the height of their mutual passion, and the existing photographs confirm the close connections, in terms of spirit and composition, between the two mediums (cat. 247 and fig. 1). Posed here in front of the filing cabinet in the Boulevard Malesherbes studio, Lucie shows every sign of having been surprised by Vuillard. Blushing, she stops reading and responds to the painter's question with a disarming, submissive smile. It should be noted in passing that the artist tackled the rare and problematic image of a smiling woman again some years later, in the

portrait of Yvonne Printemps (cat. 311). This painting, which stands a little apart from the rest of his portraits, is unusual in its frank, direct and supremely personal character, which makes it seem like the expression of an emotion too powerful and too wonderful to keep hidden. Vuillard does not analyze love, but prefers to celebrate the intensity of a moment of stolen happiness. LC

1. Cogeval in c-s 2003, no. x.45.

308

## 308

STUDY FOR "ANNETTE DREAMING" •
*Étude pour "Annette rêveuse"*

1916, graphite on paper, 10.4 × 17.4
Private collection

## 309

ANNETTE SALOMON

1917–1918, graphite on paper, 21.2 × 12.8
Private collection

309

## 310

YVONNE PRINTEMPS ON THE SOFA ·
*Yvonne Printemps dans le canapé-lit*

1919–1921, distemper on canvas, 116 × 79
Private collection

Cogeval-Salomon XI.182

*Provenance* Yvonne Printemps, Paris –Yvonne
Printemps Sale, Palais d'Orsay, Paris, Dec. 13,
1977, lot 189 (col. ill.) — Galerie Berès, Paris
— Private collection

*Bibliography* Ciaffa 1985, pp. 308–309,
fig. 168

## 311

YVONNE PRINTEMPS AND SACHA
GUITRY · *Yvonne Printemps et Sacha Guitry*

1919–1921, oil on paper mounted on canvas,
63 × 90
Museu de Arte de São Paulo, Assis de
Chateaubriand

Cogeval-Salomon XI.184

*Provenance* Studio—Wildenstein, New York,
1949—Museu de Arte de São Paulo

## 312

YVONNE PRINTEMPS: STUDY OF
THE FACE AND A HAND FOR "YVONNE
PRINTEMPS AND SACHA GUITRY" ·
*Yvonne Printemps. Étude du visage et de la
main pour "Yvonne Printemps et Sacha
Guitry"*

1919–1921, graphite on paper, 20.6 × 11.8
Private collection

## 313

YVONNE PRINTEMPS: STUDY OF
THE FACE AND A HAND FOR "YVONNE
PRINTEMPS AND SACHA GUITRY" ·
*Yvonne Printemps. Étude du visage et de la
main pour "Yvonne Printemps et Sacha
Guitry"*

1919–1921, graphite on paper, 20.7 × 12.1
Private collection

## 314

STUDY FOR "YVONNE PRINTEMPS
AND SACHA GUITRY" · *Étude
pour "Yvonne Printemps et Sacha Guitry"*

1919–1921, graphite on paper, 12.2 × 20.7
Private collection

## 315

STUDY FOR "YVONNE PRINTEMPS
AND SACHA GUITRY" · *Étude
pour "Yvonne Printemps et Sacha Guitry"*

1919–1921, graphite on paper, 12.2 × 20.7
Private collection

On May 13, 1919, Vuillard wrote in his diary,
"go to Vaudeville, Sacha and Yvonne Prin-
temps's dressing room, amazed by Y.'s features
up close…request for portraits." But Vuillard
was uncertain how to approach his portrait
of the actress and singer who was the second,
recent wife—the wedding took place in April
1919—of Sacha Guitry: "hesitating over vari-
ous plans for Yvonne P" (May 19, 1919). Some
days later he told himself he had to make a
choice: "concept of the portrait, of a portrait;
of a preconceived program; that's where the
effort and the decision are" (May 24,1919).[1]
The artist finally gave up, leaving us two vari-
ations on a single sitter, two facets of Yvonne
Printemps's somewhat naughty charm.

The same drawing-room in the Guitrys' pri-
vate residence on Avenue Élisée-Reclus, and
the same sofa, form the background to both
portraits. But in one of them (cat. 310),
the sofa—drawn with obsessive precision by
Vuillard in the preparatory sketches for the
painting—overwhelms the composition. The
foreshortened perspective finally retained

after a first, unadventurously frontal compo-
sition disturbs one's perception of the portrait
by distorting the proportions of the sofa and
thus relegating the figure to the background.
Yvonne Printemps, distant and coiled up
among her cushions, is scarcely recognizable,
more a sensual feminine presence than an in-
dividualized model. She dissolves into a
sumptuous decorative and chromatic variation
dominated by red and pink. The recumbent
female figure was actually a wonderfully con-
sistent leitmotif in Vuillard's work (e.g. *Prin-
cess Antoine Bibesco, Madame Hessel Lying on
a Divan*).

In the second portrait (cat. 311), as Guy Cogeval
points out,[2] Vuillard presents the Guitry
couple in a witty game of sentimental hide-
and-seek that recalls Sacha's plays. Shortly
before working on this painting, Vuillard had
seen Guitry and Printemps create and per-
form *Le Mari, la Femme et l'Amant* (April–
July 1919, Théâtre du Vaudeville) and *Je
t'aime* (October 1920–January 1921, Théâtre
Édouard VII). His friendship with the couple
enabled him to capture with humour and
affection the tumultuous and passionate rela-
tionship between them. There is nothing con-
ventional about this portrait of the two actors,
so famous in their day; rather, the approach
is free and spontaneous, and the result almost
like a snapshot. Vuillard focuses closely on
Yvonne Printemps's face, a close-up based on
his beautiful and detailed initial drawings of
her smile and gaze (cats. 312–315). Guitry,
in the background, largely hidden by the back
of the sofa, is for once a secondary figure,
reduced to watching his enticing yet submis-
sive wife. The look she gives him and her
famous mocking smile, eagerly seized upon
by Vuillard, express the marvellous ambiguity
of seduction—half jest, half serious. LC

1. Vuillard, Journal, III.4, fol. 61v, 63v, 65v.

2. Cogeval in C-S 2003, no. XI.184.

311

312

313

314

315

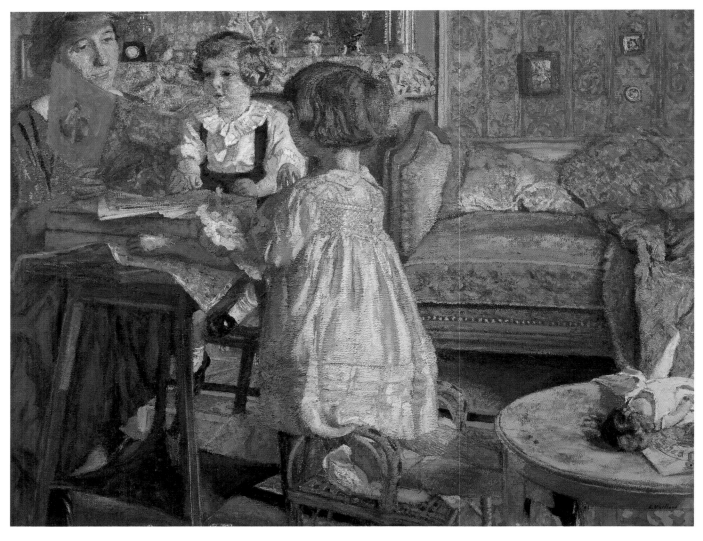

## 316

MADAME WEIL AND HER CHILDREN ·
*Madame Weil et ses enfants*

1922–1923, distemper on canvas, 103 × 131
Signed l.r.: *E. Vuillard*
Private collection, courtesy Galerie Bellier

Cogeval-Salomon XI.103

———————

*Provenance* Dr. and Mme Prosper-Émile Weil,
Paris — Private collection

*Exhibitions* Paris, Musée des Arts décoratifs,
1938, no. 173 — Paris, Orangerie, 1968,
no. 164, ill.

*Bibliography* Salomon 1945, p. 70, ill. p. 123 —
Roger-Marx 1946a, p. 93

———————

Juliette Weil was the wife of Dr. Prosper-
Émile Weil, brother of Romain Coolus and an
intimate of the Hessel circle. Around the time
this portrait was painted, she had begun play-
ing the muse, cultivating with Vuillard the
friendly but demanding relations revealed by
her letters (Salomon Archives) and becoming
for a while Lucy Hessel's rival. Here she poses
in her apartment at 24bis, avenue du Prési-
dent-Wilson, with her children Claudie and
Alain. The trio reading *Le Petit Poucet* to-
gether is consigned to the left-hand side of the
canvas, and of Claudie, rather than her fea-
tures, we see nothing but the absorbed pose of
a well-behaved little girl. The whole painting
is in fact entirely dedicated to the sweet
gravity of childhood, to the seriousness it can
accord to all kinds of learning, including —
as here — reading and games. Vuillard, a dis-
cerning observer of the world of children,
nevertheless hints at the fickleness typical of
youth in the charming detail of the doll, prob-
ably much cherished but now lying neglected
on the pedestal table. The markedly off-centre
composition is reminiscent of another paint-
ing devoted to childhood, *Claude Bernheim de
Villers* (cat. 298), suggesting that this kind of

1. Photograph by Vuillard of Madame Weil and her children,
c. 1922–1923, private collection.

apparently impromptu, dynamic framing —
actually captured in this case with some preci-
sion in a photograph (fig. 1) — struck the artist
as most appropriate to the subject. Claude
Bernheim and Alain Weil have in common the
position of their legs, all awry and too short
to properly occupy an interior designed on an
adult scale. In more general terms, this work

2. Pierre-Auguste Renoir, *Madame Georges Charpentier and Her Children*, 1878, New York, The Metropolitan Museum of Art.

forms part of a series of group portraits with children (e.g. *Madame Jean Trarieux and Her Daughters*, 1912, priv. coll. C-S IX.197; *Madame André Wormser and Her Children*, 1926–1927, London, National Gallery, C-S XI.255) of which this is the most brilliantly successful. This is probably due to the fact that here Vuillard takes up the theme where Renoir had left it, so to speak. Renoir had in fact reinvented the genre of family portraiture with his ambitious and celebrated *Madame Georges Charpentier and Her Children* (fig. 2) and further explored the formula with the chromatically intense *Children's Afternoon at Wargemont* (1884, Berlin, Nationalgalerie). What Vuillard absorbed from Renoir was his way of assigning the same value to sitter and surroundings, as in the deliberately offhand treatment of Juliette Weil, whose face is hemmed in by the book of fairy stories and the objects on the mantelpiece. By manipulating form and by confusing hierarchies, Vuillard comes close to Renoir in the subtle balance between portrait and genre scene that makes this painting so delightful. LC

# 317

"L'ILLUSIONNISTE": THE DWARF GARDEY IN THE WINGS (SKETCH) · *"L'Illusionniste". Le Nain Gardey dans les coulisses (étude)*

1921–1922, pastel and charcoal on paper, 177 × 51
Private collection

Cogeval-Salomon XI.188

*Provenance* Studio—Private collection

Around the time Bonnard was re-exploring scenography by creating the set for the 1921 Ballets suédois production of Debussy's *Jeux*, Vuillard was painting an important series based on Sacha Guitry's play *L'Illusionniste*, first performed in 1917 and revived in March 1922 at the Théâtre Édouard VII. Vuillard saw its premiere—"Go to *L'Illusionniste*, delightful evening. come home enchanted"[1]—and according to his journal worked on some sketches, but "without deciding anything." When he saw the show again in 1922, it inspired him anew. He thought initially of a screen with four panels, roughed out in a drawing: "evening at Lucy's, suggest using my theatre idea to do a screen."[2] Then, abandoning this first idea, he embarked on the execution of two distemper paintings, *Sacha Guitry, the Dwarf Gardey and His Partner in the Wings at the Théâtre Édouard VII* (fig. 1) and *Yvonne Printemps Seen from the Wings at the Théâtre Édouard VII* (1922, Paris, Galerie Bellier, C-S XI.190-2), both preceded by many preparatory drawings, including this pastel. Of Guitry's play he pictured only the prologue, a music-hall show staged at the Alhambra whose various acts included one featuring the two protagonists, a pseudo-English singer called Miss Hopkins, played by Yvonne Printemps, and the magician Teddy Brooks, played by Guitry, together with the "Gardey and Co." number performed by the dwarf clown Gardey and his female partner. Vuillard haunted the backstage area of the Théâtre Édouard VII throughout the month of April, prompting the clown to remark jokingly: "You work on Sundays too."[3] The artist was obviously delighted to plunge once again into the hectic atmosphere of performance, and the numerous sketches related to the show reveal how he prolonged this pleasure, portraying the production in a variety of formats and techniques.

The prologue to Guitry's play was theatre-within-theatre, and Vuillard constructed his compositions to mirror this mechanism. In fact, he shows us the back of the scenery exclusively, never offering a view from the auditorium. In choosing to adopt the standpoint of the actors waiting to go on, Vuillard was clearly mindful of Degas and, most especially, of Toulouse-Lautrec. In both format and subject this study also recalls the *japonisme* of his early years, here combined with the vivacious technique of pastel and bold, bright colours. The series of works on *L'Illusionniste* was Vuillard's last tribute to the world of theatre until the 1937 commission from the Théâtre de Chaillot. The artist's own theatrical memories prompted him to make this charming image from the world of entertainment, symbolized so perfectly by the clown, a portrait as biting as it is moving. LC

1. Vuillard, *Journal*, III.2, fol. 52v (November 25, 1917).

2. Ibid., III.8, fol. 18r (March 22, 1922).

3. Ibid., fol. 26v (April 23, 1922).

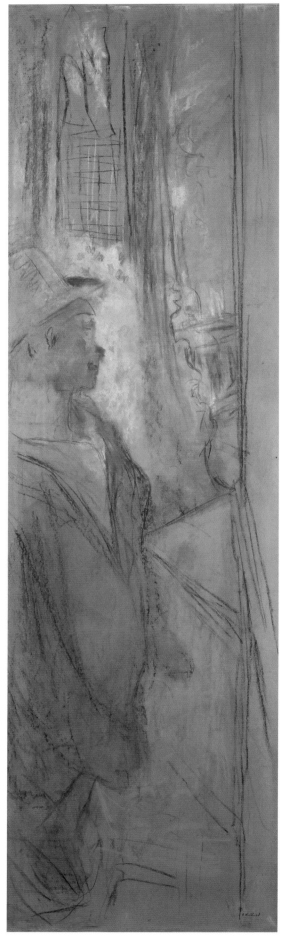

1. Édouard Vuillard, *"L'Illusionniste": Sacha Guitry, the Dwarf Gardey and His Partner in the Wings at the Théâtre Édouard VII*, 1922, distemper on paper mounted on canvas, private collection, C-S XI.190-1.

# 318

MARCEL KAPFERER · *Marcel Kapferer*

1926–1927, oil on canvas, 116 × 88
Signed l.r.: *E. Vuillard*
Private collection

Cogeval-Salomon XI.256

*Provenance* Commissioned from the artist by
Marcel Kapferer, Paris—Private collection

*Exhibitions* Paris, Musée des Arts décoratifs,
1938, no. 191—Basel, Kunsthalle, 1949,
no. 207

Vuillard was the Kapferer family's regular
portraitist. Four years after executing the
double portrait of Henry and Marcel (cat. 305),
he made a painting of their mother (1914,
priv. coll., C-S X.233). Later, shortly after Mar-
cel moved to Avenue Henri-Martin in 1920,
Vuillard portrayed his wife in front of one of
Redon's paintings of Ophelia, which was part
of their collection. This somewhat later por-
trait was one of the last commissions he
carried out for the family. Marcel Kapferer
was fifty-four years old at the time, and Vuil-
lard chose to present the great collector
among the objects of his passion, excluding
any other personal reference. This portrait
recalls the "print lovers" of bygone days, here
infused with the almost relentlessly precise
elegance of the Art Deco period. The deliber-
ately neutral background of Vuillard's studio
on Rue de Calais—grey and beige subtly
enlivened by a few of the artist's recent works
(including *Madame Vuillard at Vaucresson*
[1920–1924, priv. coll.])—allows the resolute
yet attentive presence of the sitter to assert
itself. And the power of the chromatic juxta-
position of red-brown armchair and plum-
coloured suit intensifies this pictorial conver-
gence. But the painting is a double tribute.
Vuillard's sponsor and patron actually shares
his own celebration with Bonnard, whose
lithographic screen *Promenade of the Nurse-
maids* (1895–1896), the brightest gem in
the Kapferer collection, displays behind the
collector the Japanese-style flourishes of
an earlier era. LC

1. Jean Auguste Dominique Ingres, *The Comtesse d'Haussonville*, 1845, New York, The Frick Collection.

2. Edgar Degas, *Thérèse de Gas-Morbilli*, c. 1869, pastel on paper, private collection.

# 319

JANE RENOUARDT · *Jane Renouardt*

1926–1927, oil on canvas, 130.3 × 98
Signed l.l.: *E. Vuillard*
Private collection

Cogeval-Salomon XI.258

―――――――

*Provenance* Commissioned from the artist by Jane Renouardt, Saint-Cloud, 1927—Private collection

*Exhibitions* Japan, 1977–1978 (trav. exhib.), no. 44, col. ill.—Montreal, MMFA, 1998, no. 194, col. ill. p. 85

*Bibliography* Salomon 1945, n. 12, pp. 143–144—Roger-Marx 1946a, pp. 94, 192, ill. p. 103—Brachlianoff 1990, pp. 178, 190, col. ill. p. 117—Cogeval 1993 and 2002, p. 107, col. ill. p. 109—Cogeval 1998b, no. 194

―――――――

Louise Renouardi (c. 1890–1972), who used the stage name Jane Renouardt, was a star of music hall and *théâtre de boulevard*, performing in plays by Sacha Guitry, Tristan Bernard and Henry Bernstein. She directed the Théâtre Daunou from its founding in 1921 until 1930, and was married to the actor Fernand Gravey. At the time she commissioned this portrait from Vuillard, the actress had just had her Saint-Cloud villa redecorated by Louis Süe and André Mare, who had given free rein to their highly ornamental vision of Art Deco. The entire décor, including the furniture, was designed as a play on appearances that culminated symbolically in the bathroom. And this space, in preference to the living room, became the singular setting for this delightfully showy portrait. Vuillard adapted to the situation with humour: "Today I set up right in the bathtub, where I am actually very comfortable."[1] The use of etched glass, introduced by Süe and Mare in 1924 for Jean Patou's *hôtel particulier*, here attained new heights of virtuosity with the addition of drapes and festoons and, above all, in the endlessly repeated reflections. Jane Renouardt, in a sumptuous evening gown over which the painter laboured long and hard, is centred in a space totally based on illusion. Frontal and rear views have been captured simultaneously, stunning the viewer—replaced for the occasion by the actress's little dog—into total visual perdition. What with the red velvet of the drapes, the moiré taffeta of the gown and the leopard skin of the banquette, textural and colour perception is at saturation point. The exultant nature of the painting also stems from the ironic and somewhat perverse appropriation of the references it includes. Jane Renouardt's meditative pose is that of the Comtesse d'Haussonville (fig. 1) in the Ingres portrait, later used by Degas in his pastel of Thérèse de Gas-Morbilli (fig. 2). This citation has the effect of blurring the boundaries between impish seduction and consummate vulgarity, while, in a similar shift, the looking-glass device, employed with subtlety by Ingres and Degas, is carried to extremes in the etched mirror panels. By offering a final, and exaggerated, variation of the Ingres model, Vuillard makes this ambiguous portrait seem at once a homage and a challenge. LC

―――――――

1. Quoted in Salomon 1945, pp. 143–144.

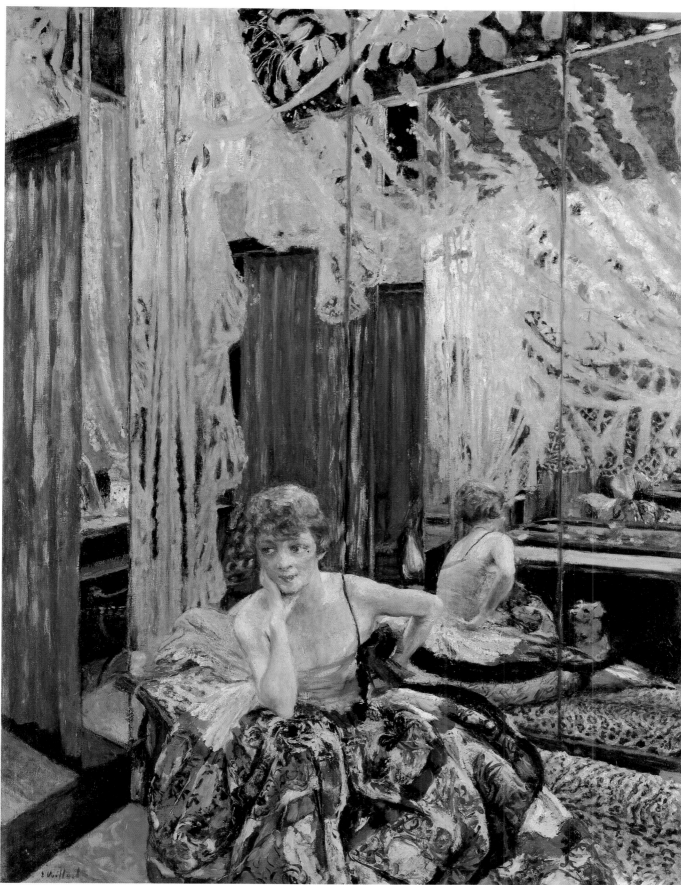

319

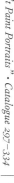

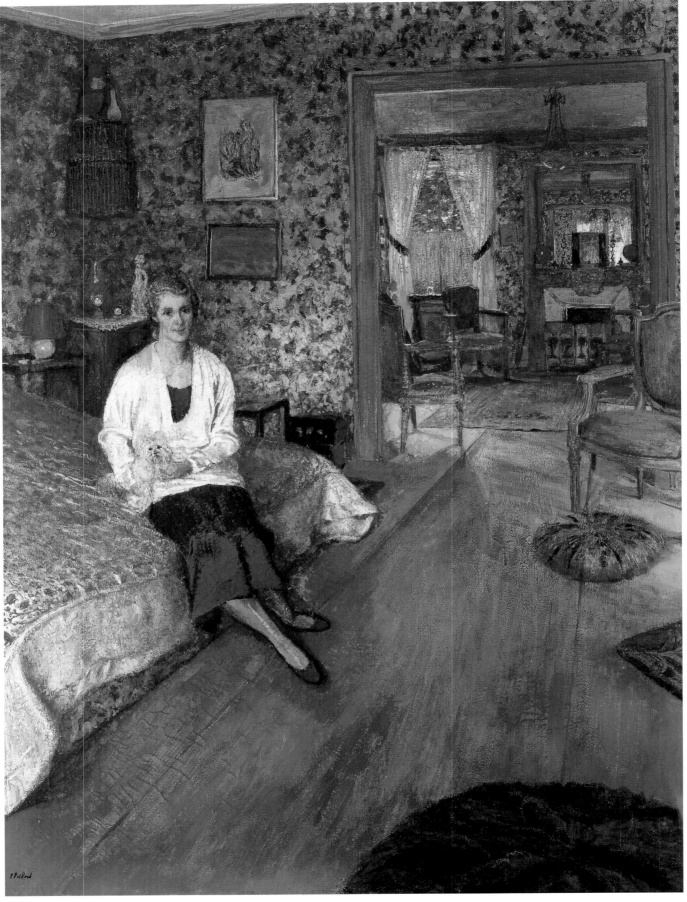

## 320

COUNTESS MARIE-BLANCHE DE POLIGNAC · *La Comtesse Marie-Blanche de Polignac*

1928–1932, distemper on canvas, 116 × 89.5
Signed l.l.: *E Vuillard*
Paris, Musée d'Orsay

Cogeval-Salomon XII.55

————

*Provenance* Commissioned from the artist by the Comtesse Jean de Polignac, Paris — Polignac Bequest to the Louvre for the Musée national d'art moderne, Paris, 1958 — Musée d'Orsay, Paris, 1986

*Exhibitions* Paris, Charpentier, 1948, no. 95 — Paris, Orangerie, 1968, no. 174, ill.

*Bibliography* Salomon 1945, p. 70, ill. p. 120 — Roger-Marx 1946a, pp. 117, 192 — Polignac 1965, pp. 133–142, ill. p. 136 — Rosenblum 1989, col. ill. p. 613 — Cogeval 1993 and 2002, p. 105, col. ill.

————

Marie-Blanche de Polignac (1897–1956), born Marguerite di Pietro, the only child of Jeanne Lanvin (cat. 326), was prominent in French musical circles after the First World War. She was close to Nadia Boulanger and, as a singer, had a marked preference for the Baroque repertoire. Ties with Francis Poulenc, Darius Milhaud, Georges Auric, Nicolas Nabokov, Igor Markevitch and Igor Stravinsky put her at the heart of the then prevailing "return to Classicism." In 1925, she wed Count Jean de Polignac, her second husband, with whom she led an extremely active social life. Their *hôtel particulier* on Rue Barbet-de-Jouy, frequented by the likes of Cocteau, Mauriac, Boris Kochno and Christian Bérard, who decorated the dining room, was a fashionable gathering place for the musicians and literati of the time. Whereas Marie-Laure and Charles de Noailles were well known as avant-garde patrons in the fields of painting, architecture and film, the name Polignac was invariably associated with music. The role-sharing of these modern-day Egerias was neatly summed up by Francis

Poulenc: "One [Marie-Laure] talks about Antonello da Messina like an old friend, while the other, Marie-Blanche [de Polignac], speaks of Monteverdi as if he were a living musician."[1]

Of all Vuillard's oeuvre, this portrait was one of the longest in the making. His journal reports chronic and very evident dissatisfaction with the work. He constantly changed and reworked the painting — unfortunately rendering it irreparably fragile — right up to the moment of delivery, in December 1932. Yet according to his sitter, Vuillard chose his compositional approach very quickly: "He examined every room in the house with that deceptively distracted, distant air and eventually chose my bedroom, with its blue-and-white morning glory chintz."[2] Once his mind was made up, Vuillard literally itemized this part of the Neuilly home, embarking on a process of spatial and documentary "squaring off." To his habitual and always innumerable sketches he this time added a series of photos of the empty rooms, which precisely captured the structure of the space, especially the complex play of interlocking elements created by the reflection in the mirror.

When he turned his attention to his model, Vuillard's work became a long quest for gentleness and harmony — clearly the key themes of this portrait — tirelessly modulated in a series of pastels. But the hesitations soon surfaced: regarding the position of the legs, at first crossed, and the gesture of the hands, originally laced but finally occupied with the dog. His concern for the slightest detail seems to have increased as time passed, for once set on canvas, Marie-Blanche de Polignac's features, as well as the lower part of the painting, were drastically reworked: "redo Polignac, warm water on face to remove craquelure from tired face."[3] Vuillard's acute dissatisfaction, which was totally at odds with his friendship for his sitter, was doubtless a sign of his need to escape. For the project was marked from the outset by a personal crisis. On December 17, 1928, while at the Polignac home, the artist received a call informing him that his mother was about to die: "leave immediately, anguish, delay, confusion."[4] From then on, it seems, the work became an outlet. This, certainly, is the theory formulated by

Jacques Salomon (and reiterated by Guy Cogeval): "I have always felt that this painting, with its exceptionally complex subject matter, represents the distraction he was seeking from his great sorrow."[5] This view is echoed in the invaluable description left by Marie-Blanche de Polignac of a Vuillard gripped, transfigured, by the intensity of his inspiration: "I would not have understood this side of his work nearly as well had I not discovered him in an absolute trance...I was witnessing something terrifying, so violent, so fervent that I was thoroughly intimidated. This was no longer the Vuillard of the Porte du Paradis, it was the young redhead of the *Revue blanche* days. I immediately fell silent. There was something physical, something moving, in the harmony between my silence and his work."[6] LC

————

1. Quoted in Laurence Benaïm, *Marie-Laure de Noailles. La vicomtesse du bizarre* (Paris: Grasset et Fasquelle, 2001), p. 244.

2. Polignac 1965, p. 136.

3. Vuillard, *Journal*, IV.1, fol. 57v (December 14, 1929).

4. Ibid., III(S).1, fol. 23r

5. Salomon 1968, p. 176; Cogeval in C-S 2003, no XII.55.

6. Polignac 1965, p. 138.

## 321

LUCIEN ROSENGART AT HIS DESK · *Lucien Rosengart à sa table de travail*

1930, oil on canvas, 115 × 148
Signed l.l.: *E Vuillard*
Paris, Musée d'Orsay, on deposit at the Musée des Beaux-Arts Jules Chéret, Nice, AM 2371

Cogeval-Salomon XII.74

————

*Provenance* Studio; M. and Mme K.-X. Roussel — Roussel Gift to the French nation, 1941; placed on deposit at the Musée des Beaux-Arts Jules Chéret, Nice, Oct. 1959

*Bibliography* Dorival 1943, p. 165 — Salomon 1945, pp. 70, 73, 135 — Roger-Marx 1946a, p. 107 — Cogeval 1993, col. ill. p. 104

————

321

Lucien Rosengart (1881–1976) was very famous as an automobile manufacturer in the period between the two world wars, and it was this fame that the portrait commissioned from Vuillard was intended to celebrate. However, the relationship between the two men was extremely tense from the outset. Vuillard had initially considered placing Rosengart among the assembly lines of his cars, as can be seen in a pastel and a sketch (priv. coll.). The industrialist disliked the idea—"he doesn't fancy the factory" (February 8, 1930)—so Vuillard opted for the office in Rosengart's private house on Avenue du Bois-de-Boulogne: "go to Rosengart's like a beaten dog; large canvas size 80, once again attempt placement without any set purpose, try to construct a characterization" (February 13, 1930). The sittings continued over the summer, bringing back old memories to Vuillard: "a little posing of the hands, which I indicate with a rough scribble; some retouching to the face, a standard hazard I have almost surmounted, red colour of the lacquered blind; I write, somewhat soothed; memory of my portrait of Waroquy [cat. 1];

methods of approach little changed since then" (June 24, 1930).[1] But when Vuillard delivered the portrait in December, Rosengart argued over the price to such an extent that agreement was impossible. The incident made a lasting and painful impression on Vuillard, and the painting, never paid for by the man who had commissioned it, went back to the artist's studio.

Vuillard's usual exactness in depicting office accessories is combined here with a less habitual coldness. As a result, the portrait of Lucien Rosengart seems like a spurious pendant to the one of Jeanne Lanvin (cat. 326), where the details of the office clearly identify the modern businesswoman but also reveal a gift for life and creation imbued with humanity. We agree with Guy Cogeval[2] when he sees in this painting, beyond the feeling of animosity, an archetype of the modern industrialist—a model that Vuillard was to employ in a looser form some years later in his portrait of Charles Malégarie (fig. 1). Here, the impression of a world turned in on itself predominates, blatantly emphasized by the two strips of blue sky glimpsed through the

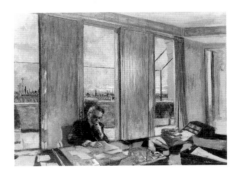

1. Édouard Vuillard, *Charles Malégarie*, 1938, distemper on canvas, private collection, C-S XII.144.

curtains. Vuillard has captured with faultless elegance a "man in a hurry" much like Morand's character, someone who keeps the real world a little too much at a distance, someone caught in the trap of his own success. LC

1. Vuillard, *Journal*, IV.1, fol. 73v, 75v, 6r–6v.

2. Cogeval in C-S 2003, no. XII.74.

390

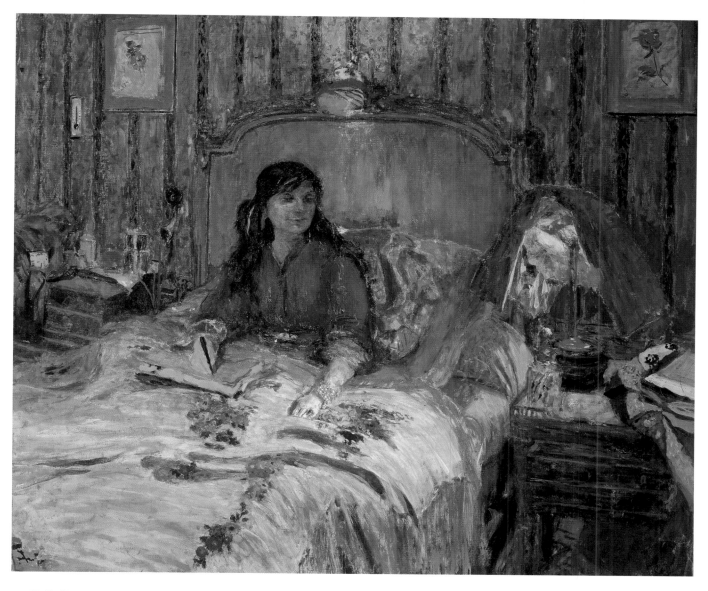

## 322

COUNTESS ANNA DE NOAILLES
(FIRST VERSION) · *La Comtesse Anna de
Noailles (première version)*

1931, distemper on canvas, 110 × 126.5
Private collection

Cogeval-Salomon XII.83

———

*Provenance* Studio—Private collection

*Exhibitions* Basel, Kunsthalle, 1949, no. 74—
Paris, Orangerie, 1968, (hors cat.)—Toronto-
San Francisco-Chicago, 1971–1972, no. 100,
ill.—Japan, 1977–1978 (trav. exhib.), no. 49,
col. ill.—Florence, Palazzo Corsini, 1998,
no. 129, col. ill. p. 168—Montreal, MMFA,
1998, no. 196, col. ill. p. 88

*Bibliography* Salomon 1945, pp. 70, 75–82,
ill. p. 79—Chastel 1946, pp. 94, 98—Roger-
Marx 1946a, pp. 105–106—Cogeval 1993
and 2002, pp. 100–101, 106 (2002)—Cogeval
1998b, p. 124

———

Romanian by birth, Princess Anna-Élisabeth
de Brancovan (1876–1933) married Count
Mathieu de Noailles in 1897. The following
year she published her first poems, and soon
came to public attention with her collections
*Le Cœur innombrable* (1901), *L'Ombre des jours*
(1902) and *Les Éblouissements* (1907); in the
years preceding the First World War she be-
came famous as the official poetess of Parisian
literary circles and high society. Anna de
Noailles's lyric pantheism—but perhaps even
more her poisonous egocentricity—fasci-
nated a whole generation of young writers,
notably Maurice Barrès and Marcel Proust.
The latter gives a sketch of her in *Jean San-
teuil*, in the character of the Vicomtesse Gas-
pard de Réveillon: "The true nature of this

1. Jean Cocteau, *Anna de Noailles*, drawing published in
*Souvenir Portraits* (New York: Paragon House, 1990).

great poet...was never apparent in what she said. On the contrary to judge from the jokes she was continually making, by the way she mocked at people who talked about spring, love, etc.—one would have gathered that she was utterly contemptuous of such matters."[1]

At the time Vuillard was commissioned to paint this portrait, Anna de Noailles's influence in Paris society was waning, eclipsed by that of personalities more in tune with the mood of the times, such as her great-niece Marie-Laure, muse and patron of the Surrealist years. Moreover, by 1931 Anna de Noailles was seriously ill—she was to die in 1933—and scarcely left her room, where she nevertheless continued to entertain her admirers. As a result, Vuillard was obliged to work with very short sittings, which made the execution of the final version of the portrait unusually long and difficult.

The odd dim light emitted by the shaded lamps and diffracted by the fabrics and the clutter of objects—in which Vuillard obviously took great delight—fully convey the famous overstuffed, richly upholstered look of the apartment at 40, rue Scheffer. The atmosphere is stifling, as though impregnated with an unwholesome perfume. Anna de Noailles's face, left in shadow by the painter, is that of some tragic heroine and looks very weary, despite the evidence that she continued writing until her death. But this is no ordinary deathbed vigil Vuillard has let himself be drawn into. More than in any other of his portraits, the artist has pushed the dissonance of contrasting colours to a point bordering on the experimental: "Working on Me de Noailles, ideas of patches of colour, got a bit lost but drew outline, blouse, hair, lamp."[2] The muted violence he achieves recalls the final glimpse of the poetess recorded by Jean Cocteau (fig. 1), in a tone of mingled admiration and irritation:

Anna de Noailles receives, lying on a wide Louis XV bed. The room is the room of a young girl, circa 1900...these yellow ribbons, these laces, this cretonne, this furniture with its twisting legs, these knickknacks of every sort, and the lady of the house! Coiffed with a crow's wing, a hairband, and a buckle (which she nicknames her Vendôme column) spiralling down over her shoulders, one would think that her wide pupils were painted on a blindfold covering her eyes, and that she raises her head to see beneath it...Why did her death remind me of the sublime scorpion which, surrounded by flames, stabs itself to death?[3] LC

1. Marcel Proust, *Jean Santeuil*, trans. Gerard Hopkins (Harmondsworth, Middlesex: Penguin Books Ltd. [1955] 1985), p. 463.

2. Vuillard, *Journal*, IV.3, fol. 56v (May 30, 1931).

3. Jean Cocteau, *Souvenir Portraits*, trans. Jesse Browner (New York: Paragon House, 1990), pp. 149–151.

## 323

THE "VOILES DE GÊNES" BOUDOIR ·
*Le Boudoir aux voiles de Gênes*

1931, oil on canvas, 88 × 79.5
Signed and dated l.r.: *E Vuillard 1931*
Private collection

Cogeval-Salomon XII.88

*Provenance* Fernand Javal, Paris—Private collection

*Exhibitions* Munich, Haus der Kunst, 1968, no. 113, ill.—Paris, Orangerie, 1968, no. 175, ill.

*Bibliography* Salomon 1961, p. 176, col. ill. p. 177

This portrait of Madame Fernand Javal is a perfect example of the sort of commission Vuillard received in profusion during the 1920s and 1930s. The wife of the owner of Houbigant perfumes is shown in her apartment on Avenue Henri-Martin, as though her image were inseparable from her setting. The sitter is even somewhat eclipsed by the elaborate decoration of her boudoir, on which the artist has focused all the effects of the painting. A preliminary sketch presents a narrower viewpoint, but all the decorative elements are already there, starting with the plants and flowers, which are depicted in the final work with the meticulous attention to detail so characteristic of Vuillard: "start yellow calceolaria

purple patch; tired without any preconceived notion" (May 11, 1931); "table on left, the sweet peas" (May 29, 1931); "red peonies right-hand side" (June 4, 1931).[1] We immediately recognize a number of the painter's firmly established compositional devices, such as the spatial construction imposed by his depiction of a corner of the boudoir, and the hinged mirror that artificially deepens the perspective and enhances our view by offering a glimpse of the other side of the room. Along with these familiar structural components, we also find one of Vuillard's favourite techniques: a use of the effects—here unreal and almost magical—of exclusively electric light, as in *Perfect Harmony* (cat. 324) and *In the Salon, Evening, Rue de Naples* (cat. 325). All these elements are subordinated to a unifying vision, an overall conception of the work that makes the portrait and the setting one. The painter's journal reflects his fundamentally decorative aspirations for this project: "go back to Mme Javal's disconcerted not to recapture any of the ideas that have excited me lately about colour harmonies (the Bonnard of the Clayes dining room that I saw again [*Dressing Table and Mirror*, 1913]); trouble with where the effect comes from. work after a fashion general harmony; weariness; leave four o'clock" (October 20, 1931); "sitting Javal, red harmony around the face, effect in the upper left, difficulty in imagining a long while, stave off hunger by daubing at random, pretend the meeting successful but risky" (December 2, 1931).[2] This search for harmony is certainly not new in Vuillard's work; one thinks, for example, of the portrait of Marie-Blanche de Polignac (cat. 320), painted around this time, which is based on similar principles. But here the softer, more mellow range of colours, the style of the furniture and décor, the setting itself—an almost anachronistic boudoir—and even the sitter's pose, evoke the eighteenth century more specifically than ever. Whereas in the decoration for Bauer (cats. 284–288) Vuillard quotes directly from paintings by Watteau and Fragonard, here he gives us a genuine reinterpretation of the rococo aesthetic. The tribute is nonetheless explicit. LC

1. Vuillard, *Journal*, IV.3, fol 52r, 56r, 57v.

2. Ibid., IV.4, fol. 26r.

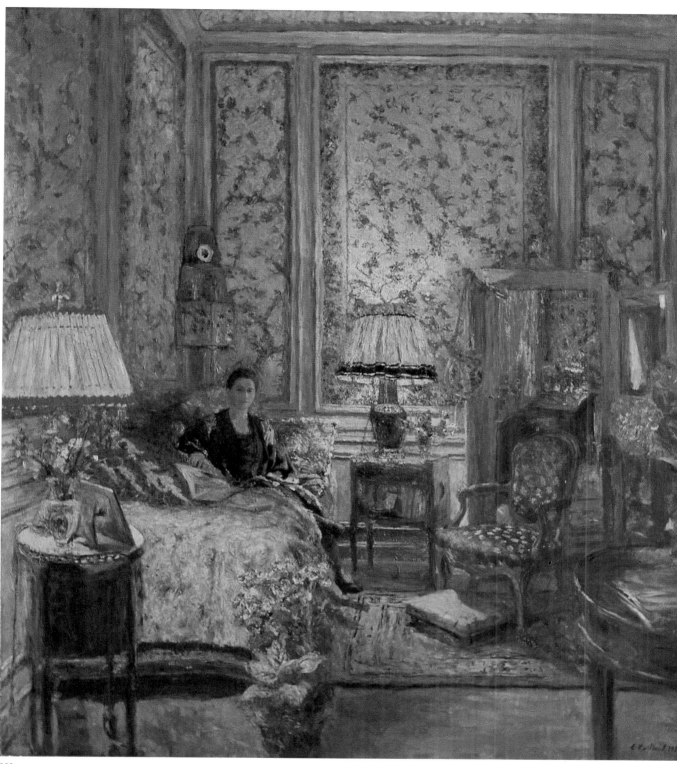

323

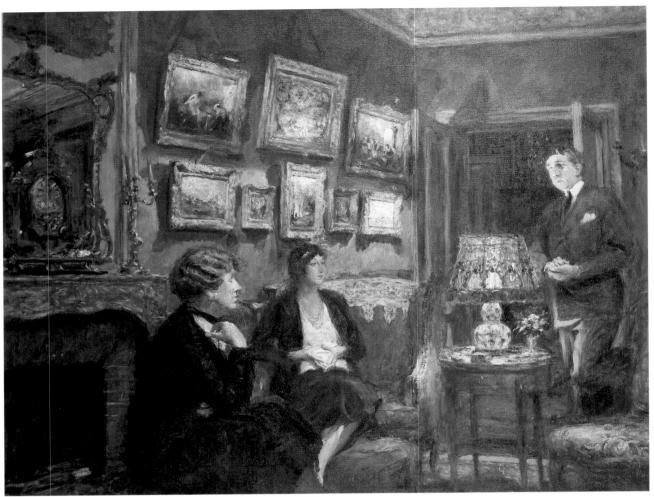

324

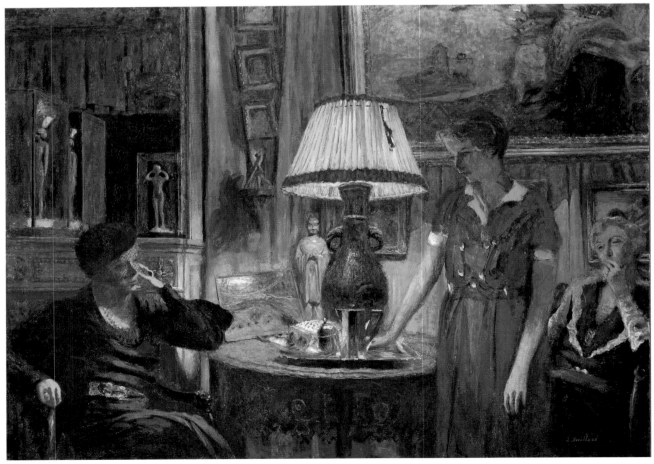

325

## 324

PERFECT HARMONY · *L'Accord parfait*

1932–1933, oil on canvas, 75 × 90
Signed l.r.: *E Vuillard*
Private collection

Cogeval-Salomon XII.95

---

*Provenance* Commissioned from the artist
by Mme A. Gilou, Paris—Knoedler, New
York—Private collection

*Exhibitions* Paris, Musée des Arts décoratifs,
1938, no. 202—Paris, Charpentier, 1948,
no. 83bis—Toronto-San Francisco-Chicago,
1971–1972, no. 91

*Bibliography* Roger-Marx 1946a, p. 81—
Salomon 1968, p. 178, ill.

---

## 325

IN THE SALON, EVENING, RUE
DE NAPLES · *Dans le salon le soir, rue
de Naples*

1933, distemper on paper mounted on
canvas, 100 × 136.5
Signed l.r.: *E. Vuillard*
Washington, National Gallery of Art,
Chester Dale Collection

Cogeval-Salomon XII.105

---

*Provenance* Commissioned from the artist by
Léopold Marchand, Paris—Galerie Bellier,
Paris—Chester Dale, New York—Chester
Dale Bequest to the National Gallery of Art,
Washington, 1963

*Exhibitions* Paris, Musée des Arts décoratifs,
1938, no. 201—London, Wildenstein, 1948,
no. 57—Edinburgh, Royal Scottish Academy,
1948, no. 115—Paris, Charpentier, 1948,
no. 94

*Bibliography* Chastel 1946, p. 98—Roger-
Marx 1946a, ill. p. 103—Brachlianoff 1990,
p. 173, col. ill. p. 97

---

Despite being commissioned by different patrons, *Perfect Harmony* and *In the Salon, Evening, rue de Naples* seem to form a pair. Composed as conversation pieces, both have as their setting the Paris salons of wealthy art lovers who made up the bulk of Vuillard's clients in the early 1930s. In both pictures, a lamp serves as the focal point around which the composition is arranged and the light diffused. The off-centre positioning of this light source in *Perfect Harmony* makes even more dramatic the impressive collection of Madame Gilou, who commissioned the work. Jacques Salomon's colourful description of this lady explains the decisive role played by objects and works of art in these paintings: "She…was feared for her wit and plain speaking. She was obviously proud of her collection of paintings, sold to her by Hessel. Corots, Renoirs and Forains jostled together on the walls, each one 'murdered' by a spotlight."[1] *In the Salon, Evening, Rue de Naples* depicts Miche Marchand—wife of the patron whom Vuillard had known for years and who is portrayed in *Le Grand Teddy* (see "Vuillard between Two Centuries," in the present volume, fig. 10)—together with her hostesses, Lucy Hessel and her daughter Lulu, in the apartment at 33, rue de Naples. We cannot fail to notice the presence, less conspicuous than that of the Gilou collection but at least as powerful, of one of the gems of Jos Hessel's collection, Bonnard's *The Coffee Service* or *At Grand-Lemps* (1909).

The execution of these two paintings was not easy for the artist. Obsessed by his desire to produce an overall sense of unity and thus create an atmosphere, Vuillard puzzled over *Perfect Harmony*: "critical sitting, the details, the clock, lampshade, trouble with keeping the notion of effect, a bit worried" (June 30, 1932). A little later he acknowledged the difficulty of having decided to employ such a concentrated light: "hesitation, crudeness of effect, question of shadows from different sources" (July 23, 1932).[2] More typically, during the painting of *In the Salon* he expressed doubts about his ability to do justice to Miche Marchand's features: "painting of Miche of Lucie botched Miche's face, reasons mechanism of the loss of clear-sightedness required for the construction of a face. what is this ambition to achieve the exact truth; what presumption when it goes against simplicity (drawing of Mother's face compared to Degas) dismal failure with Miche's face idea of correction not in the feeling but in abstract posture not everyone can achieve" (March 6, 1933).[3]

But more interesting than these procrastinations, which we know to have been more or less chronic with Vuillard, is the question of the quasi-indecipherability, even oddness, of the two scenes. Their evocation of the fashionable rituals practised in high society should hardly be threatening. Yet the cushioned atmosphere of these apartments crammed with paintings and objects, like the relationships between the figures, seems to breathe a sort of unease. Although this impression is underlined by the marked formal similarity between the portraits—due possibly in part to the fact that they were painted around the same time—there are nonetheless subtle variations in the rendering. In fact, the two pictures express opposite feelings. *Perfect Harmony*, as the title indicates, stresses the idea of an exchange between the subjects. Madame Gilou joins with her daughter, Madame Fenwick, in harmony with the very Proustian Reynaldo Hahn, in an ecstatic but perfectly proper swoon. In *In the Salon*, on the other hand, there is no hint of any conversation or exchange of glances between the sitters. The three women are isolated, each in her own space, and this impression is heightened by their poses. Miche Marchand leans pensively on her elbow, Lucy Hessel has her hand over her mouth—is she bored?—and Lulu comes across as a highly preoccupied daughter of the house. We are undoubtedly closer here to a comedy of manners than to Symbolist theatre, but in the psychological nuances they suggest, these two little extracts from the theatre of social life seem like worldly, toned-down versions of the intensely intimate family scenes of the 1890s. The time of day accords with the "dramatic" rendering of the two scenes: they are set, as the sitters' clothes suggest, not at night but in the growing gloom of day's end. In the dusk Vuillard can leave words and gestures suspended, depriving onlookers of their implications. This twilight atmosphere was exactly what was required to imbue the refined boredom of these two paintings with such enigmatic charm. LC

---

1. Salomon 1968, p. 178.

2. Vuillard, *Journal*, IV.5, fol. 39v, 45v.

3. Ibid., IV.6, fol. 40v.

## 326

JEANNE LANVIN · *Jeanne Lanvin*

1933, distemper on canvas, 124.5 × 136.5
Signed l.l.: *E. Vuillard*
Paris, Musée d'Orsay, Bequest of the
Countess Jean de Polignac, daughter of
the sitter, 1958

Cogeval-Salomon XII.107

––––––

*Provenance* Commissioned from the artist by
Jeanne Lanvin, Paris—Polignac Bequest to
the Musée national d'art moderne, Paris, 1958;
Musée d'Orsay, Paris

*Exhibitions* Paris, Charpentier, 1948, no. 100

*Bibliography* Salomon 1945, pp. 83, 135—
Roger-Marx 1946a, p. 107—Brachlianoff
1990, pp. 175, 178, ill. p. 175—Cogeval 1993
and 2002, p. 100, col. ill.

## 327

STUDY FOR "JEANNE LANVIN":
THE BOOKS · *Étude pour "Jeanne Lanvin".
Les livres*

1933, graphite on paper, 8.3 × 11.2
Private collection

## 328

STUDY FOR "JEANNE LANVIN":
THE HAND ON THE DESK · *Étude pour
"Jeanne Lanvin". La main sur le bureau*

1933, graphite on paper, 17.5 × 11.2
Private collection

## 329

STUDY FOR "JEANNE LANVIN":
THE DOG · *Étude pour "Jeanne Lanvin".
Le chien*

1933, graphite on paper, 11.1 × 17.5
Private collection

## 330

STUDY FOR "JEANNE LANVIN":
THE HAND · *Étude pour "Jeanne
Lanvin". La main*

1933, graphite on paper, 18.1 × 11.1
Private collection

## 331

STUDY FOR "JEANNE LANVIN" ·
*Étude pour "Jeanne Lanvin"*

1933, graphite on paper, 17.9 × 11.1
Private collection

## 332

STUDY FOR "JEANNE LANVIN" ·
*Étude pour "Jeanne Lanvin"*

1933, graphite on paper, 17.6 × 11.1
Private collection

## 333

STUDY FOR "JEANNE LANVIN" ·
*Étude pour "Jeanne Lanvin"*

1933, graphite on paper, 17.5 × 11.1
Private collection

––––––

Jeanne Lanvin (1867–1946) was one of the
great figures of Parisian haute couture be-
tween the two world wars. Like Paul Poiret
before her, she helped to redefine the female
silhouette in ever more fluid, flowing lines.
Yet her designs, reflecting many sources and
less radically "modern" or pioneering than
those of Chanel or Madeleine Vionnet, re-
tained a certain aristocratic and sophisticated
elegance that appealed to both socialites and
the reigning stars, from Mary Pickford to
Yvonne Printemps.

From humble beginnings as a milliner, she
turned to children's clothes after the birth of
her daughter Marguerite—the future Marie-
Blanche de Polignac—and rapidly went on
to build one of the first modern fashion and
luxury goods empires. In the 1920s, the Lan-
vin style was everywhere, from perfumes—
*Arpège*, launched in 1927, was one of the first
couturier scents—to interior decoration. In
1925, the House of Lanvin had eight hundred
employees in twenty-three workshops, in
addition to its sales staff. Jeanne Lanvin hired

Armand-Albert Rateau to design her boutiques
and to decorate her *hôtel particulier* on Rue
Barbet-de-Jouy and her villas in Cannes and
Touquet, thus establishing an aesthetically
consistent environment. An avid museum-goer
and collector—she owned a Degas *Modiste*
(1882, pastel on paper, Paris, Musée d'Orsay)
—she also loved theatre and ballet, and
created numerous stage and screen costumes.

Jeanne Lanvin's consummate professional
success was accompanied by a dazzling social
ascent, crowned in 1925 by her daughter's
marriage to Count Jean de Polignac. But it
was likely less the opportunity to immortalize
her talent than the prospect of immersion in
the world of fashion, with its connections to
his youth, that drove Vuillard's enthusiasm
for this commission, rapidly executed between
May and November 1933. The instant famil-
iarity is apparent in his initial diary entry:
"first session with Mme. Lanvin…effect of
green in grey, tall mannequin, black, fabrics,
street, quick decision; women at work, child-
hood memories."[1] At first glance, the official
office setting at the Lanvin headquarters,
22, rue du Faubourg-Saint-Honoré, and the
frontal view assert the fashion designer's
authority as a businesswoman. But beneath
the severe geometry of the Art Deco furnish-
ings designed by Eugène Printz, a multitude
of minutely observed details suggest a collec-
tor's study, filled with the curios essential to
the designer's creative process: "When one's
mind is focused on constant creation, every-
thing that the eye registers is transformed and
adapted to that creation, whatever its nature."[2]

In the background is the heart of the office,
Jeanne Lanvin's "fabric library," where sam-
ples collected during her travels spill from
open compartments. Vuillard seems to have
been particularly obsessed by this part of the
painting, and by the section of shelves, with
their rows of pattern books, order books and
other account registers, which he sketched
repeatedly (cat. 327). But in fact he subjected
the entire décor, including the dog, to pain-
staking analysis in numerous studies. He de-
tailed the bust of Marie-Blanche de Polignac
by Louise Ochsé, the inkwell, the pencil-
filled cup, the sinuous telephone cord and, of
course, Lanvin's hands (cats. 328, 330) and

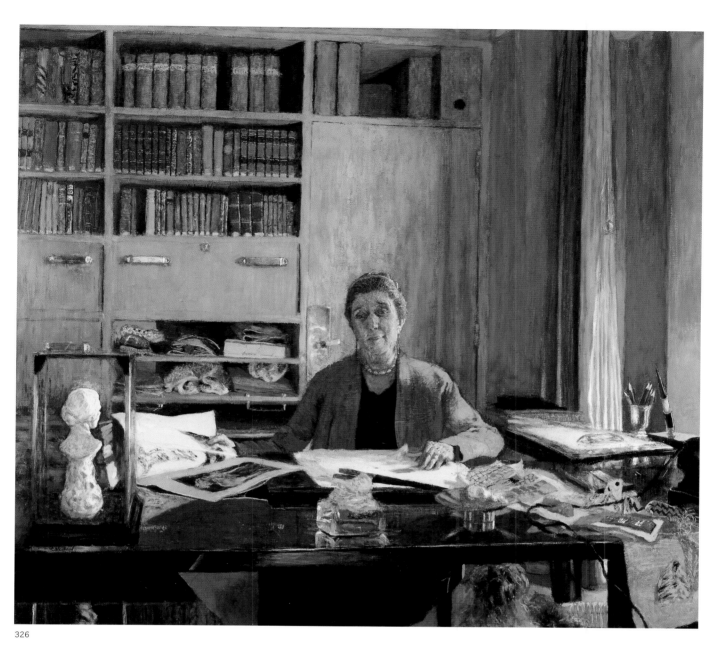

326

face, which he represented in extreme close-up—revealing even the folds of the eyelids—and from a distance (cats. 331–333). The painter also captured his subject in words, noting on several studies a little inventory of significant details: "pencils. telephone. handles. necklace. samples. hand."[3] Finally, to bring warmth and life to the metallic grey and black harmony of the furniture, he added colour with the strong tones of the bookbindings, the bright fabric samples and the complementarity of the sitter's green jacket and red Légion d'honneur decoration.

Jeanne Lanvin and Vuillard, who were the same age, had no doubt crossed paths in their younger days because they lived in the same building on rue Saint Honoré in the early

1890s. Meeting again in the early 1930s, now both famous, they had become discreet observers of a certain modernity. This portrait reveals the tacit complicity between those familiar with the rigorous demands of creation, as well as the shared satisfaction of accomplishment. On October 13, 1933, Vuillard noted in his diary, "work Lanvin grey, severities, verities"[4]—in short, a painting defined as a question of style. LC

1. Vuillard, *Journal*, IV.6, fol. 66v–67v (May 30, 1933).

2. Jeanne Lanvin, quoted in Élisabeth Barillé, *Lanvin* (Paris: Éditions Assouline, 1997), p. 14.

3. Vuillard, notes on a sheet of studies for Jeanne Lanvin, 1933 (priv. coll.)

4. Vuillard, *Journal*, IV.7, fol 2r.

327

328

329

330

331

332

333

# 334

IN THE PARK AT THE CHÂTEAU
DES CLAYES · *Dans le parc du Château
des Clayes*

c. 1933–1938, distemper on paper mounted
on canvas, 155 × 135
Private collection

Cogeval-Salomon XII.171

---

*Provenance* Studio—Private collection

*Exhibitions* Paris, Charpentier, 1948, no. 98—
Munich, Haus der Kunst, 1968, no. 145, ill.—
Toronto-San Francisco-Chicago, 1971–1972,
no. XVIII, col. ill.—Lyon-Barcelona-Nantes,
1990–1991, no. 163, col. ill. p. 45—Florence,
Palazzo Corsini, 1998, no. 132, col. ill. p. 171

*Bibliography* Salomon 1945, ill. p. 111—
Cogeval 1998a, p. 199

---

This work shows Lucy Hessel seated in the
garden of the Château des Clayes, the seven-
teenth-century château outside Versailles,
with grounds laid out by Le Nôtre, to which
the Hessels had moved from Vaucresson in
1926. The girl on the right in a red skirt is
Lulu, Lucy's adopted daughter (see cat. 325),
and the small boy to the left of centre is Jean-
Claude Bellier, son of the dealer Alphonse
Bellier.

The Château des Clayes became Vuillard's
rural retreat during the last decade of his life.
It provided the subjects not only for interiors
such as *Vuillard's Room at the Château des
Clayes* (c. 1933, Art Institute of Chicago, c-s
XII.255) but also for bucolic compositions like
his final decorative works, made for the Palais
des Nations in Geneva (see cats. 294–296)
and for the Théâtre de Chaillot, Paris
(*Comedy*, 1937).

*In the Park at the Château des Clayes* reflects an
interest in the effects of natural light, a subject
that had been explored by Vuillard with vary-
ing degrees of intensity since the later 1890s,
when he began increasingly to investigate
the external world beyond the claustrophobic
interiors of the apartments of family and
friends. It is a preoccupation that reappears in
views through windows from darkened in-
teriors into a strongly lit outdoor world (cat.
154), depictions of the landscapes dominating
the artist's various *villégiatures* (see cats.
261, 268) and the subjects of such decorative
works as the Schopfer panels (see cats. 263–
264), the Bibesco scheme (see cat. 266) and
the Bernheim series for Bois-Lurette (see
cats. 274–275). The play of light and shadow,
translated through the application of pale
and dark tones, is employed here to establish
a decorative component in what might other-
wise be read as too naturalistic a representa-
tion of figures and landscape. Vuillard had
already brought this approach to outdoor light
to a high level of sophistication in such works
as *Foliage: Oak Tree and Fruit Seller—At
the Closerie des Genêts, Vaucresson* (1918, Art
Institute of Chicago, c-s XI.1) and *The Garden
of the Clos Cézanne at Vaucresson* (1920, re-
worked 1926, 1935 and 1936, New York, Met-
ropolitan Museum of Art, c-s XI.52), where
tonal variations of blue-green and yellow-
green, respectively, are used both to describe
the fall of light and shadow and to establish
a rhythmic pattern that reduces the elements
of recession and realistic description. In this
painting a similar decorative emphasis is
achieved by treating the foliage in the fore-
ground and the parallel lines of light and
shade in the mid-ground lawn with the same
palette of yellows and greens. The quest to
reduce the degree of naturalism is also mani-
fest in the rapid execution of the figures,
which denies them any hint of three-dimen-
sional form. The flat backdrop of the vividly
azure blue sky recalls a similar use of the sky
as a flattening device in Vuillard's 1910 work
*Annette on the Beach at Villerville* (cat. 265).
MAS

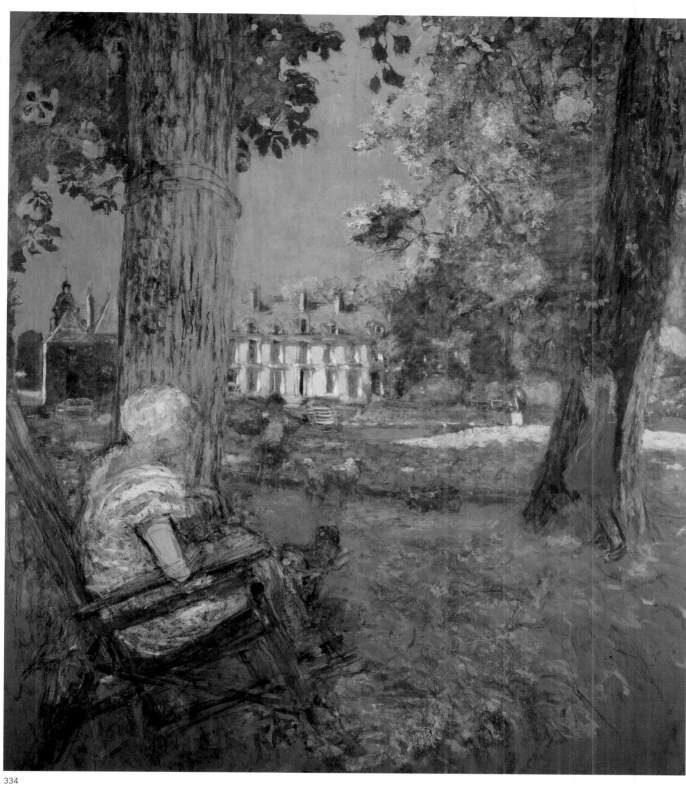

334

VUILLARD AND AMBIGUITY | Dario Gamboni

IN SEPTEMBER 1892, Degas explained that the notion of making his pastel land-scapes, then about to be exhibited at the Durand-Ruel gallery, had come to him as he stood at the open door of a railway carriage looking "vaguely" out. When Ludovic Halévy quoted Amiel's remark that "a landscape is a state of mind," Degas retorted: "A state of eye. We do not use such pretentious language."[1]

Degas's words might well be applied to Vuillard's art and attitude, but Amiel's statement also has some relevance. In fact, it is in the tension and oscillation between optics and psychology, between sensation and imagination, that we can best grasp the dynamics of what Vuillard modestly called his "research."[2] On September 6, 1890 he wrote in his diary: "Nothing matters but the state of mind one is in for suc-cessfully subjecting one's thinking to a sensation, thinking about nothing else but that sensation and finding a way to express it…Seeing, always seeing: for that activity a particular state necessary…Thus to think and to see, to think one's sensation to see what one does…"[3] He deliberately bent his mind to feeling and arrived at this para-doxical intention: feeling, sensation, must be thought, while sight is devoted to what appears on the paper or the canvas.

This meditation on the relationships between vision and thought takes another paradoxical form in two self-portraits painted more than thirty years apart, the *Self-portrait with Bamboo Mirror* (c. 1890, United States, priv. coll., c-s 1.100), almost contemporary with the diary passage cited, and the *Self-portrait in the Dressing-Room Mirror* (cat. 289) from 1923–1924. In both cases, not only is the artist not shown in the act of painting himself, but his eyes are closed or half-closed, an anomaly that shows the extent to which, despite the impression of immediacy, the act of recording and evoking physical appearance is based on a process of conceptualization. It was after looking at his "face in a mirror" that he noted, on July 15, 1894, the mental origin and destination of images: "Is not this a transcription of the images of my thought in common forms, and cannot these notations, more general than lines or dabs, recall or evoke for me the source images? In painting is it not likewise the evocation of these interior images, also by very general means, colours and shapes—art consists of intro-ducing into these means an order that suggests these images."[4]

The terms "evocation" and "suggestion" refer to a specific form of com-munication. On October 24, 1890 Vuillard wrote that "Sérusier is right to say we should not worry about subjective expression when producing. That is the business of the contemplator."[5] His language demonstrates an active conception of visual perception: for the artist, seeing is an "activity" that requires a "particular state"; those for whom the works are intended he calls "contemplators." What ensures that the spectator will take a viewpoint similar to that of the artist, and will follow the train of thought initiated by the latter, is the ambiguity that derives from the way the works are composed and that can be considered a basic characteristic of Vuillard's art, especially in the years 1890–1891. The goal of this study is to examine briefly the role, forms and meanings of this ambiguity.[6]

**States of Eye** | THE IMPORTANCE FOR VUILLARD of the 1890–1891 period is well known, but it is striking that he himself felt it to be a key moment, and strove from time to time to revive it. In 1894, finding that he was becoming "a slave to certain dimensions, certain materials" and fearing "habits that encourage laziness and dull the intelligence," he decided to "attempt to return to the work of 90–91."[7] Some weeks later, after experiencing a moment of despair as he stood before his canvases, he went to the Tuileries, where he "magically rediscovered…the emotions that had guided [him] at the start of [his] career."[8] And yet, this period itself seems to have been a time of crisis. Certainly that was the way he referred to it after the event, during his disagreement with Maurice Denis in 1898: "I came to a point where, either through personal weakness or the inadequacy of received principles, everything collapsed. Elimination by elimination, the groups of formulated ideas I had faith in were reduced to elementary ideas."[9]

This process of reduction and abstraction contributed to the ambiguity Vuillard was achieving at the time. We can analyze it by focusing on the various plastic elements: line, colour, composition and values. But it also expresses a more basic impulse, which consists in shifting interest away from the elements or individual objects toward their relationships. In late 1888 this shift affected Vuillard's still naturalist conception of art: "All we can understand is relationships. Painting is the reproduction of nature as seen in its shapes and colours, and thus of the relationships between them."[10] In order to grasp the perceived relationships, Vuillard felt, one should "not focus on any point or colour longer than on any other," a theory that led him to limit the extent of his work from nature: "Practical necessity of working above all from memory, and always to see as a whole the masses the air etc."[11] We know that at around this time Gauguin was advocating a return to memory. Vuillard developed a personal form of synthetism in the little pencil drawings that cover the pages of his diary. Remarkably effective despite their minimal format, these jottings represent synopses of compositions, reminiscent of Gustave Moreau's almost abstract painted sketches.[12] They accomplish this in black and white, often without contours—as in the sketch of a man reading under a lamp (*Journal*, I.1, fol. 24r)—reduced to a series of parallel hatchings in three values.

From 1890 on Vuillard was also exploring the possibilities of the line, especially the undulating line. The formal simplification of the resulting works and the sovereignty they grant the arabesque make some of them very difficult to read—those executed for the Théâtre Libre, for example, and the series of portraits of Coquelin Cadet (cats. 45–47). In the various versions of *Le Concile féerique* (cats. 54–56), the graphic continuity between the drawing of the figures, the abstract setting and the inscriptions blurs the categories governing the status (iconic, decorative or symbolic) of the different parts of the image. Even the signature composed of the artist's initials plays a part in the formal and sometimes narrative structure of these compositions.

In the letter to Denis quoted above Vuillard continues: "Fortunately for me, I had friends. With their help, I kept faith in the significance of simple harmonies of colours and shapes." We see him exploring each medium's expressive potential—what Albert Aurier called in March 1891 the "directly signifying characters."[13] Jottings probably made in the Assyrian and Egyptian antiquities galleries of the Louvre (fig. 1) show

how interested Vuillard was in the effects produced by the direction of lines—horizontal, rising or falling. Seurat had preceded him in this preoccupation, and like Seurat he may have found inspiration in the ideas of Humbert de Superville as transmitted by Charles Blanc's *Grammaire des arts du dessin* (fig. 2).[14] Vuillard, however, appears not to have adhered to a systematic grammar, but rather proceeded intuitively. In the composition depicting Coquelin Cadet in the role of the devil in *Grisélidis* (fig. 3), the drawing of the actor's hair develops into a broad undulating line that heightens the effect of his threatening gesture. In 1896, when working with the Théâtre de l'Oeuvre in Paris,

Edvard Munch was to use a similar effect in his lithograph portrait of August Strindberg (fig. 4), although he made a clearer distinction between subject and border, and balanced an undulating line by a zigzag.[15]

Vuillard developed this autonomous line in his paintings by representing figures in silhouette, a technique he often justified by his use of light sources, as in *Grandmother Michaud in Silhouette* (cat. 3) and *The Stitch* (cat. 86). He also took advantage of the freedom of colour achieved by Gauguin and of the off-centre layouts used especially by Degas. The resultant images are both "elementary" and enigmatic. In *The Bois de Boulogne* (fig. 5), the male observer is indicated only by a top hat in the lower left corner. In *At the Divan Japonais* (cat. 49), the different areas of colour lock into each other like

4
Edvard Munch, *August Strindberg*, 1896, lithograph, 2nd state. Courtesy of the Fogg Art Museum, Harvard University Art Museum, purchase through the generosity of Lynn and Philip A. Straus, class of 1937. © President and Fellows of Harvard College.

5
Édouard Vuillard, *The Bois de Boulogne*, c. 1890, oil on board mounted on cradled panel, private collection, C-S II.45.

pieces of a puzzle in a way that is both formally impeccable—the curve of the yellow fan is prolonged by the bridge of the nose—and figuratively disconcerting. Should we read the upper right section of the painting as an evocation of the café-concert show and the vague dark ectoplasm within it as another woman singer? In *Young Girls Walking* (cat. 31), our reading of the picture is delayed and complicated by the exaggerated forward tilt of the head of the figure on the left, and by the use of very similar values and colours for the girls' faces and hands and the light-filled openings in the fence in the upper left corner.

Vuillard used values, as well as contours and colours, to challenge the perceptual habits of the "contemplator" and to make the iconographic and thematic interpretation of his works difficult. He broke the unity of his figures by dividing them into areas of very different colours and values, and created new entities and unexpected, intriguing connections by giving similar values and colours to different objects often set far apart in the pictorial space. In the *Public Gardens* panel entitled *First Steps* (cat. 116), the big sister's head seems detached from her torso and disappears into the background because the colours of her hat blend into the clothes of the nannies behind her and because her hair, unlike her collar and dress, is similar in tonality to the ground where the nannies are sitting. At first glance she looks headless, and this oddness reinforces the disquieting impression given by the dark solid figure of the little boy.

The handling of the dress and greenery exemplify another technique developed by Vuillard, which consisted in dissolving form into a more or less continuous web of repeated elements and motifs. This technique, based initially on a personal interpretation of pointillism—as in *Grandmother at the Sink* (cat. 4)—was used subsequently in the depiction of fabrics and wallpapers, for which his mother's dressmaking workshop and his friends' and sponsors' homes provided ample opportunity. In *The Flowered Dress* (cat. 79), the element that gives the work its title, although handled in a flat manner, stands out clearly from the rest of the surface (including the face and the hands supposedly connected to it). The spatial position is contradictory: the figure seems closer than the others because of its size and the values in the dress, but this effect is negated by the elbow, the skirt and the chair, which occupy the left foreground. In his decorative work, starting with the overdoors commissioned in 1892 by Paul Desmarais (cats. 103–108), Vuillard extended over the whole surface the technique he calls in his diary "a flickering décor."[16] Sometimes mingling indistinguishably figures and backgrounds, wallpapers, dresses, cushions and carpets, as in the Vaquez panels (cats. 137–140), he created a kind of visual texture that is both endlessly various and relatively homogeneous and that represents one of the great examples of what Joseph Masheck called "the carpet paradigm."[17]

Another contemporary realization of this paradigm is found in Monet's series, particularly his paintings of the façade of Rouen Cathedral, which were executed between 1892 and 1894 and exhibited in 1895. These works' values and effects are also comparable, and it was not without justification that Clement Greenberg, in a piece on Abstract Expressionism and its antecedents, cited Monet and Vuillard (together with Bonnard) among those artists who in the late nineteenth century rejected chiaroscuro as a way of suggesting depth and volume and as a means of structuring and unifying a painting.[18] Greenberg considered this rejection of a handed-down convention as part of

the process of modernization of art that led ultimately to post-war "American-type" painting as the most complete realization of the essential flatness of the pictorial surface.

This view had some of its roots in the art theory and criticism of Vuillard's generation. The most important may be found in the first article of the "Définition du néo-traditionnisme," of 1890, in which Denis stated that the formal, physical dimension of the painting as a "flat surface covered with colours arranged in a certain order" takes phenomenological and ontological priority over its representational function.[19] Thadée Natanson, writing in 1908, shows himself influenced by this idea in his account of the decorative panels created for his apartment by Vuillard in 1895 (cats. 126–129): "Drawing, or the depiction of objects, has no value in these paintings but the plastic value of arabesque. The pleasure of naming objects is doubtless part of that given by the images, but it is not the essential part, which is abstract."[20]

The truth of this seems less apparent today. By making this "pleasure of naming objects" more difficult, more complex, more uncertain, Vuillard did not diminish it but rather increased it. He provided a pleasure similar to that which August Strindberg, writing in 1894, found in the "rapidly changing impressions" evoked by an ambiguous natural phenomenon and by the "modernist paintings that philistines find so incomprehensible."[21] The "name" given to objects by Vuillard and the spectator is neither original nor definitive. The narrator of *À la recherche du temps perdu* would also understand that the charm of Elstir's canvases "lay in a sort of metamorphosis of the objects represented, analogous to what in poetry we call metaphor, and that, if God the Father had created things by naming them, it was by taking away their names or giving them others that Elstir created them anew."[22] Degas also defined Vuillard's art as metamorphosis when he said that "from a dusty bottle of Chablis [he] creates a bouquet of sweet pea blossoms."[23]

**Models and Context** | THE MODELS THAT MAY have inspired or encouraged this use of ambiguity are many and diverse. The best known include Impressionism, with its quest for a way of seeing freed from habitual modes of representation; the art of Gauguin and his followers, which in the name of synthesis challenged the very notion of mimetic representation; that of Redon, which systematically uses visual metaphor and involves the viewer in a search for "hints of aspects"; Japanese prints, with their flatness, their expressive abbreviations and their unusual layouts; and Symbolist theatre, which Vuillard helped launch and which replaced the implicit conventions of naturalism by the explicit ones of an abstract, "suggestive" language. The series of portraits of Coquelin Cadet illustrates the freedom and audacity he found in the pantomime, one of the forms of "primitive" performance that was being explored by innovative dramatists.[24] Nancy Forgione includes Vuillard among the artists who introduced into painting the art of the silhouette as it was being practised at that time, notably in the shadow theatre shows presented by Henri Rivière at the Chat Noir nightclub.[25]

Montmartre was in those days the centre of a remarkably inventive culture, or counter-culture, that was particularly active in theatre, parody and caricature.[26] Double meanings, visual analogies and multiple images abounded, often employing devices that were still very much alive in popular imagery. I have suggested elsewhere that the visual

enigmas created by Vuillard can be compared to puzzle pictures, those inexpensive prints in which the user, often a child, tries to find one or more hidden figures.[27] Vuillard's interest in these picture games, which were common at that time, seems to me confirmed by one of the portraits of Coquelin Cadet (*Coquelin Cadet in the Role of Argan in "Le Malade imaginaire,"* 1891, United States, priv. coll.), in which the figures of two little footmen are incorporated into the actor's profile. But unlike puzzle pictures, Vuillard's works do not come with a set of instructions, and their ambiguity cannot usually be narrowed down to a hidden image. In *In Bed* (cat. 21), for example, the soft, almost drowsy shapes of the bedclothes express the sleep into which the young woman (?) has fallen, and the vertical pillows seem to watch over her like pet dogs on a tomb, but it seems unlikely that any specific figurative meaning is being suggested. In *Girl Sleeping* (fig. 6), on the other hand, the pillow takes the clear shape of a grotesque but benevolent profile, with the corner of one eye aligned with the sleeper's eye and the mouth close to hers; if one tilts this small picture so that the profile is vertical, the artist's signature turns into an ear. The use of draperies to conjure faces was much exploited by designers of puzzle pictures, and *Girl Sleeping* can be compared to a scene (fig. 7) whose innuendo actually evokes Vallotton's work even more than that of Vuillard.

6

Édouard Vuillard, *Girl Sleeping,* 1892, oil on board mounted on cradled panel, private collection (cat. 22).

7

Anonymous puzzle picture, undated (before 1901). Bibliothèque Nationale de France:

— I have come, dear child, to see your papa: Please let him know I am waiting for him.

— Oh, there is no need: can you not see he is there, next to you, ready to hear what you have to say?

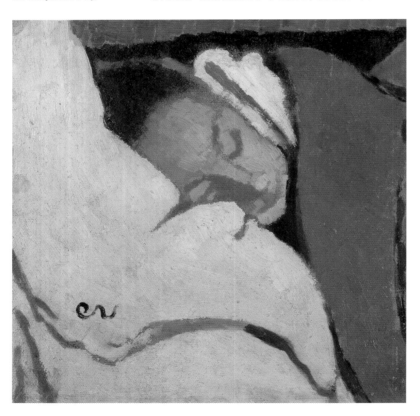

- Je viens, mon cher enfant, pour voir votre papa ; Veuillez le prévenir que je suis à l'attendre.
- Oh, c'est bien superflu : ne remarquez-vous pas Qu'il est là, contre vous, et prêt à vous entendre ?

Rather than incorporating a supplementary image, Vuillard often amused himself by making an expected image disappear, with the skill and coolness of a conjuror. In *Kerr-Xavier Roussel Reading the Newspaper* (cat. 87), it is the newspaper that vanishes, replaced by the reader's right leg. In the Natanson panels and in many other paintings, figures and objects tend to blend into the "flickering décor." Many commentators have used the image of camouflage to describe this effect,[28] and it is an idea that can be justified historically, since camouflage, first used during the Great War, was derived

mainly from painterly experiments and developed with the help of Cubist artists in France and Vorticists in England.[29] By the end of the war it had even entered the world of fashion: a humorous drawing from this period (fig. 8) reveals the links between the visual mechanisms of camouflage and those of puzzle pictures, using a motif favoured by Vuillard for somewhat similar reasons, the flowered dress.

This kinship with camouflage, and the literary and artistic references cited above, demonstrate that Vuillard's love of ambiguity was not unique, but part of a very broad cultural trend.[30] Filiz Eda Burhan suggests that the development of the Symbolist aesthetic may be explained by the influence of psychological theories and occultism, and notes that under the Third Republic many writers and artists, including the Nabis, attended the philosophy classes that had been introduced in the final year of French secondary school.[31] Maurice Denis, a fellow student of Vuillard, Roussel and Lugné-Poe at the Lycée Condorcet, asserted that the artists of his generation, following in the footsteps of Taine and Spencer, had based "the laws of the work of art" on "the structure of the eye and its physiology, the mechanism of associations and the laws of sense perception."[32] In *De l'intelligence*, first published in 1870 but often re-published and used in secondary schools, Taine had asserted the autonomy and power of the mental images that correspond to sensations, declaring in a much-quoted formula that "instead of calling hallucination a false external perception, we must call external perception a *true hallucination*."[33]

Studies in experimental psychology and psychophysiology, developed mainly in Germany during the second half of the century, also concluded that the brain has a fundamental role in perception and investigated the visual mechanisms that demonstrate this to be so. In his *Analyse der Empfindungen* (Analysis of Sensations) of 1886, Ernst Mach noted the phenomenon of the reversibility between figure and ground, and cited puzzle pictures as an example.[34] In his 1893 work *La suggestion dans l'art*, the French philosopher Paul Souriau stated that what he called *dessins à double jeu*—literally "double-play" drawings—demonstrate the "selective power of the imagination." According to him, artists call on the same "faculty of representation," for "to look at a drawing is to see chimeras in the clouds."[35]

For those attracted by the esoteric, this sort of spontaneous generation of images could be interpreted as revelation. When Strindberg was suffering the breakdown he experienced in Paris and described in his 1897 novel *Inferno*, he saw in his pillow "marble heads sculptured in the style of Michelangelo," along with other figures that seemed to him related to what he had done during the day.[36] The pillow in Vuillard's *Girl Sleeping* does not have this unnerving strangeness, and the question of possible esoteric allusions in his paintings—to which I shall return—remains open. Nevertheless, there is no doubt that the idea of "suggestion," popularized in medicine by the rediscovery of hypnosis and adopted by the writers, dramatists and artists associated with Symbolism, corresponded to his view of the genesis and effect of a work of art. In medicine and psychology, suggestion is defined as "the act by which an idea is introduced into the brain and accepted by it."[37] In the realm of art it tends to define a form of communication whose content depends on the reader's or viewer's state of mind as much as on the creator's.

8

A. Vallée, *Woman in a Landscape*, 1918, illustration published in *Fantasio*. Mary Evans Picture Library.

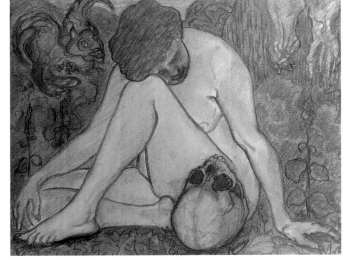

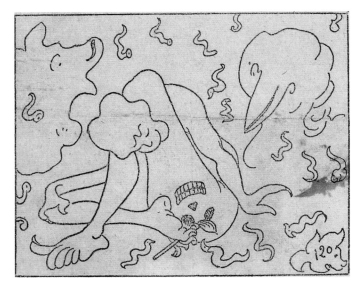

9

Paul Élie Ranson, *Nude with Skull*, c. 1892, charcoal on paper, private collection.

10

Anonymous, caricature of *Nude with Skull*, published in *Le Journal*, December 1892. Archives départementales des Yvelines, Versailles (cliché D. Balloud).

11

Félix Vallotton, *Little Girls*, 1893, woodcut, Musée cantonal des Beaux-Arts de Lausanne.

**Exchanges and Coincidence** | THE ARTISTS VUILLARD SPENT most time with were also the closest to him in their use of ambiguity. Modern art has accustomed us to deciphering relatively easily the extreme simplifications and expressive deformations of the Nabis, to the point that we sometimes have to resist the unconscious impulse toward "idea" rather than "feeling" in order to experience these works in all their initial strangeness and suggestivity. For the artists' contemporaries the shock was extreme, and their perplexity is amusingly captured in a caricature of the drawing *Nude with Skull* by Paul Élie Ranson included in the December 1892 exhibition at Le Barc de Bouteville (figs. 9–10).[38] The twisted feet of a tormented figure, which Ranson places in the upper right corner of his composition, become the head of a long-beaked bird that parallels the monster on the other side; the arabesques, raised to the level of independent entities, wriggle

like worms; and the skull resting against the nude so that its curves complete those of her thigh seems to be part of her leg, an abridgement reminiscent of the mechanisms described by analysts of dreams to explain the creation of oneiric images.[39]

Still in the realm of graphic art, Félix Vallotton obtained similar effects through the binary reduction to contrasts of black and white he employed in his woodcuts. In the 1894 work *The Bath*, for example, the profile of the maid with downcast eyes, which continues the volutes in the wallpaper, and that of her mistress engage in a comic dialogue with the bird-shaped taps. This playing about with images was rarely innocent in the oeuvre of the man who was the author of *La Vie meurtrière*. In 1894 Alfred Jarry wrote for the second volume of *Portraits du prochain siècle* a short piece on Vallotton containing an assessment of *Little Girls* (fig. 11). In it he interprets as a vampire's hands the hair framing the face of the little girl in the centre, whose eyes as round as "shields" appear to him to express terror.[40] Although clearly subjective, this reading testifies to the many associations evoked by the abstraction of this print, and to the underlying notes of seduction and threat implied by the flirtatious way the child lifts her skirt and the looks she is exchanging with the imaginary viewer (probably male). Comparable experiments with physiognomic reduction can be found in Vuillard's diary,[41] but in his fully developed works the narrative suggestions are generally more implicit.

In painting, it is Bonnard whose explorations—although more obviously humorous—are closest to those of Vuillard. Denis's work was also very similar to Vuillard's during their early experimental years, when the Nabis were rivalling each other in daring and comparing their little "icons." It is easy to imagine that a dialogue linked Vuillard's *The Bois de Boulogne* and *Sunlight on the Terrace* by Denis (1890, Paris, Musée d'Orsay), which is even more allusive and less narrative.[42] But this concord was short-lived: during the 1890s Denis, who did not hesitate to tackle subjects from Christian iconography, gradually reintroduced into both his painted and written work requirements of readability and unequivocalness that contradicted the practice of ambiguity. His religious convictions and his work as a church painter doubtless contributed to this development.[43] Gloria Groom has emphasized the contrast, already noted by Achille Segard in 1914 in his book on painter-decorators, between Vuillard's penchant for complicated surfaces and hard-to-read images, and the preference of Denis for clearly defined forms, smooth surfaces and recognizable themes.[44] Vuillard was equally deliberate in his choices, noting in his diary on August 2, 1894: "Really, for apartment decoration a subject that is objectively too exact would easily become intolerable. One becomes bored less quickly by a fabric, pictures without too much literary precision."[45]

**States of Mind** | VUILLARD'S RELATIONSHIP WITH his fellow artists and friends—relationships of emulation, exchange and competition—were essential to him. This was particularly the case with Denis and Sérusier, whose convictions were more fixed than his and who were more adept at theorizing.[46] Yet his journal records how incessantly, especially between 1890 and 1895, he questioned himself and reflected upon his own work and upon art in general. These reflections are not immediately evident in his painting, which seems—as Denis later chided—to spring primarily from the pleasure of

sensation. But Vuillard was clearly anticipating Marcel Duchamp's rejection of the saying "stupid as a painter" when he protested against the limitations of the subjects inherited from naturalism and the condemnation of "literary painting": "What could be more interesting, in fact, than this 'literature' that to some people is such a bogey. It allows us to choose this or that medium, this or that form as a mark of the emotion it has denoted; to invent as well...Why this fear of being intelligent, this determination to be animal—or machine?"[47]

In the same diary entry Vuillard defines the subject as "emotion felt in the face of appearances," thus closely linking "state of mind" and "state of eye." With the exception of his work for the theatre, which justified the recourse to fiction, Vuillard's

416

starting-point was invariably observed reality, which he offered the viewer as a kind of touchstone. Only occasionally did he explore the iconographic ambiguity of an unusual and complex subject— as in *The Goose* (cat. 35), for example, whose mood is, significantly, markedly theatrical.[48] From this perspective too he is closer to Bonnard and Vallotton than to Denis, Sérusier or Ranson, who did not hesitate to use religious faith, mysticism or the esoteric as subjects. To some extent Vuillard's attitude is comparable to that of Van Gogh, who during the summer of 1888, when he was in close contact with Bernard and Gauguin, had given up religious subjects and even destroyed two attempts at the Christ in the Garden of Olives theme, declaring that the influence of "modern reality" led inevitably back to "personal sensations."[49]

Vuillard too resolved to depart from the commonplace with the aim of transfiguring it. On October 26, 1894 he scolds himself for disliking the bad taste of his surroundings, and tries to convince himself of the artistic interest of this environment if seen from a Baudelairean point of view: "It is as difficult, even more so I think, but very instructive to comprehend a common subject (I do not say a simple one), an ordinary thing, as a recognizedly beautiful thing that has moved you. This way of understanding the world was, I believe, the endeavour originally proposed by the earliest commentators on the modern and modernity."[50] This penchant for depicting ordinary everyday subjects is reminiscent of the seventeenth-century Dutch painters and of Chardin, whom he studied closely. His interest in empty space, the fragmentary and the allusive, and the sense of mystery that often imbues his domestic scenes also recall the drawings of Georges Seurat and Charles Angrand, as well as relating his work to that of other contemporary artists, especially in Northern Europe—Vilhelm Hammershøi in Denmark and Xavier Mellery in Belgium, for example—who were reinterpreting Dutch genre painting as a kind of Symbolism.[51]

One of Mellery's works that uses the motif of a staircase (fig. 12) may be compared to Vuillard's *The Staircase Landing, Rue de Miromesnil* (fig. 13), painted two years later. *The Stairway* is more readable and focuses more on a geometrical structuring of the space. Mellery gave his drawings generic titles such as "The Life of Things" or "The Soul of Things," and in this drawing emphasis is placed on the jug and on the shadows,

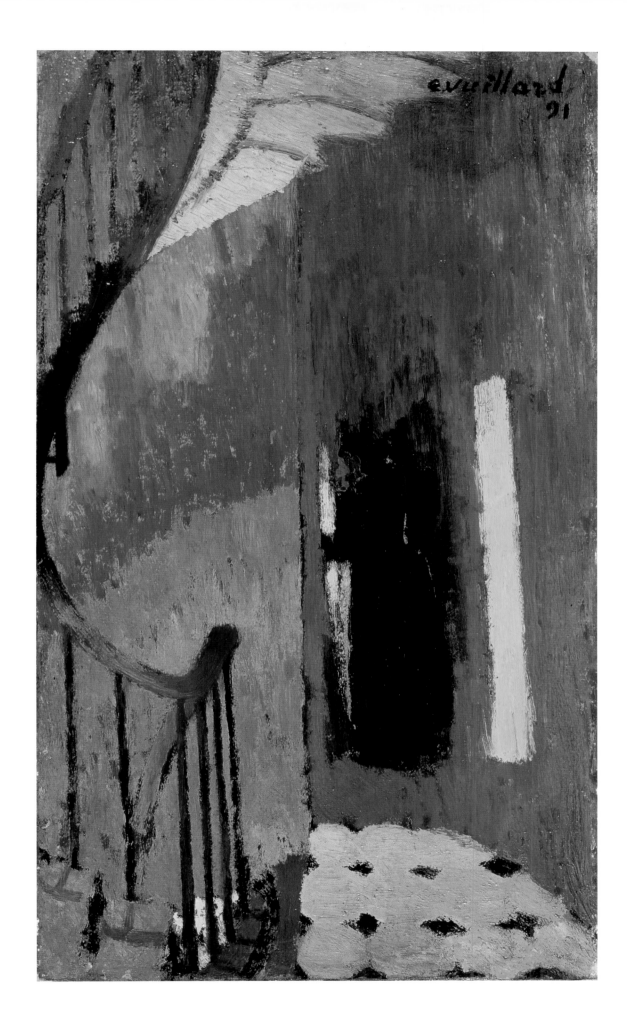

which add a ghostly echo to the figures and objects. But in both cases the staircase operates as a place of passage leading to unknown spaces: Mellery's maid seems to have reached an invisible opening at the top of the composition, while in Vuillard's more abstract and evanescent little picture a silhouette is almost taking shape on the landing.

Can we assume, then, that there exists in Vuillard's oeuvre the same kind of hidden symbolism that has been glimpsed in Dutch painting? George Mauner claims to have found the shape of a tau and esoteric allusions in a number of Vuillard's works, particularly in the partial cross above the sleeping figure in *In Bed* and in the fragment of panelling picked out by the lamp beam in *Interior, Mystery* (cat. 144).[52] The odd and seemingly arbitrary way in which these two details appear leads us to wonder what they mean. According to Jacques Salomon, Vuillard was cut off from religion early and permanently as the result of a "serious and painful crisis of conscience"—possibly the "collapse" mentioned in his 1898 letter to Denis. Nevertheless, from time to time in 1890 and 1891 he called on God to free him from "low obscure ideas" and to help him "participate in the universal harmony," even invoking the deity as a last resort against aesthetic relativism: "Is the perception of beauty subjective only? Not if we believe in objective existence, if we believe in God."[53] The way a cross is formed through an "accident" of composition or lighting is not very different from the way the artist's signature takes on an iconic character, or a profile appears in the folds of a cushion. In my view what is most important, however, is that this symbolic dimension remains hypothetical and that the image, rather than hidden, turns out to be potential.

Although what links them to states of mind may be equivocal, Vuillard's "states of eye" certainly have meaning. The unusual composition of *The Bois de Boulogne* presents a story of seduction or desire, as do *The Flirt* (cat. 18) and also probably, in a metaphorical way, the scene portrayed in *The Goose*. In *First Steps*, the apparent detachment of the elder sister's head propels her visually among the nannies, whose role she has in fact assumed. In *In Bed* and *Girl Sleeping* the inanimate objects participate in the human subject's state and provide "plastic equivalents" of that state, as Ursula Perucchi-Petri observes, citing one of Denis's key concepts.[54]

On October 27, 1894 Vuillard noted a number of visual impressions in his diary, including the following: "Seeing Kerr, Mimi and mother at table, think again about the drama."[55] A feeling of psychological tension is very often present in his domestic scenes with figures, linking them closely to the theatrical enterprises in which he had been involved. Such is the case in *Interior, Mother and Sister of the Artist* (cat. 85), with its accelerated perspective and the sister's figure, which appears constrained by the top edge of the painting to lean forward; and it is also true of *A Family Evening* (cat. 96), where the figures appear, more isolated than united, in an interior sealed off by black windows. These effects do not disappear with the artist's return to the depiction of a three-dimensional space, but are brought about by other methods—as in *Married Life* (1896, priv. coll, C-S IV.217), whose very title points to the impression of psychological observation emanating from the work, and in *The Hessels in Their Dressing Room* (fig. 14), with its triptych mirror effects.

And yet here too everything remains allusive and implicit. According to Claude Roger-Marx, Vuillard often said, "Silence protects me."[56] The use of ambiguity, which as I have briefly noted corresponded to an important turn-of-the-century trend, seems to have particularly suited him. An example may be seen in his penchant for the motif of the open door, a familiar symbol for an intermediary, dual situation.[57] It is found in many works, including *The Staircase Landing, Rue de Miromesnil, Lady of Fashion* (cat. 26) and *The Door Ajar* (1891, Avignon, Fondation Angladon-Dubrujaud, C-S IV.15), and also in his photographs (for example, *Annette Roussel in her nannie's arms*, 1899, priv. coll.). Vuillard avoided clear distinctions and precise limits. This may be one of the reasons why, as Gloria Groom points out, he was fascinated by the interior designed by Misia Natanson, which was relatively informal and showed no clear distinction between traditionally masculine and feminine spaces.[58] In July 1894 he expressed his natural preference for motifs related to women: "When for example I try to imagine a composition for the Natansons, I can think of no objects other than female ones—this is embarrassing and proves that I am not indifferent to the subject."[59] Given the rigidity of the stereotypes associated with both sexes at the time, it may well be that the deep sympathy for

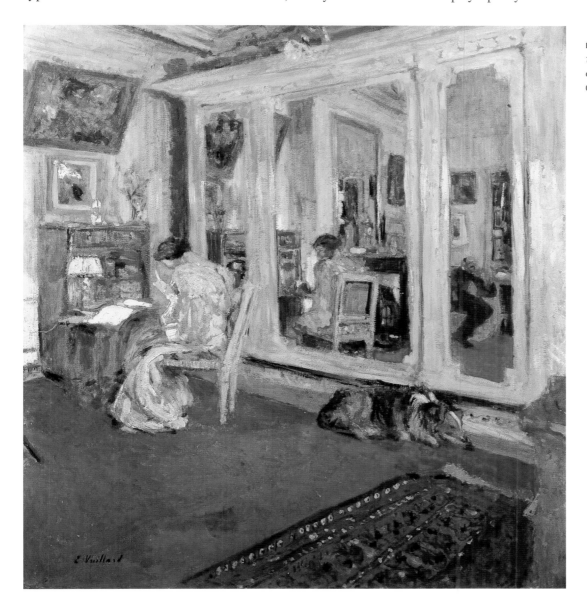

14
Édouard Vuillard, *The Hessels in Their Dressing Room*, 1903, oil on board, private collection, C-S VII.322.

women demonstrated in Vuillard's work was linked to what he saw as a certain passivity in his own makeup: "Letting myself be tossed around, perhaps I will end up acquiring some inner calm on condition never to count on external calm. If only I could cease making vague wishes. I dare nothing and am the plaything of all."[60]

This "passivity," which is also openness, favours the active participation of the spectator that is both an effect and a condition of Vuillard's art. In 1891 the playwright Paul Hervieu, also using a metaphor derived from the traditional division of sexual roles, responded as follows to Jules Huret's inquiry into the state of literature: "And what makes me doubt that Symbolism, unless it is perfected, could be truly fertile is that I find it full of pleasing forms, but combined with a kind of elusiveness that displays an almost feminine modesty; with the result, it seems to me, that it only conveys the idea if the reader is himself male, himself possesses a writer's temperament."[61] This "writer's temperament," though, could perfectly well be found in a woman—or in a child, another creature for whom Vuillard felt great empathy. Gloria Groom has noted that the decoration commissioned by the Natansons also created a delightful environment for their daughters; she quotes the testimony of Annette Vaillant, Adam Natanson's granddaughter, who loved to stand daydreaming before the big panel entitled *The Window overlooking the Woods* (cat. 142).[62] Vuillard must have been delighted, for he had taken fully to heart Sérusier's aphorism concerning the responsibility for "subjective expression" in a work of art: "That is the business of the contemplator."

1. *Degas: Letters*, ed. Marcel Guérin (Oxford: Bruno Cassirer, 1947), p. 252 (trans. slightly modified). On these landscapes see, among others, Howard G. Lay, "Degas at Durand-Ruel, 1892: The Landscape Mono-types," *The Print Collector's News-letter*, vol. 9, no. 5 (November–December 1978), pp. 142–147. On the quotation from Amiel and its significance at the end of the cen-tury, see Filiz Eda Burhan, "Visions and Visionaries: Nineteenth-Cen-tury Psychological Theory, The Occult Sciences and the Formation of the Symbolist Aesthetic in France," Ph.D. thesis, Princeton University, 1979, pp. 143–148.

2. Quoted by Claude Roger-Marx, *Dans l'intimité d'un grand intimiste: Vuillard* (paper presented to the January 22, 1969 meeting of the Académie des Beaux-Arts) (Paris: Institut de France, 1969), p. 5.

3. Vuillard, *Journal*, 1.2, fol. 19v–20r. I am grateful to Guy Cogeval and Mathias Chivot for their help in preparing this article and for having made available to me the documentation of the Édouard Vuillard catalogue raisonné, in-cluding a copy and a transcription of the artist's journal.

4. Vuillard, *Journal*, 1.2, fol. 43v.

5. Ibid., fol. 23r.

6. See an initial approach to this question in Dario Gamboni, "Con-fondre avec méthode. Remarques sur l'incertitude chez Vuillard," in Jean-Paul Monery and Jörg Zutter (eds.), *Édouard Vuillard. La porte entrebâillée*, exhib. cat. (L'Annonci-ade, musée de Saint-Tropez / Musée cantonal des Beaux-Arts de Lausanne / Milan: Skira, 2000), pp. 53–61.

7. Vuillard, *Journal*, 1.2, fol. 41v (July 10, 1894).

8. Ibid., fol. 48v (August 30, 1894).

9. Letter from Vuillard to Denis, February 19, 1898, quoted in Maurice Denis, *Journal*, vol. 1 (1884–1904) (Paris: La Colombe, 1957), pp. 136–138.

10. Vuillard, *Journal*, 1.1, fol. 12r (after November 20, 1888).

11. Ibid., fol. 12 r–v.

12. See *Gustave Moreau: Between Epic and Dream*, exhib. cat. (Chicago: The Art Institute of Chicago, 1999), cats. 58–5, 58–11, 67, 72, 73, 75, 97, 110, 118–3, 256.

13. G.-Albert Aurier, "Le sym-bolisme en peinture. Paul Gauguin," *Mercure de France*, vol. 2, no. 15 (March 1891), p. 162.

14. See, for example, *Georges Seurat, 1859–1891*, exhib. cat. (New York: The Metropolitan Museum of Art, 1991), Appendix G ("Charles Blanc"), pp. 384–385.

15. See *Munch et la France*, exhib. cat. (Paris: Réunion des musées nationaux, 1992), pp. 259–261; Elizabeth Prelinger and Michael Parke-Taylor, *The Symbolist Prints of Edvard Munch: The Vivian and David Campbell Collection*, exhib. cat. (Toronto: Art Gallery of Ontario / New Haven and London: Yale University Press, 1996).

16. Vuillard, *Journal*, 1.2, fol. 50r (September 10, 1894).

17. Joseph Masheck, "The Carpet Paradigm: Critical Prolegomena to a Theory of Flatness," *Arts Magazine*, vol. 51, no. 1 (September 1976), pp. 82–109.

18. Clement Greenberg, "'Ameri-can-Type' Painting" (1955), re-printed in C. Greenberg, *The Col-lected Essays and Criticism*, vol. 3: *Affirmations and Refusals 1950–1956*, ed. John O'Brian (Chicago and London: The University of Chicago Press, 1993), pp. 227–228. I am grateful to Yve-Alain Bois for this reference.

19. Pierre Louis [Maurice Denis], "Définition du néo-traditionnisme" (1890), reprinted in M. Denis, *Le Ciel et l'Arcadie*, texts selected by Jean-Paul Bouillon (Paris: Hermann, 1993), p. 5.

20. Catalogue of the Thadée Natanson sale at Drouot (1908), quoted by Ursula Perucchi-Petri in *Nabis 1888–1900*, exhib. cat. (Paris: Réunion des musées nationaux, 1993), p. 342.

21. August Strindberg, "The New Arts! or The Role of Chance in Artistic Creation," in *Selected Essays* (Cambridge: Cambridge University Press, 1996), p. 105.

22. Marcel Proust, *À la recherche du temps perdu*, this extract taken from *In Search of Lost Time*, vol. 2, *Within a Budding Grove* (1919), trans. C. K. Scott Moncrieff and Terence Kilmartin, rev. D. J. Enright (London: Chatto and Win-dus, 1992), p. 479.

23. Quoted in Roger-Marx, 1969 (see note 2), p. 15.

24. See, among others, Patricia Eckert Boyer, *Artists and the Avant-Garde Theater in Paris, 1887–1900: The Martin and Liane W. Atlas Collection*, exhib. cat. (Washington: National Gallery of Art, 1998), pp. 34–40.

25. Nancy Forgione, "'The Shadow Only': Shadow and Silhouette in Late Nineteenth-Century Paris," *The Art Bulletin*, vol. 81, no. 3 (Sep-tember 1999), pp. 490–512.

26. See Phillip Dennis Cate and Mary Shaw (eds.), *The Spirit of Montmartre: Cabarets, Humor, and the Avant-Garde, 1875–1905*, exhib. cat. (New Brunswick, N.J.: Jane Voorhees Zimmerli Art Museum, 1996).

27. Gamboni, 2000 (see note 6), pp. 56–57.

28. See, for example, Gloria Groom, *Édouard Vuillard: Painter-Decorator. Patrons and Projects, 1892–1912* (New Haven and Lon-don: Yale University Press, 1993), p. 124.

29. See Albert Roskam, *Dazzle Painting. Kunst als Camouflage, Camouflage als Kunst*, exhib. cat. (Rotterdam: Maritiem Museum "Prins Hendrik" / Stichting Kunst-projecten, 1987); *Camouflages*, exhib. cat. (Péronne: Historial de la Grande Guerre, 1997).

30. See Dario Gamboni, *Potential Images: Ambiguity and Indeter-minacy in Modern Art* (London: Reaktion, 2002).

31. See Burhan, 1979 (see note 1), especially pp. 42–45.

32. Maurice Denis, "Notes sur la peinture religieuse" (1896), re-printed in Denis, 1993 (see note 19), p. 36. On this subject see Jean-Paul Bouillon, "Denis : du bon usage des théories," in *Nabis 1888–1900*, 1993, pp. 61–67.

33. Hippolyte Taine, *On Intelli-gence*, reprinted in *Significant Contributions to the History of Psychology 1750–1920*, Daniel N. Robinson (ed.) (Washington, D.C.: University Publications of America, 1977), p. 226.

34. Ernst Mach, *Beiträge zur Analyse der Empfindungen* (Jena: Fisher, 1886), p. 89.

35. Paul Souriau, *La suggestion dans l'art* (Paris: Alcan, 1893), pp. 86–87, 95. See Dario Gamboni, "'Dieses Schillern der Eindrücke freute mich…': August Strindberg und unabsichtliche Bilder im Paris der 1890er Jahre," in Gerhart von Graevenitz, Stefan Rieger and Felix Thürlemann (eds.), *Die Unver-meidlichkeit der Bilder* (Tübingen: Gunter Narr, 2001), pp. 173–186.

36. August Strindberg, *Inferno, Alone and Other Writings*, ed. and trans. Evert Sprinchorn (Garden City, New York: Doubleday and Company, Inc., 1968), p. 166, note 36.

37. Hippolyte Bernheim, *New Studies in Hypnotism* (New York: International Universities Press, Inc., 1980), p. 18.

38. See *Paul Élie Ranson 1861–1909. Du Symbolisme à l'Art Nouveau*, exhib. cat. (Saint-Germain-en-Laye: Musée départemental Maurice Denis "Le Prieuré" / Paris: Som-ogy, 1997), p. 73.

39. See, among others, Sigmund Freud, *The Interpretation of Dreams*, chap. 6-C, "The Means of Repre-sentation in Dreams" (London: G. Allen and Unwin, 1937); Stefanie Heraeus, *Traumvorstellung und Bildidee. Surreale Strategien in der französischen Graphik des 19. Jahr-hunderts* (Berlin: Reimer, 1998).

40. See Stephen H. Goddard and Brian Parshall, *Ubu's Almanac: Alfred Jarry and the Graphic Arts*, exhib. cat. (Lawrence, Kansas: Spencer Museum of Art [The Uni-versity of Kansas], 1998), pp. 30, 39. For another interpretation of Jarry, comparable but further developed, see Jill Fell, "Breton, Jarry and the Genealogy of Paranoia-Criti-que," in Ramona Fotiade (ed.), *André Breton: The Power of Lan-guage* (Exeter: Elm Bank, 2000), pp. 111–123; Dario Gamboni, "Dürer als Pataphysiker. Eine Bildlektüre von Alfred Jarry," in Uwe Fleckner, Martin Schieder and Michael F. Zimmermann (eds.), *Jenseits der Grenzen. Französische und deutsche Kunst vom Ancien Régime bis zur Gegenwart. Thomas W. Gaehtgens zum 60. Geburtstag*, vol. 3 (Cologne: Dumont, 2000), pp. 29–41.

41. See, for example, Vuillard, *Journal*, 1.1, fol. 43–44, 49.

42. This work is reproduced in *Nabis 1888–1900*, 1993 (see note 20), p. 143, cat. 32, and elsewhere.

43. See J.-P. Bouillon's remarks in *Nabis 1888–1900*, 1993, p. 67, and Dario Gamboni, "'Baptiser l'art moderne'? Maurice Denis et l'art religieux," in *Maurice Denis 1870–1943*, exhib. cat. (Lyon: Musée des Beaux-Arts de Lyon / Paris: Réunion des musées nationaux, 1994), pp. 74–93.

44. Gloria Groom, *Beyond the Easel: Decorative Paintings by Bonnard, Vuillard, Denis, and Roussel, 1890–1930*, exhib. cat. (New Haven and London: The Art Institute of Chicago / Yale University Press, 2001), p. 46, with reference to Achille Segard, *Peintres d'aujourd'hui. Les décorateurs* (1914).

45. Vuillard, *Journal*, I.2, fol. 47v.

46. Ibid., fol. 45v. Like Bernard and Van Gogh, Vuillard seems to have been troubled by the spirit of competition that the "art dealer-critic" system encouraged and often reminded himself "not to worry about originality" (e.g., *Journal*, I.2, fol. 55, 1890).

47. Ibid., fol. 66 (January 1894). See Marcel Duchamp, "L'artiste doit-il aller à l'université?" (1960), reprinted in M. Duchamp, *Duchamp du signe. Écrits*, ed. Michel Sanouillet and Elmer Peterson (Paris: Flammarion, 1975), pp. 236–239.

48. See Guy Cogeval, "Le célibataire mis à nu par son théâtre, même," in Ann Dumas and G. Cogeval (eds.), *Vuillard*, exhib. cat. (Paris: Flammarion, 1990), pp. 115–116.

49. See Petra Ten-Doesschate Chu, "Destruction as a Meaningful Act: Vincent van Gogh as Destroyer of His Own Works," in Alberto Dallal (ed.), *La Abolición del arte* (XXI coloquio internacional de historia del arte) (Mexico City: Universidad Nacional Autónoma de México, Instituto de Investigaciones Estéticas, 1998), pp. 73–84, which quotes a letter written by Van Gogh to Émile Bernard early in December 1889 (letter B 21).

50. Vuillard, *Journal*, I.1, fol. 52.

51. See, for example, Bernd Growe, "The Pathos of Anonymity: Seurat and the Art of Drawing," in Erich Franz and B. Growe (eds.), *Georges Seurat: Drawings* (Boston: Little, Brown, and Company, 1984), pp. 13–50; *L'univers poétique de Vilhelm Hammershøi (1864–1916)*, exhib. cat. (Paris: Réunion des musées nationaux, 1997); Anne Pingeot and Robert Hooze (eds.), *Paris-Bruxelles / Bruxelles-Paris. Les relations artistiques entre la France et la Belgique, 1848–1914*, exhib. cat. (Paris: Réunion des musées nationaux, 1997), pp. 320–328.

52. George Mauner, "The Nature of Nabi Symbolism," *The Art Journal*, vol. 23, no. 2 (winter 1963–1964), pp. 96–103.

53. Vuillard, *Journal*, I.2, fol. 23v (October 24, 1890), 33 (April 2, 1891).

54. In *Nabis 1888–1900*, 1993, (see note 20) p. 309; see Denis, 1993 (see note 19), p. 28.

55. Vuillard, *Journal*, I.2, fol. 52v.

56. Roger-Marx, 1969 (see note 2), p. 3.

57. For George Mauner, "the theme of the open door at the end of the corridor…in Vuillard's hands… becomes the convincing symbol of the aperture leading to revelation, semi-open, a crucial step away" Mauner, 1963–1964 (see note 52), p. 98.

58. Groom, 2001 (see note 44), pp. 129–131.

59. Vuillard, *Journal*, I.2, fol. 46v (July 27, 1894).

60. Ibid., fol. 55v (November 11, 1894).

61. Jules Huret, *Enquête sur l'évolution littéraire* (Paris: Charpentier, 1891), p. 33.

62. Groom, 2001 (see note 44), pp. 124, 137.

THE INTENTIONAL SNAPSHOT | Elizabeth Easton

*Photography is the art that shows how life is made up of a multitude of fleeting moments.*
· Marcel Proust ·

THE NABI PAINTERS came of age and began their artistic careers in the late 1880s, the period that saw the invention of the Kodak roll-film camera. The portability of the Kodak and the ease with which it could be operated made it one of the most exciting innovations of the late nineteenth century. Thanks to this new tool, photography became accessible not only to the professionals of a burgeoning field, but also to amateurs from all walks of life. Artists had been drawn to photography since its invention, and painters, including Delacroix, had experimented with its techniques from the earliest years. Although there is little documentary evidence to show that the Impressionists generally embraced the medium, Edgar Degas produced an important body of work in photography during a concentrated period of activity in the mid-1890s. Around the same time, the Nabis became infected by the fever of excitement surrounding photography, but instead of emulating Degas's more conventional use of a tripod-mounted camera with glass plates (primarily the instrument of professionals), they opted for the new and improved Kodak models (intended for hobbyists) produced in 1895–1896.

The Nabis' desire to follow an artistic direction that would set them apart from the positivism of the Impressionist painters who preceded them coincided with their espousal of the new technology and greater freedom offered by the Kodak. As family archives are beginning to reveal, a significant number of the Nabi painters in addition to Vuillard, including Pierre Bonnard, Maurice Denis and Félix Vallotton, tried their hand at taking photographs, approaching the medium with varying degrees of commitment, interest and success. But just as Vuillard alone among them would continue throughout his life to push the limits of *peinture à la colle*—the glue-based medium the Nabis used for painting stage sets early on in their careers—so did he remain committed to photography long after the others had abandoned it.

Vuillard left over two thousand photographs—more than 1,700 as original prints and the rest as negatives. This vast body of work allows us not only to discover and acknowledge his mastery of a completely new artistic medium, but also to reassess the complexity of his artistic production.[1] Vuillard's photographic output is more varied in approach, if not in subject matter, than is his painted oeuvre. During the early years of his photographic experimentation, there was often a close relationship between his painted and photographic work: many of the photographs reveal a strong compositional and spatial affinity to the paintings, although the creation of fraught, dark, interior shots in the new medium remained a challenge even after the advent of the Kodak in 1888. The family members and close friends who were the primary subjects of his paintings in the 1890s also figured as his principal photographic subjects. And the distortions of pictorial space that enhanced the psychological tension in the easel paintings produced at this time were also manipulated to great advantage by Vuillard's camera lens.

There is another group of photographs, however, that embodies a completely different pictorial aesthetic: these pictures display the qualities of serendipity and spontaneity—made possible by the Kodak—that have come to define the "snapshot." Through close proximity to his subject, which affected both the focus and framing of the image, Vuillard created works of art that have no parallel in the rest of his oeuvre. Although the subject matter of these photographs remains his close circle of family and friends, they

expand our knowledge of this enigmatic painter and intensify our curiosity about him. They raise questions about deliberation and accident, about the subjectivity of his vision and the objectivity of the camera, about the empirical reality and mystical evocation that are at the core of meaning in his art.

IN NUMEROUS INSTANCES Vuillard employed the same compositional structure in his photographs as in his painted works, even when the former post-dated the latter. A photograph of Vuillard's mother and his friend Romain Coolus (fig. 1), for example,

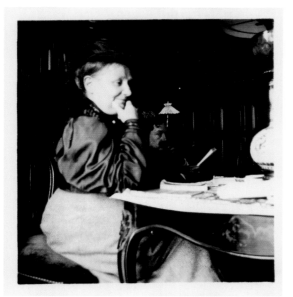

taken in the first years of the twentieth century, dates to at least a decade after the painting *The Blue Sleeve*, from 1893 (cat. 93), yet even a casual glance at the two images reveals a similar pictorial construction and a similar aesthetic. The photograph and the painting are alike in their spatial arrangements: the foreground figures loom large and dominate the composition, while the rear figures are reduced in size. In the photograph, this would have been in part a function of the camera's technical constraints; a reduced depth of field appears to flatten the space, exaggerating the size of objects in the foreground and minimizing that of objects in the background.[2]

1

Photograph by Vuillard of Madame Vuillard and Romain Coolus, c. 1905, private collection.

In the photograph, Madame Vuillard sits at a table in the foreground with her chin resting on her hand. She is not looking at the photographer, but staring somewhat reflectively into space. Behind her, barely visible, is Coolus, seen in profile, book in hand, gaze turned toward Vuillard. The photographic work exhibits several characteristics that are familiar from Vuillard's paintings, such as a complex interweaving of light and dark, a magnified foreground with a background dramatically reduced in size, and a sense of psychological interaction between sitters and artist that further compounds the spatial and compositional configurations.

In the absence of colour, a staccato play of lights and darks dominates the photograph's composition. Vuillard's mother, seen in profile at the table in the foreground, wears a pale skirt that contrasts markedly with her dark satin blouse, which itself creates lush patterns of shadow and light in the folds of the sleeve. She sits at a dark wood table on which stands, at the extreme right of the frame, a large light-coloured lamp. Only when the eye travels to the small lamp in the distance does the viewer apprehend the presence of Coolus's profile toward the rear of the picture. Seated right under the tiny lampshade, dwarfed by the monumental form of Madame Vuillard, the figure of Coolus, once perceived, plays an important compositional role. His profile points in the same direction as the imposing Madame Vuillard's, but her face is bathed in light. The barely perceptible Coolus, on the other hand, is only faintly illuminated, by an unseen

source. In neither case, in fact, is the figure actually illuminated by the lamp with which it is associated. The book or pad Coolus holds is possibly lit by the lamp behind him but is more likely reflecting a light source located near where Vuillard is standing. Although understated, Coolus's presence is emphasized by the fact that his gaze is directed at Vuillard and thus at the viewer. Compositionally, this has the effect of drawing the small, obscure elements of the background toward the picture plane. In *The Blue Sleeve*, the foreground figure almost entirely obscures the small figure in the background. In a mechanism that is virtually the reverse of that operating in the photograph, but with remarkably similar compositional results, specific compositional devices—such as the ledge toward which the foreground figure's hand points and the table abutting and leading away from it—nonetheless guide the viewer's eye to the background figure.

VUILLARD DREW INSPIRATION for his compositional approach from a number of sources; he would have observed the strong, cutting diagonals and flat areas of colour in the work of several of his contemporaries, including Degas and Gauguin, in addition to remarking similar configurations in Japanese prints. In fact, Vuillard was manipulating pictorial space in his paintings long before he began experimenting in photography, but he would have welcomed the distortions of the photographic lens as reinforcing what he had already achieved in painting.

     Although Vuillard does make frequent references in his journals to picture-taking, these most often take the form of brief notes, and he rarely if ever describes a photo session in detail. The artist's own writing about photography is virtually limited to these scattered phrases. A journal entry such as "Afterwards in the studio, I work with a photograph and a pastel from the summer"[3] suggests that, at least in the early twentieth century, he utilized certain of his photographs as *aide-mémoire* for paintings. Moreover, the artist clearly kept these *aide-mémoire*: in one of the few existing examples of Vuillard's having transcribed photographic images into paint, a work entitled *The Haystack* (cat. 266), executed in about 1909, the artist used figures from two photographs taken a couple of years previously as the subjects for his picture.[4]

     The only description of Vuillard's approach to picture-taking is by his nephew-by-marriage Jacques Salomon, and appears in an essay for the 1963 exhibition *Vuillard et son Kodak*. As Salomon married Vuillard's niece Annette in 1920, his account attests to the artist's use of the Kodak in the last decades of his life:

Vuillard owned a camera, a Kodak. It was an ordinary model, one of the bellows type. It was part of Vuillard's household. Its place was on the sideboard in the dining room. Sometimes, during a conversation, Vuillard would go to get it and resting it on some furniture or even the back of a chair, oblivious of its view finder, would point the lens in the direction of the image he wished to record: he would then give a brief warning: "Hold it please" and we would hear the clic...clac of the time exposure. The camera was then returned to its place, and Vuillard walked back to his seat. When the number 12 appeared on the little red window of the camera, Vuillard took it to his usual supplier, close to where he lived in the Rue de Clichy, to have it reloaded. The printing of the film was then entrusted to his mother. Sitting by the window overlooking the square, doing some embroidery, she watched the frame exposed to the light and when it was time she proceeded to the "fixing" in a soup plate.[5]

The informal spontaneity of the approach that Salomon describes was evidently not a component of the artfully posed scenes of Vuillard's photographic work from the 1890s, when slow shutter speeds and rudimentary focusing technology would have required his photographs of interiors to be as carefully composed as his paintings. The capabilities of the hand-held Kodak were limited, and Vuillard used the camera differently at different periods of his life. An understanding of how the camera worked can throw light on the various ways Vuillard manipulated the instrument.

The Kodak used roll film, but had a fixed focus, which is why the object in the centre of Vuillard's compositions appears in focus, while other objects fade in relation to their proximity to the centre. To reduce the fall-off at the edge of the image, the apparatus that Vuillard used had only one f-stop available. The result was what is referred to as a hyperfocal image: there was only one point of perfect focus, in the centre of the lens. When the camera was used outdoors, the exposure time ranged from $\frac{1}{15}$ to $\frac{1}{30}$ of a second. But the interior shots so frequent among Vuillard's early photographic work would have required a time exposure, which allowed the photographer to push a button that activated a simple mechanism incorporated in the shutter and then to close the shutter at his own discretion. The exposure time for an interior shot could, and probably did, last for several minutes, and for an early scene like *Madame Vuillard cooking, Rue des Batignolles* (fig. 11, cat. 169), for instance, would have been considerable. This would, in turn, have necessitated the use of a tripod.[6]

Vuillard has often been seen as the heir to Edgar Degas in regard to his paintings, and there is a similar quality of evocativeness in the two artists' photographic work as well. The majority of Degas's photographs seem to have been made around 1895, several years after the development of the Kodak. He nevertheless used professional equipment, which involved a tripod, glass plates, careful lighting and long exposures, and required his subjects to remain immobile for significant periods of time. Degas deliberately used earlier photographic machinery, while Vuillard employed the modern, potentially hand-held Kodak—but in the elaborate manner of the older artist. There are nonetheless several significant differences in the photographic practices of the two artists with respect to both approach and control, rooted principally in the apparatus each employed.

In a view camera of the kind that Degas used, the photographer looked, via the viewfinder, through the lens. This method permitted very precise focusing and framing, so the details of the artist's compositional selections are worthy of note. A contemporary account of Degas's picture-taking gives us a clue to the complex processes involved. Degas removed the sources of natural light—by drawing curtains, moving lamps and changing reflectors—and forced his friends to hold their poses for up to a quarter of an hour. Paul Valéry's inscription in the margin of Degas's photograph of Renoir and Mallarmé (fig. 2) describes the use of nine oil lamps and "a fearful quarter-hour of immobility for the subjects." As a result of the mercilessly controlled staging, Mallarmé evidently came close to being burned, for Valéry continues, "the execution... was torture for the model, endured with all the grace in the world: nearly glued to a

stove, roasting, without daring to complain. The result was worthy of a martyr." The image shows Renoir and Mallarmé posed in front of a mirror that reflects the camera, Degas, and the poet's wife and daughter. The nine petrol lamps illuminate the area so brilliantly that Degas's face, in the reflection, is obliterated by the glare.

By contrast, the hand-held Kodak that Vuillard chose to use was unable to produce a precisely controlled image: the artist could not look through the lens to frame the picture. Instead, he had to hold the camera at stomach height and look down onto the top of the apparatus, where an arrow helped direct it toward the desired object. So with a late nineteenth-century model Kodak, not only was it impossible to focus, it was even impossible to see the image that the camera was going to capture. Why, then, did Vuillard choose to use a Kodak for his interior shots? It was a device that incorporated the element of accident, since neither the clearly focused central object nor the borders of the composition could be precisely predetermined. The deliberation with which Vuillard arranged his interior shots might have been similar to Degas's, but its effect was quite different. The time exposure of the Kodak for an interior shot was left to the photographer's discretion, but could last several minutes. However, whereas Degas could focus the lens and look through it to frame his image, Vuillard could do neither.

Similar in composition to Degas's photograph of Renoir and Mallarmé, a photograph of Madame Vuillard and Paul Sérusier (cat. 235) shows Vuillard's mother standing behind the painter, whose arm rests on the mantel. In the Degas, each element of the composition is subordinated to the two figures; there are few distracting details. But in the Vuillard, all the room's features come into play—the ceiling moulding, the pictures on the wall, the mantelpiece and the objects resting on it. Sérusier poses much like an added element in a still life; Madame Vuillard, who appears to have entered the room while the picture was being taken, emerges as a ghostly spectre, her very blurriness capturing the viewer's attention. Her evanescent form in this photo contrasts with the solid, heavy presence in Vuillard's painted depictions of her, such as *Interior, Mother and Sister of the Artist*, from 1893 (cat. 85). Yet in both media she seems to command centre stage. Degas, the Impressionist, works with the medium in an empirical way, manipulating and controlling it. With Vuillard, there is an element of mystery, of chance, of intuition. Paradoxically, the more modern apparatus actually allowed for less control, and he opted for it deliberately, allowing these uncontrollable yet characteristically symbolist qualities to be part of his work.

A PHOTOGRAPH OF Misia and Thadée Natanson from 1898 (fig. 3) includes a number of compositional components that Vuillard would continue to explore in both photography and painting for the next decade. The photograph shows Thadée in the foreground, looming large across the picture plane, slightly out of focus because of his proximity to

the camera. In the distance, Misia sits in a chair against the back wall. Although much smaller than Thadée in the photograph, Misia nonetheless remains its focal point. The figure of Thadée forms a powerfully framing curve that sweeps from upper right to lower left, encouraging the viewer to focus on the clearer image of Misia.

A painting by Vuillard (fig. 4) of the same subject, executed around the same time, pictures the couple in the same room, with their positions reversed: Misia takes up the entire fore- and middle ground, while Thadée is pushed to a small section in the upper right-hand corner of the canvas. Stretched out in a serpentine curve in her armchair, eyes closed in an inner reverie, Misia shares the viewer's (and Vuillard's) space. Thadée is pushed behind the piano, a small form further reduced by the actual erasure of his facial features, scratched out with the end of the paintbrush.

Although not actually depicted in any of the paintings or photographs discussed so far, the artist nonetheless makes his presence felt. In both photographs and paintings, Vuillard expresses his feelings for Misia—a relationship he described as having the security and assurance of a perfect understanding. By effacing her husband, Vuillard depicts in paint the subtleties of a relationship he reflected upon in his diary on Christmas Eve 1896, after an evening spent with the couple: "Thadée and his wife a very good time. Tenderness, desires of work, ambitions and sensualities…home at four in the morning, slept until noon. Uncertainty and conflicting desires. An abundance of memories."[7]

Vuillard seems to have reconciled the ambiguities of his feelings for Misia in both paint and film. The photographs allowed the artist the luxury of extending indulgence in the moment—that instant captured by the camera—over a long period of time

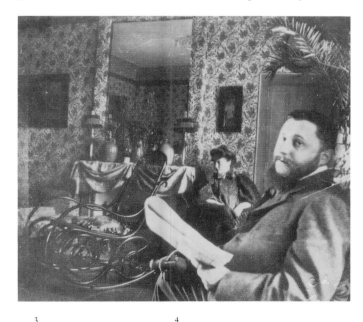

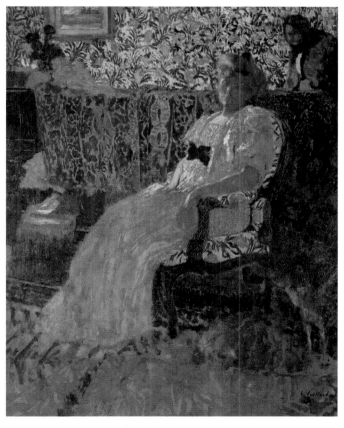

3
Photograph by Vuillard of Misia and Thadée Natanson, 1898, Bibliothèque Nationale de France.

4
Édouard Vuillard, *Woman Seated in a Chair*, oil on paper mounted on canvas, private collection (cat. 148).

and of exploring sensual impressions in a way that momentary observation precludes. Proust, an ardent lover of photography, evokes a similar attitude in his narrator's contemplation of a photograph of the Duchess of Guermantes:

This photograph was like a further encounter added to those I had already had with Madame de Guermantes; better still, an encounter *extended*, as if, by a sudden progress in our relations, she had stopped beside me, in her garden hat, and had let me examine at my leisure, for the first time, that full cheek, that turn of the neck, that corner of the eyebrows (hitherto concealed from me by the rapidity of her passing, the confusion of my impressions, the unreliability of memory); and their contemplation, like that of the throat and arms of a woman I had never seen except in a high-necked, long-sleeved gown, was for me a voluptuous discovery, a mark of favor. Those lines it had once seemed almost forbidden to look at I could now study as in a treatise of the only geometry which had any value for me.[8]

While Vuillard's photographs of Misia allowed him to ponder at length the captured images of poignant moments, of "conflicting desires," and to recall at leisure the "abundance of memories" born of her company, his paintings create a different temporal context: they offer a fantasy of Vuillard's desires fulfilled. But whereas there exists a complicity between the viewer and Vuillard in the photograph—the subject looks out at the camera, and by implication at us—there is no such direct engagement in the painting.

An important distinction between painting and photography is that in the former the artist can modify the deformations of light, space and focus to suit his purpose, while the latter does not allow similar control over the distortions of the photographic lens. In the 1898 photograph of Misia and Thadée, Vuillard manipulates the camera so as to focus on her and exploits the light source to further emphasize her predominance: the light shines directly on Misia's face and directs the viewer's gaze to her profile. Although other areas of the composition—such as Thadée's newspaper and face—are also strongly lit, they nonetheless carry less impact because they are out of focus. This remains true in other photos of the couple; she is invariably in the centre of the photographic lens and thus the centre of each picture. Since the camera he employed had no focus adjustment, Vuillard's consistent placement of Misia not only in the centre of the lens but at the appropriate focal distance from the camera must be seen as deliberate.

Nevertheless, when painting the same subject (fig. 4), the artist manipulates the surroundings to a far greater extent. He bathes his primary subject in full light and depicts legibly all the elements of the room her body faces. Everything behind her, which includes the area where her husband stands, is obscured by either scumbling or scratching and a use of muddy tones. Vuillard's focus, too, can be much more selective as a painter than when he manoeuvres the camera lens. In order to emphasize Misia's centrality to the painting, he depicts only her torso and head clearly, leaving the rest out of focus.

The intimacy of feeling Vuillard expressed for Misia in the written word, in paint and in photography was to a certain extent unfulfilled. But there is no doubt that when she was at the centre of his circle she dominated the full range of his artistic expression. The parity between the painted and photographic compositions evokes the strength of his desires, though the connection between the subject and the photographer (and, by implication, the viewer) inherent to the photographs exists only in a metaphoric realm in the paintings. As Vuillard himself states in one of his early journals: "The

expressive techniques of painting are capable of conveying an analogy but not an impossible photograph of a moment. How different are the snapshot and the Image!"[9] Undoubtedly the "Image," his painted creation, held for him a greater resonance of meaning.

A NEW WOMAN ENTERED Vuillard's life around 1900: Lucy Hessel, the wife of his dealer, Jos Hessel, cousin of the Bernheim brothers. Vuillard paid tribute to her importance by portraying her in very much the same way as he had her predecessor. In a series of photographs, Lucy is shown in poses very similar to those that Misia had held before her. This was not coincidence; in each case the composition and pictorial construction were deliberately similar (cf. cats. 168, 203).

As Lucy Hessel was Vuillard's close friend and confidante for forty years, the relationship inevitably affected the other key woman in the artist's life—his mother. In a photograph depicting the two women seated facing one another, knee to knee (fig. 5),

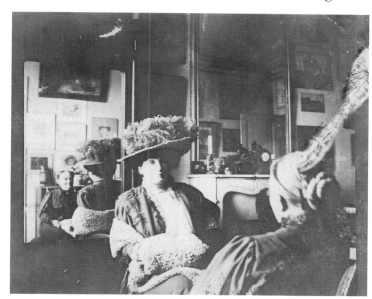

the artist constructed a composition that evokes a psychological intensity every bit as complex as that conveyed by his paintings. It is a perfect example of the symbolic structure Vuillard was able to achieve with both paint and film. Whereas Degas's role in the photograph of Renoir and Mallarmé is quite evident —he is visible in the reflection—Vuillard's presence in this picture is felt and implied, but neither explained nor revealed. The two ladies sit across from one another at an intimate, apparently convivial distance; no object, not even a table, comes between them. Madame Hessel looks directly at Vuillard with an expression of calm possessiveness. Madame Vuillard, in turn, gazes at her son's mirrored reflection (invisible to us). The artist's mother, situated in the foreground of the photograph—though seen from behind—is completely dwarfed by Madame Hessel's imposing presence and further diminished by the visual weight of the other woman's feather hat—perhaps a metaphor for the worldliness she represented in the artist's increasingly active social life.

The only connection between the two figures is through the one person absent from the picture: the artist himself. The addition of two mirrors, one above the mantelpiece to the right of Madame Hessel and one on the left, only further complicates the space, for they reflect totally different aspects of the room. Vuillard's presence is felt to a far greater extent in the mirror on the left, both because it reflects the sitters and because it is the obvious source of light. And his proximity to the scene is clear: his mother's arm

5

Photograph by Vuillard of Lucy Hessel visiting Madame Vuillard, Rue de la Tour, 1904–1908 (cat. 204).

6

Photograph by Vuillard of Romain
Coolus in a restaurant in Normandy,
1907 (cat. 233).

7

Photograph by Vuillard of Tristan
Bernard in a restaurant in Normandy,
1907 (cat. 231).

is so close to the lens that it is out of focus, suggesting that Vuillard deliberately placed himself just outside the reflection. The drama of this photograph can be seen as a microcosmic representation of the complex relationship of the two most important women in Vuillard's life, here caught between the two lenses of camera and mirror, with Lucy Hessel further trapped between the two images of his mother. By absenting himself visually, Vuillard reveals the irreplaceable nature of his presence in the two women's lives.

Since Lucy was the wife of his dealer, the life Vuillard shared with her was different from the one he had enjoyed in the private world occupied by his mother and sister or in the more bohemian company of Misia Natanson and the *Revue blanche* crowd. Vuillard's twentieth-century artistic production centred on the portraits and large-scale decorations commissioned by patrons who were members of the bourgeois circle to which Jos and Lucy Hessel introduced him. As the nature of his painted work became more impersonal than the psychologically complex pictures of family and friends that had occupied his early years, it was the photographs alone and their unique vocabulary that captured the intimacy he appeared to have abandoned.

Just as the camera had to be liberated from the tripod before photographs could begin to look like the "snapshots" so familiar to us, so did Vuillard finally free himself from the desire to control the capabilities of the mechanism and begin allowing the camera to do what it was built to do. The results represent a completely different order of artistic production, one that must be judged by an entirely different set of criteria.

THE TERM "SNAPSHOT," used initially by hunters to refer to a hurriedly fired round involving little or no aim, was applied to the taking of photographs as early as 1859 but did not enter common usage until the 1880s, with the advent of the Kodak.[10] Whether posed or not, the snapshot tends to be an image that commemorates an occasion, most often among friends or family. Roland Barthes has discussed the affective dimension of the photograph in some depth,[11] and the snapshot is obviously, by its very nature, a "sentimental" object, distinguished not by its making but by its intentionality. Such

photographs are intended as private records of a particular moment, devoid of artistic pretension or commercial aspiration. The shared experience is recalled when the photographer or those in the scene look at the picture; even years later, the image can evoke the taste, smell or emotion of the moment depicted—hence Proust's fascination with the technology.

A group of photographs of Romain Coolus, Tristan Bernard, Marcelle Aron and Lucy Hessel taken in 1907 at a restaurant in Normandy (figs. 6–9) reveals how Vuillard had by this time translated the photographic medium into a new language of intimacy. Pictured at a table in the middle of a meal, three of the four are so close to Vuillard that the lens cannot take in their entire torsos, and the tops of their heads are cropped. The artist has placed the camera either flat on the table or slightly tilted, further enhancing the sense of immediacy and animation by causing the plates, bowls and glasses that occupy the foreground to be completely out of focus. Clearly, a conversation is whirling around the photographer: Romain Coolus raises his finger to emphasize a point, while Tristan Bernard scratches his chest as he waits to respond. Marcelle Aron looks off to the right, her arm resting on the back of her chair, and only Lucy Hessel, sitting sideways on her seat, with the light from the window behind her turning the veil of her hat into a nimbus, gazes at the photographer. The intensity of the connection between the subjects of the four photographs, which is conveyed by the glances and gazes to right and left and which finally—thanks to Lucy Hessel—even includes Vuillard, is almost cinematic. The scene remains unified by the continuum of wall panelling that forms a geometric background to each picture. The radicalism of this series is perhaps best appreciated if we compare it with a 1905 photograph of a group of friends around a lunch table (cat. 214). Although it shares with the 1907 series such compositional elements as carafes of wine that loom out of focus in the foreground, in the earlier photograph each person looks directly at the camera, and there is not that sense of physical and psychological connection between the figures that makes the later group of pictures so compelling.

Two other photographs of Lucy Hessel from 1907 (cats. 226–227) embody departures from convention similar to those displayed in the series just discussed. In comparison to the posed compositions of Misia and even of Lucy herself from a few years earlier, where the figures occupy the middle of the composition and look out at Vuillard as he takes their picture, these photographs create a far greater sense of intimacy. The formal means by which Vuillard achieves this effect include his proximity to the subject: in both images, Lucy's arm is so close to Vuillard that it is cropped by the frame even as it cuts across the entire lower portion of the composition. In one photograph her hair forms an arabesque above the canopy of trees that stretches horizontally across the background; in the other, she leans back, dreamlike but hardly idealized. Romain Coolus, behind her and in perfect focus, provides a neutral foil to the unguardedness of her gaze.

Whereas Vuillard's photographs of the 1890s place his female subjects against a plethora of pattern, their clothes and the interiors competing for attention with the women themselves, in the later "snapshots" of Lucy and her circle the figures stand out from their surroundings, allowing the viewer to focus more easily on the mood of the moment. Comparison of these works with a portrait of *Misia seen in profile in a carriage* (cat. 192) reveals how far Vuillard had come. The photograph of Misia is a carefully constructed image. She sits framed in the centre of the composition, in perfect profile, parallel to the picture plane. Her hat and cloak function graphically, as flat arabesques, much as they would in a poster by Vuillard's contemporary, Toulouse-Lautrec. Vuillard's photographs of Lucy, however, capture her off-centre, out of focus, in a relaxed, uncalculated pose. These "accidental" snapshot features, intrinsic to taking a photograph with a Kodak, combine to create a much more intimate effect.

These photographs, then, are not primarily reflections of a preoccupation with composition and structure—they are responses to life. They fuse the notions of a particular moment and of the extended chronology that constitutes the relationship between the photographer and his subject. Vuillard captured these familiar moments not merely as they were happening, but almost as if he were anticipating their occurrence. He used quotidian experience as the raw material for his art in a way that suggests that it was actually life, and not art, that was his main concern.

Some of these photographs, despite their diminutive size, create a monumental effect. A photograph of Lucy Hessel taken in 1907 (fig. 10), for example, evokes at once the fleeting instant (in her glance off to the left) and the eternal solidity and grace of classical sculpture (in the drapery, which recalls that of the *Nike of Samothrace*, a sculpture Vuillard would have seen frequently on his almost daily visits to the Louvre and to which he often referred in his journals). Lucy is shown leaning against a haystack. Wearing a straw hat, a ruffled gown of white lawn and a similarly light-coloured shawl draped

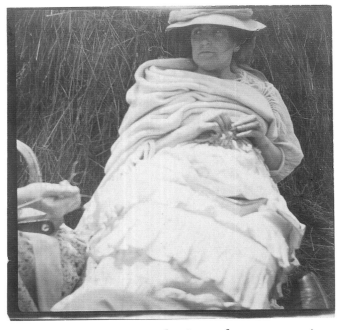

10

Photograph by Vuillard of Lucy Hessel leaning against a haystack in Amfreville, 1907 (cat. 223).

across her shoulder, the figure is cropped at both top and bottom because of its proximity to the photographer. From the crisp outline of the subject's hat and of the individual stalks of hay at the top of the composition, the focus of the image dissolves as her torso fills the foreground. The male boot just visible in the lower right corner makes one wonder—if this is in fact Vuillard's own foot—just where the artist's own body was when he took the picture. Though Lucy is fully clothed, the position of the camera can only be likened only to that of a lover.[12]

OF THE THREE WOMEN in Vuillard's life, none was more central than his mother, with whom he lived until her death, when he was sixty. The photographs he took of her span the full range of his work in the medium. Early photographs from the 1890s recall similar compositions in paint, although the 1897 picture *Madame Vuillard cooking, Rue des Batignolles* (fig. 11), where the image is in silhouette, is more evocative of a mood than any painted scene of the same subject that the artist attempted.[13] With the light coming exclusively from the window that occupies the right of the composition, Madame Vuillard is illuminated only by the rays that outline the back of her head and body. The stillness of the scene (enhanced by the fact that Vuillard must have used a tripod to achieve an adequate exposure time) recalls the domestic interiors of Vermeer, while the silhouette of Madame Vuillard's form calls to mind the halo effects achieved more recently by Seurat. The carefully constructed composition contrasts markedly with another photograph Vuillard took of the same scene on the same day. For this second picture (fig. 12), Vuillard positioned himself in front of the window, which meant that since the light was behind him he would not have needed a tripod. This image shows Madame Vuillard stirring the same soup—the blurriness of her arm indicating that the action was performed while the artist was taking the picture—but lacks the drama of the more composed photograph. And in fact this very blurriness, absent from the previous composition, demonstrates that Vuillard must have instructed his mother not to move during the lengthy exposure of the tripod shot. Other early photographs of his mother show Vuillard playing with similar kinds of dramatic lighting in ways that again recall his concomitant explorations in paint (see cats. 144, 229).

But just as Vuillard eschewed such highly composed scenes in his later photographs of Lucy, so do a pair of photographs of his mother from the 1920s display an informality not seen in his painted work. In one photograph, Madame Vuillard sits on her bed in nightgown and cap, bald and toothless (fig. 13). She looks out at her son with a benevolent gaze, her strong hands recalling the authoritative pose they held in his painting *Interior, Mother and Sister of the Artist* (fig. 15 and cat. 85), executed some thirty years before. All pretense at formality is shed in another photograph of his mother from about the same time, where she is shown drying herself after a bath (fig. 14). Draped in a dark, sleeveless top, her lower half covered with a towel, she has one leg raised in order to attend to the bare foot that rests on a stool. Her head, unadorned, is completely bald. Positioned slightly off-centre in the composition, her entire body is out of focus; Vuillard has directed the camera beyond her so that the door and the chair and cupboard in the adjacent room are at the centre of the camera's focal distance. By

11
Photograph by Vuillard of Madame Vuillard cooking, Rue des Batignolles, 1897 (cat. 169).

12
Photograph by Vuillard of Madame Vuillard cooking, a skimmer in her hand, Rue des Batignolles, 1897, private collection.

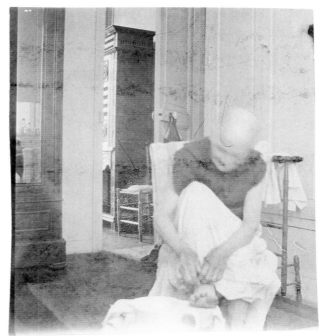

13

Photograph by Vuillard of Madame
Vuillard seated on her bed, Place
Vintimille, 1928 (cat. 252).

14

Photograph by Vuillard of Madame
Vuillard at her toilet, 1928 (cat. 251).

allowing the figure of his mother to blur in this way, the artist lends her a quality of physical evanescence that is perhaps an allusion to her advanced age.

VUILLARD LEFT A VAST and as yet largely unexplored archive of photographs. We cannot know which pictures he admired and which left him unsatisfied, and notations about the photographic works in his journals do not allow us to assess with any accuracy what resonance they carried for him. Of course, both their sheer number and their compositional complexity attest to the seriousness with which he embraced the photographic medium. The artist never exhibited his photographs, however, and until now only a few have entered the public realm. It is therefore clear that Vuillard could have had no influence as a photographer. And yet the combination of elements he put together to create his photographs anticipated the work of a photographer whose link to Vuillard might at first seem paradoxical: the American Diane Arbus.[14] Although there are evident differences between their work—Arbus portrayed people on the fringes of society, for instance, while Vuillard depicted family members and close friends—their images echo one another in numerous ways (see figs. 15 and 16). The subject matter of both photographers frequently possesses a marked narrative element, and the locus is often the home; indeed, both produced a significant number of images where people are shown in their bedrooms, even sitting on their beds. These narrative scenes display similar tensions in the relationships between the figures, enhanced by the artists' exploitation of the photographic apparatus to produce slightly skewed visions of reality. Compositionally, both photographers often constructed their scenes from a vantage point below the focal element, creating a looming effect in the figures that is at times emphasized by a strangely empty foreground. Vuillard used the means at his disposal to fashion compositions redolent of complex connections between the subjects and a certain overall sense of unease. Clearly, Diane Arbus's images are more confrontational, but she, like Vuillard, consistently manipulated the pictorial space in her own unique quest for meaning.

Vuillard's paintings and photographs both evolved over the course of his career, but in different directions. The painted work exchanged a very private pictorial language, where iconic pose and spatial complexity were used to express a highly personal iconography, for the less psychologically charged syntax of his later, more public work. His photographs, on the other hand, moved from a compositional vocabulary that mirrored that of his paintings to an innovative use of the apparatus that pushed the work to a level of spontaneity and anecdote he had not achieved in paint. In the early photographs, Vuillard orchestrated the compositions as carefully as he did his paintings, using to great advantage the creative tension resulting from his manipulation of the Kodak—aiming the camera at unusual angles, framing the compositions in unconventional ways to highlight his chosen element of focus—to portray scenes of dark or densely decorated interiors. Later in his career, the camera became the vehicle by which he chronicled a world that was no longer the centre of his painted universe. The late photographs became the expressive vehicle for a different kind of intimacy: framing his friends at such a close proximity as to crop their often unfocused bodies, and catching them in unguarded poses, Vuillard bridged the distance between himself and his art.

Vuillard's photographic production substantiates both Barthes's likening of the photograph to a memento mori and Proust's embrace of it as something that conjures the "involuntary memory" of a smell, a conversation or a distinct moment: photographs speak both to the instant and to the extended history that precedes and succeeds it.

Although Vuillard has been quoted as saying that "painting would always have the advantage over photography of being done by hand,"[15] he nonetheless manipulated this ostensibly objective medium to express a very personal vision of his most private world.

15
Édouard Vuillard, *Interior, Mother and Sister of the Artist*, 1893, oil on canvas, New York, The Museum of Modern Art, Gift of Mrs. Saidie A. May (cat. 85).

16
Diane Arbus, *Russian Midget Friends in a living room, N.Y.C. 1963*, gelatin silver print. © Estate of Diane Arbus, L.L.C. 1967.

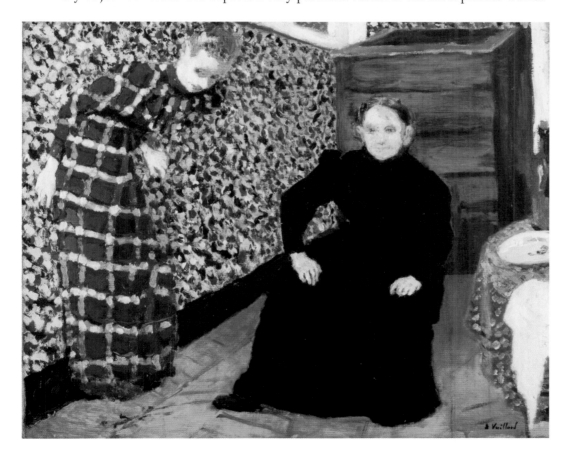

1. I would like to thank Peter Galassi, Ellen Handy and Jeffrey Rosenheim for their helpful comments on Vuillard's photographs in relation to late nineteenth-century photography. In addition, I am grateful to Jared Bark, Judith Dolkart, Gloria Groom, Joachim Pissarro and James Traub for their insightful comments concerning this essay.

Since the opening of Vuillard's journals in 1980, several publications have discussed his experimentation with photography. Émilie Daniel, "L'Objectif du subjectif : Vuillard photographe," *Les Cahiers du Musée national d'art moderne*, no. 23 (Spring 1988), pp. 83–93, Elizabeth Easton, *The Intimate Interiors of Édouard Vuillard*, exhib. cat. (Washington: The Museum of Fine Arts Houston, Smithsonian Institution Press, 1989) and "Édouard Vuillard's Photographs: Artistry and Accident," *Apollo*, no. 388 (June 1994) (on which some portions of this essay draw extensively) discuss Vuillard's photography in detail. Dorothy M. Kosinski, *The Artist and the Camera: Degas to Picasso*, exhib. cat. (Dallas Museum of Art / New Haven and London: Yale University Press, 1999) contains a chapter on Vuillard entitled "Staged Moments in the Art of Édouard Vuillard." Belinda Thompson, *Vuillard*, exhib. cat. (London: South Bank Centre, 1991) illustrates many unpublished photographs but does not discuss them specifically in the text. Ann Dumas and Guy Cogeval, *Vuillard*, exhib. cat. (Paris: Flammarion, 1990) also reproduces hitherto unknown photographs from the family archive.

Nevertheless, given the lack of access to the vast archive of unpublished photographs still in the possession of Vuillard's heirs and not opened until the preparation of the catalogue raisonné and this retrospective exhibition, all previous conclusions about Vuillard's photographic approach were necessarily based on insufficient knowledge of the work. A separate catalogue of Vuillard's photographs currently under preparation will make it possible to assess quantitatively the areas in which he concentrated his photographic activity. For example, although the majority of his photographs involve his friends and family, his sister appears as a subject for his camera long after she ceases to be portrayed in paint. And although Vuillard used a camera throughout his life, the period of greatest photographic output seems to have occurred before his mother died in 1928. Primarily a painter of people, Vuillard pursued this interest when photographing as well. But the photographs in general, especially those taken after about 1905, leave an impression of anecdote and humour, and create a sense of spontaneous connection between Vuillard and his subjects that is not evident in the painted work.

2. See Kirk Varnedoe, "The Artifice of Candor: Impressionism and Photography Reconsidered," *Art in America*, January 1980, pp. 66–78.

3. Vuillard, *Journal*, II.1, fol. 3r (November 4, 1907).

4. This transcription of images from photograph to painting was noted in the first publication devoted to Vuillard and photography: Jacques Salomon and Annette Vaillant, "Vuillard et son Kodak," *L'Oeil*, no. 100 (April 1963), pp. 14–25, 61. The photographs relating to this painting were later reproduced in a more comprehensive text on the artist and his patrons by Juliet Wilson Bareau: "Édouard Vuillard et les princes Bibesco," *Revue de l'Art*, no. 64 (1986), pp. 37–46. The article by Salomon and Vaillant was written to accompany an exhibition shown in Paris and London, which included nineteen photographs and just under thirty paintings.

5. Jacques Salomon and Annette Vaillant, "Vuillard et son Kodak" (see previous note). Jacques Salomon's short preface remains the only first-hand account of how Vuillard developed his photographs and, together with Annette Vaillant's "Some Memories of Vuillard," constitutes the only published document about his work in the medium. This translation is taken from the English version of the texts by Salomon and Vaillant that accompanied the London exhibition at the Lefevre Gallery; "Vuillard and His Kodak," in *Vuillard et son Kodak* (London: Lefevre Gallery, 1964), p. 2.

6. The Kodak, designed as a hand-held camera, was invented in 1888. It was fairly small, measuring $3\frac{1}{4} \times 3\frac{1}{4} \times 6\frac{1}{2}$ inches in size, and cost $25. The early models produced round images that were either $2\frac{1}{2}$ or $3\frac{1}{2}$ inches in diameter. When all the exposures were taken, the machine was returned to Kodak for processing and reloading (for a fee of $10). The Kodak '96 (1896), which sold for $5, made use of daylight loading film—invented in the early 1890s—and was consequently much easier for the general public to use. Vuillard's images, which produced a $3\frac{1}{2} \times 3\frac{1}{2}$-inch negative, and prints of the same size, were produced with a Kodak No. 2 Bullet (1896 Model) or No. 2 Bulls-Eye. The Bullet / Bulls-Eye shutter had two settings, instantaneous and time. The focus was correct from $3\frac{1}{2}$ feet to infinity.

The model described in the passage by Jacques Salomon as "an ordinary model, one of the bellows type" was not developed until 1906. Some of Vuillard's later photographs have negatives that measure 2.7 × 3.8 inches, attesting to his use of a different, later Kodak model. I am grateful to Mary Therese Mulligan, Curator, and especially to Todd Gustavson, Curator of Technology, at Eastman House in Rochester, New York, for providing me with technical information on early Kodaks.

7. Vuillard, *Journal*, I.2, fol. 57v (December 24, 1896).

8. Quoted in Brassaï, *Proust in the Power of Photography*, trans. Richard Howard (Chicago and London: University of Chicago Press, 2001), pp. 84–85.

9. Vuillard, *Journal*, I.2, fol. 21r (September 6, 1890).

10. Douglas R. Nickel, *Snapshots: The Photography of Everyday Life, 1888 to the Present* (San Francisco: San Francisco Museum of Modern Art, 1998), p. 9.

11. Roland Barthes, *Camera Lucida: Reflections on Photography* (New York: Hill and Wang, 1981).

12. Gloria Groom has commented (personal correspondence, January 22, 2002) that other painted images of women by Vuillard—portraits of Marguerite Chapin (1910, Cambridge, England, Fitzwilliam Museum, C-S IX.162) and Germaine Fontaine (1903, United States, Art Institute of Chicago, C-S VII.300), for example—are intimate in their radical perspective and close-up scrutiny. This is certainly true, for Vuillard remained committed to exploring pictorial complexity throughout his life.

13. This recalls Eugenia Janis's remark that Degas explored in photography what he had left unresolved in other media. See her essay "Edgar Degas's Photographic Theater," in Jacqueline and Maurice Guillaud (eds.), *Degas: Form and Space*, exhib. cat. (Paris and New York: Marais-Guillaud Éditions, 1984), p. 481.

14. I would like to thank Jeffrey Rosenheim, Assistant Curator of Photography at New York's Metropolitan Museum of Art, for pointing out the relation between Arbus's work and Vuillard's.

15. Salomon, 1964 (see note 5), p. 3.

VUILLARD AND THE "VILLÉGIATURE" | Kimberly Jones

ALTHOUGH THE NAME OF Édouard Vuillard is most closely associated with the city of Paris, which was his home from the age of nine onward, the artist travelled extensively throughout Europe over the course of his lifetime. His voyages, which were both wide-ranging and frequent, read like a Baedeker's guide to European sites.[1]

These various trips abroad shared two things in common: they tended to be fairly brief in duration, and they inspired almost no paintings—although there were a few notable exceptions, such as the 1913 visit to Hamburg with Pierre Bonnard (1867–1947) at the invitation of Alfred Lichtwart, the curator of the Kunsthalle, when Vuillard was commissioned to execute views of the port.[2] The only artistic by-products of Vuillard's travels abroad are his photographs; even these are relatively few and are arguably more documentary than purely artistic in nature.

This intriguing dearth of paintings sets Vuillard apart from many of his contemporaries, for whom travel provided rich fodder for artistic exploitation. The writer Claude Roger-Marx, commenting upon this curious lacuna, astutely observed that for Vuillard, an artist who was essentially sedentary by nature, such travels were invariably too brief to allow him to achieve the sense of "communion" requisite for his art. Consequently, outside of Paris, it was only within the context of his *villégiatures*, those extended sojourns in the countryside in the company of friends and family, that Vuillard felt comfortable enough to produce art. Only the *villégiature* provided "the illusion of being at home; a sort of pre-established harmony...between himself and the setting"[3] that was essential to Vuillard's creativity throughout his career.

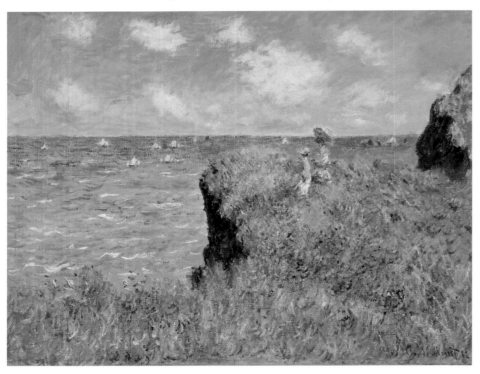

1
Claude Monet, *Walk on the Cliff at Pourville*, 1882, The Art Institute of Chicago, Mr. and Mrs. Lewis Larned Coburn Memorial Collection, 1933.443.

The *villégiature*, in particular the *villégiature estivale* or summer vacation, was an integral part of Parisian life in the nineteenth and twentieth centuries. Émile Zola (1840–1902), remarking on this phenomenon, noted: "As soon as the July sun begins burning the pavestones, everyone makes a run for it. Only people with no self-respect remain in Paris. I don't mean that everyone especially enjoys being in the country, this becomes immediately obvious; nevertheless, there's no question that from year to year the movement is growing." Although his rather facetious observation that "in two or three centuries' time Paris will be transformed into a desert between the months of August and October" has not proven to be entirely accurate, his remarks about the widespread compulsion to escape Paris in the summer months have remained valid.[4]

The concept of the *villégiature* is fundamentally and psychologically different from that of the more familiar *tourisme*. The term *villégiature* stems from the Italian *villeggiatura*, which in turn derives from the Latin *villa*, a country home, and refers specifically to a sojourn in the countryside. Inherent in the concept of the *villégiature* is the idea of repose, in contrast to *tourisme*, which implies movement and activity. While both forms of travel are based upon the idea of displacement, in the former the venue may change but the day-to-day activities remain relatively constant. Unlike the *touriste*, who thrives upon mobility and novelty, the *villégiateur* is largely sedentary, preferring stability and routine.[5]

This distinction between the *villégiature* and *tourisme* is not merely a matter of semantics. Rather, it points to a specific manner of experiencing the countryside, a way of viewing and understanding the landscape, the customs and the activities that exist outside of the more hectic professional and distinctly cosmopolitan realm of Paris.

In this respect, Vuillard the *peintre-villégiateur* is inherently different from an artist like Claude Monet (1840–1926), who in the late nineteenth and early twentieth centuries was the very embodiment of the *peintre-touriste*.[6] Whereas Monet travelled widely and tended to choose his destinations for their novelty and celebrity, Vuillard found comfort in familiarity and obscurity. It is worth noting that, with the exception of Honfleur, Trouville and Dieppe, Vuillard seems to have eschewed the sites celebrated by Monet in his extensive travels in Normandy. Étretat, Belle-Île and Pourville are noticeably absent from Vuillard's itinerary, replaced instead by less grandiose and considerably more discreet locales such as Vasouy and Amfreville. For Monet, everything he saw, every site he visited—whether the cliffs of Pourville and Petits-Dalles in Normandy, or the snow-covered peak of Mount Kolsaas in Norway—provided subject matter for his art (fig. 1).

For Vuillard the primary purpose of the *villégiature* was not the quest for fresh subject matter, but rather rejuvenation. He acknowledged this himself time and time again. In a letter to his friend and fellow painter Félix Vallotton (1865–1925), written on his return to Paris after a trip to Romanel in 1900, Vuillard talks about his desire to paint: his feverish need to produce is almost overwhelmingly intense. His solution is to escape to the countryside, to l'Étang-la-Ville, "to calm myself down or rather to put it all to use."[7]

The time he spent away from Paris in the countryside was essential to Vuillard's productivity; it offered him repose, but also a change of scenery that helped expand his own perceptions of the world around him, a fact he mentions later in the same letter to Vallotton: "I remember with the greatest pleasure my stay with you…I brought back with me that sense of freshness about everything, ideas and sensations, that above all else fills me with delight and gives me confidence."[8] Jacques Salomon, Vuillard's first biographer and a relation by marriage, would later observe: "These periods were highly productive, because of the change of scene and routine that provided him with all sorts of new subjects."[9]

Vuillard's *villégiatures* may be divided into three major periods, each associated with a different region, each with its own distinct character and band of companions. The first of these, dating from 1896 to 1901, was confined largely to the environs of Paris and corresponds to the period when Vuillard was most closely associated with the circle

of *La Revue blanche* and its muse, Misia Natanson. The second period, which dates from 1901 to 1914, centred on Normandy and Brittany and was clearly distinguished by the ascendancy of Lucy Hessel, wife of the prominent picture dealer Jos Hessel, and her circle. The third and final period, from 1917 to 1940, marked a return to the countryside surrounding Paris, first at Vaucresson and then at the Château des Clayes.

When considering the *villégiatures* of Vuillard, both the sojourns themselves and the works of art they inspired, it is essential to understand that the experience of place is only one component. The society he kept and his activities were as much a part of the *villégiature* as the sites he visited.

For Vuillard, the experience of the *villégiature* began in 1896 when the artist spent most of the month of July and almost all of the two-month period from October 20 to December 20 with Misia and Thadée Natanson at their country house, La Grangette, situated on the banks of the Seine in Valvins, not far from Fontainebleau. These two sojourns, bracketing a period of intense productivity back in Paris, were Vuillard's first true *villégiatures*, and they set a pattern that would become more firmly established in the following years, as the artist's life in Paris alternated with his experience in the countryside. The practice of the *villégiature* would quickly become essential in helping him keep himself and his art vital. There was, of course, a secondary but nonetheless important component to these sojourns at Valvins: they also served to deepen and enrich his relationship with the Natansons, who had become not only his friends but among his most important early patrons.

In her autobiography, Misia evoked life at Valvins: "The house at Valvins soon became a second branch of *La Revue blanche*. But by now I had done some sorting out, and only invited those whom I really cared for. Vuillard and Bonnard had, once and for all, made their home with me, and Toulouse-Lautrec came regularly from Saturday to Tuesday."[10] Although written more than a decade after the death of Vuillard, her description of life at La Grangette amid the company of her "vernisseurs"—Vallotton's nickname for Misia's artist friends—is apparently an accurate one, judging both by contemporary accounts and by the images created in this vibrant environment.[11]

Vuillard produced a number of paintings and sketches during these two lengthy visits to Valvins: modest landscapes, including views of La Grangette and Mallarmé's house nearby,[12] and interiors that encapsulate the life of the Natansons in their country home (cats. 145–146). Hushed, muted and intimate, such images—apart from the greater sense of air that is so fundamental to the experience of the *villégiature*—are quite similar to those the artist was painting in Paris. Although the venue has changed from city to countryside, the rules of social interaction have remained the same.

In 1897, unable to accommodate Misia's growing circle of artist friends at Valvins, the Natansons acquired a large house, Les Relais, at Villeneuve-sur-Yonne.[13] Villeneuve quickly became the centre of the Natanson social circle. In a letter to Félix Vallotton, Vuillard anticipates an upcoming visit: "I've only seen Roussel…He too is thinking of spending a few days at Villeneuve. Bonnard, who I'll see tomorrow, will leave with me. Fred [Natanson], Marthe [Mellot], [Romain] Coolus and Alex [Natanson] are all expected around the 15th. And maybe Lautrec."[14] Misia was very much in her

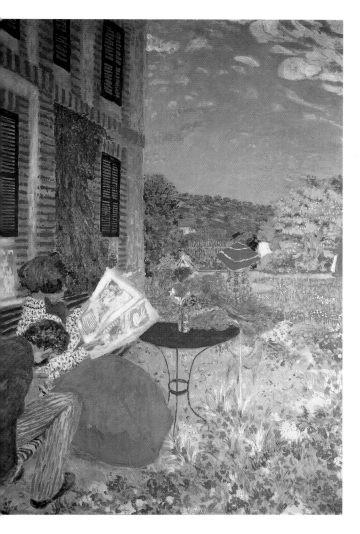

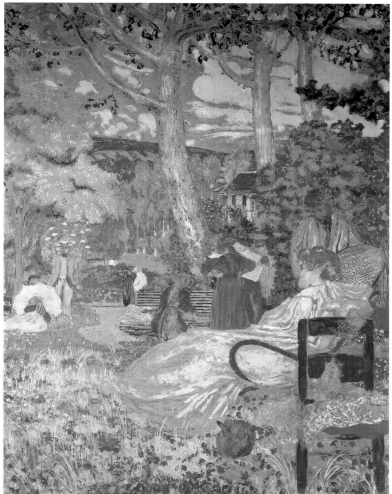

element, playing hostess to a vibrant group of artists and writers. The ebullient lifestyle at Les Relais—games of boule on the lawn, swimming in the Yonne River, lively conversation—is apparent in the numerous photographs taken by Vuillard and his friend Alfred "Athis" Natanson, the brother of Thadée.[15] The atmosphere at Les Relais was refreshingly rustic, the mode of dress informal, the furnishings simple and understated (cats. 166, 167, 177–179)—at least in comparison with those of the elegant Natanson apartment on Rue Saint-Florentin, in Paris. Yet, for all the apparent differences, existence at Villeneuve-sur-Yonne did not represent a rupture with the life the group led in Paris, but was rather an extension of it. The Natansons brought with them their society, their friends, their family, their occupations. Even the suite of decorations that Vuillard painted for Misia and Thadée travelled with them from the city to the countryside and back again, underscoring the continuity of life between the two venues (see cat. 147).

Vuillard would draw upon this experience at Villeneuve for a number of paintings, most notably the pair of panels commissioned by Jean Schopfer for his apartment on Avenue Victor Hugo (figs. 2–3).[16] Painted in 1898, *Woman Reading on a Bench* and *Woman Seated in an Armchair* encapsulate the charming world of Villeneuve-sur-Yonne and the spirit of the *villégiature*. Within the spacious garden of Les Relais, Vuillard's friends laze about, the scene redolent with the atmosphere of a summer afternoon. In the left-hand panel, Bonnard engages in conversation with Marthe Mellot as she reads the

2

Édouard Vuillard, *Woman Reading on a Bench*, 1898, distemper on canvas, private collection, C–S VI.99-1.

3

Édouard Vuillard, *Woman Seated in an Armchair*, 1898, distemper on canvas, private collection, C–S VI.99-2.

4
Félix Vallotton, *Autumn Crocuses*,
1900, Lausanne, Musée cantonal des
Beaux-Arts.

newspaper, while in the right-hand panel Misia reclines in a wicker rocking chair.[17] In
the background other figures linger and drift, bespeaking an easy camaraderie. Vuillard
captured in these panels the very essence of the *villégiature*: companionship, familiarity
and repose within an idyllic rural environment.

The same mood of languorous diversion pervades *Promenade in the Vineyard*
(cat. 151), in which a carefree outing among the vineyards surrounding the Natansons'
property is recorded and played out on a monumental scale. For this work Vuillard drew
on photographs taken during his stay—this would become a common practice in the
creation of many of his *villégiature*-inspired paintings—employing the same casual poses
and informal groupings of figures but losing something of the documentary quality
inherent in the photographs.[18] Although the identities of the figures can to a certain extent
be deduced from the photographs, they are of far less importance than the mood the
artist has tried to capture. As would be the case in his *villégiature* paintings of the years to
come, Vuillard has offered us the evocation of a lifestyle rather than a representation of
a particular event.

In addition to Valvins and Villeneuve-sur-Yonne, Vuillard had a third refuge
in the environs of Paris—L'Étang-la-Ville. In June 1899, the Roussel family—Kerr-
Xavier, Marie and their one year-old daughter Annette—moved from Levallois to L'Étang-
la-Ville, a suburb of Paris, taking up residence in a small house on Rue de la Coulette,
in a part of the village known as La Montagne. La Montagne quickly became a familiar
haunt for Vuillard and his friends. The Nabis would spend their Sunday afternoons at
Roussel's home, taking long walks in the countryside and in the forest of Saint-Germain.
Vuillard was there, as was Bonnard, Paul Ranson (1861–1909), Maurice Denis (1870–
1943), Paul Sérusier (1864–1927), Maximilien Luce (1858–1941) and Vallotton.[19]

Strictly speaking, Vuillard's sojourns at L'Étang-la-Ville were not true *villé-
giatures*, yet they can only be evaluated and understood in the context of Vuillard's on-
going dialogue with the landscape and customs of the countryside. Vuillard was a regular
guest at La Montagne year-round—and later at La Jacanette, the newly built home to

which the Roussel ménage moved in 1907. In spite of, or perhaps because of, the proximity of L'Étang-la-Ville, Vuillard would often make extended stays there, enjoying the best of both worlds: the peace and relaxation of the countryside and the more dynamic, professional activities of Paris. It was a sanctuary for Vuillard, one he shared both with his family and with those of his artist friends who visited regularly (see cats. 196–199). In a letter to Vallotton, Vuillard explained:

If I'm not disturbed I think I'll be able to get down to things now, at least I have several plans, but it takes time to recover the calm and the ideas required to make a painting after the kind of life we were leading in Paris a month ago…Going to bed early, sleeping well, not seeing too many people, living surrounded by pleasant countryside, gradually coming to understand its objects and its shapes, having people close by who care about one, without fuss, is a kind of ideal. One has to enjoy it while one's got it. I've hardly been to Paris in the past three weeks.[20]

A few weeks later, he again wrote with enthusiasm to Vallotton from L'Étang-la-Ville:

But I'm discovering some great things, marvellous spectacles, I really enjoy being in the country, I'm able to admire without being reminded of paintings. I'm astonished to see the sky, by turns blue, grey, green, and that the clouds come in all sorts of different shapes and colours, and that without bending over backwards to find subtleties there is much pleasure to be had from understanding things in simple terms. I have some good moments. When I start a painting, too.[21]

Not surprisingly, it was largely as a result of these early *villégiatures* that Vuillard began to explore landscape in greater depth, not just as a backdrop, but as a subject in its own right. This interest in landscape, whetted by his stays at Valvins and Villeneuve-sur-Yonne and encouraged by his visits to L'Étang-la-Ville, came to fruition during a stay at Romanel, Switzerland. From July to October 1900, Vallotton and his wife Gabrielle rented the Château de La Naz at Romanel near Lausanne, opening its doors to a number of guests, including Vuillard, who visited in late August to September, together with Vallotton's stepson Max Rodrigues, the actress Marthe Mellot (wife of Alfred Natanson), Gabrielle's cousin Jos Hessel, and his wife Lucy.[22]

This stay in Romanel is something of an anomaly among Vuillard's travels of this period. Not only is it a unique example of a sojourn abroad that truly qualifies as a *villégiature* rather than *tourisme*, it also, coincidentally, presages the next phase in Vuillard's *villégiatures*, as he began to shift away from Misia Natanson and her ebullient and somewhat bohemian crowd toward the companionship of Lucy Hessel and her more *mondain* circle.

During this sojourn, Vuillard spent a great deal of time in the company of Vallotton, walking and painting the hilly landscape around Romanel and Lausanne. He produced a number of paintings during his stay, most of them pure landscapes that seem to be the logical outgrowth of his studies of the rolling hillsides of L'Étang-la-Ville (see cats. 255–258). At the same time, however, they are subtle evocations of the camaraderie and artistic dialogue between Vuillard and his friend and fellow artist Vallotton. In a painting such as *The Blue Hills* (cat. 257), with its emphasis upon stylized form and its division into clearly defined bands of colour that draw the eye upward and back, Vuillard echoes the stylistic concerns found in Vallotton's landscapes of the same period (fig. 4).

Vuillard continued his exploration of landscape during a trip to Cannes in January 1901 to visit Misia and Thadée Natanson.[23] While his photographs from this visit linger lovingly upon the figure of Misia Natanson (cats. 192–195), whose marriage to Thadée was evidently deteriorating, in his paintings Vuillard appears enraptured by the landscapes of the south, luminous and sundrenched even in the winter months (cats. 261–262). Cannes was a revelation, and in the paintings he created there Vuillard displays a new awareness of light and space that he would carry with him through successive *villégiatures*.

The period from the summer of 1901 to 1914 is perhaps best described as that of the "*grandes villégiatures.*" Unlike the summers that preceded and followed, which were spent in close proximity to Paris (the summer in Romanel being the notable exception), during these years he spent virtually every summer in the Calvados region of Normandy on "La Côte Fleurie." Located along the English Channel, this forty kilometres of coastline stretching from Caen to Honfleur was renowned for the beautiful beaches, punctuated by cliffs and outcroppings, that made it a favoured resort region from the nineteenth century onward.

This change in venue was directly linked to Vuillard's deepening involvement with Jos and Lucy Hessel, who were among his closest associates for the remainder of his life. Vuillard's professional affiliation with the Galerie Bernheim-Jeune, where Jos Hessel worked, and his growing friendship with Lucy brought him increasingly into the orbit of the Hessels and their friends. For forty years, until his death in 1940, Vuillard was closely linked with the Hessels, a regular visitor to their apartments in Paris as well as a guest in the succession of country houses and villas they rented during the summer months.

The Hessels' choice of Normandy as the preferred site for their *villégiatures estivales* is hardly a surprising one. Normandy had long held a particular appeal for vacationers, *villégiateurs* and *touristes* alike, because of its relative proximity to Paris and its accessibility by train. The popularity of ocean bathing, which had been growing since the late eighteenth century, triggered the development in the early nineteenth century of a number of resorts.

For Vuillard, Normandy would have held a particular allure because of its associations with the birth of Impressionism. But the Normandy visited by Vuillard was not that of Monet, a world of dramatic seascapes and middle-class tourists. It was instead that of Marcel Proust, the Normandy of Balbec—the author's literary reconstruction of Cabourg—where the natural beauty of the Normandy coastline merged with the glittering society that populated the Grand Hôtel. One of Proust's characters, the engineer Legrandin, expounding upon the appeal of the region, remarks: "Balbec; yes, they are building hotels there now, superimposing them upon its ancient and charming soil which they are powerless to alter; how delightful it is to be able to make excursions into such primitive and beautiful regions only a step or two away!"[24]

This was no doubt a large part of the appeal of the region for the Hessels, and also for Vuillard: the unspoiled countryside nestled within this "too social valley,"[25] and the balance between the two. In that regard, it was an oddly appropriate venue for the diffident Vuillard, who, through his association with the Hessels, was moving increasingly into a world in which the mundane was irrevocably *mondain*.

From 1901 to 1914, then, Vuillard spent his summers in the company of the Hessels and their circle of friends in a variety of sites in and around the Calvados region, including Vasouy, Villerville and Criquebœuf. In 1905, the Hessels took up residence at the villa of Château-Rouge in Amfreville, where they passed three successive summers.[26] Vuillard found this region in and around Amfreville especially appealing, much more so than Vasouy, where he had been for the previous two years. In a letter to Vallotton Vuillard writes: "Here I am back again in Normandy at Amfreville, Château-Rouge, Calvados, in countryside rather different from that of Honfleur. I've brought my box and my cardboards and the very best intentions."[27] In a later letter, he expressed his preference explicitly, remarking, " Ker[r Roussel] likes this countryside much more than Vasouy, and I quite agree with him. Fields, country views and drivable roads aren't everything."[28]

Life in the Hessel entourage during these summers in Normandy was convivial and filled with innumerable social activities: trips to the beach (cat. 265), automobile excursions into the countryside (cat. 211), long, animated lunches and dinners—often with guests, such as the playwrights Henry Bernstein and René Blum—games of cards or draughts.[29] Friends would come to visit: Vallotton; the Roussels, who would rent a house nearby at Criquebœuf or Salenelles; Bonnard, who would arrive in his *Zèbre*, "a funny little car, a kind of jerky black insect with copper headlamps";[30] Madame Gilou, who would come each afternoon from Trouville to play bridge. True to the nature of the *villégiature*, the day-to-day routine in the countryside echoed that of Paris. That the life the Hessels and their guests led during their *villégiatures* was typical of wealthy Parisians at the turn of the century is evident from the literature of the day. In his comedy actually entitled *Villégiature*, Henry Meilhac described a typical household: two friends, Adrienne and Lucie, installed with their husbands "in a little château, in the heart of Normandy," occupy themselves with social calls to Yvetot, Le Havre and Rouen that carry a hint of romantic intrigue and farce.[31] The numerous photographs taken by Vuillard during these extended stays in the Normandy countryside attest to the devotion to pleasure and playfulness of the various members of the Hessel household, to the joys of long luncheons in the shade (cats. 212–214) and impromptu repasts enjoyed during a day out in the car (cats. 230–233).

The introduction of the automobile had helped to change the nature of the *villégiature*. By the turn of the century, with travel to and between locales no longer limited to train, carriage or omnibus, visitors had a greater degree of freedom and mobility. Proust, who in 1907 published an account of his travels through Normandy by automobile, delighted in this new freedom, observing: "the most precious thing the automobile has given us is a marvellous independence—it allowed one to leave when one wanted and to stop whenever one felt like it."[32] Tristan Bernard, a successful writer as well as an aficionado of cycling and automobiles, dedicated his book *Les Veillées du chauffeur* to his friend Vuillard, "companion on countless drives."[33]

During these summers in Normandy, Vuillard held a unique place in the Hessel ménage: artist in residence and perennial house guest, but also the observer who studied and recorded the daily life of the household.[34] He found a wealth of inspiration

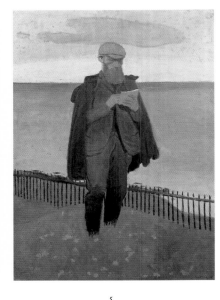

in the activities of his companions, as well as in his surroundings, and his sketchbook was never far from his hand. Annette Vaillant, the daughter of Alfred Natanson and Marthe Mellot and consequently a youthful eyewitness to these *villégiatures*, observed: "Even at breakfast time Monsieur Vuillard's piercing gaze would roam from the large table laid out in the garden to his little sketchbook. Often he would say: 'Don't move.'"[35] Vallotton, who visited Vuillard in the summer of 1902, painted his friend on an excursion to Honfleur, standing atop a dune, silhouetted against a grey sky as he sketched, the *peintre-villégiateur* in all his glory (fig. 5).

The congenial nature of these sojourns, the exuberance and spontaneity of the activities with which the days were filled, is reflected in the paintings Vuillard created in his role as artist *en villégiature*. In a deceptively casual image, Vuillard portrayed his companions Tristan Bernard, André Picard and Jos Hessel embroiled in an animated game of draughts while Marthe Mellot and two other figures bask nearby in the heat of a summer afternoon (fig. 6).[36] Glimpsed from the first-floor window of the Château-Rouge, the scene is captured with the immediacy of a snapshot, but was actually artfully arranged and constructed, for it was based largely on photographs and on a pencil sketch made on site and then completed after the fact. This was not an unusual practice for Vuillard, who produced numerous photographs during his *villégiatures* that he mined effectively when creating or reworking a painting at a later date, such as *The Haystack* (cat. 266), a painting that deftly utilizes photographs to create a luminous evocation of a past summer (see cats. 221–227).[37]

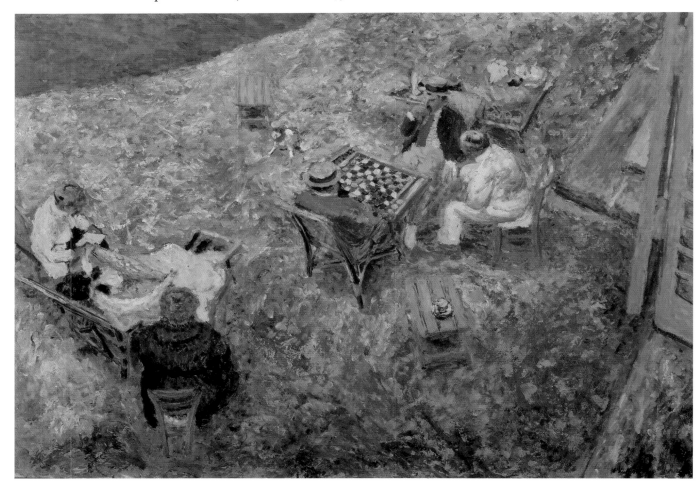

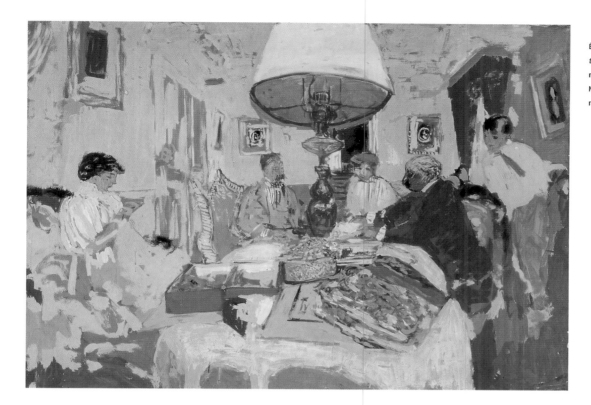

7

Édouard Vuillard, *Friends around the Table*, 1909, distemper on paper mounted on canvas, Strasbourg, Musée d'Art moderne et contemporain, C-S VIII.288.

Not all of Vuillard's *villégiatures* during this period were spent in Normandy. In 1908 he spent the summer in Le Pouliguen, a small Breton bathing resort and fishing port on the Atlantic coast. Although Le Pouliguen itself was modest, it was located a mere three kilometres from La Baule, which hosted a fashionable crowd that frequented the hotels and casino there and was easily accessible by a *tram à vapeur* that followed the coastline and linked the two sites.[38]

The following summer was also spent in Brittany, this time at Saint-Jacut de la Mer on a portion of the coast of the English Channel known as the "Côte d'Émeraude." Like Le Pouliguen, Saint-Jacut de la Mer was a bathing resort, "simple and quiet," located at the extreme end of a long peninsula ending in a rocky point between the bay of Lancieux on the right and that of Arguenon on the left.[39] The ménage took up residence in two rented villas.[40] Vaillant recalls the intense productivity of that summer as her father and Tristan Bernard collaborated on a play, *Le Costaud des Épinettes*, while "Coolus and André Picard wrote in their respective rooms. Monsieur Vuillard painted, drew."[41] From early July to the end of September Vuillard explored the region of Saint-Jacut, turning his hand to a number of landscape motifs, including the nearby ocean and such memorable sites as the Villa des Écluses, with its distinctive silhouette, and the massive form of the mill of Saint-Jacut,[42] as well as numerous interiors depicting the Hessel ménage engaged in mundane tasks and lively communal meals (fig. 7).

These two summers Vuillard spent in Brittany—and especially the summer at Saint-Jacut—were intensely productive. The paintings he produced are exceptionally striking, in large part because of a growing preference for the medium of *peinture à la colle*, or distemper. Roger-Marx has compared the Brittany paintings to the works of the Impressionists, Eugène Boudin (1824–1898) and Berthe Morisot (1841–1895) in particular, citing the blond tonalities and the spontaneity of the execution.[43] Yet such a

comparison does no justice to Vuillard. His Brittany paintings, audacious in their abstraction, subordinate the impulse toward naturalism to more fundamental pictorial concerns. While a painting such as *Promenade at the Port, Le Pouliguen* (fig. 8) has a freshness and an immediacy that is indeed reminiscent of the *plein-air* studies of the Impressionists (fig. 9), there is an emphasis on plane and silhouette that is more akin to his synthetist experiments of the 1890s. Vuillard's use of *peinture à la colle* and the smooth, matte surfaces it creates serves to heighten this effect. And the manner in which he applied the distemper is also significant: in works such as *Landscape at Saint-Jacut* (cat. 268), the paper

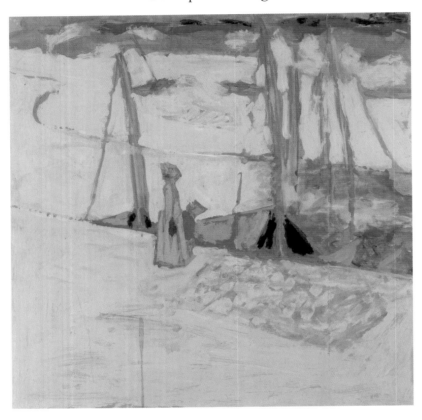

support is left liberally exposed, so that it becomes an active component of the composition. While this is not by any means new in Vuillard's work, there is an unprecedented freedom in this mingling of medium and support in the Brittany paintings, all the more striking in view of the painstaking and preplanned method imposed by *peinture à la colle*, which effectively precluded working directly from the motif. The illusion of spontaneity that permeates these paintings is precisely that. It is noteworthy, however, that it was within the less formal and restrictive context of the *villégiature* that Vuillard allowed himself to engage in such experimentation.

Perhaps the greatest expression of Vuillard's relationship to the *villégiature* is the suite of decorative panels he produced for the villa of Bois-Lurette, the summer home of the Bernheim families situated at Villers-sur-Mer (see cats. 274–275).[44] While the subject of these panels—*villégiatures* in Normandy—is entirely appropriate to their intended site, it is intriguing to note that Vuillard has depicted scenes inspired by his own *villégiatures*. Rather than depicting the Bernheims, their villa or its surroundings, the majority of these paintings show the Hessels and their entourage, echoing the tactic Vuillard had already used in 1898 for the panels he produced for Jean Schopfer (figs. 2–3)—depicting a world familiar to his patrons but inhabited only tangentially by them.[45] As in the Schopfer works, Vuillard is more concerned in these paintings with the evocation of a lifestyle than the faithful rendering of specific sites or individuals.

In the Bois-Lurette panels Vuillard has effectively encapsulated his later *villégiatures* in Normandy in the years leading up to the First World War. Each phase of the decoration embodies a different *villégiature* and a different venue. For the first of the door frames, Vuillard depicted the Hessels at Les Pavillons, the villa in Criquebœuf where they spent the summers of 1910 and 1911.[46] For the second door frame the setting is Le Coadigou, the villa in Loctudy where they summered in 1912 and the only Breton

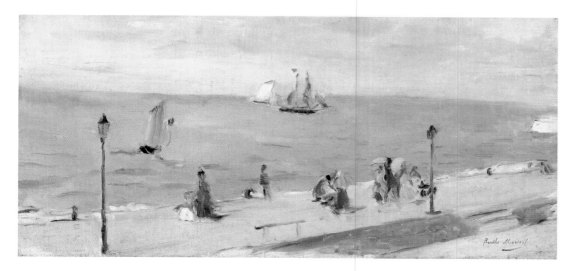

9
Berthe Morisot, *On the Beach*,
1873, Richmond, Virginia Museum of
Fine Arts, Collection of Mr. and Mrs.
Paul Mellon.

site to be included in this suite (see cats. 274, 244).[47] For the five remaining panels Vuillard divided the settings between Cabourg,[48] where he and the Hessel ménage summered in 1913, and Villers-sur-Mer, the location of Bois-Lurette (see cat. 275).[49]

In this suite of decorations, Vuillard achieves an ideal marriage of theme, location and technique—the bright, pastel palette and the loose, fluid handling of the paint surface accentuate the evocation of idyllic, sun-drenched days spent in the Normandy countryside, "entirely pervaded by the smell of the sea."[50] The extreme refinement of a panel such as *At Villers-sur-Mer: The Terrace at Bois-Lurette*, which depicts Mathilde and Suzanne Adler, the wives of Josse and Gaston Bernheim (fig. 10), relaxing on the terrace overlooking their property, becomes a perfect counterpoint to the more dynamic scene of a communal meal uniting the Natanson clan at the villa of La Divette in nearby Cabourg (cat. 275). The former is elegant and spare, the latter, by comparison, boisterous and delightfully cluttered, populated by multiple figures, some of whom remain coyly hidden from view or are glimpsed only as mirrored reflections. If these paintings are reminiscent of the early work of Monet in their exquisite luminosity and their celebration of leisure,[51] they also call to mind the scintillating palette and open compositions found in Bonnard's work of this time (fig. 11).[52]

With the declaration of war, Vuillard's *villégiatures* came to a halt. After spending a last summer at Villerville, the artist was mobilized on August 2, 1914 as a railway patrolman at Conflans. He travelled relatively rarely during the war years, apart from visits to Lausanne in October 1915[53] and again in 1916 (see cat. 248), and trips to Oullins to visit the munitions factory administered by Thadée Natanson, which would later serve as the subject for a pair of decorative panels.[54]

The year 1917 marks the beginning of the third and final phase of Vuillard's *villégiatures*. Vuillard resumed his pre-war practice of sojourning in the company of the Hessels, but while the company remained largely the same, the locales, and even the character of the *villégiatures* themselves, had changed considerably. In the post-war era, the Hessels eschewed the more fashionable sites in Normandy and Brittany in favour of the countryside near Paris. They also acquired property of their own, beginning with the Clos Cézanne, the property Jos Hessel purchased at Vaucresson in 1916 in exchange for a Cézanne painting that inspired its name.[55]

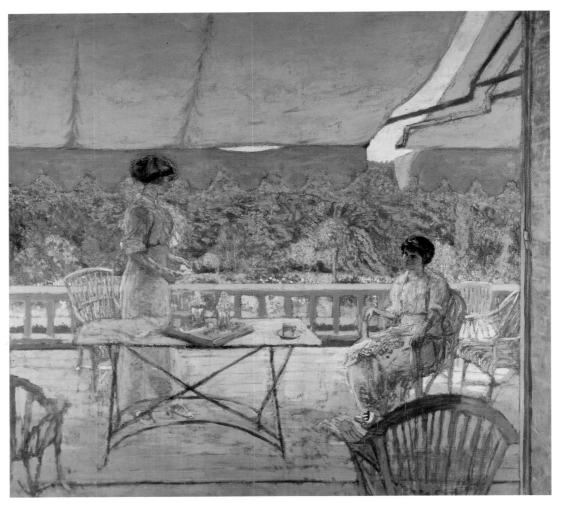

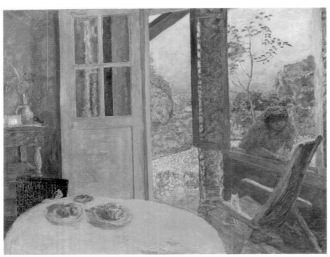

452

For the next nine years, Vaucresson would become Vuillard's privileged sanctuary outside of Paris (see cat. 249). It is, however, misleading to view Vuillard's country sojourns from this period as true *villégiatures*. They are, in fact, much closer in character to his visits to L'Étang-la-Ville, as a result not only of the proximity to Paris, but also the more subdued nature of the stays themselves. During the summer, Vuillard and his mother would rent the second floor of the Closerie des Genêts, a small villa near the Clos Cézanne that served as both domicile and studio for the artist and his mother during their stays in the countryside.[56]

Although Madame Vuillard had long accompanied her son on his *villégiatures*, she had not previously resided with her son and his friends, but rather maintained more modest accommodations nearby (see cat. 229).[57] Within the elegant and somewhat fashionable world of the Hessels and their circle Madame Vuillard seems to have to been a marginal figure, but in reality she was a constant, soothing presence and an essential component of "the illusion of being at home" that was so crucial to Vuillard's creativity. His depictions of his mother *en villégiature*—many of them captured by his Kodak rather than his brush—are strikingly similar to those created in Paris. Images of his mother preparing

or participating in a family meal (cat. 201) or sewing near a window (cat. 273) underscore the normalcy and the sense of continuity between life in Paris and that in the countryside (cat. 276).

While somewhat sedentary in contrast to the *villégiatures* spent in Normandy and Brittany, life at Vaucresson was still lively because of the presence of Lucy Hessel, who remained the consummate hostess whether in Paris or in the countryside. Many of Vuillard's companions from the summers in Normandy were regular guests, including Tristan Bernard, Romain Coolus, Alfred Natanson and Lucy's cousin Marcelle Aron, while other, more recent acquaintances, such as Sacha Guitry and Yvonne Printemps, also passed through the Clos Cézanne.[58]

12

Édouard Vuillard, *Foliage: Oak Tree and Fruit Seller*, 1918, distemper on canvas, Art Institute of Chicago, C-S XI.1.

Vuillard's *villégiatures* at Vaucresson proved to be as fruitful as those he had passed in Normandy, and the artist found inspiration for his art in the environs of both the Clos Cézanne and the Closerie des Genêts. In *Foliage: Oak Tree and Fruit Seller* (fig. 12) Vuillard adopted the same approach he had used so successfully in his earlier painting *A Game of Draughts* (fig. 6), depicting a scene viewed from a window above, in this case his mother's second-storey window at the Closerie des Genêts.[59] Although the painting itself was created as a commission for Georges Bernheim, the subject, as with all subjects inspired by Vuillard's *villégiatures*, is subdued and remarkably commonplace: a country garden dominated by a lush oak tree with a few figures interspersed and nearly hidden from view.[60] As in the paintings he created for Bois-Lurette, Vuillard had once again taken the intimate world of the *villégiature* and created an image that is at once grand and unassuming.

In 1925, the Hessels purchased a new property, the Château des Clayes, which would be the last of Vuillard's country refuges. Located between Versailles and Saint-Cyr and dating from the fourteenth century, the Château des Clayes had once been a nobleman's manor. It had been demolished during the Revolution, but was restored in

1810 and boasted a park designed by the landscape architect André LeNôtre.[61] It was here that Vuillard would spend the better part of his later years, in the company of the Hessels and his mother, who took up residence there during "the warmer months" at the request of Lucy Hessel. Jacques Salomon, who was a regular visitor, recounts: "She would move in at the beginning of spring, and after Madame Vuillard's death Édouard had his own room there. He would leave for Paris early each morning with Hessel and would return in time for dinner…"[62] Vuillard's room was located on the ground floor in one of the wings of the château with a window facing the park, which was to provide the subject of a number of his later works (see cat. 334).

Although life at the château was quite animated, especially during the weekends,[63] it was the solitude and the relative lack of distractions that Vuillard seemed to appreciate the most. The time spent at the Château des Clayes was fruitful. Salomon recalls that "one would often catch sight of Vuillard in a chair on one of the pathways, his box of pastels and his little square of cardboard on his knee…"[64] From each visit to the Château des Clayes Vuillard harvested a rich bounty of sketches depicting motifs drawn from the park, the pond, or the terrace,[65] as well as simple still lifes and even views of his own studio there, which served simultaneously during this period of production as workplace, subject and showcase (fig. 13). Though the works he created there may appear unfinished to the casual observer, they are perfect expressions of their time and place, harkening back to the fluid and boldly experimental works he had produced during his stays in Brittany some two decades earlier. During this final period at the Château des Clayes Vuillard's experience of the *villégiature* reached its logical conclusion. The "illusion of being at home" that was essential to Vuillard's creative process and that he had sought most of his life to attain had ceased to be illusory: it had become reality.

At the beginning of the Second World War, Vuillard retreated from the German army to La Baule, joining the Hessels at the Castel Marie-Louise hotel where he died on June 21, 1940. Years later, Annette Vaillant would recall with more than a little poignancy that La Baule could be seen clearly from the beach of Penchâteau and from the villa of Ker Penurge, where her family, the Hessels, and Vuillard had spent a boisterous *villégiature* in 1908.[66]

Little remains of the sites where Vuillard passed his *villégiatures*. The beach of Penchâteau has since become surrounded by "hideous houses,"[67] and the Château des Clayes was destroyed by fire in 1944 at the time of the liberation of Paris.[68] But while the sites themselves have disappeared or have been irrevocably transformed, they live on in Vuillard's ebullient evocations of placid, sundrenched summers, long past but never forgotten.

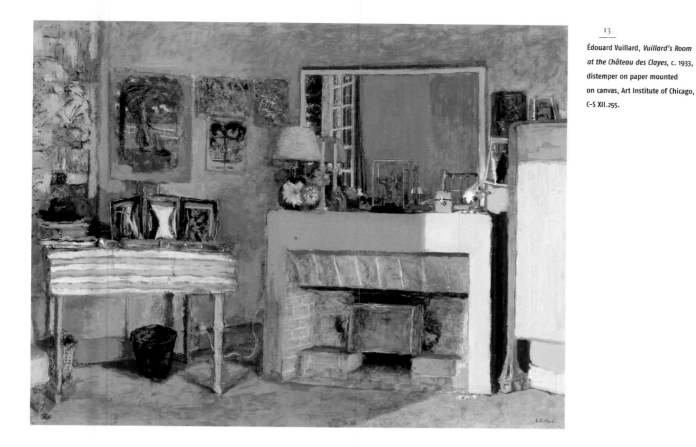

13

Édouard Vuillard, *Vuillard's Room
at the Château des Clayes*, c. 1933,
distemper on paper mounted
on canvas, Art Institute of Chicago,
C–S XII.255.

1. His travels included trips to Belgium in 1892, 1910, 1912 and 1932; Holland in 1892, 1902, 1905, 1929 and 1932; London in 1892, 1899, 1903, 1908, 1925 and 1932; Italy in 1897, 1899 (cats. 187–188), 1914 and 1932; Switzerland in 1900, 1915, 1932 and 1939; Spain in 1901 (cats. 189–191), 1910 and 1930; Vienna in 1903; Germany in 1912 and 1913. Vuillard included information about his travels in a pair of chronologies of important events, which he recorded in his journal. The second chronology, which dates from November 11–12, 1908 and is found in *Journal*, II.2, fol. 12r-v, is more complete, though there are some minor discrepancies. These chronologies are published in Elizabeth Easton, *The Intimate Interiors of Édouard Vuillard*, exhib. cat. (Washington: The Museum of Fine Arts, Houston / Smithsonian Institution Press, 1989), pp. 143–144. See also Jacques Salomon, *Vuillard* (Paris: Albin Michel, 1945), pp. 100–102, for information regarding Vuillard's travels abroad. Unfortunately, some of the dates noted by Salomon are inaccurate; the trip to Hamburg, for instance, took place in 1913, not 1905 as Salomon indicates. For more details concerning Vuillard's travels, see the chronology in Ann Dumas and Guy Cogeval (eds.), *Vuillard*, exhib. cat. (Lyon: Musée des Beaux-Arts, 1990), pp. 230–233.

2. Salomon, 1945, p. 100. Among the works Vuillard painted on this trip are *The Freighter in Dock, Hamburg* (Paris, Musée d'Orsay, C-S VIII.419) and *View of the Binnenalster* (Hamburg, Kunsthalle, C-S VIII.418).

3. Claude Roger-Marx, *Vuillard et son temps* (Paris: Éditions Arts et métiers graphiques, 1945 [1946]), p. 158.

4. Émile Zola, "Les Parisiens en villégiature," in *Oeuvres complètes*, ed. Henri Mitterand (Paris: Cercle du Livre Précieux, 1966), vol. 9, p. 1059.

5. On this distinction, see Louis Burnet, *Villégiature et tourisme sur les côtes de France* ([Paris]: Hachette, 1963), p. 10, and Jean-Didier Urbain, *Sur la plage. Mœurs et coutumes balnéaires (XIXe–XXe siècles)* (Paris: Petite Bibliothèque Payot, 1996), pp. 14–17.

6. On Monet and the influence of tourism, see in particular Robert L. Herbert, *Monet and the Normandy Coast: Tourism and Painting, 1867–1886* (New Haven: Yale University Press, 1994).

7. Letter from Vuillard to Félix Vallotton (Paris, September 1900), reproduced in Gilbert Guisan and Doris Jakubec (eds.), *Félix Vallotton. Documents pour une biographie et pour l'histoire d'une œuvre*, vol. 2, *1900–1914* (Lausanne and Paris: La Bibliothèque des arts, 1974), p. 50.

8. Ibid.

9. Salomon, 1945 (see note 1), p. 52.

10. Misia Sert, *Misia and the Muses: The Memoirs of Misia Sert* (New York: John Day, 1953), p. 40. (trans. slightly modified)

11. For Vuillard, Valvins was an ideal location for such extended sojourns—because of its charming, rustic locale and, more importantly, its dynamic and engaging society, which included not only the Natansons and other artists of the Nabi circle, but also the poet Stéphane Mallarmé. Mallarmé, who was greatly admired by the artists and writers of *La Revue blanche*, lived just a few doors away from La Grangette and became a regular visitor. Jacques Salomon, *Vuillard*, NRF collection (Paris: Gallimard, 1968), p. 64.

12. *Mallarmé's House at Valvins* (1896, priv. coll., C-S VI.8); *Mallarmé's House at Valvins* (1896, Paris, Musée d'Orsay, C-S VI.9).

13. Sert, 1953, p. 52. The town itself was founded in 1163. Its primary products were wine, grain, leather and liqueurs, and its most notable architectural feature was Les Relais itself, "the eighteenth-century former post office, decorated with mythological sculptures." See *La Grande encyclopédie, inventaire raisonné des sciences, des lettres et des arts, par une société de savants et de gens de lettres : sous la direction de mm. Berthelot…Hartwig Derenbourg [et al.]*, 31 vols. (Paris: H. Lamirault, [1886–1902]), vol. 31, p. 1006.

14. Letter from Vuillard to Vallotton (Paris, August 5, 1897), Guisan and Jakubec, 1974, vol. 1, *1884–1899* (1973), p. 160. See also Annette Vaillant, *Le Pain polka* (Paris: Mercure de France, 1974), pp. 76–78.

15. Several of Natanson's photographs are reproduced in Annette Vaillant, "Livret de famille," *L'Oeil*, no. 24 (Christmas 1956), pp. 24–35. See also Vaillant, 1974, pp. 76–79.

16. On this pair of panels and their history, see Gloria Groom, *Édouard Vuillard: Painter-Decorator. Patrons and Projects, 1892–1912* (New Haven and London: Yale University Press, 1993), pp. 99–108.

17. Salomon, 1968 (see note 11), p. 82. According to Vaillant these chairs, fabricated by a craftsman in Albi, had been sent to Thadée by Toulouse-Lautrec. Vaillant, 1974, p. 77.

18. See Gloria Groom, *Beyond the Easel: Decorative Painting by Bonnard, Vuillard, Denis, and Roussel, 1890–1930*, exhib. cat. (New Haven and London: The Art Institute of Chicago / Yale University Press, 2001), pp. 138–140.

19. Salomon, 1945 (see note 1), p. 47.

20. Letter from Vuillard to Vallotton (L'Étang-la-Ville, July 23, 1900), Guisan and Jakubec, 1974, p. 45.

21. Letter from Vuillard to Vallotton (L'Étang-la-Ville, August 10, 1900), ibid., pp. 47–48.

22. Sasha M. Newman, *Félix Vallotton*, exhib. cat. (New Haven: Yale University Art Gallery, Abbeville Press, 1991), p. 264.

23. Other guests included Romain Coolus, Alexandre Natanson, Albert André and the dealer Gaston Bernheim. See a letter from Vuillard to Vallotton (Tuesday, January 15, 1901), Guisan and Jakubec, 1974, p. 52. Vuillard says that he has been there for at least a week.

24. Marcel Proust, *In Search of Lost Time*, vol. 1, *Swann's Way*, trans. C. K. Scott Moncrieff and Terence Kilmartin (New York: Modern Library, 1998), p. 183.

25. Marcel Proust, *In Search of Lost Time*, vol. 4, *Sodom and Gomorrah*, trans. C. K. Scott Moncrieff and Terence Kilmartin (New York: Modern Library, 1999), p. 697.

26. Annette Vaillant, who was a regular visitor along with her parents Alfred Natanson and Marthe Mellot, described the villa and its society: "A few kilometres from Ranville, at the Château-Rouge, a large brick house in the Louis XIII style—Vuillard and Coolus, Tristan Bernard spent the month of August at the Jos Hessels'. The following years my parents spent their vacation with them, bringing us with them, my little sister and me." Vaillant, 1956 (see note 15), p. 32.

27. Letter from Vuillard to Vallotton (Amfreville, July 16, 1901), Guisan and Jakubec, 1974, p. 89.

28. After spending about ten days at Amfreville, the Roussels took up residence at Salenelles, "ten minutes from here." Letter from Vuillard to Vallotton ([Amfreville], July 29, 1905), Guisan and Jakubec, 1974, pp. 92–93.

29. Vaillant, 1974 (see note 14), pp. 111–116.

30. Ibid., p. 112.

31. Henry Meilhac, *Villégiature. Comédie en un acte* (Paris: Calmann Lévy, 1894), p. 1.

32. Marcel Proust, "Impressions de route en automobile," *Le Figaro* (November 19, 1907), pp. 1–3. Reprinted as "En mémoire des églises assassins," in Proust, *Pastiches et mélanges* (Paris: Éditions de la Nouvelle Revue Française, 1919), p. 98.

33. Tristan Bernard, *Les Veillées du chauffeur* (Paris: Ollendorf, 1909). Quoted in Jean-Pierre Bihr, *Regards d'Émeraude. Les pays de la côte d'Émeraude de Dinard au cap Fréhel* (Saint-Jacut de la Mer: J.-P. Bihr, 1988), p. 248.

34. According to Salomon, Vuillard was officially dubbed the *peintre-maison* of the Hessel household by the manservant Eugène. Jacques Salomon, *Auprès de Vuillard* (Paris: La Palme, 1953), p. 46.

35. Vaillant, 1974, p. 111.

36. Salomon, 1968 (see note 11), p. 112. In her memoirs, Annette Vaillant described the scene: "From his window, Monsieur Vuillard has painted the game of draughts played after coffee by André Picard, with his silky, drooping moustache, and Tristan Bernard, both of whom sport straw boaters. In his holiday uniform of white cotton drill, Jos Hessel, head exposed to the sun, lends his advice to the players. Mama, reclining in a chaise longue, reads the newspaper." Vaillant, 1974, pp. 38–39.

37. Dumas and Cogeval, 1990 (see note 1), p. 223. Roger-Marx was particularly taken by this painting, remarking: "It conjures the memory of those solemn hours, encountered sometimes in the middle of a holiday, when the communion with sky and earth occurs almost by miracle, and the city-dweller achieves a sense of deliverance." Roger-Marx, 1945 [1946] (see note 3), p. 139.

38. Paul Gruyer (ed.), *Guides Diamant. Bretagne* (Paris: Librairie Hachette et Cie., 1918), p. 157.

39. Ibid., p. 82.

40. On Vuillard's stay at Saint-Jacut see Belinda Thomson, *Vuillard*, exhib. cat. (London: South Bank Centre and the author, 1991), pp. 82–84, and Bihr, 1988, pp. 242–254.

41. Vaillant, 1974, p. 96.

42. *La Villa des Écluses* (1909, Katonah, N.Y., The Katonah Museum of Art, c-s VIII.268); *The Mill at Saint-Jacut* (1909, priv. coll., c-s VIII.332);

43. Roger-Marx, 1945 [1946], p. 142.

44. Villers-sur-Mer was a fashionable bathing site some eleven kilometres from Trouville known for its beaches as well as for the picturesque hills and luxurious vegetation of the surrounding valley. See Paul Joanne, *Itinéraire général de la France. Normandie* (Paris: Librairie Hachette et Cie., 1901), pp. 245–246. This suite, which consists of two separate commissions, the first for a pair of door frames, each consisting of a pair of vertical panels topped by an overdoor, and the second for a series of five panels of varying dimensions, was commissioned in 1911 and executed over three consecutive summers, 1911 to 1913. The villa also included panels by Bonnard, Matisse and others. On Bois-Lurette, see Belinda Thomson, *Vuillard* (Oxford: Phaidon, 1988), p. 119.

45. Groom, 2001 (see note 18), p. 244.

46. Executed in August–September 1911, but dated 1913, *At Les Pavillons in Villerville, Normandy* includes: *The Park*, left panel (priv. coll., c-s IX.159a); *In Front of the House*, right panel (priv. coll., c-s IX.159b); overdoor and lateral panels (priv. coll., c-s IX.159c–159e). See Juliet Wilson Bareau, "Édouard Vuillard et les princes Bibesco," *Revue de l'art*, no. 73 (1986), p. 46.

47. Executed in July–September 1912, *The Veranda at Le Coadigou in Loctudy, Bretagne* includes: *Lucy Hessel and Denise Natanson*, left panel (cat. 274); *Marcelle Aron and Marthe Mellot*, right panel (Musée d'Orsay, Paris, c-s IX.159g); overdoor (priv. coll., c-s IX.159h). Bareau, 1986, p. 46.

48. The Hessels rented the villa named La Divette for their summer at Cabourg. A small river, the Divette, bordered the property. The villa was apparently quite well known in fashionable circles, as evidenced by a notice that appeared in *Le Figaro* the previous summer: "A very elegant tea party the day before yesterday at the home of Madame Maneuvrier, the magnificent villa 'La Divette'." E. Delaroche, "Le Monde et la Ville. De Cabourg," *Le Figaro* (August 29, 1912), p. 2. Annette Vaillant mentions that the house was rather large and sprawling, but composed mostly of small rooms. Vuillard had the space just above the dining room on the ground floor to use as a studio. Vaillant, 1974 (see note 14), p. 189.

49. Executed in July–September 1913, *Lucy Hessel on the Balcony (at La Divette)* (priv. coll., c-s IX.159i); *On the Riverbank (at La Divette)* (priv. coll., c-s IX.159l); *At La Divette, Cabourg; Breakfast* (cat. 275); *Madame Vuillard at the Window (at the Hôtel des Ducs de Normandie, Cabourg)* (priv. coll., c-s IX.159j); *The Terrace of Bois-Lurette* (priv. coll., c-s IX.159k).

50. Roger-Marx, 1945 [1946], p. 142.

51. According to his journal, Vuillard lunched with Claude Monet at Bois-Lurette on September 12, 1913. *Journal*, II.7, fol.100v (September 12, 1913). Quoted in Groom, 2001, p. 277, note 16.

52. Bonnard first rented his Normandy home Ma Roulotte, in Vernonet, in 1910 and eventually purchased it in 1912. Nicholas Watkins, *Bonnard* (London: Phaidon Press Ltd., 1994), p. 124. Annette Vaillant recalls that visitors were frequent at Vernonet: "the Hessels are bringing Vuillard in their Hispano." Annette Vaillant, *Bonnard, ou le bonheur à vivre* (Neuchâtel: Éditions Ides et Calendes, 1965).

53. Dumas and Cogeval, 1990 (see note 1), p. 232.

54. Vuillard visited Oullins in 1916 and again in March and November 1917. See ibid. He was commissioned by Lazare Lévy, the owner of the factory, to produce a decorative program including a pair of paintings (c-s X.32-1 and 2) recording the work being carried out there by the largely female workforce. Thomson, 1988 (see note 44), p. 119. Both paintings are currently on deposit from the Musées nationaux at the Musée d'Art Moderne in Troyes.

55. Salomon, 1953 (see note 34), pp. 47, 49. Vaucresson is located just twenty kilometres from Paris and five kilometres from both Saint-Cloud and Versailles. Paul Joanne, *Itinéraire général de la France. Environs de Paris* (Paris: Hachette et Cie., 1887), p. 77. Because of its accessibility by train and its forested surroundings, Vaucresson was a popular site for *villégiatures* by the turn of the century: "Situated in a charming setting between the woods of Fausses-Reposes and Saint-Cucufa, Vaucresson has become over the past thirty years, and especially since the introduction of the railway, a very popular holiday spot. The station lies at the foot of Butard Hill, whence one has a view of the hunting lodge dating from the reign of Louis XIV." See F. Bournon, "Vaucresson," in *La Grande encyclopédie*, vol. 31 (see note 13), p. 749.

56. Jacques Salomon, who visited the artist there, commented upon "some strange painting paraphernalia that filled a corner of the room near the window," noting the table covered with "small earthenware pots, little brown vessels used for cooking eggs, grouped around a pan in which brushes were soaking; there were paper bags full of powdered pigment, and, nearby, on a little table, a spirit stove on which sat a *bain-marie*, a mustard pot with its little wooden spoon, in which the glue was cooling." Salomon, 1953 (see note 34), p. 14.

57. Annette Vaillant confirms this practice: "Monsieur Vuillard would discreetly find lodgings somewhere in the neighbourhood for her, during the summer months he spent in Normandy or Brittany with my parents and their often rowdy friends." Vaillant, 1974, p. 81. In 1905 and 1907, for example, Madame Vuillard stayed with the Roussels at Salenelles, near Amfreville.

58. Salomon, 1953, pp. 44–45.

59. Groom, 2001 (see note 18), p. 249.

60. According to Vuillard's journal, the artist began to make pencil sketches for this painting at the Closerie des Genêts on July 20, 1918 and within a week had ordered the massive canvas to be delivered to his studio in Paris. *Journal*, III.3, fol. 46v, quoted in Groom, 2001, p. 278, cat. 84, note 2. The painting itself would require five months to complete, during which time the artist travelled frequently between his studio in Paris and Vaucresson, where he continued to sketch and make notes. Groom, 2001, p. 249.

61. Salomon, 1953, p. 85.

62. Ibid.

63. Ibid., p. 86.

64. Ibid., p. 88.

65. Salomon, 1968 (see note 11), pp. 27–28.

66. "At Penchâteau, from the beach and from the windows of the house, we could see La Baule, where Vuillard came to die, heartbroken, in June 1940, in the upheaval of the exodus." Vaillant, 1974 (see note 14), p. 96.

67. Annette Vaillant, "Some Memories of Vuillard," in *Vuillard et son Kodak*, exhib. cat. (London: The Lefevre Gallery, 1964), p. 23.

68. Salomon, 1953, p. 88.

VUILLARD BETWEEN TWO CENTURIES | Laurence des Cars

Vuillard loved the environment he lived in for the unexpectedness and pungency of the sights his memory retained from day to day, from which, cloistered in his studio, he composed his numerous and varied impressions. Unadulterated nature did not provide him with so exhilarating a stimulant. He needed the theatres, the restaurants, the salons, the artificial lighting to nourish his memory and satisfy his curiosity. In terms of sensation he became ever more demanding, going so far as to seek out the bizarre, from which he derived astonishing compositions and colours and, more often than not, unusual beauty.[1]

IN FEBRUARY 1941, a little more than six months after his friend Vuillard's death, Maurice Denis looked back at a paradoxical side, axiomatic to his intimates, of the artist's personality. This quiet, reserved man lived a surprisingly social life, full of friends and fashionable events—especially in his later years—and a ceaseless, tireless curiosity. With his deep attachment to Paris, he never considered (except perhaps at the very end of his life) any prolonged absence from the city, any retreat from the world, like Bonnard's at Le Cannet. In his last letter to Vuillard, Bonnard wrote: "For me Paris is largely you."[2] The idea could easily be reversed. Vuillard was, in fact, largely Paris. This almost visceral link can be perceived first geographically, in terms of the boundaries mapped out by

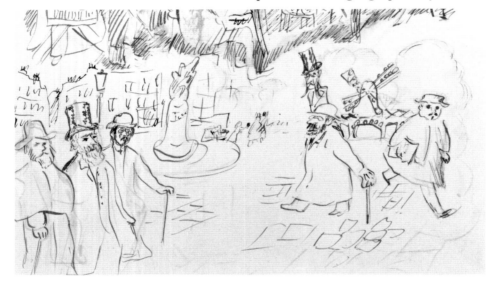

1
Pierre Bonnard, detail of the first page of the sketchbook entitled *La Vie du peintre*, c. 1910, ink and wash on paper, private collection. On the left: Roussel, Vuillard and Bonnard, Place Clichy; on the right: Toulouse-Lautrec, Gabriel Tapié de Céleyran and Maurice Denis, Place Blanche.

the addresses of his successive Parisian apartments and studios. After hesitating between Rue Saint-Honoré, Les Batignolles and Rue de la Tour, Vuillard and his mother eventually settled in 1908 on Place Vintimille. There, between the 9th and 18th arrondissements, Place Clichy became the permanent epicentre of his Paris. He sometimes migrated to smarter districts, like Passy and Neuilly during his portrait period in the 1920s and 1930s, but always to return. It was, of course, a neighbourhood of artists, but more significantly one with a dynamic nightlife, in which Vuillard—a habitué of the Moulin Rouge and the Brasserie Wepler (figs. 1–2)—took enthusiastic part. But it would be a mistake to see this life as nothing more than a picturesque setting, and Denis clearly realized this, noting how fundamentally necessary it was to Vuillard's creativity, how much it inspired him, and to what degree it should be taken into account if we are to grasp the true nature of his art. This notion is amply confirmed by a reading of the journal Vuillard kept from 1888 to 1894, and again between 1907 and 1940.[3] It tells us not only that the artist went out almost every evening and spent an enormous amount of time at the theatre, but also that he was a great reader, and that these twin poles, public and private, of his social and cultural self enriched, reflected and sometimes destabilized his work as a painter. He spent his time observing, but he commented on his observations, striving to "comprehend" and thus to paint his world—or rather his successive worlds—more successfully.

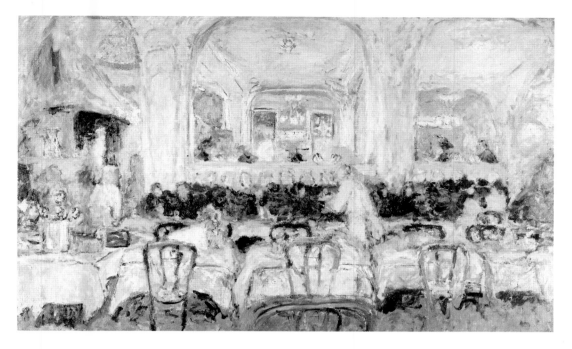

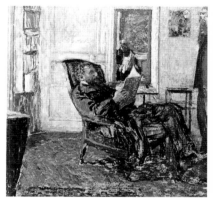

2
Édouard Vuillard, *The Café Wepler*,
1908 – 1910, reworked in 1938, dis-
temper on canvas, The Cleveland
Museum of Art, Gift of the Hannah
Fund, C-S VII.542.

3
Édouard Vuillard, *Portrait of Thadée
Natanson*, 1906, distemper on canvas,
Paris, Musée d'Orsay, C-S VII.404.

**Page by Page** | THE FIRST PUBLIC PERIOD of Vuillard's cultural history was of course that of the Nabi years, of *La Revue blanche* and his experiences in the avant-garde theatre. Between 1890 and 1896 his involvement in innovative literary and theatrical circles had, as we know, considerable influence, as regards both sensibility and form, on the development of his painting (see "Vuillard Onstage," in the present volume). But there was a complementary and more private corollary to this fascinating period of creativity that both preceded and accompanied it: reading and writing. More than forty years after the battles of what Mallarmé described as the "friendly, ready-for-anyone *Revue blanche*," when Thadée Natanson (fig. 3) recalled in his memoirs a "subtle and sensual Vuillard" he could not help painting a portrait of the artist as reader:

It was his intuition also that made him probe so deeply into the books he read. Always attentively, if the word is strong enough. From the catechism and Bible of his childhood to Sainte-Beuve's *Volupté*, perhaps the first book from which his ardent youth absorbed the tainted essence of sombre secrets and which excited his sensuality, to Taine's *Intelligence*, which led him to ponder a number of theories, none more deeply than that of the Signs. But I believe that no writer, except perhaps for Mallarmé later on, had as much influence on his newly awakened consciousness as Buffon. These were some of the authors that influenced him most, at least in his youth, for he went on reading and always read, not for the sake of it or to talk about it, but from a need to acquire knowledge. He read unaffectedly, and always had to hand the basic dictionary information. Among others, he read everything published by Delacroix and Baudelaire, and all manner of books having to do not only with painters and the plastic arts but with all kinds of subjects, even politics (after Retz), and, page by page, the nine fat volumes of M. Henri Brémond's *Histoire du sentiment religieux en France*. All this did not restrict his daily reading of contemporary writers, not just friends like Paul Valéry and Jean Giraudoux, and none more assiduously than Mallarmé: in the images and rhythms of *L'Après-midi d'un Faune* he discovered the precepts of the true art of poetry.[4]

Missing from this broad survey, since Thadée Natanson did not know of its existence, is Vuillard's journal, in which from 1888 on he daily recorded his thoughts and actions and which in itself constitutes a genuine literary experiment.[5] But Natanson was perfectly

right in identifying the crucial, one might say fundamental, role of the Mallarmean experience in Vuillard's life and work. Rather than an ongoing reading pursued throughout a lifetime, this experience took the form of a profound assimilation, certainly at work in the 1890s, of a difficult and demanding poetic vision from which, no matter how one may judge his later painting, the artist probably never strayed.

      The encounter with Mallarmé was not purely through books. In addition to the signs of a fervent admiration—a complete manuscript copy of *L'Après-midi d'un Faune*, a signed copy of *Divagations* always to hand, the reciting of perfectly memorized poems—there were also several meetings. Through the good offices of Thadée Natanson, Vuillard attended a number of Mallarmé's Tuesday Evenings and on one of these occasions heard the poet's premiere reading of *Un coup de dés*. Jacques Salomon, the painter's nephew, recalls the artist's mixed feelings: "The evening left him bewildered,

4
Édouard Vuillard, *Autumn in Valvins: View of the Seine with Mallarmé's House on the Right*, 1896, oil on board, Paris, Musée d'Orsay, C-S VI.9.

5
Édouard Vuillard, *Stéphane Mallarmé*, 1896, graphite on paper, private collection.

and the 'cliquey' atmosphere of the dining room on Rue de Rome chilled him at once. When we asked him what effect the reading of the famous poem had had on him, he only smiled."[6] Contact between the two men undoubtedly became more personal and direct when in the autumn of 1896 Vuillard, who was staying with the Natansons at Valvins, paid a neighbourly visit to the poet. A few sketches and two paintings of Mallarmé's house, together with some portrait drawings, record glimpses of the place and of his host (figs. 4–5; cats. 163–164).[7] But the next stage in this relationship, unfortunately never realized, was the plan for a "deluxe edition" of the still unfinished *Hérodiade*, to be illustrated by Vuillard. The idea originated with Ambroise Vollard: "As Monsieur Redon has illustrated *Un coup de dés* it might be a good idea for art lovers who, like you, appreciate variety, to have *Hérodiade* illustrated by another artist. I had thought of Vuillard but did not want to broach the subject with him before knowing

your feelings in the matter."[8] Mallarmé was immediately enthusiastic: "Let's finish the *Coup de dés*; before *Hérodiade*: yes, I would be delighted to have Vuillard illustrate this poem, suggest it to him and who knows if he might not yield to the temptation; for he *can do anything*."[9] In fact, bringing the two creators together had already occurred to Félix Fénéon in October 1895 when, requesting a text for *La Revue blanche*, he wrote to the poet: "I would then ask Vuillard for a portrait of Stéphane Mallarmé, which, if you'd like, would be published at the same time."[10] This project came to nothing, like Vollard's, although Mallarmé was still exhorting the latter in the spring of 1898: "Don't let Vuillard leave Paris without having given you the right answer; tell him, to encourage him, that I'm happy with the longer poem: for once, it's true."[11] The poet's sudden death in September of that year put a stop to the project, on which, it seems, Vuillard had never even begun to work.

**Correspondences** | IN SPITE OF THIS MISSED opportunity, the shock wave of the Mallarmean revelation continued to reverberate subtly, but for far longer than is generally supposed, through Vuillard's mind and work. It has been noted, quite rightly, that Vuillard's *intimisme*, his evocations of the silence of things, his variations on a closed world, so charged with meaning in the 1890s, are almost always in perfect accord with Mallarmé's poems. André Chastel, in his marvellous essay "Vuillard et Mallarmé," stressed the extent of this connection: "The world of which the young Vuillard dreamed is a silent refuge, seen by lamplight, a Mallarmean world, minus the abstract constellations and symbols but with their expectation or foreshadowing nonetheless persisting here and there. This central construct not only gives rise to a certain lyrical quality, it dictates an aesthetic."[12] But although there is an immediately identifiable Mallarmean moment in Vuillard's oeuvre, it does not encompass the full scope of the correspondences. This early inculcation actually became a definitive stamp that endured throughout later developments in the painter's artistic language. "Around 1900 he began moving toward broad forms and a more direct style that enabled him to focus simultaneously on the original feeling and on descriptive richness," wrote André Chastel, further noting that Vuillard's "whole oeuvre owes some of its value to the profoundly moving poetry it once encountered."[13] The clearest evidence of the lastingness of the Mallarmean influence is found in the journal. In her doctoral dissertation, which is a literary study of Vuillard's journal, Françoise Alexandre identifies regular recurrences of Mallarmé's presence in Vuillard's reading and writing. For example, in 1914, in the anguish and uncertainty triggered by the outbreak of war, he read and re-read Mallarmé "with enormous interest" (November 3, 1914), and in 1918 he acquired Albert Thibaudet's book *La poésie de Mallarmé*, first published in 1913. In the journal's daily entries we find such telling remarks as "Mallarmean work, form colours without objectivity of subjects" (May 2, 1917), or, more subtly, "Undulating and varied torment apprehension forgotten, one must reckon with resources that are not constant, both moral and intellectual" (April 22, 1918), where the painter's doubt is linked textually to the poet.[14]

**Figures** | THE MAJOR STYLISTIC SHIFT to a reclaimed Impressionism that occurred in Vuillard's work around 1900, but more especially his gravitation, at the same period, toward a new social circle—with the thematic corollary of the early portraits—are the main basis for a Proustian reading of his work.[15] Tempting though this approach may be, however, it seems to work only on a rather general level of interpretation. Proust and Vuillard admittedly both knew pre-war Parisian society; but were they talking about the same thing, and if so, were they talking about it in the same way? On close examination the social and aesthetic correspondences seem less apparent than expected. The first flaw in the argument is a matter of social milieus. The liberal upper-class world of the Hessels and the Bernheims, the focal point of Vuillard's social life, was not that of *In Search of Lost Time*, and in fact the truly Proustian portrait still remains to be discovered in the works of Blanche, Boldini or Helleu. The most overtly "fashionable" of Vuillard's portraits date from the 1920s and 1930s, and it is this new era, no longer that of Proust, that he captures in these paintings. Because their circle and their histories are linked to the pre-war years, the most Proustian of Vuillard's heroines, *Princess Antoine Bibesco* (1913, reworked in 1919, Museu de Arte de São Paulo, C-S IX.224), *Countess Anna de Noailles* (cat. 322) and *Countess Marie-Blanche de Polignac* (cat. 320), seem in the end somewhat isolated in the midst of a new world of theatre and film actresses, famous couturières, and the wives of industrialists and bankers. These women's male counterparts, from *Henry and Marcel Kapferer* (cat. 305) to *Lucien Rosengart* (cat. 321), belong more to the hurried world of Morand than to that of *Within a Budding Grove*. In common there remain, of course, the descriptive details and the litany of references to the passage of time—notably those linked to fashion and décor. But whereas in Proust's oeuvre this approach is all-encompassing and deeply nostalgic, in Vuillard's its aim (despite his many reworkings and alterations) is to capture immediacy, and there is little concern with continuity. Vuillard's language, implacably pictorial, is definitely closer to the poetic than to the novelistic form. It is hardly surprising, then, that it is precisely in Proust's most poetic passages that the parallel with Vuillard's work, including his journal, is most striking.

But it is paradoxically in respect to their lives, rather than their work (their mutual knowledge of which was likely quite slim), that we must look for the most credible links—tenuous though they may be—between the two creators. Vuillard and Proust did meet, probably at *La Revue blanche* in the 1890s and definitely a while later at the home of the Bibesco princes, as well as on the coast of Normandy in the summer of 1907. Proust paid a visit to Vuillard at that time and described the meeting to Reynaldo Hahn, who would be portrayed by the artist in the 1930s (cat. 324): "Yesterday I went to see Vuillard, who was wearing a blue workman's overall (rather too soft a blue, like an Augusta Holmes workman in a *Song of the Trade Guilds*). He says in an intense way 'a chap like Giotto, don't you know, and again a chap like Titian, don't you know...knew just as well as Monet, don't you know, a chap like Raphael etc.' He must say a chap every twenty seconds, but he's a rare creature."[16] Proust gave the verbal mannerism to Elstir, but more importantly, the "rare creature" was almost certainly the principal source of the following characterization: "The effort made by Elstir to strip himself, when face

to face with reality, of every intellectual notion, was all the more admirable in that this man who made himself deliberately ignorant before sitting down to paint, forgot everything that he knew in his honesty of purpose (for what one knows does not belong to oneself), had in fact an exceptionally cultivated mind."[17]

Vuillard's personality, then, probably interested Proust more than his painting. In his turn, although only late in life, the artist shared his impressions of the writer: "Beneath a sophisticated manner that did not in the least detract from his charm, one soon learned to believe in the sincerity of his interest in the arts. I think his love of painting was not just that of a man of letters. It seems to me that he really appreciated Vermeer's work and from the few lines of his that I have read I retain the memory of an attentive person with a far greater desire to know than to be sarcastic, like some of his circle."[18] This statement confirms the existence of a respectful but definite distance between the two men, suggesting a relationship more incidental than profound, like the one described by Annette Vaillant, daughter of the actress Marthe Mellot and Alfred Natanson. She remembered the summer of 1913 at the Grand Hôtel at Cabourg, when Vuillard was working on a portrait of Dr. Gosset's wife "in a sunny room looking out on the gardens of the Casino...Marcel Proust, during that last summer of peacetime, was for his part shut up in his apartment on the top floor overlooking the sea, harnessed to *In Search of Lost Time*."[19]

**The Modern Spectacle** | ON NOVEMBER 3, 1912 Vuillard wrote in his journal: "emotion on entering the theatre, diffidence at the idea of the panels I must paint."[20] Some months earlier he had agreed to design a decoration for the foyer of the Comédie des Champs-Élysées, the small theatre adjoining the Théâtre des Champs-Élysées.[21] In becoming part of the most important architectural and decorative endeavour in pre-war Paris, Vuillard gained the opportunity to immerse himself yet again in his enduring passion for the theatre. But twenty years after his collaborations with Antoine, Paul Fort and Lugné-Poe, he was moving in a completely different dramatic sphere. Symbolist theatre and the kind of boulevard productions the artist attended so often after 1900 were worlds apart. One cannot speak of a break, however, for Vuillard never stopped being a theatre-goer, and there can be no doubting the sincerity of his delight as a spectator. This shift toward lighter comedies of manners and entertainment was shared, moreover, by a generation of writers who were all close friends of Vuillard (and sometimes his patrons): Tristan Bernard, Romain Coolus, Antoine Bibesco, Octave Mirbeau and even on occasion Thadée Natanson. This list would soon include Georges Feydeau (fig. 6) and Sacha Guitry, who also became intimates of the artist (see cats. 302 and 311). Through his network of friendships, Vuillard was probably the only artist who could claim to bridge the gap between these two extremes of turn-of-the-century Parisian theatre. The decorative program for the Champs-Élysées is illuminating in this respect. On September 26, 1912 Vuillard wrote, "morning's decision. Abandon antique subjects," and on October 17, "description of Theatre foyer—decide modern subject."[22] In fact, he took inspiration from the theatre of the day by depicting *Le Malade imaginaire*, which was running at the Odéon—Molière was, with Shakespeare, one of the authors

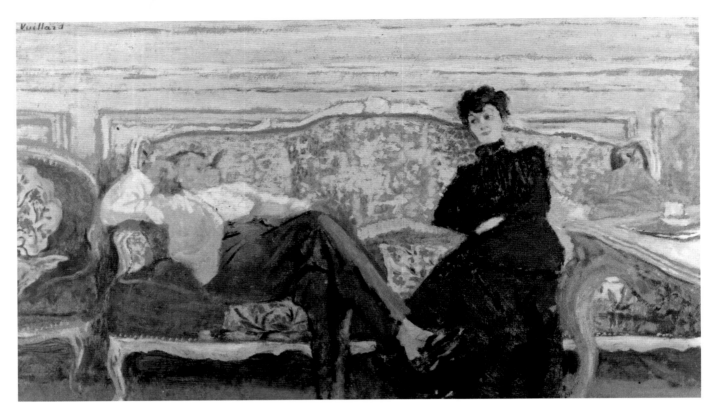

he admired most devotedly—Tristan Bernard's *Le Petit Café* (fig. 7), then playing at the Palais Royal, *Faust*, also playing at the Odéon in early 1913, and *Pelléas et Mélisande*, revived at the Opéra-Comique around the same time. The eclecticism of the choices demonstrates the artist's by now more settled and inclusive tastes—he either would or could no longer choose between classic comedy, romantic and Symbolist drama, and contemporary comedy. Two other panels suggest, in a discreet but unmistakable way, links to another era. *The Guignol* (1913, Foyer de la Comédie des Champs-Élysées. C-S IX.221–5) evokes the interest of the Symbolist generation in puppet shows, and *Lugné-Poe* (fig. 8) conjures the presiding genius of modern theatre and an old friend of Vuillard's. The actor, although shown adjusting his fake beard, presents a picture of gravity and self-containment that can be amusingly compared to the outrageous portrait of *Sacha Guitry in His Dressing Room* (cat. 302), painted at almost the same time.

Vuillard could well have been among the "cast" of *Ceux de chez nous* (1915), a passionately patriotic film by Guitry that pays tribute to the forerunners of French modern art. Like many contemporary critics, Guitry, a friend and client of the Bernheims, saw Vuillard's work, especially his décors, as the immediately recognizable symbol of the modern "artistic" interior. His panel entitled *A Sunny Morning* (1910, priv. coll., C-S IX.156) actually became part of the set of *Un beau mariage*, which opened at the Théâtre de la Renaissance in 1911, and of *La Prise de Berg-op-zoom*, presented at the Théâtre du Vaudeville in 1912.[23] Eight years later, in the stage directions for *Je t'aime*, Guitry noted that in the apartment of the hero, an architect by profession, there should hang on the wall "a Claude Monet, a Cézanne and two Vuillards."[24] Vuillard was at the time a close friend of Guitry and his new wife Yvonne Printemps, the "Sachas" as he calls them in his journal, and frequently visited them at their house on Avenue Élisé-Reclus (fig. 9). Guitry's play *L'Illusionniste* (cat. 317) launched him on a group of paintings in which he re-explores the world of cabarets and theatre, so dear to Degas and Lautrec, by focusing on this *monstre sacré* of modernity. In these works Vuillard depicts the performances from the wings, a compositional device he favoured and often used in other contexts. This viewpoint enabled him to offer a starkly unadorned image of the show by revealing and dramatizing its hidden side. For this purpose, boulevard theatre was just as meaningful as more demanding plays—if not more so—because of its fundamentally unchanging presence in his practice. But though he was perfectly at home in Guitry's kind of production he still kept abreast of modern avant-garde theatre during the pre-war years. He was bored by Claudel's *L'Otage*[25] but thrilled by the Ballets russes, attending a number of their performances between 1911 and 1914: "afternoon rush for ticket to the ballets russes"

*Vuillard between Two Centuries*

467

(May 18, 1911); "Russes, Petrushka and Prince Igor, great pleasure, savagery" (May 1914). He dined at Misia's house with Diaghilev (January 1, 1914), and at Lucy Hessel's met Isadora Duncan, finding her an "unusual person" (February 10, 1914), all the while continuing to frequent the Moulin Rouge, the Folies-Bergères and the Cirque Médrano.[26]

The stage thus became the ideal setting for synthesis, for a fusing of sources and styles—perhaps, in fact, the real laboratory of Vuillard's classicism. His last tribute to the world of the theatre certainly exemplifies this approach. *Comedy*, the large panel he designed in 1937 for the new Théâtre de Chaillot, consummates this wonderful concurrence by bringing together, in a wooded setting inspired by the Château des Clayes, the Hessel estate, characters from Shakespeare (Bottom and Titania) and Molière (Scapin, Alceste, Célimène) in a dream-like neo-classicism that Jean Cocteau would not have disdained.[27]

**Order Regained** | IN VUILLARD'S CASE the First World War seems to have been experienced less as a rupture than as a temporary suspension of a very intense social and cultural life. At the age of forty-six, too old for active service, he was mobilized for a few months as a reserve railway patrolman at Chennevières, near Conflans-Sainte-Honorine. Relieved of his military duties in December 1914, he returned to an "empty" Paris (May 27, 1915), where most of the museums, galleries and theatres were closed. Despite dwindling commissions, he went on working in a daily effort of will power and self-discipline, and he read a great deal. Vuillard's wartime reading reflects his preoccupations, which were primarily historical and political. Struggling to understand the situation, he turned to Daudet, Barrès, Augustin Thierry's *Lettres sur l'histoire de France*, Anatole France's *Le Génie latin* and the 1870–1871 issues of the satirical magazine *Le Charivari*. Since the *Revue blanche* years he had been a friend of Léon Blum

10

Édouard Vuillard, *Le Grand Teddy*, 1918, reworked in 1930, distemper on canvas, Geneva, Fondation Oscar Ghez, C-S X.226.

468

(cat. 165), whose socialist ideas he probably to some extent shared. On two occasions during the war, Vuillard took advantage of this friendship, and the one with Philippe Berthelot, to help his brother and to join the Roussels in Switzerland. But the serious and clear-sighted introspection of his journal now betrays a certain sense of guilt. "Thought of the war perpetual latent anxiety. Incitement to the duty that is work. Same subject on the whole in all the papers. That is the reality of the moment, being productive, each doing what he can. Embarrassment at the dreadful sacrifice of others" (January 12, 1916); and some months later: "All intellectual pleasure seems stolen these days because it is merely solitary and can only be" (November 27, 1916).[28] His main reading at the time, which mirrors these thoughts, was Flaubert's *L'Éducation sentimentale*, whose hero, Frédéric Moreau, witness to his own lack of political and intellectual commitment, awoke a personal

echo in the artist: "Contrast between what is happening and what one is. Frédéric. Education" (January 12, 1916).[29] And this was not the only parallel with Flaubert's protagonist. The war was also the period of the "2 Lucies" (October 6, 1917),[30] of the intense love affair with Lucie Belin, one of his models (cat. 307), which no doubt complicated somewhat his relationship with Lucy Hessel, fortunately busy with her charity work. In the end, in the midst of the agony and the waiting, Vuillard's circle of close friends did not really change. He still saw the Hessels—Jos Hessel had been his dealer since 1912—Tristan Bernard and Marcelle Aron, Romain Coolus and Thadée Natanson; with the initial support of this small group (plus, of course, Misia), he became very active again once the war was over.

In fact, Vuillard painted a great deal during the 1920s and 1930s. This period of success and endless commissions saved him from the social and critical oblivion that might have been expected after the schism—particularly generational—created by the war. But Vuillard remained extraordinarily visible (he never exhibited as much as he did between the wars) and even in vogue. The great exploration of tradition to which he henceforth devoted himself was perfectly in tune with the kind of cultural neo-classicism then flourishing. But into this basic approach he was perfectly capable, when the occasion warranted, of integrating stylistic elements that heralded a new era—for example, the markedly Art Deco accents of the decorative panel he made for the Grand Teddy tea room (fig. 10). Doubtless through Misia, now officially Madame Sert, Vuillard met Coco Chanel in 1921, the year she opened her boutique at 31, rue Cambon and launched her celebrated *No. 5* perfume. He drew her portrait (fig. 11) and sketched the couturière and patron's drawing room. Given the stylistic innovations inaugurated by Chanel and the deluxe neo-classical elegance of Jeanne Lanvin (cats. 326–333), we can assert that Vuillard was acquainted with two pivotal figures of the revolution in women's fashions, of which he was such a careful chronicler in his paintings. As becomes clear, Vuillard's place in society was not reflected exclusively in his familiarity with the loftier elements of the business world. His social circle was an eclectic one, and thus marvellously stimulating. What other painter of the period could bring the same critical clear-sightedness to recording for posterity such a panoply of sitters as Edward G. Robinson, Marie-Blanche de Polignac, Elvire Popesco, David David-Weill, Yvonne Printemps and Philippe Berthelot? To this network of milieus and destinies must be added new literary acquaintances, most notably Jean Giraudoux (fig. 12) and Paul Valéry,[31] whose work undoubtedly represented the artist's last great enthusiasms in contemporary literature. "In the last twenty years of his life," wrote Jacques Salomon, "we often saw him absorbed in Sainte-Beuve's *L'Histoire de Port-Royal* or *La Vie de Rancé*, and at the very end, in the Abbé Brémond's *L'Histoire littéraire du sentiment religieux en France*; he was deeply interested in the lives of these great thinkers consumed by the love of God. *The Imitation of Christ* was his bedside book."[32] Had Vuillard become a mystic, finally coming full circle to a fresh encounter with his Marist education? We cannot know the answer, but until the 1930s he continued to be a great reader whose sometimes delightfully unexpected choices encompassed eminently modern subjects (they included, when it first appeared in French in 1934, Gertrude Stein's *Autobiography of Alice B. Toklas*).[33]

11
Édouard Vuillard, *Coco Chanel*, 1921, graphite on paper, private collection.

Édouard Vuillard, *Jean Giraudoux*,
1926, pastel on board, private collec-
tion, C-S XI.254.

Vuillard's career culminated in recognition of the most official kind: he
became a member of the Institut de France in 1937, and in 1938 was given a huge retro-
spective at the Musée des Arts décoratifs. The reactions were not all positive, indeed far
from it; references to the artistic depletion and rigidity of an elderly painter were at
first hesitant, then more frequent. Claude Roger-Marx wrote of the 1938 exhibition: "A
respectful semi-silence was maintained by the critics: in general they seemed loth to dis-
cuss the work of the last fifteen years."[34] But the fact remains that Vuillard, an artist who
lived through the great switch from the nineteenth to the twentieth century, belonged
fully to both epochs. "His oeuvre is a chronicle of Paris life; it is the mirror of a civiliza-
tion,"[35] wrote his friend Waldemar George in 1938. To which Vuillard might well have
replied, in the words by Paul Valéry that he copied out so faithfully in his journal on
September 24, 1922: "But it is the indefinable circumstances, the secret encounters, the
facts visible to one person only, the others that are to that one person so familiar or com-
fortable he is unaware of them, that are the core of the work. One can easily discover
for oneself that these incessant, impalpable events are the concentrated matter of our
true character."[36]

The title of this essay is inspired by that of Antoine Compagnon's book *Proust entre deux siècles* (Paris: Le Seuil, 1989).

1. Maurice Denis, *Journal*, vol. 3 (1921–1943) (Paris: La Colombe, 1959), pp. 222–223.

2. Letter from Bonnard to Vuillard, late May or early June 1940, published in *Bonnard/Vuillard Correspondance*, ed. Antoine Terrasse (Paris: Gallimard, 2001), p. 105.

3. All the volumes that have come down to us are kept in the Bibliothèque de l'Institut, Paris.

4. Thadée Natanson, *Peints à leur tour* (Paris: Albin Michel, 1948), pp. 376–377.

5. On this question, and particularly on the literary aspects of Vuillard's journal, see Françoise Alexandre, "Édouard Vuillard. Carnets intimes. Édition critique," doctoral dissertation, Université de Paris 8, 1997–1998.

6. Jacques Salomon, *Vuillard, témoignage* (Paris: Albin Michel, 1945), pp. 33–34.

7. It seems there exist only two, not three, canvases of Mallarmé's house (priv. coll.; Musée d'Orsay). The other paintings said to be of the poet's house in fact depict the Natansons' house, La Grangette (information provided by Mathias Chivot). See Guy Cogeval and Antoine Salomon, *Vuillard: Critical Catalogue of Paintings and Pastels* (Paris: Wildenstein / Milan: Skira, 2003), no. VII.7.

8. Letter from Ambroise Vollard to Stéphane Mallarmé, September 14, 1897, published in Stéphane Mallarmé, *Correspondance : compléments et suppléments*, in *French Studies*, ed. Lloyd James Austin, vol. 6, no. 1 (1994), p. 53.

9. Handwritten postcard from Stéphane Mallarmé to Ambroise Vollard, September 15, 1897, Paris, Salomon Archives, published in Mallarmé, *Oeuvres complètes*, ed. Bertrand Marchal (Paris: Gallimard, "La Pléiade," 1998), p. 817.

10. Handwritten postcard from Félix Fénéon to Stéphane Mallarmé, October 23, 1895, Paris, Bibliothèque littéraire Jacques Doucet.

11. Handwritten postcard from Stéphane Mallarmé to Ambroise Vollard, May 12, 1898 (J.-P. Morel coll.), published in Mallarmé, *Oeuvres complètes* (see note 9), p. 819.

12. André Chastel, "Vuillard et Mallarmé," *La Nef*, vol. 4, no. 26 (January 1947), p. 19.

13. Ibid., p. 24.

14. Vuillard, *Journal*, II.7, fol. 50r; III.3, fol. 20v.

15. See Jean-Paul Monery, "Édouard Vuillard : de l'indicible au déscriptif," in Jean-Paul Monery and Jöra Zutter (eds.), *Édouard Vuillard. La porte entrebaîllée*, exhib. cat. (L'Annonciade, Musée de Saint-Tropez / Musée cantonal des Beaux-Arts de Lausanne / Milan: Skira, 2000), pp. 47–51; See also *Marcel Proust. L'écriture et les arts* (Paris: Bibliothèque nationale de France, 1999). Also worth noting is the poetic link between Proust and Vuillard suggested by Julien Gracq in *En lisant, en écrivant* (Paris: José Corti, 1980), p. 101.

16. Letter from Marcel Proust to Reynaldo Hahn, September 1 or 2, 1907, published in Marcel Proust, *Correspondance*, vol. 7 (1907), ed. Philip Kolb (Paris: Plon, 1981), p. 267.

17. Marcel Proust, *À l'ombre des jeunes filles en fleur*, this extract taken from *In Search of Lost Time*, vol. 2, *Within a Budding Grove* (1919), trans. C. K. Scott Moncrieff and Terence Kilmartin, rev. D. J. Enright (London: Chatto and Windus, 1992), p. 485.

18. Letter from Vuillard to M. E. Chernowitz, December 6, 1936, quoted in Maurice E. Chernowitz, *Proust and Painting* (New York: International University Press, 1945), p. 200. On the meeting between Proust and Vuillard see also Jean-Yves Tadié, *Marcel Proust*, vol. 2 (Paris: Gallimard, [1996] 1999), p. 37, note 2.

19. Annette Vaillant, *Le pain polka* (Paris: Mercure de France, 1974), p. 190.

20. Vuillard, *Journal*, II.

21. For a complete study of the building and its decoration, see *1913. Le Théâtre des Champs-Élysées*, exhib. cat. (Paris: Musée d'Orsay, Réunion des musées nationaux, 1987–1988).

22. Vuillard, *Journal*, II.6, fol. 31r.

23. See Gloria Groom, *Édouard Vuillard: Painter-Decorator. Patrons and Projects, 1892–1912* (New Haven and London: Yale University Press, 1993), pp. 203–204.

24. Quoted in Dominique Desanti, *Sacha Guitry. Cinquante ans de spectacle* (Paris: Grasset et Fasquelle, 1982), p. 140.

25. Vuillard, *Journal*, II.7, fol. 35v (June 5, 1914). "Claudel's L'Otage salle Malakoff. embarrassment, boredom torment." Vuillard met Claudel at a dinner at Madame Chausson's house on January 15, 1914, and recorded his own reaction: "embarrassment, distant, not happy with myself." He also saw *L'Échange* on January 22, 1914 at the Théâtre du Vieux-Colombier.

26. Ibid., II.5, fol. 12r; II.7, fol. 32v, 14v, 22r.

27. Vuillard and Cocteau met, or rather ran across each other, a number of times, but Vuillard does not seem to have taken to the writer's personality at all.

28. Vuillard, *Journal*, II.9, fol. 24v; III.1, fol. 33r.

29. Ibid, fol. 24v.

30. Ibid, fol. 40v.

31. Vuillard lunched with Paul Valéry on April 29, 1917 at the Fontaines, where he heard a reading of *La Jeune Parque*. Three letters from Valéry to Vuillard are held in the Salomon Archives. One of them was sent by the writer to the artist on the death of his mother in 1928.

32. Salomon (see note 6), p. 90.

33. This information kindly provided by Guy Cogeval.

34. Claude Roger-Marx, *Vuillard: His Life and Work* (New York: Éditions de la Maison Française, 1946), p. 42 (trans. slightly modified).

35. Waldemar George, "Vuillard et l'âge heureux." *L'Art vivant*, no. 221, May 1938, p. 35.

36. The passage comes from *Au sujet d'Adonis*, published in *Revue de Paris* (February 1, 1921) and in *Variété* (1924). Vuillard also read Valéry's *Charmes* in September 1922 while working on the Kapferer frieze. On September 22 he wrote: "afternoon drunk on Valéry's Charmes" (*Journal*, III.8, fol. 62v).

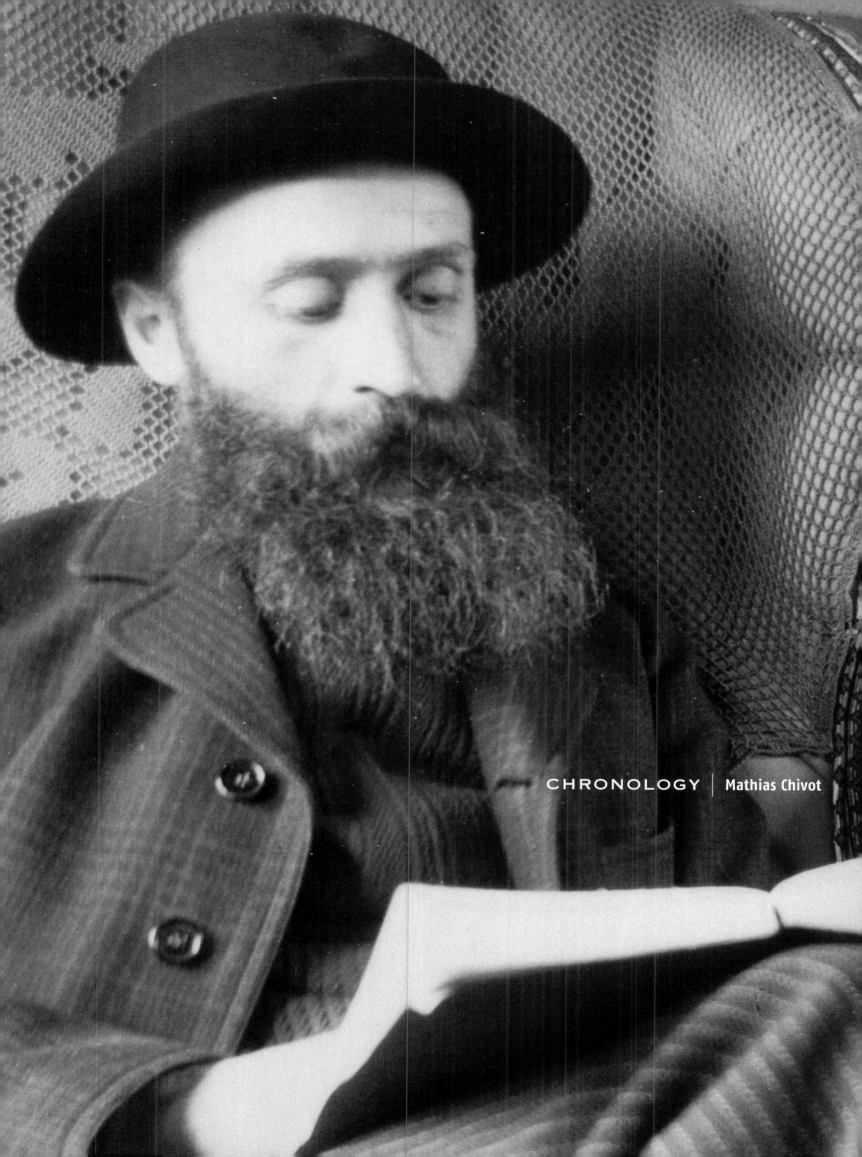

CHRONOLOGY | Mathias Chivot

### 1868

Édouard Vuillard is born on November 11 in Cuiseaux (Saône-et-Loire), the son of Honoré Vuillard, a retired captain of the Infanterie de la Marine employed as a tax inspector, and Marie Michaud, corset-maker. The youngest of three children, he has a sister, Marie (born in 1861), and a brother, Alexandre (born in 1863).

### 1877

Upon Honoré Vuillard's retirement, the family moves to Paris, where they share an apartment with Madame Vuillard's family, the Michauds, at 18, rue de Chabrol. Vuillard attends the Rocroy-Saint-Léon school, run by the Marist brothers, before being admitted in 1879 as a scholarship student to the Lycée Fontanes (which reverts to it earlier name, the Lycée Condorcet, in 1883).

### 1883

Upon the death of Madame Vuillard's father, the family moves to 20, rue Daunou, into the building that also houses Madame Vuillard's corsetry and dressmaking business.

### 1884

On April 19, Honoré Vuillard dies at the age of seventy-two. Édouard pursues his studies at the Lycée Condorcet, entering the final year—the "Rhétorique" class—in October. He takes his first drawing classes; he executes some powerful charcoals on large sheets of paper, which he marks *"rhétorique,"* in addition to making copies after Michelangelo and casts of classical statuary. He begins lasting friendships with Kerr-Xavier Roussel (who, just one year older, is in the same class), Maurice Denis and Aurélien Lugné-Poe.

### 1885

In October, the Vuillard family, together with Madame Vuillard's mother, move to 6, rue du Marché-Saint-Honoré. Vuillard leaves the Lycée Condorcet in November and, encouraged by his friend Roussel, becomes a student of Maillart in his studio on Place Fürsten-berg, formerly Delacroix's studio. In his "autobiographical notes" Vuillard gives a succinct summary of the latter part of this year: "November 1885 leave Condorcet / rue du Marché St Honoré / hang around the Louvre" (*Journal*, II.2, fol. 12r, November 11, 1908). Shunning the example of his father and brother, he rejects the idea of a military career.

### 1886

Vuillard takes courses at the Académie Julian, in the studios of Bouguereau and Robert-Fleury. With recommendations from them and from Gervex he applies to the École des Beaux-Arts, but fails the entrance exam in February and July.

### 1887

In February Vuillard fails the École des Beaux-Arts entrance exam for a third time, but on July 21 is finally accepted. Meanwhile, he attends Robert-Fleury's life classes. In October the family moves once again, this time to 10, rue de Miromesnil, where Vuillard begins to paint still lifes.

### 1888

In July, Vuillard is accepted for the second time into the "painting" section of the École des Beaux-Arts. In October, he joins the class of Gérôme: "88 spell at school, Gérôme 6 weeks" (*Journal*, II.2, fol. 12r, November 12, 1908). In November he begins keeping a journal. Aside from a break between 1898 and 1905, he will keep it regularly until 1940, recording his daily observations in a telegraphic style.

Meanwhile, Sérusier returns from Brittany with *The Talisman*, a work he executed under the instruction of Gauguin, and lays down the principles of Nabi painting. Denis, Bonnard, Ranson and Ibels become the first *Nebiim* (prophets).

### 1889

Vuillard executes his first masterpiece, a self-portrait with his friend Waroquy (cat. 1)—"portrait of Waroquy in grandmama's room" (*Journal*, II.2, fol. 12r). In addition to being re-admitted to the "painting" section of the École des Beaux-Arts, Vuillard has a work accepted for the Salon in May, a Conté crayon portrait of his grandmother Désirée Michaud. On leaving the École des Beaux-Arts at the end of the school year, he begins to frequent the Nabi circle. His "autobiographical notes" already mention his relationship with time and the importance of preserving memories: "begin to work from memory."

He performs his military service at Lisieux (Calvados), from November 9 to December 21.

### 1890

"90 the Sérusier year. Bonnard by Denis" (*Journal*, I.2, fol. 12v). Vuillard begins to attend meetings of the Nabi group, held in the cafés on Passage Brady or in Ranson's studio.

In January, he converts the attic of 10, rue de Miromesnil into a studio.

During the summer, Lugné-Poe introduces him to the actor Coquelin Cadet, who will be his first patron (see the watercolours begun this same year, cats. 45–48). He also meets the dramatist and inventor Rodolphe Darzens, for whom he makes several poster designs. In *Art et critique*, Denis publishes an article entitled "Définition du néo-traditionnisme," which lays the theoretical foundations of avant-gardism.

In the fall, Vuillard attends a presentation of *L'Enfant prodigue*, a pantomime by Carré and Wormser in which Félicia Mallet plays the lead role. The artist uses this subject as the basis for a series of inspired watercolours and washes, as well as for various poster designs (cats. 50–52).

### 1891

Vuillard has his first exhibitions and becomes involved in the avant-garde theatre (Ibsen, Maeterlinck, Roinart).

In April, he begins sharing a studio at 28, rue Pigalle with Bonnard, Lugné-Poe and the theatre critic Georges Roussel.

He makes his first foray into Symbolist theatre by painting the sets for *L'Intruse*, presented by Paul Fort's Théâtre d'Art troupe at the Vaudeville on May 20 and 21. He also does sets for Maeterlinck's *Les Aveugles* and Retté's *Berthe au grand pié*.

From August 1 to September 30, Vuillard takes part in the Nabi group's first exhibition, at the Château de Saint-Germaine-en-Laye, where he exhibits *The Intruder* (cat. 57), *The Flowered Dress* (cat. 79) and two pastels, one a landscape and the other representing a person in profile. The first critical responses to his work appear (Lugné-Poe in *Art et critique*, Fénéon in *Le Chat noir*, Georges Roussel in *La Plume* and Gustave Geffroy in the *Journal des artistes*). Only Fénéon remains lukewarm: "…the young woman's gleaming neck [*The Flowered Dress*], the slickly-applied neck of a Salon painter. Still-indecisive works where one finds fashionable technique, literary gloom, sometimes a fine, tender harmony" (F. Fénéon, *Le Chat noir*, September 19, 1891).

In October, Vuillard leaves Rue Miromesnil with his mother and sister and moves to 346, rue Saint-Honoré. At the same time, he decides to take a studio by himself a few doors away from the first one, at 24, rue Pigalle.

Pierre Veber introduces Vuillard to the Natanson brothers, including Thadée, founder of *La Revue blanche*, who makes the journal's office space available for Vuillard's first one-man exhibition. This year of many exhibitions closes in December with the presentation of works by the *Peintres impressionnistes et symbolistes* at the Barc de Bouteville gallery, on Rue Le Peletier.

### 1892

Vuillard does the sets for a Ranson adaptation of *La Farce du Pâté et de la Tarte*, which is presented at the residence of State Councillor Coulon, on Rue de la Faisanderie, one of a number of avant-garde theatre performances.

Vuillard executes his first decorative cycle, for Monsieur and Madame Paul Desmarais, who, along with the Natansons, the Schopfers and Dr. Vaquez, are among Vuillard's chief patrons prior to 1900. The six overdoors (cats. 103–108) are completed on January 20, 1893.

From November 7 to December 2, Vuillard travels to Belgium, Holland and then London with his friend Kerr-Xavier Roussel, who is keen to leave Paris and so extricate himself from an amorous adventure with a servant: "Kerr and Caro. Trip to Belgium, Holland and London" (*Journal*, "autobiographical notes," II.2, fol. 12v).

In November, Vuillard exhibits five paintings and two graphic works—including *Seamstress with Scraps* (cat. 81), *In the Lamplight* (cat. 84) and *Sleep* (C-S II.124)—at the third Barc de Bouteville exhibition.

In December, the Desmarais accept his proposal for a screen (C-S v.32-1 to 5).

### 1893

Vuillard's Grandmother Michaud, one of his three "muses," dies on January 9. The artist finishes the Desmarais screen by the end of the month.

The period from April to July is punctuated by weddings: Thadée Natanson and Misia Godebska, Maurice Denis and Marthe Meurier, and, finally, Kerr-Xavier Roussel and the artist's sister, Marie. Vuillard records the latter event in several works, a nuptial cycle that includes *The Suitor* (cat. 89), *The Bridal Chamber* (cat. 90) and *The Chat* (cat. 92).

Vuillard continues to be actively involved in the avant-garde theatre: in October he becomes a founding member of Lugné-Poe's Théâtre de l'Oeuvre, designing programs and sets for Ibsen's *Rosmersholm* (cat. 66) in October and *Un Ennemi du peuple* (cat. 67) in November, and for Hauptmann's *Âmes solitaires* (cat. 68) in December.

Meanwhile, he takes part in the *Portraits du vingtième siècle* exhibition at the Barc de Bouteville, where he presents his portrait of *Lugné-Poe* (cat. 37), and, in October and November, in the fifth *Exposition des peintres impressionnistes et symbolistes*, where he shows eleven paintings.

In October his friendship with Misia and Thadée Natanson deepens.

### 1894

In January, Vuillard receives a commission to do a decorative cycle for Alexandre Natanson's dining room; the nine panels and two overdoors of *The Public Gardens* (cats. 111–118) will be executed from August to September and installed at the Natanson residence in December.

During the winter and spring, Vuillard does programs and sets for the Théâtre de l'Oeuvre (*Au-dessus des forces humaines*, cat. 69, *Une nuit d'aveil à Céas L'Image*, cat. 71, *Solness le constructeur*, cat. 72, and *La Gardienne*, cat. 74, among others). Ibels introduces Siegfried Bing to the Nabi group; Bing proposes a commission for stained-glass windows to be executed by Tiffany. Vuillard completes the cartoon for his window (*The Chestnut Trees*, cat. 125) and, in April 1895, the window is presented alongside those of his colleagues at the annual exhibition of the Société nationale des Beaux-Arts.

From May 20 to June 30 Vuillard takes part in the Nabi exhibition in the Paris offices of *La Dépêche de Toulouse*, along with Bonnard, Denis, Ibels, Ranson, Roussel, Sérusier and Vallotton.

On December 13, Marie Roussel delivers a stillborn child after several weeks of suffering: "Marie's horrible delivery." The Roussel couple's relationship deteriorates.

### 1895

Vuillard meets Jos and Lucy Hessel for the first time. According to Segard, they are introduced by Vallotton.

Between May and September, Vuillard designs a porcelain table service for Jean Schopfer, a critic and patron (see cats. 131–136).

The tribulations of the Roussel couple continue: "complications in the Roussel household." Kerr-Xavier Roussel, who is having an affair with France Ranson's sister, Germaine

Rousseau, leaves Marie in July. The scandal continues to reverberate within the Nabi group until the couple is reunited in late November or early December, at which time they move to 15, place Dauphine.

On December 26, Siegfried Bing inaugurates the Maison de l'Art nouveau with an exhibition in which Vuillard shows three masterpieces of decorative art: the Thadée Natanson panels, also known as *The Album* (cats. 126–129), the table service for Schopfer and the cartoon for the Tiffany stained-glass window, *The Chestnut Trees*.

The Natansons introduce Vuillard to Mallarmé.

### 1896

In January, Vuillard and his mother leave 346, rue Saint-Honoré and move into a smaller apartment at number 342 on the same street. Vuillard executes *The Tuileries Gardens*, the first lithograph in the *Landscapes and Interiors* series, for Vollard.

He designs a number of theatre programs, including one for Ibsen's *Les Soutiens de la société* (cat. 73).

In July Vuillard is invited for the first time to La Grangette, the country home of Misia and Thadée Natanson in Valvins. He makes a second visit there between October and December. During the summer, Dr. Henry Vaquez commissions him to do four panels that will come to represent one of the high points of his career (cats. 137–140). He rents a studio at 7, rue Drouot.

On November 6, the Roussel couple's second child, "Petit-Jean," born on August 26, dies.

On December 10, the Théâtre de l'Oeuvre presents Alfred Jarry's *Ubu roi*, with sets by Vuillard, Bonnard, Sérusier and Toulouse-Lautrec.

### 1897

In January, Vuillard collaborates with his colleagues Ranson and Sérusier on Bjørnson's play, *Au-delà des forces humaines*.

From April 6 to 30, Vuillard shows twelve paintings, including *Large Interior with Six Figures* (cat. 143), in the Nabi exhibition held at Ambroise Vollard's gallery.

He spends the months of July, August and October at Les Relais, the new country house of Thadée and Misia Natanson at Villeneuve-sur-Yonne. His first photographs, taken with a recently acquired Kodak, date from this period.

Upon his return to Paris in November, he moves with his mother to 56, rue des Batignolles.

### 1898

Two of Vuillard's patrons commission him to do major works: *Woman Reading on a Bench* and *Woman Seated in a Chair* (C-S VI.99-I and 2), for Jean Schopfer, and *Figures in an Interior*, a screen for Stéphane Natanson, Thadée's cousin (cat. 141).

In January, Vuillard collaborates with his friends Bonnard, Roussel and Ranson on the decoration of the auditorium of the Théâtre des Pantins; Natanson assures his readers

that even if they are not certain of having a good time, they must "go anyway, to see the decorations by Bonnard, Vuillard, Roussel and Ranson, but especially those by Bonnard and Vuillard" ("Petite Gazette de l'art," *La Revue blanche*, February 1, 1898).

In July Vuillard again spends his vacation at Les Relais and, in August, continues working on the album of lithographs for Vollard.

Annette, daughter of Marie and Kerr-Xavier Roussel, is born on November 30 at Levallois.

### 1899

Vuillard travels to London with Bonnard.

In February, the Vollard album, *Landscapes and Interiors*, is exhibited at the Galerie Vollard.

In March, Vuillard moves again with his mother, to 28, rue Truffaut.

In April, he travels with Bonnard and Roussel to Milan and Venice (see photos, cats. 187–188).

During the summer he paints *The First Fruits* (C-S VII.63) and *The Window overlooking the Woods* (cat. 142), two decorative panels intended for the *hôtel particulier* of Adam Natanson, father of the Natanson brothers, at 85, rue Jouffroy; these two panels confirm the artist's new, freer approach to space.

### 1900

In April, Vuillard sends eleven paintings to the Nabi group's first exhibition at the Galerie Bernheim-Jeune.

During the spring and summer, he visits his sister and brother-in-law, the Roussels, at L'Étang-la-Ville. This lengthy stay coincides with a renewed interest in landscape painting. In July, Vuillard finishes *Promenade in the Vineyard* (cat. 151), part of a decorative cycle for Jack Aghion to which Bonnard, Denis and Roussel also contribute.

From late August to September, Vuillard stays with the Vallottons in Switzerland, at the Château de La Naz, in the company of the Hessels. Lucy Hessel becomes part of Vuillard's life; she will continue to figure in the artist's paintings until his death.

### 1901

On February 6, Marie gives birth to Jacques Roussel.

From February 21 to March 5, Vuillard travels through Spain with Bonnard and the Bibesco brothers (see photos, cats. 189–191).

In March, he takes part in the exhibition organized by La Libre Esthétique, in Brussels, to which he sends four paintings.

From April to May, he exhibits for the first time at the Salon des Indépendants.

In July, Vuillard pays a visit to the respected Odilon Redon at Saint-Georges-de-Didonne (see photo, cat. 186). He then rejoins the Hessels for his first *villégiature* in Vasouy, Normandy.

In late September he is in Vienna, and he later joins Misia in Rheinfelden.

### 1902

On April 15, Vuillard rents a studio at 223bis, rue du Faubourg-Saint-Honoré.

Between March and May, he again takes part in the Salon des Indépendants, exhibiting eight paintings, and in the second exhibition of the Nabi group at the Galerie Bernheim-Jeune, to which he sends thirteen paintings.

During the summer he rents Les Myosotis, in Villerville, with his mother and the Roussels. Later, he makes a brief trip to Holland with Kerr-Xavier Roussel and the Hessels.

### 1903

In January and February, Vuillard travels with Misia and Thadée Natanson to Vienna to visit the 16th Viennese Secession, which is showing seven of his paintings. *The Salon with Three Lamps* (cat. 156) is shown at the Berlin Secession.

In July, he divides his time between London, where he visits Alfred Sutro, and Vasouy, where he stays with the Hessels at La Terrasse. He captures the indolent atmosphere of this holiday in a series of paintings.

In December, the French state makes a first purchase of his work: *Luncheon* (C-S VII.162).

### 1904

In February and March, Vuillard sends nine paintings to La Libre Esthétique in Brussels, and also shows at the Indépendants.

He paints a series of portraits of Arthur Fontaine and his family in their apartment at 2, avenue de Villars. The Fontaines, along with the Gangnats, the Hessels, the Bernheims and others, make up Vuillard's new circle of patrons and friends, the majority of whom belong to the upper strata of the political, business and banking bourgeoisie.

In October, Vuillard and his mother move into a larger apartment at 123, rue de la Tour, in Passy. This is the first time Vuillard has left the "Carré Saint-Honoré."

From mid-October to mid-November he takes part in the second Salon d'Automne, which devotes a whole room to his work. The critics, led by Mauclair, Marx and Vauxcelles, are enthusiastic.

### 1905

This is the first Amfreville year: between 1905 and 1907 Vuillard will portray a number of scenes from daily life there, either with his Kodak or in an abundance of sketches and oils.

At the third Salon d'Automne, in October and November (the "den of wild beasts"), his decorative cycles from before 1900—*The Vaquez Panels* (cats. 137–140) and *The Terrace at Vasouy* (cats. 263–264)—are shown publicly for the first time.

### 1906

Vuillard continues to take part in numerous exhibitions: in March–April, he sends three paintings to the Indépendants; the Bernheim brothers give him his first solo exhibition; in the spring he sends seven decorative panels, including the panels known as *The Album*, made for Thadée Natanson (cats. 126–129 and C-S V.96-2), to the 11th Berlin Secession.

He spends the summer with the Hessels at Château-Rouge in Amfreville.

### 1907

In the fall Vuillard rents a studio at 112, boulevard Malesherbes, which he will keep until 1933.

After executing *Tennis* (C-S VIII.235) for Alexandre and Olga Natanson, he receives a commission from Emmanuel Bibesco for two decorative panels, *The Alley* (C-S VIII.226) and *The Haystack* (cat. 266), which recreate the atmosphere of afternoons in Amfreville.

### 1908

In February, Vuillard makes a short trip to London with Bonnard and Alfred Edwards. He returns to England in April with the Hessels, then goes on to Scotland where he joins the "Alfreds" (Natanson), Romain Coolus, and Marcelle and Sam Aron. Upon his return, he works on the panels titled *Paris Streets* (C-S VII.515-1 to 4).

In July, he moves with his mother to 26, rue de Calais, near Place Clichy. The building, where they will live for close to twenty years, overlooks Place Vintimille, which will become the subject of numerous works.

Vuillard spends the summer, from July 16 to September 18, with the Hessels at Le Pouliguen, in Brittany.

On October 5, the Académie Ranson is established. Among its teachers are Vuillard, Bonnard, Roussel, Vallotton, Denis and Maillol.

### 1909

The summer is spent in Brittany at the Hessels' villa, Les Écluses, in Saint-Jacut de la Mer.

In November, Vuillard begins work on a cycle of decorative panels featuring *Place Vintimille* for Henry Bernstein (see cats. 269–270), to accompany the *Paris Streets* group, which the patron has recently acquired. The artist will deliver the four panels in March 1910.

On December 3, he and Bonnard visit Claude Monet at Giverny.

### 1910

Vuillard spends his summer at Criquebœuf in Normandy: he undertakes a series of large distemper panels, including *The Garden Gate* (C-S VIII.365), *Sunny Morning* (C-S IX.155), *Before the Door* (cat. 273) and *Annette on the Beach at Villerville* (cat. 265).

Marguerite Chapin, the future Princess Bassiano, becomes part of Vuillard's circle; he paints her with her dog in about April (C-S IX.162), and in November at her request begins working on the large decorative piece *The Library* (C-S IX.164). He executes his first distemper portrait, *Marcelle Aron* (C-S VIII.369).

### 1911

Vuillard exhibits at Bernheim-Jeune in February, June and July.

Between May and June, he executes a five-panel screen for Marguerite Chapin (cat. 271) and in the summer receives a commission from Gaston and Josse Bernheim for a decoration for their villa, Bois-Lurette (see cats. 274–275). On September 10 he installs the first panels, *At Les Pavillons, Criquebœuf* (C-S IX.159.1-5).

### 1912

New patrons from the Hessels' circle flock to have their portraits done by the master. They include Madame Jean Trarieux, Théodore Duret (cat. 304), René Blum, and Henry and Marcel Kapferer (cat. 305). At the same time, Vuillard undertakes the first sketches for *The Surgeons* (cat. 306), one of his masterpieces.

In May, Vuillard receives a commission to decorate the foyer of the Théâtre des Champs-Élysées with seven panels and three overdoors.

In July, he delivers the second group of panels for Bois-Lurette—*The Veranda at Le Coadigou in Loctudy* (cat. 274 and C-S IX.159. 7-8)—to the Bernheim brothers.

Despite his acceptance into the bourgeoisie of the Third Republic, in October Vuillard, along with Bonnard and Roussel, refuses the Légion d'Honneur: "I seek no other reward for my efforts than the esteem of people of taste." (*Le Temps*, "Trois artistes refusent le ruban rouge," October 26, 1912.)

### 1913

From June 9 to 30, Vuillard and Bonnard visit Hamburg on the invitation of Alfred Licht-wark, director of the Hamburger Kunsthalle. Vuillard receives commissions for a portrait of Senator Roscher (C-S IX.227) and for three views of the River Alster (C-S VIII.418, 420 and 421) for the Kunsthalle.

In July he begins painting the last five decorative panels for the interior of Bois-Lurette (C-S IX.159.9-13 and cat. 275).

In October, he moves with Madame Vuillard from the fourth to the second floor of 26, rue de Calais.

### 1914

In January, Vuillard meets Lucie (Ralph) Belin, who becomes his model. She also becomes, after Misia Natanson and Lucy Hessel, one of the three loves of his life. Their idyll will last throughout the war. Numerous photographs, sketches and paintings, such as *Lucie Belin Smiling* (cat. 307), attest to their relationship.

In August, after France declares war on Germany, Vuillard returns to Paris from the country; he is mobilized as a railway patrolman at Conflans-Sainte-Honorine.

### 1915

Visiting the Roussel family during their prolonged stay in Switzerland, Vuillard meets Dr. Henri-Auguste Widmer, who makes his first visit to the artist's Paris studio on November 30. He will collect the artist's work throughout the 1920s and 1930s.

On December 21, Vuillard meets Isadora Duncan: "go to Isadora Duncan's received with great coquetry, long idle chats ending with me kissing her" (*Journal*, II.9, fol. 19r).

### 1916

Émile Lévy, who had commissioned Vuillard to decorate his office at the Éclairage Électrique firm, dies unexpectedly.

In March, Vuillard visits the arms factory at Oullins near Lyon, which is run by Thadée Natanson.

### 1917

From February 3 to 22, Vuillard serves as official war artist to the troops in the region of Gérardmer (Vosges). It is there that he executes a series of pastels imbued with a muted, snowy atmosphere. He begins work on *Interrogation of the Prisoner* (cat. 282).

Over the course of the year he executes three major works: two panels entitled *The War Factory* (C-S X.32-1 and 2) for the office of Lazare Lévy, *The Laroche Door Panels* (C-S X.125-1 to 3, completed in February 1918) and *The Chapel of the Château of Versailles* (cat. 283).

In August, Francis Jourdain commissions him to decorate Le Grand Teddy, a fashionable café.

### 1919

In May, Vuillard meets Juliette Weil, wife of Dr. Prosper-Émile Weil (cat. 316); she is to become one of the artist's closest friends, and will remain so until his death.

During the war years, major figures of the Paris bourgeoisie have continued to appear in Vuillard's order book: Georges Viau, Madame Frantz Jourdain, wife of the celebrated architect and designer (1914), Dr. Vaquez (1915), Madame Kapferer, Jacques Laroche, the Gossets, Princess Bibesco and Yvonne Printemps (1919).

### 1921 – 1922

Camille Bauer asks Vuillard to do two decorative panels for his residence in Basel. In May 1921, Vuillard delivers *The Salle La Caze* (cat. 287) and *The Salle des Cariatides* (cat. 288), which he complements during the spring of 1922 with a second pair, *The Salle Clarac* and *The Medieval Gallery at the Musée des Arts décoratifs* (cat. 286). The entire cycle—including the two overdoors (cats. 284–285)—is completed by July 1922.

From 1917 to 1924, Vuillard divides his summers between Le Clos Cézanne, the Hessel residence, and the Closerie des Genêts, rented by his mother at Vaucresson, where he paints a group of spatially loose works, radiant with light.

Vuillard is still keenly interested in theatre—henceforth boulevard theatre. In March 1922, Sacha Guitry's new play, *The Illusionist*, inspires him to do two panels with the same name (see cat. 317).

### 1923

Aside from the other projects undertaken during this year—*Madame Vuillard at the Closerie des Genêts* (Musée des Beaux-Arts de Lyon, C-S XI.31), *Self-portrait in the Dressing-Room Mirror* (cat. 289)—Vuillard will, from August to November, sketch out his initial ideas for what will become the "Anabaptists," a series of portraits of Roussel, Bonnard, Maillol and Denis (see cats. 291–292). He will continue to work on this series until 1937.

### 1925

Vuillard works on the portrait of Misia Sert and her niece, Mimi, in sessions that take the form of rather sour reunions. He also undertakes a series of in situ portraits of Gabrielle Jonas and her daughter Irène Montanet, in flashy interiors done in kitsch colours (e.g. C-S XI.234). This approach, which critics see as the height of "bad taste," is also found in the portrait of Germaine Tartière (1926, C-S XI.247) and in the two versions of the portrait of the *Countess Anna de Noailles* (1931, see cat. 322).

Vallotton dies on December 29, and Vuillard is much affected by this loss.

### 1927

Vuillard continues to do portraits of the Parisian elite (*Madame Jean Bloch and Her Children*, C-S XI.259, *Madame Lyon and Her Children*, C-S XI.265, *Fridette Faton and the Bonze*, C-S XI.268) and cosmopolitan society (he begins work on the portrait of Dr. Widmer, C-S XI.253).

On August 15 his brother, Alexandre, dies. Two weeks later, Vuillard and his mother move to 6, place Vintimille.

### 1928

Madame Vuillard dies in December, while Vuillard is working on the portrait of the daughter of Jeanne Lanvin, Countess de Polignac (cat. 320).

### 1929

From March 26 to April 13, Vuillard travels by car through Spain with Coolus and the Hessel and Laroche families. After spending July at Jean Laroche's home in Pont-l'Évêque, he travels to Holland with the Hessels and the Laroches.

### 1930 – 1936

Vuillard divides his time between Paris, the Château des Clayes—owned by the Hessels since 1925—and several trips abroad (London in March 1932, Italy in September 1934, Switzerland in August 1936). Death strikes some of his closest friends: Jean Schopfer in January 1931; Jean-Louis Forain on July 13, 1932, Alfred Natanson in August; Jacques Laroche in August 1935; Alexandre Natanson in March 1936, Dr. Vaquez in April.

In June 1936, Vuillard takes part in a retrospective exhibition entitled *Peintres de la Revue blanche* at Bolette Natanson's gallery, Les Cadres.

In July, Vuillard works on his panel for the Chaillot palace, *Comedy* (c-s xii.134), commissioned by the French state. In August, the City of Paris buys his sketches and the four canvases in the "Anabaptists" series.

### 1937

Vuillard accepts the League of Nations' commission to decorate its headquarters, in Geneva; he executes his most monumental work, *Peace, Protector of the Muses* (c-s xii.142; see cats. 294–296), a tribute to the great tradition of French painting.

### 1938

In January, Jos Hessel introduces Vuillard to Sam Salz, the famous New York dealer, who ensures a place for Vuillard's work in the great American collections, and whose portrait the artist will execute in 1939.

On February 5, Vuillard is elected to the Académie des Beaux-Arts.

From May to July the Musée des Arts décoratifs devotes a major retrospective to Vuillard's fifty-year career.

Between August 15 and September 5, Vuillard goes to Geneva to oversee the installation of *Peace, Protector of the Muses*; he puts the finishing touches on the work and signs it.

### 1940

Vuillard executes his final two portraits (*Alfred Daber and His Daughter*, c-s xii.161, *Madame Wertheimer*, c-s xii.162) and, suffering from pulmonary edema, leaves Paris for La Sarthe with Daber on June 10. On June 16, he joins the Hessels, who are staying at the Hôtel Castel Marie-Louise in La Baule.

On June 21, at the Castel Marie-Louise, Vuillard dies.

EXHIBITIONS AND SOURCES CITED

## EXHIBITIONS

### 1891
Saint-Germain-en-Laye, Château national, August 1–September 30.

### 1892
Paris, Le Barc de Bouteville, *Troisième exposition des peintres impressionnistes et symbolistes*, November.

### 1893
Paris, Le Barc de Bouteville, *Quatrième exposition des peintres impressionnistes et symbolistes*, April–May.

Paris, Le Barc de Bouteville, *Portraits du vingtième siècle*, July–September.

Paris, Le Barc de Bouteville, *Cinquième exposition des peintres impressionnistes et symbolistes*, October–November.

### 1895–1896
Paris, Maison de l'Art Nouveau (Siegfried Bing), *Salon de l'Art Nouveau*, December 26–January.

### 1897
Paris, Vollard, *Les Dix. Exposition des œuvres de MM. P. Bonnard, M. Denis, Ibels, G. Lacombe, Ranson, Rasetti, Roussel, P. Sérusier, Vallotton, Vuillard*, April 6–30.

### 1898
Paris, Vollard, *Expositions des œuvres de MM. P. Bonnard, M. Denis, Ibels, Ranson, X. Roussel, Sérusier, Vallotton, Vuillard*, March 27–April 20.

### 1899
Paris, Durand-Ruel, *Les Symbolistes et les Néo-impressionnistes. Exposition* [Bonnard, Denis, Hermann-Paul, Ibels, Ranson, Redon, Roussel, Sérusier, Vallotton, Vuillard], March 10–31.

### 1900
Paris, Bernheim-Jeune, *Oeuvres de Bonnard, Maurice Denis, Ibels, Aristide Maillol, Hermann-Paul, Ranson, Roussel, Sérusier, Vallotton, Vuillard*, April 2–22.

### 1901
Brussels, *La Libre Esthétique, Huitième exposition de La Libre Esthétique*, March 1–31.

Paris, Grandes Serres de l'Exposition universelle, *Artistes indépendants*, 17th exhibition, April 20–May 21.

### 1903
Berlin, Secession.VII, spring.

### 1905
London, New Gallery, *Fifth Exhibition of the International Society of Sculptors, Painters, and Gravers*, January–February.

Paris, Grand Palais, Salon d'Automne, 3rd exhibition, October 18–November 25.

### 1906
Berlin, Secession.XI, spring.

Paris, Bernheim-Jeune, *Vuillard*, May 19–June 2.

Paris, Grand Palais, Salon d'Automne, 4th exhibition, October 6–November 15.

### 1908
Munich, Secession, May 15–end of October.

Paris, Bernheim-Jeune, *Vuillard. Panneaux décoratifs, pastels, portraits, peintures à l'huile*, February 17–29.

Paris, Bernheim-Jeune, *Vuillard*, November 11–24.

### 1910
Brussels, La Libre Esthétique, *L'Évolution du paysage*, March 12–April 17.

### 1911
Munich, *Secession*, May 16-end of October.

### 1912
Paris, Bernheim-Jeune, *Édouard Vuillard*, April 15–27.

### 1913
Paris, Bernheim-Jeune, Vuillard. *Oeuvres récentes*, December 15–30.

### 1916
New York, Knoedler, *Paintings by Contemporary French Artists*, January 5–29.

### 1920
Glasgow, McLellan, *French Pictures at the McLellan Galleries*, January.

Paris, Musée des Arts décoratifs, *Le Musée de la Guerre*, September 15–October 15.

### 1922
Leipzig, Stadtgeschichtliches Museum, *Moderne Kunst aus Privatbesitz*.

### 1924
Paris, Hôtel de la Curiosité et des Beaux-Arts, *Première exposition de collectionneurs (au profit de la Société des Amis du Luxembourg)*, March 10–April 10.

### 1930
New York, Museum of Modern Art, *Paintings in Paris from American Collections*, January 19–February 16.

New York, Jacques Seligmann, *Paintings by Bonnard, Vuillard, Roussel*, October 6–25.

### 1932
Zurich, Kunsthaus, *Pierre Bonnard, Édouard Vuillard*, May 29–July 3.

### 1934
London, Arthur Tooth & Sons, *Paintings and Pastels by É. Vuillard*, June 7–30.

### 1936
Paris, Les Cadres (Bolette Natanson), *Peintres de la Revue blanche*, June 12–30.

### 1937
Paris, Musée des Arts décoratifs, *Le Décor de la vie de 1900 à 1925*.

Paris, Petit Palais, *Les Maîtres de l'art indépendant, 1895–1937*, June–October.

### 1938
Paris, Musée des Arts décoratifs, *É. Vuillard*, May–July.

### 1938–1939
Chicago, Art Institute, *Loan Exhibition of Paintings and Prints by Pierre Bonnard and Édouard Vuillard*, December 15–January 15.

### 1939
Washington, Phillips Memorial Gallery (Phillips Collection), *Vuillard*, January 22–February 22.

### 1941–1942
Paris, Orangerie des Tuileries, *Donations Vuillard*, November–February.

### 1943
Paris, Parvillée, *L'École de Pont-Aven et les Nabis, 1888–1908*, May 11–June 11.

**1945**

London, Lefevre, *School of Paris (Picasso and His Contemporaries)*, May–June.

**1946**

Berne, Kunsthalle, *Édouard Vuillard, Alexander Müllegg*, June 22–July 28.

Brussels, Palais des Beaux-Arts, *Vuillard (1868–1940)*, October.

**1948**

Edinburgh, Royal Scottish Academy (Arts Council of Great Britain), *Pierre Bonnard & Édouard Vuillard*, August 17–September 18.

London, Wildenstein, *Édouard Vuillard*, June.

Paris, Charpentier, *Vuillard*, October 8–December 5.

**1948–1949**

Paris, Charpentier, *Danse et Divertissements*, December 15–March 15.

**1949**

Basel, Kunsthalle, *Édouard Vuillard (1868–1940), Charles Hug*, March 26–May 1.

**1953**

London, O'Hana, *Coronation Exhibition*, June 10–July 31.

Paris, Bernheim-Jeune, *Vuillard*, May 15–June 30.

**1954**

Cleveland, Cleveland Museum of Art, *Édouard Vuillard*, January 26–March 14; New York, Museum of Modern Art, April 7–June 6.

London, Wildenstein, *Paris in the Nineties*, May 12–June 23.

Vevey, Musée Jenisch, *Paris 1900*, July 17–September 26.

**1955**

New York, Museum of Modern Art, *Paintings from Private Collections*, May 31–September 5.

Paris, Musée national d'art moderne, *Bonnard, Vuillard et les Nabis (1888–1903)*, June 8–October 2.

**1956**

Paris, Huguette Berès, *Vuillard le lithographe. Pastels, gouaches, dessins*, April 20–May 15.

**1957**

Zurich, Kunsthaus, *Sammlung Raguar Moltzau, Oslo*, February 9–March 31.

**1958**

Zurich, Kunsthaus, *Sammlung Emil G. Bührle*, June 7–end of September.

**1958–1959**

Munich, Haus der Kunst, *Sammlung Emil Georg Bührle, Zürich*, December 5–February 15.

**1959**

Milan, Palazzo Reale, *Édouard Vuillard*, October–November.

**1960**

Albi, Musée Toulouse-Lautrec, *Hommage à É. Vuillard*, July 11–September 25.

London, Lefevre, *XIX and XX Century French Paintings*, February–March.

**1960–1961**

Paris, Musée national d'art moderne, *Les Sources du XXᵉ siècle. Les Arts en Europe de 1884 à 1914*, November 4–January 23.

**1962**

Minneapolis, Institute of Arts, *The Nabis and their Circle*, November 14–December 30.

**1962–1963**

Brooklyn, Brooklyn Museum, *The Louis E. Stern Collection*.

**1963–1964**

Mannheim, Kunsthalle, *Die Nabis und ihre Freunde*, October 23–January 6.

**1964**

Hamburg, Kunstverein, *Vuillard. Gemälde, Pastelle, Aquarelle, Zeichnungen, Druckgraphik*, June 6–July 26; Frankfurt am Main, Kunstverein, August 1–September 6; Zurich, Kunsthaus, September 17–October 25.

New York, Wildenstein, *Vuillard*, October 16–November 21.

Washington, Corcoran Gallery of Art, *Modern Paintings and Sculpture in Washington Collections*, April 30–May 24.

**1966**

Washington, National Gallery of Art, *French Paintings from the Collection of Mr. and Mrs. Paul Mellon and Mrs. Mellon Bruce*, March 18–May 1.

**1968**

Munich, Haus der Kunst, *Édouard Vuillard, K-X. Roussel*, March 16–May 12.

Paris, Orangerie des Tuileries, *Édouard Vuillard, K.-X. Roussel*, May 28–September 16.

**1971–1972**

Toronto, Art Gallery of Ontario, *Édouard Vuillard, 1868–1940*, September 11–October 24, 1971; San Francisco, California Palace of the Legion of Honor, November 18–January 2; Chicago, Art Institute, January 29–March 12.

**1972**

Indianapolis, Museum of Art, *New Treasures: A Six-Year Retrospective*, October 19–December 10.

Munich, Haus der Kunst, *Weltkulturen und Moderne Kunst. Die Begegnung der Europäischen Kunst und Musik im 19. und 20. Jahrhundert mit Asien, Afrika, Ozeanien, Afro- und Indo-Amerika*, June 16–September 30.

**1975**

Brussels, Musées Royaux des Beaux-Arts de Belgique, *Bonnard, Vuillard, Roussel*, September 26–November 30.

**1976**

Indianapolis, Museum of Art, *Caroline Marmon, Fesler Collection*.

**1977–1978**

Japan, *Vuillard*, travelling exhibition.

**1978**

Washington, National Gallery of Art, *Small French Paintings from the Bequest of Ailsa Mellon Bruce*, June.

**1979–1980**

London, Royal Academy of Arts, *Post-Impressionism: Cross-Currents in European Painting*, November 17–March 16.

**1980**

Washington, National Gallery of Art, *Post-Impressionism: Cross-Currents in European and American Painting 1880–1906*, May 25–September 1.

**1982–1983**

Saint-Germain-en-Laye, Musée départemental Maurice Denis "Le Prieuré," *L'Éclatement de l'impressionnisme*, October 11–January 16.

**1984–1985**

Washington, National Gallery of Art, *The Folding Image: Screens by Western Artists of the Nineteenth and Twentieth Centuries*, March 4–September 3; New Haven, Yale University Art Gallery, October 11–January 6.

**1985–1986**

New Brunswick, N.J., Jane Voorhees Zimmerli Art Museum, The State University of New Jersey, *The Circle of Toulouse-Lautrec: An Exhibition of the Work of the Artist and of His Close Associates*, November 17–February 2.

Washington, Hirshhorn Museum and Sculpture Garden, Smithsonian Institution, *Selections from the Collection of Marion and Gustave Ring*, October 17–January 12.

**1987**

London, Thomas Gibson Fine Art, *19th & 20th Century Masters and Selected Old Masters*, June–July.

**1989–1990**

Houston, Museum of Fine Arts, *The Intimate Interiors of Édouard Vuillard*, November 18–January 29; Washington, Phillips Collection, February 17–April 29; Brooklyn, Brooklyn Museum, May 18–July 30.

**1990–1991**

E. G. Bührle Collection, *The Passionate Eye: Impressionist and Other Master Paintings from the Collection of Emil G. Bührle*, Zurich, travelling exhibition.

Lyon, Musée des Beaux-Arts, *Vuillard*, September 19–November 19; Barcelona, Fundació Caixa de Pensions, December 4–January 27; Nantes, Musée des Beaux-Arts, February 15–April 20.

**1991–1992**

Glasgow, Art Gallery and Museum, Kelvingrove, *Vuillard*, September 7–October 20; Sheffield, Graves Art Gallery, October 26–December 18; Amsterdam, Van Gogh Museum, January 9–March 8.

**1993–1994**

Zurich, Kunsthaus, *Die Nabis Propheten der Moderne*, May 28–August 15; Paris, Grand Palais, *Nabis 1888–1900*, September 21–January 3 (November 21).

**1995**

Montreal, Montreal Museum of Fine Arts, *Lost Paradise: Symbolist Europe*, June 8–October 15.

**1998**

Florence, Palazzo Corsini, *Il tempo dei Nabis*, March 28–June 28.

Montreal, Montreal Museum of Fine Arts, *The Time of the Nabis*, August 20–November 22.

**1999–2000**

San Francisco, Museum of Modern Art, *The Artist and the Camera: Degas to Picasso*, October 2–January 4; Dallas, Museum of Art, February 1–May 7; Bilbao, Fundación del Museo Guggenheim, June 12–September 10.

**2000–2001**

Montreal, Montreal Museum of Fine Arts, *Hitchcock and Art: Fatal Coincidences*, November 16–March 18; Paris, Musée national d'art moderne, June 6–September 24.

Saint-Tropez, L'Annonciade, *Édouard Vuillard. La porte entrebâillée*, July 1–October 1; Lausanne, Musée cantonal des Beaux-Arts, October 14–January 7.

**2001**

Chicago, Art Institute, *Beyond the Easel: Decorative Painting by Bonnard, Vuillard, Denis, and Roussel, 1890–1930*, February 25–May 16; New York, Metropolitan Museum of Art, June 26–September 9.

## SOURCES

Note: The sources cited below are those referred to in abbreviated form in the catalogue entries and the introductions to the various catalogue sections.

**Bablet 1975**
Denis Bablet. *Esthétique générale du décor de théâtre de 1870 à 1914*. Paris: Éditions du CNRS, 1975.

**Bacou 1964**
Roseline Bacou. "Décors d'appartements au temps des Nabis." *Art de France*, no. 4 (1964), pp. 190–205.

**Ballew 1990**
Emily Jane Ballew. "Édouard Vuillard's 'Jardins Publics': The Subtle Evocation of a Subject." Master's thesis, Rice University, 1990.

**Bareau 1986**
Juliet Wilson Bareau. "Édouard Vuillard et les princes Bibesco." *Revue de l'art*, no. 74 (1986), pp. 37–46.

**Barilli 1967a**
Renato Barilli. "Il Gruppo dei Nabis." *L'Arte moderna*, vol. 2, no. 12 (1967), pp. 81–120.

**Barilli 1967b**
Renato Barilli. "Bonnard, Vuillard e la poetica degli interni." *L'Arte moderna*, vol. 2, no. 13 (1967), pp. 121–160.

**Barilli 1967c**
Renato Barilli. "Il Simbolismo nella pittura francese dell'Ottocento." *Mensili d'arte*, no. 8 (1967).

**Baumann 1966**
Felix Andreas Baumann. "Hinweis auf einige Neuerbungen." *Jahresbericht der Zürcher Kunstgesellschaft* (1966), pp. 61–66.

**Bernier 1983**
Georges Bernier. *La Revue blanche: Paris in the Days of Post-Impressionism and Symbolism*, exhib. cat. New York: Wildenstein, 1983.

**Boyer 1988**
Patricia Eckert Boyer. "The Nabis, Parisian Vanguard Humorous Illustrators, and the Circle of the Chat Noir." In P. E. Boyer (ed.), *The Nabis and the Parisian Avant-Garde*, exhib. cat. New Brunswick, N.J. and London: Rutgers University Press, 1988, pp. 1–79.

**Boyer 1998**
Patricia Eckert Boyer. *Artists and the Avant-Garde Theater in Paris, 1887–900: The Martin and Liane W. Atlas Collection*, exhib. cat. (Washington, New York). Washington: National Gallery of Art, 1998.

**Boyle-Turner 1993**
Caroline Boyle-Turner. *Les Nabis*. Lausanne: Edita, 1993.

**Brachlianoff 1990**
Dominique Brachlianoff. "Les portraits tardifs." In *Vuillard*, exhib. cat. (Lyon, Barcelona, Nantes). Paris: Flammarion, 1990, pp. 173–194.

**Chastel 1946**
André Chastel. *Vuillard 1868–1940*. Paris: Floury, 1946.

**Chastel 1948**
André Chastel. *Vuillard. Peintures, 1890–1930* (introd.). Paris: Éditions du Chêne, 1948.

**Chastel 1953**
André Chastel. "Vuillard." *Art News Annual Christmas Edition XXIII (Part II)*, vol. 52, no. 7 (November 1953), pp. 26–57, 180–184.

**Chastel 1990**
André Chastel. "Au-devant de Vuillard." In *Vuillard*, exhib. cat. (Lyon, Barcelona, Nantes). Paris: Flammarion, 1990, pp. 15–51.

**Ciaffa 1985**
Patricia Ciaffa. "The Portraits of Édouard Vuillard." Ph.D. diss., Columbia University. Ann Arbor, Mich.: University Microfilms, 1985.

**Clay 1971**
Jean Clay. *L'impressionnisme*. Paris: Hachette, "Réalités," 1971.

**Cogeval 1986**
Guy Cogeval. *Les années post-impressionnistes*. Paris: Nouvelles Éditions Françaises, 1986.

**Cogeval 1990**
Guy Cogeval. "Le célibataire mis à nu par son théâtre, même." In *Vuillard*, exhib. cat. (Lyon, Barcelona, Nantes). Paris: Flammarion, 1990, pp. 105–135.

**Cogeval 1993**
Guy Cogeval. *Vuillard. Le temps détourné*. Paris: Réunion des musées nationaux / Gallimard, "Découvertes," 1993 (see Cogeval 2002).

**Cogeval 1998a**
Guy Cogeval. *Il tempo dei Nabis*, exhib. cat. Florence: Palazzo Corsini / Artificio, 1998.

**Cogeval 1998b**
Guy Cogeval. *The Time of the Nabis*, exhib. cat. Montreal: The Montreal Museum of Fine Arts, 1998.

**Cogeval 2002**
Guy Cogeval. *Vuillard: Post-Impressionist Master*. New York: Harry N. Abrams, 2002 (new version, in English, of Cogeval 1993).

**Cousseau and Ananth 1990**
Henry-Claude Cousseau and Deepak Ananth. "Les ruses de l'intimisme : remarques sur la modernité de Vuillard." In *Vuillard*, exhib. cat. (Lyon, Barcelona, Nantes). Paris: Flammarion, 1990, pp. 161–170.

**C-S 2003**
Guy Cogeval and Antoine Salomon. *Vuillard: Critical Catalogue of Paintings and Pastels*. Paris: Wildenstein / Milan: Skira, 2003.

**Daniel 1984**
Émilie Daniel. "Vuillard, l'espace de l'intimité." Thesis, Institut d'Art et d'Archéologie, Paris, 1984.

**Daulte 1964**
François Daulte. *Chefs-d'œuvre des collections suisses : de Manet à Picasso*. Lausanne: Skira, 1964.

**Denis 1913**
Maurice Denis. *Théories, 1890–1910. Du symbolisme et de Gauguin vers un nouvel ordre classique*. Paris: Bibliothèque de l'Occident, (1912) 1913.

**Denis 1957a**
Maurice Denis. *Journal*, vol. 1 (1884–1904). Paris: La Colombe, 1957.

**Denis 1957b**
Maurice Denis. *Journal*, vol. 2 (1905–1920). Paris: La Colombe, 1957.

**Denis 1959**
Maurice Denis. *Journal*, vol. 3 (1921–1943). Paris: La Colombe, 1959.

**Dorival 1943**
Bernard Dorival. *Les étapes de la peinture française contemporaine*, vol. 1: *De l'impressionnisme au fauvisme, 1833–1905*. Paris: Gallimard, 1943.

**Dorival 1957**
Bernard Dorival. *Les peintres du vingtième siècle*, vol. 1: *Nabis, fauves, cubistes*. Paris: Pierre Tisné, "Pictura," 1957.

**Dorival 1961**
Bernard Dorival. *L'école de Paris au Musée national d'art moderne*. Paris: Somogy, "Trésors des grands musées," 1961.

**Dugdale 1965**
James Dugdale. "Vuillard the Decorator," part 1: "First Phase: the 1890s." *Apollo*, vol. 81, no. 36 (February 1965), pp. 94–101.

**Dumas 1990**
Ann Dumas. "À la recherche de Vuillard." In *Vuillard*, exhib. cat. (Lyon, Barcelona, Nantes). Paris: Flammarion, 1990, pp. 53–102.

**Duranty 1876**
Louis Émile Edmond Duranty. *La Nouvelle Peinture. À propos du groupe d'artistes qui expose dans les galeries Durand-Ruel*. Paris: Floury, (1876) 1946.

**Easton 1989**
Elizabeth Easton. *The Intimate Interiors of Édouard Vuillard*, exhib. cat. (Houston, Washington, Brooklyn). The Museum of Fine Arts, Houston / Washington: The Smithsonian Institution Press, 1989.

**Easton 1994**
Elizabeth Easton. "Vuillard's Photography: Artistry and Accident." *Apollo*, vol. 138, no. 388 (new series) (June 1994), pp. 9–17.

**Ellridge 1993**
Arthur Ellridge. *Gauguin et les Nabis*. Paris: Pierre Terrail, 1993.

**Escholier 1937**
Raymond Escholier. *La peinture française. XXᵉ siècle*. Paris: Floury, "Bibliothèque artistique," 1937.

**Fels 1925**
Florent Fels. *Propos d'artistes*. Paris: La Renaissance du livre, n.d. [1925].

**Forgione 1992**
Nancy Ellen Forgione. "Édouard Vuillard in the 1890s: Intimism, Theater and Decoration." Ph.D. diss., The Johns Hopkins University, 1992.

**Frèches-Thory 1979**
Claire Frèches-Thory. "Jardins publics de Vuillard." *La Revue du Louvre*, vol. 29, no. 4 (October 1979), pp. 305–312.

**Frèches-Thory and Terrasse 1990**
Claire Frèches-Thory and Antoine Terrasse. *Les Nabis*. Paris: Flammarion, 1990.

**Groom 1990**
Gloria Groom. "Landscape as Decoration: Édouard Vuillard's Île-de-France Paintings for Adam Natanson." *The Art Institute of Chicago Museum Studies*, vol. 16, no. 2 (1990), pp. 146–165.

**Groom 1993**
Gloria Groom. *Édouard Vuillard: Painter-Decorator. Patrons and Projects, 1892–1912*. New Haven and London: Yale University Press, 1993.

**Groom 2001**
Gloria Groom. *Beyond the Easel: Decorative Painting by Bonnard, Vuillard, Denis, and Roussel, 1890–1930*, exhib. cat. (Chicago, New York). Chicago: The Art Institute of Chicago / New Haven and London: Yale University Press, 2001.

**Guisan and Jakubec 1973**
Gilbert Guisan and Doris Jakubec (eds.). *Félix Vallotton. Documents pour une biographie et pour l'histoire d'une œuvre*, vol. 1 (1884–1899). Lausanne and Paris: La Bibliothèque des Arts, 1973.

**Guisan and Jakubec 1974**
Gilbert Guisan and Doris Jakubec (eds.). *Félix Vallotton. Documents pour une biographie et pour l'histoire d'une œuvre*, vol. 2 (1900–1914). Lausanne and Paris: La Bibliothèque des Arts, 1974.

**Guitry 1952**
Sacha Guitry. *18 Avenue Élisée Reclus*. Monte Carlo: Raoul Solar, 1952.

**House and Stevens**
John House and MaryAnne Stevens (eds.). *Post-Impressionism: Cross-currents in European Painting*, exhib. cat. London: Royal Academy of Arts / Weidenfeld and Nicolson, 1979.

**Humbert 1954**
Agnès Humbert. *Les Nabis et leur époque, 1888–1900*. Geneva: Pierre Cailler, "Peintres et sculpteurs d'hier et d'aujourd'hui," 1954.

**Huyghe 1939**
René Huyghe. *La peinture française. Les contemporains*. Paris: Pierre Tisné, "Bibliothèque française des arts," 1939.

**Jamot 1906**
Paul Jamot. "Le Salon d'Automne." *Gazette des Beaux-Arts*, vol. 36, no. 594 (December 1, 1906), pp. 472–474.

**Kahng 1990**
Eik Kahng. "Staged Moments in the Art of Édouard Vuillard." In Dorothy Kosinski (ed.), *The Artist and the Camera: Degas to Picasso*, exhib. cat. Dallas Museum of Art / New Haven and London: Yale University Press, 1990, pp. 250–263.

**Koella 1993**
Rudolf Koella. "Les intérieurs des Nabis : un écrin pour l'homme." In *Nabis 1888–1900*, exhib. cat. (Zurich, Paris). Paris: Réunion des musées nationaux, 1993, pp. 91–102.

**Komanecky 1984**
Michael Komanecky. "A Perfect Gem of Art." In M. Komanecky and Virginia Fabbri Butera, *The Folding Image: Screens by Western Artists of the Nineteenth and Twentieth Centuries*, exhib. cat. (Washington, New Haven). New Haven: Yale University Art Gallery, 1984, pp. 41–119.

**Lhote 1933**
André Lhote. *La peinture. Le cœur et l'esprit* and *Parlons peinture. Essais*. Paris: Denoël, 1933.

**Lhote 1956**
André Lhote. *La peinture libérée*. Paris: Grasset, 1956.

**Lugné-Poe 1930**

Aurélien Lugné-Poe. *La Parade*, vol. 1: *Le Sot du tremplin. Souvenirs et impressions de théâtre*. Paris: Gallimard-NRF, 1930.

**Lugné-Poe 1931**

Aurélien Lugné-Poe. *La Parade*, vol. 2: *Acrobaties. Souvenirs et impressions de théâtre (1894–1902)*. Paris: Gallimard-NRF, 1931.

**Lugné-Poe 1933**

Aurélien Lugné-Poe. *La Parade*, vol. 3: *Sous les étoiles. Souvenirs de théâtre (1902–1912)*. Paris: Gallimard-NRF, 1933.

**Makarius 1989**

Michel Makarius. *Vuillard*. Paris: Hazan, 1989.

**Marx 1892a**

Roger Marx. "L'art décoratif et les 'symbolistes'." *Le Voltaire* (August 23, 1892).

**Marx 1892b**

Roger Marx. "Notules d'art." *Le Voltaire* (October 1, 1892).

**Marx 1892c**

Roger Marx. "Mouvement des arts décoratifs," *La Revue encyclopédique*, vol. 2, no. 45 (October 15, 1892), pp. 1485–1505.

**Mauner 1978**

George L. Mauner. *The Nabis: Their History and Their Art, 1888–1896*. New York and London: Garland Publishing, "Outstanding Dissertations in the Fine Arts," 1978.

**Muhlfeld 1893**

Lucien Muhlfeld. "À propos de peintures" (June 25, 1893). In *La Revue blanche*, vol. 4. Geneva: Slatkine Reprints, 1968, pp. 453–460.

**Natanson 1896**

Thadée Natanson. "Peinture. À propos de MM. Charles Cottet, Gauguin, Édouard Vuillard et d'Édouard Manet" (December 1, 1896). In *La Revue blanche*, vol. 11. Geneva: Slatkine Reprints, 1968, p. 518.

**Natanson 1948**

Thadée Natanson. *Peints à leur tour*. Paris: Albin Michel, 1948.

**National Gallery of Art 1975**

*European Paintings: An Illustrated Summary Catalogue*. Washington: National Gallery of Art, 1975.

**Negri 1970**

Renata Negri. "Bonnard e i Nabis." *Mensili d'arte*, no. 37 (1970).

**Perucchi-Petri 1972**

Ursula Perucchi-Petri. *Bonnard und Vuillard im Kunsthaus Zürich*. Zurich: Kunsthaus, "Sammlungsheft," 1972.

**Perucchi-Petri 1976**

Ursula Perucchi-Petri. *Die Nabis und Japan. Das Frühwerk von Bonnard, Vuillard und Denis*. Munich: Prestel-Verlag, 1976.

**Perucchi-Petri 1990**

Ursula Perucchi-Petri. "Vuillard et le Japon." In *Vuillard*, exhib. cat. (Lyon, Barcelona, Nantes). Paris: Flammarion, 1990, pp. 137–158.

**Perucchi-Petri 1993a**

Ursula Perucchi-Petri. "Les Nabis et le japonisme." In *Nabis 1888–1900*, exhib. cat. (Zurich, Paris). Paris: Réunion des musées nationaux, 1993, pp. 33–59.

**Perucchi-Petri 1993b**

Ursula Perucchi-Petri. "'Le paysage des grandes villes' : rues, places et jardins publics." In *Nabis 1888–1900*, exhib. cat. (Zurich, Paris). Paris: Réunion des musées nationaux, 1993, pp. 75–89.

**Philadelphia Museum of Art 1965**

*Checklist of Paintings in the Philadelphia Museum of Art*. Philadelphia Museum of Art, 1965.

**Polignac 1965**

Marie-Blanche de Polignac. "Édouard Vuillard, souvenirs." In *Hommage à Marie Blanche, Comtesse Jean de Polignac*. Monaco: Jaspard, Polus et Cie, 1965, pp. 133–142.

**Preston 1971**

Stuart Preston. *Édouard Vuillard*. New York: Harry N. Abrams, "The Library of Great Painters," 1971.

**Puvis de Chavannes 1926**

Henri Puvis de Chavannes. "Un entretien avec M. Édouard Vuillard, contribution à l'histoire de Puvis de Chavannes." *La Renaissance de l'art français et des industries de luxe*, no. 2 (February 1926), pp. 87–90.

**Ranson-Bitker and Genty 1999**

Brigitte Ranson-Bitker and Gilles Genty. *Catalogue raisonné de l'œuvre de Paul Ranson*. Paris: Somogy, 1999.

**Rewald 1956**

John Rewald. *Post-Impressionism: From Van Gogh to Gauguin*. New York: The Museum of Modern Art, 1956.

**Rishel 1989**

Joseph J. Rishel. *Masterpieces of Impressionism & Post-Impressionism: The Annenberg Collection*, exhib. cat. (entries). Philadelphia Museum of Art, 1989.

**Ritchie 1954**

Andrew Carnduff Ritchie. *Édouard Vuillard*, exhib. cat. New York: The Museum of Modern Art, 1954.

**Robichez 1957**

Jacques Robichez. *Le symbolisme au théâtre. Lugné-Poe et les débuts de L'Oeuvre*. Paris: L'Arche, 1957.

**Robinson 1992**

William H. Robinson. "Vuillard's *Under the Trees* from the Nabi Cycle *The Public Gardens*." *The Bulletin of the Cleveland Museum of Art*, vol. 79, no. 4 (April 1992), pp. 111–127.

**Roger-Marx 1932**

Claude Roger-Marx. "Portrait de Vuillard." *Formes*, no. 23 (March 1932), pp. 240–241.

**Roger-Marx 1945**

Claude Roger-Marx. "Les portraits et leurs modèles." *Pages françaises*, no. 7 (November 1945), pp. 111–114.

**Roger-Marx 1946a**

Claude Roger-Marx. *Vuillard: His Life and Work*. New York: Éditions de la Maison française, 1946 (trans. of *Vuillard et son temps*. Paris: Éditions Arts et métiers graphiques, [©1945] 1946).

Note: Antoine Salomon recalls the race between André Chastel, Claude Roger-Marx and Jacques Salomon to be the first to publish a book-length study on Vuillard. When Salomon succeeded in having his book printed on December 28, 1945, Roger-Marx, whose book was not actually printed until January 1946, responded by securing a 1945 copyright (fourth trimester) for his manuscript. Chastel's book was not printed until August 31, 1946.

**Roger-Marx 1946b**
Claude Roger-Marx. "Édouard Vuillard 1867–1940." *Gazette des Beaux-Arts*, vol. 29, no. 952 (June 1946), pp. 363–377.

**Roger-Marx 1948a**
Claude Roger-Marx. "Pinceaux, scalpels, drogues et peintures." *Formes et Couleurs*, vol. 10, no. 1 (1948), n.p.

**Roger-Marx 1948b**
Claude Roger-Marx. *Vuillard*. Paris: Éditions Arts et Métiers graphiques, 1948.

**Roger-Marx 1968**
Claude Roger-Marx. *Vuillard. Intérieurs.* Paris and Lausanne: La Bibliothèque des arts, "Rythmes et couleurs," series 2, no. 3 (1968).

**Rosenblum 1989**
Robert Rosenblum. "Vuillard." In *Les peintures du Musée d'Orsay*. Paris: Nathan, 1989, pp. 604–613.

**Russell 1971**
John Russell. "The Vocation of Édouard Vuillard." In *Édouard Vuillard, 1868–1940*, exhib. cat. (Toronto, San Francisco, Chicago). London: Thames and Hudson, 1971, pp. 11–71.

**Russell 1974**
John Russell. *The Meanings of Modern Art*, vol. 2: *The Emancipation of Color*. New York: The Museum of Modern Art, 1974.

**Salomon 1945**
Jacques Salomon. *Vuillard, témoignage de Jacques Salomon*. Paris: Albin Michel, 1945.

**Salomon 1953**
Jacques Salomon. *Auprès de Vuillard*. Paris: La Palme, 1953.

**Salomon 1961**
Jacques Salomon. *Vuillard admiré*. Paris: La Bibliothèque des Arts, 1961.

**Salomon 1968**
Jacques Salomon. *Vuillard*. Paris: Gallimard-NRF, 1968.

**Salomon and Vaillant 1963**
Jacques Salomon and Annette Vaillant. "Vuillard et son Kodak." London: The Lefevre Gallery, n.d. [1963]. Also published in French in *L'Oeil*, no. 100 (April 1963), pp. 14–25, 61.

**Schopfer 1897**
Jean Schopfer. "Modern Decoration." *The Architectural Record*, vol. 6, no. 3 (January–March 1897), pp. 243–255.

**Schweicher 1949**
Curt Schweicher. *Die Bildraumgestaltung, das Dekorative und Ornamentale im Werke von Édouard Vuillard*. Trier: Paulinus, 1949.

**Schweicher 1955**
Curt Schweicher. *Vuillard*. Berne: Alfred Scherz, 1955.

**Segard 1914**
Achille Segard. *Peintres d'aujourd'hui. Les décorateurs*, vol. 2. Paris: Paul Ollendorff, 1914.

**Sert 1953**
Misia Sert. *Misia and the Muses: The Memoirs of Misia Sert*. New York: The John Day Company, 1953.

**Sérusier 1942**
Paul Sérusier. *ABC de la peinture*. Paris: Floury, (1921) 1942.

**Sidlauskas 1997**
Susan Sidlauskas. "Contesting Femininity: Vuillard's Family Pictures." *The Art Bulletin*, vol. 79, no. 1 (March 1977), pp. 85–111.

**Sutton 1948**
Denys Sutton. "Édouard Vuillard, 1868–1940." *Maanblad voor Beeldende Kunsten*, vol. 24, no. 10 (October 1948), pp. 246–250.

**Terrasse 1992**
Antoine Terrasse. *Pont-Aven. L'École buissonnière*. Paris: Gallimard, "Découvertes," 1992.

**Thomson 1988**
Belinda Thomson. *Vuillard*. Oxford: Phaidon, 1988.

**Thomson 1991a**
Belinda Thomson. *Vuillard*, exhib. cat. (Glasgow, Sheffield, Amsterdam). London: The South Bank Centre, 1991.

**Thomson 1991b**
Richard Thomson *et al. Toulouse-Lautrec*, exhib. cat. (London, Paris). New Haven and London: Yale University Press, 1991.

**Troy 1984**
Nancy J. Troy. "Toward a Redefinition of Tradition in French Design, 1895 to 1914." *Design Issues*, vol. 1, no. 2 (Autumn 1984), pp. 53–59.

**Troy 1991**
Nancy J. Troy. *Modernism and the Decorative Arts in France: Art Nouveau to Le Corbusier*. New Haven and London: Yale University Press, 1991.

**Vaillant 1956**
Annette Vaillant. "Livret de famille." *L'Oeil*, no. 24 (Christmas 1956), pp. 24–35.

**Vaillant 1974**
Annette Vaillant, *Le pain polka*. Paris: Mercure de France, 1974.

**Vollard 1957**
Ambroise Vollard. *Souvenirs d'un marchand de tableaux*. Paris: Club des Librairies de France, (1937) 1957.

**Waldfogel 1963**
Melvin Waldfogel. "Bonnard and Vuillard as Lithographers." *Minneapolis Institute of Arts Bulletin*, vol. 52, no. 3 (September 1963), pp. 67–81.

**Weisberg 1986**
Gabriel P. Weisberg. *Art Nouveau Bing: Paris Style 1900*. New York: Harry N. Abrams, 1986.

INDEX | CREDITS

# Index

Note: Page numbers in italics indicate illustrations. Unattributed works of art are by Vuillard.

Index of works by Vuillard illustrated in the catalogue follows on page 497.

## A

*The Abduction of Persephone*, 5
Abreu, Lilita, 42
Abstraction and Nabi group principles, 53
Aghion, Jack, 222, 224
Alexandre, Arsène, 145, 188, 287, 320, 331
Alexandre, Françoise, 463
*The Alley*, 30, 242, 243, *303*
*Âmes solitaires* (Hauptmann) (play), 33
*L'Ami Fritz* (Erckmann and Chatrian) (book), 102
"L'Amour du mensonge" (Baudelaire) (poem), 69
Anet, Claude, 192. *See also* Schopfer, Jean
Angrand, Charles, 416
Anjou, René d', 96
*Anna de Noailles* (Cocteau) (fig. 1), *391*
Antonello da Messina, *Christ Blessing*, 60
*Portrait of a Man (Il Condottiere)* (fig. 1), *60*
*The Apprentices*, 75
*April* (Denis), 85
*Araignée de Cristal* (Rachilde) (play), 92
Arbus, Diane
*Russian Midget Friends in a living room* (photo—fig. 16), 436, *437*
Aron, Marcelle, 242, 244, *266*, *267*, *268*, *269*, *273*, 303, 364–365, *433*
*Arrangement in Flesh Colour and Black: Portrait of Theodore Duret* (Whistler), 369
Arts Incohérents movement, 72, 95
*At Les Pavillons, Criquebœuf*, 317
*At the Louvre: The Etruscan Gallery* (Degas) (fig. 1), *338*
*At the Louvre: The Paintings Gallery* (Degas) (fig. 2), 338, *339*
*Au-delà des forces humaines* (*Beyond our Power*) (Bjørnson) (play), 117, 124
*Au sujet d'Adonis* (Valéry) (book), 470
*August Strindberg* (Munch), *409*
*Autour d'une cabine* (Reynaud) (puppet show) (fig. 14), 17, *19*
*Autumn Crocuses* (Vallotton) (fig. 4), *444*
Avril, Suzanne, 250, *251*

## B

Bachelard, Gaston, 4
Bacon, Francis, 44
Bady, Berthe, 93, *117*
Ballets russes, 467–468
Bang, Herman, 15, 117, 124
Baron, Louis, *367*
Barthes, Roland, 243, 432
Bataille, Nicolas
*The Great Harlot*, 40
*The Bath* (Vallotton), 415
*Bather and Cabana* (Picasso) (fig. 2), *72*
Baudelaire, Charles, 54, 56, 69, 219
Bauer, Camille, 325, 334, 337
Bauer, Henri, 113
Beaubourg, Maurice, 12, 117, 118, 124, 210
Beckmann, Max, 332
Belin, Lucie, 30, 244, *280*, *281*, *375*, *469*
Bellier, Jean-Claude, 402
Bénac, André, 38–39
Berger, Jean, 374
Bernard, Émile, 64, 79, 89, 305
Bernard, Tristan, 34, 242, *266*, *267*, *268*, *269*, *273*, 303, 432, 447, 466
Bernheim, Gaston, 224, 317, 360, 362–363
Bernheim-Jeune Gallery, 182, 228, 285, 303, 325, 330, 356
Bernheim, Josse, 224, 317, 362–363
Bernstein, Henry, 306, 308, 386
Berthelot, Philippe, 37, *39*
*Beyond our Power* (*Au-delà des forces humaines*) (Bjørnson) (play), 117, 124
Bibesco, Antoine, 256, *257*
Bibesco, Emmanuel, 30, 256, *257*, 303
Bing, Siegfried, 165, 184, 188, 192, 194
Biollay, Maurice, 99
Bjørnson, Bjørnstjerne, 117
Blanc, Charles, illustration in *Grammaire des arts du dessin*, 408
Blanche, Jacques-Émile, 332
Blum, Léon, 34, 38, 235, *238*, 244, 468
Bonnard, Marthe, 240–241, *276*, *277*
Bonnard, Pierre, 130
ambiguity in work, 415
as an "Army painter," 332
association with Misia Natanson, 206
*Bourgeois Afternoon*, 297
ceramics work, 192
*The Coffee Service*, 395
*The Croquet Game* compared to *Women in the Garden* (cat. 58), 115
decorative panels owned by Jean Schopfer, 296
designing the set for Debussy's *Jeux*, 383
designs for stained glass, 184
*The Dining Room in the Countryside* (fig. 11), 451, *452*
toward Dreyfus affair, 34
with group at L'Étang-la-Ville, *258*, *259*
in Hotel Inglès in Madrid, 256, *257*
importance of opinion to Vuillard, 358
influence of Vuillard on, 305
interest in photography, 242
link with the Bernheim-Jeune Gallery, 325
*The Mantelpiece*, 100
nudes by, 326
painting the Théâtre des Pantins as part of Nabi group, 52
*Peignoir*, 69
photograph of, *248*, *249*, *254*, *255*
portrait in *The Anabaptists: Bonnard, Denis, Maillol, Roussel* (cats. 291–292), 40, 345, *346*
portrait of by Vuillard, *236*
portrait of Vuillard, 60
poster for *La Revue blanche* (journal) (fig. 1), *235*
*Promenade of the Nursemaids: A Frieze of Fiacres*, 179, 183, 385
rejecting work on League of Nations, 350
*Self-portrait* (fig. 2), *343*
sharing a studio with Vuillard, 80, 83, 176
sketchbook of, *460*
at the table, *276*, 277
trying photography, 424
visiting Misia Natanson, 442
on Vuillard and Paris, 460
*Vuillard's Profile* (fig. 7), *9*
walking with group, *276*, 277
*Woman Lying on a Bed*, 326
Boudin, Eugene, 449
Boulanger, General Georges, 65
*Bourgeois Afternoon* (Bonnard), 297
*A Boy with a Sword* (Manet) (fig. 1), *74*
Boyer, Patricia Eckert, 99
Boyer, Raymond, 331
Braun, Adolphe, 97
*Breakfast* (Signac), 134
Brittany, 304–306, 449–450
Burhan, Filiz Eda, 413

## C

Caillebotte, Gustave
*Skiffs* (fig. 1), *286*
Camée, Georgette, 116
*Camera Lucida* (Barthes) (book), 243
*The Candlestick*, 331
Carnot, Sadi, 32
Carrière, Eugène, 52, 54
Casimir-Périer, Jean, 32
Cazalis, Auguste, 52
*Celebrities and Simple Souls* (Sutro) (book), 35
Chagall, Marc, 92
Chanel, Coco, *469*
Chapin, Marguerite, 30, *31*, 309
Chardin, Jean-Baptiste-Siméon, 130, 339
Chastel, André, 24–25, 64, 77, 141, 221, 325, 356, 463
Chastel, Roger, 350
Chat Noir cabaret, 95
*Le Chat Noir* (magazine), 68
Château des Clayes, 2, *46*, 402, 442, 453–454
Chevreul, Michel-Eugène, 286
*Children around a Pond, Les Tuileries*, 85
*Christ and the Buddha* (Ranson), 11
*Christ Blessing* (Antonella da Messina), 60
*Cipa Listening to Misia*, 26
Clair, Jean, 72, 82
Claudel, Camille, 96
Claudel, Paul, 50, 467, 471
Cocteau, Jean, 92 (fig. 1), *391*, 392
*The Coffee Service* (Bonnard), 395
Cogniat, Raymond, 230, 344
Colmet d'Âage, Henri, 9
*The Comb*, 228
Combes, Émile, 33
*Comedy*, 45, 47, 245, 468
*The Comtesse d'Haussonville* (Ingres) (fig. 1), *386*
*Le Concile féerique* (Laforgue) (poem), 110
*Il Condottiere* (Antonello da Messina), 60
Conservatoire de Musique et de Déclamation, 98
Coolus, Romain, 200, *433*
with artist's mother, *425*
association with Misia Natanson, 26, 206
brother of Prosper-Émile Weil, 382
at the Château-Rouge, *266*, 267
in *Interior, The Salon with Three Lamps* (cat. 156), 230
with Lucy Hessel at Amfreville, 270, *271*
photographs of, *250*–*251*
portrait of by Vuillard, *236*
on portraiture, 357
psychological traits in Vuillard, 4–5
in a restaurant in Normandy, *274*, *275*, 432
Coquelin Cadet, *102*, *103*, *104*, 407, 411
Corot, Jean-Baptiste-Camille, 288, 294
Cousturier, Edmond, 188
Craig, Edward Gordon, 16, 117
Cremnitz, Maurice, 149
*The Croquet Game* (Bonnard), 115
*Le Cuer d'amours espris* (René d'Anjou) (fig. 1), *96*

## D

Daber, Alfred, 6, 34
Darzens, Rodolphe, 72
Dausset, Louis, 233, 297
"De Gauguin et de Van Gogh au Classicisme" (Denis) (article), 324
Debussy, Claude, 28, 96, 115, 219, 383
Degas, Edgar, 130, 141
toward Dreyfus affair, 33
*Edmond Duranty* (fig. 1), *369*
on his pastel landscapes, 406
influence on Vuillard's portraits, 356
*At the Louvre: The Etruscan Gallery*, *338*
*At the Louvre: The Paintings Gallery*, 338, *339*
as a photographer, 424, 427–428
"Renoir and Mallarmé" (photo—fig. 2), *428*
*Thérèse de Gas-Morbilli* (fig. 2), *386*
on Vuillard's art, 411
Denis, Marthe, *260*
Denis, Maurice, 130, 212
on "a new classical order," 324
*April*, 85
as an "Army painter," 332
on colours, 53
toward Dreyfus affair, 33, 34
on *Figures in an Interior* (cats. 137–140), 195
frontispiece for *The Lady from the Sea*, 116
*Frontispiece for the Program of "L'Intruse"* (fig. 1), *112*
interest in photography, 242, 424
introducing Vuillard to Arthur Fontaine, 365
*Jacob Wrestling with the Angel* (fig. 1), 85
letter to Lugné-Poe, 100
*The Mystical Grape-Harvest* (fig. 1), *115*
on Nabi gatherings, 11
on the painting of *Talisman* by Sérusier, 52
portrait in *The Anabaptists: Bonnard, Denis, Maillol, Roussel* (cats. 291–292), 40, 345, *347*
relationship as essential to Vuillard, 415
reproaching Vuillard's impressionistic tendencies, 325
on Sérusier in the theatre, 11–12, 93
as student of philosophy, 413
*Sunlight on the Terrace*, 415
using decorative borders in paintings, 222
using framed light-coloured backdrops, 96
on Vuillard's confidence, 83
on Vuillard's creative process, 207
Vuillard's disagreement with, 407
Vuillard's letter to about stained glass project, 184
on Vuillard's personality, 460
with wife Marthe, *260*

Dervaux, Adolphe, 320
*Design for the Program of the Inaugural Production of "Ubu-Roi"* (Jarry) (fig. 31), *33*
Desmarais, Paul and Léonie, 166
Desmarais screen, *167*
*The Dessert* (Matisse), 134
*The Dining Room in the Countryside* (Bonnard) (fig. 11), 451, *452*
Dix, Otto, 332
*Doctor Parvu*, 348
*Doctor Vaquez at the Hospital*, 348
*Doctors Vaquez and Parvu at the Saint-Antoine Hospital*, 374
Dortu, M. G., 105
Dou, Gerard, 130
Dralin, Georges, 331
*The Drawer*, 75
Dreyfus affair, 32, 33, 220
Duchamp, Marcel, 416
Duranty, Edmond, 357
Duret, Théodore, 369–370

### E

Eakins, Thomas, 374
École des Beaux-Arts, 5, 15, 52, 80
*Edmond Duranty* (Degas) (fig. 1), *369*
*L'Éducation sentimentale* (Flaubert) (book), 468–469
*Edward of England Pays Homage to Philippe Le Bel for Aquitaine* (anonymous) (fig. 12), *14*
*The Electoral Meeting*, 33
*An Enemy of the People* (*Un ennemi du peuple*) (Ibsen) (play), 124
Ensor, James
 *Russian Music*, 219
L'Étang-la-Ville, 444–445
Exhibitions of Vuillard's work, 484–486
 at Bernheim-Jeune Gallery, 285 (*See also* Bernheim-Jeune Gallery)
 first solo in 1906, 330
 *The Haystack* (cat. 266) at Bernheim-Jeune Gallery, 303
 International Society of Sculptors, Painters and Gravers, 216
 at La Libre Esthétique, 228
 in offices of *La Revue blanche*, 235
 review of 1906 exhibit, 331
*Exposition des peintres impressionnistes et symbolistes*, 130

### F

Fagus, Félicien, 219
*Farce du pâté et de la tarte* (anonymous) (play), 94
Faure, Félix, 32
Fauvism, 60, 360
Fénéon, Félix, 33
Fenwick, Madame, 395
*Fêtes du centenaire de la République* (anonymous) (fig. 30), *33*
*La Fille aux mains coupées* (Quillard) (play), 12, 92
Flaubert, Gustave, 468–469
*Les Fleurs du Mal* (Baudelaire) (poems), 54

*Flowers*, 330
*Flowers on a Mantelpiece*, 330
Fontainas, André, 207, 231, 300
Fontaine, Arthur, 365
Fontaine, Jacqueline, 365–366
Forgione, Nancy, 151, 152, 167, 411
Fornachon, Mademoiselle, 153
Fort, Paul, 11, 92, 110, 112, 113
Fra Angelico, 167
Fragonard, Jean-Honoré, 179, 392
Francis, Sam, 305
Frèches-Thory, Claire, 194
Freud, Lucian, 44
Freud, Sigmund, 72, 77
Front Populaire, 38
*Frontispiece for the Program of "L'Intruse"* (fig. 1) (Denis), *112*
Fuller, Lois, 93

### G

Galerie Bernier, 356
Galerie L'Oeil, 240
*The Garden of the Clos Cézanne at Vaucresson*, 244, 406
*Garden* (Roussel) (fig. 1), *184*
Gardey (the dwarf), 384
*La Gardienne* (Régnier) (play), 12, 93
*Gathering in a Park* (Watteau), 179
Gauguin, Paul, 52, 64, 192, 305, 407, 409, 411
 *Meyer de Haan*, 63
Geffroy, Gustave, 149, 212
George, Waldemar, 470
German Expressionism, 332
Ghéon, Henri, 231
Ghirlandaio, Domenico
 *Portrait of an Old Man with a Young Boy*, 8
Giacometti, Alberto, 44
Gide, André, 197
Gilou, Madame, 395
Giraudoux, Jean, 469, *470*
Godebski, Cipa, 157, 286
Godebska, Misia, 157. *See also* Natanson, Misia
Gosset, Antonin, 372–374
Gosson, Léo, 59
Gourmont, Remy de, 100
*Grammaire des arts du dessin* (Blanc) (book), 408
*Le Grand Teddy*, 395, (fig. 10), *468*
*Les Grands Initiés* (Schuré) (book), 110
*The Great Harlot* (Bataille), 40
Greenberg, Clement, 410
Groom, Gloria, 192, 194, 204, 222, 224, 296, 415, 419
Guilbert, Yvette, *106*
 in *At the Divan Japonais* (cat. 49), 56, 66, 105
 onstage gestures of, 55
Guitry, Lucien, *368*
Guitry, Sacha, 44–45, 220, 356, *367*, 377, 383, 386, *466*, 467

### H

Hahn, Reynaldo, 395
Halévy, Ludovic, 406
*The Half-Open Door*, 107, 419
Hammershøi, Vilhelm, 416
Hauptmann, Gerhardt, 33
Haviland & Co., 192
Henraux, Albert, 42
Henry, Frédéric, 5, 52, 155
 in *A Family Evening* (cat. 96), 155
Hepp, Pierre, 228, 287
Hermant, Pierre, 5, 52
*Hérodiade* (Mallarmé) (poem), 462
Hervieu, Paul, 420
Hessel, Jos, 34, 74–75, 360
 acquiring *Promenade in the Vineyard* (cat. 151), 224
 at Les Étincelles villa in the country, 157
 possessing Vuillard's diary, 6, 7
 reaction to affair between his wife and Vuillard, 28
 renting Château-Rouge in summer, 330
 representing Vuillard, 362
 travelling with Vuillard, 284
 at Villa Anna, 322
 as Vuillard's agent, 432
Hessel, Louise, *264*, *267*
Hessel, Lucy, 34, 74–75, 146, 469
 with Alfred Natanson at Clos Cézanne, *281*
 anger at Vuillard's love affairs, 32
 argument with Vuillard, 50
 and the Bernheim ladies, *275*
 in *Decoration for Bois-Lurette* (cats. 274–275), 450–451
 at Les Étincelles villa in the country, 157
 in *The Haystack* (cat. 266), 303
 image inserted into *The Terrace at Vasouy* (cats. 263–264), 296
 Juliette Weil as rival to, 382
 leaning against haystack, *434*
 in *Madame Hessel in Her Boudoir — II* (cat. 297), *359*–360
 next to decorations for Bois-Lurette, *279*
 in *In the Park at the Château des Clayes* (cat. 334), 402–403
 in *Perfect Harmony* (cat. 40), 395
 photographed in Amfreville by Vuillard, *267*, *269*, *270*–*271*
 in photographs by Vuillard, 244, *263*, *264*
 relationship with Vuillard affected by affair with Lucie Belin, 375
 in a restaurant in Normandy, *274*, *275*
 in studio on Boulevard Malesherbes, *278*
 summers in the country with Vuillard, 304–306, 442, 446–449
 travelling with Vuillard, 284
 in *Twilight at Le Pouliguen* (cat. 267), 304

urging Vuillard to leave the Bernheim gallery, 362
 vacationing at Vaucresson, 453
 Vuillard shifting focus toward, 445
 Vuillard's affair with, 242–243
 with Vuillard's mother, *281*, *431*, 431–432
 walking with group, *276*, 277
Hessel, Lulu, 45–46, 244, 282, *351*, 395, 402–403, 418, *419*
Hiroshige, 308, 343
Hodler, Ferdinand, 288
Hokusai, 308
Hugo, Victor, 12
Huisman, Philippe, 105
Huret, Jules, 420

### I

Ibels, Henry, 34, 184
Ibsen, Henrik, 94, 212
 *An Enemy of the People* (play), 50
 *The Lady from the Sea* (play), 116–117
 Lugné-Poe on production of *Rosmersholm*, 13, 15
 *Master Builder*, 95
 possible inspiration for *The Conversation* (cat. 77), 133
 Vuillard and Lugné-Poe collaborating on plays by, 12, 124
 Vuillard's interest in plays by, 116–117
Impressionism, 179, 216, 287, 325, 369, 411
*In Search of Lost Time* (Proust) (book), 464, 465
*Inferno* (Strindberg) (book), 413
Ingres, Jean Auguste Dominique
 *The Comtesse d'Haussonville* (fig. 1), *386*
 influence on Vuillard's portraits, 356, 365
 *Louis-François Bertin* (fig. 1), *142*, 143
 *The Muse of Lyric Poetry*, 369
*Inheritance* (Munch) (fig. 19), 22
Institut de France, 470
*Intérieur* (Maeterlinck) (play), 154
*Interior with Pink Wallpaper*, 211
International Society of Sculptors, Painters and Engravers, 216
*L'Intruse* (Maeterlinck) (play), 12, 112–113

### J

La Jacanette, 444–445
*Jacob Wrestling with the Angel* (Denis) (fig. 1), 85
Jamot, Paul, 356, 360
Japanese art influence, 53
 on *Boating* (cat. 254), 286
 on the Desmarais panels, 167
 exhibit held at École des Beaux-Arts, 15
 inspiring *Coquelin Cadet in "L'Ami Fritz"* (cat. 45), 102
 Kunisada print composition, 58
 on Nabi group, 164
 on *Octagonal Self-portrait* (cat. 6), 60

on *Screen for Stéphane Natanson* (cat. 141), 200
 on *The Stitch* (cat. 86), 143
 on Vuillard, 411
 Vuillard's admiration for, 130
 on Vuillard's landscapes, 308, 309
Jarry, Alfred, 55, 93, 415
 *Design for the Program of the Inaugural Production of "Ubu-Roi"* (fig. 31), *33*
Javal, Fernand, 392–393
*Jean Santeuil* (Proust) (book), 391–392
Journal of Vuillard, 4, 6–8
 on apartment decoration, 415
 on colours, 81
 on commission from Henry Bernstein, 308
 on concentration, 72
 on *Countess Anna de Noailles (first version)* (cat. 322), 392
 on crafting a work of art, 63
 on the difference between photography and painting, 241–242
 on expressing sensations, 69
 on financial situation of artist, 362
 on generalization of the imagination, 179
 going to cinematograph, 243
 on his appearance, 23
 on his passivity, 419
 on his surroundings, 416
 indicating Mallarmé's influence on Vuillard, 463
 on *Jeanne Lanvin* (cat. 326), 396, 397
 as a literary experiment, 461
 on *Lucien Rosengart at His Desk* (cat. 321), 390
 on *Mademoiselle Jacqueline Fontaine* (cat. 301), 365
 on Monet's landscapes, 308
 on mother's death, 2
 on older ways of understanding, 339
 on painter's fear of being intelligent, 416
 on the period preceding World War II, 38
 on photography, 243
 on portrait of Yvonne Printemps, 377
 on relationships in art, 53
 on *In the Salon, Evening, Rue de Naples* (cat. 325), 395
 on seeing and states of mind, 406
 sketches in (fig. 1), *408*, (figs. 5–6), *7*
 on spirituality, 77
 on *The Surgeons* (cat. 306), 373
 on the tapestries at the Musée de Cluny, 176
 on *The "Voiles de Gênes" Boudoir* (cat. 323), 392
 on work and working, 97
 during World War I, 332, 468

## K

Kahn, Gustave, 320

Kandinsky, Wassily, 4, 13, 92

Kapferer, Henry, *371*

Kapferer, Marcel, *371, 385*

Khnopff, Fernand, 242
    *Listening to Schumann*, 219
    *Portrait of Marguerite* (fig. 1), *81*

Kirchner, Ernst Ludwig, 332
    *Klangfarbenmelodie*, 27

Kunisada, Utagawa, 58, 149, 167

## L

*The Lacemaker* (Vermeer), *143*

*The Lady from the Sea* (Ibsen)
    (play), 116–117

Laforgue, Jules, 110

*Landscapes and Interiors* album,
    211, 284

Lanvin, Jeanne, 37, 389,
    396–401, 469

Laroche, Jean, 37

Le Sueur, Eustache
    *Raymond Diocrès*, 343

League of Nations, Geneva, 45, 350

Lebasque, Henri, 332

Leclercq, Julien, 228

Legion of Honour award, 35

Lemaître, Jules, 93, 113

Lemercier de Neuville, 96

Lenoir, Alexandre, 312

Lépine, Louis, 33

Letters, 16
    of condolence to the artist after
        death of mother, 49
    exchanged between Lucy Hessel
        and Lucie Belin, 50
    from Lucie Belin to Vuillard, 30
    from Vuillard to Misia
        Natanson, 27
    from Vuillard to Vallotton about
        country retreats, 445
    from Vuillard to Vallotton about
        landscapes, 284
    from Vuillard to Vallotton about
        loss of nephew, 212
    from Vuillard to Vallotton about
        need to paint, 441
    from Vuillard to Vallotton from
        Normandy, 447

Lévy, Emile, 312, 314

Lévy, Lazare, 37, 244, 457

Lhote, André, 357

La Libre Esthétique, 228, 233

*Lilacs* (1899–1900), 303

*Listening to Schumann* (Khnopff),
    219

*Little Girls* (Vallotton) (fig. 11),
    *414*, 415

*Little Nemo in Slumberland*
    (McCay) (fig. 1) (comic strip), *77*

Lorenzetti, Ambrogio, 167

Loucheur, Louis, 37

*Louis-François Bertin* (Ingres)
    (fig. 1), *142*, 143

Louvre Museum, Paris, 6, 7,
    337–338, 407–408

Luce, Maximilien, *258, 259*

Lugné-Poe, Aurélien, 12
    collaboration with Nabi
        group, 92
    collaboration with Sérusier, 11
    collaboration with Vuillard,
        124, 212
    at the Conservatoire de Musique
        et de Déclamation, 98
    directing style of, 93
    performing Ibsen's *The Lady
        from the Sea* and *Rosmersholm*,
        116–117
    portrait of by Vuillard, *97,
        117, 466*
    on problems with *Âmes solitaires*
        by Hauptmann, 33
    sharing a studio with Vuillard, 176
    *Le Sot du tremplin* (book), 98
    staging Maeterlinck's
        *L'Intruse*, 113
    on Vuillard's interest in the
        theatre, 94
    on Vuillard's set design for
        Ibsen's *Master Builder*, 95

Lycée Condorcet, 5, 9

Lysés, Charlotte, 367, 368

## M

Mach, Ernst, 413

*Madame Albert Henraux*, 42

*Madame André Wormser and
    Her Children*, 383

*Madame Georges Charpentier
    and Her Children* (Renoir)
    (fig. 2), *383*

*Madame Jean Trarieux and Her
    Daughters*, 383

*Madame Val-Synave*, 324, 326

*Madame Vuillard Sewing*, 157

Maeterlinck, Maurice, 93
    absence of man onstage, 93
    characters created by, 13
    *Intérieur* influencing *A Family
        Evening* (cat. 96), 154
    *L'Intruse* (play), 12, 112–113
    puppet theatre, 16, 96
    *Seven Princesses*, 94

Magnin, Julien, 9, 52

Maillart, Diogène, 52

Maillol, Aristide, 40, *346*

Maison de l'Art Nouveau (gallery),
    165, 184, 188, 192

Malégarie, Charles, 390

Mallarmé, Stéphane, 69, 206, 235,
    *237, 238*, 305, *428*, 461–463

Mallet, Félicia, 107, 109

*Man at the Helm* (Rysselberghe), 286

Manet, Édouard, 130
    *A Boy with a Sword* (fig. 1), *74*
    on Théodore Duret, 369

*The Mantelpiece* (Bonnard), 100

Marchand, Miche, 395

*Maritime Panorama* (Mesdag), 179

Marlowe, Christopher, 2

*The Marriage of Figaro* (Beau-
    marchais) (play), 105

*Married Life: The Absence*, 155, 418

Marx, Roger, 167, 207, 331

Masayoshi, Kitao, 68

Mascagni, Pietro, 102

Masheck, Joseph, 410

*The Master Builder* (Ibsen)
    (play), 12, 95

Matisse, Henri
    *The Dessert*, 134

Mauclair, Camille, 93, 188, 197

Mauner, George, 80, 212, 418

McCay, Winsor
    *Little Nemo in Slumberland*
        (fig. 1) (comic strip), *77*

Meilhac, Henri, 105, 447

Mellery, Xavier
    *The Stairway* (fig. 12), *416*, 418

*Las Meninas* (Velázquez), 54

Mesdag, Hendrik Willem
    *Maritime Panorama*, 179

Méthey, André, 192

Meyer de Haan (Gauguin), 63

Michaud, Marie Antoinette
    Désirée (grandmother), 130
    Conté drawing of, 54
    in *Dinnertime* (cat. 2), *55*
    in *The Flowered Dress*
        (cat. 79), 134
    in *Grandmother at the Sink*
        (cat. 4), *58*
    in *Grandmother Michaud in
        Silhouette* (cat. 3), 56–57, *57*
    in *Lunchtime* (cat. 78), 134
    in *The Staircase Landing, Rue
        de Miromesnil* (cat. 76), 132

Michaud, Prosper-Justinien
    (grandfather), 56

Michelangelo, 343

*A Midsummer Night's Dream*
    (Shakespeare), 45–46

*Misia Playing the Piano for
    Cipa*, 188

*Miss Helyett*, 120

Molière, 465

Monet, Claude, 294, 303, 306,
    308, 410, 441
    *Walk on the Cliff at Pourville*
        (fig. 1), *440*

*Monsieur Bertin* (Ingres), 143

*Monsieur Bute* (Biollay) (play), 99

Morand, Eugène, 103

Moreau, Gustave, 369, 407

Moreno, Marguerite, 93

Morice, Charles, 195, 304

Morisot, Berthe, 449
    *On the Beach* (fig. 9), *451*

Mouclier, Marc, 52

Muhlfeld, Lucien, 34

Munch, Edvard, 55
    *Anxiety* (fig. 2), *113*
    *August Strindberg*, 409
    *Inheritance* (fig. 19), *22*
    *The Operation* (fig. 3), *374*
    *Self-portrait between Clock
        and Bed* (fig. 1), *343*
    *Sketch for Ibsen's "Ghosts"*
        (fig. 10), *13*

*The Mystical Grape Harvest*
    (fig. 1) (Denis), *115*

## N

Nabi group, 8–11, 51–90, 324
    anti-naturalistic aspects of, 130
    dabbling in ceramics, 192
    at L'Étang-la-Ville, 444
    *The Flirt* (cat. 18), *72–73*
    influence of photography
        on, 424
    Kerr-Xavier Roussel, 63
    Léo Gosson exhibiting with, 59
    *The Little Delivery Boy* (cat. 19),
        *74–75*
    and Mallarmé, 461–463
    naming of, 52–53
    paintings of Vuillard's family,
        55–58, 66–67, 82
    paintings of women's fashions,
        69–71, 80–81
    Paris' public gardens, 84–88
    puppet shows, 94
    rejecting perspective, 164
    seeing *Le Cuer d'amours espris*
        by René d'Anjou, 96
    self-portraits, 60–61, 83
    sleeping figures, 76–79
    theatre work, 92–93
    Vallotton and Vuillard in, 225
    working with the Théâtre
        d'Art group, 113

*Nabi Landscape* (Ranson), 11

Natanson, Adam, 165, 188, 204

Natanson, Alexandre, 165, 176,
    179, 182, *246*, 303

Natanson, Alfred, 443
    founding *La Revue blanche*, 235
    with Lucy Hessel at Clos
        Cézanne, *281*
    photograph of, *263*
    photograph of Vuillard and his
        sister, *75*
    teaching Vuillard photography,
        241

Natanson, Annette, *263*. See also
    Vaillant, Annette Natanson

Natanson, Misia, 25–27
    apartment depicted in *Interior,
        The Salon with Three Lamps*
        (cat. 156), *228*
    deterioration of marriage to
        Thadée, 446
    with husband Thadée
        (photo—fig. 3), *429*
    interior designed by, 419
    at La Grangette, 213
    in *Misia and Vallotton at
        Villeneuve* (cat. 147), 216
    as muse to *La Revue blanche*, 206
    in *The Nape of Misia's Neck*
        (cat. 149), 220
    photographed in Cannes,
        *258, 259*
    photographs of, *246, 250–251*
    in *Promenade in the Vineyard*
        (cat. 151), 224
    relationship to Vuillard as
        expressed in paintings and
        photographs, 428–431
    in *Screen for Stéphane Natanson*
        (cat. 141), 200
    summers in the country with
        Vuillard, 442, 443
    Vuillard in love with, 241

Vuillard shifting focus away
    from, 445
    in *Woman*, 43
    in *Woman in the Countryside*
        (cat. 150), 221
    in *Woman Seated in a Chair*
        (cat. 148), 219

Natanson, Olga, 179, 183

Natanson, Stéphane, 165, 166, 200

Natanson, Thadée
    on abstraction of line in
        decorative panels, 411
    apartment depicted in *Interior,
        The Salon with Three Lamps*
        (cat. 156), *228*
    commissioning decorative
        panels from Vuillard, 165, 188
    on depth in *The Widow's
        Visit (The Conversation)*
        (cat. 153), 226
    deterioration of marriage to
        Misia, 446
    on Félix Vallotton's preference
        of Vuillard as a painter, 22–23
    as a Jew in France, 34
    on Kerr-Xavier Roussel, 63
    in *Misia and Vallotton at
        Villeneuve* (cat. 147), 216
    with Misia (fig. 23), *25*
    photographed in Cannes,
        *258, 259*
    running a munitions factory
        during World War I, 244
    on *The Suitor* (cat. 89) and
        *The Bridal Chamber* (cat. 90), 149
    on Vuillard as a reader, 461
    on Vuillard's Cannes land-
        scapes, 294
    Vuillard's portrait of (fig. 3), *461*
    with wife Misia (photo—
        fig. 3), *429*

Neo-Impressionism, 58, 59, 287

Noailles, Anna de (Countess),
    391–392

*Noailles II*, 44

Normandy, 446–449

*La Nouvelle peinture* (Duranty)
    (book), 357

*Nude with Skull* (anonymous)
    (fig. 10), *414*

*Nude with Skull* (Ranson)
    (fig. 9), *414*

## O

*On the Beach* (Morisot) (fig. 9), *451*

*Open Window Overlooking the
    Woods*, 89

*An Operation by Dr. Péan at the
    Hôpital International* (Toulouse-
    Lautrec) (fig. 2), *374*

*The Operation* (Munch) (fig. 3), *374*

*Operation* (Schad), 374

*Origins* (Redon), 27

Osthaus, Karl Ernst, 224

**P**

*Pauvre Pierrot* (Reynaud)
(puppet show), 149
*Peignoir* (Bonnard), 69
Perucchi-Petri, Ursula, 68, 77, 418
*Phonographies Darzen* (fig. 1), *72*
Picard, André, 268, 269
Picasso, Pablo, 92
*Bather and Cabana* (fig. 2), *72*
*Young Philosopher*, 356
Pierrot, 11, 107–109
Pille, Henri, 95
Piot, René, 332
Place Vintimille, Paris, 86
in *Berlioz Square (sketch)*
(cat. 272), 312–314
in *Five-Panel Screen for Miss
Marguerite Chapin: Place
Vintimille* (cat. 271), 309–311
in *Study for "Place Vintimille"*
(cats. 269–270), 306–308
*La Plume* (journal), 97
Poe, Edgar Allan, 12, 97
Pointillism, 58, 59, 410. *See also*
Seurat, Georges
Poiret, Paul, 396
Poirier, Claude
*The Presentation of Jesus in
the Temple*, 334
Polignac, Marie-Blanche de,
37–38, 388–389, 396
*Poor Pierrot* (anonymous)
(fig. 15), *19*
Pop Art, 60, 64
Popesco, Elvire, *44*, 45
*Portrait of a Man (Il Condottiere)*
(Antonello da Messina), *60*
*Portrait of an Old Man with a
Young Boy* (Ghirlandaio), 8
*Portrait of André Bénac*, 38–39
*Portrait of Marguerite* (Khnopff)
(fig. 1), *81*
*Poster for "La Revue blanche"*
(Bonnard) (fig. 1), *235*
*Pot of Flowers, Rue Truffaut*, 331
Poulenc, Francis, 389
Poussin, Nicolas, 343
Poyet, Louis, *19*
*The Presentation of Jesus in the
Temple* (Poirier), 334
Printemps, Yvonne, 44–45, 368,
377–381, 383, *467*
*Promenade of the Nursemaids:
A Frieze of Fiacres* (Bonnard),
179, 183, 385
Proust, Marcel, 391–392, 430,
446, 447, 464–465
*The Pursued Woman*, 23
Puvis de Chavannes, Pierre, 45,
164, 179, 324, 350
*Rest* (fig. 1), *222*

**Q**

Quillard, Pierre, 12, 92

**R**

Rachilde, "Madame," 92
Ralph, Lucie, 375. *See also* Belin,
Lucie
Ramadier, Paul, 37

Rambosson, Yvanhoe
*Reclining Woman in Bits*, 79
Rank, Otto, 8
Ranson, France (Paul's wife), 153
Ranson, Paul, 53
apartment depicted in *Woman
in Blue* (cat. 95), 152–153
*Christ and the Buddha*, 11
confrontation with Germaine
Rousseau and Kerr-Xavier
Roussel, 20, 209
with group at L'Étang-la-
Ville, *258*
lending Vuillard studio space, 11
on *The Mystical Grape-Harvest*
(fig. 1) by Maurice Denis, 115
*Nabi Landscape*, 11
*Nude with Skull* (fig. 9), *414*
with other artists in L'Étang-la-
Ville, 259
as part of Nabi group, 52
possible collaboration with
Vuillard, 222
on Vuillard and Bonnard, 83
Rasetti, Georges, 192
Rateau, Armand-Albert, 396
*Reclining Woman*, 79
*Reclining Woman in Bits*
(Rambosson), 79
*The Red Room* (Vallotton), 210
Redon, Odilon, 244, *254*, 411
*Origins*, 27
*La Règle du jeu* (Renoir) (film), 45
Régnier, Henri de, 12, 93, 124
Rembrandt van Rijn, 34, 374
René d'Anjou
*Le Cuer d'amours espris*
(fig. 1), *96*
"Renoir and Mallarmé" (Degas)
(photo—fig. 2), *428*
Renoir, Auguste, *279*, *428*
*Madame Georges Charpentier
and Her Children* (fig. 2), *383*
Renoir, Jean, 45
Renouardt, Jane, 386–387
*Rest* (Puvis de Chavannes)
(fig. 1), *222*
Retté, Adolphe, 110
*La Revue blanche* (journal), 165,
166, 230
background of, 235
on decorative panels by
Vuillard, 188
during the Dreyfus affair, 33–34
Félix Fénéon with, 33
Proust and Vuillard meeting
at, 464
Vuillard's association with,
16, 206, 442
*Revue d'Art dramatique*
(journal), 92
Reynaud, Émile, *19*, 149
Rimbaud, Arthur, 113
Rippl-Rónai, József, 192
Rivière, Henri, 411
Rixens, Jean-André, 52
Robinson, Edward G., 45

Roger-Marx, Claude, 191, 356
on dearth of paintings from
Vuillard's travels, 440
on *Doctor Louis Viau*
(cat. 293), 348
on *Figures in an Interior*
(cats. 137–140), 197
on *Five Panels for Thadée
Natanson* (cats. 126–130), 27
on *Interrogation of the Prisoner*
(cat. 282), 332
on *Portrait of André Bénac*, 39
on *Portrait of Marcelle Aron*
(cat. 300), 365
on reserved manner of
Vuillard, 5
on *Théodore Duret in His
Study* (cat. 304), 369
on the use of white in *The
Surgeons* (cat. 306), 374
on Vuillard's Brittany
paintings, 449
on Vuillard's silence, 419
on Vuillard's work during last
years of life, 470
Rosengart, Lucien, 43–44,
389–390
*Rosmersholm* (Ibsen) (play), 12, 13,
15, 116–117
Rousseau, Germaine, 19, 20, 153,
154, *208*, 209
Rousseau, Ida, 153, 210
Roussel, Annette (niece), 241
in *Annette on the Beach at
Villerville* (cat. 265), 300–301
with brother and grandmother,
*280*, 281
with brother Jacques, *261*
in *Child Playing: Annette in
Front of the Rail-Backed Chair*
(cat. 159), 233
in *Before the Door* (cat. 273),
315–316
with father, *279*
infant, *248*, *249*
in the Louvre with Vuillard, 338
with parents, *280*, 281
seated on a bed, *265*
at the table, *276*, 277
walking with group, *276*, 277
in *The White Room* (cat. 158), 232
Roussel, Jacques (nephew), *261*,
*265*, *276*, 277, *280*, 281
Roussel, Kerr-Xavier, 9, 58, 130
affair with Germaine Rousseau,
153, 154, 209
with daughter Annette, *279*
decorative panels owned by
Jean Schopfer, 296
depositing Vuillard's diary with
the Institut de France, 7
in the dining room of Rue
Truffaut, *252*
at L'Étang-la-Ville, 444–445
in *A Family Evening* (cat. 96), 155
*Garden* (fig. 1), *184*
with Jacques and Annette, *265*
marriage to Vuillard's sister, 17,
131, 147
nude photographs of, *254*
photograph of (anonymous), *63*

portrait in *The Anabaptists:
Bonnard, Denis, Maillol, Roussel*
(cats. 291–292), 40, *345*
relationship with Marie
Vuillard, 157
with sister-in-law Louise, *260*
in *The Table: End of a Lunch at
the Vuillard Home* (cat. 98), *156*
taking a photograph set up by
Vuillard, 240
Vuillard meeting as a student at
Lycée Condorcet, 5
Vuillard's portraits of, *62*, *145*
walking with group, *276*, 277
with wife and daughter, *248*,
249, *280*, 281
in window in Venice, 254, *255*
during World War I, 36
Roussel, Madame, *276*, 277
Roussel, Marie Vuillard (sister), 130
in *The Chat* (cat. 92), 150
in *The Conversation* (cat. 77), 133
depositing Vuillard's diary with
the Institut de France, 7
in the dining room of Rue
Truffaut, *252*
in *Dinnertime* (cat. 2), *55*
in *The Dressmakers* (cat. 12),
66–67
in *The Enigmatic Smile*
(cat. 24), *79*
at L'Étang-la-Ville, 444–445
in *A Family Evening*
(cat. 96), 155
in *The Flowered Dress*
(cat. 79), 134
in *Girl Sleeping* (cat. 22), 79
with husband and daughter,
*248*, 249, *280*, 281
in *Interior (Marie Leaning Over
Her Work)* (cat. 82), *139*
in *Interior, Mother and Sister of
the Artist* (cat. 85), 142–143
loss of son, 212
in *Lunchtime* (cat. 78), 134
in *Marie at the Balcony Railing*
(cat. 88), 146
marriage to Kerr-Xavier
Roussel, 17, 131, 145, 147
miscarriage of, 154
in *Mother and Daughter against
a Red Background* (cat. 27), *82*
in *Mother and Daughter at the
Table* (cat. 80), 137
in *The Mumps* (cat. 81), 140
photograph with Vuillard
(Alfred Natanson), *75*
portrait of, 59
relationship with Kerr-Xavier
Roussel, 157
in *The Table: End of a Lunch at
the Vuillard Home* (cat. 98), *156*
in *The Widow's Visit (The
Conversation)* (cat. 153), 225
in *Woman in Bed* (cat. 23), 79
in *Woman Seated in a Dark
Room* (cat. 97), *155*

*Russian Midget Friends in a
living room* (Arbus)
(photo—fig. 16), *437*
*Russian Music* (Ensor), 219
Rysselberghe, Théo van
*Man at the Helm*, 286

**S**

Salengro, Roger, 38
Salis, Rodolphe, 95, 96
Salomon, Annette, 376
Salomon Archives, 16
Salomon, Jacques, 74
on death of Vuillard's mother,
389
description of how Vuillard
used his camera, 426
identifying figures in *Woman in
Blue* (cat. 95), 153
on Jos Hessel's reading of
Vuillard's diary, 6
in the Louvre with Vuillard, 338
memory of Vuillard, 4
on painting of *Madame Vuillard
Lighting the Stove* (cat. 290), 344
on Vuillard at Château des
Clayes, 454
on Vuillard's being cut off from
religion, 418
on Vuillard's photographs, 240
on Vuillard's *villégiatures*, 441
Salon de la Société nationale des
Beaux-Arts, 184
Sarrault, Albert, 37
Satie, Erik, 92
Saupique, Georges, 312
Schad, Christian, 374
Schnerb, J.-F., 304
Schopfer, Clarisse Langlois, 296
Schopfer, Jean, 165, 192, 194, 296
*The Terrace at Vasouy*
(cats. 263–264), 244, 296
Schopfer panels, 25, 27, 28, 221,
227, 296, 450
Schuré, Édouard
*Les Grands Initiés*, 110
Segard, Achille, 195, 415
*Self-portrait* (Bonnard) (fig. 2), *343*
*Self-portrait between Clock and Bed*
(Munch) (fig. 1), *343*
*Self-portrait with Bamboo Mirror*, 406
Sert, José-Maria, 220
Sert, Misia, 469. *See also*
Natanson, Misia
Sérusier, Paul, 83, 130
toward Dreyfus affair, 33
with group at L'Étang-la-Ville,
*258*, 259
influence on Vuillard, 8, 89
leaning against the mantel-
piece, *275*
painting backdrop for *Fille
aux mains coupées*, 92
palette of Vuillard compared
to, 85
*Paul Ranson in Nabi Costume*
in Vuillard's *Woman in Blue*
(cat. 95), 153
relationship as essential to
Vuillard, 415
*Talisman*, 52, 53
theatre work, 11–12

Seurat, Georges, 56, 143, 179, 416
  *A Sunday on La Grande Jatte*, 179
  *Young Woman Powdering Herself*, 58
*Seven Princesses* (Maeterlinck) (play), 94
Signac, Paul
  *Breakfast*, 134
Silvestre, Armand, 103
*Sketch for Ibsen's "Ghosts"* (Munch) (fig. 10), *13*
*Skiffs* (Caillebotte) (fig. 1), *286*
*Sleep*, 77
*Le Sot du tremplin* (Lugné-Poe) (book), 98
Souriau, Paul, 413
*Le Spleen de Paris* (Baudelaire) (poems), 56
*The Stairway* (Mellery) (fig. 12), *416*, 418
Steen, Jan, 130
Stein, Gertrude, 469
Steinlein, Théophile Alexandre
  *Story of a Cat, a Dog and a Magpie* (fig. 1), *68*
*Story of a Cat, a Dog and a Magpie* (Steinlein) (fig. 1), *68*
Stoullig, Edmond, 113
Stravinsky, Igor, 46, 48
*A Street Strongman* (fig. 4), *6*
Strindberg, August, 124, 409, 411, 413
Stroheim, Erich von, 45
*A Sunday on La Grande Jatte* (Seurat), 179
*Sunlight on the Terrace* (Denis), 415
*A Sunny Morning*, 467
Sutro, Alfred, 13, 35
Symbolism, 12, 77, 81
  "Battle of Hernani," 113
  in contrast with Vuillard's paintings of interiors, 130
  in decorative panels by Vuillard, 191
  hidden in Vuillard's work, 418
  Huret on "feminine modesty" of, 420
  influenced by narcotics, 82
  in *Interior, Mystery* (cat. 144), 212
  in interior scenes of Vuillard, 131
  musical experiences depicted, 219
  nature of decorative art, 167
  psychodrama in Vuillard's paintings, 133
  Serpent Woman, 100
  in theatrical world, 92, 93, 143, 411
  Vuillard's approach to natural motifs, 305
  *Women in the Garden* (cat. 58) exemplifying, 113
*The Symphony* (Vallotton) (fig. 24), *26*
Synthetism, 8
  Brittany paintings, 450
  *The Dressmakers* (cat. 12), 66
  *Lilacs* (cat. 10), 64
  in *Lugné-Poe* (cat. 37), 97
  *Man Reading* (cat. 8), 63
  in theatrical world, 92

**T**

Taine, Hippolyte, 413
*Talisman* (Sérusier), 52, 53
*Tearing Along*, 105
*Le Temps* (newspaper), 35
Théâtre d'Art, 92, 93, 112, 113
Théâtre de l'Oeuvre, 92, 97, 117, 118, 123–128
Théâtre de Pupazzi, 96
Théâtre des Champs-Élysées, 317, 465–466
Théâtre-Libre, 99, 100
*Thérèse de Gas-Morbilli* (Degas) (fig. 2), *386*
Thibaudet, Albert, 463
Thiébault-Sisson, François, 285, 304
Third Republic, 32–34
Thomson, Belinda, 167, 288, 360
Tiffany, Louis Comfort, 184
Toulouse-Lautrec, Henri de, 130
  association with Misia Natanson, 206
  compared to Vuillard, 100
  discovering Yvette Guilbert, 105
  influence of posters on *The Stitch* (cat. 86), 143
  lithograph of scene from *Beyond our Power* (play), 117
  *An Operation by Dr. Péan at the Hôpital international* (fig. 2), *374*
  portrait of by Vuillard, 235, *237*
  visiting Misia Natanson, 442
Toyokuni, Utagawa, 72
Tuileries public gardens, Paris, 85, 176, 182

**U**

*Ubu Roi* (Jarry) (play), 33

**V**

Vaillant, Annette Natanson, 219, 224, 240, 241, *263*, 420, 448, 449
Valéry, Paul, 42, 427, 469, 470
Vallée, A.
  *Woman in a Landscape* (fig. 8), *413*
Vallotton, Félix, 130, 204
  approach to landscapes, 288
  as an "Army painter," 332
  association with Misia Natanson, 206
  *Autumn Crocuses* (fig. 4), *444*
  *The Bath*, 415
  with group at La Terrasse, *264*
  with group at L'Étang-la-Ville, *258*, 259
  interest in photography, 424
  letter from Vuillard about country retreats, 445
  letter from Vuillard about decorative panels, 222
  letter from Vuillard about landscapes in country, 284
  letter from Vuillard about loss of nephew, 212

letter from Vuillard about need to paint, 441
letter from Vuillard from Normandy, 447
*Little Girls* (fig. 11), *414*, 415
in *Misia and Vallotton at Villeneuve* (cat. 147), 216, *217*
portrait of by Vuillard, 216, *217*, 224–225
preference for Vuillard as a painter, 22–23
*The Red Room*, 210
*The Symphony* (fig. 24), *26*
*Vuillard Sketching at Honfleur* (fig. 5), *448*
*Woman in a Purple Dress by Lamplight* (fig. 1), 20, *210*
woodcut prints, 286
during World War I, 325
Vallotton, Gabrielle, *264*
"Valvins diary," 157
Van de Velde, Henry, 192
Vaquez, Henri, 188, 195
Vaucresson, 451–453, 457
Vauxcelles, Louis, 309
Veber, Pierre, 2–3, 5, 52, 235
*Les Veillées du chauffeur* (Bernard) (book), 447
Velázquez, Diego Rodríguez da Silva
  *Las Meninas*, 54
Velde, Henry van de, 192
*Venus de Milo*, 324, 343
Verhaeren, Émile, 233
Verkade, Jan, 83
  *Red Apples* in Vuillard's *Woman in Blue* (cat. 95), 153
Vermeer, Johannes, 130
  *The Lacemaker*, *143*
  *A Young Woman Standing at a Virginal*, 143
Versailles in *The Chapel at the Château de Versailles* (cat. 283), 334
*La Vie muette* (Beaubourg) (play), 12, 117, 118, 210
*Villégiature* (Meilhac) (play), 447
Villeneuve-sur-Yonne, 216, 221, 224, 286, 296, 442–443
Villers-sur-Mer, 457
Vollard, Ambroise, 192, 211, 462
Vuillard, Alexandre (brother), 3, 32
Vuillard, Édouard
  in Amfreville, *267*
  with Antoine Bibesco on a train in Spain, 256, *257*
  death of, 454
  in the dining room of Rue Truffaut, *253*
  family of, 55
  with group at La Terrasse, *264*
  with group at L'Étang-la-Ville, *258*, 259
  with his mother, *278*
  at Kerr-Xavier Roussel's house, *276*, 277
  with Misia Natanson, *246*
  in the photograph "La Jacanette," 241
  seated at the dining room table, *275*

in studio on Boulevard Malesherbes, *ii*
with Suzanne Avril and Misia Natanson, 250, *251*
in *The Table: End of a Lunch at the Vuillard Home* (cat. 98), 156
in Venice, 254, *255*
walking on beach, *269*
*Vuillard et son kodak* (exhibit), 240, 426
Vuillard, Honoré (father), 32, 145
Vuillard, Marie Michaud (mother), *vi–vii*
  accompanying Vuillard on *villégiatures*, 452–453
  on affair between Roussel and Germaine Rousseau, 209
  with artist, *278*
  in *The Chat* (cat. 92), 150
  at Château des Clayes, 454
  cleaning green beans, *261*
  in *The Conversation* (cat. 77), 133
  death of, 2, 389
  depicted in *Large Interior with Six Figures* (cat. 143), 210
  developing Vuillard's photographs, 426
  in the dining room of Rue Truffaut, *253*
  in *Dinnertime* (cat. 2), 55
  doing her hair, *262*, 263
  in *Before the Door* (cat. 273), 315–316
  in *The Dressmakers* (cat. 12), 66–67
  in *A Family Evening* (cat. 96), 155
  with her daughter-in-law, *272*
  at her toilet, *281*
  in *Interior, Mother and Sister of the Artist* (cat. 85), 142–143
  involved in Vuillard's photography, 243
  in kitchen, *247*
  with Lucy Hessel, *281*, 431, 431–432
  in *Lunchtime* (cat. 78), 134
  in *Madame Vuillard Lighting the Stove* (cat. 290), 343–344, *344*
  in *Madame Vuillard Reading the Newspaper* (cat. 154), 227–228
  in *Mother and Daughter against a Red Background* (cat. 27), *82*
  in *Mother and Daughter at the Table* (cat. 80), 137
  photographs of, *435–436*
  posing for photograph, 244
  relationship as essential to Vuillard, 2–4
  with Romain Coolus, 425
  seated, *277*

seated on her bed, *282*
with son Alexandre and his wife, *276*, 277
in *The Table: End of a Lunch at the Vuillard Home* (cat. 98), *156*
turning the family home into workshop, 130
on Vuillard's devotion to Pierre Puvis de Chavannes, 50
in *The White Room* (cat. 158), 232
in *The Widow's Visit (The Conversation)* (cat. 153), 225
in *Woman Arranging Her Hair* (cat. 155), 228–229
in *The Yellow Curtain* (cat. 94), *152*
Vuillard, Marie (sister). See Roussel, Marie Vuillard (sister)
Vuillard, Marie (sister-in-law), *272*
*Vuillard Sketching at Honfleur* (Vallotton) (fig. 5), *448*
*Vuillard's Profile* (Bonnard) (fig. 7), *9*
*Vuillard's Room at the Château des Clayes* (fig. 13), 402, 454, *455*

**W**

Wagner, Richard, 93, 113
*Walk on the Cliff at Pourville* (Monet), *440*
*War Factory (Daytime)*, 37, 325, 374
Warhol, Andy, 60
Waroquy, 52, *54*
Watteau, Jean-Antoine, 392
  *Gathering in a Park*, 179
Weil, Juliette, 6, 32, 382–383
Whistler, James, 369
  *Arrangement in Flesh Colour and Black: Portrait of Theodore Duret*, 369
*Woman in a Landscape* (Vallée) (fig. 8), *413*
*Woman Lying on a Bed* (Bonnard), 326
*Woman in a Purple Dress by Lamplight* (Vallotton) (fig. 1), 20, *210*
*Woman with a Dog*, 309
World War I, 36–37, 244, 314, 325, 332, 412–413, 451, 468–469

**Y**

*Young Philosopher* (Picasso), 356
*Young Woman Powdering Herself* (Seurat), 58
*A Young Woman Standing at a Virginal* (Vermeer), 143
*Young Woman with Her Hand on a Doorknob*, 79
*Yvonne Printemps in an Armchair*, 44–45

**Z**

*Zenobia Found on the Banks of the Araxes*, 5
Zola, Émile, 440
"Zouave" Nabi (Vuillard's nickname), 53

496

## Index of Works by Vuillard Illustrated in the Catalogue

*1893 sketchbook* (cat. 99), 157, *158*
*1894–1895 sketchbook* (cat. 100), 157, *159*

### A

*The Album* (fig. 1) as part of *Five Panels for Thadée Natanson* (cats. 126–130), 27–28, 188, *191* See also *Five Panels for Thadée Natanson* (cats. 126–130)
*Âmes solitaires* (lithograph for playbill) (cat. 68), 123, *125*
*The Anabaptists: Bonnard, Denis, Maillol, Roussel* (cats. 291–292), 40, 326, 345–347
  *Aristide Maillol* (fig. 2), *346*
  *Kerr-Xavier Roussel* (fig. 1), *345*
  *Maurice Denis* (cat. 292), 345, *347*
  *Pierre Bonnard* (cat. 291), 345, *346*
*Anna de Noailles (first version)* (cat. 322), 44, 357, *391*, 391–392
"Annette and Kerr-Xavier Roussel and Madame Vuillard" (photo—cat. 243), *279*
*Annette Natanson, Lucy Hessel and Miche Savoir at Breakfast* (cat. 275) as part of *Decoration for Bois-Lunette* (cats. 274–275), 228, 317, *319*
*Annette on the Beach at Villerville* (cat. 265), 300–301, *301*, 315
"Annette Roussel in her nannie's arms" (photo), 419
"Annette Roussel seated on a bed" (photo—cat. 209), *265*
*Annette Salomon* (cat. 309), *376*
*Aristide Maillol* (fig. 2) as part of *The Anabaptists: Bonnard, Denis, Maillol, Roussel* (cats. 291–292), *346*
*At La Divette, Cabourg: Annette Natanson, Lucy Hessel and Miche Savoir at Breakfast* (cat. 275) as part of *Decoration for Bois-Lurette* (cats. 274–275), 317, *319*
*At the Café-Concert* (cat. 63), *120*
*At the Divan Japonais* (cat. 49), 56, 66, 72, 105–106, *106*, 409–410
*At the Opera* (fig. 41), *44*, 45, 46
*The Attic of La Grangette at Valvins* (cat. 145), 213–215, *214–215*
*The Attic of La Grangette at Valvins* (cat. 146), 213, *215*
*Au-delà des forces humaines* (lithograph for playbill) (cat. 70), 123, *126*
*Au-dessus des forces humaines; L'Araignée de Cristal* (lithograph for playbill) (cat. 69), 123, *125*
"Auguste Renoir in his studio" (photo—cat. 245), *279*
*Autumn in Valvins: View of the Seine with Mallarmé's House on the Right* (fig. 4), *462*

### B

*The Bay of Cannes, Seen from the Terrace* (cat. 262), 294, *295*
*Before the Door* (cat. 273), 315–316, *316*
*Berlioz Square (sketch)* (cat. 272), *312–313*, 312–314
*The Bernheim Villa at Villers-sur-Mer: The Terrace at Bois-Lurette (Mmes Josse and Gaston Bernheim)* (fig. 10), 451, *452*
*The Black Cups* (fig. 39), 42, *43*
*The Blue Hills* (cat. 257), 287, 288, 290–291, 445–446
*The Blue Sleeve* (cat. 93), 150–151, *151*, 153, 425, 426
*The Boa* (cat. 14), 69–70, *70*
*Boating* (cat. 254), 227, 284, *286*, 286–287
*The Bois de Boulogne* , 23, (fig. 5), *409*, 415, 418
*The Bridal Chamber* (cat. 90), 19, 147, *148*, 149

### C

*Café in the Bois de Boulogne at Night — The Garden of Alcazar* (cat. 65), 120, *122*
*The Café Wepler* (fig. 2), *461*
*Cannes, Garden on the Mediter-ranean* (cat. 261), *283*, 294, *295*
"Cattle in front of the car in Brittany" (photo—cat.211), *266*, 267
*The Chapel at the Château de Versailles* (cat. 283), 36, *323*, 334–335, 335
*Charles Malégarie* (fig. 1), *390*
*The Chat* (cat. 92), *150*
*The Chestnut Trees* (cat. 125), 157, 184–185, *185*
*Child Playing: Annette in Front of the Rail-Backed Chair* (cat. 159), 233–234, *234*
*Choosing a Book* (cat. 138) as part of *Figures in an Interior* (cats. 137–140), 195, *196*
*Claude Bernheim de Villers* (cat. 298), 300, 356, 360, 360–361, *361*, 382
*Coco Chanel* (fig. 11), *469*
*The Conjuring Act* (cat. 62), 118–119, *119*
*The Conversation* (cat. 114) as part of *The Public Gardens* (cats. 111–124), (fig. 18), 22, *163*, 171, *174*
*The Conversation* (cat. 77), 132–133, *133*
*Coquelin Cadet in "L'Ami Fritz"* (cat. 45), *102*
*Coquelin Cadet in the Role of Léridon* (cat. 47), *104*, 104–105
*Countess Anna de Noailles (first version)* (cat. 322), 44, 357, *391*, 391–392
*Countess Marie-Blanche de Polignac* (cat. 320), 2, 322, *388*, 388–389, 392

### D

*Daybook* (cat. 101) (sketches), 157, *160–161*
*Decoration for Bois-Lurette* (cats. 274–275), 317–320, 450–451
  *The Bernheim Villa at Villers-sur-Mer: The Terrace at Bois-Lurette (Mmes Josse and Gaston Bernheim)* (fig. 10), 451, *452*
  *At La Divette, Cabourg: Annette Natanson, Lucy Hessel and Miche Savoir at Breakfast* (cat. 275), 317, *319*
  *The Veranda at Le Coadigou in Loctudy* (cat. 274), 317, *318*
*Decorations for Camille Bauer* (cats. 284–288), 325, 334, 336–341, 392
  *The Medieval Gallery at the Musée des Arts Décoratifs* (cat. 286), 337, *338*
  *The Salle Clarac* (fig. 3), 338, *339*
  *The Salle des Cariatides at the Louvre* (cat. 288), 337, *341*
  *The Salle La Caze at the Louvre* (cat. 287), 337, *340*
  *Vuillard's Mantelpiece (Overdoors I & II)* (cats. 284–285), *336*, 337
*The Demonstration* (cat. 11), 33, 55, 65
*Design for a Frontispiece for Félicia Mallet in "L'Enfant Prodigue"* (cat. 53), 107, *109*
*Design for a Frontispiece for "The Marriage of Figaro"* (cat. 48), *104*, 104–105
*Design for a Program for the Théâtre-Libre* (cat. 42), *100*, 124
*Design for a Program for the Théâtre-Libre* (cat. 43), 100–101, *101*
*Design for a Program for the Théâtre-Libre: "Le Concile féerique"* (cat. 54), *110*, 407
*Design for a Program for the Théâtre-Libre: "Le Concile féerique"* (cat. 55), 110–111, *111*, 407
*Design for a Program for the Théâtre-Libre: "Monsieur Bute"* (cat. 40), *99*
Desmarais panels *See Six Overdoors for Monsier and Madame Paul Demarais* (cats. 103–110)
*Dinnertime* (cat. 2), *10*, 11, 55, 212
*Doctor Georges Viau* (fig. 1), *348*
*Doctor Louis Viau* (cat. 293), 45, 325, 348–349, *349*, 374
*The Dressing Table* (cat. 128) as part of *Five Panels for Thadée Natanson* (cats. 126–130), 186, *190*
*The Dressmakers* (cat. 12), 11, 66–67, *67*
*The Dressmaking Studio—I* (cat. 103) as part of Desmarais panels (cats. 103–110), 166–167, *168*
*The Dressmaking Studio—II* (cat. 104) as part of Desmarais panels (cats. 103–110), 166–167, *169*

### E

"*L'Enfant Prodigue": Pierrot at the Door* (cat. 52), 107–108, *108*
"*L'Enfant Prodigue": Pierrot Weeping* (cat. 51), 107–108, *108*
*The Enigmatic Smile* (cat. 24), *79*
*Un ennemi du peuple (An Enemy of the People)* (lithograph for playbill) (cat. 67), 123, 124, *125*
"*Etincelles*" *Sketchbook* (cat. 102), 157, *162*
"Excursion party in the hills around Villeneuve-sur-Yonne" (photo—fig. 1), 224

### F

*The Factory: The Big Chimney at Night* (cat. 34), *90*
*The Family after Dinner* (fig. 1), 134, *137*
*A Family Evening* (cat. 96), 19, *154*, 154–155, 209, 231, 418
*Family Lunch* (fig. 16), 19, *20*, 22
*Félix Vallotton in His Studio* (cat. 152), 224–225, *225*
*Figures in an Interior* (cats. 137–140), 195–199
  *Choosing a Book* (cat. 138), 195, *196*
  *Intimacy* (cat. 139), 195, *198*
  *Music* (cat. 140), 195, *199*
  *Work* (cat. 137), 195, *196*
*Figures in an Interior: Screen for Stéphane Natanson* (cat. 141), 25, 200–202
*The First Fruits* (cat. 142) as part of *Île-de-France Landscape* (fig. 1), 204, 222
*First Steps* (cat. 116) as part of *The Public Gardens* (cats. 111–124), 172, *177*, 410, 418
*Five-Panel Screen for Miss Marguerite Chapin: Place Vintimille* (cat. 271), 30, 309–311, *310–311*
*Five Panels for Thadée Natanson* (cats. 126–130), 22, 27–28, 186–191
  *The Album*, (fig. 1) 188, *191*
    compared to *Figures in an Interior* (cats. 137–140), 195
    compared to Jean Schopfer's table service, 192
  *The Dressing Table* (cat. 128), 186, 188, *190*
  *Preliminary Sketch for the "Natanson Panels"* (cat. 130), 186, *191*
  *The Stoneware Pot* (cat. 129), 186, 188, *190*, 191, 216

*The Dressmaking Studio—I* (cat. 103) as part of Desmarais panels (cats. 103–110), 166–167, *168*
*The Dressmaking Studio—II* (cat. 104) as part of Desmarais panels (cats. 103–110), 166–167, *169*

*The Striped Blouse* (cat. 126), 186, *187*, 188
*The Tapestry* (cat. 127), 186, 188, *189*
*The Flirt* (cat. 18), 23, 55, 65, 72–73, *73*, 120, 405
*The Flowered Dress* (cat. 79), *iv–v*, 134–135, *135*, 228, 410
*Foliage: Oak Tree and Fruit Seller —At the Closerie des Genêts, Vaucresson* (fig. 12), 402, *453*, 457
*Four Ladies with Fancy Hats* (cat. 17), 69, *71*
*Frères; La Gardienne; Créanciers* (lithograph for playbill) (cat. 74), 123, *128*
*Friends around the Table* (fig. 7), *449*

### G

*A Game of Draughts* (fig. 6), *448*, 453
*A Game of Shuttlecock* (cat. 107) as part of Desmarais panels (cats. 103–110), 85, 166–167, *168*
*The Garden* (cat. 263) as part of *The Terrace at Vasouy* (cats. 263–264), 296, *298*
*Gardening* (cat. 106) as part of Desmarais panels (cats. 103–110), 166–167, *169*
*Gaston and Josse Bernheim* (cat. 299), 356, 362–363, *363*
*Girl Sleeping* (cat. 22), *78*, 78–79, *412*, 413, 418
*Girl Wearing an Orange Shawl* (cat. 32), *88*
*Girl with a Hoop* (cat. 30), 85
*The Goose* (cat. 35), 55, *95*, 416, 418
*Le Grand Teddy* (fig. 10), 395, *468*
*Grandmother at the Sink* (cat. 4), 58, 59, 66
*Grandmother Michaud* (fig. 1), *56*
*Grandmother Michaud in Silhouette* (cat. 3), 11, 56–57, *57*, 59, 105, 409
*The Green Dinner* (fig. 1), 134, *137*, 156
*Grisélidis* (cat. 46), *103*, 124, *408*
*The Guinguette* (cat. 64), 120, *121*, 122

### H

*Hat with Green Stripes* (cat. 15), 69–70, *70*, 80
*The Haystack* (cat. 266), 242, 243, *302*, 302–304, 426, 448
*Henri de Toulouse-Lautrec* (cat. 162), 235, *237*
*The Hessels in Their Dressing Room* (fig. 14), 418, *419*

**I**

*Île-de-France Landscape: The First Fruits* (fig. 1), *204*

*Île-de-France Landscape: The Window Overlooking the Woods* (cat. 142), 22, *203*, 203–204, 222,284, 294, 420

*"L'Illusionniste": The Dwarf Gardey in the Wings (sketch)* (cat. 317), 383–384, *384*

*In Bed* (cat. 21), 53, 74, *76*, 76–77, 225, 418

   compared to *Interior, Mystery* (cat. 144), 212

   compared to *Lugné-Poe* (cat. 37), 97

   compared to puzzle pictures, 412

   compared to *Seated Nude* (cat. 25), 80

*In the Lamplight* (cat. 84), 140–141, *141*, 240

*In the Park at the Château des Clayes* (cat. 334), 402–403, *403*

*In the Public Garden—The Straw Hat* (cat. 29), *84*, 84–85

*In the Salon, Evening, Rue de Naples* (cat. 325), 392, *394*, 394–395

*Interior (Marie Leaning Over Her Work)* (cat. 82), *139*

*Interior, Mother and Sister of the Artist* (cat. 85), 15, 16, 82, *142*, 142–143, 240, 418

   compared to Diane Arbus' photographs, 436–437

   compared to photograph of Madame Vuillard and Paul Sérusier (photo—cat. 235), 428

   compared to *The Conversation* (cat. 77), 133

*Interior, Mystery* (cat. 144), 22, 132, 155, 211–212, *212*

*Interior, The Salon with Three Lamps* (cat. 156), 27, *228*

*Interior with Hanging Lamp* (fig. 1), 211, *212*

*Interior with Red Bed (The Bridal Chamber)* (cat. 90), 19, 147, *148*, 149

*Interior with Worktable (The Suitor)* (cat 89), 7, (fig. 19), *18*, 19, 146–147, *148*, 149

*Interrogation of the Prisoner* (cat. 282), 36, 325, 332–333, *333*

*Intimacy* (cat. 139) as part of *Figures in an Interior* (cats. 137–140), 195, *198*

*The Intruder* (cat. 57), *112*, 112–113

**J**

*Jacqueline Baudoin* (fig. 38), *42*

"Jacques and Annette Roussel at La Montagne" (photo—cat. 200), *261*

"Jacques Roussel, Madame Vuillard and Annette Roussel in the salon" (photo—cat. 246), 280, 281

*Jane Renouardt* (cat. 319), 357, 365, 386–387, *387*

*Jean Giraudoux* (fig. 12), 356

*Jeanne Lanvin* (cat. 326), 396, *397*

*Jos Hessel and Gaston Bernheim in Their Office on Boulevard de la Madeleine* (fig. 1), *362*

**K**

"Kerr-Xavier and Annette Roussel" (photo—cat. 174), *249*

"Kerr-Xavier, Jacques and Annette Roussel in Salanelles" (photo—cat. 210), *265*

"Kerr-Xavier, Jacques and Annette Roussel, Lucy Hessel and Pierre Bonnard walking in the vicinity of 'La Jacanette' "(photo—cat. 237), *276*, 277

"Kerr-Xavier, Marie and Annette Roussel" (photo—cat. 172), *239*, 248, 249

"Kerr-Xavier, Marie and Annette Roussel" (photo—cat. 173), *248*, 249

*Kerr-Xavier Roussel* (cat. 9), 62, 62–63

*Kerr-Xavier Roussel* (fig. 1) as part of *The Anabaptists: Bonnard, Denis, Maillol, Roussel* (cats. 291–292), *345*

"Kerr-Xavier Roussel and his sister-in-law Louise at La Montagne" (photo—cat. 197), *260*

"Kerr-Xavier Roussel dancing nude" (photo—cat. 185), *254*

"Kerr-Xavier Roussel in the dining room" (photo—cat. 180), *252*

"Kerr-Xavier Roussel nude" (photo—cat. 184), *254*

*Kerr-Xavier Roussel Reading the Newspaper* (cat. 87), *145*, 157, 412

*The Kiss* (cat. 20), *75*

**L**

*Lady of Fashion* (cat. 26), 80–81, *81*, 107, 132, 212

"Landscape at L'Étang-la-Ville" (photo—fig. 2), *204*

*Landscape at Rheinfelden* (cat. 259), 287, *293*

*Landscape at Romanel* (cat. 256), 287, 288, 290, *439*

*Landscape at Romanel* (cat. 258), 287, 288–289, *292*

*Landscape at Saint-Jacut* (cat. 268), 304–306, *305*

*Landscape Studies* (cat. 33), *89*

*Large Interior with Six Figures* (cat. 143), (fig. 17), 20, 21, *208–209*, 208–210, 483

*Léon Blum* (cat. 165), 235, *238*

*The Library* (figs. 2 and 28), 30, *31*, *309*

*Lilacs*, c. 1890, (cat. 10), *51*, 53, *64*

*Lilacs*, c. 1899–1900, 303

*The Little Delivery Boy* (cat. 19), 74–75, *75*, 132

*Little Girl in Front of Railings* (fig. 1), *86*

"Louise Hessel, Lucy Hessel, Vuillard, Gabrielle and Félix Vallotton at La Terrace" (photo—cat. 207), *264*

"Lucie Belin" (photo—fig. 1), *375*

"Lucie Belin at home" (photo—cat. 247), 280, 281

"Lucie Belin in her room" (photo—fig. 29), *31*

*Lucie Belin Smiling* (cat. 307), 30, *375*

*Lucien Guitry* (cat. 303), *368*

*Lucien Rosengart at His Desk* (cat 321), 43–44, 357–358, 389–390, *390*

"Lucy Hessel and Alfred 'Athis' Natanson at the Clos Cézanne" (photo—cat. 249), *281*

"Lucy Hessel and Madame Vuillard on the avenue in the park of the Château des Clayes" (photo—cat. 250), *281*

"Lucy Hessel and Marcelle Aron beneath the staircase of the Château-Rouge" (photo—cat. 215), *267*

"Lucy Hessel and Marcelle Aron in front of a haystack in Amfreville" (photo—cat. 222), *270*

"Lucy Hessel and Marcelle Aron on the beach at Vasouy" (photo—fig. 26), *29*

"Lucy Hessel and the Bernheim ladies at the Château Rouge" (photo—cat. 234), *275*

"Lucy Hessel at Coadigou in Loctudy next to decoration for Bois-Lurette" (photo—cat. 244), *279*

"Lucy Hessel at the window" (photo—cat. 205), *263*

"Lucy Hessel in a meadow" (photo—cat. 226), 270, 271

"Lucy Hessel in a restaurant in Normandy" (photo—cat. 232), *274*, 275, (fig. 9) *433*

"Lucy Hessel in the studio on Boulevard Malesherbes" (photo—cat. 241), *278*

"Lucy Hessel laughing, leaning against a haystack" (photo—cat. 224), 270, *271*

"Lucy Hessel leaning against a haystack" (photo—cat. 223, fig. 10), *270*, *434*

"Lucy Hessel reclining on the grass" (photo—cat. 225), 270, *271*

"Lucy Hessel seated in front of the fireplace of La Terrase" (photo—cat. 208), *264*

"Lucy Hessel seated in the salon of La Terrase" (photo—cat. 203), *262*, 263

"Lucy Hessel visiting Madame Vuillard" (photo—cat. 204), *263*, 431

*Lugné-Poe* (cat. 37), 80, *97*, 225

*Lugné-Poe* (fig. 8), *466*

*Lugné-Poe and Berthe Bady* (cat. 60), *117*

"Lulu Hessel in the menagerie at the Château des Clayes," *46*

"Lulu Hessel posing for "Peace, Protector of the Muses" (photo—cat. 253), *282*

*Luncheon* (cat. 264) as part of *The Terrace at Vasouy* (cats. 263–264), 296, *299*

*Lunchtime* (cat. 78), *134*

**M**

*Madame Hessel in Her Boudoir—II* (cat. 297), *359*, 359–360

"Madame Roussel mère, Marthe Bonnard, Vuillard, Annette Roussel and Pierre Bonnard around the table at Kerr-Xavier Roussel's house" (photo—cat. 238), 240–241, *276*, 277

"Madame Vuillard" (photo—cat. 170), *247*

"Madame Vuillard and her daughter-in-law Marie in Vuillard's salon-studio" (photo—cat. 228), *272*

*Madame Vuillard and Marie* (fig.1), *82*

"Madame Vuillard and Romain Coolus" (photo—fig. 1), *425*

"Madame Vuillard at her toilet" (photo—cat. 251), 2, *281*, 436

"Madame Vuillard cleaning green beans at Myosotis" (photo—cat. 201), *261*

"Madame Vuillard cooking, a skimmer in her hand" (photo—fig. 12), *435*

"Madame Vuillard cooking" (photo—cat. 169), *247*, 427, 435

"Madame Vuillard doing her hair" (photo—cat. 202), *262*, 263

"Madame Vuillard dressed to go out" (photo—fig. 2), *3*

"Madame Vuillard, her son Alexandre and his wife, Marie, in Lorient" (photo—cat. 239), *276*, 277

"Madame Vuillard in an armchair in the dining room" (photo—cat. 182), *253*

"Madame Vuillard in her room in Salenelles" (photo—cat. 229), *272*, vi–vii

*Madame Vuillard Lighting the Stove* (cat. 290), 326, 343–344, *344*

"Madame Vuillard, Place Vintimille" (photo—fig. 1), *3*

*Madame Vuillard Reading the Newspaper* (cat. 154), *227*, 227–228

"Madame Vuillard seated on her bed" (photo—cat. 252), 2, *282*, 436

"Madame Vuillard seated" (photo—cat. 240), *277*, 423

"Madame Weil and her children" (photo—fig. 1), *382*

*Madame Weil and Her Children* (cat. 316), 382, 382–383

*Mademoiselle Jacqueline Fontaine* (cat. 301), 356, 365–366, *366*

*Man Reading* (cat. 8), 62, 62–63

*Man with Two Horses* (cat. 36), *96*, 96–97

*The Mantelpiece* (cat. 281), 326, *330*, 330–331

*Marcel Kapferer* (cat. 318), *385*

"Marcelle Aron brushing her hair in her room" (photo—cat. 219), *268*, 269

"Marcelle Aron reclining on the stairs of the Château-Rouge" (photo—cat. 218), *268*, 269

"Marcelle Aron ascending the stairs of the Château-Rouge" (photo—cat. 216), *267*

"Marcelle Aron in a restaurant in Normandy" (photo—cat. 230), *273*, (fig. 8), *233*

*Marie at the Balcony Railing* (cat. 88), *157*

"Marie, Kerr-Xavier and Annette Roussel" (photo—cat. 248), *280*, 281

"Marie Roussel in an armchair in the dining room" (photo—cat. 181), *252*

"Marthe Denis with a dove at La Montagne" (photo—cat. 199), *260*

"Marthe Mellot, Annette Natanson and Alfred 'Athis' Natanson" (photo—cat. 206), *263*

"Maurice and Marthe Denis at La Montagne" (photo—cat. 198), *260*

*Maurice Denis* (cat. 292) as part of *The Anabaptists: Bonnard, Denis, Maillol, Roussel* (cats. 291–292), 345, *347*

*The Medieval Gallery at the Musée des Arts Décoratifs* (cat. 286) as part of *Decorations for Camille Bauer* (cats. 284–288), 337, *338*

*Michel Feydeau on a Carpet* (fig.1), 360, *361*

498

"Misia and Thadée Natanson in
the salon of La Croix des
Gardes, in Cannes" (photo—
cat. 195), *258, 259*

"Misia and Thadée Natanson"
(photo—fig. 3), *429*

*Misia and Vallotton at Villeneuve*
(cat. 147), 188, 216–217, *217, 491*

*Misia at the Piano* (cat. 157), *231*

"Misia Natanson and Romain
Coolus" (photo—cat. 176), *250*

"Misia Natanson in a rattan chair
at La Croix des Gardes, in
Cannes" (photo—cat. 194),
*258, 259*

"Misia Natanson in front of the
credenza" (photo—cat. 175), *250*

"Misia Natanson in the salon of
Les Relais" (photo—cat. 179),
*251, 252*

"Misia Natanson on the steps of
La Croix des Gardes, in
Cannes" (photo—cat. 193),
*258, 259*

"Misia Natanson seated on a chaise
lounge" (photo—cat. 168), *246*

"Misia Natanson seen in profile in
a carriage in Cannes" (photo—
cat. 192), *258, 259, 434*

*Monsieur and Madame Georges
Feydeau* (fig. 6), *466*

*Mother and Daughter against a Red
Background* (cat. 27), 16, *82*

*Mother and Daughter at the Table*
(cat. 80), *129, 133, 136,* 136–137

*The Mumps* (cat. 81), 138, *140*

*Music* (cat. 140) as part of *Figures
in an Interior* (cats. 137–140),
195, *199*

## N

*The Nape of Misia's Neck* (cat. 149),
26, 220

*Nine Silhouettes of Women—
Studies of Seamstresses*
(cat. 13), *68*

*Nude in the Studio* (cat. 277),
326, *327*

*Nude Seated in an Armchair*
(cat. 278), 326, *328*

*Nude with Raised Arms (Claire
Cala)* (cat. 280), 326, *329*

*Une nuit d'avril à Céos; L'Image*
(lithograph for playbill)
(cat. 71), 123, *126*

*Nursemaids and Children in a
Public Park* (cat. 108) as part
of Desmarais panels
(cats. 103–110), 166–167, *169*

*The Nursemaids* (cat. 113)
as part of *The Public Gardens*
(cats. 111–124), 171, *174*

## O

*Octagonal Self-portrait* (cat. 6),
11, 53, 60–61, *61*

"Odilon Redon" (photo—
cat. 186), *254*

*Onstage Rehearsal* (cat. 38), *98*

*Overdoor—I* (cat. 123)
as part of *The Public Gardens*
(cats. 111–124), 172, *182*

*Overdoor—II* (cat. 124)
as part of *The Public Gardens*
(cats. 111–124), 172, *182*

## P

*Panel for Prince Emmanuel Bibesco:
The Haystack* (cat. 266),
302–304. *See also The Haystack*
(cat. 266)

"Paul Élie Ranson, Félix Vallotton,
Pierre Bonnard, Maximilien
Luce, Paul Sérusier and Vuillard
at La Montagne" (photo—
cat. 196), *259*

"Paul Sérusier leaning against
the mantelpiece and Madame
Vuillard's shadow" (photo—
cat. 235), *275, 428*

*Peace, Protector of the Muses:
Decoration for the Palais de la
Société des Nations, Geneva*
(cats. 294–296), 45, 350–353,
*351, 402*

*First Sketch* (cat. 294), 350, *352*
*Second Sketch* (cat. 295), 350, *353*
*Third Sketch* (cat. 296), 350, *353*

*Peace, Protector of the Muses*
(fig. 1), *350*

*Perfect Harmony* (cat. 324), 357,
392, *394,* 394–395

*Le Petit Café* (fig. 7), *466*

*Phonographies Darzen* (fig. 1), *72*

*Pierre Bonnard* (cat. 161), 235, *236*

*Pierre Bonnard* (cat. 291) as part
of *The Anabaptists: Bonnard,
Denis, Maillol, Roussel*
(cats. 291–292), *346*

"Pierre Bonnard" (photo—
cat. 171), *248, 249*

"Pierre Bonnard and Emmanuel
Bibesco at the Hotel Inglès in
Madrid" (photo—cat. 191),
*256, 257*

"Pierre Bonnard and Kerr-Xavier
Roussel at the window in
Venice" (photo—cat. 188),
*254, 255*

*Place Vintimille* (figs. 1 and 2), *308*

*Place Vintimille or Berlioz Square*
(fig.1), *314, 371*

"Place Vintimille undergoing
construction work" (photo—
fig. 2), *314*

"Place Vintimille, viewed from
the fourth floor of the Rue de
Calais" (photo—fig. 1), *309*

*Portrait of Elvire Popesco* (fig. 40),
*44, 45*

*Portrait of Henry and Marcel
Kapferer* (cat. 305), 40, 300,
356, *371*

*Portrait of Marcelle Aron* (cat. 300),
357, *364,* 364–365

*Portrait of Philippe Berthelot*
(fig. 36), 38, *39*

*Portrait of Thadée Natanson*
(fig. 3), *461*

*Program for the Théâtre-Libre*
(cat. 41), *99*

*Promenade at the Port, Le Pouliguen*
(fig. 8), *450*

*Promenade* (fig. 2) as part of
*The Public Gardens*
(cats. 111–124), 176, *177*

*Promenade in the Vineyard*
(cat. 151), 25, 221, 222–224,
*224, 444*

*The Public Gardens* (cats. 111–124),
19, 22, 171–183, 194
*The Conversation* (cat. 114),
*163,* 171, *174*
*First Steps* (cat. 116), 172, *177,*
410, 418
*The Nursemaids* (cat. 113),
171, *174*
*Overdoor—I* (cat. 123), 172, *182*
*Overdoor—II* (cat. 124), 172, *182*
*Promenade* (fig. 2), 176, *177*
*The Questioning* (cat. 112),
171, *173*
*The Red Parasol* (cat. 115),
171, *175*
*Square de la Trinité* (fig. 21)
Study for—with layout of the
room (cat. 120), *181*
Study for (cat. 119), 172, 176, *180*
Study for (cat. 120), 172, *181*
Study for Four Panels in
(cat. 122), 172, *181*
Study for Triptych in (cat. 121),
172, *181*
*The Two Schoolboys* (cat. 117),
172, *178,* 182
*Under the Trees* (cat. 118), 172,
*178,* 182
*Young Girls Playing* (cat. 111),
171, *173*

## Q

*The Questioning* (cat. 112)
as part of *The Public Gardens*
(cats. 111–124), 171, *173*

## R

*Reclining Nude* (cat. 44), 100–101,
*101*

*The Red Parasol* (cat. 115)
as part of *The Public Gardens*
(cats. 111–124), 171, *175*

*Rehearsal at the Conservatory*
(cat. 39), *98*

"The road from Grenada to
Cadiz seen from a horse-drawn
carriage" (photo—cat. 189), *256*

*Romain Coolus* (cat. 160), 235, *236*

"Romain Coolus and Lucy Hessel
in Amfreville" (photo—
cat. 227), 270, *271*

"Romain Coolus and Misia Natan-
son descending the stairs at
Les Relais" (photo—cat. 177),
250, *251*

"Romain Coolus in a restaurant in
Normandy" (photo—cat. 233,
fig. 6), *274,* 275, *432*

"Romain Coolus, Lucy Hessel and
an unidentified woman in the
garden of the Château-Rouge"
(photo—cat. 213), *266, 267*

"Romain Coolus, Tristan Bernard
and Marcelle Aron in the
garden of the Château-Rouge"
(photo—cat. 212), *266, 267*

*Rosmersholm* (lithograph for
playbill) (cat. 66), *123,* 124, 152

## S

*Sacha Guitry in His Dressing Room*
(cat. 302), xi, 356, *367,* 466

*Sacha Guitry, the Dwarf Gardey
and His Partner in the Wings at
the Théâtre Édouard VII* (fig. 1),
383, *384*

*The Salle Clarac* (fig. 3), 338, *339,*
as part of *Decorations for Camille
Bauer* (cats. 284–288)

*The Salle des Cariatides at the
Louvre* (cat. 288) 337, *341* as part
of *Decorations for Camille Bauer*
(cats. 284–288),

*The Salle La Caze at the Louvre*
(cat. 287) as part of *Decorations
for Camille Bauer* (cats. 284–
288), 337, *340*

*Scene from a Play by Ibsen* (cat. 59),
*116,* 116–117

*Scene from "L'Enfant Prodigue":
Pierrot Begging His Father's
Pardon* (cat. 50), 107–108, *108*

*Screen for Stéphane Natanson:
Figures in an Interior* (cat. 141),
25, *200–202*

*Seamstress with Scraps* (cat. 81), *138*

*Seated Nude* (cat. 25), *80*

*Self-portrait against the Light*
(fig. 8), 8, *9*

*Self-portrait* (cat. 7), 60–61, *61*

*Self-portrait in the Dressing-Room
Mirror* (cat. 289), 324, *342,*
343, 406

*Self-portrait of the Artist with His
Sister* (cat. 20), *75*

*Self-portrait with Cane and Straw
Hat* (cat. 28), 79, *83*

*Set Design for "La Vie Muette" by
Maurice Beauborg* (cat. 61), *118*

*Six Overdoors for Monsier and
Madame Paul Demarais*
(cats. 103–110), 164, 166–170,
200, 410
*The Dressmaking Studio—I*
(cat. 103), 166–167, *168*
*The Dressmaking Studio—II*
(cat. 104), 166–167, *169*
*A Game of Shuttlecock* (cat. 107),
85, 166–167, *168*
*Gardening* (cat. 106), 166–167,
*169*
*Nursemaids and Children in a
Public Park* (cat. 108), 166–167,
*169*
sketches for (cat. 109–110),
166, *170*
*Stroking the Dog* (cat. 105),
166–167, *168*

*Sketch for "Le Concile féerique"* (cat.
56), 110–111, *111,* 407

*Sketch for "The Bois de Boulogne"*
(fig. 20), *23*

*Sketch for the "Desmarais Panels"*
(cat. 109), 166–167, *170*

*Sketch for the "Desmarais Panels"*
(cat. 110), 166–167, *170*

*Sketch for "The Widow's Visit"*
(fig. 1), *226*

*Sketch for "The Suitor"* and
*"The Bridal Chamber"* (cat. 91),
147, *149*

*Solness le Constructeur* (lithograph
for playbill) (cat. 72), *123, 127*

*Les Soutiens de la société* (litho-
graph for playbill) (cat. 73), 123,
*127,* 152

*Square de la Trinité* (figs. 1 and 21),
*24,* 176, 179

*The Staircase Landing, Rue de
Miromesnil* (cat. 76), *132,* 137,
416–418, *417*

*Stéphane Mallarmé* (cat. 163),
235, *237*

*Stéphane Mallarmé* (cat. 164), 235,
*238, 459*

*Stéphane Mallarmé* (fig. 5), *462*

*The Stevedores* (cat. 5), 11, *59*

*The Stitch* (cat. 86), 138, 143–145,
*144,* 409

*The Stoneware Pot* (cat. 129)
as part of *Five Panels for Thadée
Natanson* (cats. 126–130), 186,
188, *190,* 191, 216

*The Straw Hat* (cat. 29), *84,* 85
See also *In the Public Garden—
The Straw Hat* (cat. 29)

*A Street Strongman* (fig. 4), *6*

*The Striped Blouse* (cat. 126)
as part of *Five Panels for Thadée
Natanson* (cats. 126–130), *1,*
186, *187*

*Stroking the Dog* (cat. 105)
as part of Desmarais panels
(cats. 103–110), 166–167, *168*

*Study for "Annette Dreaming"*
(cat. 308), *376*

*Study for "Grandmother at the
Sink"* (fig. 1), *58*

*Study for "Jeanne Lanvin"*
(cat. 331), 396, *400*

*Study for "Jeanne Lanvin"*
(cat. 332), 396, *401*

*Study for "Jeanne Lanvin"*
(cat. 333), 396, *401*

Study for "Jeanne Lanvin":
  The Books (cat. 327), 396, 398
Study for "Jeanne Lanvin":
  The Dog (cat. 329), 396, 399
Study for "Jeanne Lanvin":
  The Hand (cat. 330), 396, 400
Study for "Jeanne Lanvin":
  The Hand on the Desk (cat. 328),
  396, 398
Study for "Kerr-Xavier Roussel
  Reading the Newspaper"
  (fig. 1), 145
Study for "Marie at the Balcony
  Railing" (fig. 1), 146
Study for "Place Vintimille"
  (cat. 269), 306–308, 307
Study for "Place Vintimille"
  (cat. 270), 306–308, 307
Study for "The Chapel at the
  Château de Versailles"
  (fig. 1), 334
Study for "The Chapel at the
  Château de Versailles"
  (fig. 2), 334
Study for "The Dressmakers":
  Madame Vuillard (fig.1), 66
Study for "The Dressmakers":
  Marie Vuillard (fig.2), 66
Study for "The Public Gardens":
  Square de la Trinité (figs. 1
  and 21), 24, 176, 179
Study for "Yvonne Printemps and
  Sacha Guitry" (cat. 314), 377, 381
Study for "Yvonne Printemps and
  Sacha Guitry" (cat. 315), 377, 381
Sunlit Interior: Madame Vuillard's
  Room at La Closerie des Genêts
  (cat. 276), 320–322, 321
The Surgeons (cat. 306), (fig. 37),
  40, 41, 320, 325, 348, 372–373,
  372–374
"Suzanne Avril, Misia Natanson
  and Vuillard in Misia's room"
  (photo—cat. 178), 250, 251
Swiss Landscape (cat. 255), 287,
  288, 288–289
Swiss Landscape (cat. 260), 287, 293

**T**

The Table: End of a Lunch at the
  Vuillard Home (cat. 98), 156
Table service commissioned by
  Jean Schopfer (cats. 131–136),
  192–194, 193
The Tapestry (cat. 127) as part of
  Five Panels for Thadée Natanson
  (cats. 126–130), 186, 189
The Temptation of Saint Anthony
  (fig. 3), 5
The Terrace at Vasouy
  (cats. 263–264), 244, 296–299
  The Garden (cat. 263), 296, 298
  Luncheon (cat. 264), 296, 299

Théodore Duret in His Study
  (cat. 304), 356, 369–370,
  370, 374
"Tristan Bernard and André Picard
  on the stairs of the Château-
  Rouge" (photo—cat. 217),
  268, 269
"Tristan Bernard and, on the
  right, Lucy Hessel" (photo—
  fig. 1), 303
"Tristan Bernard in a restaurant in
  Normandy" (photo—cat. 231),
  273, (fig. 7) 432
"Tristan Bernard, Louise Hessel,
  Vuillard and Lucy Hessel at
  the Château-Rouge" (photo—
  cat. 214), 267
Twilight at Le Pouliguen (cat. 267),
  304–306, 305
Two Nude Figure Studies (cat. 279),
  326, 329
The Two Schoolboys (cat. 117)
  as part of The Public Gardens
  (cats. 111–124), 172, 178

**U**

Under the Trees (cat. 118)
  as part of The Public Gardens
  (cats. 111–124), 172, 178

**V**

Vaquez Panels: Figures in an Interior
  (cats. 137–140), 195–199, 196,
  198, 199
The Veranda at Le Coadigou in
  Loctudy (cat. 274) as part of
  Decoration for Bois-Lurette
  (cats. 274–275), 317, 318
La Vie muette (lithograph for
  playbill) (cat. 75), 123, 124, 128
The "Voiles de Gênes" Boudoir
  (cat. 323), 392–393, 393
"Vuillard and Alexandre Natanson
  in front of Les Relais" (photo—
  cat. 166), 246
"Vuillard and Antoine Bibesco
  on a train in Spain" (photo—
  cat. 190), 256, 257, 473
"Vuillard and his mother"
  (photo—cat. 242), 278
"Vuillard and Lucy Hessel at the
  Château des Clayes" (photo—
  fig. 35), 38
"Vuillard and Lucy Hessel in
  Amfreville" (photo—cat. 221),
  269
"Vuillard and Misia Natanson in
  the park of Les Relais" (photo
  —cat. 167), 246
Vuillard and Waroquy (cat. 1), 54
"Vuillard at the window in Venice"
  (photo—cat. 187), 254, 255
"Vuillard in an armchair in the
  dining room" (photo—
  cat. 183), 253
Vuillard's Mantelpiece (Overdoor I)
  (cat. 284) as part of
  Decorations for Camille Bauer
  (cats. 284–288), 336, 337

Vuillard's Mantelpiece (Overdoor II)
  (cat. 285) as part of
  Decorations for Camille Bauer
  (cats. 284–288), 336, 337
"Vuillard on the beach at Mere-
  ville-Franceville" (photo—
  cat. 220), 268
Vuillard's Room at the Château des
  Clayes (fig. 13), 402, 454, 455
"Vuillard seated at the dining-
  room table" (photo—
  cat. 236), 275
"Vuillard with Yvonne Printemps
  and Sacha Guitry" (photo—
  fig. 9), 467

**W**

War Factory (Evening) (fig. 33),
  36, 325, 374
"War factory at Oullins"
  (photo—fig. 34), 37
The White Room (cat. 158), 205,
  232–233, 233
The White Salon (fig. 27), 29
The Widow's Visit (The Conversa-
  tion) (cat. 153), 225–226, 226
The Window (fig. 11), 14, 15
The Window Overlooking the Woods
  (cat. 142), 203, 203–204, 420.
  See also Île-de-France Landscape:
  The Window Overlooking the
  Woods (cat. 142)
Woman Arranging Her Hair
  (cat. 155), 228–229, 229
Woman in an Armchair (fig. 4), 429
Woman in Bed (cat. 23), 78, 78–79
Woman in Blue (cat. 95), 19–20,
  152–153, 153, 209
Woman in Profile Wearing a Green
  Hat (cat. 16), 69, 71, 97
Woman in the Countryside (cat. 150),
  221, 221–222
Woman Reading on a Bench (fig. 2),
  25, 28, 221, 443
Woman Seated in a Chair (cat. 148),
  218–219, 219
Woman Seated in a Dark Room
  (cat. 97), 19, 155, 209
Woman Seated in an Armchair
  (figs. 3 and 25), 25, 28, 221, 443
Women in the Garden: "Le Cantique
  des Cantiques" (cat. 58), 91, 93,
  113–115, 114
Work (cat. 137) as part of Figures
  in an Interior (cats. 137–140),
  195, 196

**Y**

The Yellow Curtain (cat. 94), 152
Young Girls Playing (cat. 111) as
  part of The Public Gardens
  (cats. 111–124), 171, 173
Young Girls Walking (cat. 31), 75,
  79, 86–87, 87
Yvonne Printemps and Sacha Guitry
  (cat. 311), 377, 379
Yvonne Printemps on the Sofa
  (cat. 310), 377, 378
  detail, 355
Yvonne Printemps: Study of the
  Face and a Hand for "Yvonne
  Printemps and Sacha Guitry"
  (cat. 312), 377, 380
Yvonne Printemps: Study of the
  Face and a Hand for "Yvonne
  Printemps and Sacha Guitry"
  (cat. 313), 377, 380

## Illustrations

Every effort has been made to locate copyright holders for the photographs used in this book. Any omissions will be corrected in subsequent editions.

*Chapter Openers (details)*

page ii: Anonymous photograph (probably taken by Lucie Belin) of Vuillard in his studio on Boulevard Malsherbes, c. 1915, private collection

pages iv, v: cat. 79
pages vi, vii: cat. 229
page xi: cat. 302
page 1: cat. 126
page 51: cat. 10
page 91: cat. 58
page 129: cat. 80
page 163: cat. 114
page 205: cat. 158
page 239: cat. 172
page 283: cat. 261
page 323: cat. 283
page 355: cat. 310
page 405: cat. 18
page 423: cat. 240
page 439: cat. 256
page 459: cat. 164
page 473: cat. 190
page 475: cat. 166
page 476: cat. 167
page 478: cat. 183
page 479: cat. 242
page 483: cat. 143
page 491: cat. 147

## Photography Credits

*Backward Glances*

fig. 10: © Munch Museum (Andersen / de Jong)

fig. 19: © Munch Museum (Andersen / de Jong)

fig. 23: Jean-Loup Charmet

fig. 42: Bureau française de diffusion de presse

*Catalogue*

cat. 1: © 1987 The Metropolitan Museum of Art

cat. 2: © 2002 The Museum of Modern Art, New York

cat. 8: © RMN-Hervé Lewandowski

cat. 13: © Réunion des Musées Nationaux/Art Resource, NY; Louvre, Paris, France; fig. 1: Bibliothéque Nationale, Paris

cat. 18, fig. 2: © Réunion des Musées Nationaux/Art Resource, NY

cats. 21, 111, 112, 113, 114, 115, 283, 298, 320: ©Réunion des Musées Nationaux/Art Resource, NY; Musée d'Orsay, Paris, France; photographs by Hervé Lewandowski

cat. 36, fig. 1: Photograph by René d'Anjou

cats. 45, 120, 121, 122: © Réunion des Musées Nationaux/Art Resource, NY, Louvre, Paris, France, photograph by Michèle Bellot

cat. 58, fig. 1: Galerie Hopkins-Custot, Paris

cat. 63: © Réunion des Musées Nationaux/Art Resource, NY, Louvre, Paris, France, photograph by Gérard Blot

cat. 65: © The Art Institute of Chicago. All Rights Reserved.

cat. 79: Photograph by Luiz Hossaka

cat. 85: © 2002 The Museum of Modern Art, New York.; fig. 1: © Réunion des Musées Nationaux/Art Resource, NY, photograph by Gérard Blot

cat. 86, fig. 1: © Réunion des Musées Nationaux/Art Resource, NY, photograph by R.G. Ojeda

cat. 97: The Montreal Museum of Fine Arts, photograph by Christine Guest

cat. 117: Musées royaux des Beaux-Arts de Belgique

cat. 124, fig. 1: Wildenstein Archives

cat. 127: © 2001 The Museum of Modern Art, New York

cat. 142: © 2002 The Art Institute of Chicago

cat. 145: Photograph by Malcolm Varom, N.Y.C. 2002

cat. 151: © 2002 Museum Associates/LACMA

cat. 152: © RMN-Hervé Lewandowski

cats. 166–189, 192–199, 201–222, 224–235, 237–242, 245, 246, 248–251: Museum of Fine Arts, Montreal, photographs by Brian Merrett

cats. 190, 191, 200, 223, 236, 243, 244, 247, 252, 253: Museum of Fine Arts Montreal, photographs by Christine Guest

cat. 254: © RMN-Hervé Lewandowski

cat. 256: © Virginia Museum of Fine Arts, photograph by Ron Jennings

cat. 276: © Tate, London, 2001

cat. 293: © Réunion des Musées Nationaux/Art Resource, NY, Musée du Prieuré, St. Germain-en-Laye, France

cat. 297: Board of Trustees of the National Museums and Galleries on Merseyside (Walker Art Gallery)

cat. 299, fig. 2: Swiss Institute for Art Research

cat. 311: Photograph by Luiz Hossaka

cat. 321: © Giraudon/Art Resource, NY; Musée des Beaux Arts; Jules Cherot, Nice, France

cat. 325: © Réunion des Musées Nationaux/Art Resource, NY; Musée d'Orsay, Paris, France; photograph by Jean Schormans

*Vuillard and Ambiguity*

fig. 11: Photograph by J.-C. Ducret

*The Intentional Snapshot*

fig. 2: © 2002 The Museum of Modern Art, New York

*Vuillard and the "Villégiature"*

fig. 1: © The Art Institute of Chicago

fig. 4 : photograph by J.-C. Ducret

fig. 8 : © Réunion des Musées Nationaux/Art Resource, NY; photograph by Hérve Lewandowski

fig. 9 : © Virginia Museum of Fine Arts, photograph by Ron Jennings

This book was typeset in Fournier, Copperplate Gothic, and Fago by Stinehour Press in Lunenburg, Vermont, and the National Gallery of Art, Washington. It was printed on a Heidelberg Speedmaster 102-10 by Grafisches Zentrum Drucktechnik in Ditzingen-Heimerdingen, Germany, on Scheufelen Phoenix Motion Xantur, 150gsm.